Manuel Neri

Manuel Neri

Early Work
1953–1978

WITH TEXT BY

Price Amerson
John Beardsley
Jack Cowart
Henry Geldzahler
Robert Pincus

The Corcoran Gallery of Art
Washington, D.C.

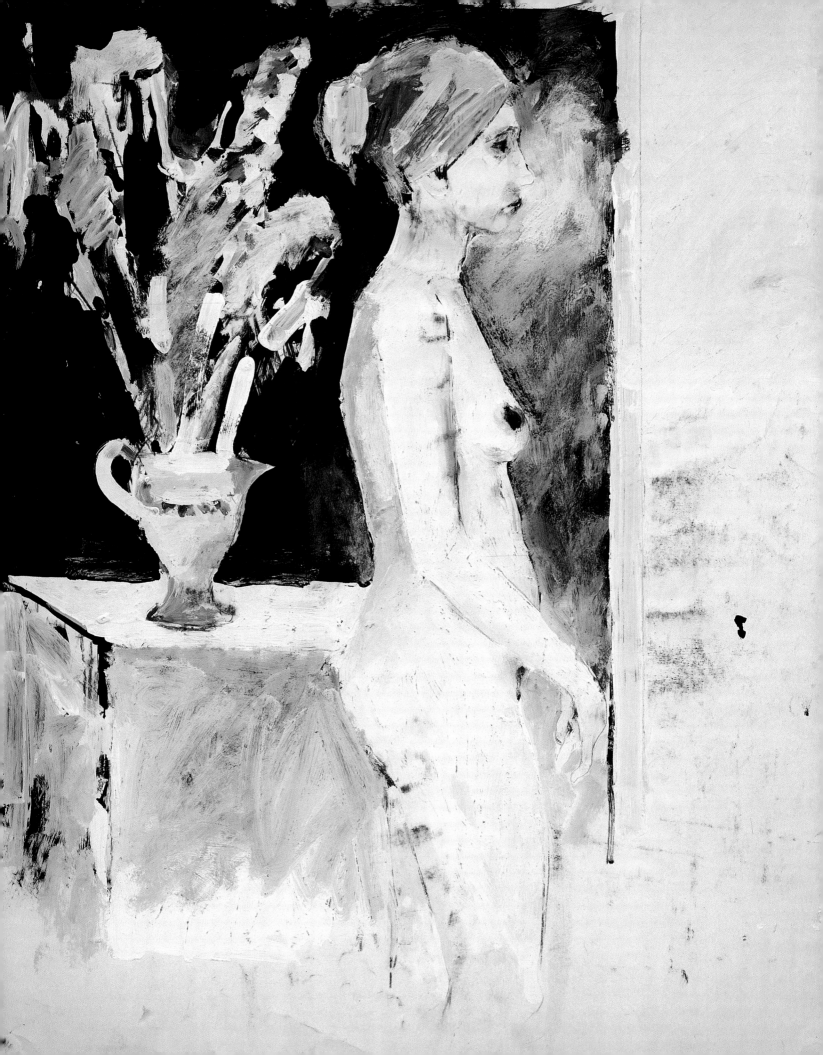

CONTENTS

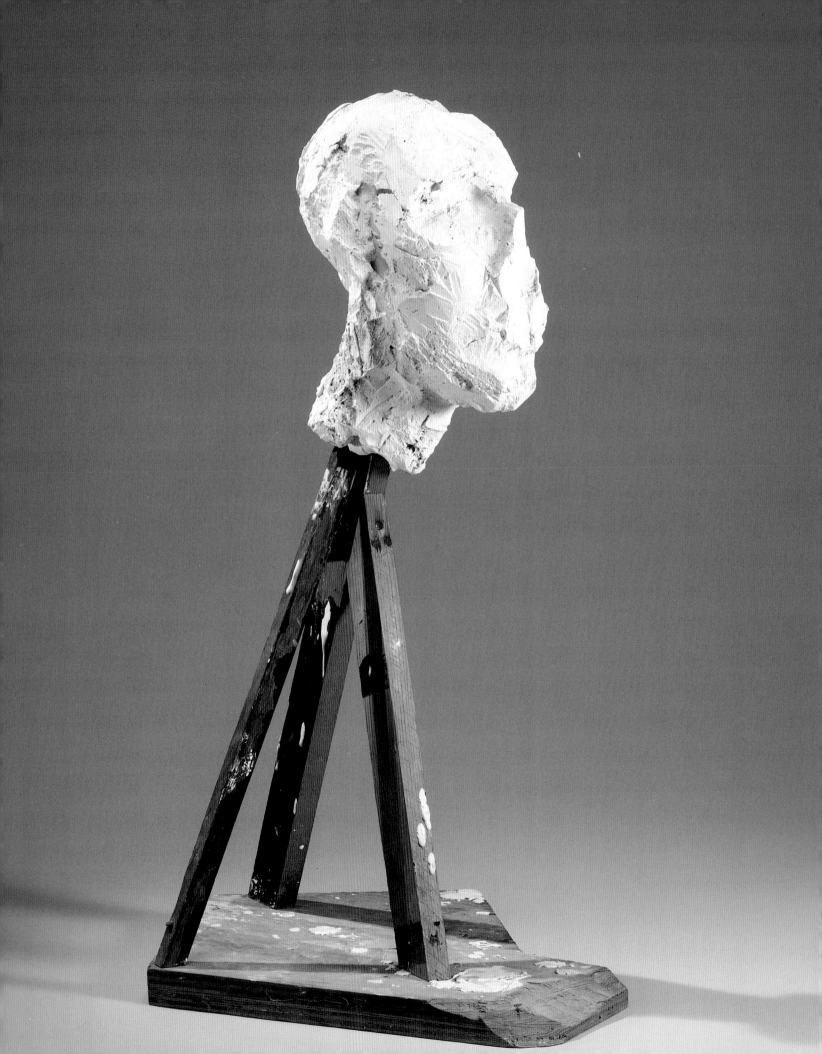

FOREWORD

JACK COWART

Imaginative sympathies, rhythms of thought, apocalyptic vision, and a poet/ performer's urgent desire to find out the future are central to Allen Ginsberg's 1955 *Howl,* a vital period piece of raucous reactionary postwar San Francisco Beat and Funk free speech. This current monograph is shaped by our own empathy to that work and period and the curious, surprisingly complex, related developments of Manuel Neri. The result is a purposeful collection of impressionistic and expressionistic essays, not a linear survey.

The 1950s to 1970s were arguably some of our country's most fecund and contradictory decades for art, along with so much else. Neri's early works and ideas, like the period, were individually rich and disjunct, but in the new long view they acquire a sweeping overall poetic continuity and persuasive power. His qualities have been given less than their due in current Bay Area social and art historical studies. Extensive new imagery, documentation, and appraisal are provided here to aid future critics in their search for a more balanced view of who did what when, to whom, for whom, in spite of and in addition to.

In this vaunted Northern California land of water, bright light, stunning vistas, cliffs, and hills, Neri has taken up the existential quest of the beauty of the unfinished, the unfinishable. His early works have extremes of surface and texture which relate to their creative birth and their succeeding stages of "death" (and perhaps re-birth) through the artist's continued searching treatments and attacks on them. Some of this begins with avant-garde Beat-era performances, where nihilism, sex, atomic/hydrogen bomb terror, and the hope for intellectual redemption actively battle. Neri mixes in ritualistic, improvisational theater and process art. He follows with a darker vision where his frozen gestures still haunt.

Neri's paintings are thickly sculpted and his sculptures and drawings are often heavily painted. The artist thus stands outside the mainstream of his more recognized and stylistically disciplined Bay Area contemporaries. It is he who seems most willful and responsive to trying almost anything or any formal device at least once. He establishes no precondition of finish to these sorties. If they fail or stop midway, his roaming interests can always find something else posing equal risk and frustration.

When working, Neri looks his models and sculpture straight in the eye, intending that he and they view the public directly as well. There is

Opposite:
Scribe, c. 1969; Reworked 1972.

no oblique escape. Willem de Kooning frequently spoke of how his own art incorporated "slipping glimpses" of the world, but Neri's begins with and keeps a harsh, fixed glare. It stalks and pins the subject down, making a heightened pressure point between the artist and model, the sculpture and us. Neri searches to reveal not only the outward physical realities but also the inward emotional charge. Locked into this double orbit we are made to feel uneasy by this direct connection to the loaded form and its evident process of creation.

When working abstractly, Neri jumps scale altogether in pursuit of some unbounded architectural vision. There he seems to hover high above us, looking down at strange city ruins and antique monuments. However beautifully crafted, these geometric forms seem to refresh the artist and then push him back to his first order of business: the figure and its rude, passionate fights in hope of making more profound human contact.

Neri's art life is thus balletic, with beautiful weightless leaps between the sweaty heavy grips of living partners in full view of the audience. Like most, Neri's backstage life is one of liaisons, marriages, births, abrasion, removes, new attractions, worries, and realities. These further inform and mature the artist in endless preparation and search of the perfect and whole performance, a search which Manuel Neri continues today.

This monograph began a number of years ago in an effort to discover and restore Neri's early works to public view, before too much more was lost or faded from memory. Manuel Neri and Anne Kohs are due particular thanks for this half decade of push and pull, advice and consent. We have made every effort to provide accurate dates and information about Neri's voluminous early oeuvre. However, it is acknowledged that various of our propositions represent speculative best guesses using all our referencing skills. The artist, rightly, was more interested in creating his work than in scientifically cataloguing it. He frequently reworked objects at a later date, sometimes radically changing their form, and there is very little consistent early documentation. All of this is very much the nature of living contemporary art, yet we hope to have at least defined a starting point for a more accurate dating and inventory of Neri's most important historical period.

There has been continued editorial expansion and specialization of the project, beginning with the initial comprehensive overview written by John Beardsley, followed by the personal appraisal of the late Henry Geldzahler and subsequent focused essays by Price Amerson, Robert Pincus, and myself, and the comprehensive chronology. Throughout, Ed Marquand has lived the design process of this book. Anne Kohs has devoted profound energies to establishing the specific image juxtapositions and the careful compositional relationships between illustrations and text in this monograph. Her dedication and the support of Ed and his team, particularly John Hubbard and Jessica Eber, have now led to a delightful visceral gestalt allowing the drama of Neri's work to leap off the page. The texts have been

carefully reviewed by the keen editorial eye of Lorna Price, who applied her skills as a wordsmith in producing a unified text. The content was further refined by Diane Roby, who assisted in editing and rewriting portions of the texts, and together the two have compiled a thorough chronology of the artist's life. We are also particularly grateful to Paul Anbinder of Hudson Hills Press for his interest and support of this project.

This monograph is published on the occasion of a select retrospective of early sculpture, painting, and works on paper organized and circulated by The Corcoran Gallery of Art. To this exhibition and catalogue we also acknowledge the contributions of Kathryn Baldwin, Jane Curliano, Llisa Demetrios, Armelle Futterman, Mara Leimanis, Nina Trowbridge, and Jennifer Tunny at Anne Kohs & Associates; and at the Corcoran, Johanna Halford-MacLeod, Rhonda Howard, Victoria Larson, and Cindy Rom.

The establishment of the Manuel Neri art archives and study center at The Corcoran Gallery of Art during the research for this monograph has been one of the many profoundly gratifying results of the collaboration between the artist, his friends and supporters, and all of us at the Corcoran. We acknowledge with deep gratitude that generosity which will allow these riches to be made available to our art school students, museum visitors, researchers, and the broad new public audiences in our nation's capital.

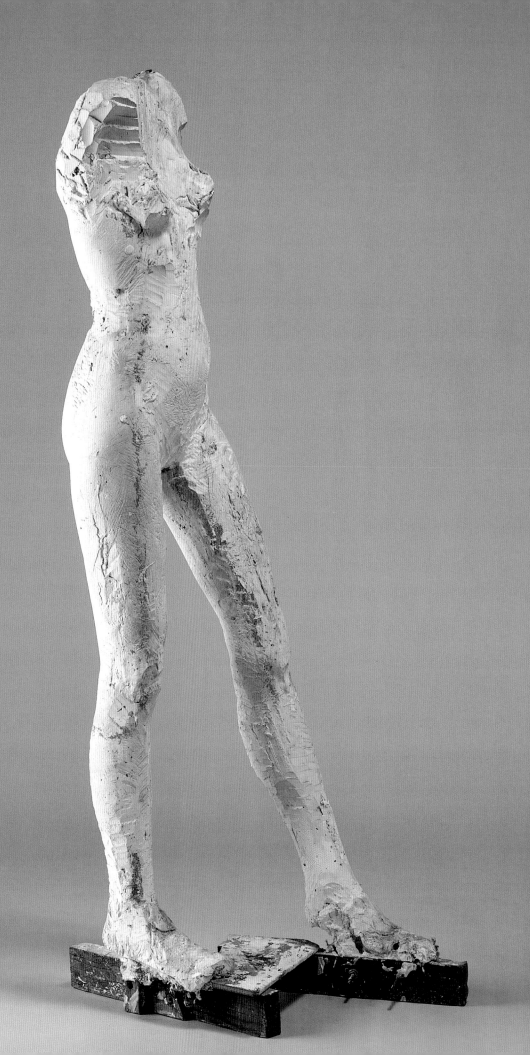

INTRODUCTION

HENRY GELDZAHLER

Manuel Neri works in a century-old tradition: the esthetic of the fragmented torso that Rodin established as a key element in sculpture, in which he formalized the awful yet pleasurable shock we experience on observing mutilation which we accept in art but would find horrifying in the flesh. This tradition has been maintained in Western art from the Renaissance rediscovery of classic proportion by way of the broken torsos of unearthed Greek and Roman sculpture. The Venus de Milo, the most widely known and admired precursor to the esthetic adopted by Rodin, and eighty years later by Manuel Neri, was uncovered on a Greek island as late as 1820; until then, the relatively intact Medici Venus had been the cynosure of every connoisseur.

What amazes me, after knowing Neri's work for thirty years, is the continuing vitality of his innovation. In an evergreen inspiration, the sculptor had the gall to take figurative sculpture a step farther by painting vivid brushstrokes on his version of the classical female icon. He uses color not as decoration but as an integral element in his sculpture, both highlighting its anatomy and working to abstract it, forcing us to see the figure in a novel manner.

Color in Neri's work comes about not as an afterthought or as a device, but grows out of both his background and his ambition as a Bay Area figurative artist of the 1950s. Thus we can begin our consideration of the quality and appeal of Neri's sculpture by the formulation, still astonishing after almost four decades of his work, that he has married the Greco-Roman canon of beauty in its post-Rodin fragmented mode to the stylistic imperative of abstract expressionism as it was seen in the Bay Area in the 1950s.

Manuel Neri's first ambition was to be an engineer. While pursuing his studies, he sat in on some art courses, and he soon realized that art need not be merely decorative but that it was actually an affair of the gut, something visceral to which he could dedicate himself fully. The work of the ceramist Peter Voulkos provided Neri's epiphany. After a stint in the army in Korea, he entered a succession of art schools in Oakland, Berkeley, and San Francisco. During the years of his apprenticeship, in which he worked with Voulkos, Neri attended the California College of Arts and Crafts, where his teachers included Richard Diebenkorn and Nathan Oliveira. In 1957 he enrolled in the California School of Fine Arts to continue his studies with Elmer Bischoff.

Opposite:
Untitled, 1974.

Neri's first attraction was to ceramics, but he soon felt that Voulkos had something of a lock on the medium. Neri tells us that he moved into sculpture partly because "it was a natural jump, taking that kind of color from a three-dimensional form onto other mediums. I didn't see any problem in taking it from a ceramic piece over to a figurative piece." An additional factor in his concentrating on sculpture was his almost daily contact with the inches-thick paintings of his friend Jay DeFeo. "My paintings kept getting thicker and thicker, and one day I said to myself, 'What am I doing here? If these things get any thicker they're going to fall off the wall. I might as well do sculpture.' So I decided to bring my color ideas from both ceramics and painting into sculpture."

Manuel Neri's art, particularly his attitude toward the figure, must be seen in the context of the work of his teachers and colleagues—most tellingly in the work of David Park, Richard Diebenkorn, Elmer Bischoff, and Nathan Oliveira—in the movement usually referred to as the Bay Area figurative school. It isn't too simplistic to conceive of Neri's sculpture as the human figure plucked from their paintings, rendered three-dimensional, and painted in a manner consonant with Bay Area figuration's styles of brushwork and color. One characteristic of the school is the passivity of figures in relation to the agitated brushwork in which they are suspended. From the start, however, Neri's approach to the figure was more emotive and existentially committed, more felt than the work of his counterparts in painting. While Neri's singular use of paint may best differentiate his work from that of his colleagues in figurative sculpture, his genius in the use of plaster is the basis of his success as an artist. This is obvious when we study Neri's plaster figures, most of which remain perfectly white, in their "natural" state.

Neri says "I just love plaster. It's cheap. You can do anything with it. You can keep adding to the figure. If you don't like what you have, you can start over. And I love that dead white." The way in which he gouges and slashes parts of the plaster female stands in marked contrast to those lovingly modeled areas in which he reveals his tenderness. Not all of Neri's incursions into the plaster, however, need to be seen in such energetic terms as gouging and slashing. He files and sands, and also creates texture on the pieces, using spatulas, knives, and his own hands when it suits him to do so. When asked why he does such violence to his work, Neri says, "I don't see it as attacks. I remove anything that portrays character; those things just get in the way for me." It is the gesture and the "body language" that fascinate him: "I don't like the figure to have a definite face or character. Even the hands and feet can suggest too much. The figure is enough for me." With plaster, "what's taking place on the surface of the structure when I move the material around or hack into it is no different from pushing paint around. . . . Color is part of what's happening on the surface, and it does not relate to actual anatomical form." I think it is not too much to say that the work in plaster is at the heart of Manuel Neri's vision, ambi-

Opposite:
Bull Jumper, 1980; Reworked 1987.

tion, and achievement. In plaster the savage and tender meet to communicate his esthetic and his attitude toward women and to the world. It is clear that the main drive of Neri's life and work is the adoration of that which is female, of 'Woman' in general and, more particularly, individual women. "I find the opposite sex fascinating. There is something magic about women and the female form. It says so much about me. It's the whole White Goddess idea, the old European myth." Neri's goal in making sculpture, and the standard by which he judges himself, is the extent to which he is able to "catch the sensibility of a whole person. . . ." Since 1972, Neri's model Mary Julia has represented both Woman and the individual woman to him. Neri tells us that her intensity inspired him to make his most radical work, radical in terms of the unambiguous sexual positions in which the figure is memorialized so forcefully; that its only precedent is the anatomically explicit sculpture of some of Rodin's women. Although Neri, sometimes with an irritated "I'm just a Beat sculptor," shrugs off learned arguments about which myth he is alluding to in a piece like *Bull Jumper,* we cannot suppress our knowledge of Minoan initiation ceremonies when we contemplate this original and harshly poignant sculpture.

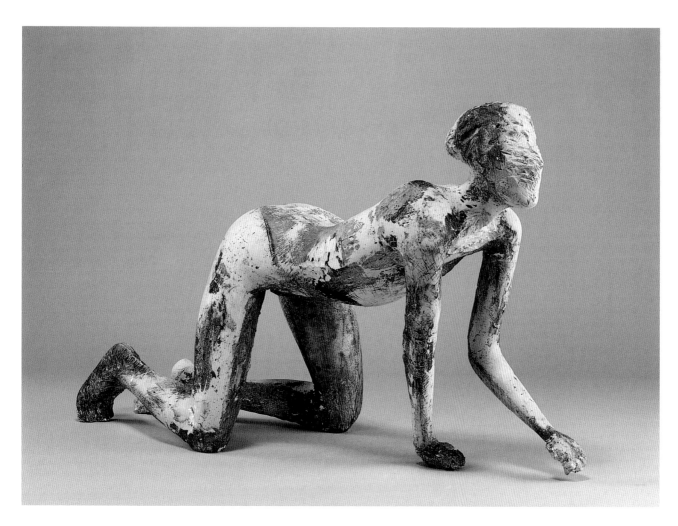

Mary Julia was transformed by her years with Neri. From simply being a model she became a central figure in the sculptor's life. As both were caught up in the vortex of a complicated relationship she, in the process, developed a strong character, partly, one guesses, to counter the sculptor's ego and intensity. Their collaborative book (her poems, his etchings) was called *She Said: I Tell You It Doesn't Hurt Me*. All this is wonderfully caught in a poem Mary Julia wrote called "Hug Me Dead":

> I want you to hug me dead with those
> huge warm arms of yours. Nothing else
> matters outside. The only thing of interest
> is the lightning because it might crack
> above my head—harder—frighten me good
> make me grateful.

In a series of heads of the Japanese model Makiko, Neri's work moves in a very different direction. Rather than the anatomical boldness of Rodin, we see neo-classicism in the careful and smooth modeling of a face in which the features are repressed in service of the form's fluidity; here we see links to another strain of modern sculpture that comprehends artists rarely thought of together—Medardo Rosso and Charles Despiau, for instance. We feel in the "Makikos" that ecstatic moment in which we breathlessly encounter some essence of beauty itself. We need know nothing of the context of their making to fall under their spell, neither the model's background nor the stylistic matrix in which the artist has worked. The sculpture is all. For several reasons, among them the fragility of plaster and the increasing call on Neri's work to appear in several places at the same time, in the late 1970s he rather reluctantly began casting some of the plasters in bronze: "As I was beginning to earn more money, I was able to cast in bronze. I don't care for bronze in itself. It has a lot of connotations I don't care for. The idea of its being a traditional museum item bothers me. That's why I paint the bronze figures. I think then you really get away from that." Neri's work in both bronze and marble, another material he turned to in the 1980s, has a finished, permanent look that is inimical to his working methods in plaster. In plaster Neri builds—he adds; he takes away. In bronze and marble, he saws and files and gouges in different ways, responding to the properties of each material. He uses a glossier, oil-based enamel on the bronzes, but allows the Carrara marble's coloration to vary the surface within each piece, though he sometimes uses a frescolike wash to dim or highlight its surface. Truth to each material, and to his highly developed poetic stance toward Woman, ties the work in a single esthetic. Neri's work can be seen to fit comfortably in both an American and European context. While it unmistakably originates in the wide wake of abstract expressionism, it is equally at home, especially in its sculptural aspect, in a modernist European tradition. One need only see the subtle balletic poses and movements of Neri's women to sense that he has studied Degas's dancers in

painting and in sculpture. Pierre Restany, a French critic and historian who has written sympathetically of his work, said in 1984, "Neri belongs by instinct to the great modern tradition of statuary. When he is exalted, he sees the model through the eyes of Rodin; when he flees from himself he draws it as Giacometti would have done." Manuel Neri's exultation, like Rodin's, results from the successful evocation in sculpture of his ecstatic encounters with women. In Giacometti's work, light and intensity of feeling it burn away the human form, a compelling existentialist metaphor. Life diminishes us, but a stubborn spiritual core survives. Manuel Neri adds color and subtracts anatomy to produce an artistic equivalent to his intensely felt commitment to a life of the senses that coexists in him with alienation. As for Giacometti, the sculpture works because it is a metaphor for Neri's life, a life lived without cant or self-deception.

May 1993, Southampton

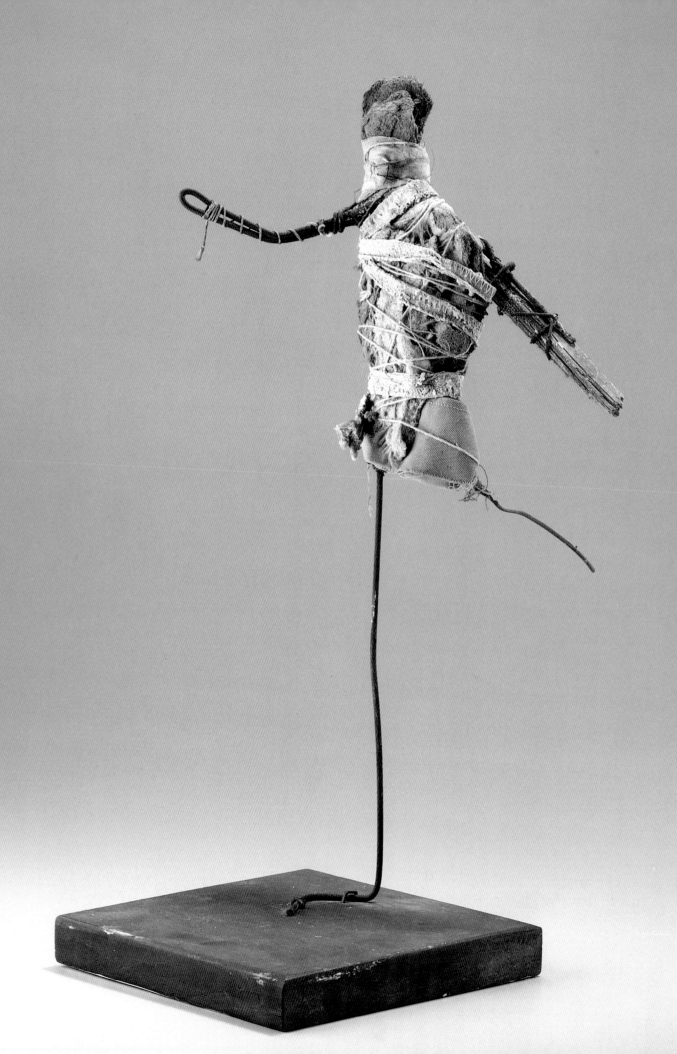

THE HAND'S OBLIGATIONS

JOHN BEARDSLEY

Let that be the poetry we search for: worn with
the hand's obligations, as by acids, steeped in sweat
and in smoke, smelling of lilies and urine, spattered
diversely by the trades that we live by, inside the law
or beyond it.

A poetry impure as the clothing we wear, or our
bodies, soup-stained, soiled with our shameful
behavior, our wrinkles and vigils and dreams,
observations and prophecies, declarations of loathing
and love, idylls and beasts, the shocks of encounter,
political loyalties, denials and doubts, affirmations
and taxes . . .

Those who shun the "bad taste" of things will fall
flat on the ice.

<div style="text-align:center">

Pablo Neruda
"Toward an Impure Poetry"[1]

</div>

Manuel Neri is widely celebrated for his association with what has come to be known as the Bay Area figurative school. His commitment to the human subject is seen as part of a larger tendency that originated among artists in and around San Francisco in the 1950s and 1960s. But his connections with this loosely defined movement are complicated and, at times, contradictory. Neri's involvement with the figure was never absolute; he has moved freely between abstraction and figuration through most of his career, even electing at times to concentrate on the creation of gestural abstract paintings or geometric abstract sculptures—though never to the exclusion of the figure. Indeed, Neri's abstract work often helped him focus on formal and chromatic concerns that he would later bring to bear in conveying the full emotional and psychological weight of the figure. Even within his figurative work, there was much that set Neri apart from other artists in the Bay Area school: he was a sculptor in a group composed of painters, and he was as much impelled by other artistic inclinations—local, national, international—as by Bay Area figuration. He seems to have

Opposite:
1. *Wire Figure No. 1,*
c. 1956–57.

1

been motivated by a desire to reconcile figurative art with the objectives of cubism, abstract expressionism, minimalism, and other modern movements, especially through explorations of gesture, proportion, architectural space, fragmented form, and the expressive power of color. What is more, Neri has nurtured a lifelong avocation for modern poetry, which perhaps has shaped his sensibilities as much as any visual art. All this makes reckoning with his work a far more elusive and complex challenge than one might first believe.

There is, to begin with, some cause to question whether Neri was drawn to the figure for the same reasons as other Bay Area artists. It is generally agreed that the progenitors of Bay Area figuration—David Park especially, followed by Elmer Bischoff, Richard Diebenkorn, and then others—abandoned nonobjective painting and turned to the human subject in the early 1950s as a reaction against the hegemony that abstract expressionism achieved during the postwar years, particularly in New York, but also in some measure in San Francisco.[2] This was the thesis of the first exhibition to examine Bay Area figurative art, held at the Oakland Art Museum in 1957.[3] It was sustained by the artists' statements: Park, for example, said in 1952 that nonobjective paintings were often "so visually beautiful that I find them insufficiently troublesome, not personal enough." He added, "I often miss the sting that I believe a more descriptive reference to some fixed subject can make."[4] According to tradition, these progenitors set the example for a subsequent generation of figurative artists, among them Nathan Oliveira, Joan Brown, and Manuel Neri.

Neri came of age artistically among these painters, and his figurative art was undoubtedly nurtured by their commitment to the human subject. But Neri seems to have shared less than other Bay Area figurative artists in the reaction against pure abstraction. For Neri it was never a matter of favoring either figuration or abstraction. Rather, his main interest seems to have been in drawing on the full range of artistic sources available to him and synthesizing those interests in the development of his own creative voice. He has recalled that while abstract expressionism "was a part of the background we had," the art schools he attended were still oriented toward Europe, and he learned as much from looking at the figurative sculpture of Fritz Wotruba, Alberto Giacometti, Marino Marini, and Henry Moore as he did from looking at the representational art of California.[5]

Neri was also sustained in his commitment to figurative art by the art of Mexico, where he spent three months in 1956 with classmate Billy Al Bengston. He had already been exposed to the work of Diego Rivera in San Francisco, notably through the Mexican artist's murals at the California School of Fine Arts (now the San Francisco Art Institute) and at the Pacific Stock Exchange (now the San Francisco City Club). He recalls that Rivera's work was especially influential in the Bay Area: "That's about all there was," he remembers, at least in terms of recent art. In general, Neri

recalls feeling, as a Mexican American, that the art of Mexico and Spain represented his particular cultural patrimony—something he describes as "another world, part of our tradition, that is often ignored."

If Neri did not share in the reaction against abstraction, then neither did he instantly and wholly embrace the regional aesthetic alternative. Neri and other Bay Area artists were developing a style that was something of a hybrid between abstract expressionism and figuration, combining the roughly textured surfaces and shallow picture space of the former with the subject matter of the latter: figures, landscapes, and interiors. Neri moved freely between the poles of abstraction and representation throughout the 1950s, not settling into a style comparable to that of the Bay Area figurative artists until near the end of the decade.

Neri recalls that while the influence of abstract expressionism was profound among his peers, their exposure to the work was secondhand, through black-and-white illustrations in magazines. The apparent aggressiveness and spontaneity of approach led them to imagine that the paintings were constructed of thick layers of brilliant, harshly contrasted colors. In applying their assumptions about the works, they created paint surfaces and color contrasts that were unique to the Bay Area. It was only later, when they began to see paintings from the New York school firsthand, that they realized how subdued those works were in coloration and surface treatment in relation to their own works and those of other artists in the Bay Area.

Neri's direct exposure to abstract expressionism came through the painter Clyfford Still, who taught at the California School of Fine Arts between 1946 and 1950. Neri sat in on some of his classes, saw his show at the Metart Galleries in 1950, and would later say, "Still was an impossible shit, but he taught me a few very important things—he was a complete romantic, but uncompromising: 'What I do is important.' He taught you to have respect for yourself and held you responsible for what you did. I'm a true romantic and wanted to hear those words."[6] In 1951, while enrolled in classes at the California College of Arts and Crafts (CCAC) in Oakland, Neri began an even more important association, with Peter Voulkos, the ceramist known for his enormous, rough, nonfunctional vessels owing much to the spirit of abstract expressionism. Neri admired Voulkos's physically unbounded approach to clay: "[He] forced himself onto the material . . . instead of taking that kind of sacred approach toward ceramics that most people did. It was just clay."[7] Neri's association with Voulkos seems particularly significant given the venturesome, even impetuous approaches to material and technique that he, too, would later develop.

Neri's initial involvement with art was interrupted when he was drafted in late 1952 and posted to Korea in the fall of 1953. When he returned from Korea in early 1955, he reenrolled at CCAC, his tuition covered by the G.I. Bill. Photographs reveal that the first works Neri made after returning from Korea were abstract paintings and mixed-media sculptures, both figurative and gestural.

Neri showed a group of these sculptures as early as January 1956, in a two-person exhibition with Bruce McGaw at the 6 Gallery, a San Francisco artists' cooperative of which Neri was a member. Alfred Frankenstein reported in the *San Francisco Chronicle* that "Neri is at his best in his large, tangled, dramatic sculptures," but he took exception to an assemblage evidently done in the spirit of contemporaneous paintings by Robert Rauschenberg: "When Neri fixes a pair of overalls to a canvas and covers it with a film of paint, one thinks of nothing so much as the song about Mrs. Murphy's chowder."[8] Frankenstein was inclined, however, to be somewhat forgiving. He took note of a statement on the 6 Gallery wall: "The group that runs this institution commits itself to exhibiting not only successes and matured achievements but half steps, blunders and fumblings by the way."[9] Frankenstein observed, "This emphasis on process, on the doing rather than the thing done, is displayed in an extreme form . . . the whole thing is both fascinating and a little appalling. . . ."

Neri's first show—and Frankenstein's review of it—suggest that the artist was also involved in the newly evolving San Francisco aesthetic that later was described as "funk," a term borrowed from jazz. Neri remembers that with respect to art, the funk idea implied "immediacy. You'd jump into something without stopping to think, just to see what the results would be." "The whole funk idea was to look into new ideas and new materials," Neri said in 1975. "We treated everything equally. . . . The same thing with junk. A lot of people used house paint. No one worried much if some of it fell off. A lot of the assemblages and paintings are still falling apart."[10] Funk artists worked with whatever materials were at hand, partly for economic reasons, but also to achieve spontaneity and rawness.

Neri's involvement with the funk aesthetic can be seen in several of his early figurative sculptures. These are small, extraordinary, mixed-media creations made of scraps of wood, cloth, wire, newspaper, cardboard, and string—whatever happened to be around the studio. Neri remembers that he could not afford better materials, but he also acknowledges the funk impulse to try anything, even junk.

With these fetishlike figures, the artist pursued impulsiveness on the one hand, and gesture and body language, especially as they convey emotion, on the other. These ideas came to inform all his subsequent figurative sculpture. *Wood Figure No. 1*, for example, a forceful, striding figure with outstretched arms, projects an air of self-confidence as well as an energy and grace in motion that would characterize many of Neri's later depictions of the human form. It also provides a precedent for later works, in that details of the figure are presented summarily or not at all. Neri eventually became a master at using the partial figure to imply through gesture the form and character of the whole person.

Opposite:
2. *Wood Figure No. 1,*
 c. 1956–57.

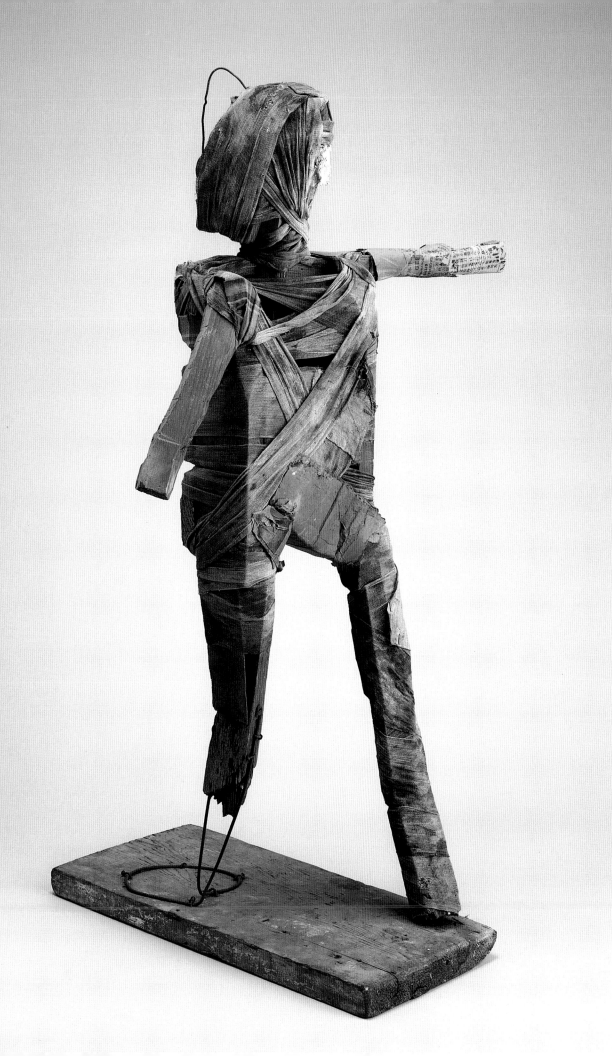

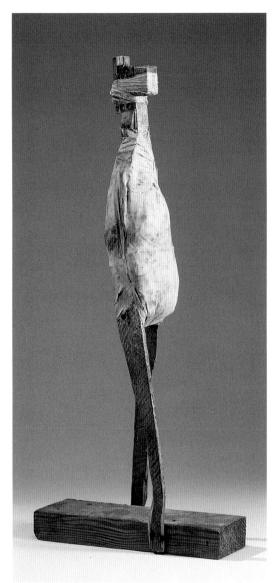

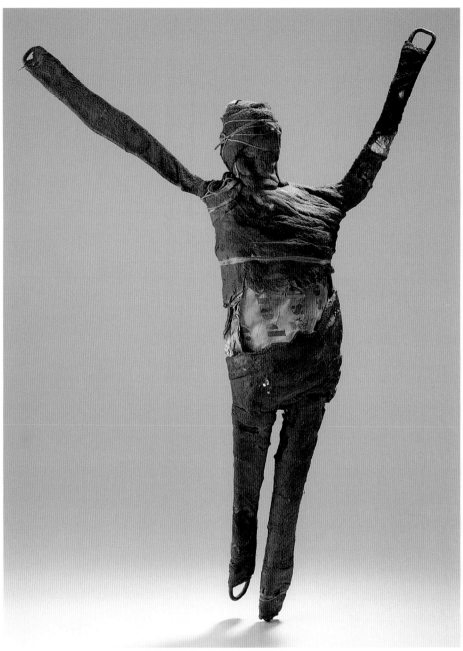

Consistent with the funk aesthetic, Neri made no effort to disguise or elevate his humble materials: *Wood Figure No. 1* displays its wood and wire armature covered with plaid cloth and yellowed newsprint. Even rougher and in some respects more remarkable is *Sutee Figure I,* shrouded in burned cloth. Neri remembers that in making it he was experimenting with resin in combination with fabric, a process he understood incompletely. The figure suddenly "burst into flames," with a result that Neri greatly liked. With its scorched surface and its painfully elongated arms stretched out and seemingly pinned behind it, this figure seems like some ancient icon—a charred crucifix, perhaps. But lacking a cross, the figure is less the specific representation of Christ than a more generalized image of physical surrender.

Left:
3. *Untitled Standing Figure,*
 c. 1956–57.

Right:
4. *Sutee Figure I,* c. 1956–57.

6

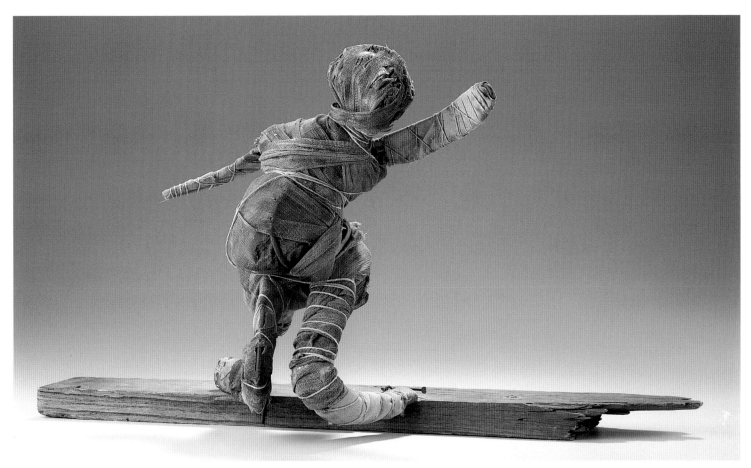

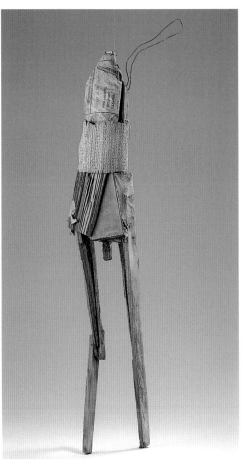

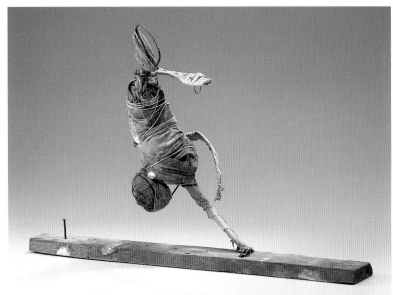

Top:
5. *Sutee Figure III*, c. 1956–57.

Bottom left:
6. *Wood and Grasscloth Figure*, c. 1956–57.

Bottom right:
7. *Sutee Figure II*, c. 1956–57.

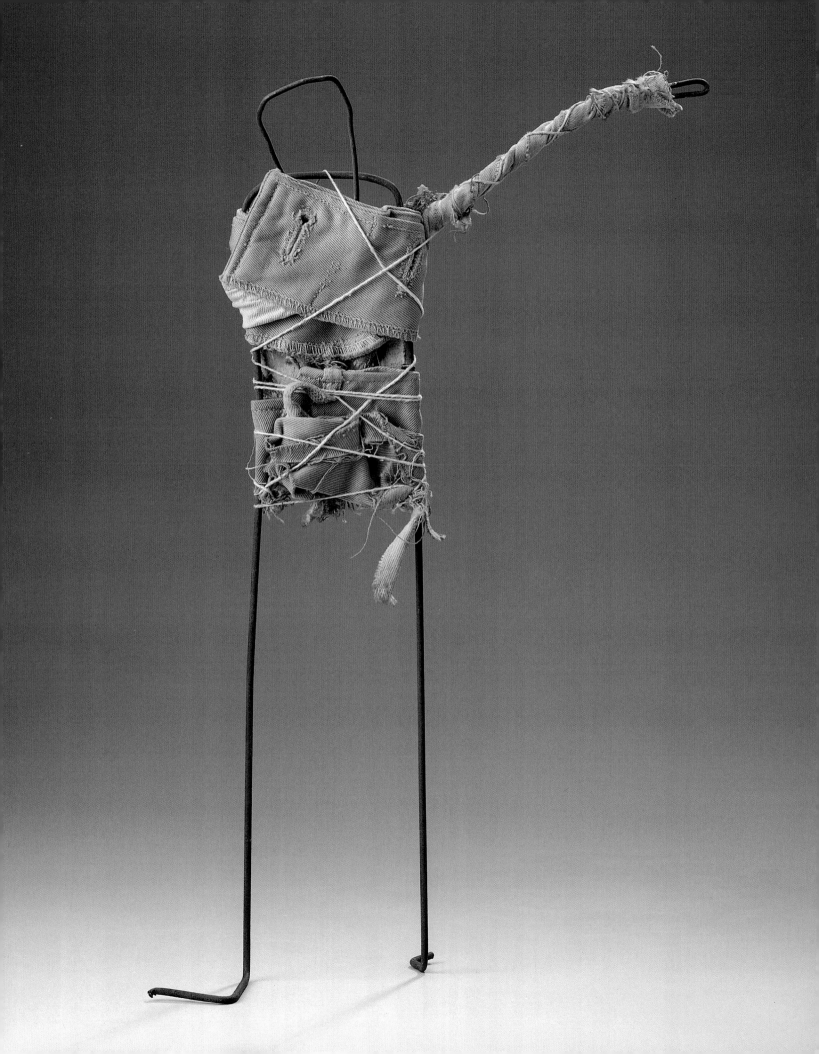

The funk aesthetic was part of a larger and more familiar phenomenon, the Beat era, which swept San Francisco in the mid-1950s. Beat poets and writers, jazz musicians, and funk artists comprised a bohemian underground and shared feelings of alienation from the perceived complacency of 1950s America. Many were alarmed by the burgeoning arms race; more were horrified by the prospect of nuclear annihilation. They chafed at what they saw as American society's excessive materialism and the pressures to conform to political and behavioral norms, as exemplified in particular by the anti-Communist "witch hunts" of Senator Joseph McCarthy. Although no coherent school or style united poets, musicians, and artists, they nonetheless shared a taste for the ironic or absurd, prizing the rough, the imperfect, and the crude. As the San Francisco critic Thomas Albright put it, "Improvisation became the highest form of creativity."[11]

The Beat generation centered itself in the coffeehouses, bars, and bookstores of San Francisco's North Beach district. Although Neri lived in Oakland after returning from Korea, he quickly gravitated to the San Francisco scene. He remembers the time as "vibrating, electric." He recalls "amazing jazz—you could listen to Miles Davis all night for the price of a beer." He heard poet Kenneth Rexroth give readings to jazz accompaniment at a bar called The Cellar. He joined the 6 Gallery, which was becoming important as the center of Beat activity. In fact, Neri was involved in organizing one of the central events of the Beat era: a reading by six poets at the 6 Gallery on the night of October 7, 1955, at which Allen Ginsberg gave the first full reading of his epic poem of outrage, *Howl*.[12] Neri quickly and thoroughly inserted himself into the artistic life of San Francisco, and by late 1956 or early 1957 he moved alone to the city. At the same time, he transferred to the California School of Fine Arts, where he remained enrolled through the summer of 1958.

Although Neri insists that funk artists "wanted to consider ourselves complete illiterates—we wanted nothing to do with words," he also acknowledges that the spirit of Beat poetry "was important to us. It was speaking to our time." His enthusiasm for poetry went beyond works by his immediate contemporaries, however. His first wife, Marilyn Hampson, remembers that he was then becoming immersed in European and Latin American poetry. "We both loved poetry, especially Lorca and Neruda. We spent all our money at City Lights" (the bookstore that Peter Martin and Lawrence Ferlinghetti had opened a few years earlier in North Beach). "When he wasn't working, Manuel read continually," Marilyn recalls. "He always had a book in his face." (She also recalls, however, that he loved the newly proliferating television: "To this day, I can't watch reruns of *I Love Lucy*. Manuel always had it on.") The importance of poetry to their relationship was recalled in an agonized letter she wrote to Neri several years after they had separated, in which she recollected part of a poem by García Lorca that he had once transcribed for her:

Opposite:
8. *Wire Figure No. 2,*
c. 1956–57.

9

Cold cold like river water
was the first kiss
that tasted of kiss and was
for my child lips
like the fresh rain

Is it in you
Black Night?

Hot hot like fountain water
my errant love
Castles without firmness,
of moist shadows

Is it in you
Black Night?[13]

Although Neri was then reading many poems, something in the mysterious sensuality of "Black Night" and its evocation of keenly felt loss arrested him. One begins to recognize in it a sensibility that would be honed in the artist in the years to come.

Mark di Suvero offers additional testimony to Neri's growing interest in poetry at the time. The two had met in 1956, when di Suvero was a student at the University of California, Berkeley. Their friendship deepened the next year, when Neri was working in a basement studio under Caffé Trieste on Grant Street in North Beach. Neri recalls, "We had vital interests we connected on: sculpture, poetry, women." He remembers "shouting arguments about going to New York," where di Suvero felt impelled to go, and Neri did not. Both men remember a trip they took through the Los Padres National Forest to Los Angeles in Neri's old hand-throttle convertible. "We pulled out the throttle and sat on the backs of the seats, steering with our feet," Neri recounts. Later, di Suvero would memorialize the trip in an inchoate but moving poem composed shortly after he was nearly crushed to death in an elevator accident that left him paralyzed for about a year:

lines written in a wheelchair,
summer, New York, 1962

when we rode like kings the desert,
Manuelito, Manuelito
roaring wind behind us sings
Los Padres, Los Padres tan perdito
and the road so straight it does not wind
so straight the desert sun is blind
where wind in our faces tore our hair and wore
the rocks down
in that intense of unrelenting air
we did not guess/swamp horror comfort and fear
whose long straight road has led us here.[14]

Opposite:
9. *Markos*, 1958; Reworked
1963.

10

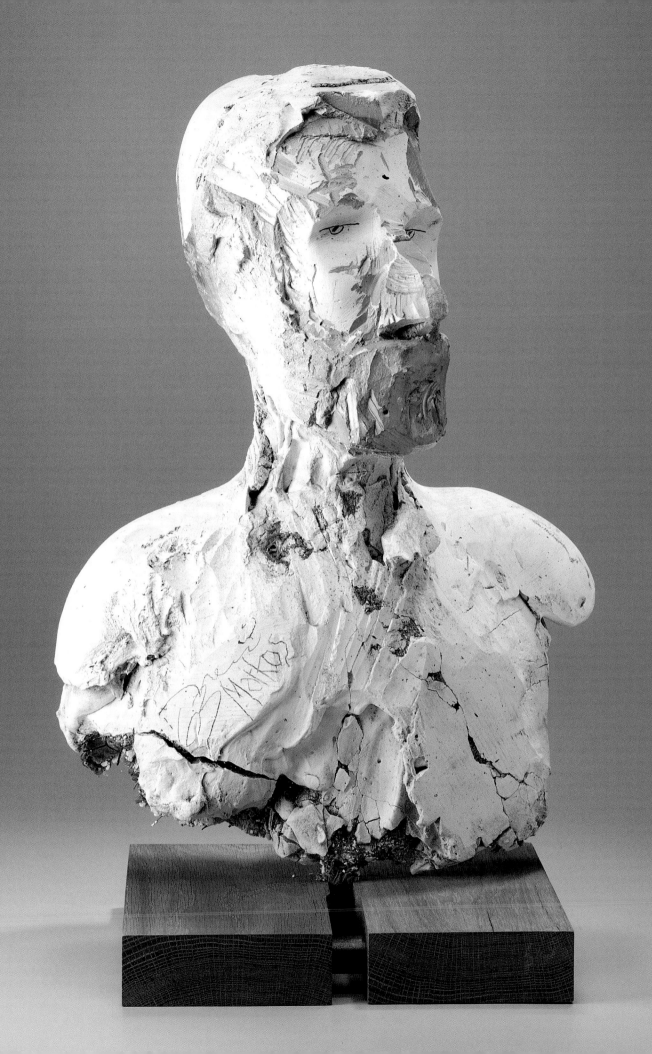

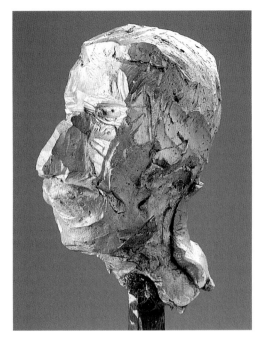

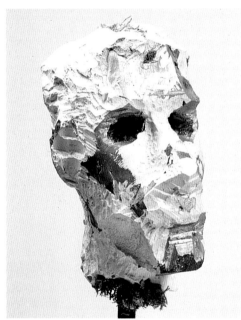

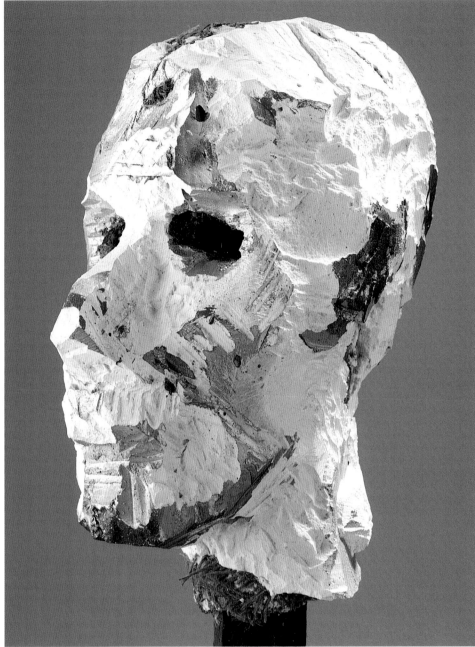

Di Suvero remembers, "We were very involved in poetry: we would discuss García Lorca, Neruda. Not like academics—we were very intense about it, especially the Spanish and South American poets." Their interest in García Lorca and Neruda, he remembers, had both literary and political dimensions: the poets became friends during the Spanish Civil War when Neruda was posted to Spain by the Chilean government; some of Neruda's angriest poems were occasioned by the war and the death of García Lorca at the hands of the fascist Guardia Civil. Di Suvero characterizes their sensibility at the time as a kind of "anguished surrealism. We were like open wounds to the world. We felt everything."

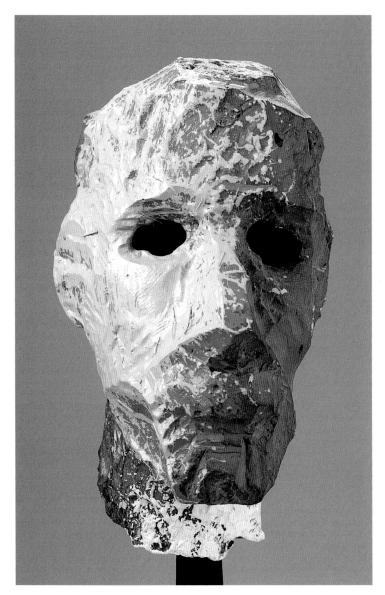

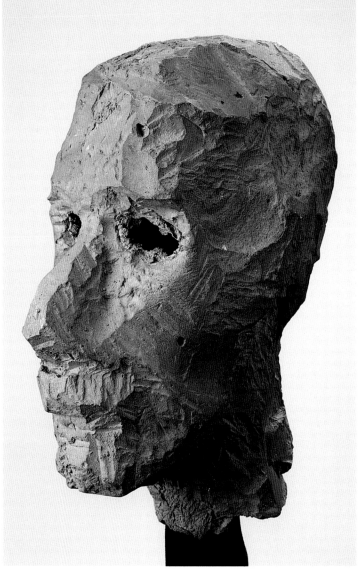

Neri's friendship with di Suvero has continued for more than forty years and has been an important part of both their lives. The friendship occasioned some of Neri's most compelling plaster sculptures from the late 1950s, including a bust titled *Markos*, which was begun in 1958 and re-worked in 1963. The bust is remarkable for its combination of classical and modern associations. Neri has captured the personality of his friend with a funky, expressionistic technique; at the same time, he has evoked the Roman tradition of portrait busts used to commemorate events or to remember and honor family members. Neri made several other heads of di Suvero in those years. One he covered with aluminum paint. Another was reworked in the early 1980s, before a mold was taken for casting the head in bronze. Two casts were made in 1982, one of which Neri painted. What makes this particular head disturbing—both in the plaster and in the bronze casts—is that there are holes where the eyes should be.

Left:
13. *Head of Markos in Bronze* (Cast 1/4), 1980.

Right:
14. *Head of Markos in Bronze* (Cast 2/4), 1980.

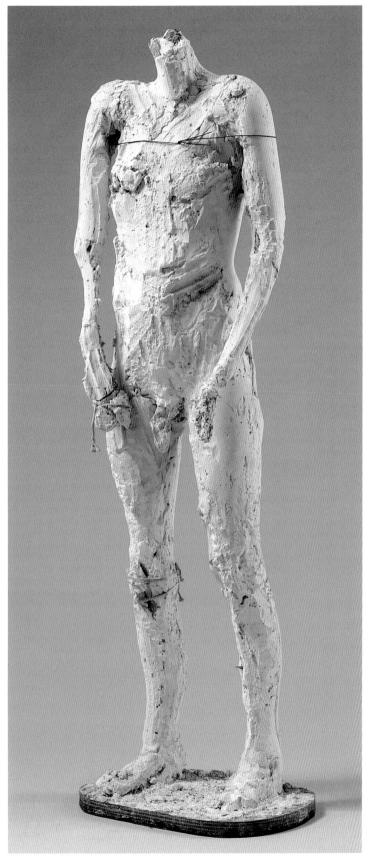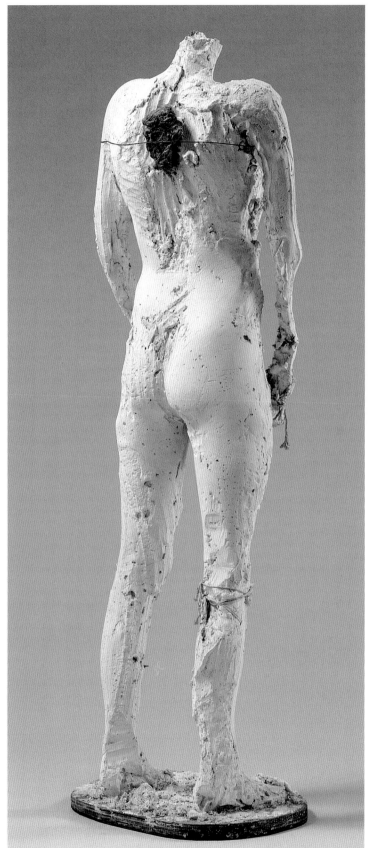

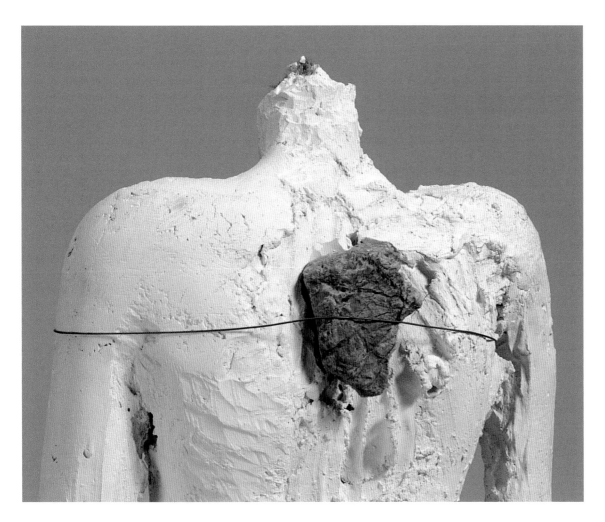

In a later life-size figure of di Suvero, *Markos Doloroso,* Neri planned to combine the plaster sculpture with a head cast in bronze. The plaster, dated circa 1970, is an emotionally charged portrait of Neri's longtime friend, which makes reference to the accident that had left di Suvero temporarily paralyzed. Neri had seen the devastating effect of this disaster first-hand: on his first trip to New York in the spring of 1960, he arrived to stay with di Suvero just three days after the accident. He remained only a few days then, but after di Suvero came out of the hospital Neri again traveled to New York to help him rearrange his studio and return to work.

Some of the trauma of the accident, as experienced by di Suvero and registered by Neri, is conveyed in this rigid figure. The torso seems immobilized on the steel spike of the armature; there is little sense of active musculature. The arms hang limp; one of them is literally pinioned by a wire that wraps around the torso. At the back, the wire compresses a stone into the figure's spine. The sculpture doesn't suggest the immediate pain of the accident; instead, it evokes the long aftermath—the months of paralysis during which di Suvero struggled to make his shattered body work again. It shows how vivid the recollection of di Suvero's agony remained for Neri.

15–17. *Markos Doloroso,* c. 1970.

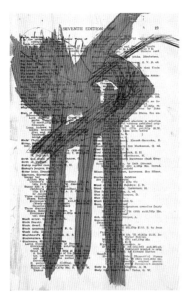

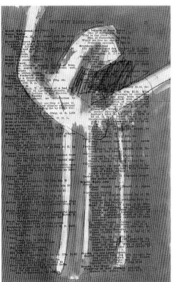

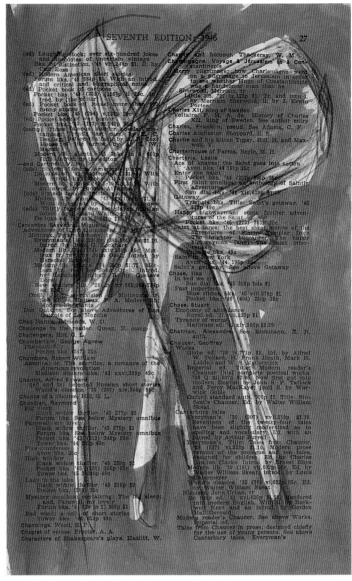

Neri's early works on paper show the range of ideas he was assimilating, and the tenacity with which he pursued both figuration and abstraction through the late 1950s. He executed some of his earliest drawings in about 1953 on the printed pages of a published reference volume, *Catalogue of Reprints in Series Sketchbook,* using a surplus library book as an inexpensive alternative to drawing paper. This sketchbook, done before Neri went to Korea, includes studies for sculptures of various kinds, many revealing an organic source, such as several three-legged forms and numerous plant-like groupings of irregular shapes held aloft on slender stalks. Evident in these early drawings are several features that eventually became characteristic of the artist's abstract works on paper: a free combination of media, a loose handling of pencil and brush, and a use of both positive and negative form, with the image either defined in color against a white background or unpainted and floating against a color field.

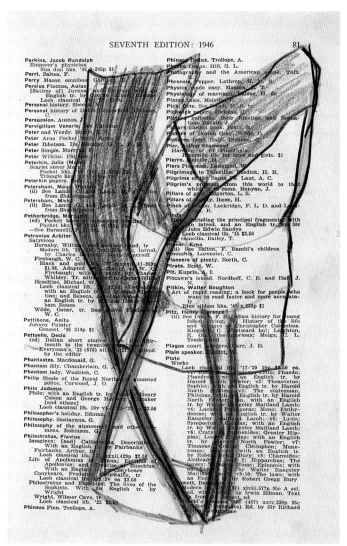

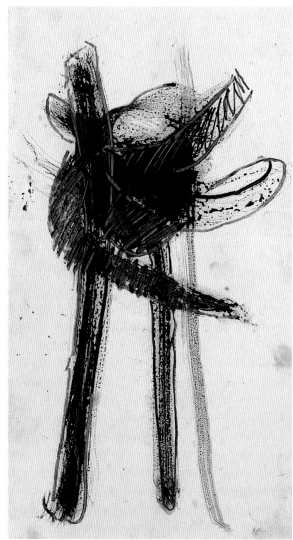

Neri's exploration of abstract form continued in a second suite of drawings, the *Eucalyptus Series,* executed on salvaged sheets of mimeograph paper after his return from Korea. These works are studies for sculptures of eucalyptus branches and reveal a continued interest in organic sources of abstraction. The *Eucalyptus Series* studies suggest considerably more artistic confidence than the earlier drawings in the *Catalogue of Reprints in Series Sketchbook.* The brushwork is at once freer and more emphatic, with more variety and interest in the organic forms.

Drawings such as those on pages 19 and 21 in the *Catalogue of Reprints in Series Sketchbook* were translated quite literally into three dimensions using tree limbs, while others, such as that on page 81, became sculptures in plaster or metal. The *Eucalyptus Series* drawings became wooden sculptures and employed branches from the eucalyptus tree, one of Neri's primary sources of sculptural material at the time. These sculptures belong to a group of complex wooden assemblages that Neri showed at the 6 Gallery in early 1956.

Left:
21. *Catalogue of Reprints in Series Sketchbook,* page 81, c. 1953.

Right:
22. *Eucalyptus Series No. 18,* 1955.

17

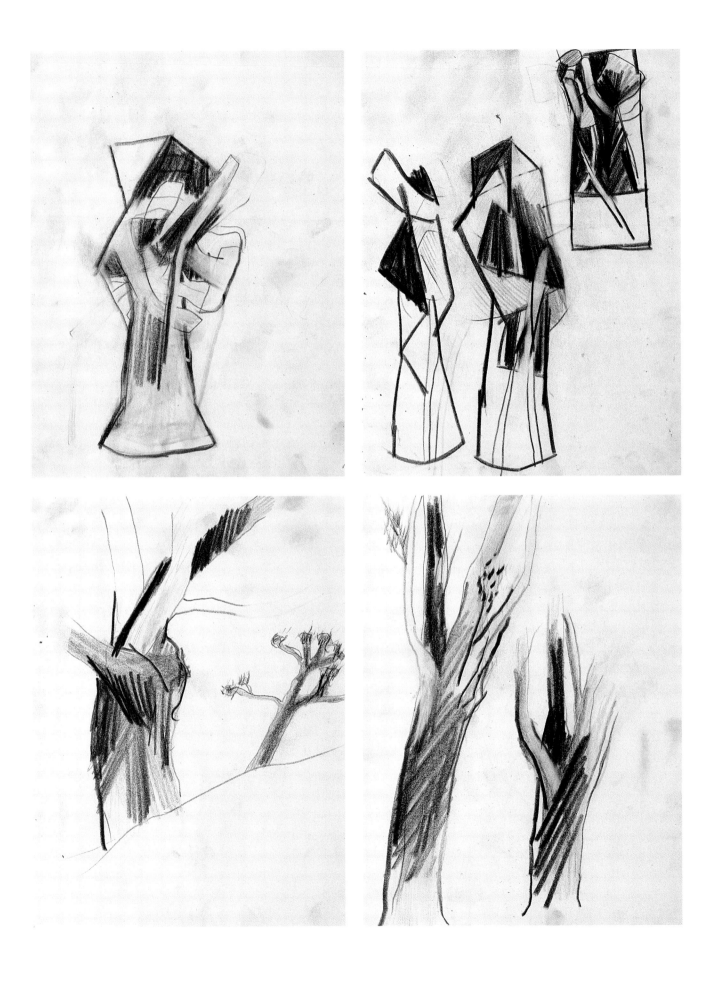

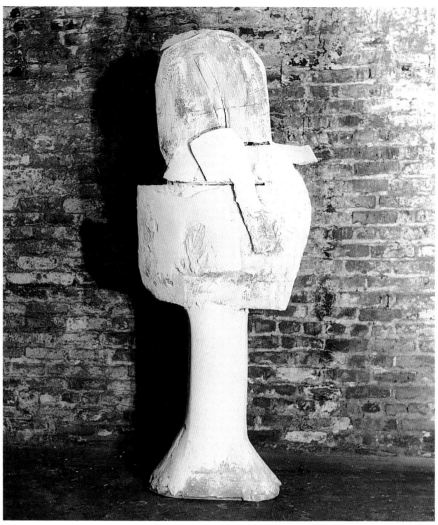

A group of drawings from the *Raoul Sketchbook* demonstrates the evolution of Neri's most important abstract sculptures of the late 1950s. These cardboard and plaster constructions were predominantly vertical and were painted in vivid colors. Often just shy of the height of a human figure, the sculptures, known as *Stelae*, are sometimes described as totemic, but this sketchbook suggests an organic source: the book contains several drawings of trees, some of which seem to metamorphose into the fractured, planar surfaces of the *Stelae* sculptures. Paradoxically, however, the sequence of drawings within the sketchbook suggests the reverse metamorphosis, as if Neri worked from the stele back to its organic source.

Color and form also came together in *Stelae Studies*, a particularly sustained and accomplished series of drawings related to the *Stelae* sculptures. The studies (there are well over sixty in this particular group from the mid- to late 1950s) demonstrate that Neri had by then achieved great confidence with color: some show him using it to create bold contrasts; others reveal him blending areas or related hues (as in *No. 20*).

Left:
27. *Stelae I*, c. 1957–59.
Right:
28. *Stelae Study No. 47*, c. 1957.

Opposite:
Top left:
23. *Raoul Sketchbook*, page 11,
 c. 1955–59.

Top right:
24. *Raoul Sketchbook*, page 13,
 c. 1955–59.

Bottom left:
25. *Raoul Sketchbook*, page 16,
 c. 1955–59.

Bottom right:
26. *Raoul Sketchbook*, page 17,
 c. 1955–59.

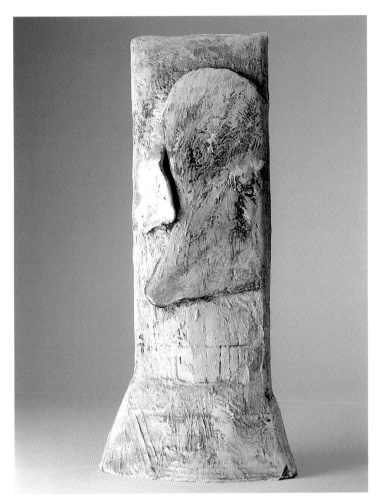

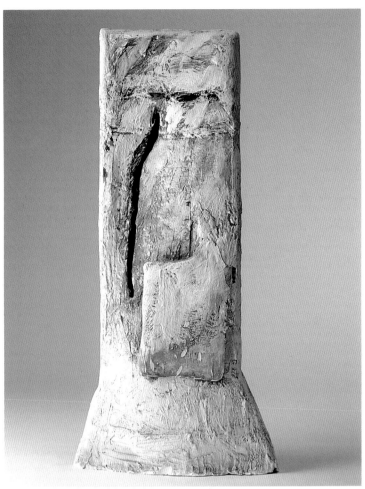

Neri continued these varying techniques in coloring some of the *Stelae* sculptures, which were abstract enough to allow him the freedom he needed to experiment with painted sculpture. He recalls that he was "having a hard time being free with color on the figure," so he created these abstract forms on which he could paint with less inhibition. Some of these works have clearly delineated areas of color *(Stelae III)*, while the colors are smudged and blended in others *(Stelae II)*. The last sculptures in this series—*Stelae VI* and *Stelae VII*—with surfaces left unpainted, show Neri's focus shifting more to structural concerns. An air of funkiness marks the sculptures: the materials are crude, the execution appears swift, and durability has clearly been sacrificed to impulsiveness. This group of sculptures was the focus of Neri's first museum exhibition: seven of them, along with two plaster heads, were shown at the San Francisco Museum of Art in early 1959, in a four-person exhibition that also included Sam Francis, Wally Hedrick, and Fred Martin. The same works formed the nucleus of Neri's solo exhibition at the Dilexi Gallery in the summer of 1960.

29–30. *Stelae II,* c. 1957–59.

Opposite:
Left:
31. *Stelae III,* c. 1958.

Top right:
32. *Stelae Study No. 20,* c. 1957.

Bottom right:
33. *Stelae V,* c. 1958.

20

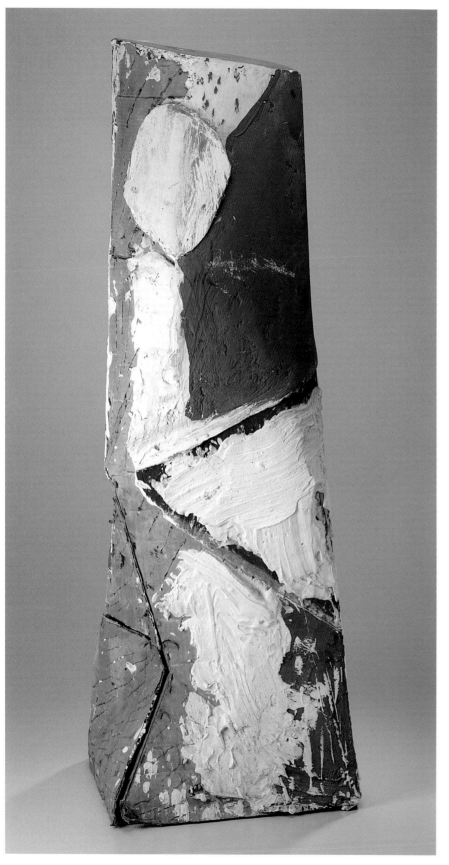
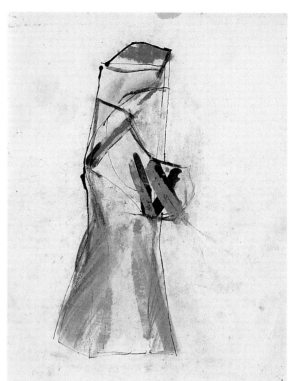
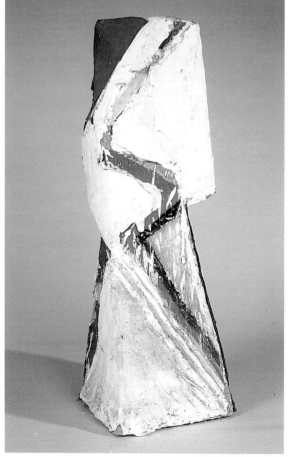

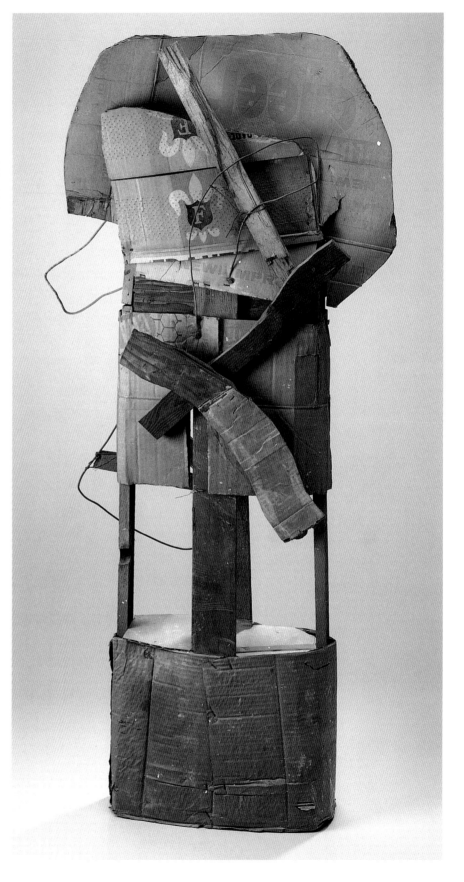

Top left:
34. *Stelae Study No. 44*, c. 1957.

Bottom left:
35. *Stelae Study No. 45*, c. 1957.

Right:
36. *Stelae VI*, 1958–60.

Opposite:
37. *Stelae VII*, 1958–60.

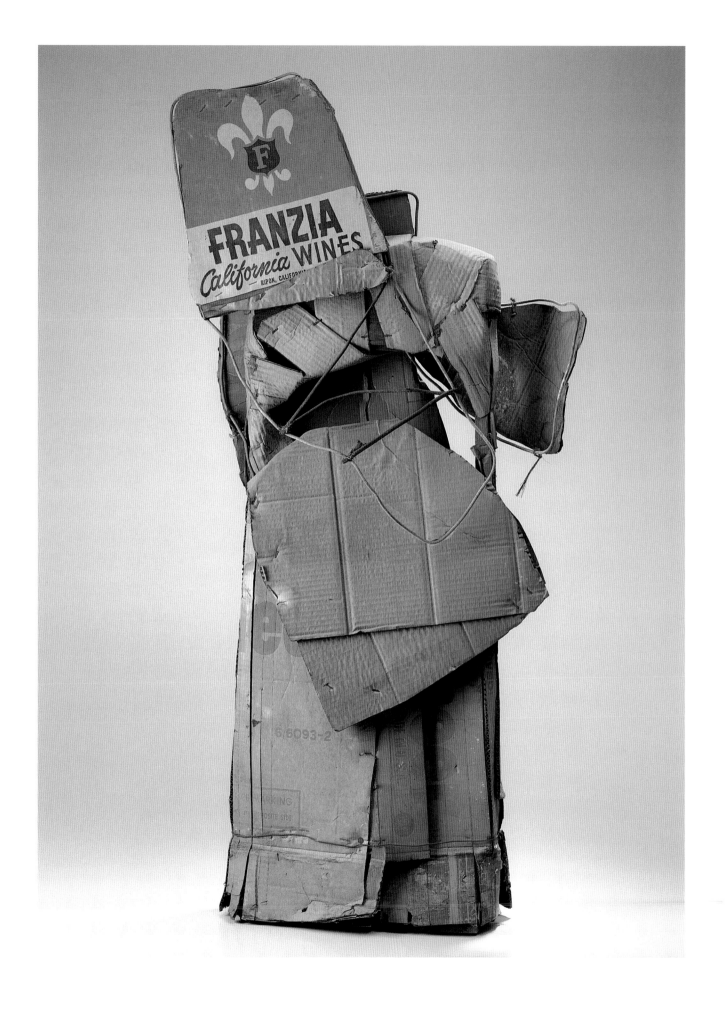

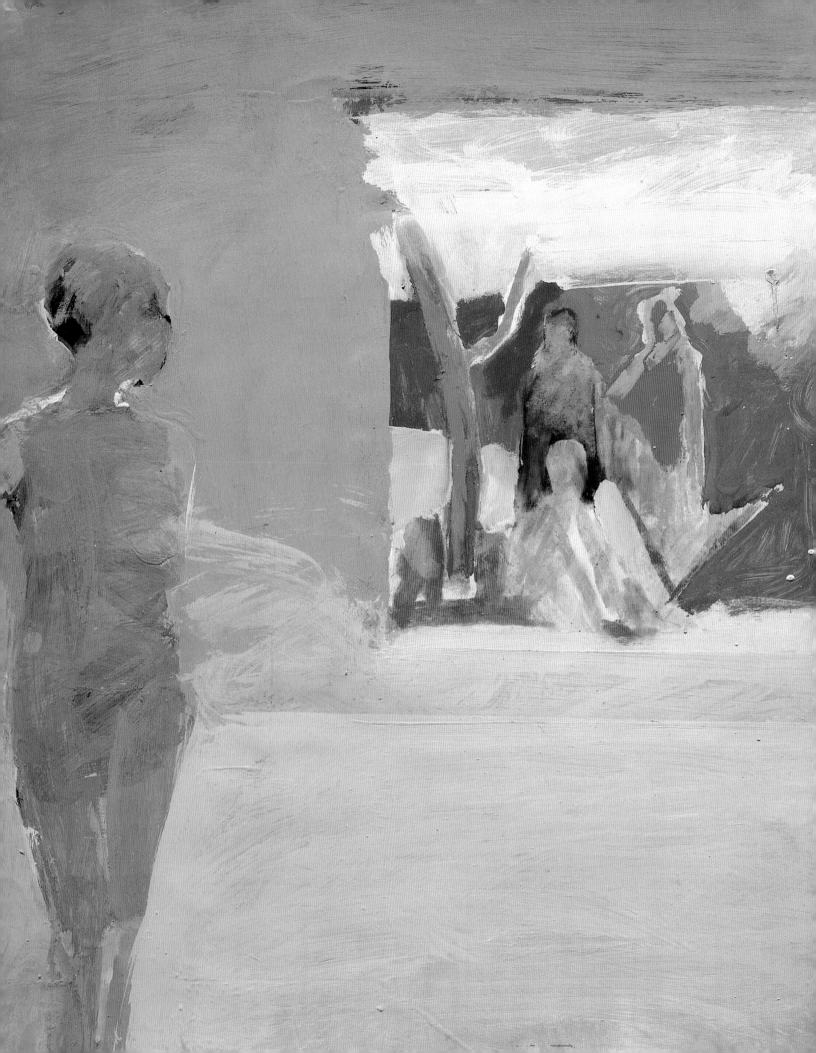

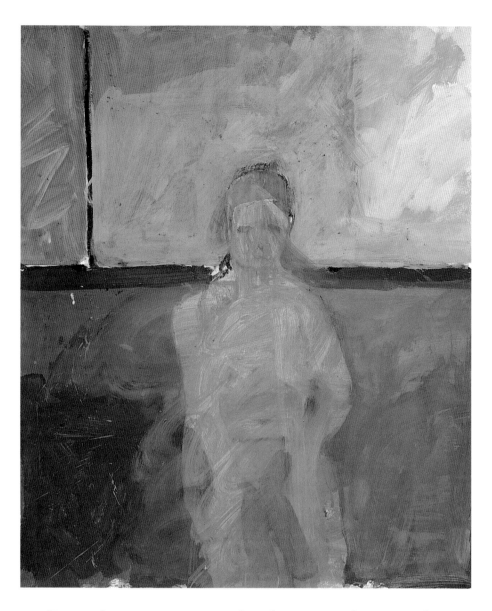

Various figurative paintings and works on paper also survive from Neri's early years. Some were done at CCAC, where he studied with Nathan Oliveira and Richard Diebenkorn, among others; some are from the California School of Fine Arts, where he took classes with Elmer Bischoff. A number of these early paintings clearly reveal a debt to his teachers. The brushed tempera drawing *Untitled Figure Study No. 11*, for example, brings Oliveira and Diebenkorn to mind, with its single figure isolated, yet integrated into a generalized background, which is divided into broad areas of somber colors. The surface is scumbled: the features of the subject are effaced, and the figure seems to disappear into the background. In *Untitled (Nude Model with Bischoff Painting)*, the figure is similarly treated—isolated, dissolved in atmosphere, and blended into the hues of the abstracted ground. The brushwork is loose and the color is rich, more like Bischoff's, combining pale blue underpainting overlaid with vivid pink. Moreover, the composition places the model beside a characteristic Bischoff painting of the time, a group of figures in a landscape.

39. *Untitled Figure Study No. 11,* 1957.

Opposite:
38. *Untitled (Nude Model with Bischoff Painting),* 1957.

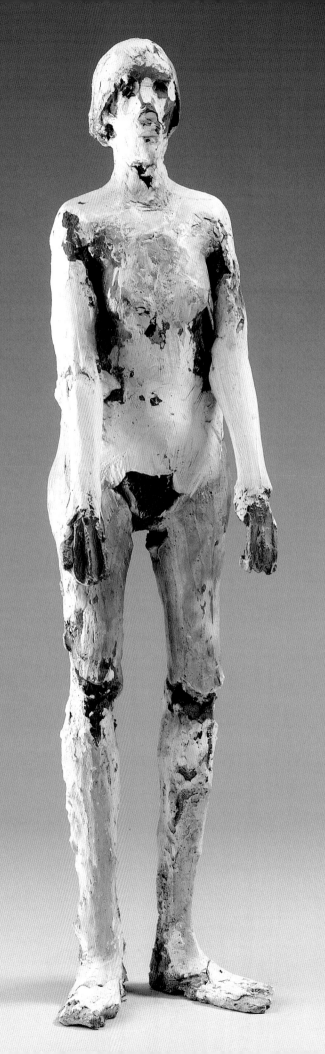

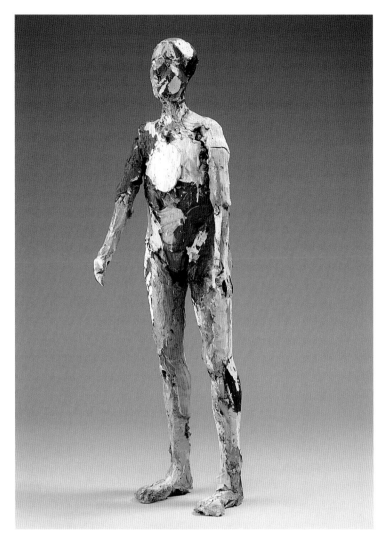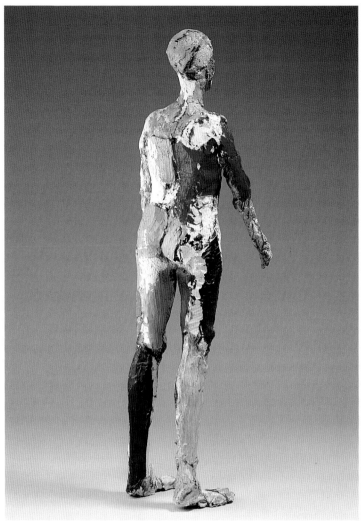

By the late 1950s, Neri's commitment to figurative sculpture began to solidify. In the summer of 1958, he withdrew from the California School of Fine Arts; in 1959 he began teaching there. The income permitted him to buy more durable materials and to rent a large studio on Mission Street in the Embarcadero section of San Francisco. The new studio gave Neri the space to create life-size plaster figures in which he brought together many of the ideas addressed in previous work: the material and the applied color of the abstract sculptures, the rough grace of the small figures, and the emotional complexity of narrative paintings. Like the small fetish sculptures, the life-size plasters are characterized by sketchy details. Sculptures such as *Hombre Colorado* and *Chanel* suggest the great speed and vigor with which they were made. Plaster was slapped onto the wood and wire armatures, then hacked off with rasp and chisel. Cracks in the surface were left undisguised. Color, used to emphasize gesture and form and to add emotional weight, was brushed on the rough forms, then chipped off or painted over. Poses are deliberately stiff and awkward, conveying an air of emotional uncertainty.

41–42. *Hombre Colorado,* c. 1957–58.

Opposite:
40. *Chanel,* c. 1957–58.

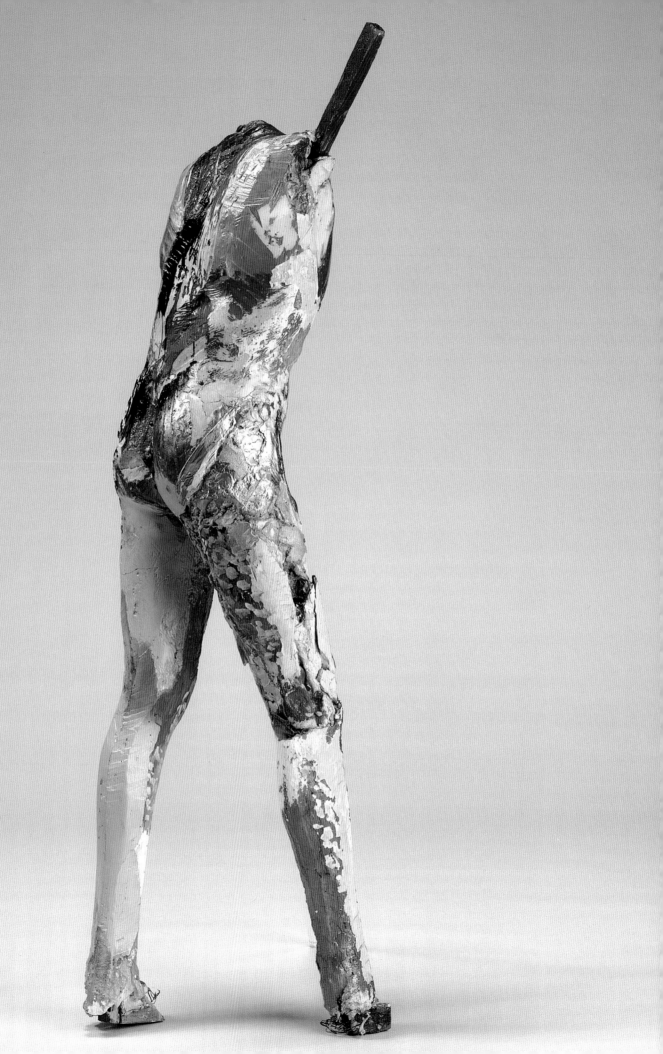

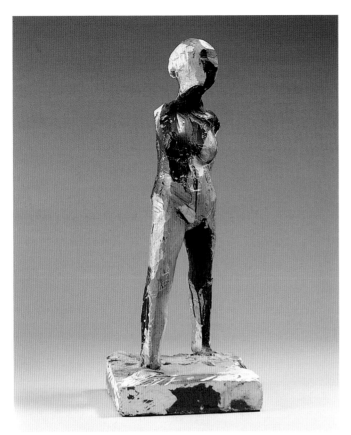

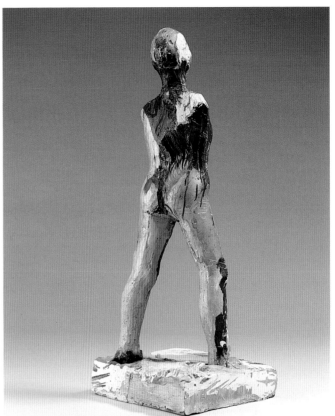

Hombre Colorado and *Chanel* are somewhat unusual for Neri in these years: they are full figures. More typical are partial figures, such as *Untitled Standing Figure*, 1957–58, *Beach Figure*, and Untitled, 1959. Neri left these figures incomplete, in part, he remembers, because he admired the fragmentary quality of classical sculpture. "When I began to really look at all that early Greek sculpture, not just the forms involved, but what happened to the pieces with time—the missing heads and arms—the figure was often brought down to just the bare essentials in terms of structure." He wanted to limit the specific personality of his figures so they might project a more universal presence. "That's why I went back to a lot of figures and started tearing off the heads and arms—because I could see that in some cases they got in the way. Often the figure had too much character to it."[15]

Like many of Neri's early figures, these are somewhat androgynous. They nevertheless differentiate themselves as "male" and "female": one has the fuller chest and narrower hips of a man; the others have the slightly rounded bosom and belly as well as the fuller hips of a woman. In each, texture is handled somewhat differently—rougher on the male, smoother on the females, especially around the shoulders, breast, and hips. Color is treated the same on both, not in the conventional way of suggesting light and shadow, but as a means of underscoring the vitality of the figures, as if Neri were using color to map bodily heat, pain, or emotion. Color is most intense around torsos, bellies, and groins; on the male figure, it is also vivid around the truncated arm, suggesting a bloody wound.

44–45. *Beach Figure*, 1958.

Opposite:
43. *Untitled Standing Figure*, 1957–58.

Following pages:
46–47. Untitled, 1959.

29

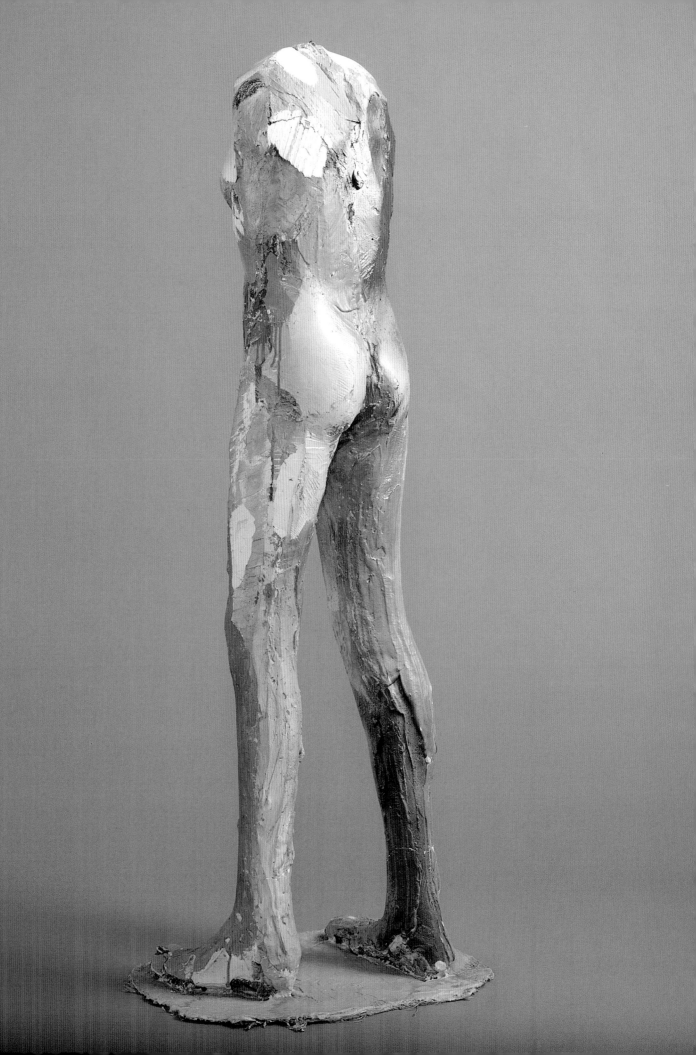

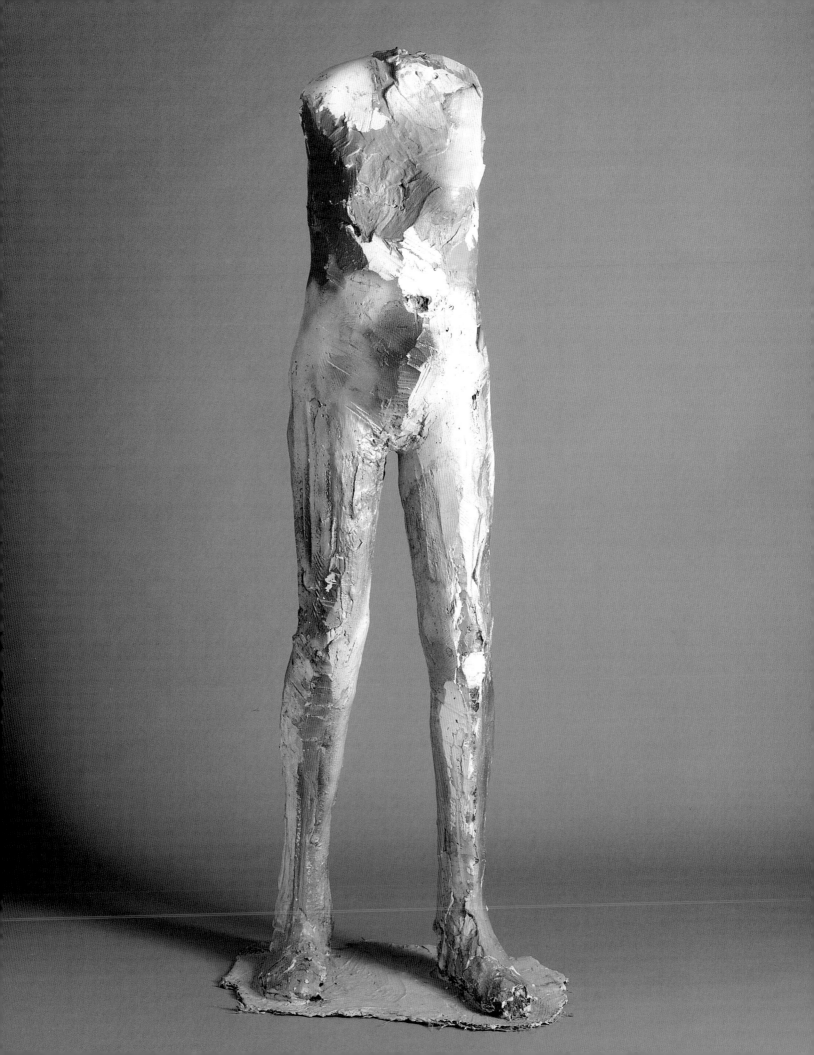

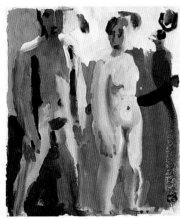

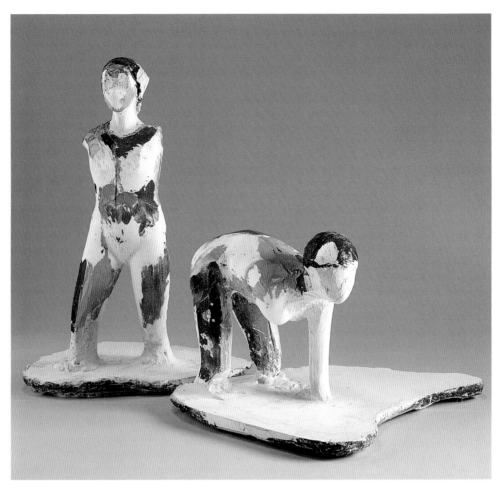

Neri was now doing that for which he has long since been celebrated, making plaster sculptures in a style very much like that of the Bay Area figurative painters, combining the human subject with the roughly textured surfaces and the loose painting technique of abstract expressionism. Moreover, he was using color as Park and Bischoff were, not to reiterate form but to amplify mood. The parallels between Neri and the Bay Area painters are especially clear in a pair of sculptures, *Couple: Male Figure* and *Couple: Female Figure,* in which both pose and color evoke the work of his mentors.

Yet Neri's attitude toward his material was still as much an expression of funk aesthetics as of Bay Area figuration. Neri later praised plaster both for its versatility and its expendability: it provided him, he said, with "a mere blob. You can do anything with it, at any time. And it's cheap. If you want to you can just throw it away."[16]

Top left:
48. Elmer Bischoff, *Two Figures at the Seashore*, 1957.

Bottom left:
49. David Park, *Standing Nude Couple*, 1960.

Right:
50. *The Bathers*, 1958.

Opposite:
Left:
51. *Couple: Male Figure*, 1962.

Right:
52. *Couple: Female Figure*, 1962.

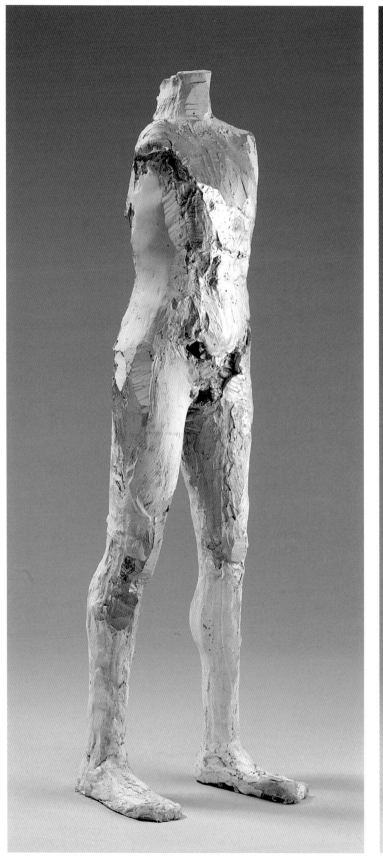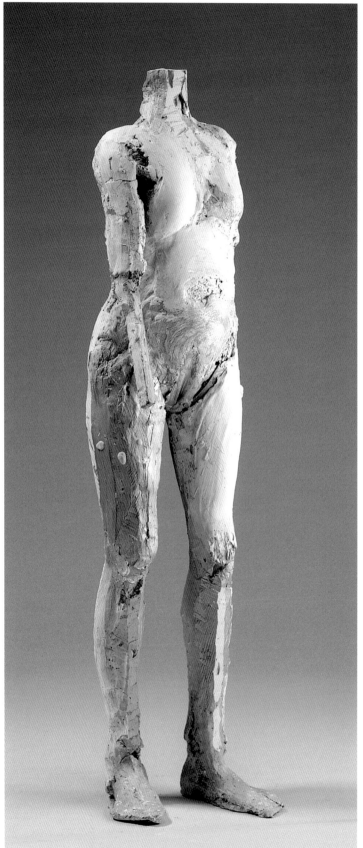

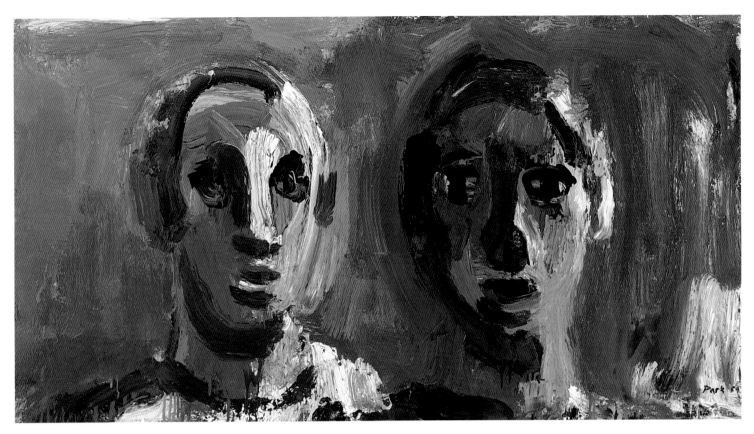

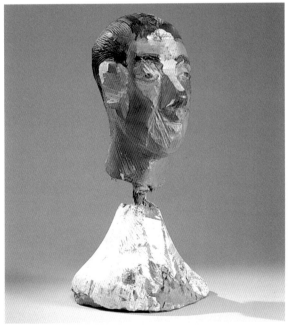

Neri's approach to Bay Area figurative style is also apparent in a series of heads, some of them predating the first surviving full figures. The features of *Dr. Zonk,* for example, are shaped in broad strokes, somewhat like the faces that Park was then painting, particularly the broad plane of the nose and the simple black spots indicating eyes. At the same time, the title reminds us of the blend of jazz-derived funk and abstract expressionist figuration that was Neri's particular trademark: "Dr. Zonk" was the nickname of a jazz musician who played in San Francisco clubs.

Top:
53. David Park, *Couple,* 1959.

Bottom:
54. *Dr. Zonk,* 1958.

Opposite:
55. *Portrait Series I,* c. 1959.

34

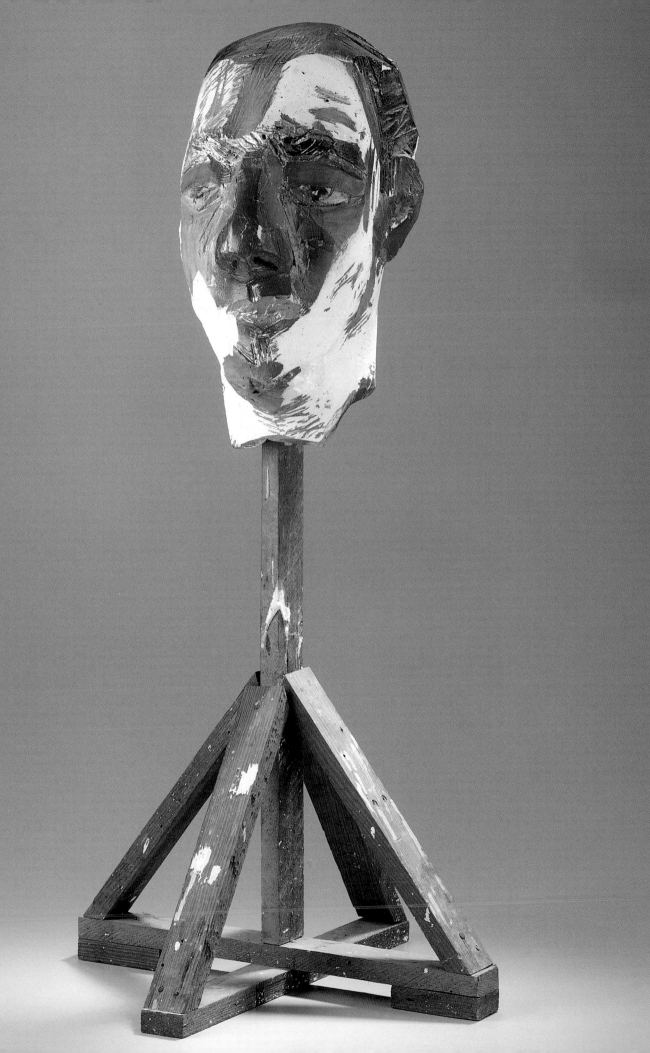

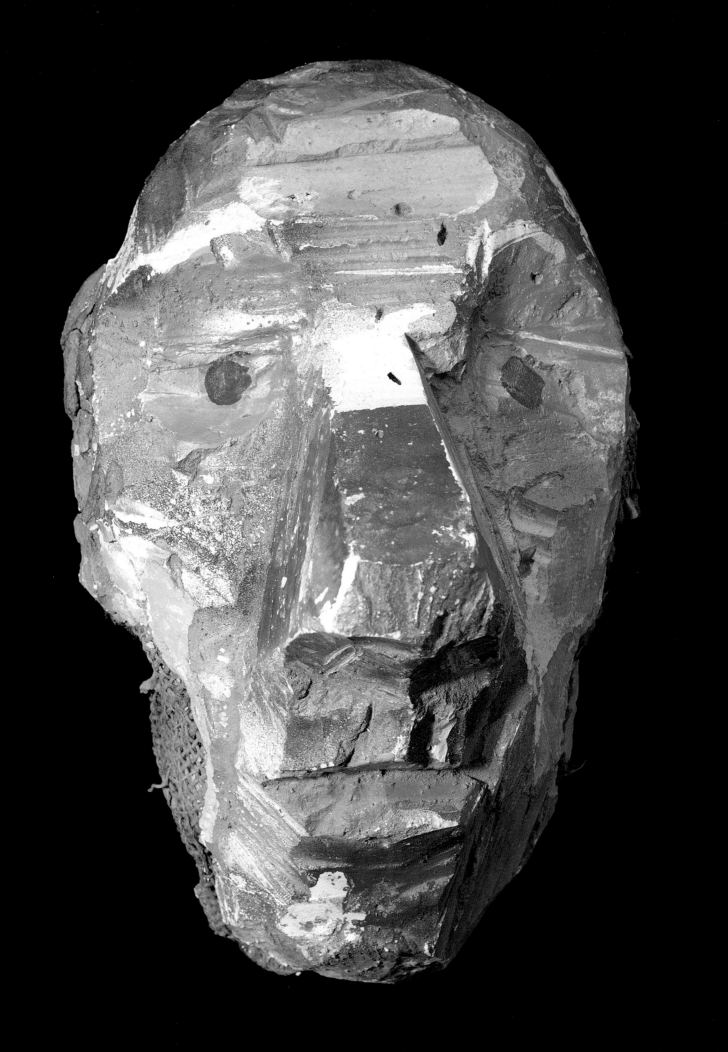

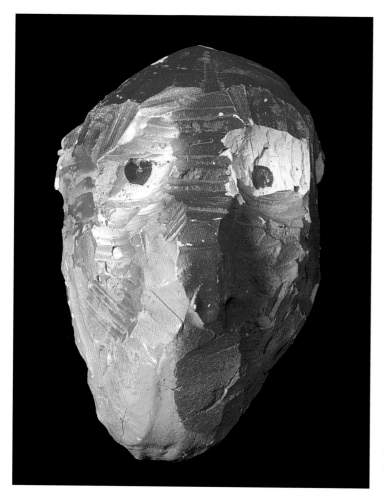

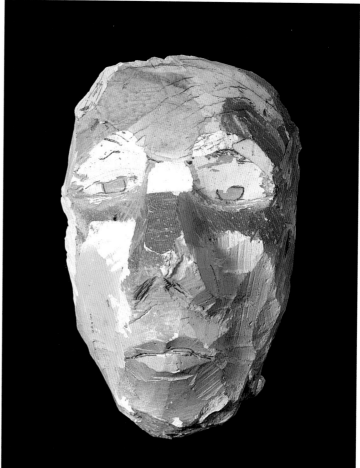

Top left:
57. *Plaster Mask II*, c. 1960.

Top right:
58. *Plaster Mask III*, c. 1960.

Bottom:
59. David Park, *Crowd of Ten*, 1960.

Opposite:
56. *Plaster Mask I*, c. 1960.

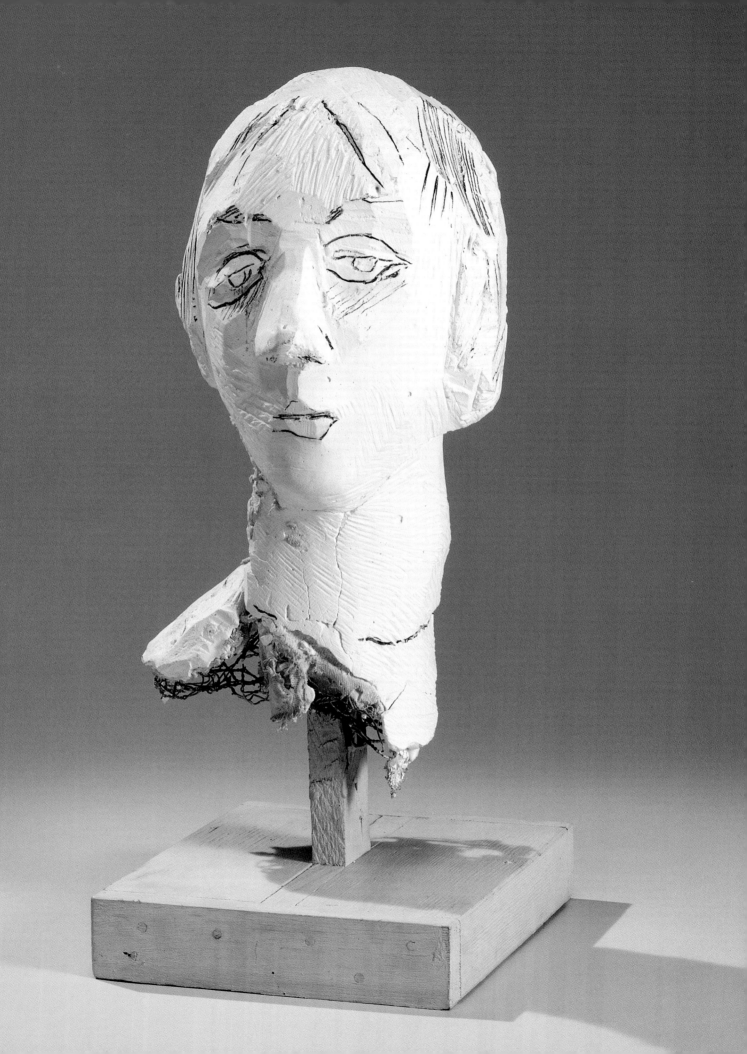

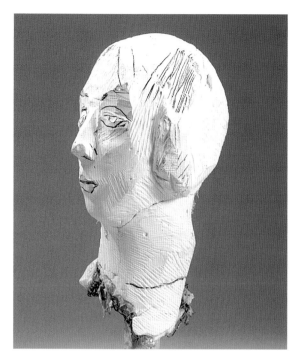
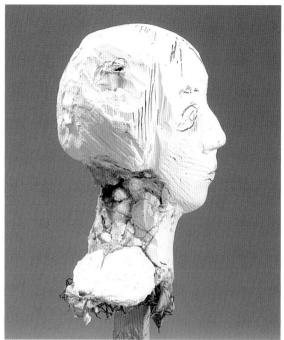

Neri's deepening involvement with the Bay Area figurative style in these years paralleled a profoundly important episode in his personal life: his growing attachment to the painter Joan Brown. The two had met in Bischoff's painting class in 1957; they became friends and began to show their work together the next year in impromptu exhibitions in the coffee-houses and bars of North Beach. Like Neri, Brown was already married: she to Bill Brown, another fellow student. By 1959, she was estranged from her spouse, living with Neri in North Beach and sharing the Mission Street studio.

Although eight years younger than Neri, Brown was in some respects the more worldly and adventurous: as a nineteen-year-old student in 1957, for example, she had invited newspaper critics to her exhibition at the 6 Gallery and earned a lengthy review for the effort.[17] She also achieved national recognition before Neri: she was given a solo exhibition in 1960 at the Staempfli Gallery in New York, and the same year was selected for the exhibition "Young America 1960" at the Whitney Museum of American Art. At twenty-two, she was the youngest artist in the show.

During the years with Brown, Neri's work deepened and matured in subtle ways. His figures became more expressive emotionally, with wider variety in the poses and a greater control of the surface treatment. Although he depicted few men, those he did were both subtle and sophisticated in their emotional characterizations. There is something poignant about *Seated Male Figure*, for example, who leans against a stool: he seems strong but passive. The absence of color underscores an air of resignation. Even more affecting is *Standing Male Figure*. With his blank eyes, his beaklike nose and jutting chin, his compressed torso and elongated legs, he recalls various figures and busts by Giacometti and evokes some of the same feelings of stoicism and alienation evident in that sculptor's figures.

60–62. *Head of Joan Brown,* c. 1959.

Following pages:
Left:
63. *Seated Male Figure,* 1959.

Right:
64. *Standing Male Figure,* c. 1960; Reworked mid-1960s.

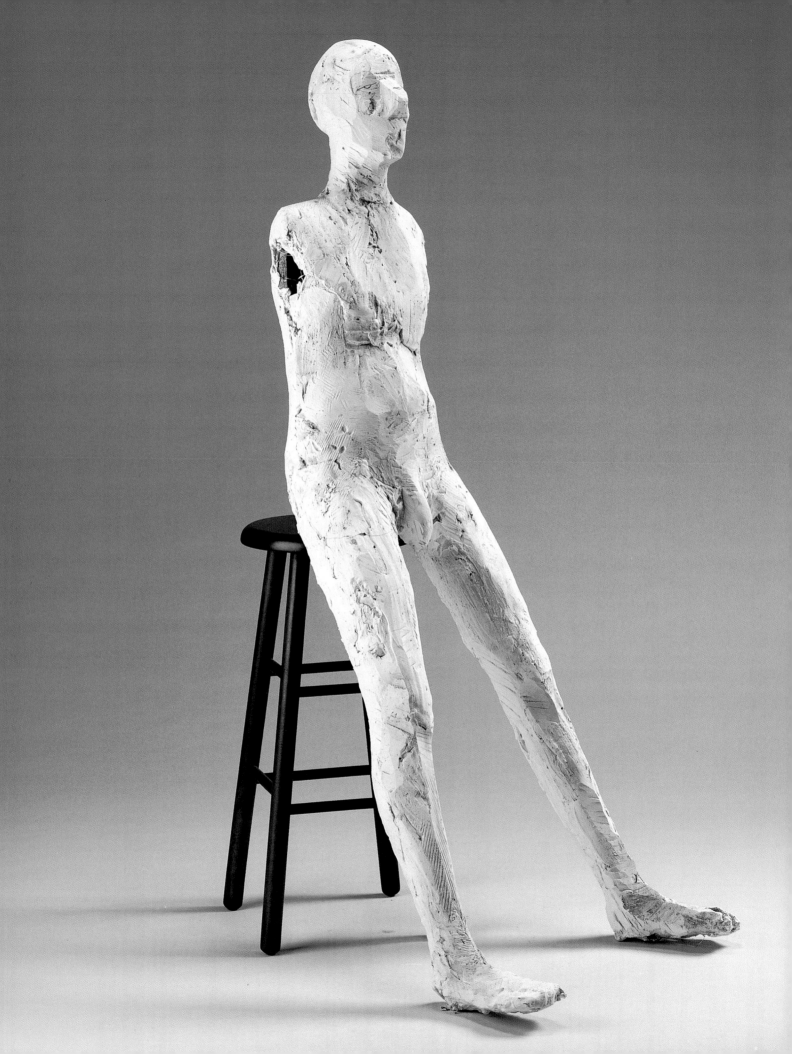

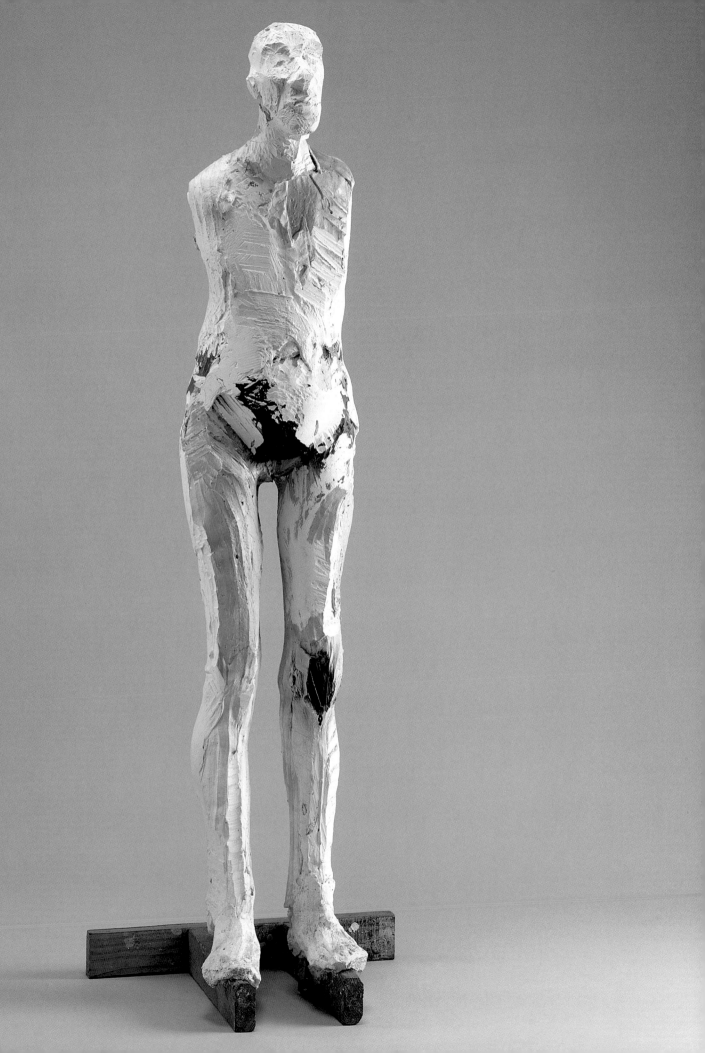

The relationship between Brown and Neri is recalled by di Suvero, who was a friend of both, as "amazingly symbiotic." Each seemed to have been stimulated by the other's example. Brown remembered that "Manuel and I always influenced each other a great deal, way before we were ever together."[18] This exchange deepened as they worked side by side on a number of projects: both, for example, made small, funky sculptures of birds reminiscent of Neri's earlier pieces assembled from junk materials. Neri's plaster figures appeared in a number of Brown's paintings; when Brown was painting moons, Neri made several whimsical crescents out of painted plaster. The two artists traveled together as well: both went to Europe for the first time in 1961, visiting Spain, Italy, France, and England. For Neri, it was a particularly significant journey, exposing him directly to everything from the Elgin marbles to Francis Picabia and Giacometti.

Top:
65. Joan Brown, *Models with Manuel's Sculpture*, 1961.

Bottom:
66. Joan Brown, *Figure with Manuel's Sculpture*, 1961.

Opposite:
67. *Seated Female Figure with Leg Raised*, 1959.

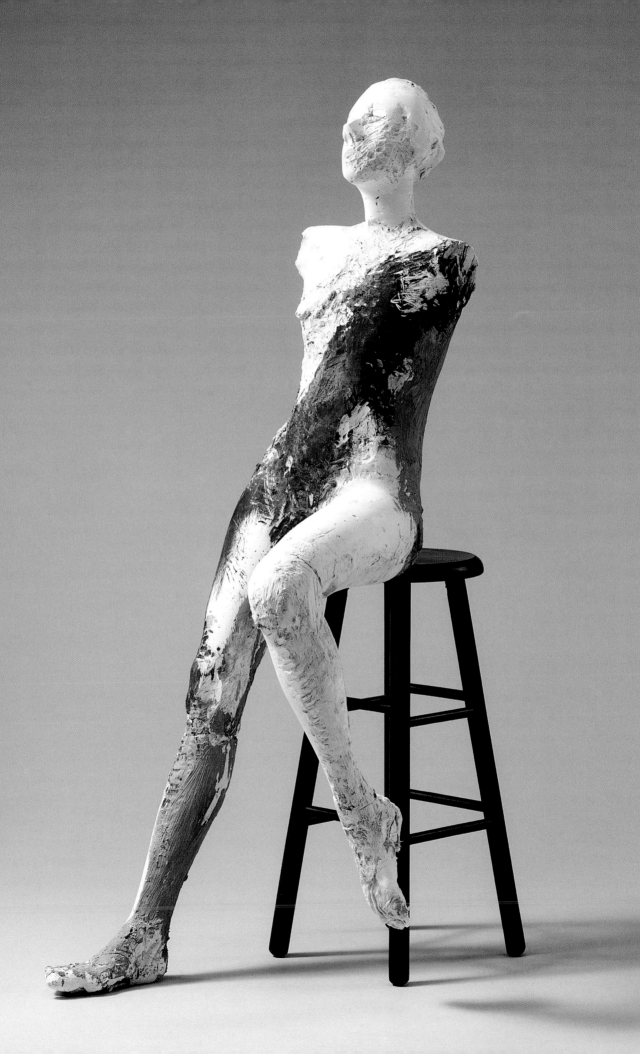

Left:
68. *Moon Sculpture I*, c. 1960.

Top:
69. *Drawing for Moon Sculpture No. 4*, c. 1960.

Bottom:
70. *Drawing for Moon Sculpture No. 5*, c. 1960.

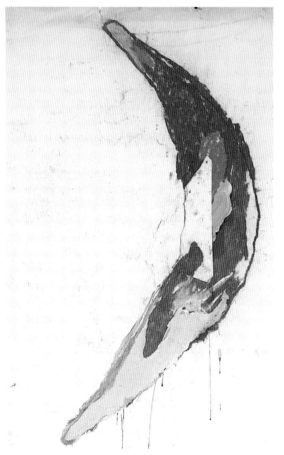

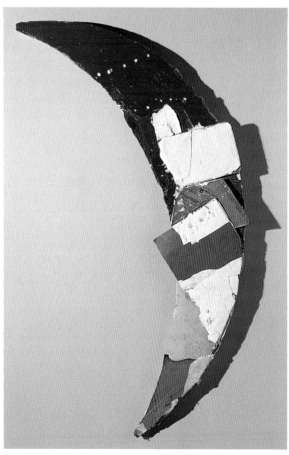

Top:
71. Joan Brown, *Dogs Dreaming of Things and Images*, 1960.

Bottom left:
72. *Drawing for Moon Sculpture No. 3*, c. 1960.

Bottom right:
73. *Moon Sculpture II*, c. 1960.

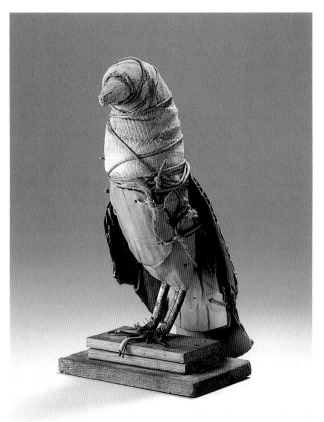

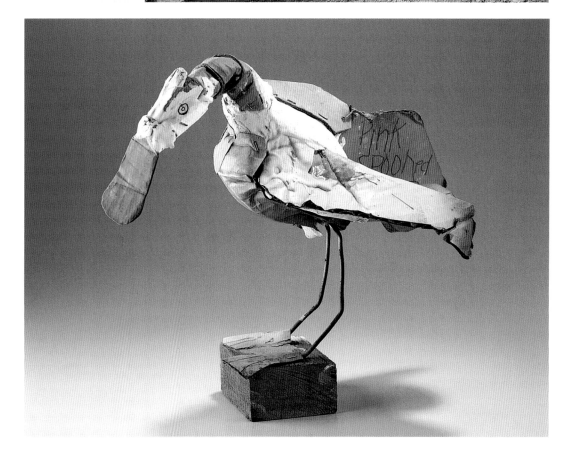

Top left:
74. Joan Brown, *Untitled (Bird)*,
 c. 1960.

Top right:
75. Joan Brown, *Refrigerator
 Painting*, 1964.

Bottom:
76. *Pink Spooned Snap*, c. 1960.

Opposite:
77. *Hawk*, c. 1957–60.

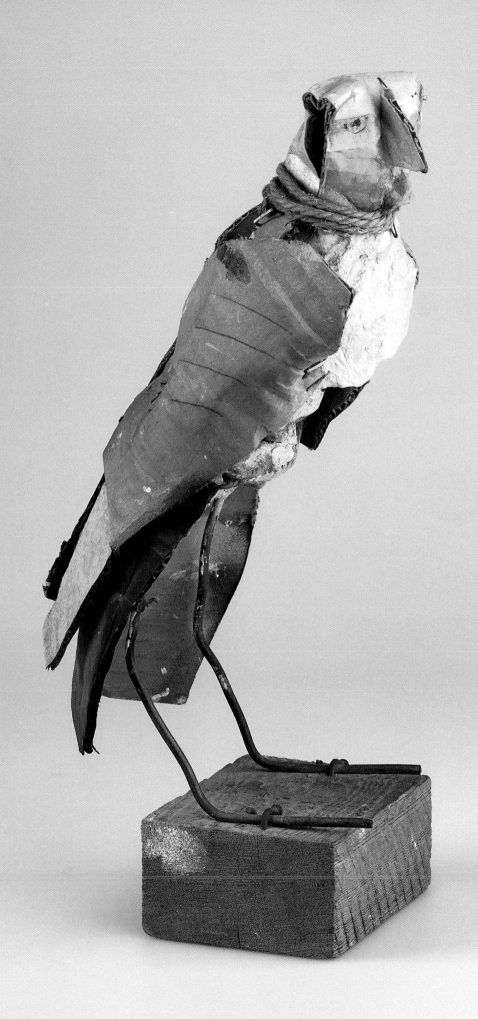

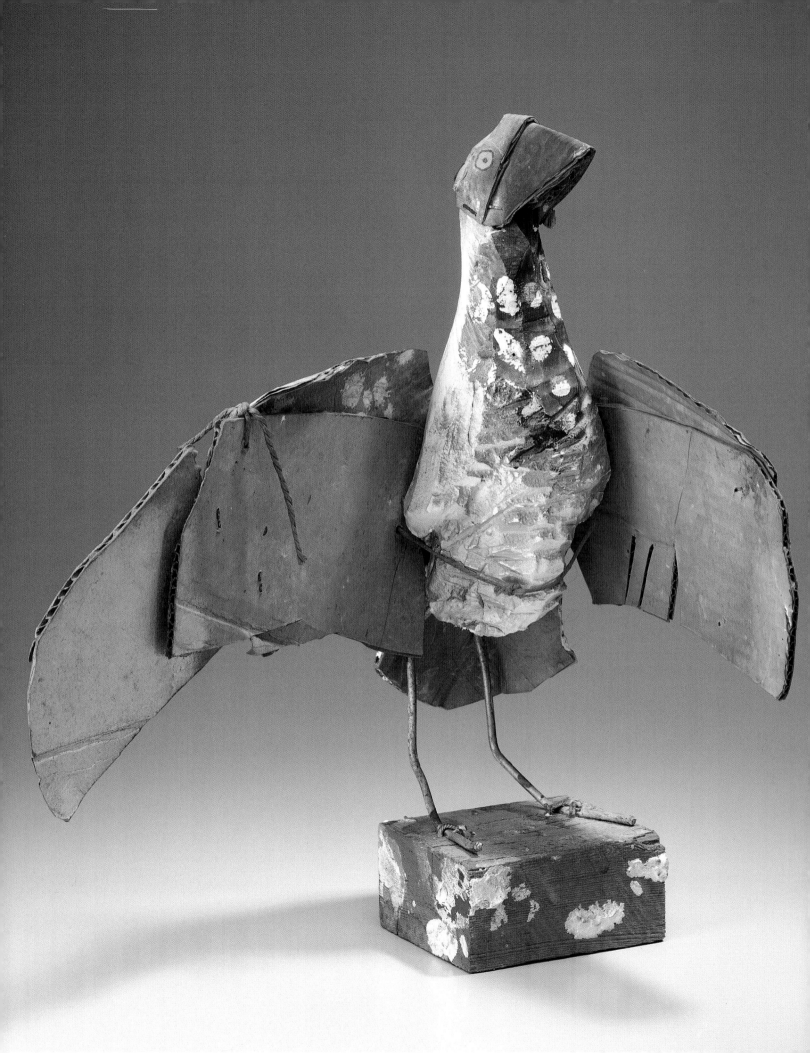

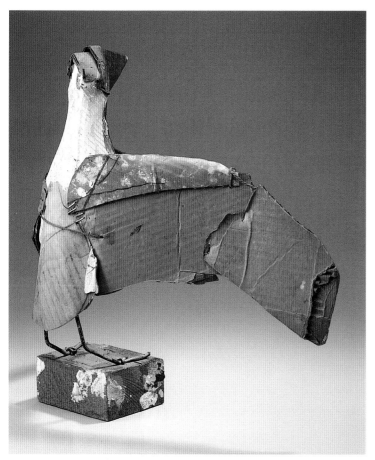

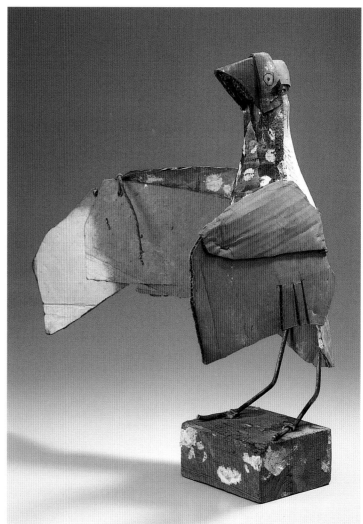

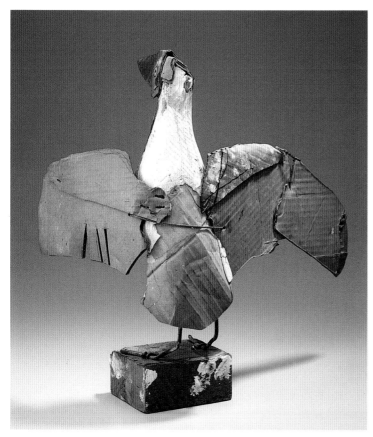

78–81. *Untitled (Bird)*,
c. 1957–60.

Top, left to right:
82. *Joan Brown and Sculpture No. 1, 1963.*

83. *Joan Brown and Sculpture No. 2, 1963.*

84. *Joan Brown Working on Sculpture of Seated Girl, 1963.*

Bottom:
85. *Seated Girl I (Bather),* c. 1960.

Opposite:
86. *Seated Girl II (Bather),* c. 1960–63.

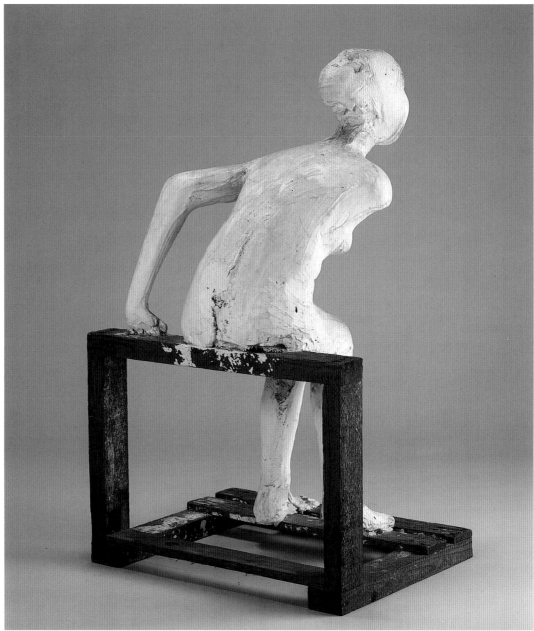

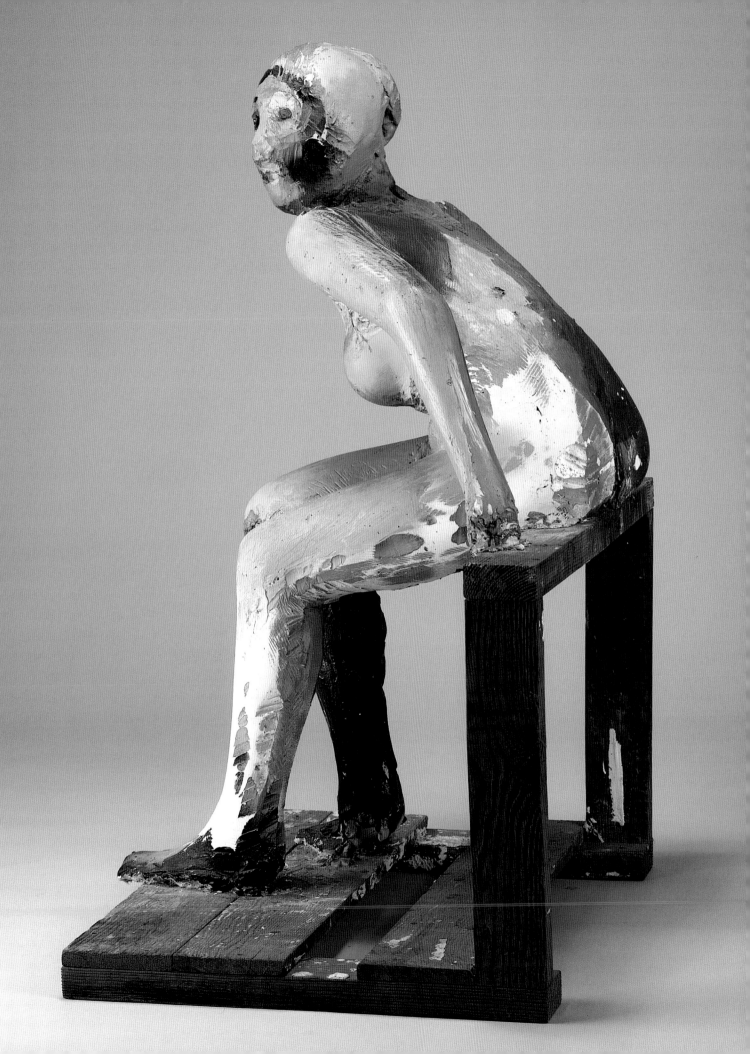

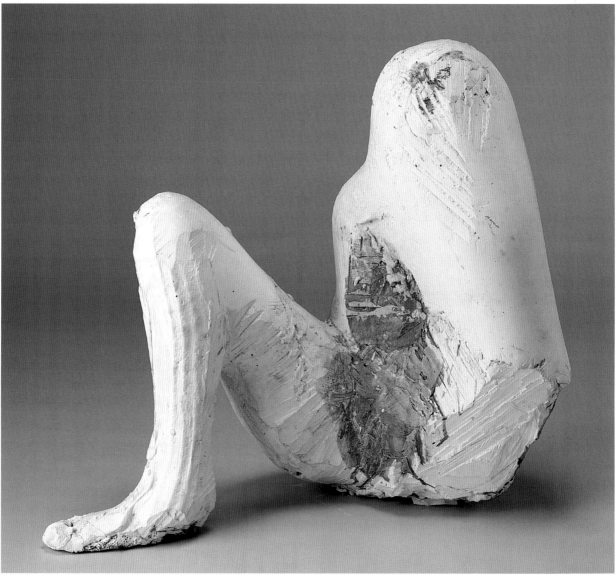

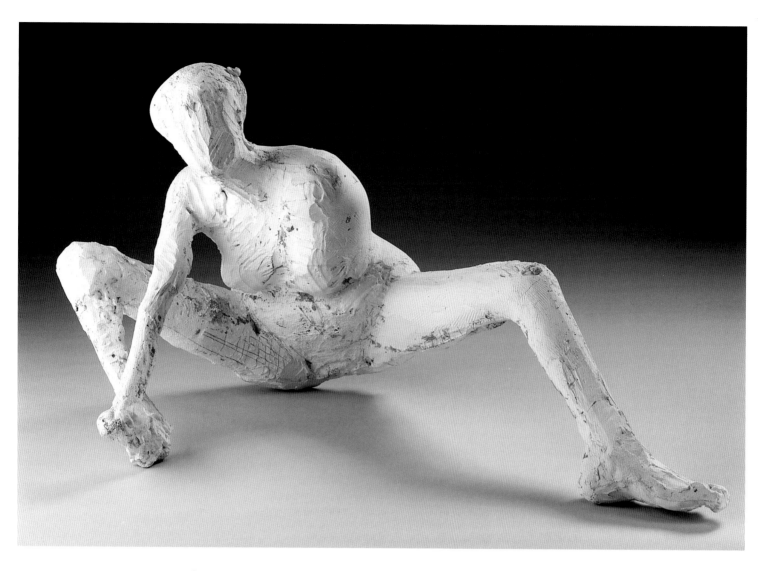

Neri's representations of women likewise grew more potent in the early 1960s. It was in these years that he began to solidify the lithe, sensual, yet somewhat anonymous image of the archetypal woman that has continued to be so central to his sculpture to this day. *Shrouded Figure, Seated Female Figure,* and *Kneeling Figure* are all portrayed in exaggerated athletic postures; they all convey a vigorous physicality. Yet *Kneeling Figure* and *Seated Female Figure* suggest that Neri was wrestling with two distinct notions of women. The former is archetypal, like some fertility figure, while the latter carries more of the personality of the model. The tension between these two paradigms—the iconic on the one hand, the individualized on the other—would remain one of Neri's most fertile artistic conceits.

90. *Seated Female Figure,* 1961.

Opposite:
Top left:
87. *Untitled Figure Study,* 1977.

Top right:
88. *Miseglia Sketchbook,*
 page 36, c. 1975.

Bottom:
89. *Shrouded Figure,* c. 1960;
 Reworked 1962–64.

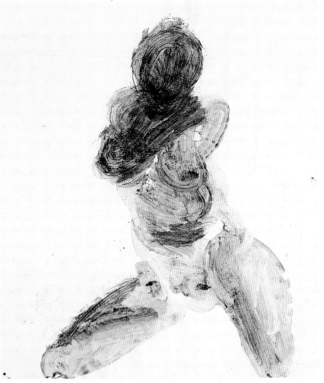
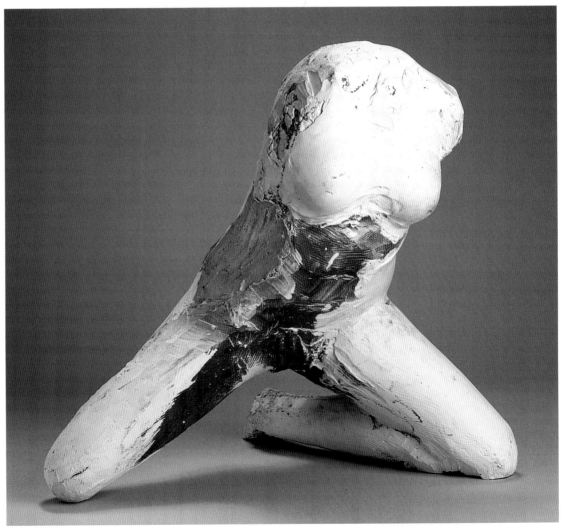

Top left:
91. *Study for Seated Female Figure*, 1963.

Top right:
92. *Study for Kneeling Figure*, 1963.

Bottom:
93. *Kneeling Figure*, c. 1960; Reworked 1962–64.

Neri's involvement with the figure in the early 1960s also earned him his first real critical success. The first solo exhibition devoted exclusively to his figurative sculpture, at the New Mission Gallery, San Francisco, in 1963, received enthusiastic notice, as did his participation in various group exhibitions including "California Sculpture Today," organized by the Oakland Art Museum, also in 1963. In the August 1963 issue of *Artforum*, which was then published in San Francisco, critic John Coplans described Neri as "a very curious and powerful figurative sculptor." He noted Neri's involvement with abstract painting and funk, and said that Neri and Brown shared "a mutual inspiration and a crazy mixture of something both passionate and sloppy which includes a complete indifference to materials."[19] The next month, the magazine's managing editor Philip Leider wrote even more enthusiastically about Neri. Reviewing the show at the New Mission Gallery, Leider said that Neri had produced "a series of sculptured images so penetrating, so disturbing that this becomes, easily, the finest and most absorbing one-man exhibition that San Francisco has seen since, perhaps, Bruce Conner's opening exhibition at the Batman Gallery [in 1960]."[20]

To both critics, it was clear even then that Neri was not simply a product of the Bay Area figurative school. In the October 1963 issue of *Art in America*, Leider, writing of the group of artists then teaching at the San Francisco Art Institute, including Neri, Brown, Hedrick, Frank Lobdell, and William Wiley, said that these artists "have nothing in common with Bay Area figurative art, which, for all its influence that appears in their work, might never have existed. Both in sculpture and in painting . . . the major preoccupation is with parody and the grotesque."[21] While Leider exaggerated to make his point (it has never been accurate to say that Neri had *nothing* in common with Bay Area figuration), he was certainly correct that the connection was overdrawn at the expense of a more complex reading of Neri's work.

Coplans made a similar point the following year. Writing in the June 1964 *Art in America* of the generation of artists who had recently emerged in San Francisco—among them Neri, Brown, Alvin Light, Robert Hudson, and Carlos Villa—Coplans noted that "underlying their work is the notion of 'funk'. . . . To be 'funky' is to be completely casual and informal, deliberately dumb and corny, free-wheeling and spontaneous. . . . As much as anything else, it is an attempt not only to vitalize their work, but also to protect themselves from falling into a dull provincialism, slickness, or a debilitating habit of 'good taste.'"[22]

In all, it seemed that by 1964, Neri had everything going for him. He had developed a powerful and personal figurative style that, especially in its depictions of women, aspired to the mysterious sensuality of the poets he most admired. His work was beginning to be seen in solo exhibitions and in group shows of California art. And a pair of influential critics were speaking highly of his art, and seeming to understand the complexity of

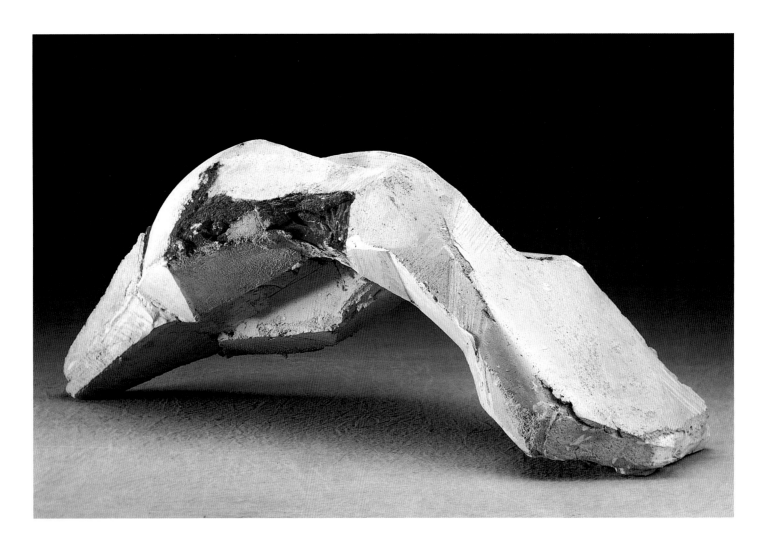

94. *Torso Grande I, 1963.*

its origins as well as its deliberate embrace of the passionately crude—the "bad taste of things," in Neruda's words. Yet just at this moment, Neri entered a period of artistic experimentation, which found a profoundly important parallel in his personal life.

It may be that the symbiotic power of Neri's relationship with Brown can most readily be measured by observing what happened to his work after the relationship ended. Though he and Brown had married shortly before their son was born in 1962, they were growing apart by 1964. They had spent the summer of that year together in Boulder as Visiting Artists at the University of Colorado, and showed together in December at the David Stuart Galleries in Los Angeles. But Neri remembers that their relationship had already foundered.

Separating from Brown, Neri moved into a new studio on California Street in San Francisco, where he continued to pursue his interest in the figure. Now, however, he focused on exploring the figure through its various parts, in order to determine the fundamental, most essential elements of its structure. (Neri originally posed this problem for himself in response to the figure fragments he saw in museums during his travels in Europe with Brown in 1961, and it was critical to the rethinking and reworking of his sculptures after his return.)

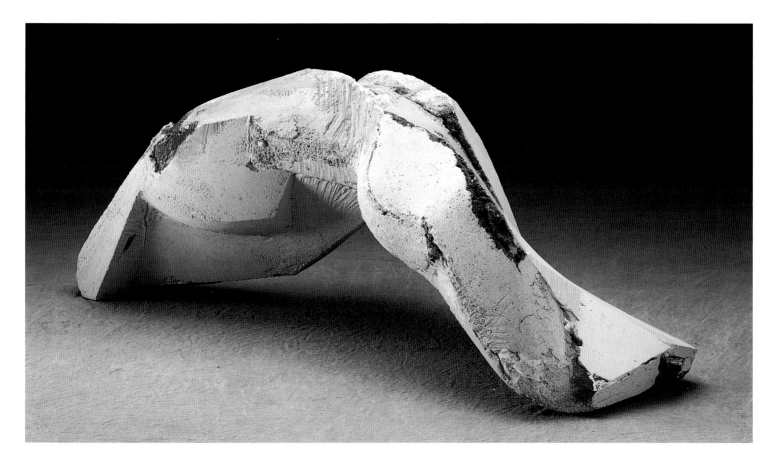

Neri's interest in the geometry of the partial figure gave rise to a pair of torsos that are almost cubist in their distortion, displacement, and reordering of the figure's elements. Large—they measure over five feet—and constructed of plaster with aggregate, these torsos translate the figure into a sequence of interrupted planes; color is used to heighten and exaggerate form as well as to contrast one shape with another. Neri's exploration of sculptural form through the figure here comes close to the brink of abstraction, a direction he would periodically return to throughout his career.

In 1965 Neri was appointed Visiting Lecturer at the University of California, Davis, beginning an association that occasioned his move that same year to Benicia, a town on Carquinez Strait about thirty miles east of San Francisco toward Davis. There he bought an abandoned church, which he converted into a studio and living space (where he still lives). His position on the Davis faculty provided him with a measure of financial security that he had not previously enjoyed. He remembers these as "hard times" nevertheless. His personal life was in flux: he and Brown divorced in 1966; the next year, he married Susan Morse, a graphic designer who was then a student at CCAC, and whom he had met in 1965 through Mark di Suvero. Susan remembers that Neri spent a lot of time on the renovation of the church, and that it took him time "to get adjusted to the big space." When the dust finally settled and he returned to work, he began a group of geometric drawings and sculptures and a series of works based on religious themes.

95. *Torso Grande II, 1963.*

57

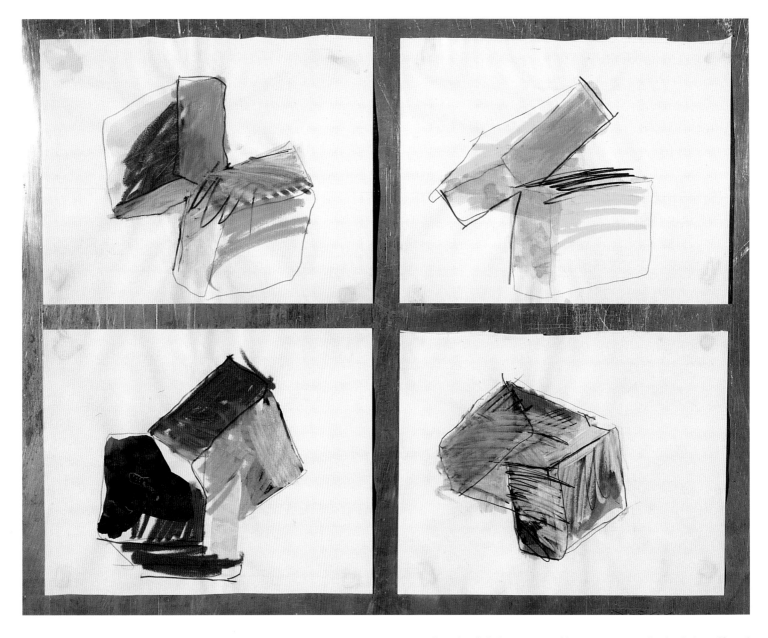

First came small, colorful drawings of boxes, some of which he affixed to sheets of stainless steel, and then came large canted and stacked stainless steel boxes with edges painted in fluorescent colors. These were shown in an exhibition at Quay Gallery, San Francisco, in 1966, at a time when geometric abstraction was very much in the air. The minimalist style, with its emphasis on primary form and structure, had by then superseded abstract expressionism as the reigning movement, in both painting and sculpture. Moreover, minimalism was not confined to New York: it had notable adherents in California as well, especially in Los Angeles. And minimalism was hotly debated in the pages of *Artforum*, which had only recently moved from San Francisco, first to Los Angeles, then to New York.

96. *Studies for Geometric Sculptures I, 1966.*

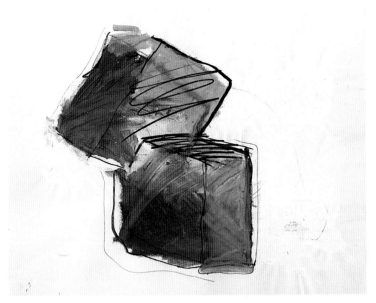

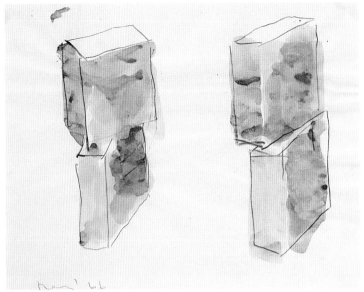

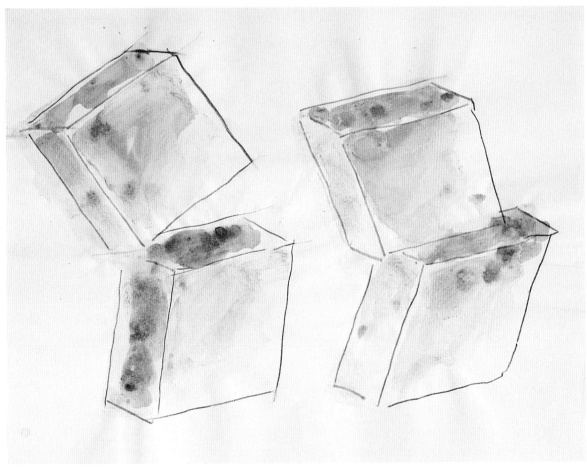

Top left:
97. *No Hands Neri Sketchbook,*
 page 58 (verso), c. 1966.

Top right:
98. *Study No. 1 for Geometric*
 Sculptures, 1963.

Bottom:
99. *No Hands Neri Sketchbook,*
 page 67 (verso), c. 1966.

Following pages:
Left:
100. *Geometric Sculpture No. 2,*
 1966.

Right:
101. *Geometric Sculpture No. 1,*
 1966.

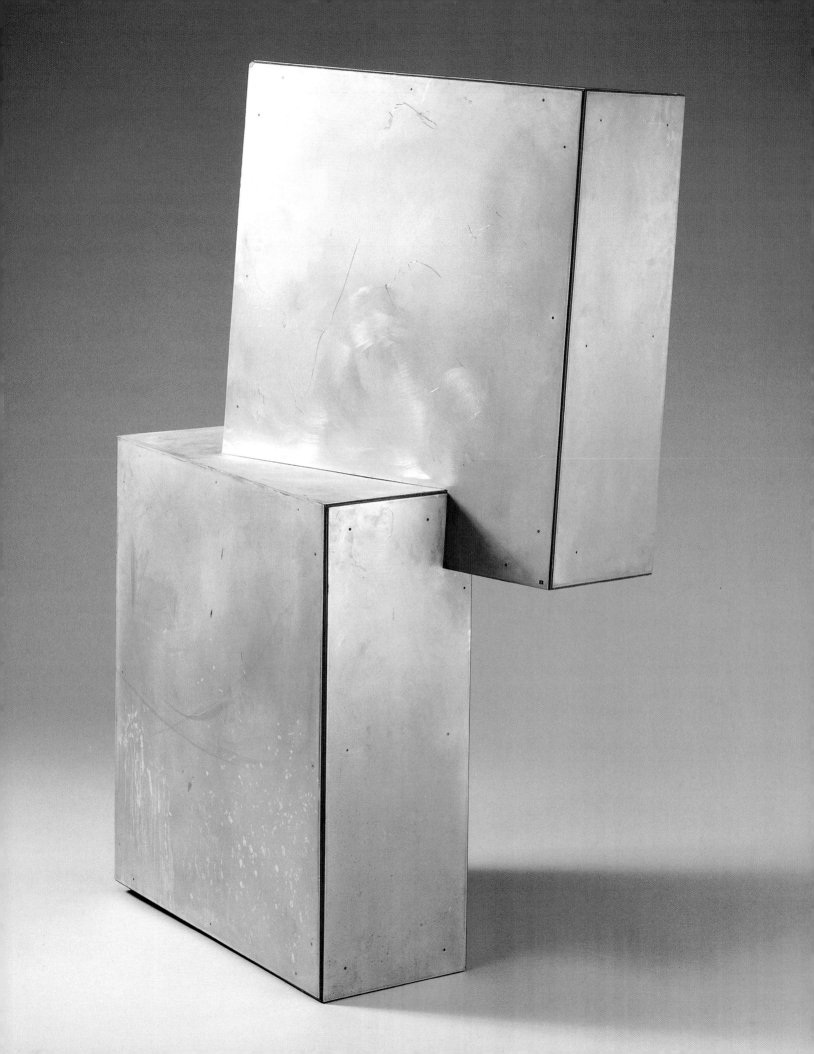

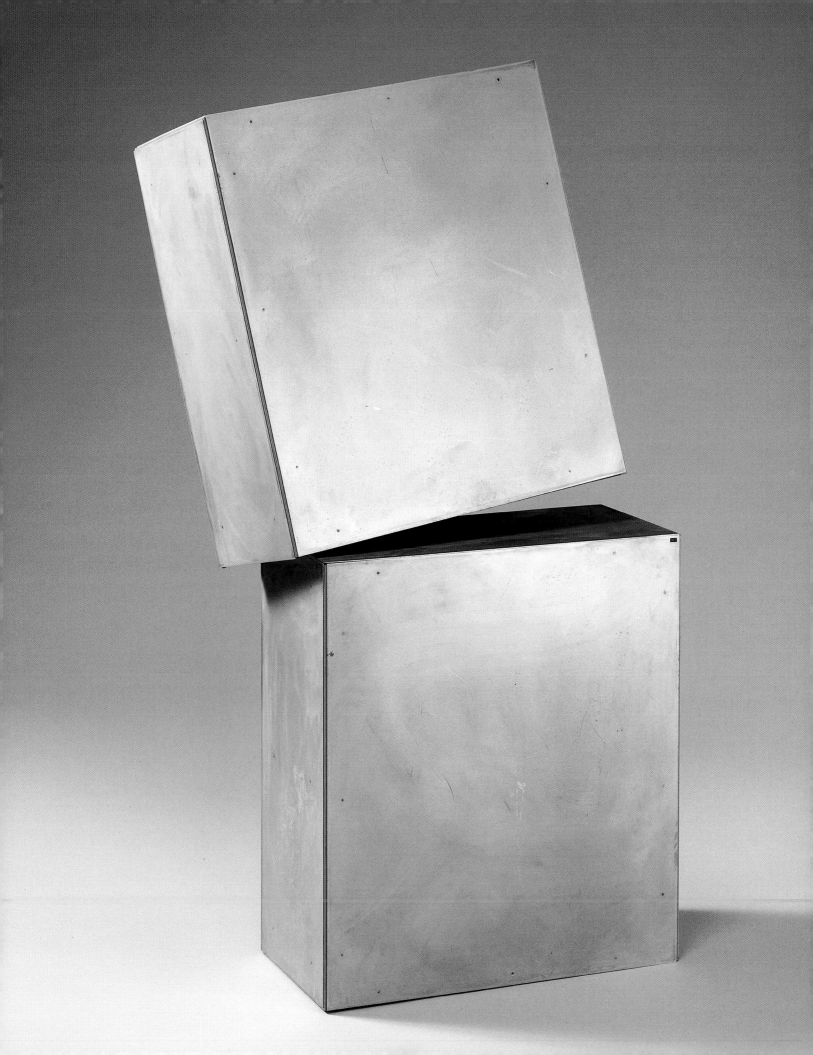

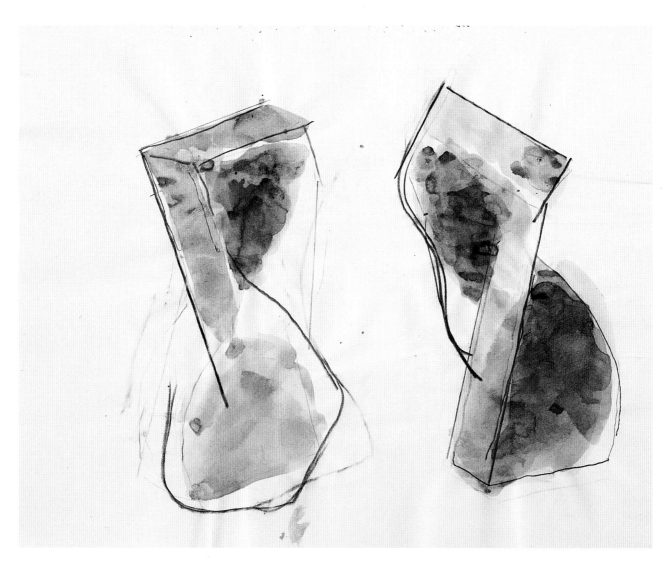

But Neri's involvement with geometric abstraction was much more complicated, and less complete, than a simple "effort to get with minimalism," as he caustically puts it. His forms were never completely regular and precise: they were always slightly asymmetrical or imperfect. His sculptures seldom lost the sense that they were handmade. Indeed, they show a significant lingering debt to the funk aesthetic. "When [sculpture] got too clean, it lost its magic. Some of [my work] began to look like that, and it turned me off." His reaction ran very much against the minimalist orthodoxy, which favored the machine-tooled look. In 1968 he again exhibited boxlike sculptures at Quay Gallery, this time open-form works made of wood and rough plaster mixed with an aggregate. Whatever the superficial similarities with minimalism, in other words, it was clear that Neri was pursuing these geometric forms in his own style and for his own reasons. He was exploring what he called the "purity of line," but he was also demonstrating a nascent interest in architectural form, especially as a foil for the figure, a project that would occupy him intermittently through the early 1970s (and again in the mid-1980s, with the *Arcos de Geso* sculptures in bronze and plaster, and the *Mujer Pegada* series in marble).

102. *No Hands Neri Sketchbook*, page 75 (verso), c. 1966.

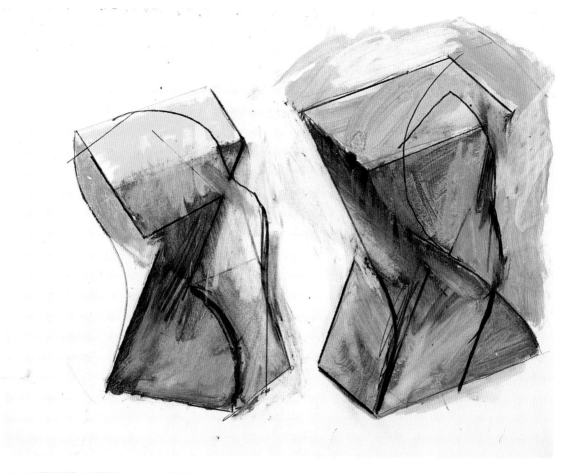

Top:
103. *No Hands Neri
Sketchbook*, page 82
(verso), c. 1966.

Bottom:
104. *No Hands Neri
Sketchbook*, page 83
(verso), c. 1966.

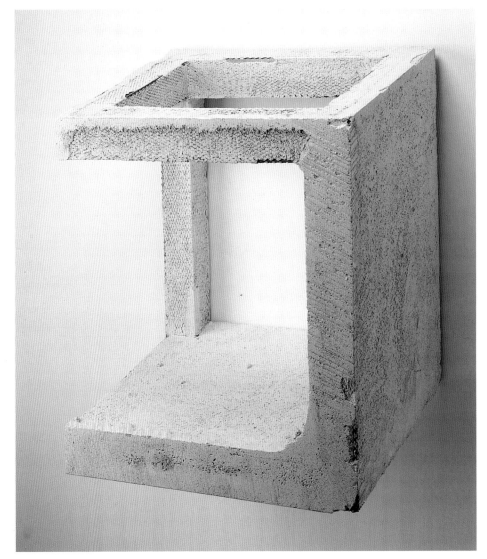

Top left:
105. *No Hands Neri Sketchbook*, page 43 (verso), c. 1966.

Top right:
106. *No Hands Neri Sketchbook*, page 24 (verso), c. 1966.

Bottom:
107. *Open Box Form I*, 1968.

Opposite:
108. *Open Box Form II*, 1968.

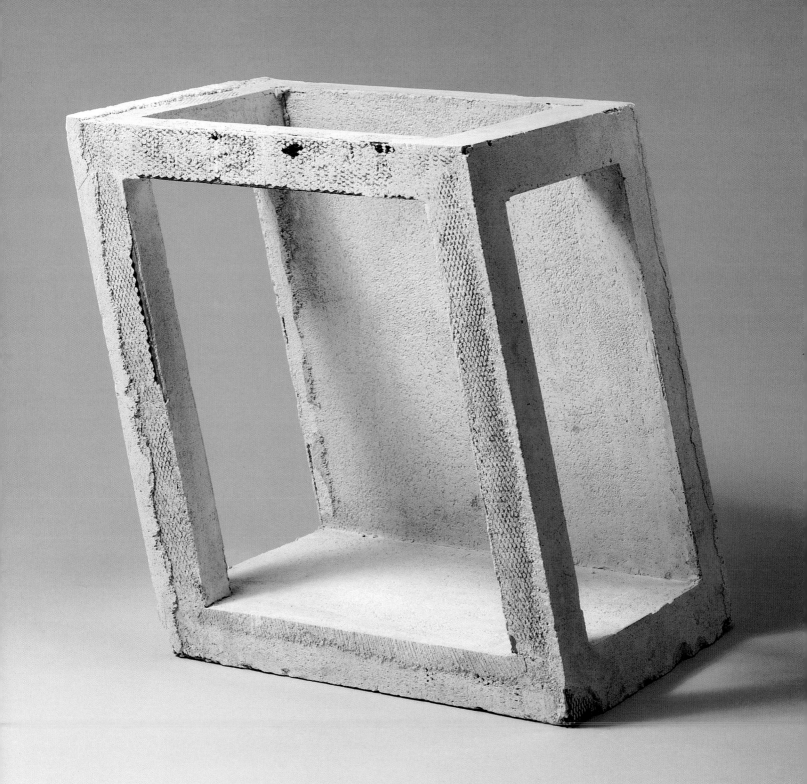

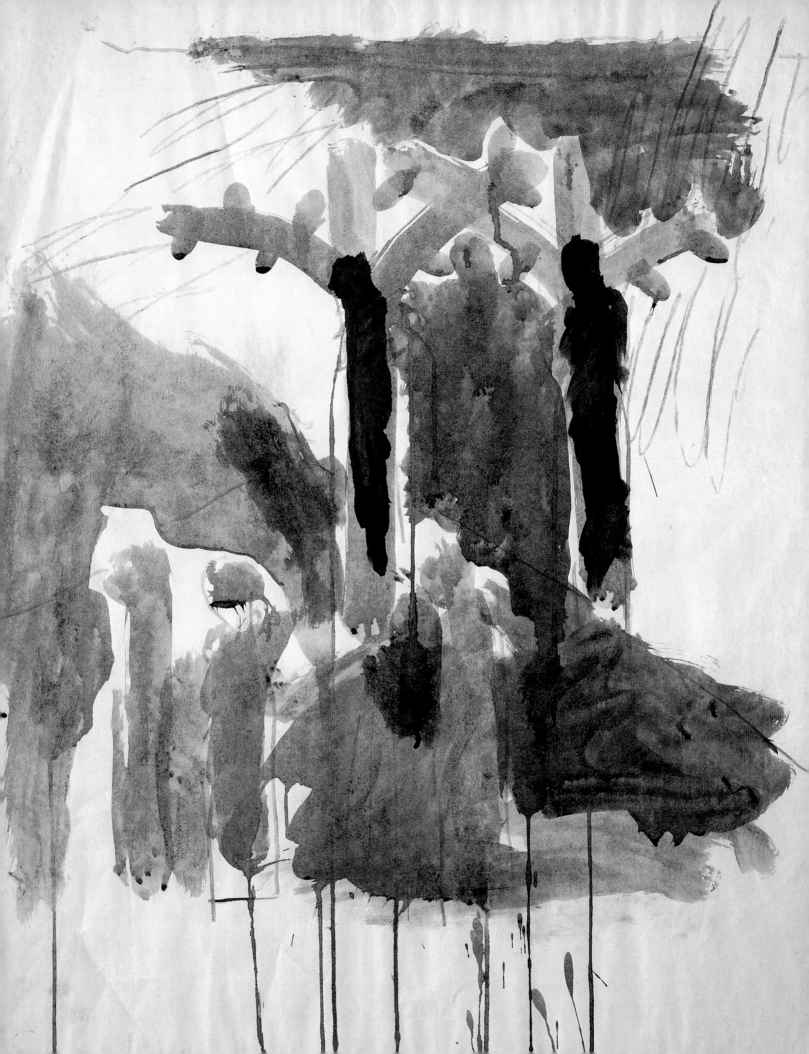

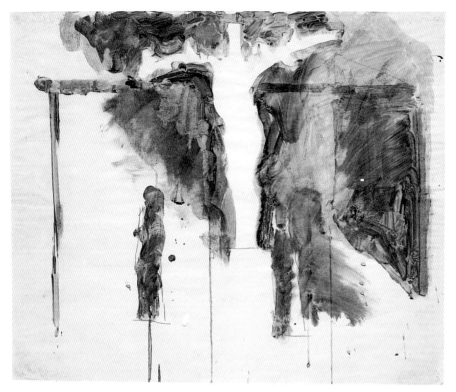

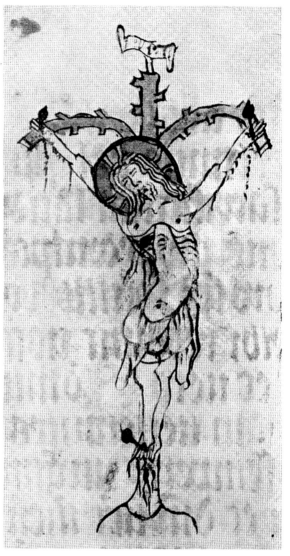

Shortly after his move to the former church in Benicia in 1965, Neri made a series of drawings depicting the Crucifixion. He recalls that they were inspired by a reproduction of a fourteenth-century religious print that he came across in a book: strikingly, the print depicted the Cross not constructed from finished timbers, but from the branching limbs of a tree, which symbolized the Tree of Life, or the Tree of Knowledge, reborn through the blood of Christ. Neri found himself compelled by this image of death and resurrection. He used it to create both black-and-white and vivid color sketches that show Christ on the Cross flanked by two robed figures, presumably the Virgin Mary and either Mary Magdalene or Saint John. The studies show that Neri experimented with different positions for the standing figures, and variously with light figures against a dark ground and vice versa. The first of these sketches employs a saturated, even seemingly blood-drenched palette consistent with Neri's use of color on his sculpture of that year. Far from lacking the intensity of the color studies, the black-and-white depictions of the same subject maintain the vivid emotional tone of the series by virtue of their rapid execution and dripping ink.

Left:
110. *Ink Drawing of Crucifixion IV*, 1965.

Right:
111. Drawing of Crucifixion, c. mid-14th century.

Opposite:
109. *Ink Drawing of Crucifixion I*, 1965.

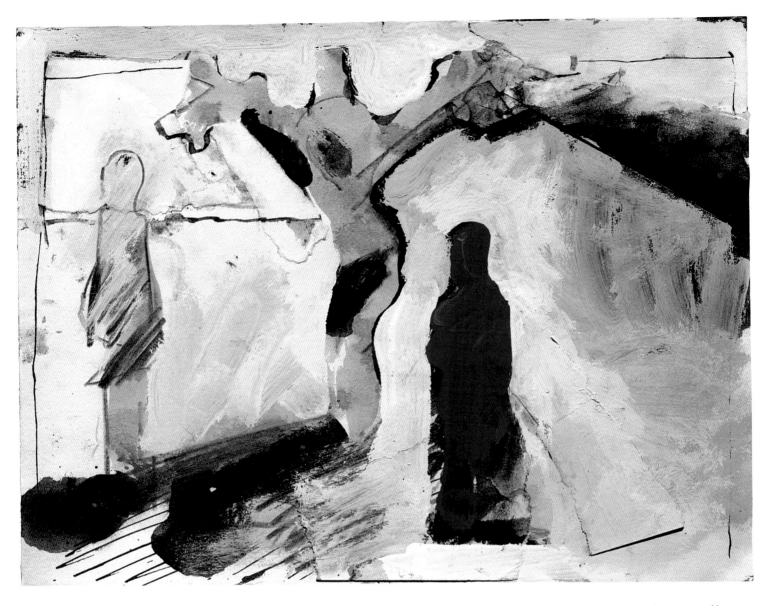

112. *Crucifixion Drawing No. 1,*
 1963.

Opposite:
Top:
113. *Crucifixion Drawing No. 4,*
 1963.

Bottom left:
114. *Crucifixion Drawing No. 3,*
 1963.

Bottom right:
115. *Crucifixion Drawing No. 2,*
 1963.

Neri's move to the former church also led him to plan a series of large-scale plaster reliefs around the theme of the Crucifixion. Accustomed to the ornately decorated churches of his Catholic boyhood, Neri may have been taken aback by the spartan interior of the former Congregational church that was now his studio and home. Almost reflexively, it seems, he wanted to fill it with icons: "You move into a church," he says, "what else do you do?" Two studies for these reliefs survive (figs. 118–19); they were rapidly executed in crayon with crosshatched lines. They do not depict the Crucifixion itself, but the kneeling figures give a sense of the religious subject. Both sketches show the same figures in various groupings and suggest that the reliefs—which were never executed—might have constituted a narrative, like the Stations of the Cross.

68

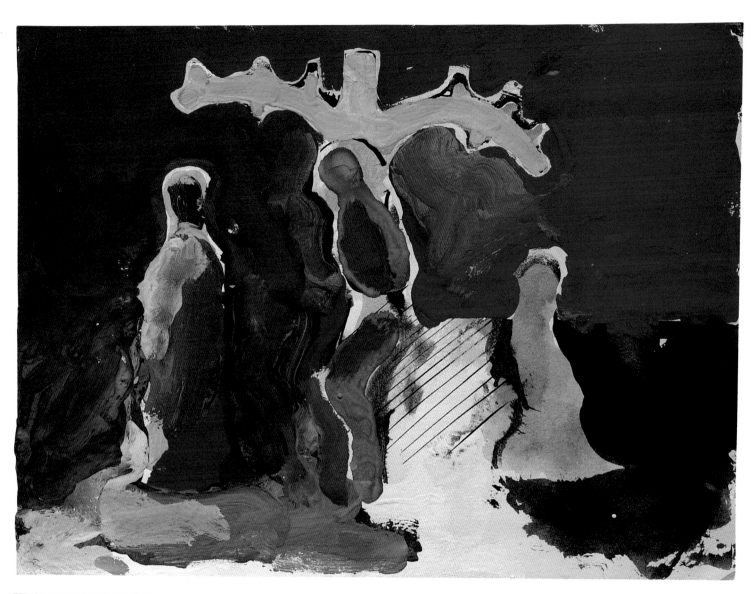

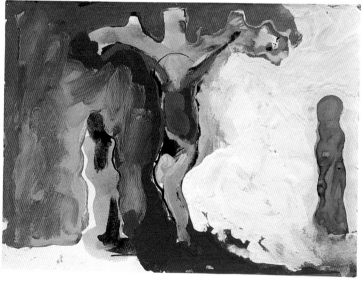
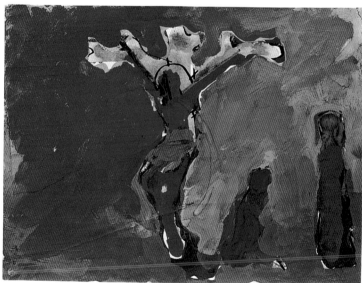

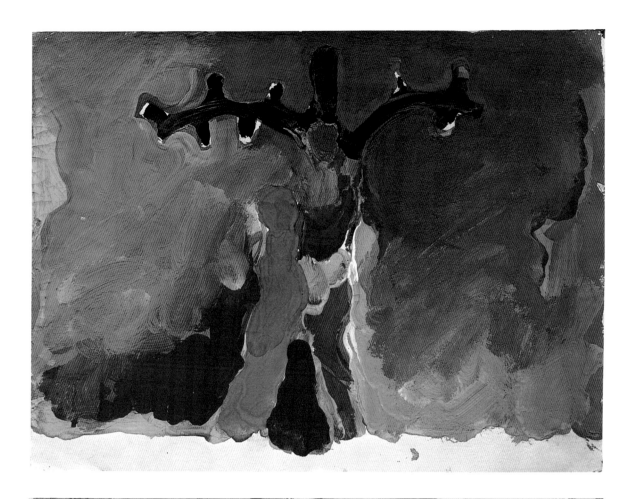

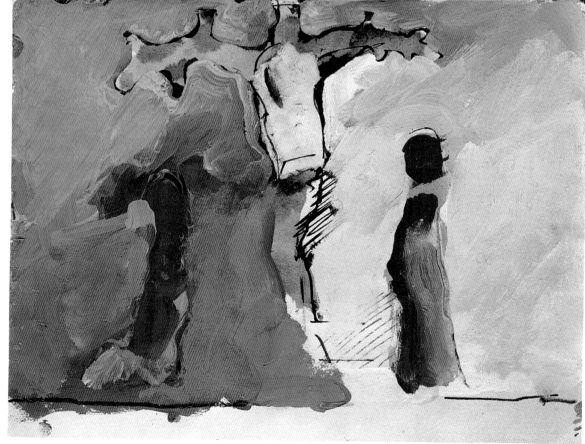

Top:
116. *Crucifixion Drawing No. 5*,
 1963.

Bottom:
117. *Crucifixion Drawing No. 6*,
 1963.

Opposite:
Top left:
118. *Study for Relief Icons No. 2*,
 c. 1965.

Top right:
119. *Study for Relief Icons No. 1*,
 c. 1965.

Bottom:
120. *Crucifixion Drawing No. 7*,
 1963.

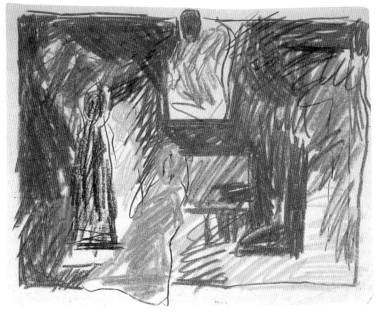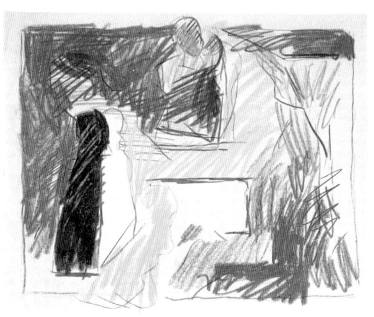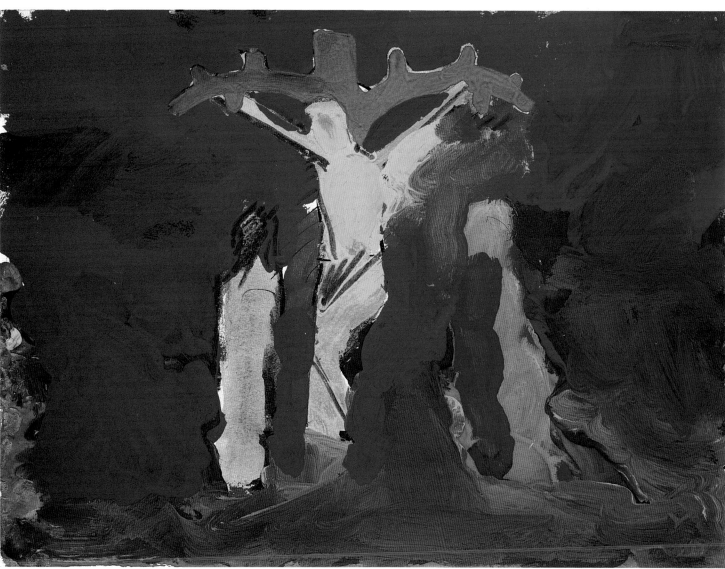

Top left:
121. *Study No. 4 for Tikal Series,*
 c. 1969.

Bottom left:
122. *Study No. 2 for Tikal Series,*
 c. 1969.

Right:
123. *Repair Sketchbook,* page 37,
 c. 1969.

Concurrent with his religious works, occasioned by the move into the church, Neri maintained his interest in geometric form. This continuing exploration was further stimulated by his experience with pre-Columbian architecture on several trips to South America. Visiting Inca and Nazca sites in Peru in 1969, he became interested not simply in the architecture he saw, but also in the way it connected with its setting—how ceremonial spaces were arranged, for example. He was also captivated by the way the Nazca line drawings on the earth articulated the contours of the landscape. He described the Nazca lines as "a magical use of nature"; at the Inca sites, he examined the arrangement of the thrones. Above all, he was concerned with the ritualistic implications of the structures.

Several groups of sculptures were inspired by Neri's exposure to pre-Columbian architecture; some of them even bear the names of archaeological sites such as Tikal and Tula. One group from 1969 consists of simple, truncated pyramidal shapes with barely the suggestion of steps, which are reminiscent of raised ceremonial spaces. Another displays the solid, blocky look of pre-Columbian pyramids as well as their stepped forms. Later wood and wire mesh sculptures, some of which received a coat of resin, continued the simple geometric vocabulary, though some came to resemble portals, and others the more familiar stepped pyramid. The last of these geometric forms, a group of linear sculptures in cardboard and resin from 1972, make reference to the Nazca lines of Peru. As is often the case in Neri's work, these forms were explored and refined in numerous drawings and collages, and simultaneously expressed in sculpture.

124–25. *Tikal Series I* and *Tikal Series II* in progress in Benicia studio, 1969.

126. *Architectural Forms III
from Tula Series*, 1969.

Opposite:
Top left:
127. *Rock No. 73*, c. 1967–69.

Top right:
128. *Rock No. 75*, c. 1967–69.

Bottom left:
129. *Study No. 2 for Archi-
tectural Forms III
from Tula Series*, 1969.

Bottom right:
130. *Study No. 1 for Archi-
tectural Forms III
from Tula Series*, 1969.

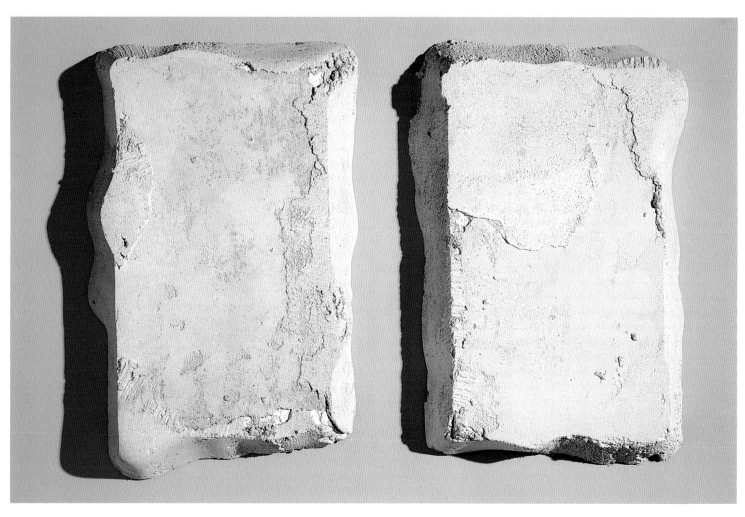

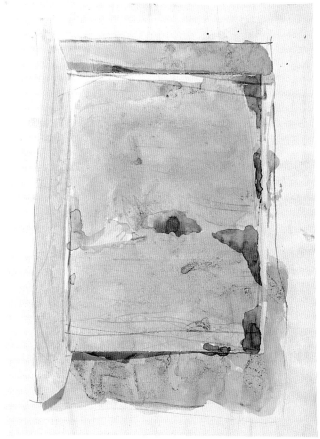

Top:
131. *Architectural Forms IV from Tula Series*, 1969.

Bottom:
132. *Rock No. 77a*, c. 1967–74.

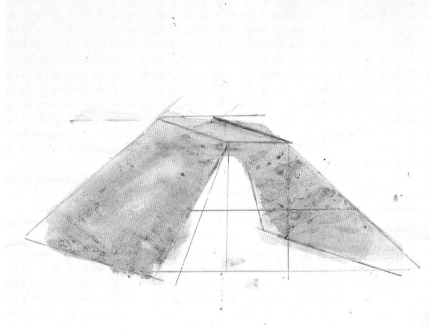

Top:
133. *Architectural Form V from Tula Series*, 1969.

Bottom:
134. *Study No. 3 for Architectural Form V from Tula Series*, c. 1969.

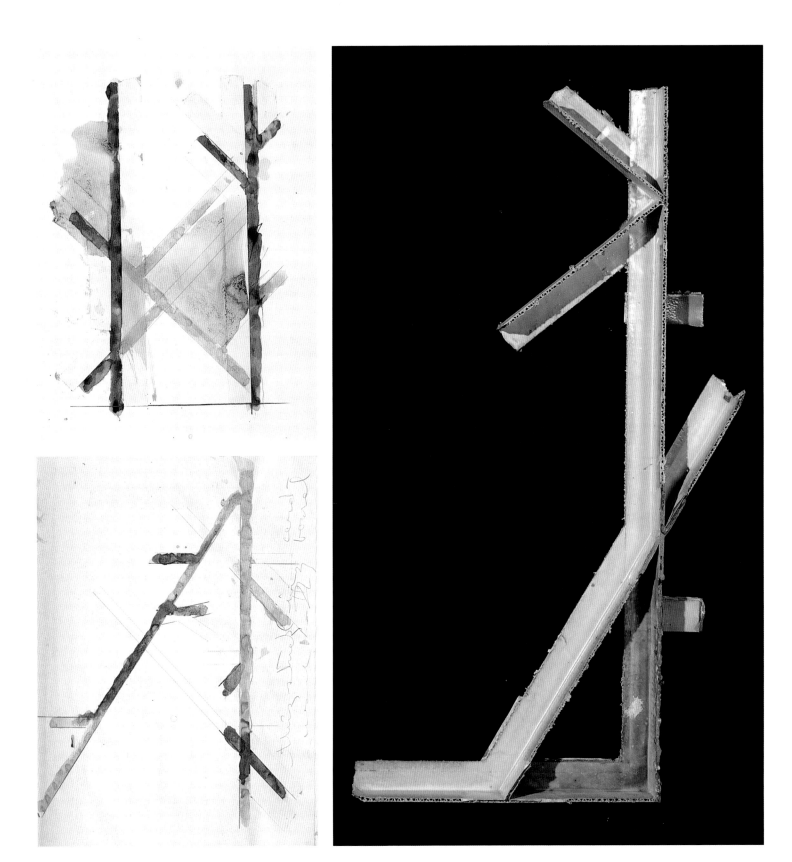

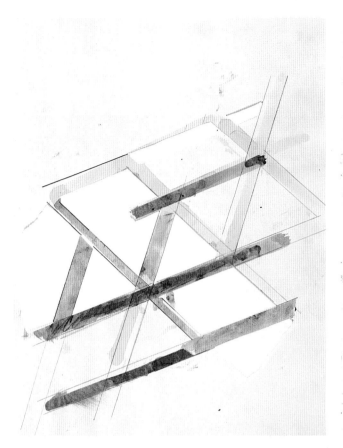

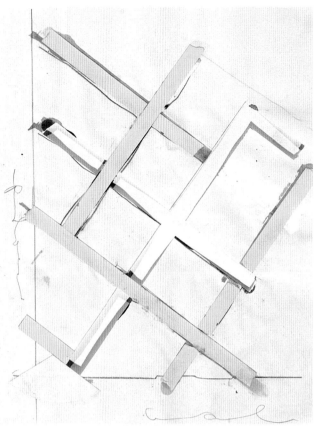

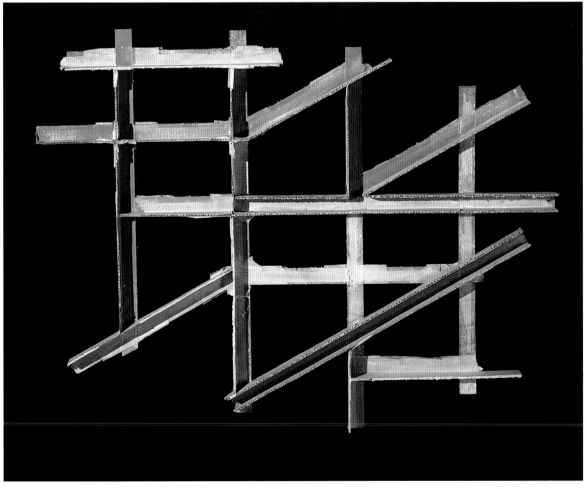

Top left:
138. *Ladder Sketchbook*, page 51, 1971–72.

Top right:
139. *Projections Sketchbook*, page 18, c. 1965–83.

Bottom:
140. *Emborados Series—Nazca Lines II*, 1972.

Opposite:
Top left:
135. *Ladder Sketchbook*, page 66 (verso), 1971–72.

Bottom left:
136. *Ladder Sketchbook*, page 75, 1971–72.

Right:
137. *Emborados Series—Nazca Lines III*, 1972.

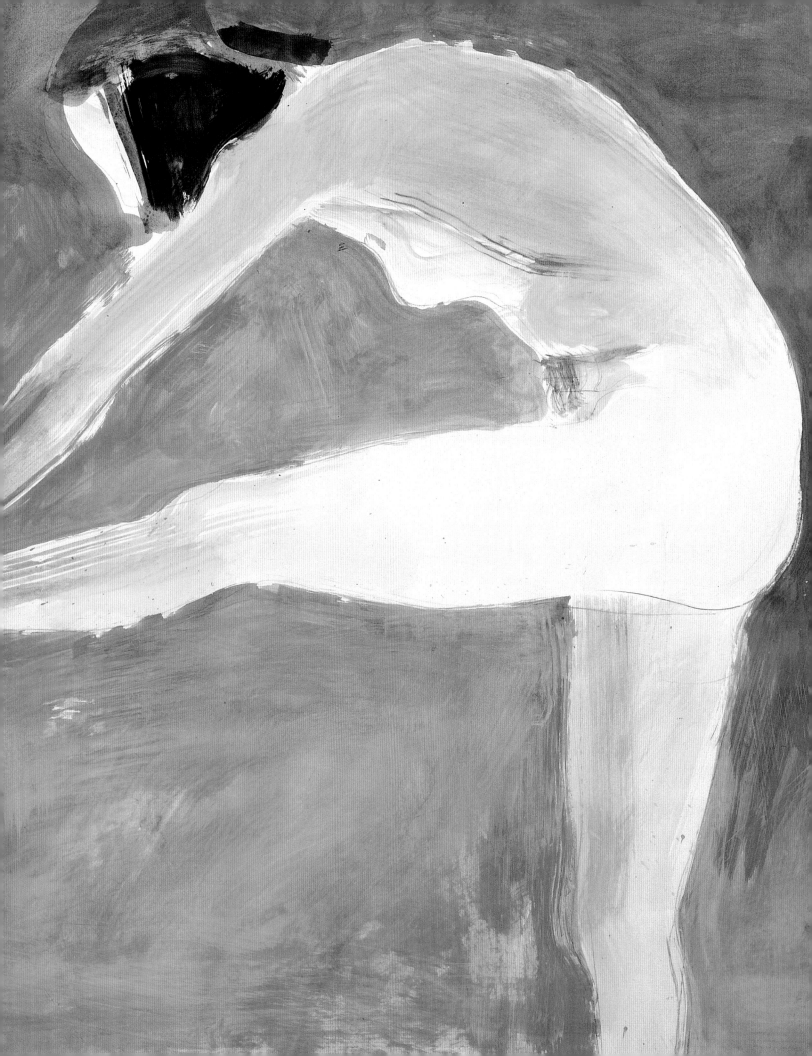

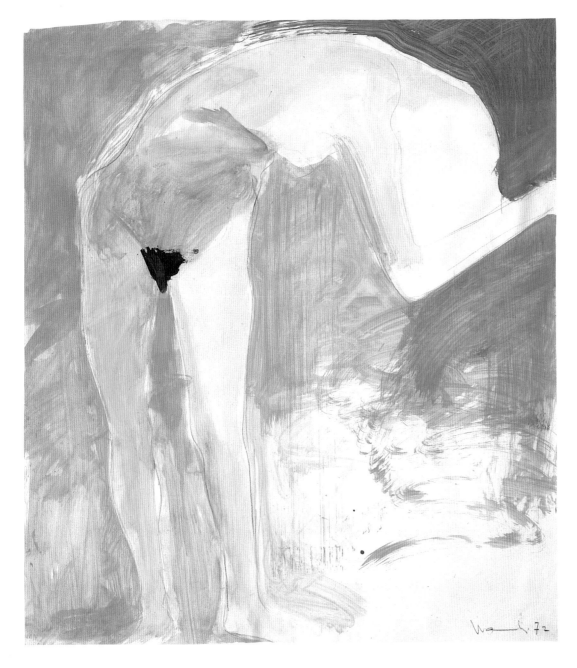

Gradually, however, Neri returned to focusing on figurative work, prompted by two events in particular. Late in 1972, Neri met Mary Julia Raahauge (now Klimenko), who came to provoke him artistically in the same way and with the same intensity as had Joan Brown fifteen years earlier. Within two years, Mary Julia had become virtually his only model, and she has remained his principal model to the present. With Mary Julia, structure and gesture took on new importance in Neri's figurative sculpture, and he developed a new technique for constructing his figures, applying the plaster over a steel armature and a styrofoam core. This and the fact that he was working directly with a live model on a regular basis brought Neri to a freer and more expressive handling of the figure. The new work had much more personality and more varied poses than his earlier work.

142. *Mary Julia No. 2, 1972.*

Opposite:
141. *Mary Julia No. 1, 1972.*

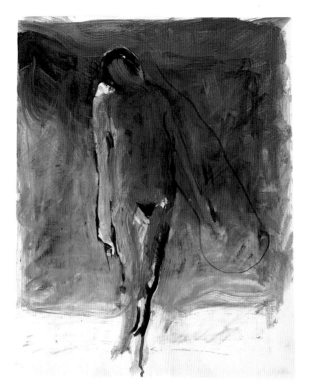

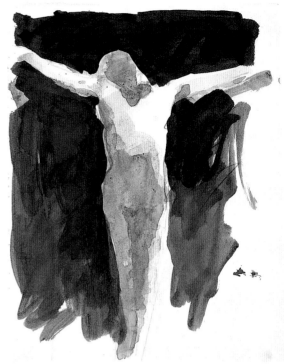

Neri's other incentive for returning to the figure was a proposal for a commission to create a pair of sculptures for a convent near Los Altos, California, in 1973, which brought him back to the religious themes he had begun to explore several years earlier. It might seem unlikely that an artist of Manuel Neri's temperament would have such sustained interest in religious subject matter: his approach to the figure is overwhelmingly sensual and emotional rather than spiritual or didactic. Yet he warmed to the challenge posed by the possibility of his first overtly religious commission. "I was raised a Catholic," he acknowledged, "and it all bubbled up." "They wanted a Crucifixion," Neri remembers, "but it was the image of Christ in Ascension that really knocked me out." Neri made dozens of studies for this work, both of the Crucifixion and of the resurrected Christ, with Mary Julia as his model.

Working variously in charcoal, in watercolor and ink wash, or in acrylic, he sketched out several possibilities for the Christ figure. Some drawings clearly suggest the image of Christ on the Cross: *Crucifixion Sketchbook,* page 24 (verso) (fig. 286), for example, in which the arm looks forcibly held aloft and to the side; or *Crucifixion Sketchbook,* page 29 (verso), in which the head slumps to the chest. Others suggest the Deposition, such as *Crucifixion Sketchbook,* page 31 (verso) and *Crucifixion Sketchbook,* page 34 (verso). In both of these drawings, the whole figure seems limp, and the arms are held out slightly from the side, as if the body were being supported from behind. The intensity of the image is heightened in all of the *Crucifixion Sketchbook* studies by the fact that the figure is lighter in tone than the background and seems to float against a void. These qualities prefigure those of the finished sculpture, a fiberglass shell that was to be suspended behind the altar.

Left:
143. *Crucifixion Sketchbook,*
 page 31 (verso), 1973.

Right:
144. *Crucifixion Sketchbook,*
 page 29 (verso), 1973.

Opposite:
145. *Crucifixion Sketchbook,*
 page 34 (verso), 1973.

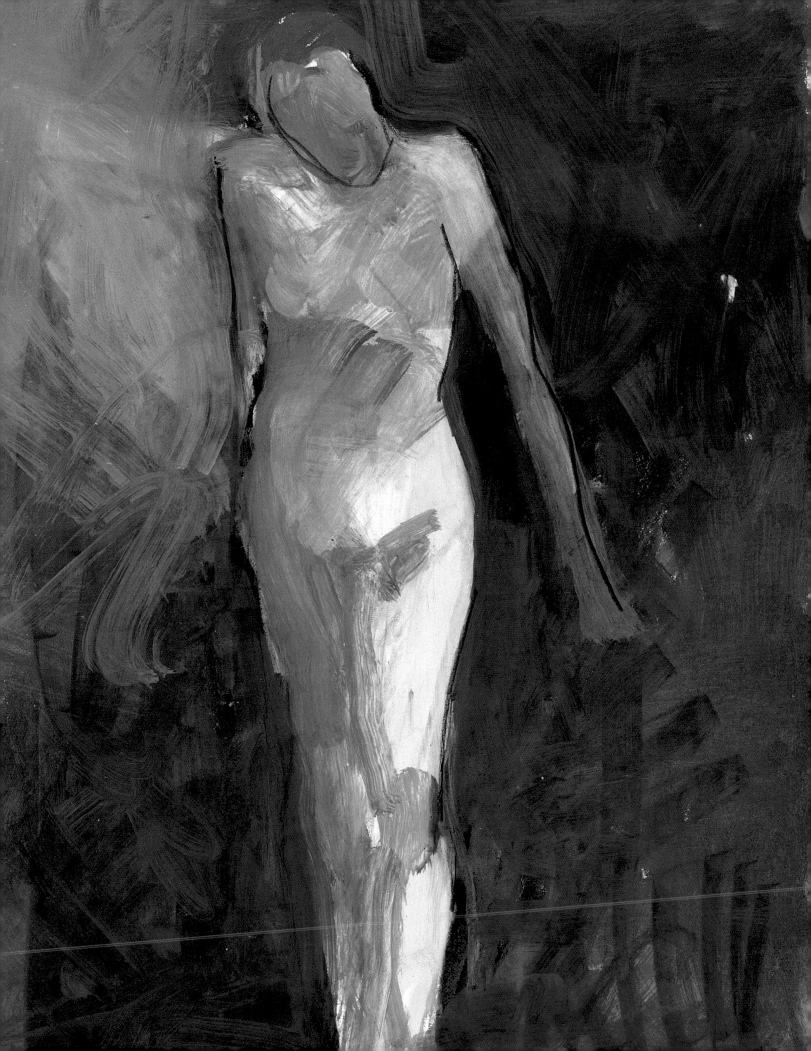

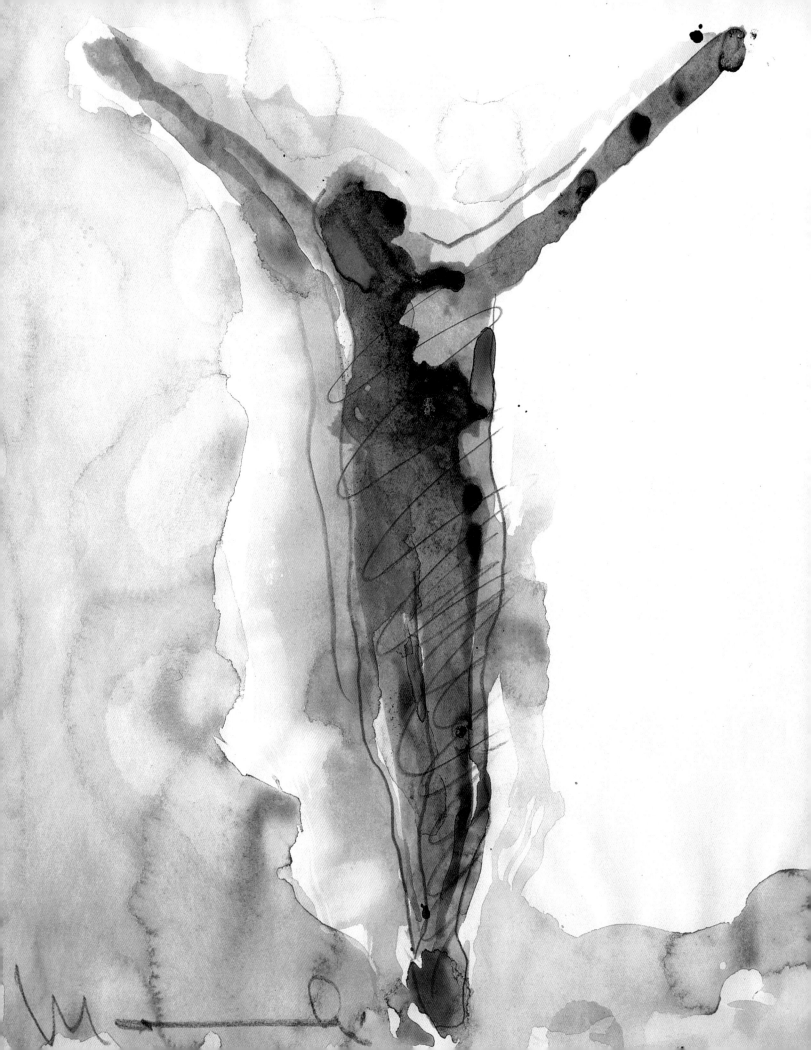

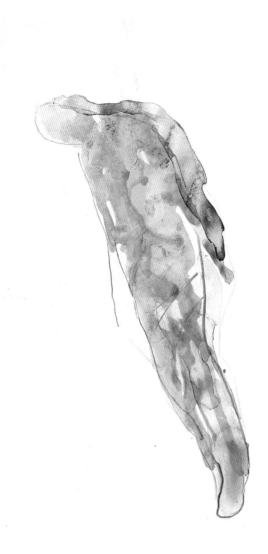

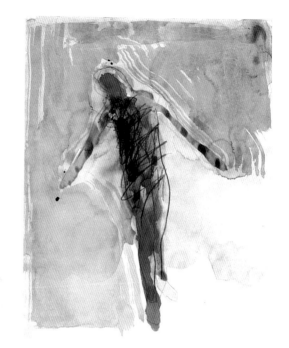

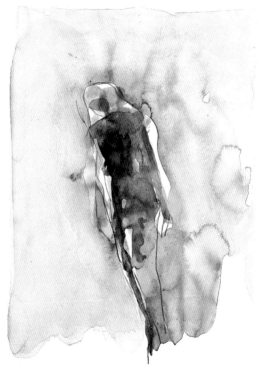

In another suite of studies, Neri depicted the figure in a pale watercolor wash against a light background. While *Study for Ascension No. 16* and *Study for Ascension No. 17* continue to suggest the Deposition and the Crucifixion, respectively, other studies in the group *(No. 22* and *No. 29)* show Neri developing the image that would be translated into the sculpture finally submitted for approval. These latter sketches show an almost translucent figure with arms held close to the body and head tilted forward. It is an image of almost complete passivity, in which the body again seems levitated in space.

These drawings provide compelling evidence of why religious subjects attracted Neri. They demonstrate that he was less interested in doctrine than in conveying the same psychological drama he was exploring in his secular figures. The languid sensuality and androgyny of these figures is likewise characteristic of Neri's nonreligious works, many of which blend the sacred and the profane, the sensual and the spiritual. It seems that Neri recognized in the religious image an especially vivid medium through which to investigate his recurring theme: the power of pose and gesture to evoke the emotional life of the subject.

Left:
147. *Study for Ascension No. 22,* 1973.

Top right:
148. *Study for Ascension No. 16,* 1973.

Bottom right:
149. *Study for Ascension No. 29,* 1973.

Opposite:
146. *Study for Ascension No. 17,* 1973.

85

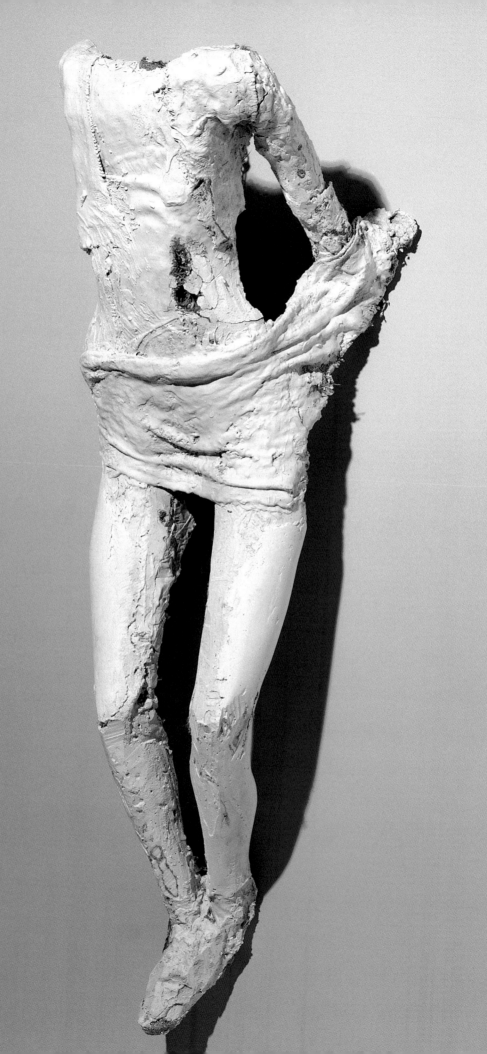

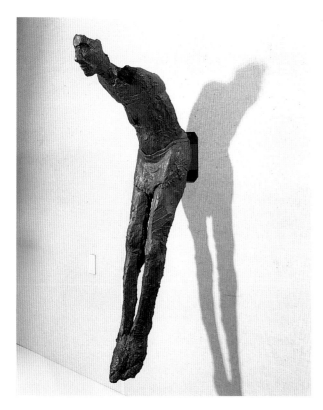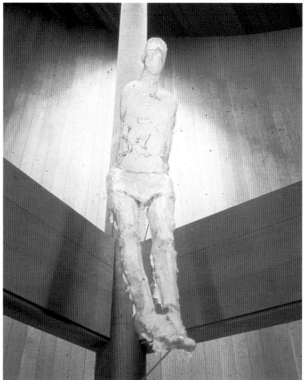

These *Ascension* drawings led to a series of plaster sculptures of the Christ figure, also in various poses, which likewise concentrated on the emotional connotations of posture. Most are shells, created by draping plaster-soaked burlap over an armature; they depict only the front of the body. All are partial figures: some lack arms; most are without heads. In pose, they combine aspects of various subjects: some have the crossed feet and draped loins of the crucified Christ; in others the arms hang limp, as in the Deposition. Several of them tilt forward from the waist: Neri was anticipating the fact that the figure would be viewed from below.

At some stage, one of the armless versions of the leaning plaster Christ was given a head. This image was cast in fiberglass, a medium that gave the figure a deliberately immaterial quality appropriate to the notion of Christ in Ascension. Neri was aiming to evoke the idea of Christ's transfiguration from human to God, and he recognized the importance of translucence in creating this effect. Yet Neri's sculpture is hardly an image of Christ triumphant: if anything, the figure—thin and devoid of arms—seems utterly frail. It conforms to no recognized traditional model of the Christ figure: it is neither the man who suffered and died on the Cross nor the glorious, resurrected Son of God. When it was installed above the altar in the church and lit from behind, the effect proved entirely too spectral for the congregation's taste, and the figure was promptly taken down and returned to the artist, who did not receive the commission. It was "just too raw an idea for them to handle," Neri later recalled. "[But] I was satisfied with what I did. After one hell of a hassle with myself—digging up that whole religious issue and finding out just how I felt about it again, it was not an easy thing to do."[23]

Left:
151. *Untitled Male Figure Fragment* (Cast from *Christ in Ascension*), 1974.

Right:
152. Installation of *Christ in Ascension*, 1973. Photographer unknown.

Opposite:
150. *Christ Figure III*, 1973.

87

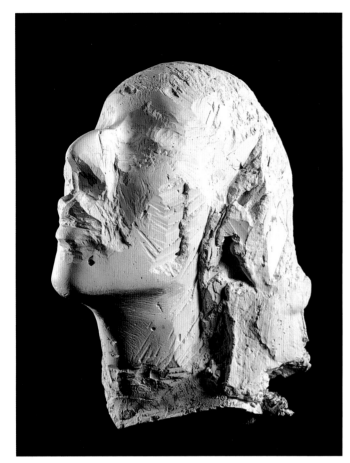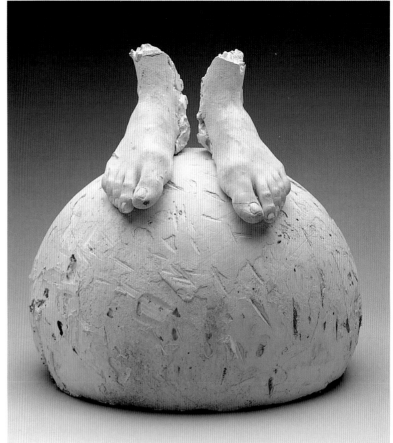

As Neri was working on the Christ figures, he was also making plaster studies for a representation of the Virgin. Although the full figure is quite stiff, two fragments are arresting. *Mi Judia* is a head which was detached from a figure of the Virgin (which also survives). With eyes mostly closed but with a smooth, strong chin and nose, and with surface alternately chipped and polished, it conveys the same combination of anguish and stoicism as his earlier *Standing Male Figure* (fig. 64). The other fragment is a pair of feet on a sphere—the Virgin was to have been standing on a globe, like ancient representations of the goddess of fortune.

Left:
153. *Mi Judia,* 1973.

Right:
154. *Mary's Feet,* 1973.

Opposite:
155. *Virgin Mary,* 1973.

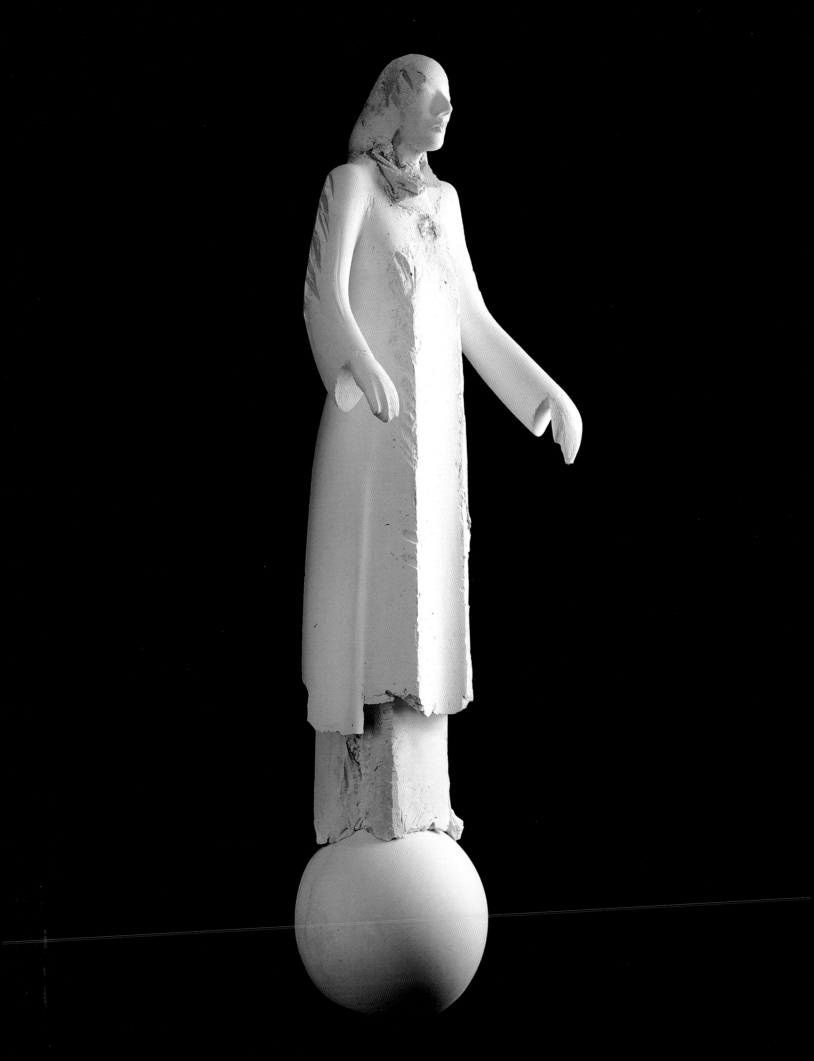

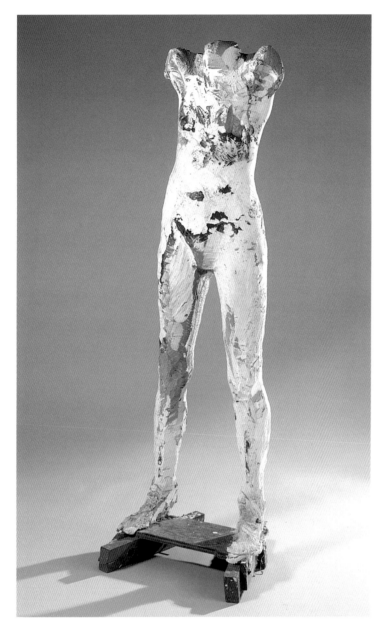

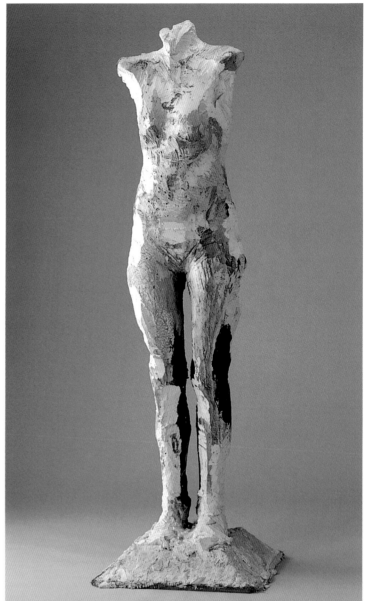

Before Neri's work with Mary Julia began in earnest, he made some of the most depersonalized figures of his career. The poses were rigidly frontal; most of the figures were without arms and heads. The look was archaic and hieratic, like Cycladic or Egyptian idols. Here again Neri was turning to the example of ancient sculpture to convey the archetypal or talismanic image of woman. *Untitled Standing Figure I*, 1974, is a case in point. The pose has a distinctly hieratic flavor: the feet are together and planted squarely on the base; the figure's weight is evenly distributed on both legs. The torso faces forward; the shoulders are treated symmetrically. The neck shows no sign of torsion. Though the pose looks archaic, the surface decidedly does not. The plaster is hacked and abraded. Vivid yellows and silvery grays animate the breasts, belly, and thighs; bold black delineates the inner and outer contours of the legs. Texture and color together lend the figure an air of vigor and sensuality.

Left:
156. *Untitled Standing Figure*,
 1974.

Right:
157. *Untitled Standing Figure I*,
 1974.

90

Like several similar figures, this sculpture was made for—and during—an exhibition at San Jose State University in early 1974. On a platform in the center of the gallery, Neri, surrounded by plaster, buckets, carving tools, and brushes, worked on a number of figures and busts. He visited the gallery as often as every two or three days to continue developing the sculptures. Despite or perhaps because of the pressure of this public presentation, these figures are among the most successful of his works from this period. In their combination of hieratic classicism and a particularly modern sort of expressionism, they recall Neri's first full figures from the late 1950s. They showed the artist to be once again fully confident in his handling of the human form.

Shortly after the San Jose exhibition, Neri's work began to change. Mary Julia was now working regularly with him, posing for drawings and sculptures. A housewife and the mother of three, she had a zeal for poetry that figured as prominently in their relationship as it had in Neri's earlier ones. While they worked, she read aloud to him from a wide range of poets: Rainer Maria Rilke or Octavio Paz, Neruda or Maura Stanton. Neri encouraged her literary ambitions, and when she decided to enroll in college and began to compose poetry, she shared it with him. "I was writing to him and for him," Mary Julia remembers. The characterization that seems most appropriate for the relationship is synergistic, as each provided a creative impetus for the other.

Inspired, it seems, by the forceful personality of Mary Julia, Neri began to relax his long-held reservations about the complete figure, and in the mid-1970s he started consistently to incorporate both heads and arms into his representations of the body. Before this, he had felt that heads and arms conveyed too much character; now, character was precisely what he wanted. He told an interviewer in 1976 that he wanted "to catch a sensibility of the person . . . the whole person and what they're into as much as possible. I've been working with Mary [Julia] almost . . . three years now . . . and really feel very comfortable working with her and . . . like seeing her as a complete person."[24] The balance in Neri's representation of the female figure was now tipping from the archetypal to the individual.

A sculpture from 1975, *Mary Julia,* suggests the ways in which Neri's approach to the human subject was beginning to change. This figure has the air of a distinct personality. The knot of hair at the back of the head, the particular curve of the hips and buttocks, carefully traced in smoothed plaster—these are the features of a particular person, sensuously apprehended. At the same time, Neri stopped short of making an explicit portrait. He clearly wanted to convey the force of personality, but without abandoning his commitment to a vigorous, raw, unpolished style. Mary Julia, he observed, "has a fantastic intensity about her body. I wanted the same intensity, with a varied, strong, active surface but as minimal as possible."[25]

Following pages:
Left:
158. *Mary Julia,* 1973.
Right:
159. *Mary Julia,* 1975;
Reworked 1991.

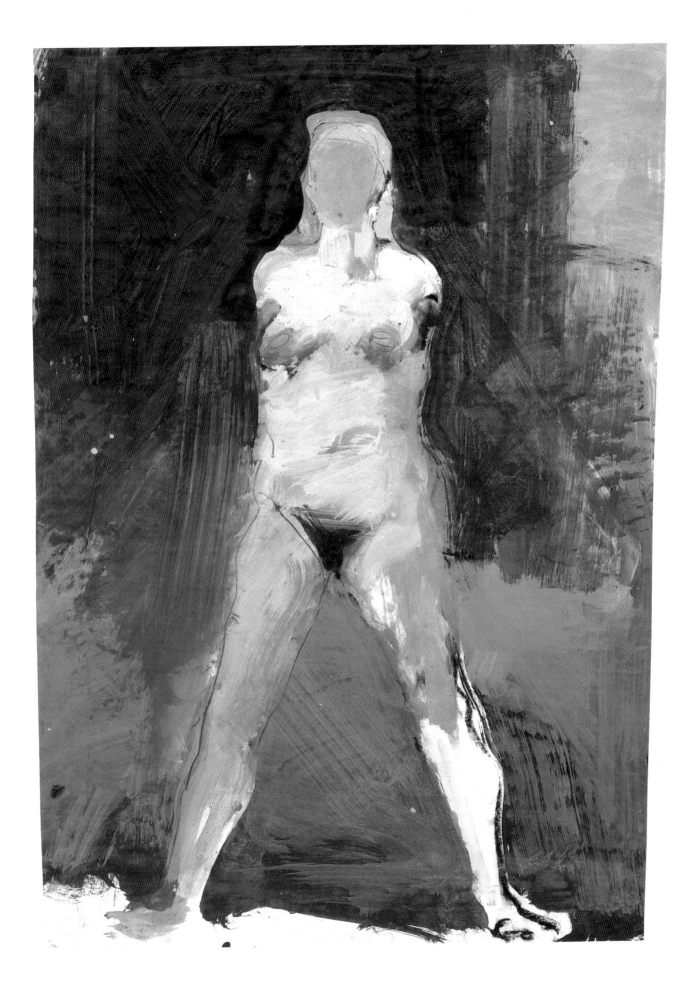

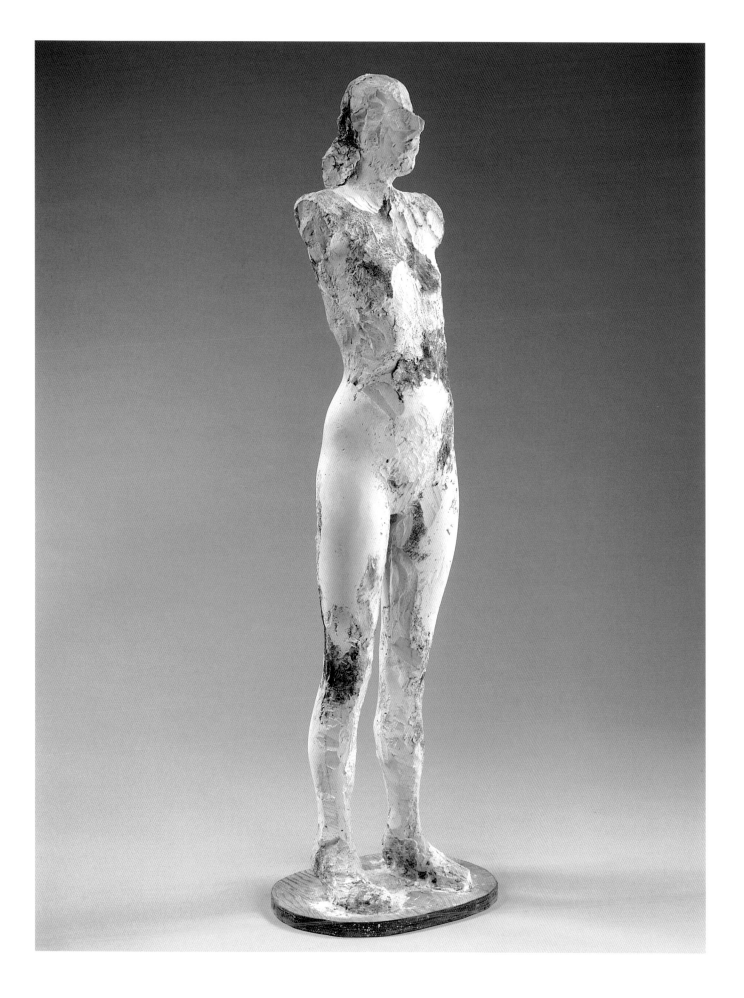

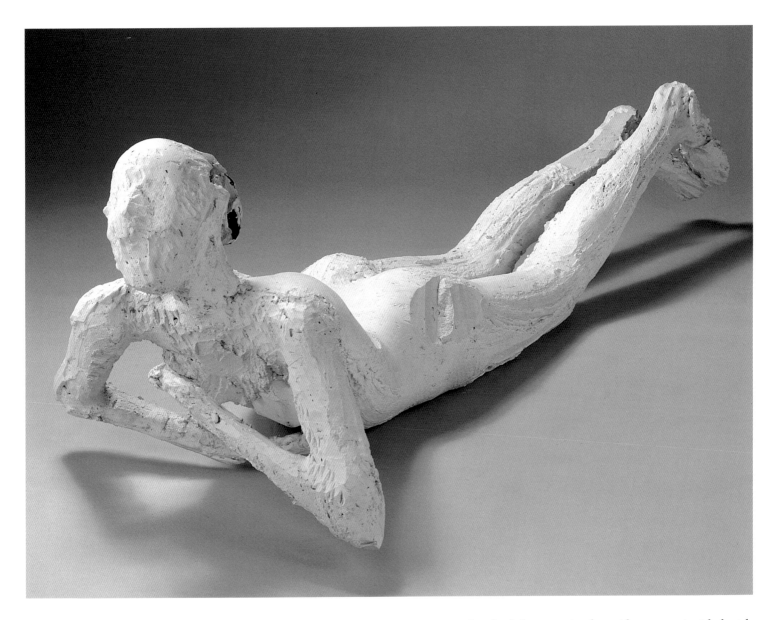

160. *Acha de Noche II, 1975.*

Neri's attention to individual character in the mid-1970s coincided with an expanded interest in gesture. Inspired in part by a book about the Russian dance impresario Serge Diaghilev, Neri began to experiment with new positions of the body. He acknowledged in 1981 that in his earlier work, "the posing of the figures was based on a more traditional attitude, and today I really want something else." The example of the choreographers used by Diaghilev provided Neri with a repertoire of unusual postures and gestures. "The manner in which [they] used people, and what [they] did with them, was just fantastic," says Neri.[26]

Acha de Noche I[27] resonates with the spirit of modern dance: in fact, the pose was taken from a photograph of a Diaghilev ballet. Prone except for the inclined head, the figure seems about to rise, as if at the beginning of some choreographed ritual. Color is used sparingly here—the body is just slightly darkened with lampblack, reinforcing the nocturnal setting.

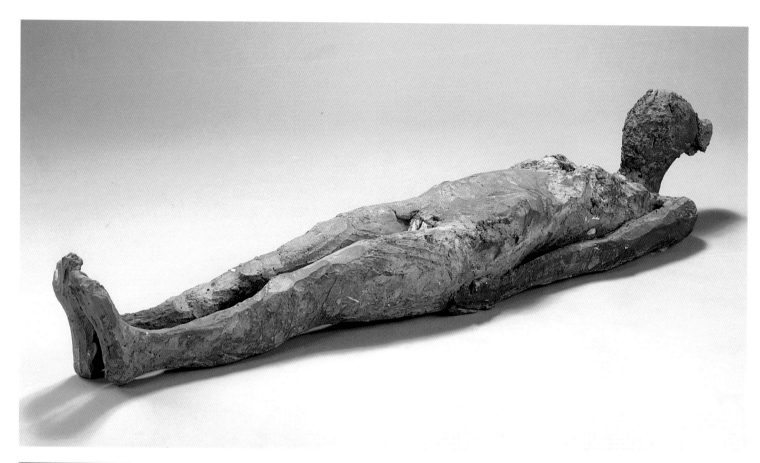

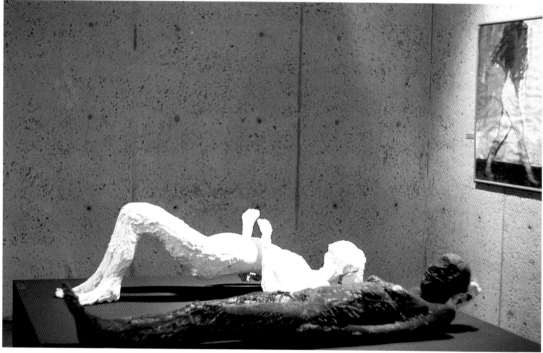

Top:
161. *Acha de Noche I*, 1975.

Bottom:
162. *Acha de Noche I* and *Acha de Noche IV* in "Manuel Neri, Sculptor," The Oakland Museum, 1976. Photo by Lorraine Capparell.

straight on side view

Top:
163. *Sculpture Study No. 2 (Acha de Noche III)*, c. 1975.

Bottom:
164. *Study for Acha de Noche III (detail)* from *Majic Act Sketchbook*, c. 1975.

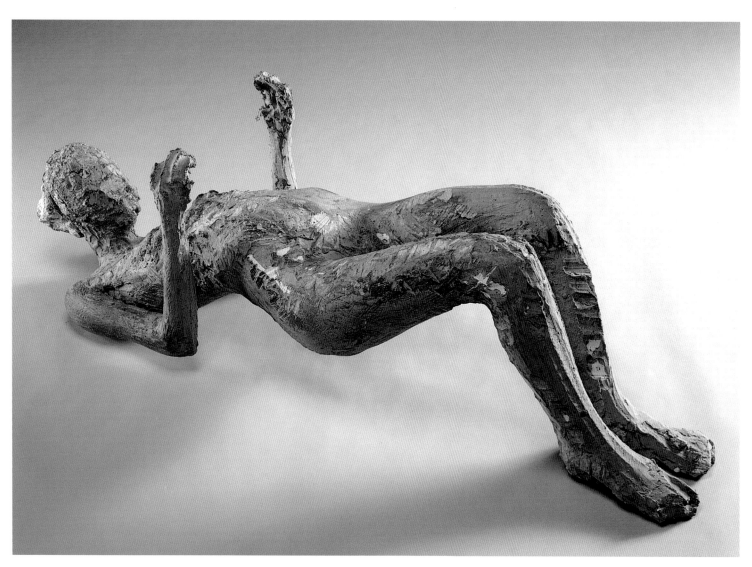

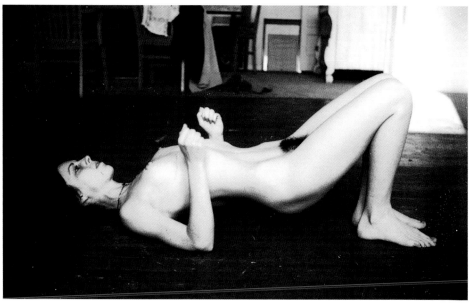

Top:
165. *Acha de Noche III*, 1975.

Bottom:
166. Mary Julia posing for
Acha de Noche III, 1975.
Photo by Manuel Neri.

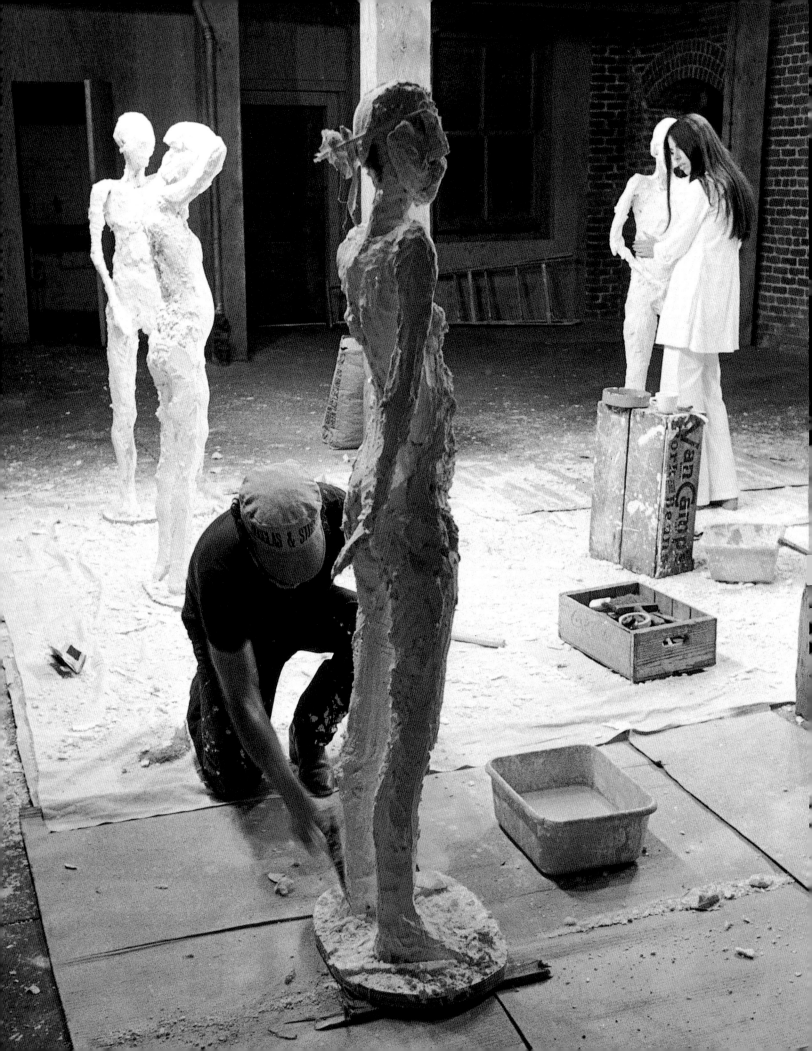

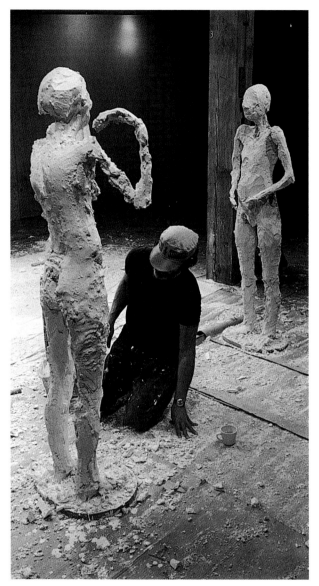

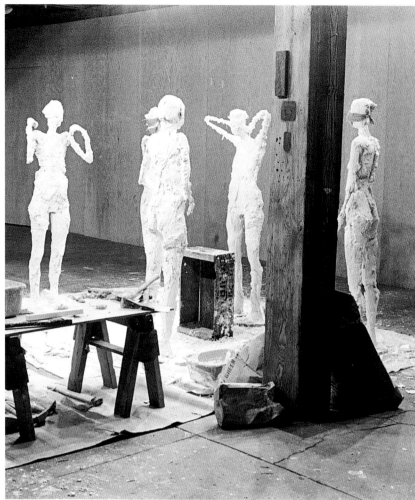

Neri's interest in both gesture and the sensibility of the individual came together clearly in a brief but highly significant exhibition in May 1976, "The Remaking of Mary Julia," at 80 Langton Street, an alternative space in San Francisco, where Neri again set up an exhibition of sculpture in progress. Working in the gallery with Mary Julia, he executed eight figures in eleven days. He relied on a series of active gestures to convey the varied moods of his subject. One figure seems tentative, her head slightly bowed and hands crossed in front of her. Another looks languid and sensual, arms stretched behind her head. The active gestures are reinforced by strong, active surfaces. Because of the speed with which the figures were made, these are some of the roughest surfaces of Neri's career to that point. The plaster is punctuated with lumps, gouges, and crevices, and only rarely smoothed. Neri left all the figures unpainted, concentrating exclusively on the capacity of gesture and surface to convey the spirit of the figure.

167–69. "The Remaking of Mary Julia: Sculpture in Progress" at 80 Langton Street, San Francisco, 1976. Photos by Phillip Galgiani.

99

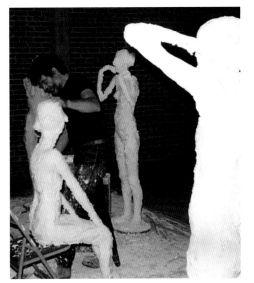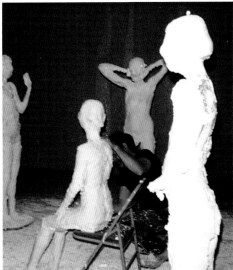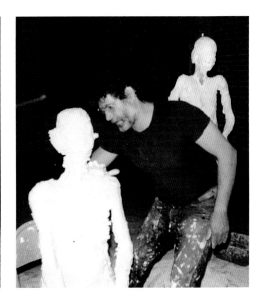

As model, muse, and confidante, Mary Julia had a privileged view of Neri's aims and methods in these sculptures. In the mid-1970s, she composed "Manuel," a long prose poem in which she described Neri at work. Although not about the figures in the 80 Langton Street show—it is set in the Benicia studio, and describes black-painted figures such as *Acha de Noche I* and *III*—the poem aptly characterizes the spirit of Neri's work of the time. It begins with a description of the studio, illuminated by a single bare bulb:

> Under this light are six or seven stark plaster women.
> . . . Outside the circle of light are shadows and stained glass
> windows, small things breathing quietly, because inside the
> light there is a tension between this man and these
> mute female figures. He is drunk and occasionally lets
> out something like a war cry, pours more wine, stares
> at them, picks up an axe and slashes her thigh off. He
> exposes some of the white styrofoam used to cover the
> metal armature. In this light it shines and dances and
> doesn't affirm the pain I saw him inflict. All night
> it goes on. He mixes runny white plaster and throws
> handfuls at them, on their asses, so it runs down their
> legs. He mixes black paint and walks with his brush
> among them. This one gets a black face and that one a
> streak down her side. He throws his cigar butts into
> the rubble at his feet, layers of plaster and butts,
> some with red lipstick on them. There are apple cores
> and dead flowers, each one with a story. He cuts each
> woman with an axe or a machete and they grow more
> beautiful. Finally he is tired. They have taken
> enough of him tonight . . . [28]

170–72. Photographs taken by
Mary Julia of Neri
working at 80 Langton
Street, 1976.

100

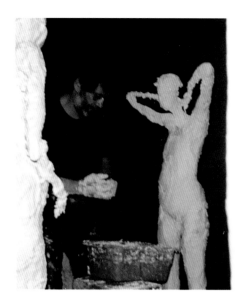
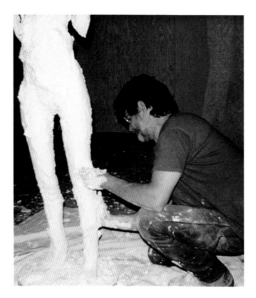
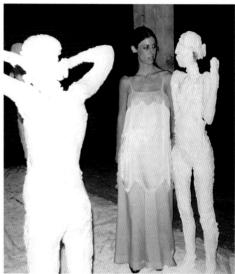

Had we been present at 80 Langton Street during "The Remaking of Mary Julia," we might have seen something like this: Neri working with Mary Julia present, moving among the figures in an improvised choreography, impulsively shaping and hacking at them. We might have sensed the emotional subtext and discerned in the lithe sensuality of the figures the mapping of an erotic journey.

We might also have felt the tension not only between the artist and his work, but also between the artist and his subject. If the relationship between Neri and Mary Julia was extremely productive for each of them, it was also full of conflict. This antagonism was the explicit subject of another roughly contemporaneous poem by Mary Julia, "Surface Secrets":

> It's the axe swinging heating up the air
> It's the axe swinging heating up the air
> It's the axe swinging heating up the air
>
> and when it sinks into the fine white
> i feel it almost to my bones
> splintering me
> a man/coarse black hair/eyes/mexican
> you have no business doing me that way[29]

Left and center:
173–74. Photographs taken by Mary Julia of Neri working at 80 Langton Street, 1976.

Right:
175. Photograph taken by Manuel Neri of Mary Julia at 80 Langton Street, 1976.

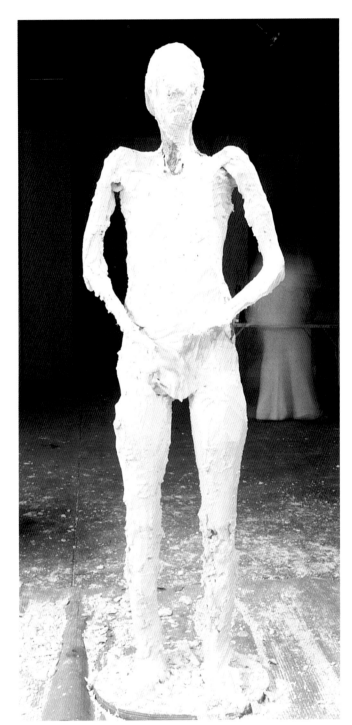

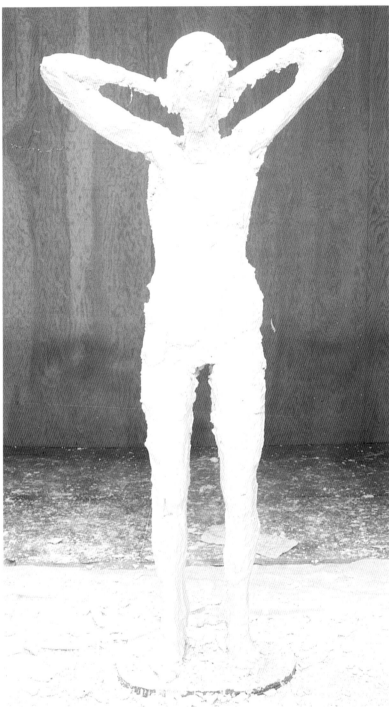

Left:
176. *Remaking of Mary Julia
 No. 1* (in progress), 1976.
 Photo by Phillip Galgiani.

Right:
177. *Remaking of Mary Julia
 No. 2* (in progress), 1976.
 Photo by Phillip Galgiani.

The pain inflicted was not physical, of course, but emotional: the poem expresses Mary Julia's anger at the fact that their relationship, so productive in the studio, was otherwise so tormented. "In the studio, things were perfect," Mary Julia recalls. "The sculptures were ours, like a child. Out of the studio, we were like amputees." In her anger and disappointment, she transcribed and sent to Neri a translation of Neruda's poem, "Fable of the Mermaid and the Drunks":

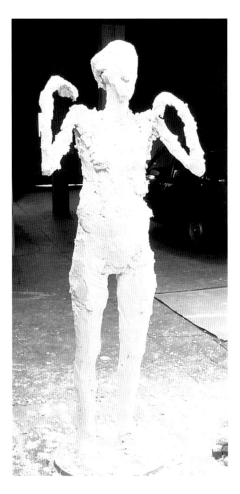

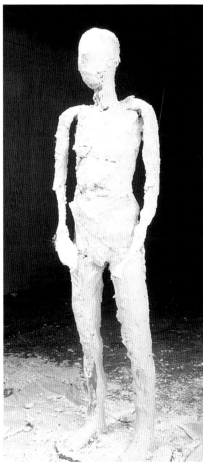

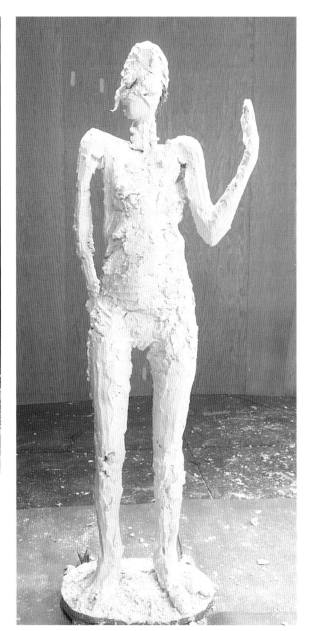

All these fellows were there inside
when she entered, utterly naked.
They had been drinking, and began to spit at her.
Recently come from the river, she understood nothing.
She was a mermaid who had lost her way.
The taunts flowed over her glistening flesh.
Obscenities drenched her golden breasts.
A stranger to tears, she did not weep.
A stranger to clothes, she did not dress.
They pocked her with cigarette ends and with burnt
corks, and rolled on the tavern floor in raucous laughter.
She did not speak, since speech was unknown to her.
Her eyes were the color of faraway love,
her arms were matching topazes.
Her lips moved soundlessly in coral light,
and ultimately, she left by that door.
Hardly had she entered the river than she was cleansed,
gleaming once more like a white stone in the rain;
and without a backward look, she swam once more,
swam toward nothingness, swam to her dying.[30]

Left:
178. *Remaking of Mary Julia
No. 3* (in progress), 1976.
Photo by Phillip Galgiani.

Center:
179. *Remaking of Mary Julia
No. 4* (in progress), 1976.
Photo by Phillip Galgiani.

Right:
180. *Remaking of Mary Julia
No. 5* (in progress), 1976.
Photo by Phillip Galgiani.

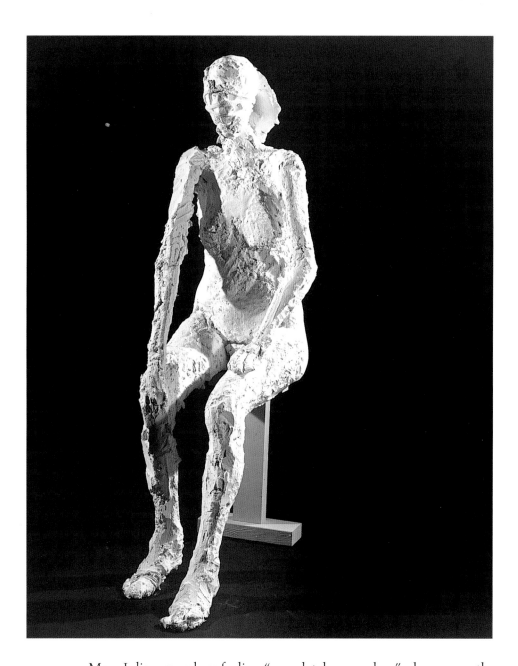

Mary Julia remembers feeling "completely powerless"; she apparently identified with the total naïveté and vulnerability of the mermaid, who responded to the abuse of the drunks with soundless speech and faraway love, and then passed from existence.

Some sense of the conflict between artist and subject can be discerned in the figures from "The Remaking of Mary Julia." One seems particularly clenched: her shoulders hunched, her arms held stiffly in front of her, and her hands tightened into fists. Among other contemporaneous figures done in the same rough style are several that suggest this emotional subtext as well: one standing woman who holds her face in her hands, and a seated figure who has her head literally bound in ropes. Neri had used the device of binding before, as in the figure *Markos*; it has both practical dimensions—literally holding the shards of plaster together—and emotional ones. Here the bound head might be seen as a metaphor for barely contained fury.

181. *Remaking of Mary Julia
No. 6* (later titled *Nancy*),
1976.

Opposite:
182. *Remaking of Mary Julia
No. 8*, 1976.

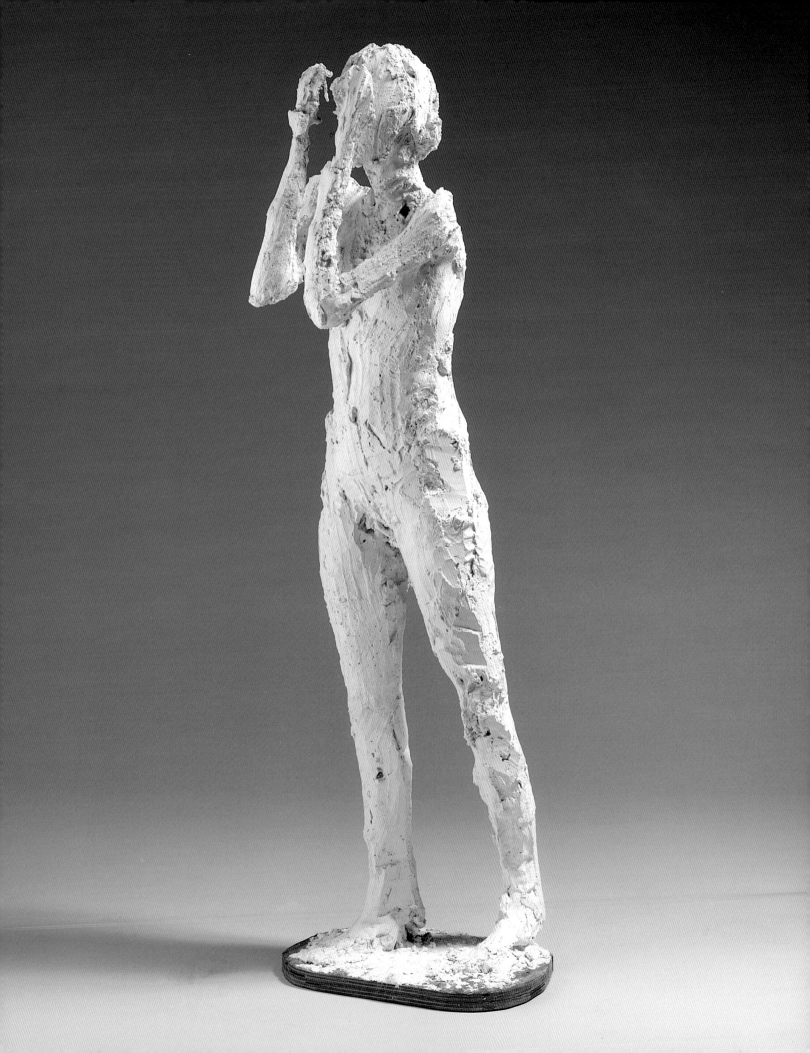

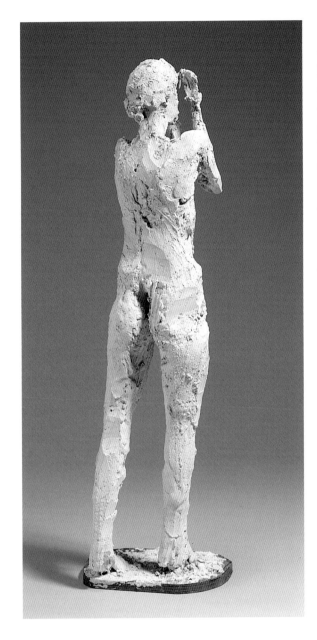

Although these figures carried more of the individual personality of their subject than almost any Neri had made before, Mary Julia remembers feeling that they were finally about the artist and his emotions more than they were about her. She was close enough to Neri's figurative work to be deeply aware of its paradox: it approaches the individual, but stops short of the portrait, insisting on some sense of its subject as archetype. To Mary Julia, the archetype wasn't even an image of woman: "The archetype is Manuel, and his emotions. Through me, he claimed himself."

Neri acknowledges that even in these personalized figures of Mary Julia, he was holding on to a more universal idea of the figure. "The female figure carries a message pertinent to both the male and the female," he maintains. "It's a human form that touches all of us." It is very much his point that these figures are open to various interpretations: they may be seen as expressions of an erotic odyssey or as celebrations of a lithe sensuality; they seem to chart both the emotions of the subject and the artist's reactions to them; they represent in different measures at different times both woman and women, both archetype and individuals with distinct emotions, personalities, and physical attributes.

We can now see that the figures of "The Remaking of Mary Julia" were the beginning of a sustained period of vigorous production and high accomplishment for Neri. He would continue to explore the expressive possibilities of the full figure, using a wide variety of postures suggestive of a broad range of emotional states. He would also continue to execute much of his most interesting work in plaster, and as he achieved some measure of financial success, he also started to cast his plaster figures in bronze. He soon added marble to his materials, and in the mid-1970s began to spend part of each year in Carrara, Italy, working with the local stone.

In retrospect, it seems clear that by 1976, with these figures of Mary Julia, Neri had put in place the last pieces of a puzzle he had been assembling for over twenty years. He had learned to use color, but also how to do without it, letting the surface carry the expressive burden. He had explored the possibilities of architectural form, though it was not yet obvious to what end he would eventually put the lessons he had learned. He had synthesized a variety of powerful precedents, from archaic and classical sculpture to abstract expressionist painting. He had assimilated the lessons of both his immediate artistic environment—that of the Bay Area figurative school and Beat-era funk—and his own cultural traditions, those of southern Europe and Mexico. Most important, nourished especially by modern Spanish and Latin American poetry, he had mastered his particular, and particularly compelling, image of the female form. By 1976 Neri was poised for supremely self-confident, accomplished, and distinctive figurative work.

183. *Remaking of Mary Julia No. 8*, 1976.

NOTES

1. Pablo Neruda, "Toward an Impure Poetry," in *Pablo Neruda, Five Decades: Poems 1925–1970*, edited and translated by Ben Belitt (New York: Grove Press, 1974), pp. xxi–xxii.

2. Caroline A. Jones, *Bay Area Figurative Art: 1950–1965* (Berkeley: University of California Press, 1990) is the most recent and authoritative source on the history of this artistic episode.

3. Paul Mills, *Contemporary Bay Area Figurative Painting* (Oakland: Oakland Art Museum, 1957). The exhibition toured to the Los Angeles County Museum of Art and the Dayton Art Institute.

4. David Park, in *Contemporary American Painting*, exhibition catalogue (Urbana: University of Illinois, 1952), p. 220.

5. Unless otherwise noted, all quotations are taken from conversations with the author.

6. Neri, quoted in Jones, *Bay Area Figurative Art*, p. 133.

7. Neri, quoted in Thomas Albright, "Manuel Neri: A Kind of Time Warp," *Currant* (April/May 1975), p. 11.

8. Alfred Frankenstein, "A Look at Current Exhibitions," *San Francisco Chronicle*, Jan. 22, 1956.

9. This statement is quoted in *Lyrical Vision: The '6' Gallery, 1954–1957* (Davis, CA: Natsoulas/Novelozo Gallery, 1989), p. 87.

10. Neri, quoted in Albright, "Manuel Neri: A Kind of Time Warp," p. 13.

11. Thomas Albright, "The Beat Era: Bay Area 'Funk,'" in *Art in the San Francisco Bay Area, 1945–1980* (Berkeley: University of California Press, 1985), p. 82. Albright provides the best account of the connection between funk and the Beat era.

12. This event is sometimes incorrectly remembered as a solo performance by Ginsberg on the night of October 13, 1955. See the announcement written by Ginsberg and published in *Lyrical Vision*, p. 31.

13. Federico García Lorca, "Balada interior," in *Libro de Poemas* (Madrid, 1921). The complete text in the original Spanish can be found in *Federico García Lorca: Obras Completas* (Madrid: Aguilar, 1975), pp. 244–45. A copy of Marilyn's letter and Neri's transcription are in the Manuel Neri Papers, Archives of American Art, Smithsonian Institution.

14. Mark di Suvero, from an unpublished letter to Neri, February 1962, in Neri's possession.

15. Neri, quoted in Jan Butterfield, "Ancient Auras—Expressionist Angst: Sculpture by Manuel Neri," *Images and Issues* (Spring 1981), p. 40.

16. Neri, quoted in Albright, "Manuel Neri: A Kind of Time Warp," p. 13.

17. See Jones, *Bay Area Figurative Art*, p. 147.

18. Joan Brown, cited in Jones, *Bay Area Figurative Art*, p. 141.

19. John Coplans, "Sculpture in California," *Artforum* (August 1963), p. 5.

20. Philip Leider, "Manuel Neri, New Mission Gallery," *Artforum* (September 1963), p. 45.

21. Philip Leider, "California After the Figure," *Art in America* (October 1963), p. 77.

22. John Coplans, "Circle of Styles on the West Coast," *Art in America* (June 1964), p. 30.

23. Neri, quoted in an interview conducted on July 19, 1976, by George Neubert for the Archives of California Art; on deposit at The Oakland Museum.

24. Ibid., p. 8.

25. Ibid.

26. Neri, quoted in Butterfield, "Ancient Auras—Expressionist Angst," p. 41.

27. A number of Neri's titles can be read as a play on words, both in the original Spanish and in English translation. Here, *hacha*, Spanish for "axe," is spelled without the initial "h," resulting in a form similar to the English "ache." "Axe" can also be transposed to "acts," or "Acts of the Night." Like many who have grown up speaking Spanish in the home without formal education in its spelling and grammar, Neri is inventive in his use of the language, which often adds subtle layers of meaning to the titles of his works.

28. Mary Julia Klimenko, "Manuel," in *The Depression Has Been Here for a Long Time* (privately printed, c. 1976), unpaginated. A copy was provided to the author by Mary Julia Klimenko.

29. Mary Julia Klimenko, "Surface Secrets," in *The Depression Has Been Here for a Long Time*.

30. Pablo Neruda, "Fable of the Mermaid and the Drunks," translated by Alastair Reid, in *Pablo Neruda: Selected Poems*, edited by Nathaniel Tarn (Boston: Houghton Mifflin Co., 1990), p. 357. Originally published in England by Jonathan Cape Ltd.; first American edition published by Delacorte Press, 1972.

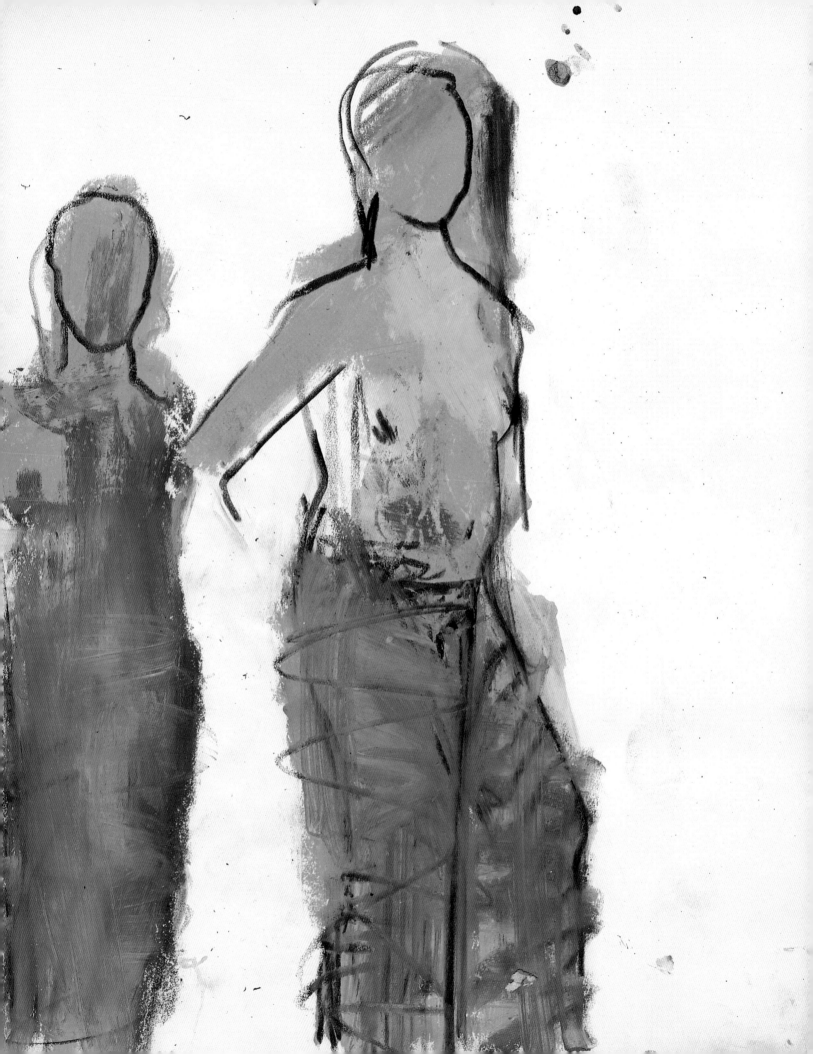

MANUEL NERI'S
EARLY SKETCHBOOKS

PRICE AMERSON

Manuel Neri's sketchbooks provide a unique overview of the artist's interests and activities over almost forty years.[1] They also frequently provide insight into the artist and the development of his career as he works out and often reworks ideas and subjects. The sketchbooks thus become an invaluable resource for the historian as well as the biographer; they also become a fascinating record of the artist for the scholar, artist, or student. The sketchbooks reflect Neri's creative processes and the spontaneity and the dichotomies of his mind and hand, theory and practice, the rational and the intuitive.

From the surviving sketchbooks, it is clear that this activity begins early in his career; today, the artist continues this practice with a passion. For Neri, the sketchbooks collectively are a rich, sometimes dense overlay and repository of ideas and concerns. In the sketchbooks he explores initial ideas in quick sketches, which are at times accompanied by notes. Many of them evolve through successive stages and develop into more finished drawings and concepts. Others record more fleeting visual and written notes.

Many of Neri's fellow artists and former students relate how impressed they were that Neri was always sketching, whether he was the student or the teacher. Several sketchbooks seem to document class exercises done when he was a student, and others record studies he did as the teacher during a class assignment. Still others contain sketches related to the artist's domestic life and family activities. One may find names, addresses, and other similar notes juxtaposed with information on art materials, technical information, Neri's comments on his own works, or brief passages of poetry or philosophy; the blank sketchbook pages have also, from time to time, served the artist as a diary.

In addition to their freshness and immediacy, which often emerge in the entries whether visual or written, the sketchbooks also demonstrate the artist's spontaneity. One can follow Neri relentlessly pursuing an idea, and then laying the sketchbook down for a few minutes, or even abandoning it for a number of years, eventually returning to continue or rework sections in the same or different media. A series of studies may suddenly end or be interrupted; when the artist picks up the sketchbook again, he is interested in another subject or problem and thus fills the pages with studies that sometimes appear upside down with respect to previous sections.

184. *Figure Study No. 54,* c. 1957; Reworked c. 1980.

109

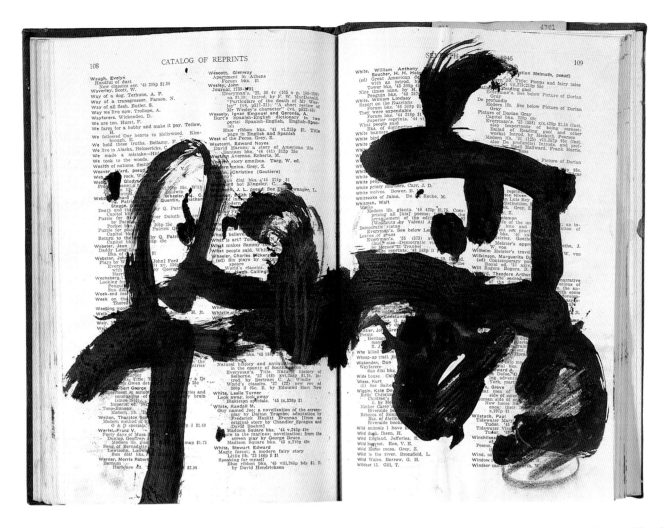

185. *Catalogue of Reprints in Series Sketchbook*, pages 108–109, c. 1953.

Or he may decide to remove sheets, or even at times add collage, or cut and tear sections of pages to edit the image or create "sculptural" overlays of images on successive pages. At first glance, a number of the sketchbooks may seem to be randomly filled, but they prove on closer examination to record various ideas that more or less date contemporaneously; it is not uncommon, however, to find sketchbooks that contain materials entered over a considerable period of time.

The earliest extant sketchbook is an appropriated printed reference book entitled (in retrospect, perhaps ironically) *Catalogue of Reprints in Series Sketchbook*.[2] Utilizing a variety of media—graphite, acrylic, charcoal, and gouache—Neri filled the printed pages with study after study for sculpture. Primarily the forms explore abstracted linear, open constructions to be made of eucalyptus wood. Color is a consistent concern; frequently forms are spontaneously fashioned by large areas of orange wash and controlled by the line of colored pencil in bold contrast to the regular columns of printed type on the pages. Occasionally Neri's studies will be executed in black wash, thus becoming more calligraphic and somewhat similar to Franz Kline's well-known studies on Manhattan telephone book pages.[3]

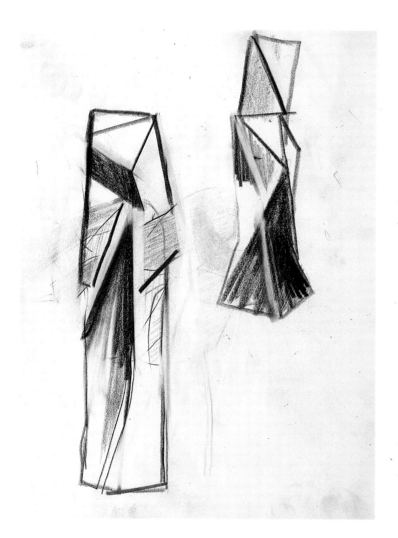

The artist dates these early sketches to circa 1953, and thus they were executed before he served a two-year hitch in Korea in the U.S. Army.[4] These sketches anticipate points of departure in his work after his return in 1955, when he made a firm commitment to art. Specifically, the works demonstrate Neri's assimilation and experience in working with Peter Voulkos and the discovery of expressive and gestural energy invested anew in the traditional forms and functions of ceramics. The sketches, along with numerous other sketchbooks from later in the decade, not only serve to document Neri's early ideas, but also record early sculptures that were realized but no longer survive. In several sketchbooks *(Raoul Sketchbook, Clipper Sketchbook, Casting Sketchbook)*, numerous ideas are recorded for a series of cardboard and plaster sculptural abstract monoliths that the artist called "stelae." While we know that a number of these works were executed after 1958 and were even exhibited at the San Francisco Museum of Art in 1959 and the Dilexi Gallery in 1960,[5] it is primarily the sketchbooks, along with other loose drawings that were at one time undoubtedly parts of sketchbooks, which preserve this period of sculptural activity.[6]

Left:
186. *Raoul Sketchbook*, page 12,
 c. 1955–59.

Right:
187. *Raoul Sketchbook*, page 30
 (verso), c. 1955–59.

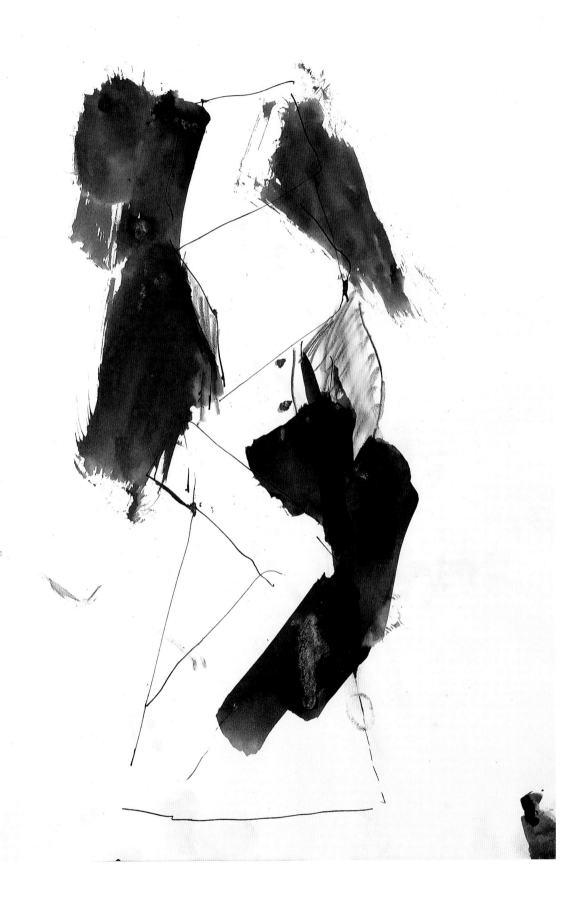

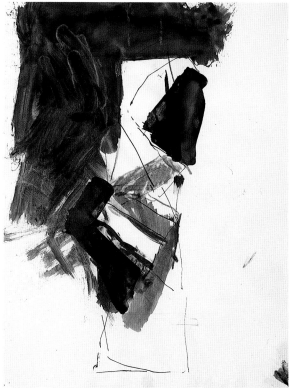

Top left:
189. *Clipper Sketchbook,*
 page 21, 1955–59.

Bottom left:
190. *Clipper Sketchbook,*
 page 22, 1955–59.

Right:
191. *Clipper Sketchbook,*
 page 25, 1955–59.

Opposite:
188. *Clipper Sketchbook,*
 page 23, 1955–59.

Left:
192. *Casting Sketchbook,* page 55,
 c. 1959.

Right:
193. *Raoul Sketchbook,* page 27
 (verso), c. 1955–59.

Opposite:
194. *Casting Sketchbook,* page 51,
 c. 1959.

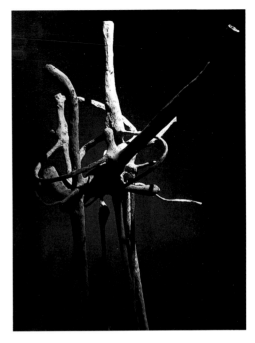

Thus in the sketchbooks one is able to trace Neri's development in and from the earlier abstract eucalyptus-branch sculptures through another group of studies of organic and anthropomorphic forms and energy for which the artist makes the notation "green trees" *(Green Trees Sketchbook)*. The latter sketches are undoubtedly connected to a body of works described as "plantlike constructions," which were shown at the 6 Gallery in 1957.[7] They and the previously noted organic and abstracted structural forms both anticipate and provide transition into the colorful, abstracted-loop ceramic and plaster sculptures of the 1960s for which Neri subsequently received considerable attention.[8] In these works Neri combined a free-form, looping arc with a squared base, unifying disparate elements through surface treatment and vivid color. Three of the clay loop forms were included in *Abstract Expressionist Ceramics*, an exhibition at the University of California, Irvine, in 1966. Although hints of geometric shapes appear on these sculptures, they are mostly composed of vigorously manipulated lumps of clay that were subsequently glazed and fired. According to the artist, the possibilities of "color and three-dimensional form" he found in the ceramic medium were "very important to [his] development and it [ceramics] still is."[9]

Such drawings also reflect the artistic milieu of the San Francisco Bay Area within which the young artist had begun to interact, and in which he subsequently emerged as a major contributor. It thus is not surprising to find an occasional sketch related to the wood constructions of contemporary sculptors Alvin Light *(Raoul Sketchbook)* and Arlo Acton *(Green Trees Sketchbook)*.[10]

Left to right:
195. *Green Trees Sketchbook,*
 page 4, c. 1955–58.

196. *Green Trees Sketchbook,*
 page 12, c. 1955–58.

197. Untitled, 1955–56.

Opposite:
198. *Green Trees Sketchbook,*
 page 16, c. 1955–58.

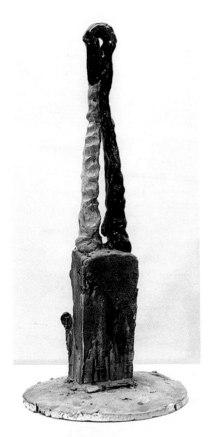

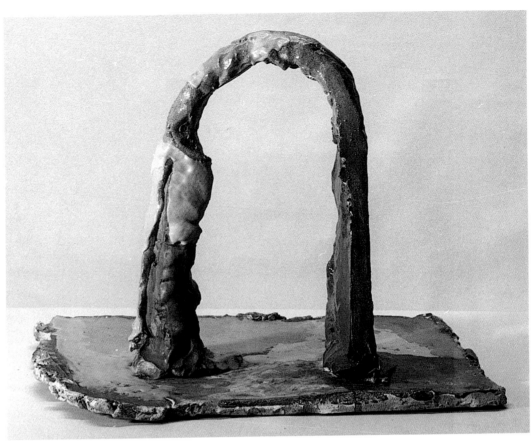

Neri's ceramic and plaster sculptures seem to have evolved from and no doubt concurrently with an impressive series of collage and color-wash studies that appear repeatedly in the *SFAI Sketchbook,* and occasionally in the *Clipper Sketchbook.* On many of these sheets, Neri explores the artistic possibilities of the arc, using color and torn pieces of paper to experiment with and "sculpt" form and structure. These *Sketchbook* studies constitute one of his most sustained investigations of an abstract idea and demonstrate clearly that Neri's involvement with abstraction was quite strong and enduring in his early years as an artist.

Left:
199. *Ceramic Loop III,* c. 1956–61.

Right:
200. *Ceramic Loop II,* c. 1956–61.

Opposite:
Top, left to right:
201. *SFAI Sketchbook,* page 16, c. 1956–60.

202. *SFAI Sketchbook,* page 8, c. 1956–60.

203. *SFAI Sketchbook,* page 57, c. 1956–60.

Bottom left:
204. *Ceramic Loop IV,* c. 1956–61.

Bottom right:
205. *SFAI Sketchbook,* page 60, c. 1956–60.

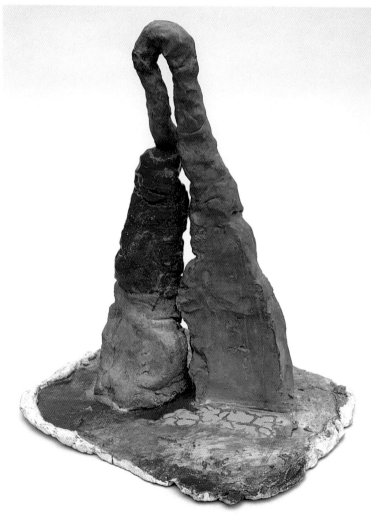

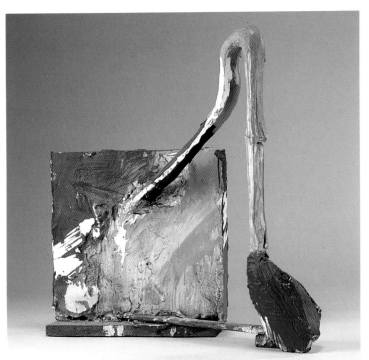 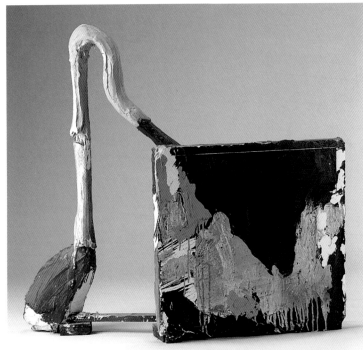

Top:
206–7. *Plaster Loop I*, c. 1960.

Bottom:
208. *Study for Loop Sculpture*,
 c. 1957.

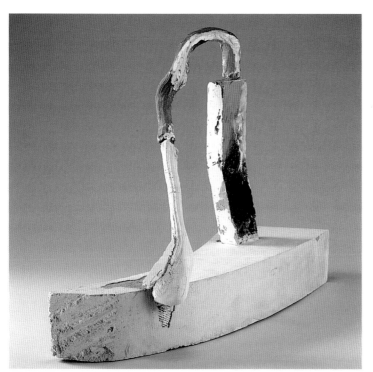
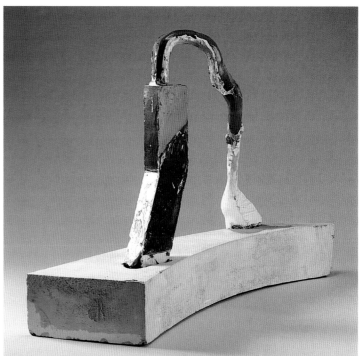

Top:
209–10. *Plaster Loop VI*, c. 1960.

Bottom:
211. *Study for Loop Sculpture*
 (verso), c. 1957.

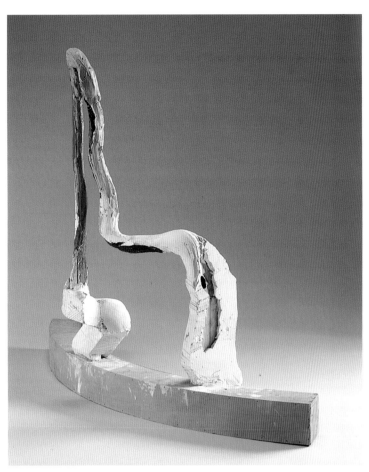

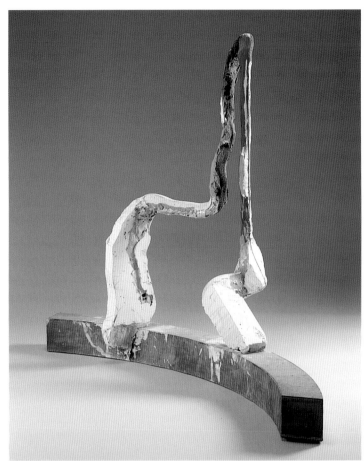

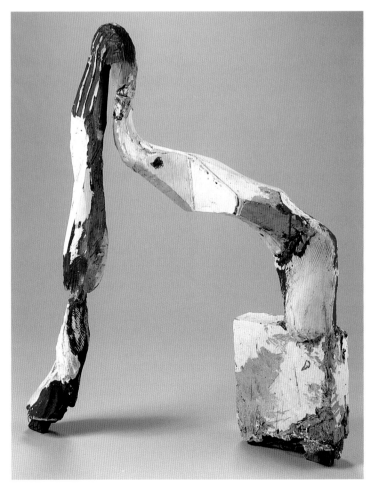

Top:
212–13. *Plaster Loop V,* c. 1960.

Bottom:
214. *Plaster Loop II,* c. 1960.

Opposite:
215. *Clipper Sketchbook,* page 23,
1955–59.

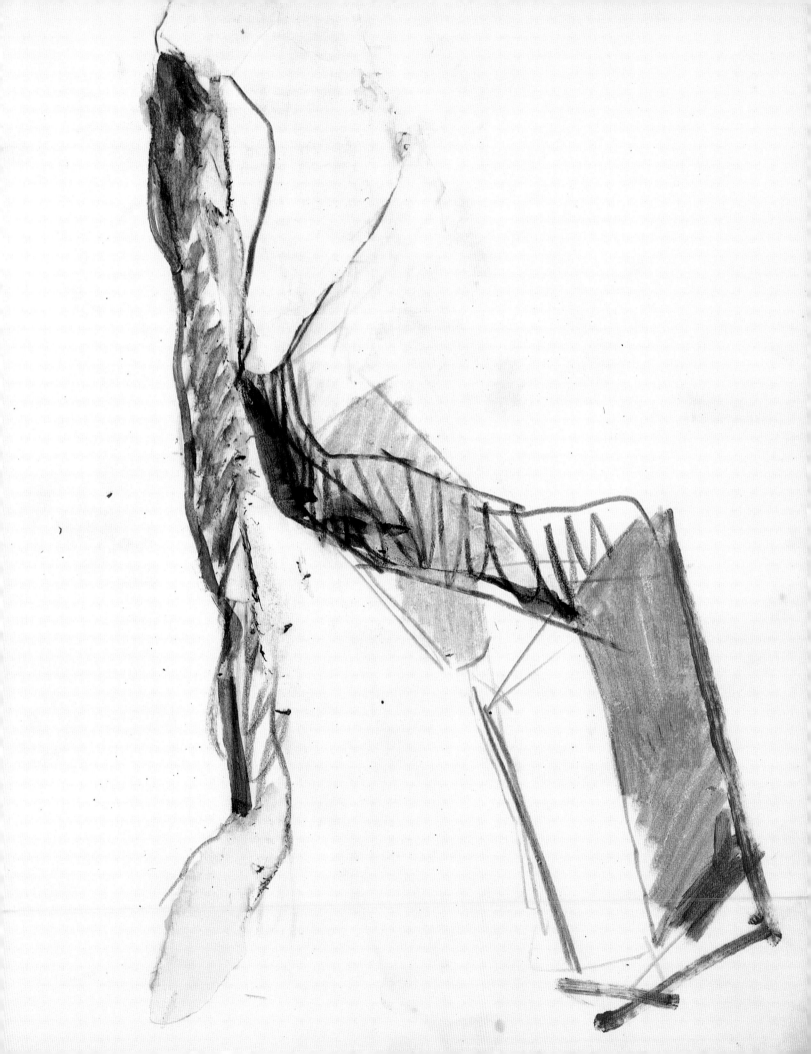

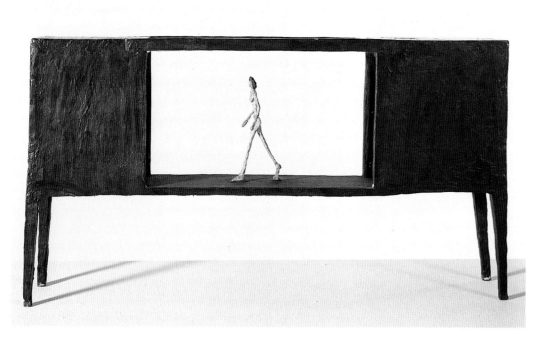
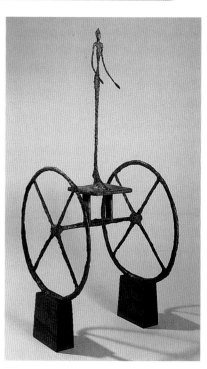

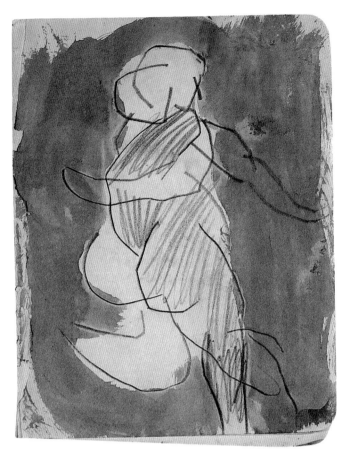 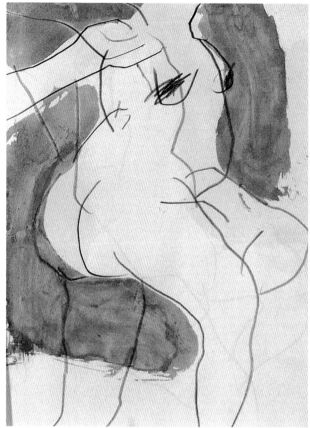

The sketchbooks also reveal early interests in contemporary European art. Juxtaposed with a variety of subjects in the *Landscapes Sketchbook* are two quick studies derived from reproductions of sculptures by Alberto Giacometti which, at the time, Neri would have seen as recent works by the Swiss sculptor. Neri's interest in European artists is usually discussed after he and Joan Brown traveled together in Europe in 1961. The work of Giacometti is frequently cited as an influence on Neri's later figurative sculpture. These sketches are fascinating in that the figure in Giacometti's sculpture is not emphasized by the young Neri; rather, it is form and relationships of shapes, space, and scale that are quickly analyzed.

If later sketchbooks from the decade of the 1950s and early 1960s reaffirm Neri's early explorations of abstracted conceptual forms and ideas, they also demonstrate his increasing interest in the human figure and especially its potential as a formal and expressive subject. In general, Neri's ventures into abstract compositions relate to the waning hold that abstract expressionism had on Bay Area painters and sculptors; the figurative works relate to the emerging interest among numerous artists and the development in the late 1950s of what is generally referred to as Bay Area figurative art. Many of the artists still associated with this transitional period in Bay Area art were Neri's teachers and/or contemporaries.[11] For Neri, the divergent styles and subjects were interrelated rather than separated, and served to fuse and mold distinctive characteristics of his art.

Left:
220. *Landscapes Sketchbook*,
 page 43 (verso), c. 1955–56.
Right:
221. *Landscapes Sketchbook*,
 page 36 (verso), c. 1955–56.

Opposite:
Top left:
216. *Landscapes Sketchbook*,
 page 23, c. 1955–56.

Top right:
217. *Landscapes Sketchbook*,
 page 22 (verso), c. 1955–56.

Bottom left:
218. Alberto Giacometti, *Figurine
 dans une boîte entre deux
 maisons*, 1950.

Bottom right:
219. Alberto Giacometti,
 The Chariot, 1950.

125

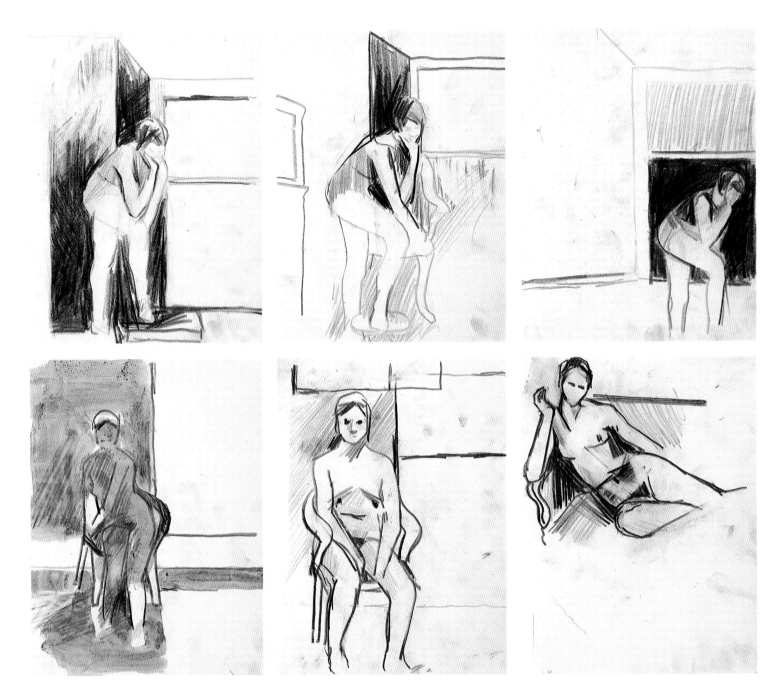

Figurative sketchbooks from the late 1950s—*Casting Sketchbook, Fair Play Compositions Sketchbook,* and *Etter Sketchbook*—record a variety of sessions with the live model, whether in the figure-drawing classroom or from group figure-drawing sessions with other artists—Joan Brown, William H. Brown, Gordon Cook, and Alvin Light.[12] The figure may be studied repeatedly for form and pose, but just as consistently, there is a growing concern with the attitude and psychology of limbs, posture, and movement, which anticipates concerns that become central to Neri's figurative works of the late 1970s. In a few instances, one has a sequence of sketchbook sheets

Top, left to right:

222. *Casting Sketchbook,* page 8, c. 1959.

223. *Casting Sketchbook,* page 7, c. 1959.

224. *Casting Sketchbook,* page 9, c. 1959.

Bottom, left to right:

225. *Casting Sketchbook,* page 21, c. 1959.

226. *Casting Sketchbook,* page 31, c. 1959.

227. *Casting Sketchbook,* page 60, c. 1959.

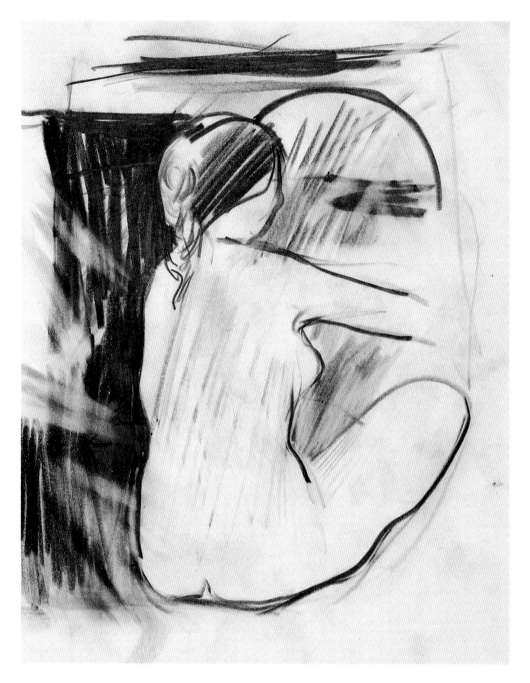

(Figure Studies Sketchbook) that show the model rendered in wash in the 1950s and then, more than twenty years later, the same figures are reworked and transformed with oil stick. *Green Trees Sketchbook* also contains some studies which seem more directly related to Neri's early efforts in figurative sculpture; two pages show several masklike faces in profile which seem to be related to heads and busts executed by the artist during this decade in various materials—wire, cloth, wood, and plaster—and thus anticipate the expressive figural vocabulary developed subsequently in Neri's work.[13]

228. *Fair Play Compositions Sketchbook*, page 25, c. 1959.

127

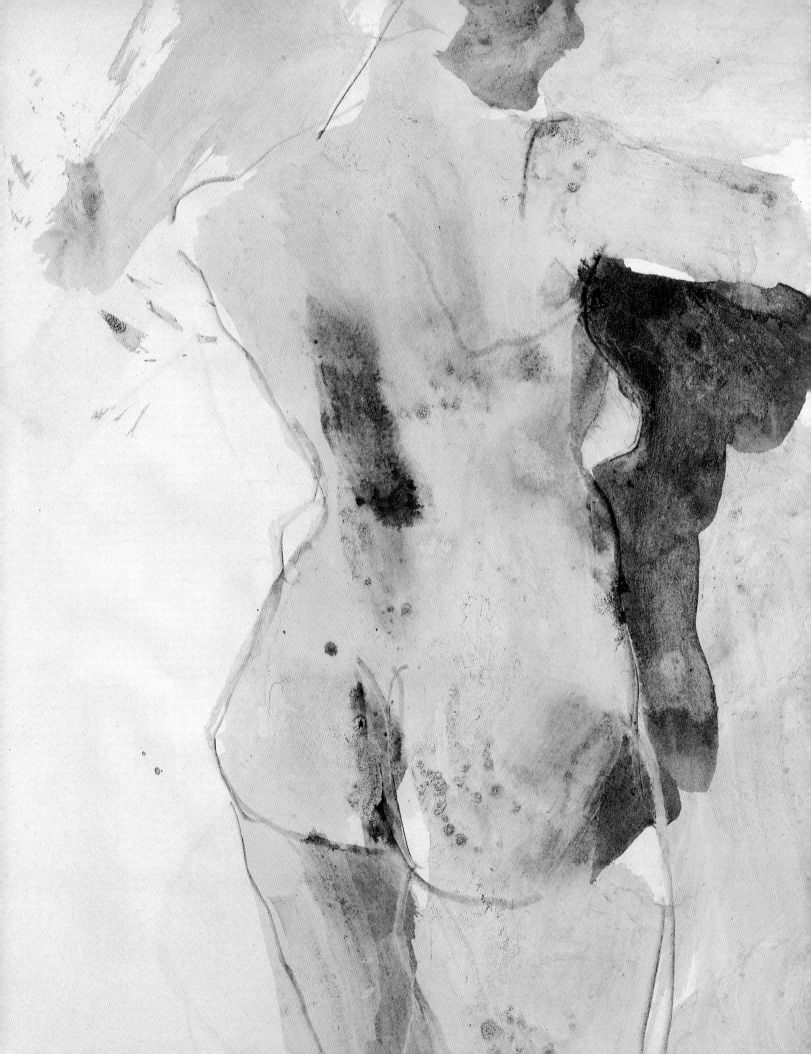

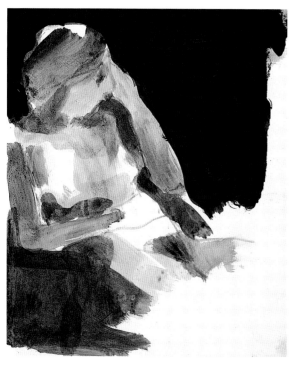

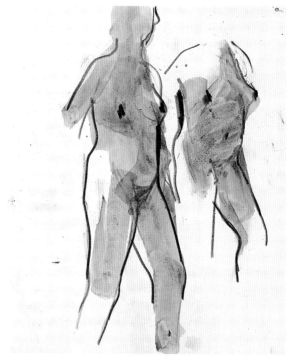

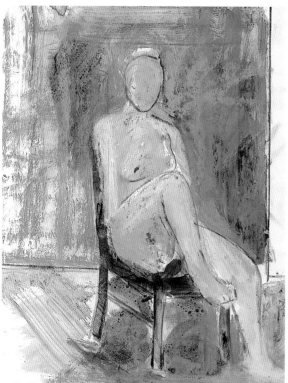

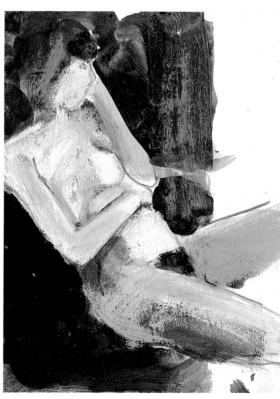

Top left:
230. *Figure Study No. 34*, c. 1957;
 Reworked c. 1980.

Top right:
231. *Figure Study No. 53*, c. 1957;
 Reworked c. 1980.

Bottom left:
232. *Figure Study No. 4*, c. 1957;
 Reworked c. 1980.

Bottom right:
233. *Figure Study No. 33*, c. 1957;
 Reworked c. 1980.

Opposite:
229. *Etter Sketchbook*, page 68,
 c. 1959.

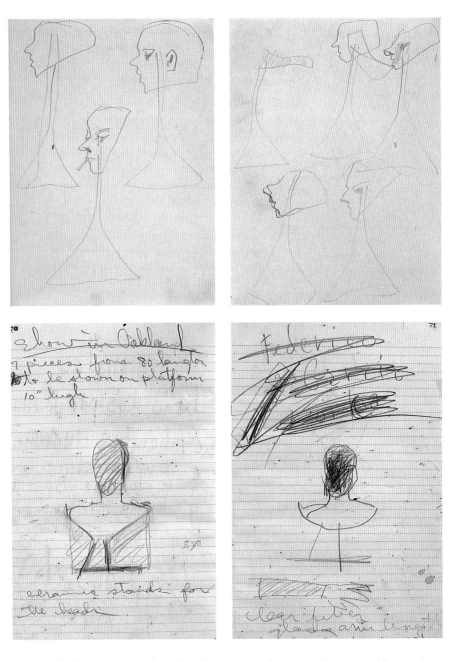

In the later *Repair Sketchbook,* a series of pages is dominated by studies of heads in profile. In general, these seem to relate to numerous plaster heads, many of them titled after literary figures, executed by the artist in the decade of the 1970s. Several of the sketches, as well as some found in *Unos Actos de Fe Sketchbook,* however, can be closely associated with even later works, specifically a series of painted bronze heads from 1981–83 based on the model Makiko Nakamura.

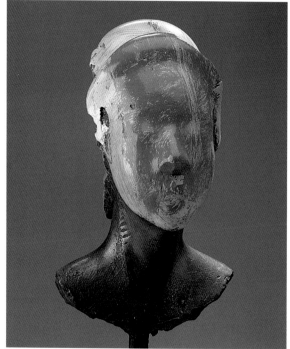

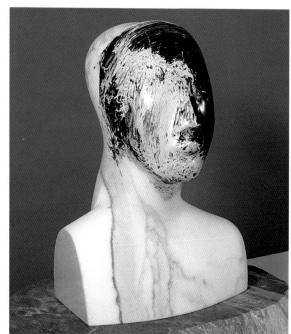

Top left:
238. *Repair Sketchbook*, page 72,
c. 1968–75.

Top right:
239. *Makiko No. 3* (Cast 1/4),
1981.

Bottom left:
240. *Makiko*, 1980.

Bottom right:
241. *Maki No. 3*, 1994.

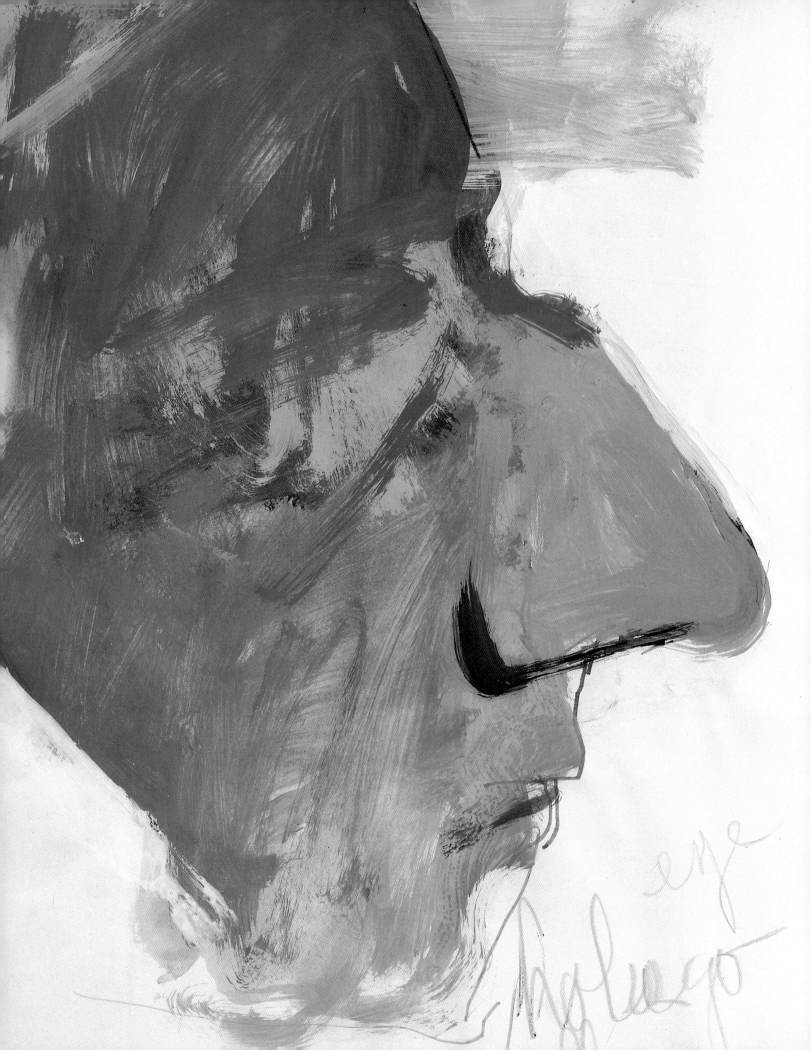

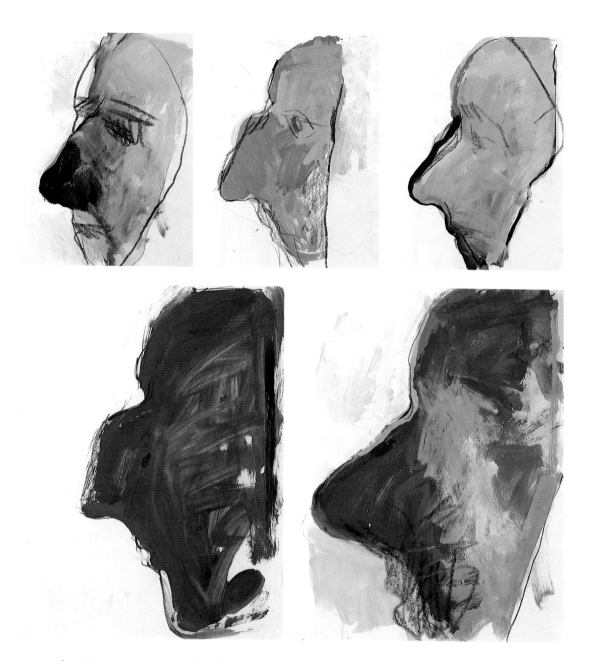

Other faces on sheets in this sketchbook are distinctive in the figure's pronounced nose. This feature seems to reflect a synthesis of a diverse number of "portraiture" sources, some of which had long fascinated the artist and range from ancient Tarentum clay grotesque masks, to Egyptian mummies with their "exposed" large noses, to features of life models that informed his work at this time.

Top, left to right:
243. *Repair Sketchbook*, page 83, c. 1968–75.

244. *Repair Sketchbook*, page 74, c. 1968–75.

245. *Repair Sketchbook*, page 81, c. 1968–75.

Bottom left:
246. *Repair Sketchbook*, page 78, c. 1968–75.

Bottom right:
247. *Repair Sketchbook*, page 79, c. 1968–75.

Opposite:
242. *Repair Sketchbook*, page 77 (verso), c. 1968–75.

Top:
248. *Landscapes Sketchbook,*
 page 2, c. 1955–56.

Bottom:
249. *Casting Sketchbook,* page 1,
 c. 1959.

Opposite:
Left:
250. *Fair Play Compositions
 Sketchbook,* page 16, c. 1959.

Top right:
251. *Fair Play Compositions
 Sketchbook,* page 3, c. 1959.

Bottom right:
252. *Fair Play Compositions
 Sketchbook,* page 17, c. 1959.

Several sketchbooks address a wide range of subjects, of which some are not commonly associated with the artist's works. As early as the mid-1950s one finds numerous pages devoted to quick graphite studies of observed landscapes *(Landscapes Sketchbook)*. Graphite studies of figures, animals, and seagulls, individually and in landscape settings, appear periodically in at least two sketchbooks of the late 1950s, *Casting Sketchbook* and *Fair Play Compositions Sketchbook,* and provide an alternative to sketches more commonly associated with the studio. The latter sketchbooks suggest their origin in events of the artist's private life—family outings or travel journals.

Girl under net

Top left:
253. *Fair Play Compositions Sketchbook*, page 29, c. 1959.

Top right:
254. *Fair Play Compositions Sketchbook*, page 28, c. 1959.

Bottom left:
255. *Fair Play Compositions Sketchbook*, page 26, c. 1959.

Bottom right:
256. *Fair Play Compositions Sketchbook*, page 27, c. 1959.

In *Fair Play Compositions Sketchbook*, one finds colorful sketches which, at first glance, suggest Neri's early painted plaster and cardboard sculptures. The studies, however, are for stage sets designed by the artist for San Francisco's American Conservatory Theater (A.C.T.) and its production of Jean Cocteau's drama *The Infernal Machine*. According to the artist, he immediately rushed out to get a copy of the play when asked to design the sets, and soon became totally absorbed in the surrealist tragedy and in creating sets appropriate for Cocteau's "strange, large monster magic."[14]

Other books preserve sketches that can easily be classified as still life and reveal interests rarely discussed in connection with Neri's work. On a series of pages from *Stick Sketchbook*, an organic form sensitively studied and beautifully rendered in ink and wash is thoughtfully identified for us by the artist as a "dried bee."

Top left:
257. *Stick No. 46*, c. 1970.

Top right:
258. *Stick No. 43*, c. 1970.

Bottom left:
259. *Stick No. 51*, c. 1970.

Bottom right:
260. *Bee IV*, c. 1970.

Another sketchbook, *Rock,* contains an equally impressive series of still-life studies. The subject, a coffeepot and other kitchen tools and utensils, is explored repeatedly in terms of line and form with varying emphases on both the positive and negative areas and relationships of the objects in the composition. The setup may well have been composed by Neri for a drawing class in the Department of Art at the University of California, Davis, and the artist becomes absorbed in the problem as well. One of the sketches is accompanied by a note of criticism: "too small/not using the space of your paper/get a camera. . . ."

In sketchbooks dating from the late 1950s *(Fair Play Compositions Sketchbook, Casting Sketchbook, Etter Sketchbook,* and *Figure Studies Sketchbook),* one finds sketches that seem to reflect more domestic situations and to parallel Neri's early association with Joan Brown. Brown poses for concise figure studies; her dog is quickly rendered in several studies as it sleeps or "poses." Some of the sketches may even be by Joan Brown. A similar collaboration can be found in the *No Hands Neri Sketchbook.* A series of playful sketches involves the hand of Susan Morse, to whom Neri was married from 1967 to 1976 (they separated in 1972); one of her sketches depicts a caricature of Neri with outstretched arms astride a bull, hence the inscription "No hands Neri."

Left:
261. *Rock No. 26,* c. 1967–74.

Right:
262. *Rock No. 27,* c. 1967–74.

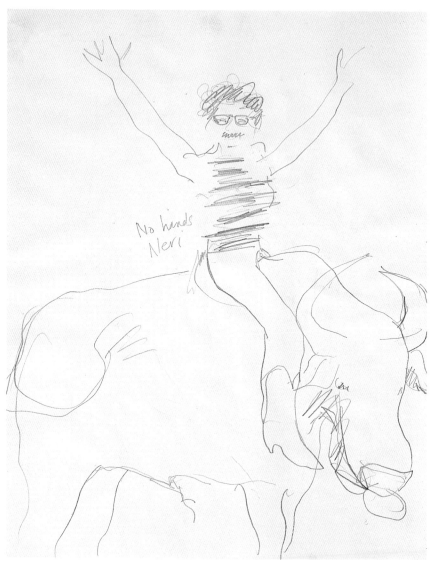

No hands
Neri

Top, left to right:
263. *Fair Play Compositions Sketchbook,* page 79, c. 1959.

264. *Casting Sketchbook,* page 22, c. 1959.

265. *Fair Play Compositions Sketchbook,* page 73, c. 1959.

Bottom:
266. Drawing by Susan Morse Neri, *No Hands Neri Sketchbook,* page 6, c. 1966.

Top left:
267. *CSFA Sketchbook,* page 13,
 c. 1962–64.

Top right:
268. *CSFA Sketchbook,* page 5,
 c. 1962–64.

Bottom:
269. *Projections Sketchbook,*
 page 64, c. 1965–83.

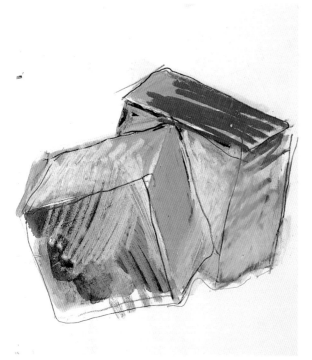
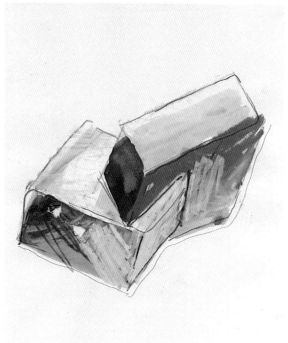

Other sketchbooks contain a series of landscape studies which provide the artist's observations of the changing conditions of light and mood. A series of Clear Lake views (in Lake County, California) from the *CSFA Sketchbook* record spontaneous impressions of the interplay of atmospheric conditions and changes, and offer fascinating parallels with interests displayed in the same sketchbook in figure studies that focus on the spontaneity and change of the model's gestures. In this sketchbook are also sketches and collages that clearly relate to Neri's teaching activities at the California School of Fine Arts in 1963 and 1964.

Neri's engagement with landscape in the 1960s moves from depictions of the condition of a particular place, such as Clear Lake, to other sketchbooks (e.g., *Projections Sketchbook*) in which he records "Benicia Waterfront" and dates it "1965,"[15] to sites with archaeological interest, sketches in which he records details from both memory and visual sources.

In the *No Hands Neri Sketchbook,* the artist will move from figure studies where the figure is isolated and/or paired to a series of studies for sculptures made of surplus steel and aluminum "blocks" that are also, in a parallel fashion, studied individually or paired. The latter studies, executed in both black and white and vivid color washes, relate to a period in Neri's work in which he investigated through countless drawings various sculptural ideas to be executed in more permanent materials while continuing to experiment with throw-away materials—cardboard, cloth, burlap, and plaster. Many of the works, both freestanding and wall-mounted pieces in impermanent materials, were realized and even exhibited, but today few remain in good condition.[16]

Left:
270. *No Hands Neri Sketchbook,*
 page 65, c. 1966.

Right:
271. *No Hands Neri Sketchbook,*
 page 66, c. 1966.

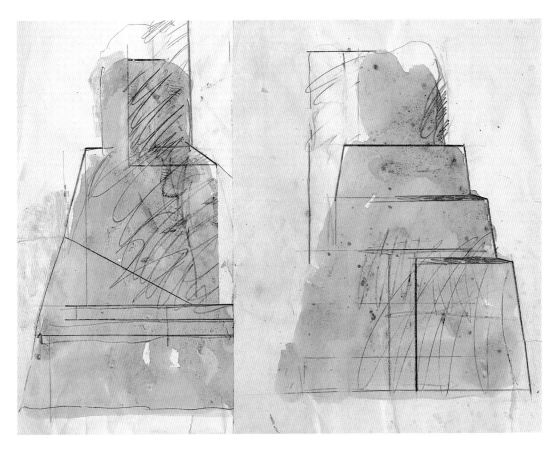

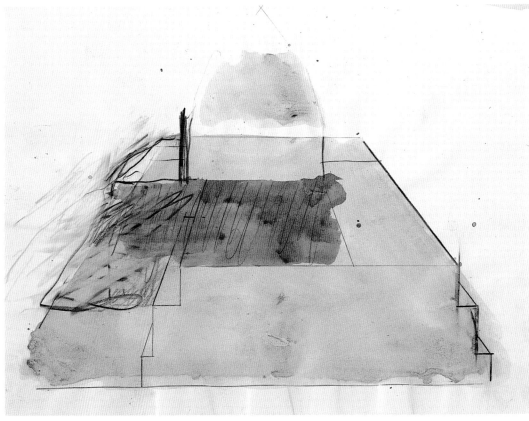

Top:
272. *Study No. 5 for Tikal Series I,*
 c. 1969.

Bottom:
273. *Repair Sketchbook,* page 33,
 c. 1968–75.

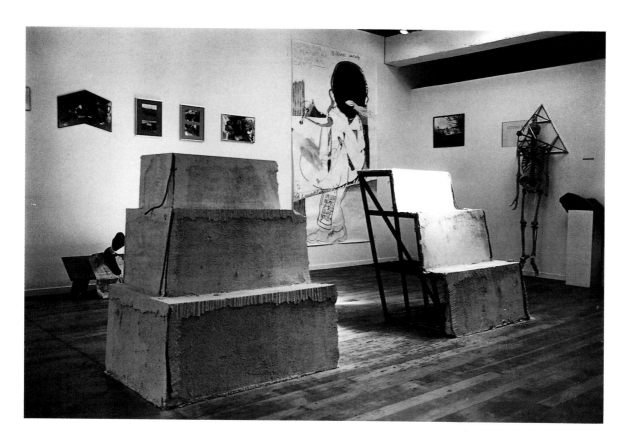

These sketchbooks date more or less contemporaneously with others in which the artist devotes page after page to a long-standing fascination with pre-Columbian sites, particularly Tikal and Tula, that he first visited in the 1950s with Billy Al Bengston. Neri speaks of the interest this trip aroused in pre-Columbian architecture and other ancient cultures, "especially in the setting of structure and architecture and a consciousness of the land and the relationship of land and vanished people who occupied the sacred areas and temples."[17]

The architectural forms and details of the stepped pyramid at Tula become the subject for several pieces executed for and related to "The Repair Show," an exhibition mounted in March and April of 1969 at the Berkeley Gallery, San Francisco, for which artists were asked to develop pieces on the theme of repair.[18] Neri included two large freestanding pieces entitled *The Great Steps of Tula* and *Monument for the Repair of a National Image*.[19] Using cardboard, plaster, lath, and chicken wire, the two pieces simultaneously evoke the stairstep facades of the Tula model, yet juxtapose the solidity of the forms with the fragility of the materials and the exposed open skeleton of their support framework. Even the juxtaposition of their titles seems to imply contrast and comparison of time, age, and cultural meaning.

274. *The Great Steps of Tula* and *Monument for the Repair of a National Image* in "The Repair Show," Berkeley Gallery, 1969. Photo by Jack Fulton.

units that stack up together

At least one notebook *(Repair Sketchbook)* survives intact and contains numerous studies of Tula and Tikal; it documents the artist evolving ideas for sculptures on the repair theme. Pencil and watercolor sketches of geometric architectural derivations from pre-Columbian monuments, and wash drawings of mysterious architectural fragments and settings populated, at times, by solitary figures are juxtaposed with notes on sculpture. For example, the artist writes "repair of the great steps of Tula" on a drawing, then on subsequent pages notes "steps for repair show"; on other pages "slanting steps" and "steps into wall" appear with sketches, and then he notes with some resolution, "units that stack up together."

Left:
275. *Repair Sketchbook,* page 39,
 c. 1968–75.

Right:
276. *Repair Sketchbook,* page 40,
 c. 1968–75.

Opposite:
277. *Repair Sketchbook,* page 41,
 c. 1968–75.

In the same sketchbook, Neri documents an interest in related sources. For example, the infamous "slant step," which intrigued and beguiled so many Bay Area artists in the late 1960s, is not ignored by Neri.[20] Specific and more generalized references to this non-art object, a plywood and green linoleum "step" discovered and purchased in a salvage shop by William T. Wiley and Bruce Nauman in 1965, which subsequently inspired countless art objects, appear in several sketchbooks (see also *Stick Sketchbook* and *Projections Sketchbook*). Along with studies for the Tula steps and "The Repair Show," the "slant step's" sensuous profile is sketched, and one even finds written notations, e.g., "slant step sundial," which indicate Neri's consideration of pieces based on the "slant step."

Another thematic exhibition, "The Ladder Show," for which artists were asked to execute specific works was mounted in October 1972 at the Artists Contemporary Gallery in Sacramento. Neri devotes a section of the *Ladder Sketchbook* to his concept for the show, a thin, elongated ladder in wood (20 ft. × 12 in.).[21] The subject and its formal and structural implications as well as his recent obsession with stepped sculptural forms inform Neri's ideas as he records them in graphite and watercolor. The studies, primarily emphasizing the regular but jagged profile of the piece, explore the ladder form as a single object and in parallel multiples. On one sketch page, Neri identifies the placement and installation of the piece in a corner; on another he writes "flying buttress" as an apparent structural analogy, but there is also a striking visual correspondence between the drawings of his ladder in profile and the familiar patterned device of Gothic cathedrals. In one of the drawings he carefully scribbles a word so that it "ascends" the steps of the ladder. Possibly "enlightenment" or "alignment," it perhaps was meant to provide metaphorical meaning to the utilitarian form.

Left:
278. *Repair Sketchbook*,
 page 71, c. 1968–75.

Right:
279. *Ladder Sketchbook*,
 page 17, 1971–72.

280. *Ladder Sketchbook,*
page 20, 1971–72.

Variations on the basic form of vertical and slanted elements and the fascination with common materials pervade a significant part of Neri's sculpture and works on paper during the late 1960s and into the decade of the 1970s. The *Repair Sketchbook* contains numerous studies reflecting an ongoing interest in large wood and plaster constructions, which the artist identifies as "street grids" and "totems." References to "lead and glass" accompany many of the street-grid studies, which clearly suggest an architectural reference to lattice-type windows and, to Neri's mind, seem to have equivalents with "lath and fiberglass."

In the *Repair Sketchbook*, the artist makes significant notes that roughly correspond to his new interest in fiberglass as a sculptural medium. It is well known that Neri used fiberglass in a series of figure fragments cast from earlier plaster figures. These pieces were specifically part of a developing body of work for an exhibition at the San Francisco Museum of Art in the autumn of 1971.[22] He identifies and juxtaposes the words "fiberglass" and "stained glass" on successive pages, as if realizing and establishing an analogy between the two in terms of light and color and as formal aspects of the work to consider and reconsider.

Left:
282. *Emborados Series—Nazca Lines V*, 1971.

Right:
283. *Repair Sketchbook*, page 59, c. 1968–75.

Opposite:
281. *Repair Sketchbook*, page 57, c. 1968–75.

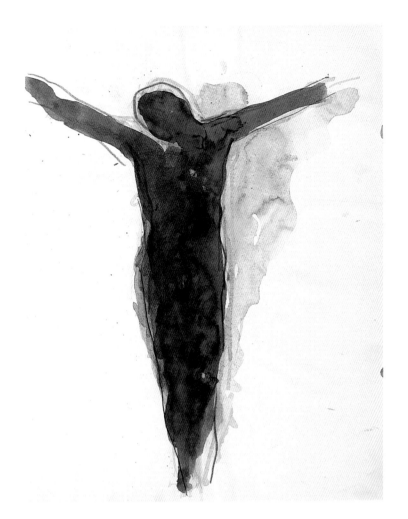

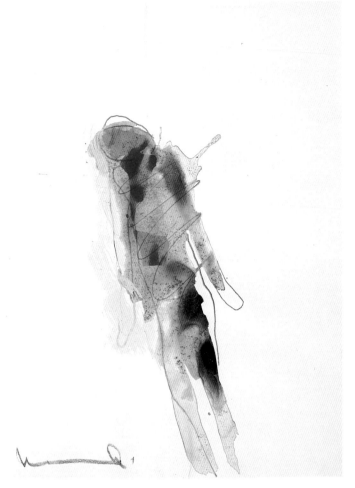

A sketchbook that apparently dates only a few years later and which contains a suite of figure studies for a Crucifixion sculpture intended for a Los Altos convent chapel *(Crucifixion Sketchbook)* contains Neri's notes for further pieces to be cast with plaster and rubber latex molds as well as other notes specifically to remind himself that "when reliefs are finished paint with resin and fiberglass."

This sketchbook and another, *Rock Sketchbook,* contain valuable studies and records of Neri's working methods for the Los Altos project. They also document early drawing sessions with model Mary Julia Raahauge. Through line and vivid wash, several of the drawings depict Mary Julia in various poses. These are juxtaposed with sheets on which Neri transposes the life drawings into depictions specifically related to the themes of the Crucifixion and Ascension.

Left:
284. *Crucifixion Sketchbook,*
 page 30 (verso), c. 1972–73.

Right:
285. *Rock No. 40,* c. 1967–74.

Opposite:
286. *Crucifixion Sketchbook,*
 page 24 (verso), c. 1972–73.

288. *Rock No. 6*, c. 1967–74.

Opposite:
287. *Crucifixion Sketchbook,*
 page 22, c. 1972–73.

Practical and philosophical notes continue frequently to accompany Neri's visual ideas. In the series of early studies for sculptures in the *Green Trees Sketchbook*, the artist notes structural solutions, for example, "thing is all held together by wire." In the later *No Hands Neri Sketchbook*, he strikes a more philosophical note: "I sometimes think it is not possible— but it does happen." In another book *(Ladder Sketchbook)*, he notes "chopped up" followed by "forget it." On another sheet he again comments on a structural detail: "this stuck in cardboard wall"; on the back of the page he writes, "putting things down on paper/the life you want to control neatly placed side by side." Finally, in another sketchbook the artist repeatedly writes: "On bad days I stand here and everything is okay."

289. *Rock No. 44,* c. 1967–74.

NOTES

1. Over thirty sketchbooks have been located in the artist's collection; they form the basis of this study. Through the years other sketchbooks have been presumably lost or dismantled. I am indebted to Anne Kohs & Associates, and especially to Armelle Futterman, for unfailing assistance and many contributions to this study. For the sake of reference and identification, the sketchbooks have been titled recently according to the first written entry and/ or the type of sketchbook used.

2. Seventh edition; edited by Robert M. Orton (New York: The H. W. Wilson Co., 1946). The book, deaccessioned by the California College of Arts and Crafts library, was purchased by Neri at an Oakland bookstore. Over fifty related sketches for eucalyptus sculptures are known that seem to date several years later, after Neri's return from Korea. Executed in colored inks and graphite and occasionally incorporating acrylic and crayon, the studies are on the reverse of mimeographed correspondence (11 × 8¼ in.) and on heavier paper (8¼ × 18 in.), the latter sheets removed from a ledger book at some point.

3. This is not intended to imply a direct source for Neri, but more of a correspondence in the relationship between the expressive stroke of the brush and the "found" printed-matter page. By this date, however, the young Neri was certainly aware of the work of some of the New York abstract expressionist artists, primarily through reproductions in magazines and exhibition catalogues. Calligraphy was of interest to Neri rather early on. He recalls that calligraphy by young Japanese artists, in particular, which he saw while serving in the U.S. Army from 1953–55, impressed him greatly. (Conversation with the artist, December 26, 1990.)

4. Conversation with the artist, December 26, 1990.

5. Neri's works were included in the exhibition "Four Man Show: Sam Francis, Wally Hedrick, Fred Martin, Manuel Neri," in February 1959 at the San Francisco Museum of Art; the Dilexi exhibition was in June–July 1960.

6. At least fifty single-sheet drawings survive, in graphite only as well as in graphite, ink, and pastel, representing studies for painted plaster and cardboard sculptures. The size (11 × 8 in.) and format of the sheets indicate that they were originally bound together as a sketchbook or sketchpad.

7. Two-person show with Jo-Ann Bentley Low in February–March 1957.

8. See John Coplans, ed., *Abstract Expressionist Ceramics*, exhibition catalogue (Irvine: The Fine Arts Gallery, University of California, 1966), in which *Loop No. 1* and *Loop No. 2* are reproduced; these and *Loop No. 3* are cited in the exhibition checklist. See also Peter Selz, ed., *Funk*, exhibition catalogue (Berkeley: University Art Museum, University of California, 1967), in which *Loop No. 1* is reproduced, and, with *Loop No. 2* and a plaster and cardboard *Moon*, is in the checklist. The date 1961 is cited for all works in both exhibitions. It is interesting to note that *Loop No. 1* and *Loop No. 2* were at that time in the collection of Peter Voulkos. However, the same ceramic loops also appear in Garth Clark and Margie Hughto, *A Century of Ceramics in the United States, 1878–1978* (New York: E. P. Dutton, 1978) with the date 1956.

9. Conversation with the artist, December 26, 1990.

10. During this period Neri shared a studio with Alvin Light, as well as with Charles Ginnever.

11. Neri has commented several times on the more relaxed relationship between teacher and student in the late 1950s: "We were constantly learning from each other." (Conversation with the artist, December 26, 1990.)

12. From 1959 to 1962 these artists met for weekly drawing sessions. Subsequently Neri participated in weekly drawing groups in 1969 and 1972–74 with Joan Brown, Gordon Cook, Robert Arneson, and Elmer Bischoff.

13. Probably the best known of the early busts is the painted plaster *Dr. Zonk*, dating from 1958. For discussion of this and later heads, see Caroline A. Jones, *Manuel Neri: Plasters*, exhibition catalogue (San Francisco: San Francisco Museum of Modern Art, 1989), p. 11ff.

14. Conversation with the artist, March 19, 1993.

15. The date corresponds with the year that Neri purchased and moved into an abandoned Congregational church in Benicia.

16. Aluminum and plaster boxes were exhibited at the Quay Gallery, San Francisco, in 1968; "geometric sculptures" were shown at the San Francisco Art Institute in 1970.

17. Conversation with the artist, December 26, 1990. Elsewhere, Neri has stated, "I was intrigued by the way they [the pre-Columbian structures] imposed themselves on their environment as related to the conceptual ideas in contemporary art," cited in Caroline A. Jones, *Manuel Neri: Plasters*, pp. 19–20, n. 36.

18. Formed in 1964 in Berkeley as a cooperative gallery with monthly dues for artists, the Berkeley Gallery was mainly supported by Marian and Jim Wintersteen. The gallery moved to San Francisco in 1966 and gained notoriety for mounting "The Slant Step Show" in September. See *The Slant Step Revisited*, exhibition catalogue (Davis: Richard L. Nelson Gallery, University of California, 1983).

19. Works in the exhibition were photographed by Jack Fulton and spiral-bound as "catalogue" documentation for the show. The two cited works by Neri are the only two that appear in the photographic essay. There seems to be some confusion in the literature as to how many pieces by Neri were in the show. Jones, *Manuel Neri: Plasters*, p. 20, for example, notes: "Neri's contribution to the 'Repair Show' was a large environmental construction, evoking pre-Columbian architecture in the process of decay and resurrection." There is also a large-scale wall-piece construction of painted cardboard and wire mesh, *The Repair of the Great Steps of Tula*, which seems to date contemporaneously and at times was thought to have been included in the exhibition. We know that Neri also executed numerous small constructions of the steps cut from ink wash studies and mounted on wire mesh frameworks. Most of them, or at least the surviving pieces, seem to date a few years later and are testaments to his continuing fascination with the theme.

20. See the Nelson Gallery catalogue *The Slant Step Revisited* for this famous saga.

21. The show was organized by artist Darrell Forney, who also produced the catalogue, in which the entry for Neri's piece is noted as a late addition, and the piece is not illustrated.

22. See Gerald Nordland, *Arts of San Francisco: Manuel Neri*, exhibition brochure (San Francisco Museum of Art, 1971).

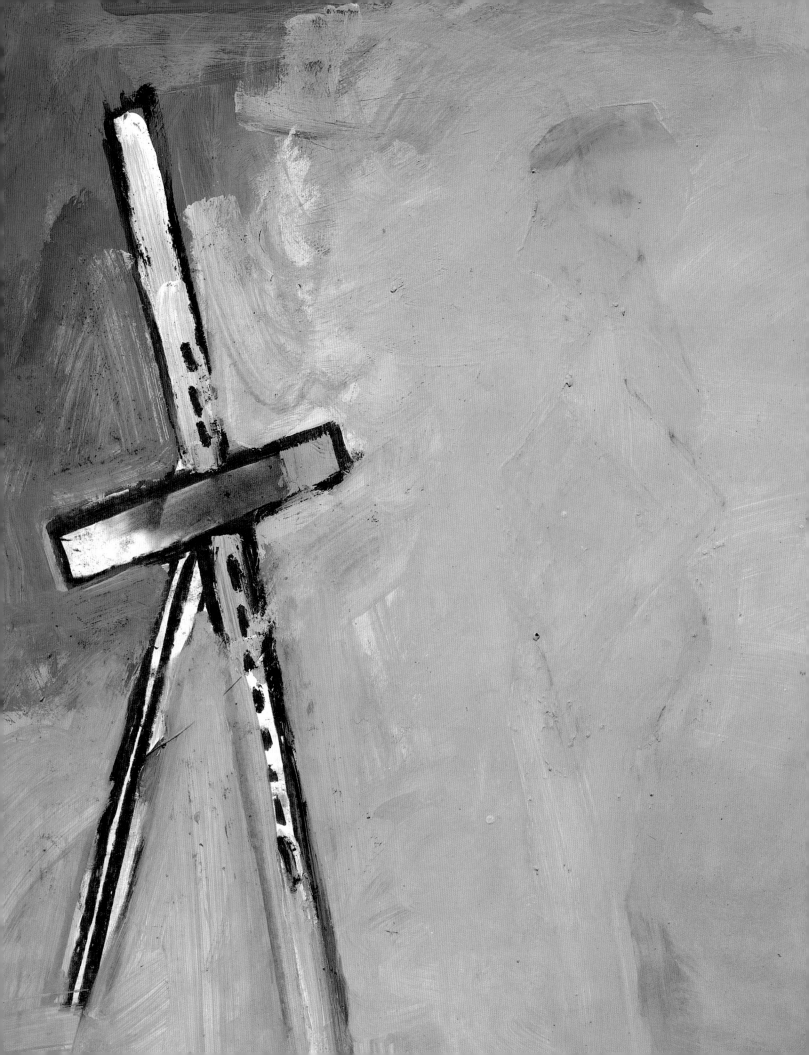

A LA PINTURA

Neri's Painted Papers, Painting Sketches, "Cut Color"
and "Window" Paintings, 1956–1959

JACK COWART

Al pincel	A Paintbrush
A ti, vara de musica rectora,	Baton that conducts us to music, sea's
concertante del mar que te abre el lino,	virtuoso that tacks toward an ocean of canvas—to you,
silencioso, empapado peregrino	pilgrim of silence and wayfarer drenched in a voyage
de la noche, el crepúsculo y la aurora.	whose time is the midnight's, the dusk's, and the dawn's.
A ti, caricia que el color colora	Caress that the colors have colored,
fino estilete en el operar fino,	stylus that tempers its point for a master's employment,
escoba barredera del camino	broom to sweep clean and open the way to a journey,
que te ensancha, te oprime y te aminora.	enlarging, confining, diminishing itself for your pleasure . . .

—Rafael Alberti, from *A la pintura*[1]

From late 1956 until late 1959, Manuel Neri evolved from an art school student to a mature, independent artist, and in the process produced groups of remarkable and diverse experimental paintings on both paper and canvas. At least sixty drawings—expressing painterly concerns through tempera (semi-opaque watercolor), acrylic, or pastel—and twenty-six thickly painted large-scale oil and mixed-media canvases survive.

This essay—"A la Pintura," "to painting,"—owes its title to the magical mid-1940s poem cycle *A la pintura (Poema de color y la línea)* by the poet/artist Rafael Alberti.[2] He was responding, as a twentieth-century Spaniard, to the profound, almost surreal, essences of the rich history, materials, and spirituality of painting. Alberti appraised its formative effects upon his creative life, a life which began simultaneously in both painting and poetry.[3] I sense in Manuel Neri a similar history and deep, reverential appreciation for these fundamental principles. Neri, like Alberti, chose the rich visual matrices of imaginative, figurative, and painterly allusion over its near, but minor, relation—literal realism.

Few have previously recognized Manuel Neri's surprising and substantial body of early, two-dimensional, painted work. It was in his paintings and painted papers, figurative as well as nonfigurative, that he developed his special skills for polychromy and brushwork, which he then applied radically to sculpture, his primary sensual and public medium. Neri stopped working with oil on canvas after 1959, possibly taking Richard Diebenkorn's advice that he should stop painting and "stick to sculpture," something he

290. Untitled Figure Study No. 12, 1957.

supposedly did "better."[4] But, to the present day, Neri continues to paint on paper, forcefully building on his early independent acrylics and temperas. Thus over the last four decades, he has created a dramatic and extraordinary body of hundreds of works on paper that remain distinctly painterly in their ambitions and the rich visual effects of their dry and water-based pigments.[5]

In late 1956, Manuel Neri began to study painting with Elmer Bischoff at the California School of Fine Arts in San Francisco. This was not Neri's first focus on painting, as he had been active the previous year at the California College of Arts and Crafts in Oakland with other Bay Area figurative and abstract painters: Frank Lobdell, Nathan Oliveira, and Diebenkorn, among others. The general history of Bay Area figurative painting is well treated in several recently published volumes, notably those of Caroline Jones and Thomas Albright.[6] The authors document the numerous evolutionary crosscurrents of art historical, art school, political, and social influences in both San Francisco and the East Bay (particularly Berkeley and Oakland). They also confirm the existence of a remarkably fertile seedbed, with active awareness of European modern art (from Cézanne to Matisse and Munch, Picasso to Kandinsky, German expressionism, dada and surrealism to *l'art brut*), and direct knowledge of contemporary American developments (from early abstraction to gestural painting and New York abstract expressionism). The regional art schools and museums and distinguished artists from inside and outside the community (Clyfford Still, Mark Rothko, Hans Hofmann, Hassel Smith, among so many others) brought and broadcast all this news.

Neri was not at this time a mature artist, but he was a particularly aggressive one, actively changing styles, studio and living partners, materials and focus, and probing for areas of comfort and personal relevance. As a veteran returning from Korea, with his wide participation in the California College of Arts and Crafts (CCAC), the California School of Fine Arts (CSFA), the art activities at the University of California, Berkeley, plus artist cooperatives (the 6 Gallery, "Ratbastards") and jazz, funk, and Beat-generation clubs, Neri was in a privileged position to absorb and appraise all these diverse influences. Neri positioned his art and self-expression through prodigious energies born of pervasive frustration and challenge. The years of the mid- to late 1950s were his time of inspired risktaking. There was nothing to lose financially, culturally, or personally, and everything to gain.

Bischoff, a distinguished figurative painter, found emotional and expressive values in the natural elements of color and light.[7] He believed in painterly values and a personal and painterly process steeped in visual memory. He avoided any insistence that his students should adhere to his personal figural interest, even though such politics of style and content would intensify throughout the late 1950s into the early 1960s.[8] Whether his students' works were abstract or imagist, it was their painting *process* that mattered most to Bischoff.[9]

Immediately before his studies with Bischoff at CSFA, Neri was creating energetic and gritty abstracted funk assemblage sculpture. Yet upon entering Bischoff's class, he began making painterly tempera drawings in a more classical and structured style. These works were determined, no doubt, by the posed studio model and formal class exercises, as well as by the compositional and figurative influences, filtering in through Bischoff, of Matisse, Bonnard, and Munch, among others.

Critically, Neri's quick shift is also an early indication of his purposeful, lifelong exploration of the tension between abstraction and representation. Abstraction means many things, but one formal core value is that of an expansiveness of "ground," where the visual field dominates imagery. During this early period, Neri is simultaneously absorbing both the abstract and the figural. This will lead to his personal synthesis in which, by the early 1960s, he will sculpturally "wrap" the abstracted visual and painterly (nonfigurative) ground onto and around his own representational three-dimensional forms. This difficult forced union of nonfigurative and figurative (field upon image) in sculpture is uniquely disruptive and distinguishes Neri's work as a hybrid product of this period of Bay Area art.

During this time we also see Neri's first attempts to reconcile the reigning Bay Area "masters" (David Park, Bischoff, Smith, Lobdell, Diebenkorn, and even his closer contemporary Oliveira) with his own artmaking. Neri would subsequently find ways to distance his art from their art and artistic force, finding his own legitimate voice in the process. And finally, it was his ultimate ambition to be the artist who would successfully combine all the influences above (European, New York, Bay Area) and create a grand new formula comprising not only the geometrical but also the figurative and abstract.

What I call Neri's "painted papers" of late 1956–57 are notable and curious works. Several look like the studio assignments they are, but others are transcendently beautiful and display artistic maturity and insight. Sixteen of the known twenty-one are roughly thirty inches high by twenty-five inches wide. Most are rendered in tempera, pastel, and charcoal, with evident scumbled strokings and colorful facture. Clouds of pigment float within geometrical backgrounds, alluding to studio walls, windows, or the backs of paintings, where stretcher bars are exploited as excuses for rectilinear, constructivist pattern. Given the semitransparent nature of tempera, the white paper shines through, adding light and atmosphere. Often, fine-grained pastel lies on top, offering its own sensual reward. Curious underlayers of hot color define background planes and create a visual space, advancing or receding.

The posed nude models, lightly standing, seated in chairs, upon stools, or on the floor, are evocations of attitude rather than anatomical portraits. They are ghostly, flattened signifiers of human shape set into fields of color. Remote and lonely, these untitled figure studies are compositional studies

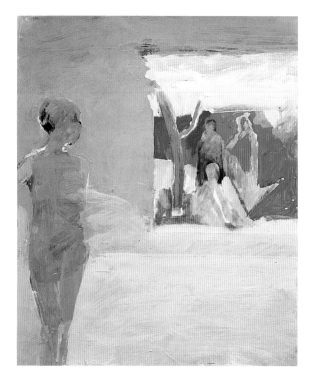

of forms, animate and inanimate. Sometimes the backgrounds are more "alive" than the model. Neri's expressive brushstrokes speak, making these paintings on paper visually more effective than some of his paintings on canvas. In the latter, thick, buttery layers of oil block light coming back up to the surface, rendering them less evanescent, contrary to so many other Bay Area painters addicted to their region's renowned play of bright light and strong shadow.

Untitled (Nude Model with Bischoff Painting) is particularly interesting for its depiction of a female nude posed beside a Bischoff painting of figures in a landscape. Lavish painted veils of pink and white color the implied interior space. Darker greens and oranges construct the landscape painting, which also suggests a view through a window. This creates a curious tension between the notional "inside" and "outside," between the exterior nudes surveilling the interior nude, and vice versa. The pinks and white are broadly overpainted, obscuring what appears to be a more detailed, earlier rendering. In the finished work, however, the depictive elements are eliminated, as the heavily brushed pigment overlaps edges, is scumbled over facial and anatomical features, and generally reduces the bulk or mass of the nude, thinning it down. It is as if Neri is already chiseling away at a plaster sculptural figure, scaling it back to make a more expressive, attenuated form.

The homage to Bischoff is clear in the painting citation, but the overall composition is also reminiscent of Diebenkorn's and Park's interior/exterior paintings. There, too, as Matisse and so many other prior artists taught, stretched canvases hanging on walls and windows can be related to each other as geometrical, almost antinaturalistic elements, creating distinct vignettes, inward or out, open or closed, or both. All these shapes and surfaces are flat, ultimately abstract, and mutually exploitable, giving great latitude to the artist.

291. *Untitled (Nude Model with Bischoff Painting)*, 1957.

Opposite:
292. *Untitled Figure Study No. 3*, 1957.

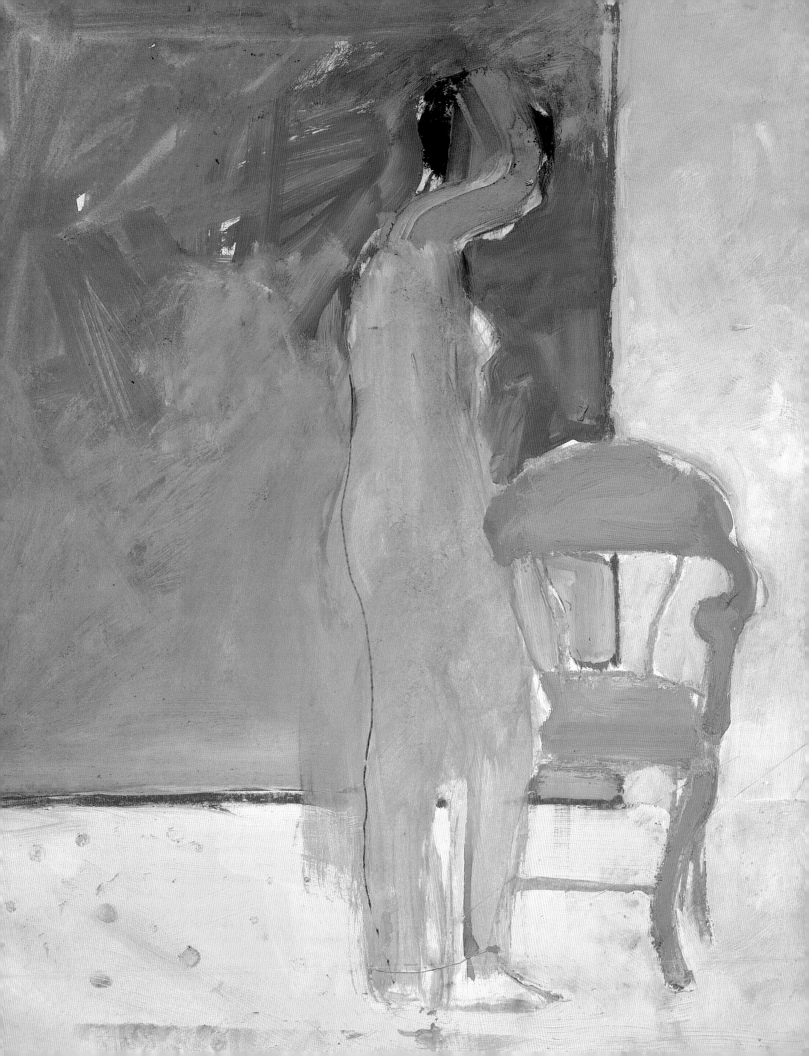

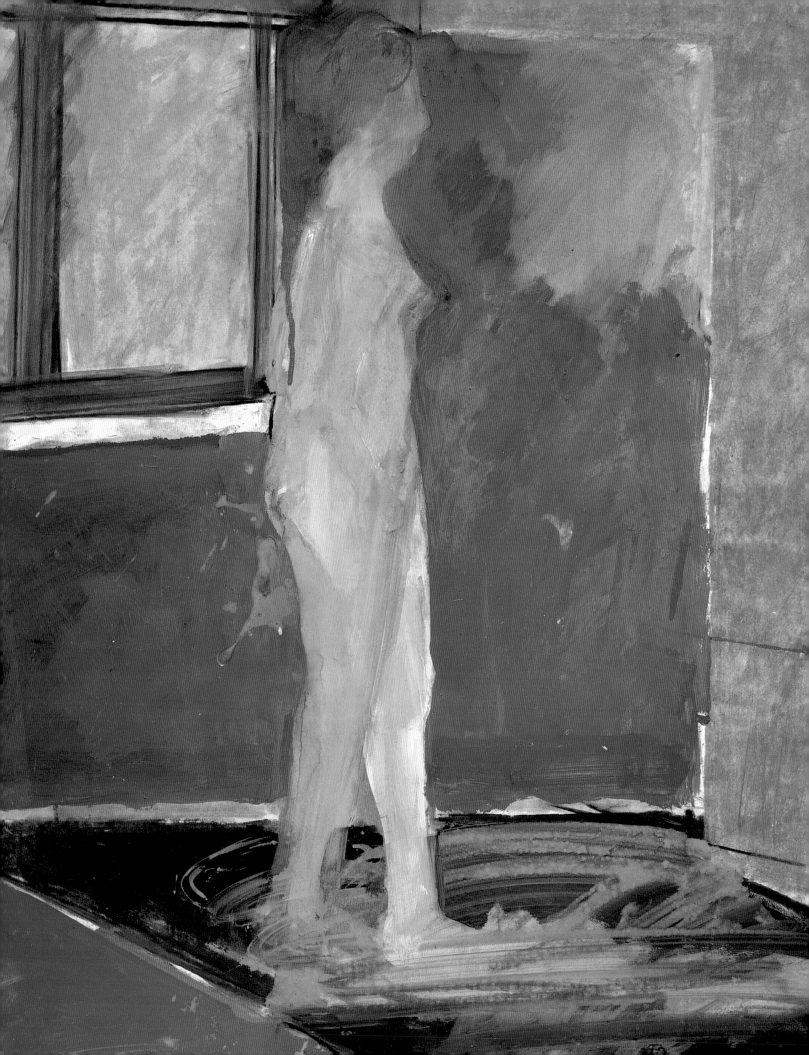

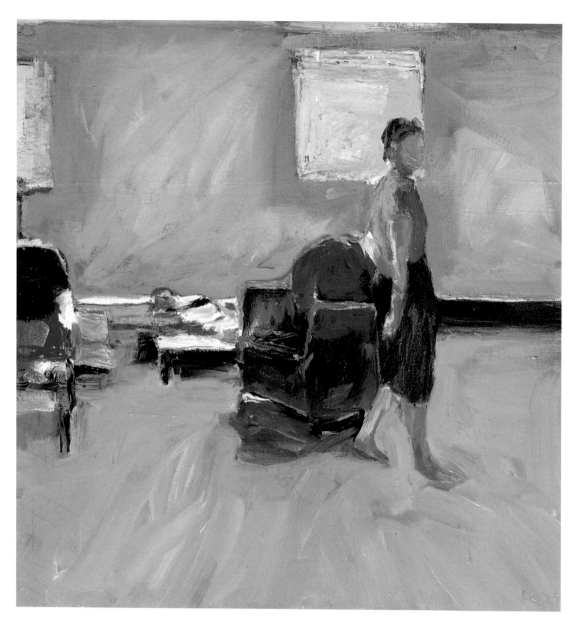

Untitled Figure Study No. 16 again denies volumetric or illusionistic prominence to the centrally posed model, as a broadly brushed gray tempera wash reduces its detail and mass. Instead, strong architectural elements prevail. Black and red floor planes, brown and blue walls, and a luminous orange double-pane window at the left give a strong interior feeling. A closed intimacy permeates, not unlike Diebenkorn's oil painting *Girl in a Room*, 1958. By comparison, however, Neri's work has curious sources of illumination, where the white ground radiating through the depicted wall and floor corners enlivens the scene. Diebenkorn's light logically flows in from the central window, pools upon the wall and floor, and glints across the tops of the chairs, which themselves cast shadows, even if the female figure mysteriously does not. Both Neri's painted paper and Diebenkorn's painted canvas retain an odd, suspended animation, hovering in time and place.

294. Richard Diebenkorn, *Girl in a Room*, 1958.

Opposite:
293. *Untitled Figure Study No. 16*, 1957.

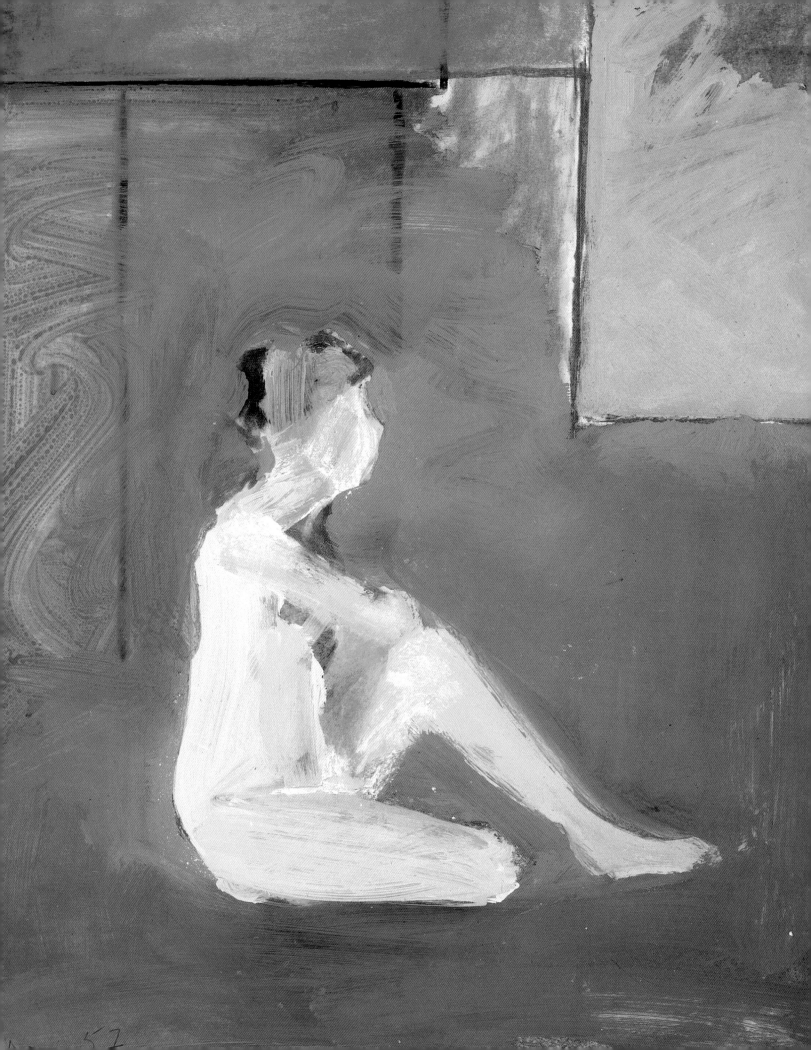

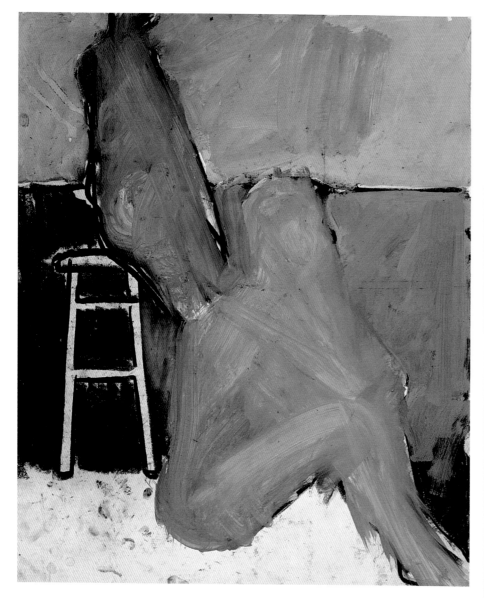

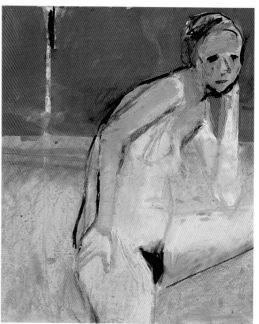

Untitled Figure Studies Nos. 5, 11, and *17* convey an unusual, disturbing sense of volume. Their ghostly seated cutout shapes are like thinly sliced specimens pinned to a visually flattened background of strong color zones. Again, an odd, hermetic nature prevails, allowing the energetic brushwork to become all the more evident, visually eating into the contours, or massing within and over them. Each element, therefore, takes on an imprecise dynamic.

Each of Neri's extant tempera and pastel figure studies has its own unusual palette. Ranging through pinks, blues, oranges, yellows, grays, browns, and purples, they appear as carefully considered chromatic exercises. Wet colors are swiped over dry colors, form edges are heightened by rich pastels. Most are single figures upon architectural constructed grounds of color planes that set an emotional and visual mood for the painted paper sheets.

Left:
296. *Untitled Figure Study
No. 17, 1957.*

Top right:
297. *Untitled Figure Study
No. 11, 1957.*

Bottom right:
298. *Untitled Figure Study No. 2,*
1957.

Opposite:
295. *Untitled Figure Study No. 5,*
1957.

165

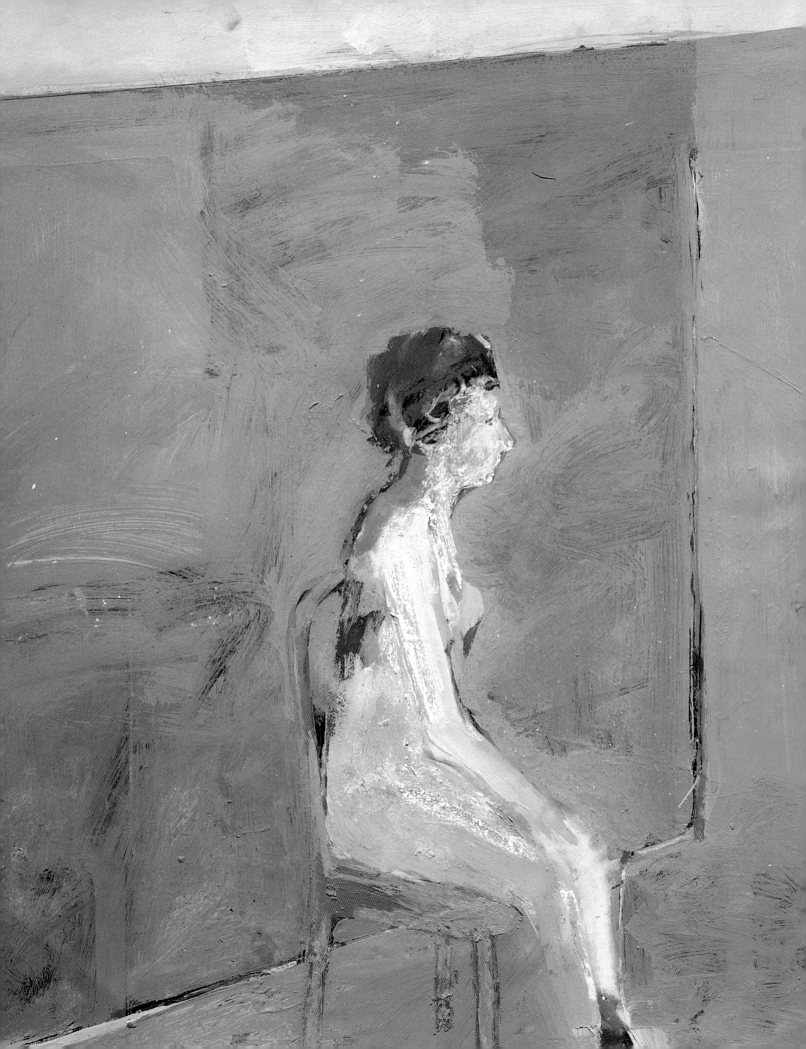

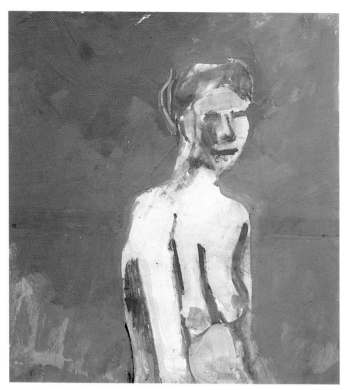

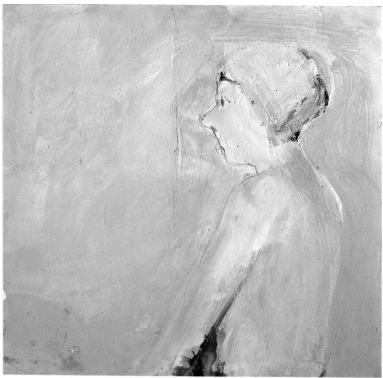

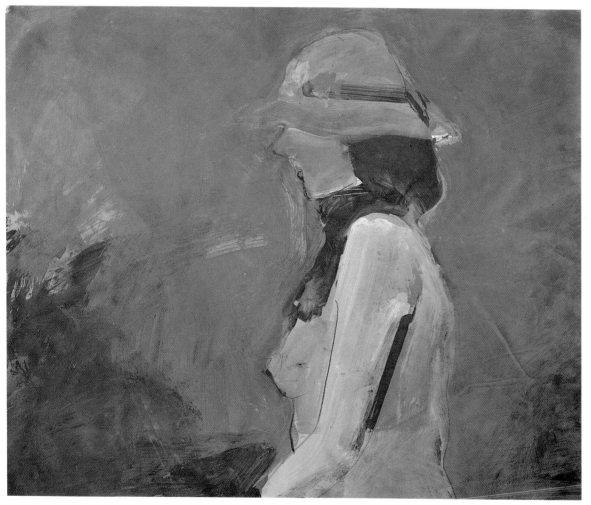

Top left:
300. *Untitled Figure Study
 No. 21, 1957.*

Top right:
301. *Untitled Figure Study
 No. 26, 1957.*

Bottom:
302. *Untitled Figure Study
 No. 25, 1957.*

Opposite:
299. *Untitled Figure Study
 No. 23, 1957.*

Following pages:
Left:
303. *Untitled Figure Study
 No. 4, 1957.*

Right:
304. *Untitled Figure Study
 No. 22, 1957.*

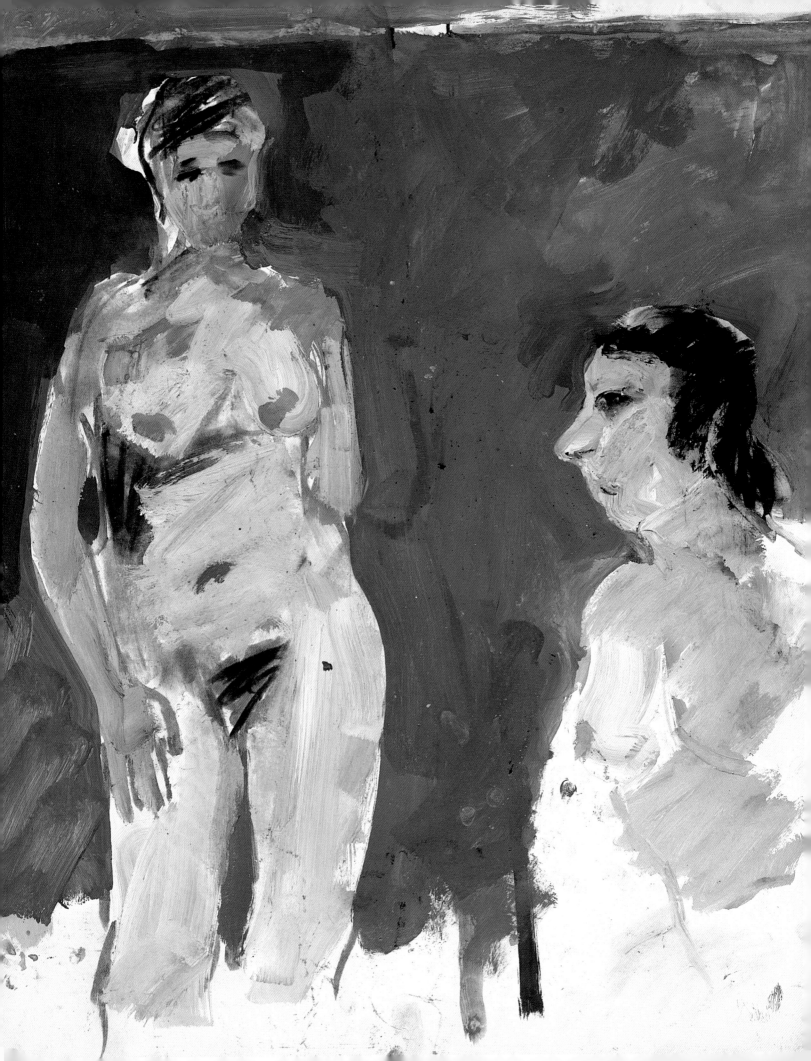

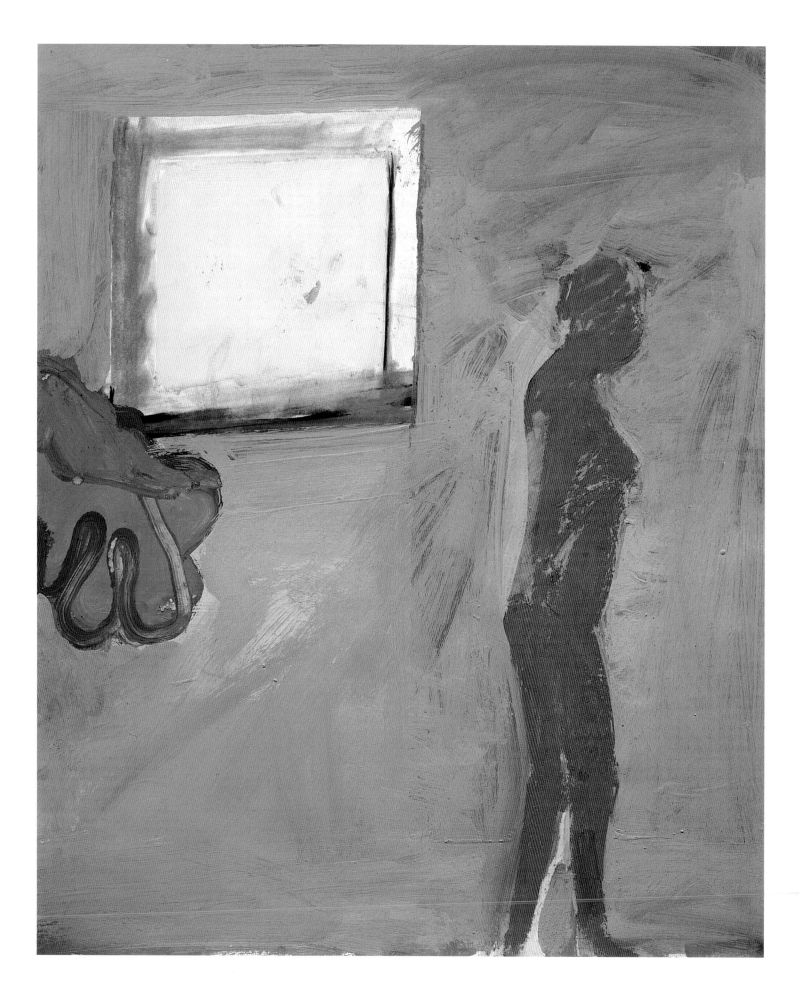

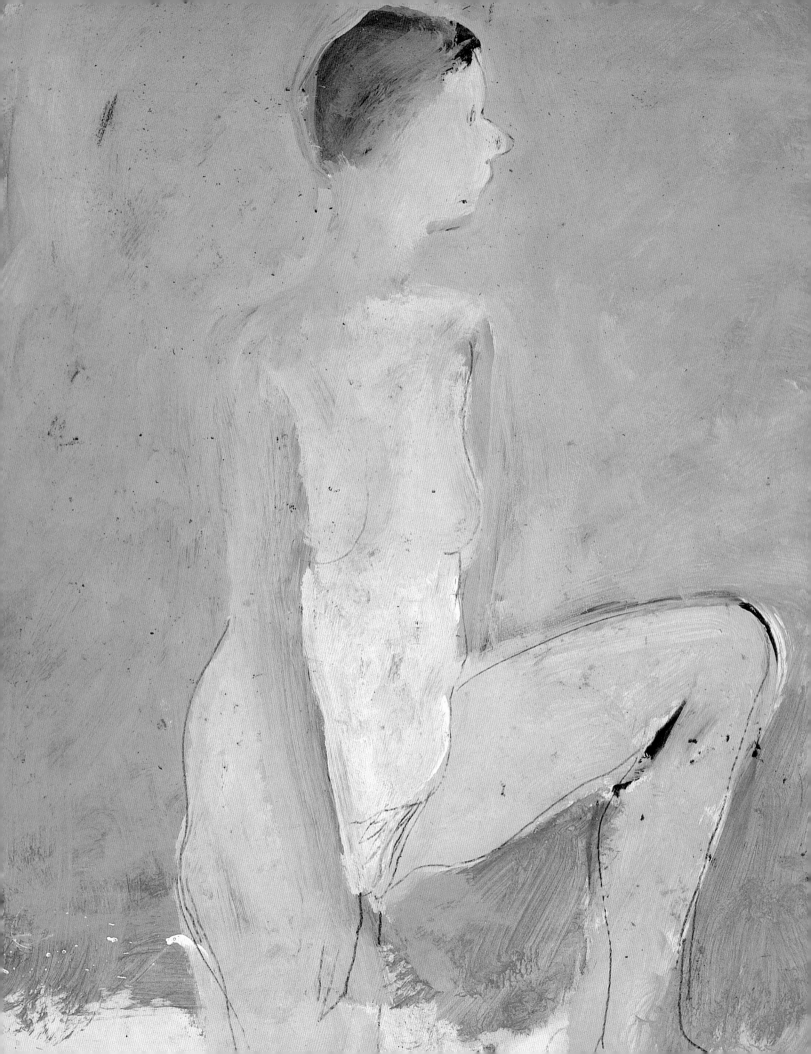

A recently discovered archival photograph shows a large painting of a model in a chair, her body partly composed by paper collage, set against the high "horizon" of a tipped-up floor meeting a clear wall. Probably unfinished, either by Neri or Joan Brown, this may be life-size, and points toward the monumental painting common among Bay Area artists, as well as Neri's subsequent figural sculpture. The generalized shape and its hierarchical, rational or formal (Apollonian) composition, as well as its aggressively shallow space, remain suggestive of Neri's early painted papers and, especially, his large earlier figural painting *Woman Bath*. This latter work, of cut and pasted red and orange oil and canvas elements, depicts an exceedingly tight segment of an awkwardly posed model.[10] Neri will appropriate this bather composition later in his Balthus-like paintings *Young Man Stealing* and Untitled, both of 1958 (figs. 323 and 324).

306. *Woman Bath*, 1955.

Opposite:
305. *Untitled Figure Study No. 1*, 1957.

A group of nine smaller tempera and graphite drawings reveals a more hedonist, erotic (Dionysian) side.[11] This series, titled *Ritual Dance* and dating from 1957–58, is made up of highly gestured, quick, painterly studies alluding to figures in frenetic abandon or self-gratification, perhaps in the out-of-doors. Their "ritual" is, decidedly, sexual foreplay. They also connect Cézanne's great *Bathers* to Rodin's nudes to Derain's fauve *L'Age d'or* to Matisse's *The Joy of Life*, 1905–06, and his 1930s Barnes Foundation *Dance*, perhaps all the way up to the Bischoff figures-in-landscape painting Neri illustrated in his *Untitled (Nude Model with Bischoff Painting)* (fig. 291).

Irregularly shaped, sometimes with torn paper edges, and executed in curious reddish iron earthtones, moss greens, and magentas, Neri's *Ritual Dance* painted papers appear as fragments of some imagined erotic Pompeian fresco or neolithic cave painting. They are rituals of mating, of feeling. The elongated figures, looking as if they are made of soft clay, tend to slide across the surface of the sheet, their contours reset by wavering pencil lines. Neri has pushed the paint around, freely blending zones in eccentric, nongeometrical ways. There are curious psychological and artistic powers in these intimate painted papers.

307. Henri Matisse, *The Joy of Life*, 1905–6.

Ritual Dance No. 16, for example, is the antithesis of the earlier structured figure studies. Thick paint has now been laid on ungrounded paper, with the floating, elongated body shape and color zones literally cut in by jagged, irregular graphite lines scoring the pigment. This carving into the paint creates a raw visual energy, especially as the compositional view is set slightly from above, tipped to the right, askew and slippery. Gone are the formal constructions of studio walls, floors, windows, chairs, or other "locking" devices. This *Ritual Dance* is in an indeterminable, dreamlike realm, an androgyne model's hand placed sexually. Treated in an informal, variant, expressive impressionism, this thirteen-inch-square painted paper loosens many of the boundaries of color, form, and content.

Ritual Dance No. 14 is more fragmentary, irregularly shaped by cut and torn edges, with the seated male model in profile, stretched from the top of the sheet to the bottom in a long S-curve. Dark brown encroaches on the torso and legs, capturing the form, one odd shape within another. The whites and pinks blend from flesh tone to seating surface, to a rectangle on the right to a band across the top of the sheet. It is a simple pictorial composition but a complex sculptural one, in which Neri, cutting with a pencil into a void of color, seems focused on allusions to some ancient mythic history.

308. *Ritual Dance No. 16,* 1957–58.

Top:
310. *Ritual Dance No. 13*,
 1957–58.

Bottom:
311. *Ritual Dance No. 20*,
 1957–58.

Opposite:
309. *Ritual Dance No. 14*,
 1957–58.

Top:
312. *Ritual Dance No. 10,*
 1957–58.

Bottom:
313. *Ritual Dance No. 17,*
 1957–58.

Ritual Dance No. 17, another "fragment," stages the thinly painted, deeply bending female model before a chair, its seat possibly draped with clothing. Yet the brushy soft lavender-and-green background and white highlights suggest the out-of-doors. Neri's visual contradictions in these small awkward moments add a sense of intrigue. The viewer is engaged in the curiosities of these dialogues: What is happening and why—especially in *Ritual Dance No. 5*, or other related drawings like *Woman Dressing for Kabuki I, Drawing 1*, and *Woman Dressing for Kabuki I, Drawing 3*?

314. *Ritual Dance No. 5*, 1957–58.

Following page:
Top left:
315. *Woman Dressing for Kabuki I, Drawing 1*, late 1950s.

Top right:
316. *Woman Dressing for Kabuki I, Drawing 2*, late 1950s.

Bottom left:
317. *Woman Dressing for Kabuki I, Drawing 3*, late 1950s.

Bottom right:
318. *Woman Dressing for Kabuki I, Drawing 4*, late 1950s.

woman Dressing for kabuki

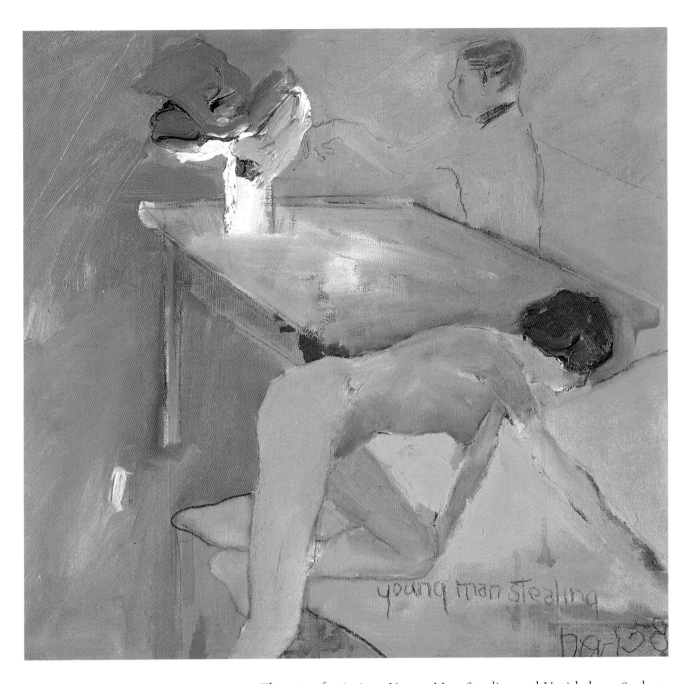

323. *Young Man Stealing*, 1958.

Previous page:
Top left:
319. *Woman Dressing for Kabuki II, Drawing 1*, late 1950s.

Top right:
320. *Woman Dressing for Kabuki II, Drawing 2*, late 1950s.

Bottom left:
321. *Woman Dressing for Kabuki II, Drawing 3*, late 1950s.

Bottom right:
322. *Woman Dressing for Kabuki II, Drawing 4*, late 1950s.

The pair of paintings *Young Man Stealing* and Untitled, 1958, close the period of Neri's overtly figural two-dimensional work and incorporate aspects of both groups of preceding drawings. They also remind us that Neri and his contemporaries were intensely interested in the properties and effects of painterly color, as demonstrated by virtually all the works in the landmark 1957 Oakland Art Museum exhibition "Contemporary Bay Area Figurative Painting."[12] Color was very much "in the air." The artists mixed influences of fauvism, expressionism, and abstract expressionism with the natural intensity of Bay Area light, a special light which makes forms visually alive.

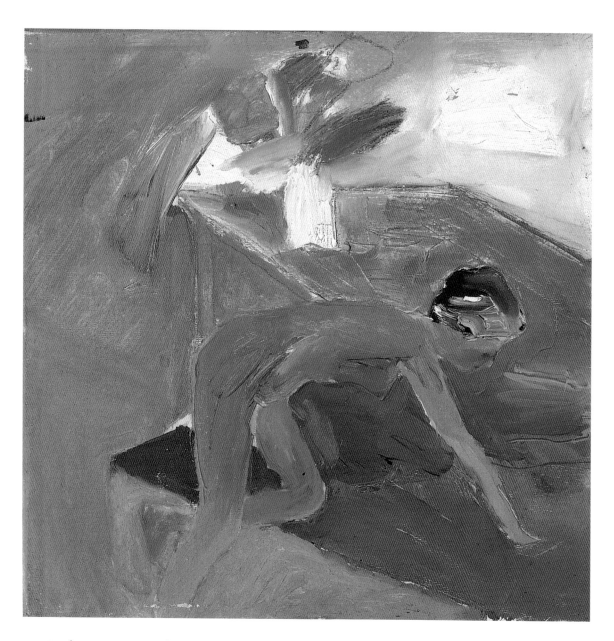

In these two particular paintings, highly colored in reds, yellows, and oranges, sculpted into with pencil points and brush handles, and scraped thin with a palette knife, the square of each of the picture planes is counteracted by the V-shapes of a platform and table, the crouching model, and a thickly painted still life. Elsewhere, paint is thinly brushed on or scrubbed into the linen. Neri's handling of the paint, while attempting some bravura, remains illustrative, filling the compositional zones. What is the young man stealing? His hand is near what looks to be a vase of flowers, given the related element in the other painting and another group of still life sketches (figs. 325–28). Some observers have suggested it may be a purse, but the form is most especially like Neri's contemporary abstract cardboard sculptures or bent wooden tree forms.[13] Regardless, in this furtive painting, the artist creates a cloaked message, ambivalent and intentionally obscure.

324. Untitled, 1958.

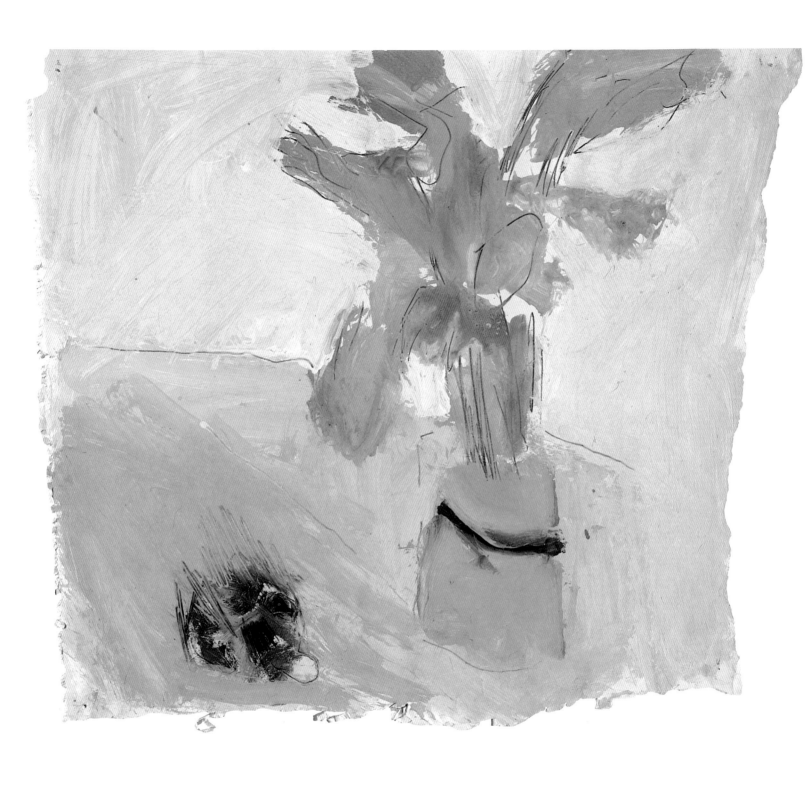

325. *Floral Study No. 1, 1957.*

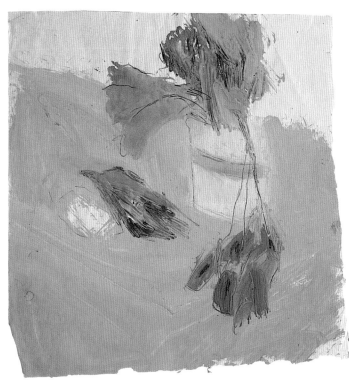

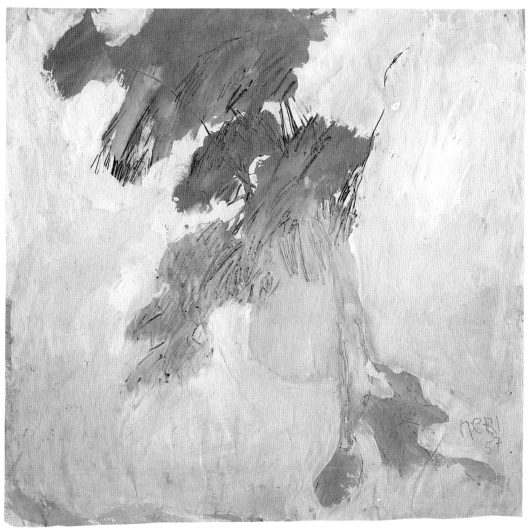

Top left:
326. *Floral Study No. 2*, 1957.

Top right:
327. *Floral Study No. 3*, 1957.

Bottom:
328. *Floral Study No. 4*, 1957.

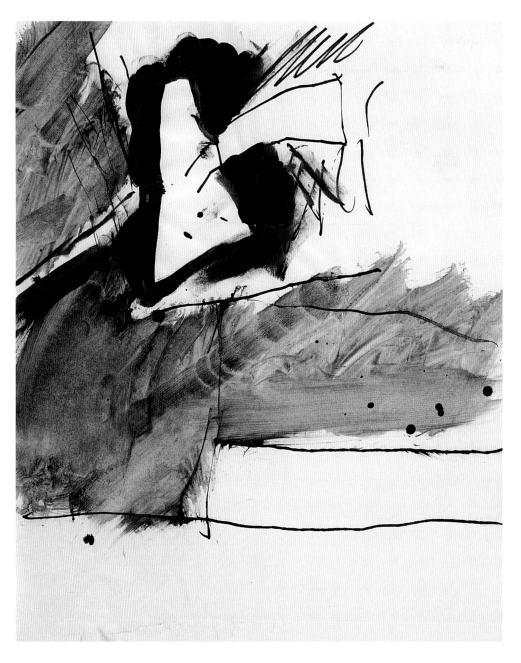

During the summer of 1958, Neri left Bischoff's class when the G.I. benefits that supported his education expired. Given Neri's acknowledged "romantic" personality, the shift was probably inevitable, and this new freedom opened a period of eighteen months where his drawings, paintings, and sculpture (notably his *Loops*)[14] shifted to a dominant abstraction. The artist has said that his intentional and periodic turns to abstraction were "an interruption, to clear my mind."[15] The subsequent experimental works engaged aspects of gestural abstract expressionism, constructivism, and the independent issues of form, color, and the lushness of pure materials. These freer sketches and paintings carry forward artistic tensions, wit, anger, a funk neo-dada confrontation, jazz influences, improvisation, and a sense of counterauthoritarian expression.

329. *Sketches for Painting Series No. 6, 1958.*

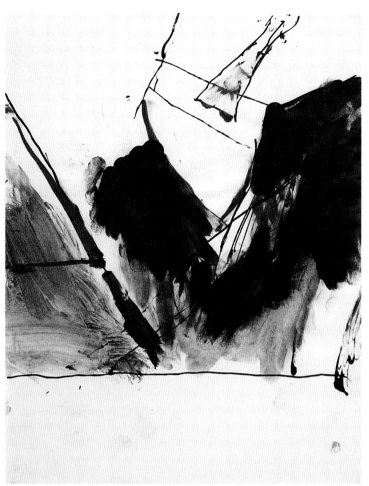
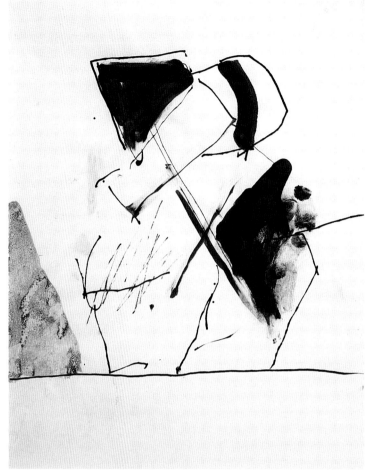

There are at least forty independent drawings dating from 1958–59 titled *Sketches for Painting Series* and *Pastel Studies for Painting Series*, of which approximately half are monochrome ink and graphite. In the *Sketches for Painting Series*, some of the medium is applied in smudges and prints by the artist's fingers. A stick, brush, and pen are also used to create other lines (figs. 329–31). The *Pastel Studies for Painting Series* are highly colored mixed-media acrylics and pastels (figs. 332–35, 338–39) that relate to a group of four large and one small untitled abstract paintings, which probably date from the same period (figs. 340–44).

The preparatory and study sketches are usually eight and one half by eleven inches each, with a few exceptions, and show the artist manipulating a wide range of eccentric geometrical shapes and colors, ink washes, lines, and tonalities. These may very well derive from Neri's mid-1950s free-form assemblage sculptures and constructions, but here the artistic obligation is to flatten them onto a visual plane. In most cases, Neri floats the elements in space, defining neither up nor down. Rather, it is the strong lines or shapes which give the sheets their visual direction. While not deriving from a series of coherent sketchbooks, the sum of these drawings nonetheless gives an energetic sequence of artistic trial and error and highly focused visual thinking.

Left:
330. *Sketches for Painting Series No. 8*, 1958.

Right:
331. *Sketches for Painting Series No. 9*, 1958.

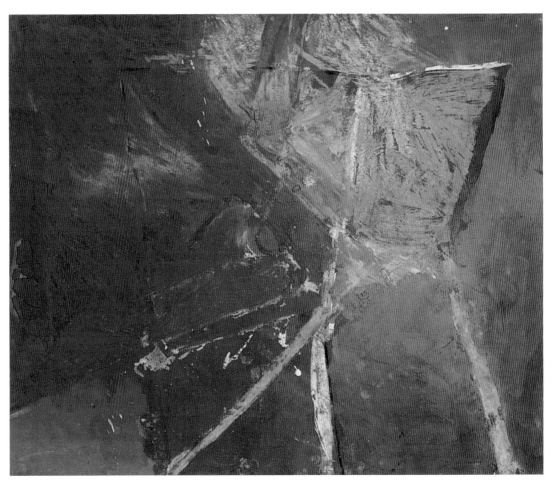

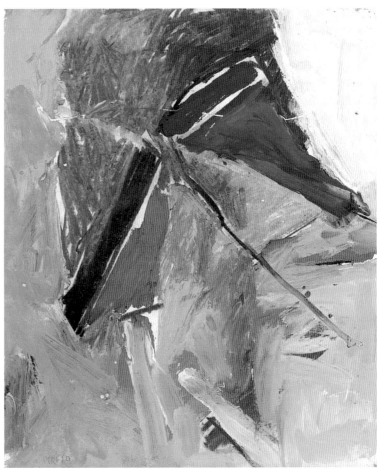

Top:
332. *Pastel Studies for Painting
 Series No. 7*, c. 1958–60.

Bottom:
333. *Pastel Studies for Painting
 Series No. 4*, c. 1958–60.

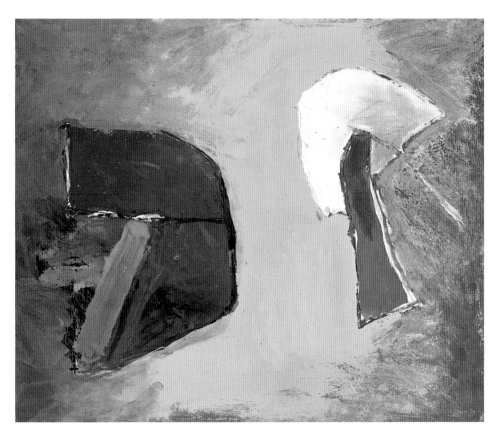

Top:
334. *Pastel Studies for Painting
 Series No. 14*, c. 1958–60.

Bottom:
335. *Pastel Studies for Painting
 Series No. 18*, c. 1958–60.

Top left:
336. *Sketches for Painting Series No. 2*, 1958.

Top right:
337. *Sketches for Painting Series No. 17*, 1958.

Bottom:
338. *Pastel Studies for Painting Series No. 2*, c. 1958–60.

Opposite:
339. *Pastel Studies for Painting Series No. 5*, c. 1958–60.

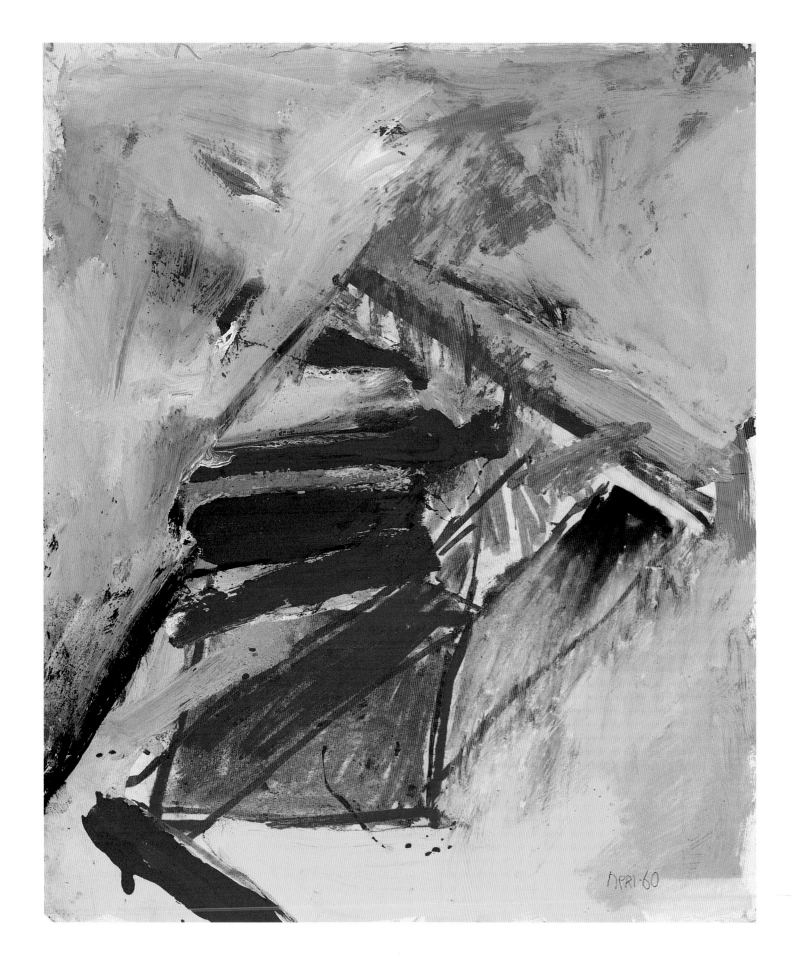

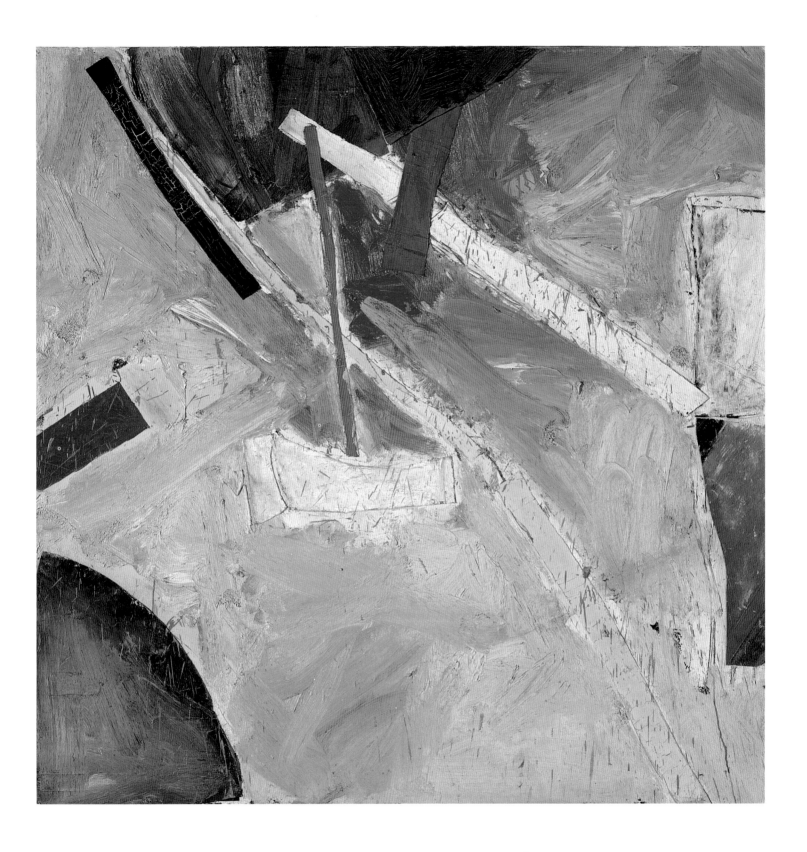

340. *Collage Painting No. 3,*
1958–59.

As previously noted, Neri habitually turns to abstraction to force new issues before returning to his hybrid figurative art. These painterly sketches show him analyzing isolated shapes, both curvilinear and rectilinear, and assessing the role played by nonillustrative color. The resulting oil paintings further exploit the very physical, material aspects of thick pigment and cut and pasted collage canvas elements, operating outside any aspiration or requirement for illusionism.

Neri created the four large untitled paintings to which these sketches relate through a direct, inherently sculptural process: he cut out elements of pure painted color, not unlike Matisse making his own gouache decoupées. Neri then collaged these strong "color cuttings" onto an abstractly painted ground, frequently repainting around the collaged parts, splashing over their edges, overlapping and adjusting them in this brusque process. Parts of these resulting nonobjective paintings stir memories of Willem de Kooning's contemporary gestural abstract landscapes, the hard-edged shapes of Ad Reinhardt and Stuart Davis, funk assemblages, and Hassel Smith's works. Further, in Oliveira's canvases Neri could see an energizing freedom and expressiveness, a manipulation of the paint medium,[16] especially in the way he laid thick wet paint on the canvas.[17] An interesting relation concerns the 1959 oil paintings and cut-paper collages of Joan Brown (fig. 342).

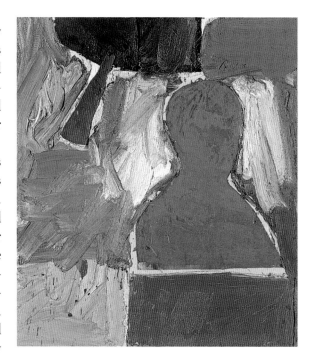

Brown, his companion in 1958, and later his wife, made abstract paper collages but did not transfer them directly onto canvas. Rather, she built up remarkably thick, slablike layerings of paint, enjoying the physical exuberance of applying the oil paint, "sculpting" it.[18] Neri's large untitled paintings employed abstract shapes but, as direct collages, they were more crudely cut and blatantly improvised. His emphasis seemed to be less about the beauty of paint and more about the vertigo produced by large, flat, painted color cuttings floating upon indeterminate fields, like some free-form, dissembled cubist collage.[19]

One of the largest and most complex of these paintings is *Collage Painting No. 1* (fig. 343). It presents a diagrammatic, exploded view focused on the impact of surface and color. Cut canvas parts are dispersed architectonically over a thick oil ground. Visually lighter elements are mired in heavily brushed paint. Their hard edges of flat red, yellow, blue, black, and brown contrast with the modulated areas of mixed greens, reds, and tans. Contemporary drawings related to this and his other untitled cut-color collage paintings can be found in his *Sketches for Painting Series, Pastel Studies for Painting Series* and various *Clipper Sketchbook* sheets, where geometric sculptural elements are set upon broadly executed backgrounds, contrasting structure to impression, local shape to generalized atmosphere.

341. *Collage Painting No. 5,* 1958–59.

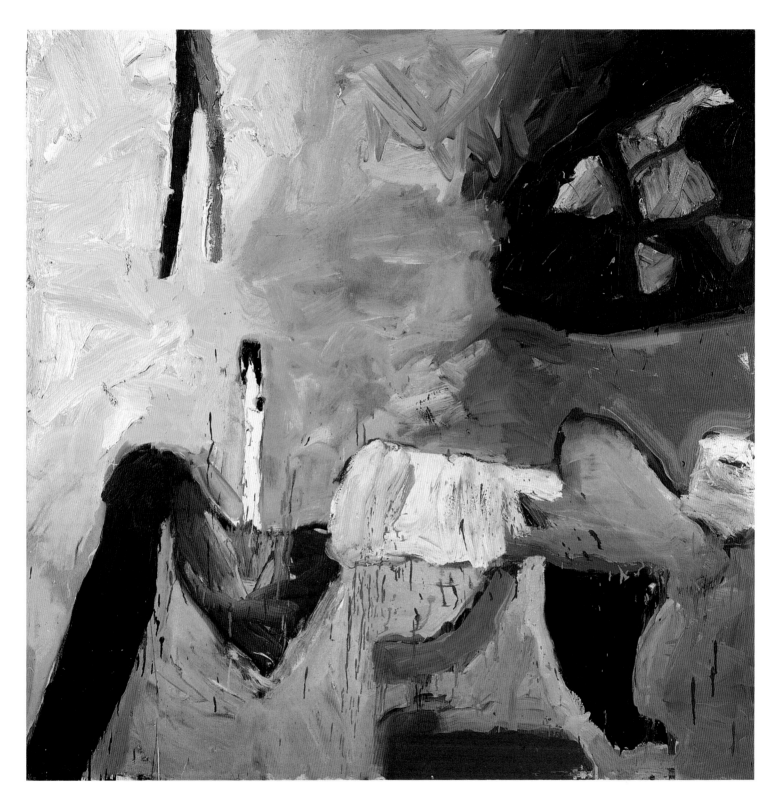

342. Joan Brown, *Swimming Party and Bicycle Ride*, 1959.

Opposite:
343. *Collage Painting No. 1,* 1958–59.

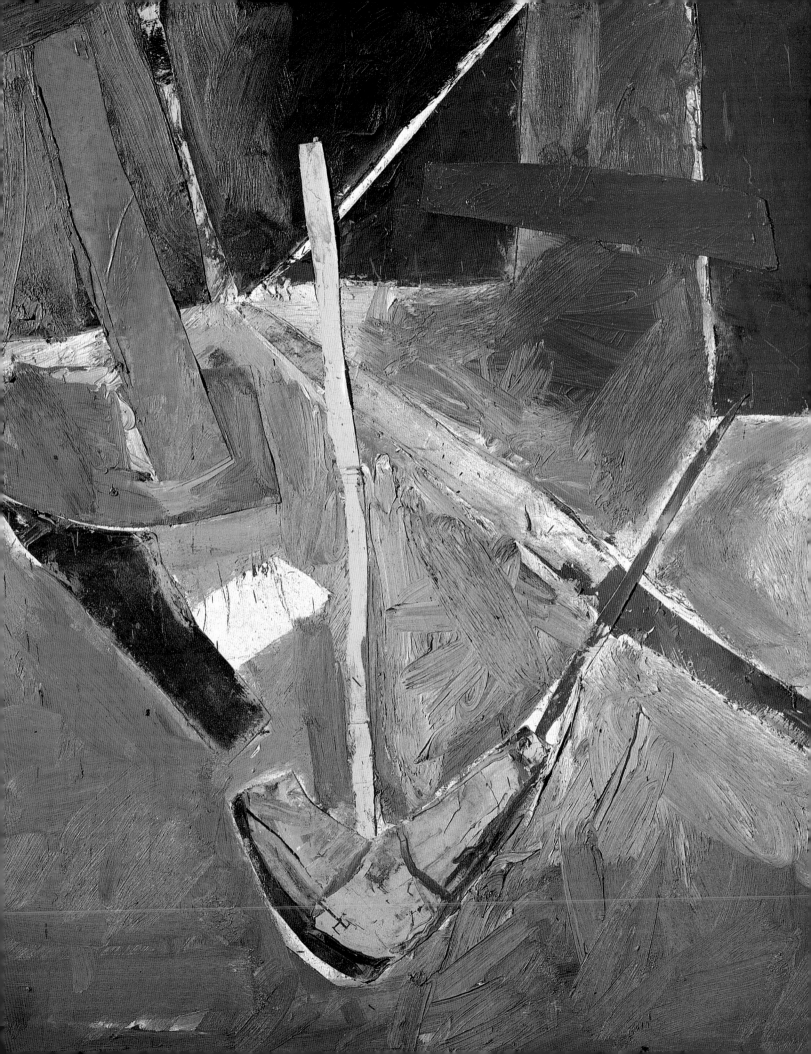

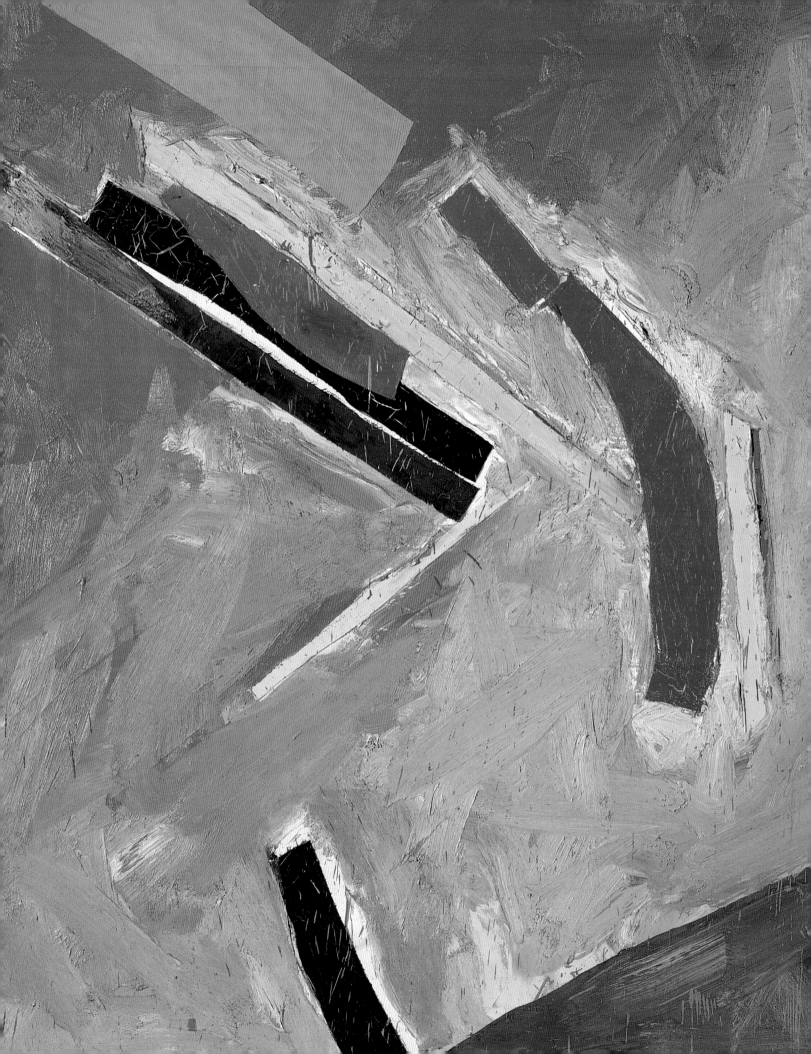

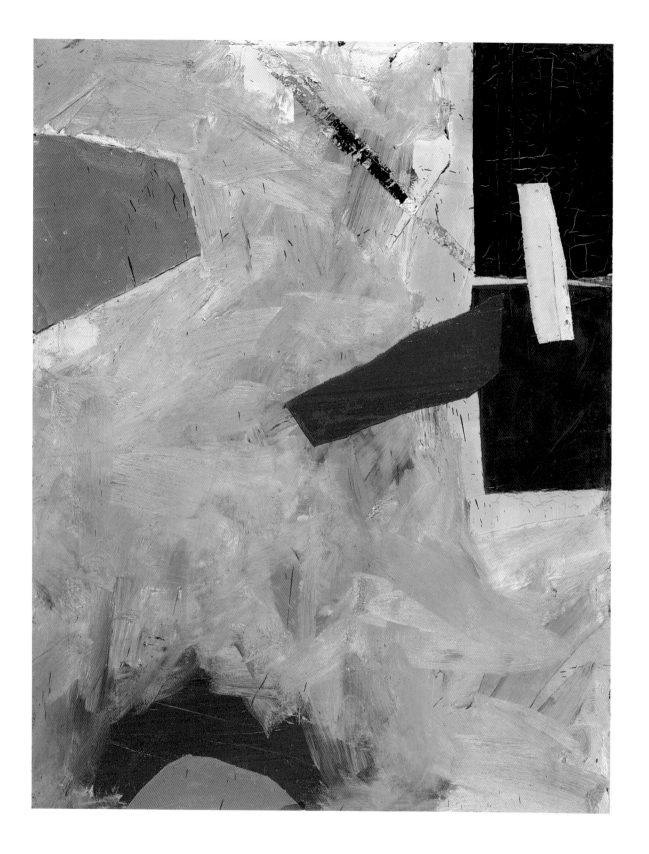

345. *Collage Painting No. 4,*
1958–59.

Opposite:
344. *Collage Painting No. 2,*
1958–59.

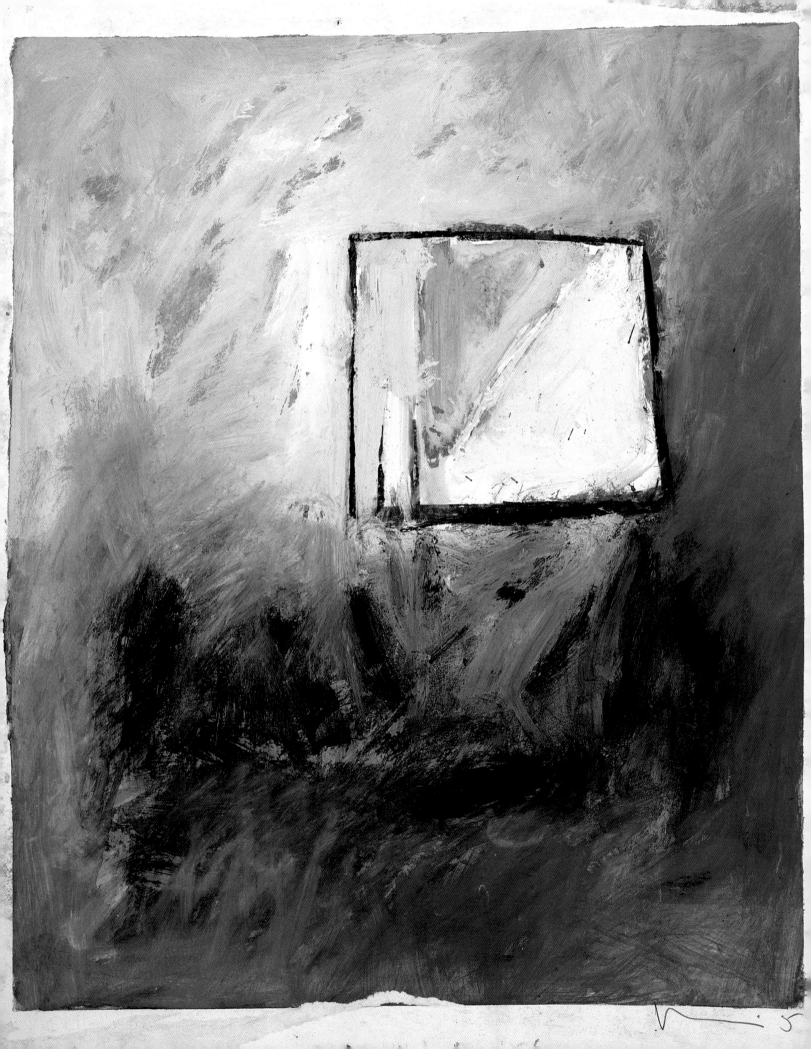

The final body of paintings from this period includes Neri's *Window Series*, of which at least nineteen, plus nine related drawings, are extant. Each work is decidedly eccentric: some sort of rectangular or square "window" form is shown, floating variously on thick and thin skins of pigment.[20] These are more purely paintings than pictures. There is little roomlike structure or illusionism. It is as if Neri decided to mix the broad artistic window concepts of his fellow Bay Area figurative artists with the nonobjective paint handling of artists in New York (Hofmann, Rothko, Philip Guston, Jack Tworkov) and California (Still, Lobdell, Smith, Jay DeFeo, among others).

Some of Neri's window forms appear to let light in, as brighter pigments are applied nearby, but there are no illusionistic views out. Some other windows are virtually submerged in thick grounding paint. Only by reading the brushstrokes can one see their trace. Various others are shimmering, impressionistic evocations. Neri approaches the notion of a window and its long history in art,[21] but he subverts and derails our expectations. It is as if he wants to prove he can do a classical "window painting," *pace* Matisse and Diebenkorn, but twists it to an artistically distorted and very personal point. Almost all are executed in disturbing, odd, almost ugly mixes of colors. The paintings are neither seductive nor intentionally beautiful. While they seem to start out being about a window, Neri then changes the colors, shapes, sizes, and orientations, denying the subject matter, trying for something else. This contrary search for the "something else" is quite like all the rest of Neri's work. For example, his sculptures will begin whole but they end up deeply carved away, fragmented, changed into personal, discontented glimpses of their point of origin.

Several of Neri's windows may also refer to that ubiquitous contemporary device, the television—our own electronic window. But Neri's are not on a broadcast channel, they are screens flooded with overloading, luminous static.[22] In a Beat-generation reactionary position, this artist denies access or communication. Formerly, such windows marked boundaries between private, interior spaces and public, exterior ones. If the window format was the same as the painting edges, then it became the same, a portable sculptural penetration of a wall surface. If the depicted view through was blank, it became a mirror or mystery. Open or closed, the implied perspectival aperture created a sense of place, scale, and habitation. Neri's windows hover ambivalently, frustrating any and all such localization.

Further, most of these window paintings have a very shallow visual appearance and don't give a secure interior or private studio feeling. They create the effect, rather, of an exterior wall pierced by a closed window. This makes the viewer an outsider. It is also a metaphor for Neri, the outsider artist, being outside the previous generation of insiders (Diebenkorn, Park, Bischoff, and others), either closed off or having left on his own.

Opposite:
346. *Drawing for Window Series No. 5*, 1958.

197

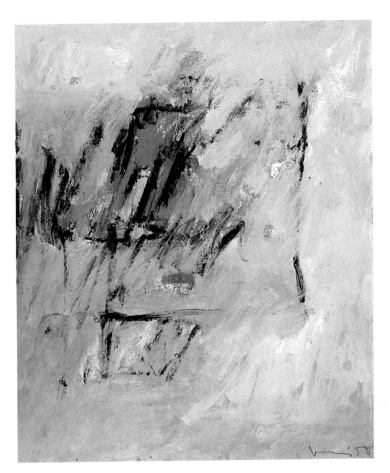

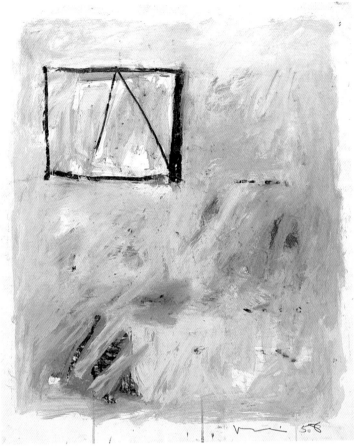

These works can be divided formally into three groups. The grouping may imply a dating sequence, but except in one case, dates cannot be confirmed. The current numeration in their titles is not sequential, but rather an accounting method of stylistic groupings: five of the oil paintings have a clearly geometrical bias *(Nos. 10, 12–15)*; thirteen are much more lyrically expressive or of a softer focus *(Nos. 1, 2, 4, 6–9, 11, 16–20)*; and two have dominant, thick slabs of pigment and very high graphic energy *(Nos. 3 and 5)*. The nine extant window drawings can also be arranged along related stylistic and interpretive lines.

The only reliably dated work in this group is *Window Series No. 12* (fig. 356), in which "Neri 58" is scored into what was the still-wet paint surface. The central area of thick, mixed gray and pink oils is slathered on with a broad blade, bounded by a monolithic yellow zone on the right. Odd slices, implied room shapes, enter from the top. The "open" area of the "window" is more visually dense than the surrounding "wall," unless we place ourselves on the more luminous outside, looking in. Should that be the case, a general order returns to this small work.

Left:
347. *Drawing for Window Series No. 2*, 1958.

Right:
348. *Drawing for Window Series No. 6*, 1958.

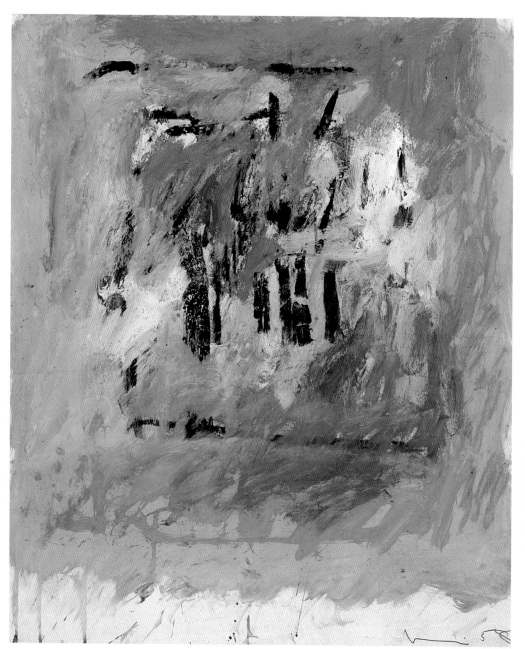

Left:
349. *Drawing for Window Series No. 7*, 1958.

Top right:
350. *Drawing for Window Series No. 10*, 1958.

Bottom right:
351. *Drawing for Window Series No. 11*, 1958.

Following pages:
Left:
352. *Drawing for Window Series No. 1*, 1958.

Right:
353. *Drawing for Window Series No. 8*, 1958.

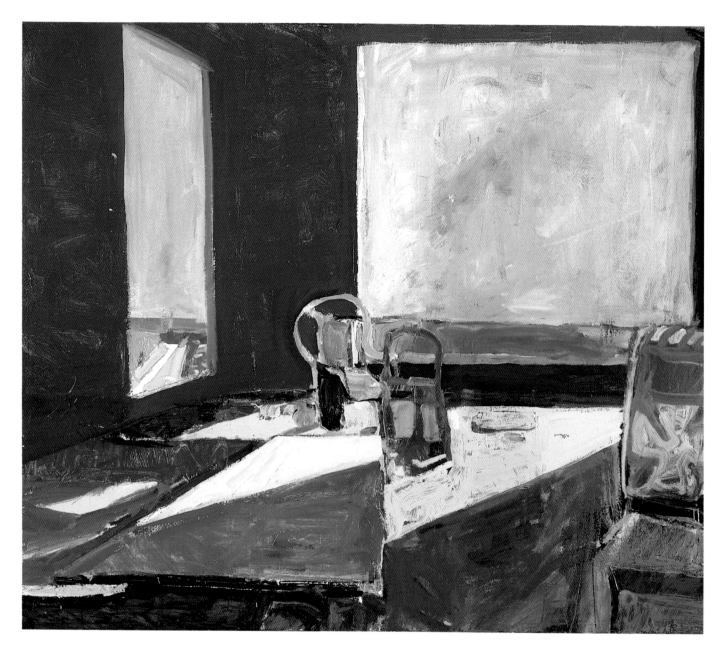

The larger *Window Series No. 10* again reverses the play of the compositional window rectangle against the implied wall, especially when compared to Richard Diebenkorn's striking *Interior with View of the Ocean*, 1957. Diebenkorn's depicted square window opens aggressively back to a sky blue space, allowing bright sunlight to enter in on a sharp diagonal. Neri's window is dark gray, black, and blue, making an odd darkness more reminiscent of Matisse's *French Window at Collioure*, 1914, where saturated black metaphorically replaces light, absorbing all color in a profound denial of expectation.[23] Neri's irregular point of muted yellow, mixed with blue and green, seems to bounce light up to the upper left corner of the canvas, but with none of the sharp brilliance evident in Diebenkorn's painting.

355. Richard Diebenkorn, *Interior with View of the Ocean*, 1957.

Opposite:
354. *Window Series No. 10*, 1958–59.

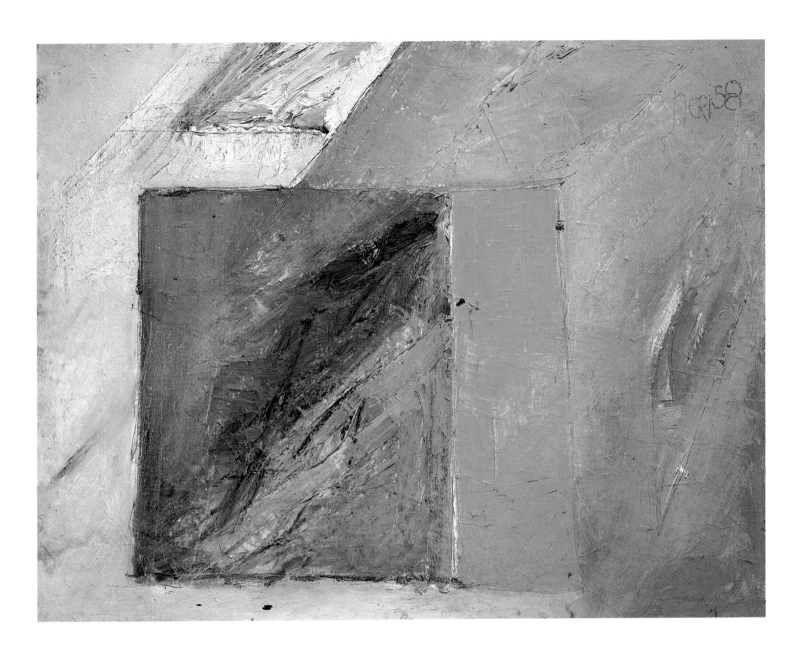

356. *Window Series No. 12, 1958.*

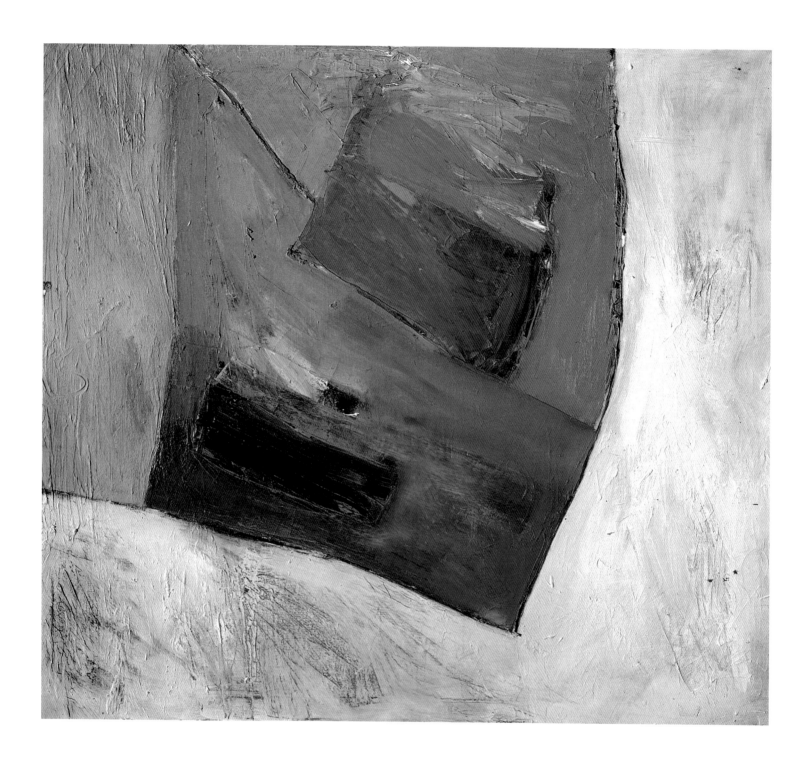

357. *Window Series No. 14, 1958.*

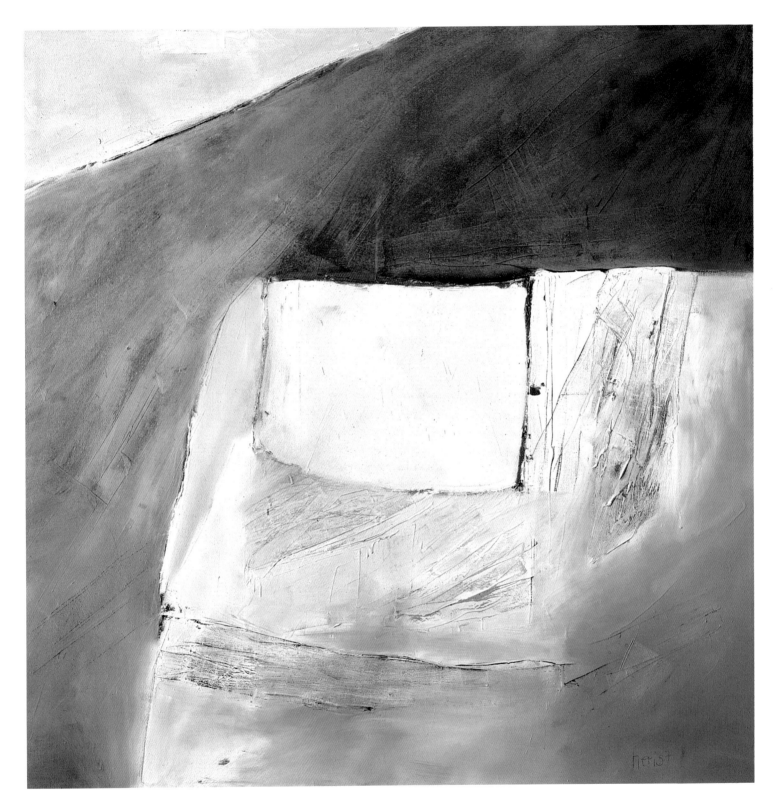

358. *Window Series No. 15,*
 1957.

Opposite:
359. *Window Series No. 1,*
 1958–59.

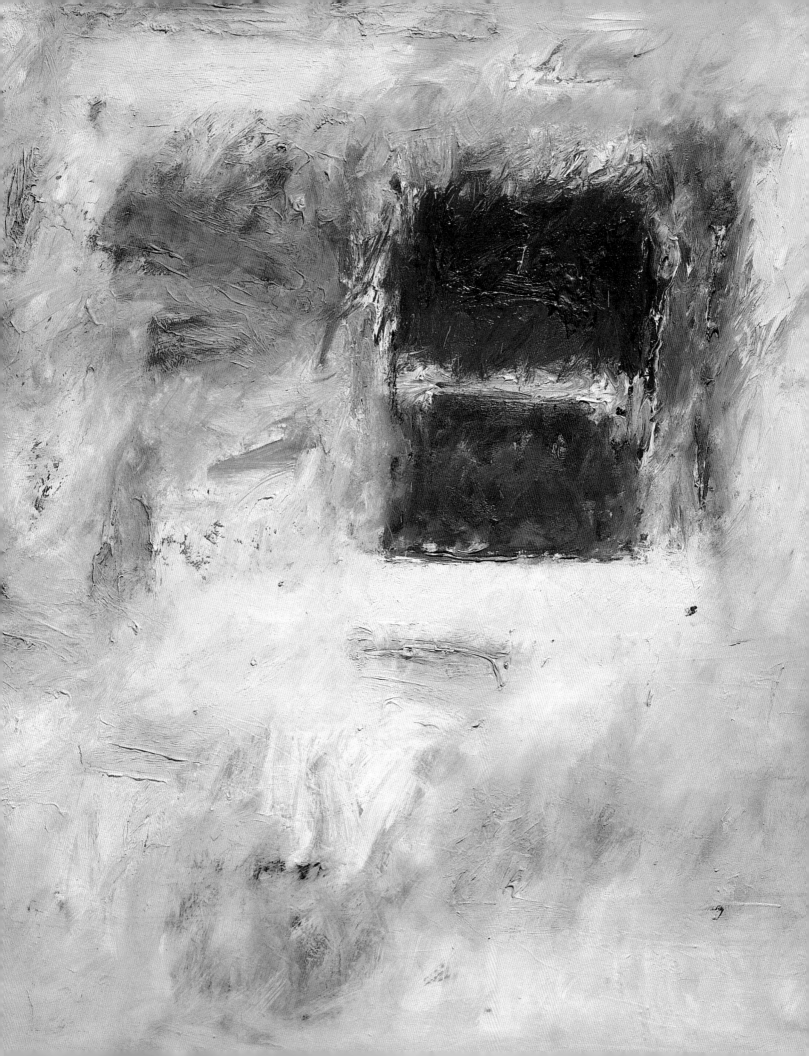

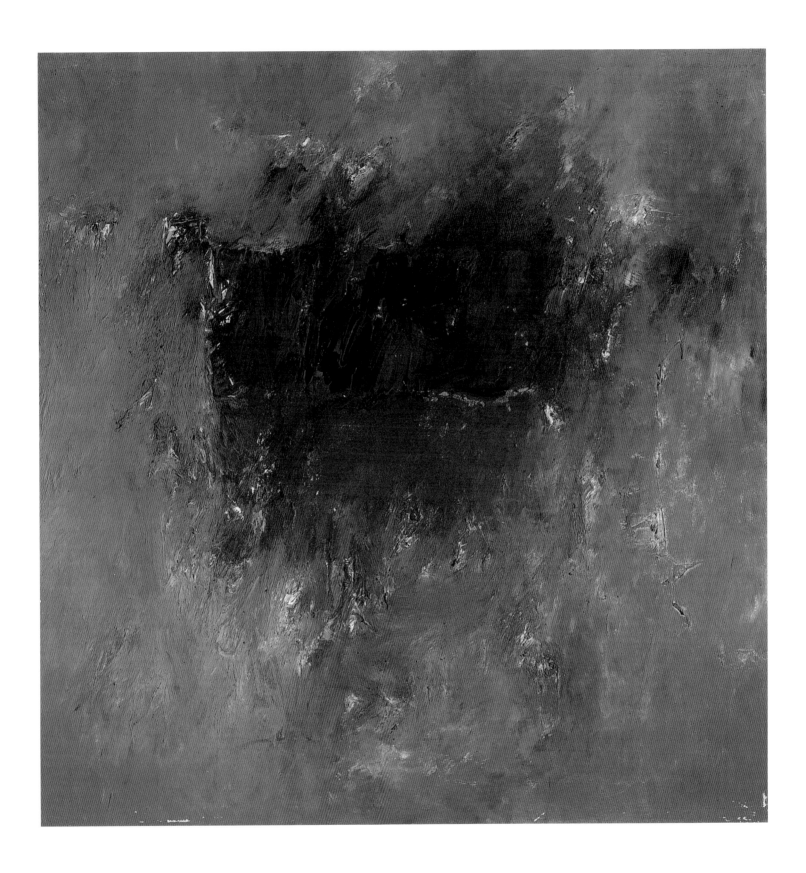

360. *Window Series No. 2,*
1958–59.

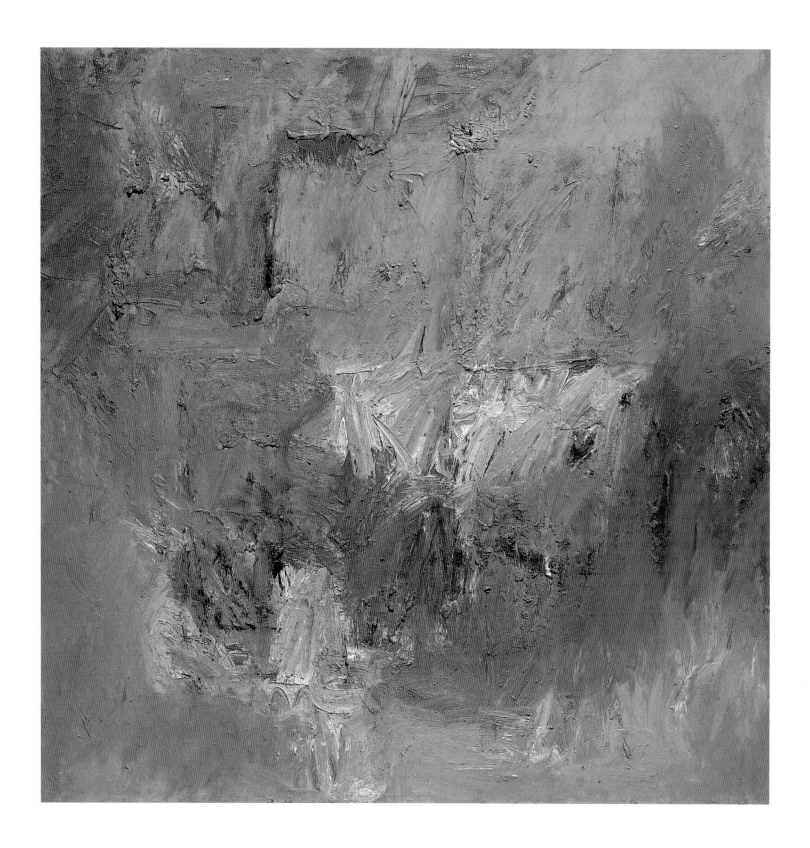

361. *Window Series No. 4,*
1958–59.

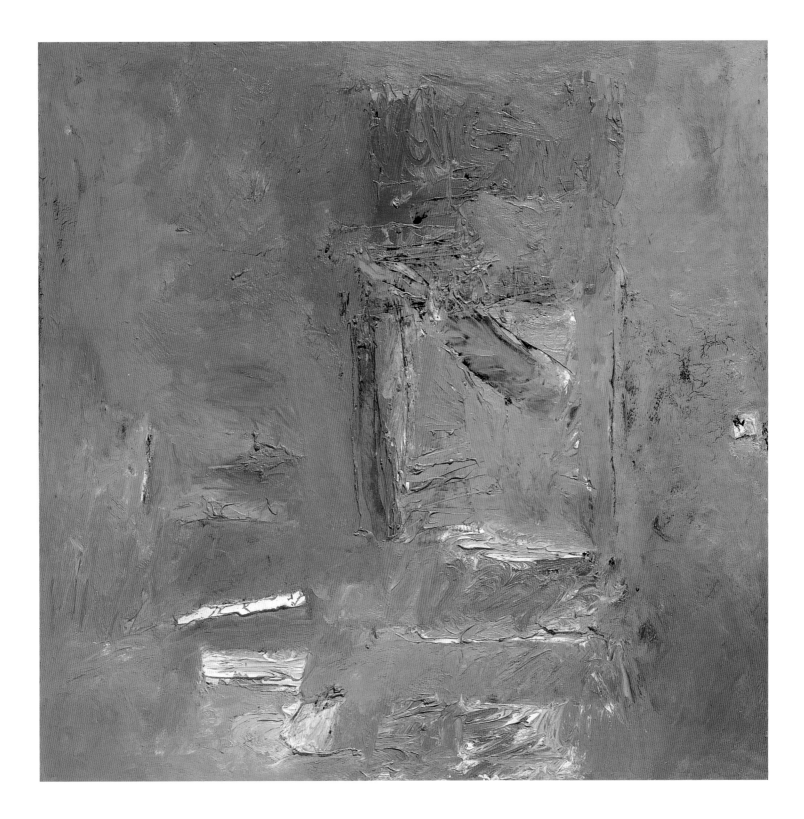

362. *Window Series No. 6,*
 1958–59.

Opposite:
363. *Window Series No. 7,*
 1958–59.

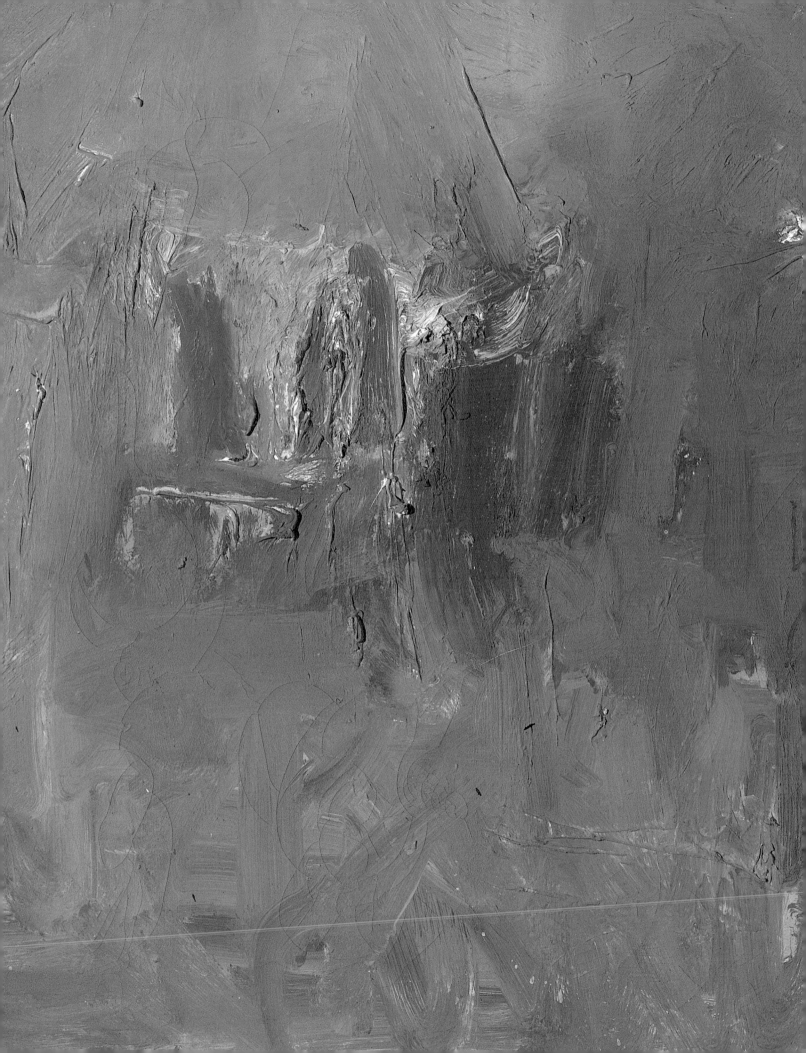

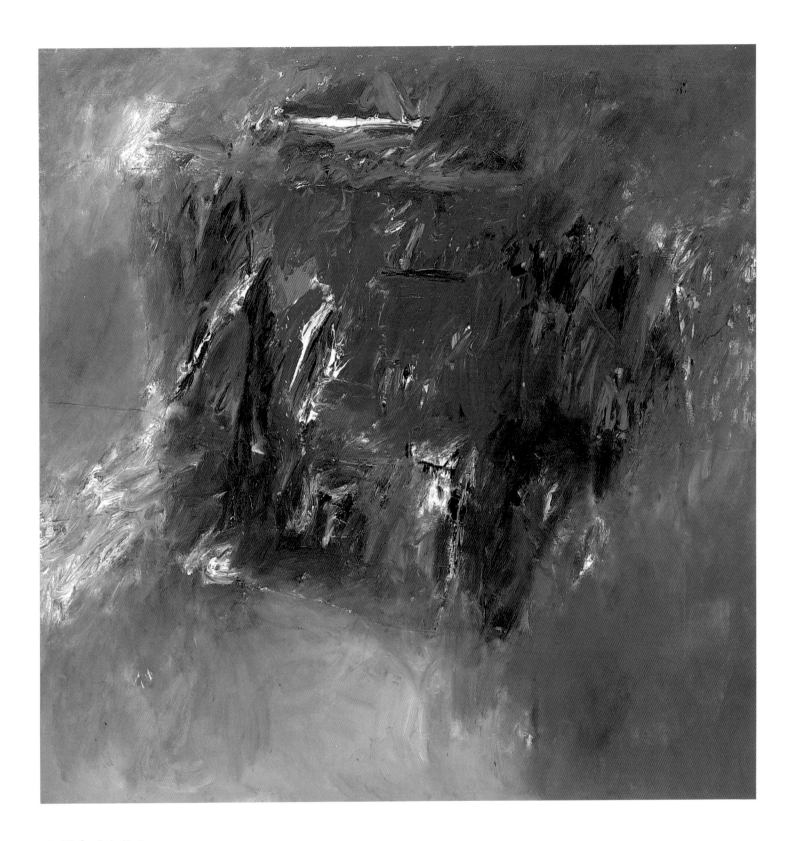

364. *Window Series No. 8,* 1959.

Opposite:
365. *Window Series No. 11,*
 1959.

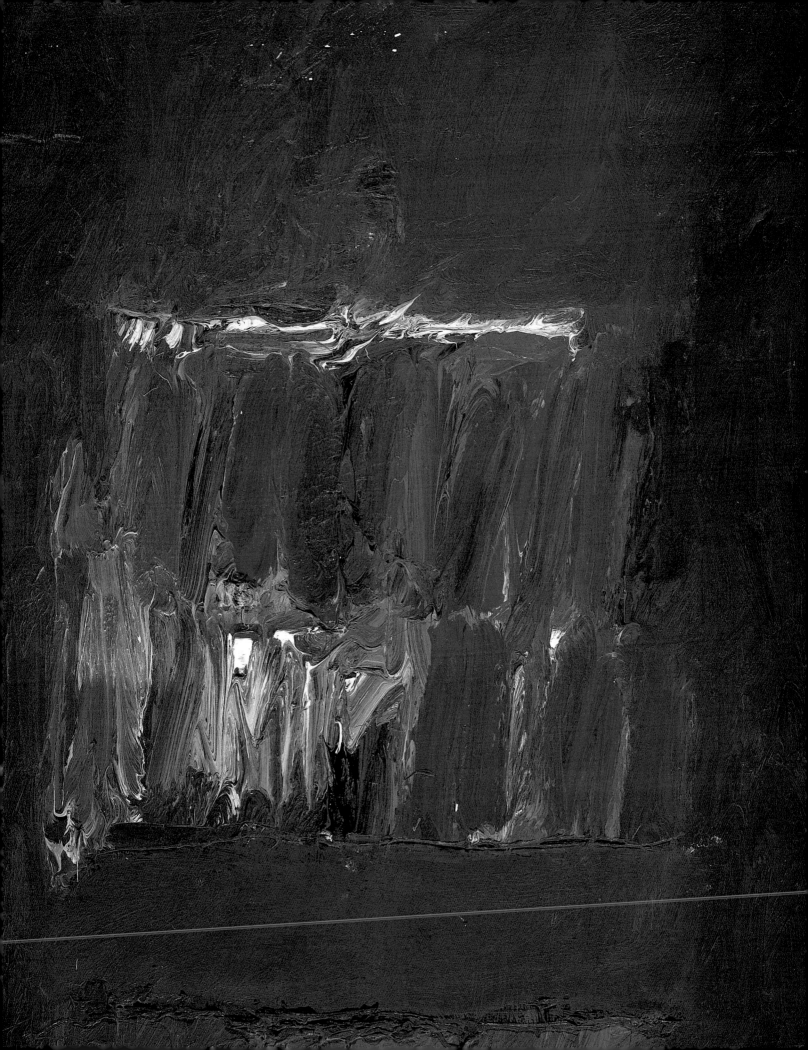

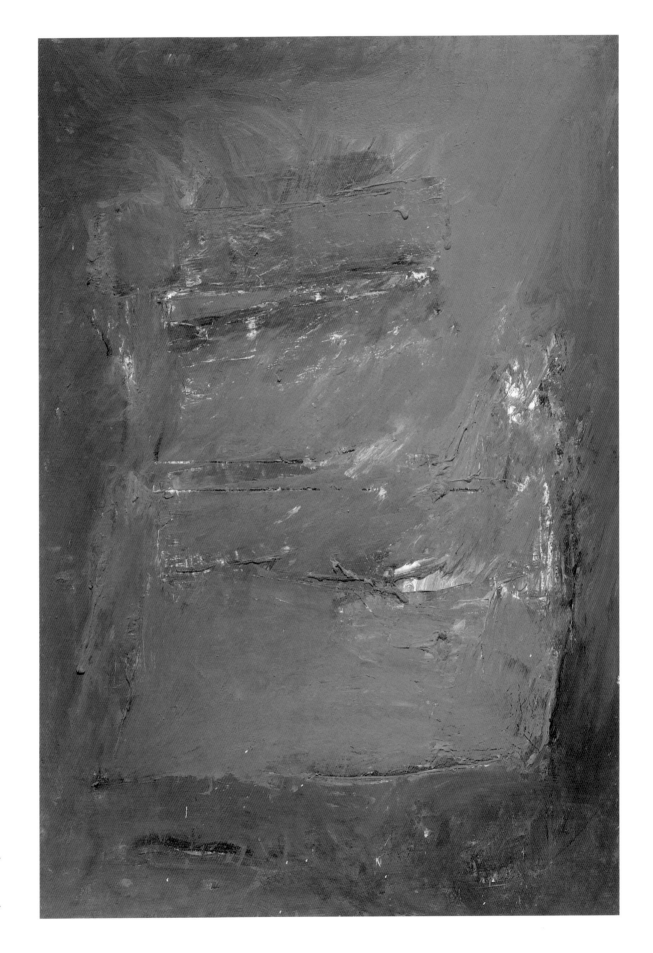

366. *Window Series No. 17*, 1958–59.

Opposite:
367. *Window Series No. 20*, 1958–59.

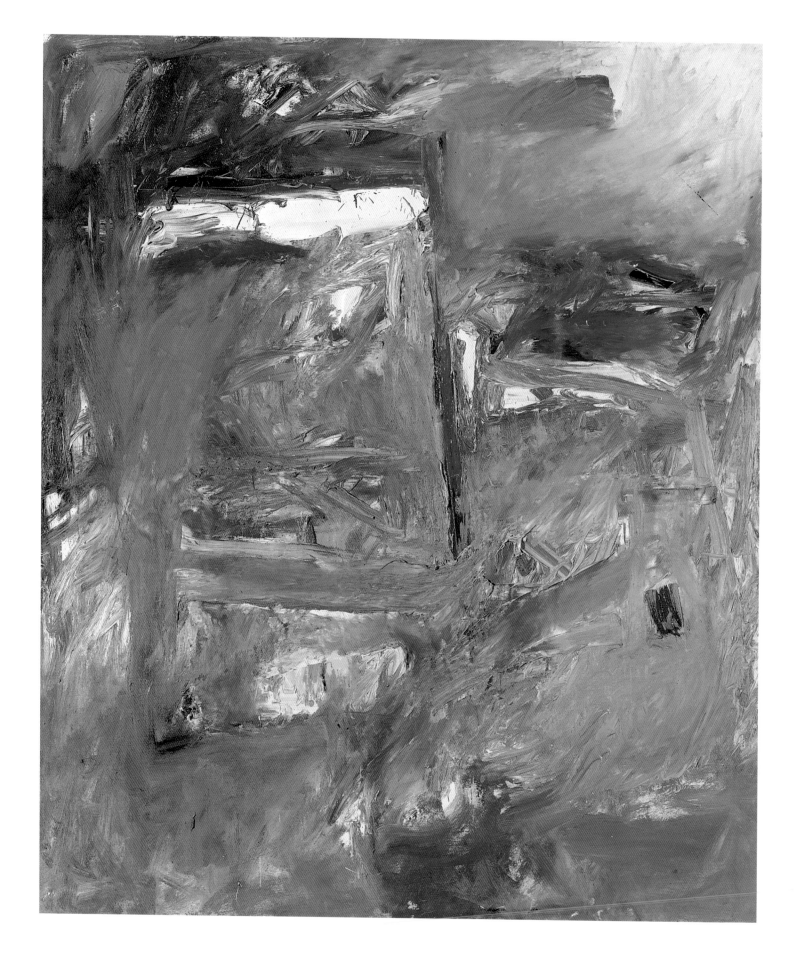

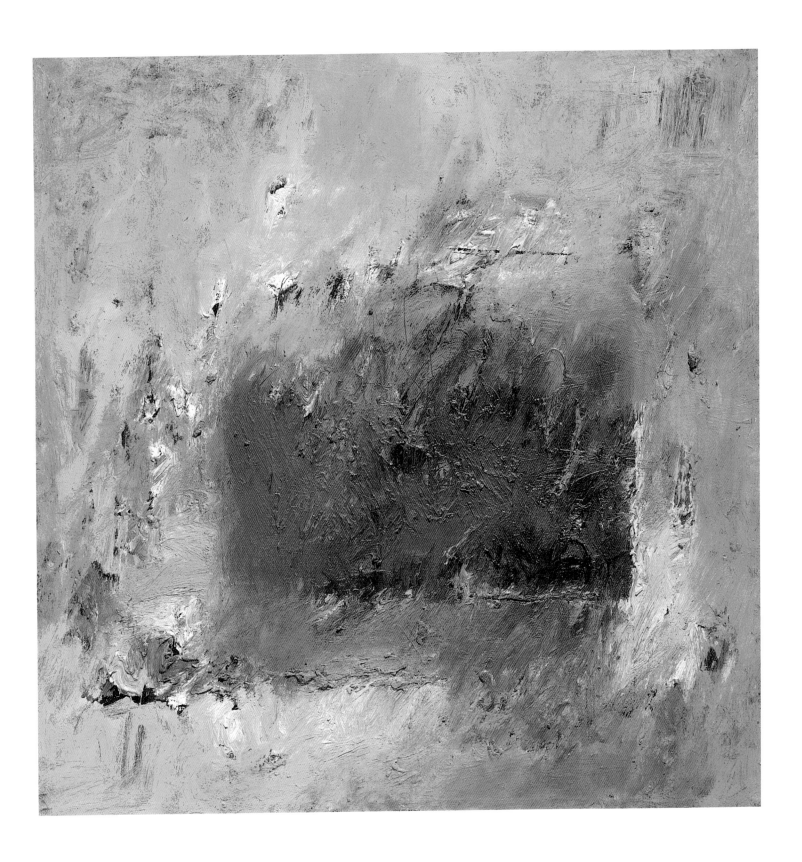

368. *Window Series No. 18,*
 1958–59.

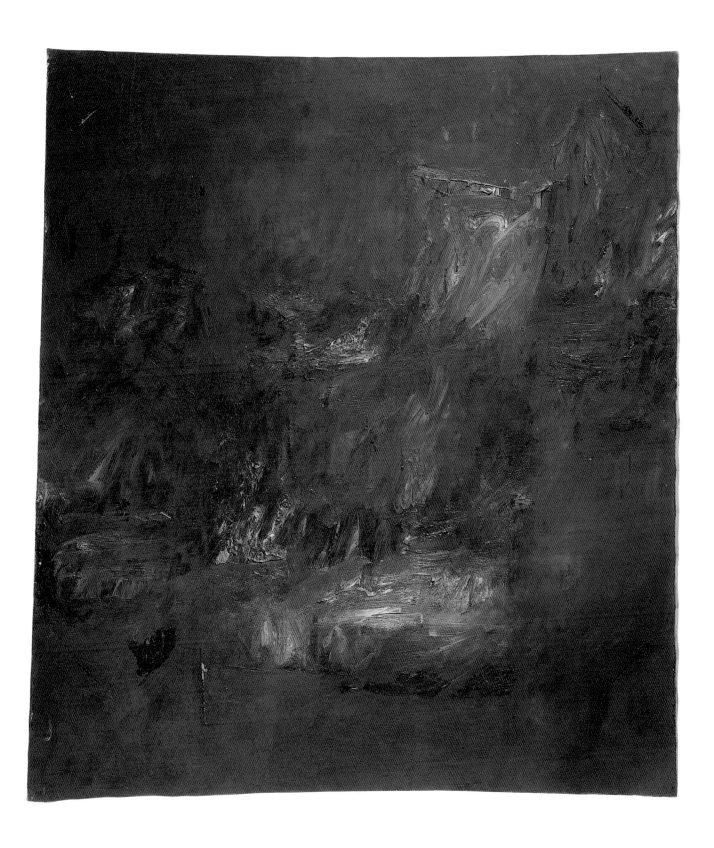

369. *Window Series No. 19,*
1958–59.

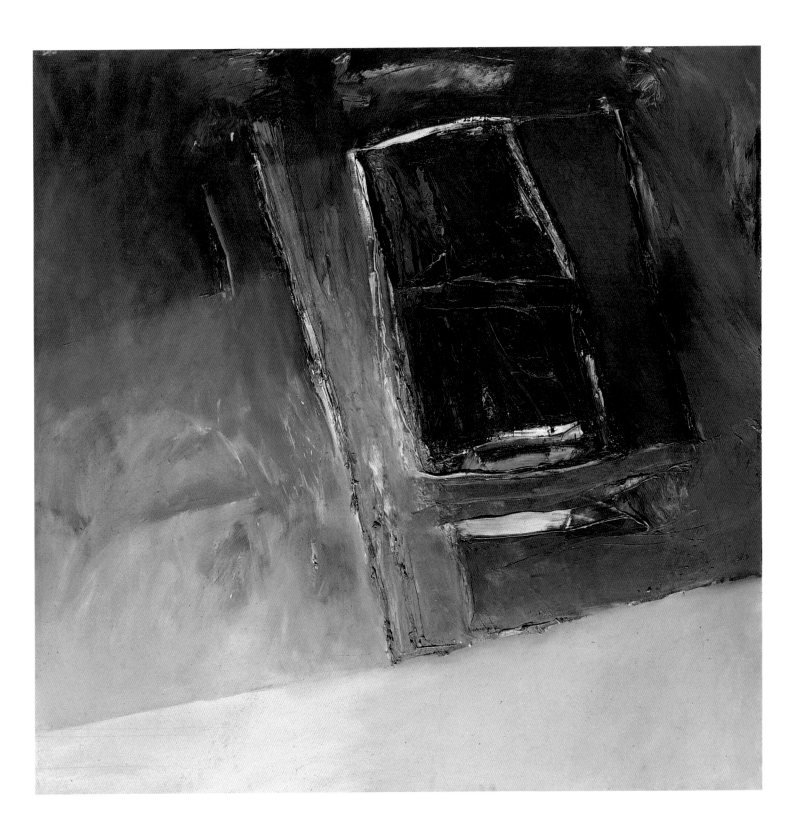

370. *Window Series No. 13*, 1959.

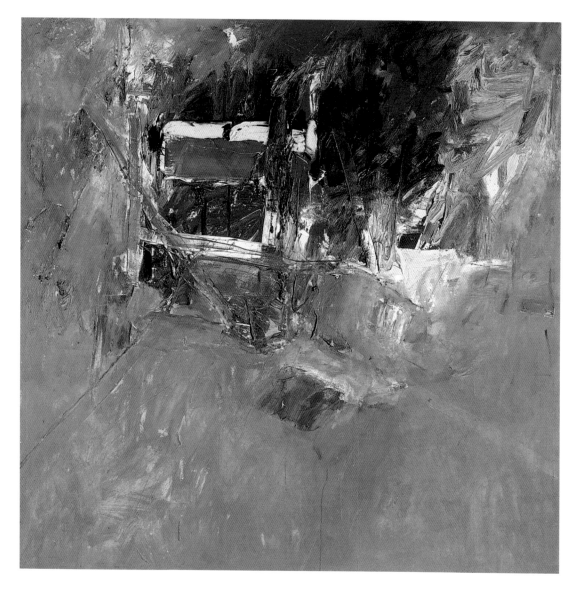

Window Series No. 13 is a further vertiginous distortion. The irregular dark window shape torques to the left, the whitish floor pitches up to the right, and both are surmounted by an odd crimson wall. A rude bead of hot red paint, applied directly from the tube, cuts through the lower windowpane. There is a bloody, nightmarish ambient that floats the viewer off to the side, denying any control by the square of the canvas and following various of the nonperspectival aspects of previous abstract expressionist sources.

A related but larger and more thickly painted canvas, *Window Series No. 5*, also suspends an odd and heavily pigmented window rendering in the upper left of the canvas in a heavy network of highly gestured brushstrokes and scrapings. Fleshy pinks, dark reds, greens, and blacks load the upper regions of the almost six-foot-square canvas, with the lower register opening out in thinly brushed tones. This creates an implied perspective, further enhanced by barely visible orthogonals entering from the left and right canvas edges, meeting just below the dark receding window.

371. *Window Series No. 5,*
1958–59.

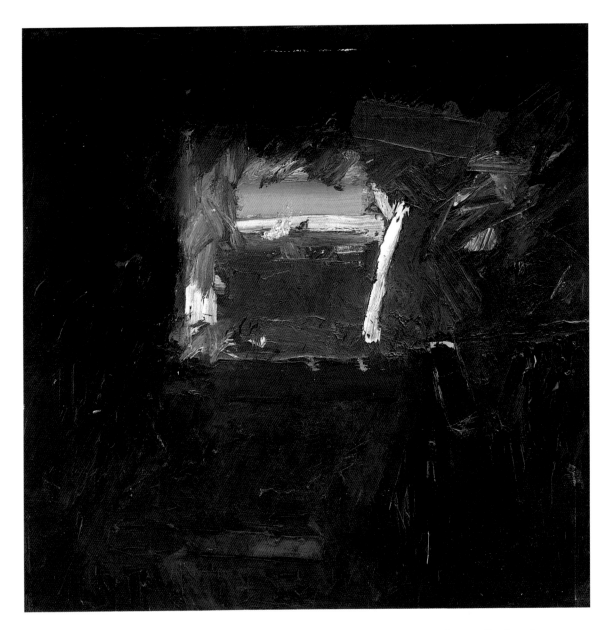

Window Series No. 3 is arguably the most classically handsome, re-solved, and tightly composed of the works. The largest of the series, nearly seven feet square, it features luminous red, white, and yellow swathes bounded by thick white and black, with residual blue and orange under-shadows. Some areas of paint are applied like stucco or adobe, others are scraped, heavily brushed, or laid on like icing with a large flat blade. The central window glows as if viewed in a surrounding darkness. One is drawn to, and simultaneously pushed back by, this small aperture. Neither the artist nor the viewer can enter.

With this large oil painting and his earlier painted papers, so convinc-ingly blending abstraction with figural allusion, Neri has conquered the unruly beasts of oil, palette, and composition. His "experimental virtues"[24] have proven to be their own reward. And finally, Neri has demonstrably given back to his painting mentors something quite valuable in kind . . . *a la pintura.*

372. *Window Series No. 3, 1959.*

NOTES

1. *Select Poems by Rafael Alberti,* translated and edited by Bellit (Berkeley: University of California Press, 1966), p. 179.

2. Rafael Alberti, *A la pintura: Poema de color y la línea (1945–1952)* (Buenos Aires: Losada, 1953). See also *Rafael Alberti, Poesías completas* (Buenos Aires: Losada, 1961). Of special note is, of course, the remarkable *livre d'artiste* produced by Robert Motherwell, *A la pintura,* published by ULAE in 1972, inspired by, and containing excerpts of, this Alberti cycle.

3. For further literary analysis of Alberti's poem cycle and artistic life see *Rafael Alberti,* "El escritor y la crítica," edited by Manuel Duran (Madrid: Taurus Ediciones, 1975); especially Ana Maria Winkelmann, "Pintura y Poesía en Rafael Alberti" (pp. 265–74) and Angel Crespo, "Realismo y Pitagorismo en el libro de Alberti *A la Pintura*" (pp. 275–92).

4. Thomas Albright, "Manuel Neri: A Kind of Time Warp," *Currant* (April/May 1975), p. 14. The more complete context for this, Neri recalled, is: "[Diebenkorn] said I should stick to sculpture. He thought I was a lousy painter, but he really liked the sculpture and the way it was combined with color."

5. See also Jack Cowart and Price Amerson, *Manuel Neri—A Sculptor's Drawings,* exhibition catalogue (Washington, DC: The Corcoran Gallery of Art, 1994).

6. Caroline A. Jones, *Bay Area Figurative Art: 1950–1965* (Berkeley: University of California Press, 1990).Thomas Albright, *Art in the San Francisco Bay Area, 1945–1980* (Berkeley: University of California Press, 1985).

7. Jones, p. 24.

8. Jones, p. 37.

9. Jones, p. 37.

10. This work was shown at the experimental 6 Gallery in 1955 or 1956. See *Lyrical Vision: The '6' Gallery, 1954–1957,* exhibition catalogue (Davis, CA: Natsoulas Novelozo Gallery, 1989), for additional information and documentary photographs.

11. Not all of these *Ritual Dance* drawings have been located. Early exhibition records document a *Ritual Dance No. 19;* presumably there were at least eighteen others.

12. Paul Mills, *Contemporary Bay Area Figurative Painting,* exhibition catalogue (Oakland: Oakland Art Museum, 1957).

13. See Neri's *Raoul Sketchbook,* c. 1955–59, and his *Green Trees Sketchbook,* 1955–58, for drawings related to these now destroyed or lost sculptures; also see fig. 197, p. 116.

14. See Neri's *SFAI Sketchbook,* c. 1956–60, and figs. 199–215, pp. 118–23. Neri is also reflecting on the abstract and material laissez-faire and energies of Peter Voulkos, with whom he worked in 1952.

15. Thomas Albright, "Manuel Neri's Survivors: Sculpture for the Age of Anxiety," *Artnews* (January 1981), p. 59.

16. Jones, p. 120.

17. See works such as Nathan Oliveira's *Seated Man with Object,* 1957 (pl. 1, Thomas Garver, *Nathan Oliveira, a Survey Exhibition 1957–1983,* exhibition catalogue [San Francisco: San Francisco Museum of Modern Art, 1984]). See also works of the prior generation, such as David Park's *Boy with Red Collar,* 1959 (pl. 52, Richard Armstrong, *David Park,* exhibition catalogue [New York: Whitney Museum of American Art, 1988]).

18. Whitney Chadwick, "Working It Out: Joan Brown and Manuel Neri," in *Working Together: Joan Brown and Manuel Neri, 1958–1964,* exhibition catalogue (Belmont, CA: The Wiegand Gallery, College of Notre Dame, 1995), unpaginated.

19. They may also be a response to Diebenkorn's 1957-era landscapes and his 1958 interiors, the former having geological units actively jumbled together, the latter having severe, enigmatic, geometric units dominating the composition.

20. One should reserve judgment on some of the oil paintings, as they may not, in fact, represent finished works (*No. 4* and *No. 19*).

21. See Suzanne Delehanty, *The Window in Twentieth-Century Art,* exhibition catalogue (Purchase, NY: Neuberger Museum, 1986), for relevant interpretive essays and examples of artists using the motif.

22. Neri recalls a drawing instructor of the period telling his students to go home and draw their scrambled TV screens. This is a suggestive notion, even if televisions were comparatively rare amongst struggling artists, if one notes various "screenlike" Neri drawings: *Drawing for Window Series No. 5, Drawing for Window Series No. 6, Window Series 6b;* and paintings: *Window Series No. 4, Window Series No. 2, Window Series No. 18, Window Series No. 15, Window Series No. 11,* among others.

23. See color plate in Pierre Schneider, *Matisse* (New York: Rizzoli, 1984), p. 446.

24. I thank Caroline Jones for this word pair. Jones, p. 17.

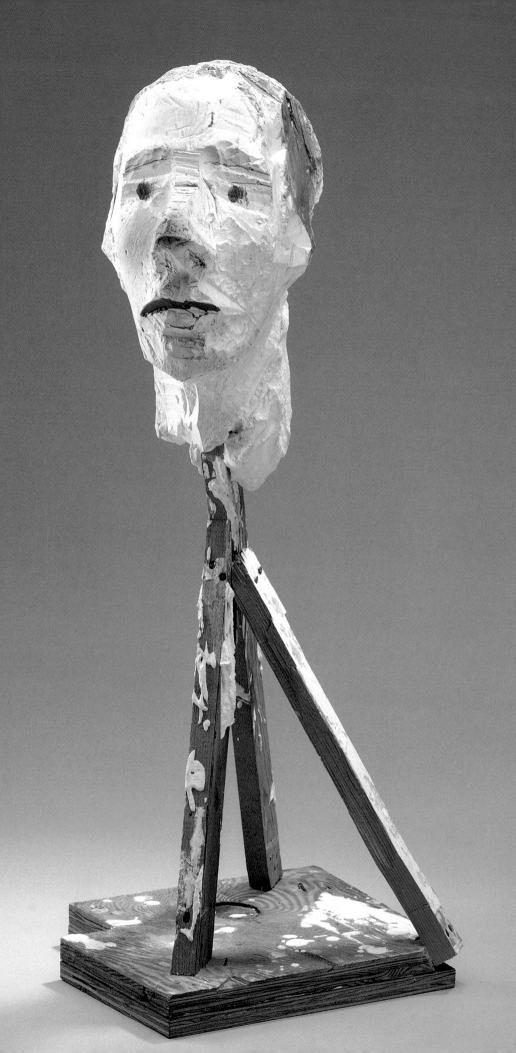

THE MAKING OF MANUEL NERI
Figures, Fragments, Heads, and Drawings

ROBERT L. PINCUS

Manuel Neri's exhibition "The Remaking of Mary Julia" was the third of three shows emphasizing his composing process. Mounted in 1976, it implicitly declared his link to the long-standing tradition of the sculptor who works from the model. This activity was dramatized by the exhibition as it was conceived and realized. Neri and Mary Julia Raahauge, his model for a series of sculptures, employed the gallery at 80 Langton Street as a studio from early until late evening. Only the armature had been constructed ahead of time; the figure was to take shape in the gallery over several days, and anyone who wished to witness evidence of the artist's progress could visit the gallery during daytime hours. Neri created his own portrait of the sculptor: a process-oriented one that depicted the artist at work with his model, that created figures within the framework of this exhibition. The works completed in the gallery became the show for its duration.

By the mid-1970s, being an aesthetic outsider was not a major worry for Neri, who had long defined himself as a cultural outsider. In the *Rock Sketchbook*, dating from circa 1967–74, he jotted down the following thought: "Spanish speaking/American living in/an alien world."

He was, at the same time, an insider, as postwar art history instructs us, since he was a central participant in the creation of a San Francisco Bay Area figurative movement during the 1950s and early 1960s, even if he was the only sculptor among the artists who forged that movement. In 1957 he shaped the first of the plaster figures that became the central portion of his oeuvre. Yet alienation from American culture at large (and even, to narrow the focus, from the New York art world) was one of the overriding values in Neri's milieu, a phenomenon signified by the close identification of Bay Area artists with Beat poetry. Even if he was part of a community of artists and writers, a subculture, he could still perceive himself to be quite alien from the culture of which it was a small part.

Neri helped arrange Allen Ginsberg's first public reading of *Howl*, on October 7, 1955. Most literary and cultural historians agree that this event marked the beginning of the San Francisco poetry renaissance. And though Neri's taste in poetry runs to the Chilean Pablo Neruda and the Spaniard Federico García Lorca, there is a vital link between his sensibility and that of the Beats. García Lorca wrote a book about his time in the United States, the posthumously published *A Poet in New York* (1940), that expresses his

Opposite:
373. *Male Head No. 4*, c. 1969;
Reworked 1972–74.

223

bewilderment and anger at what he found here; Ginsberg found inspiration in García Lorca's writing for one of his finest poems, "A Supermarket in California."[1]

Art historians and curators have often noted the biographical link between Neri and the Beat writers without seeing the deep bond between writing like Ginsberg's and Neri's early sculpture. Figures such as Ginsberg and Jack Kerouac, essentially romantics, saw signs of the supernatural and the transcendent in marginal places and people. An apt example is Ginsberg's poem "Sunflower Sutra," in which he and Kerouac spot a "dead grey shadow" of a sunflower down by the San Francisco docks, and Ginsberg concludes, "We're not our skin of grime, we're not our dread bleak duty imageless/ locomotive, we're all golden sunflowers inside. . . ."—hence the Beats' much-repeated wordplay on the terms *beat* and *beatific*.[2] Neri's figures present us with a parallel romantic vision, in sculpture. Its style drew vigorously upon the figurative expressionism of painters such as his former teachers at the California College of Arts and Crafts (in 1955 and 1956), Richard Diebenkorn and Nathan Oliveira, and his companion and wife from 1959 to 1966, Joan Brown. But Neri, by applying his romantic tendencies to sculpture of an expressionist variety, made a vital contribution to the tradition of figurative sculpture—a contribution insufficiently acknowledged in general histories of either American art or twentieth-century art. Neri's oeuvre has been marked and catalyzed by an ambivalence toward classical notions of the figure, and more specifically the nude, which has been central to his art. His art argues against the kind of reasoning that Kenneth C. Clark puts forth, separating nudity, as a form of idealization, from nakedness, the reality of flesh itself. Neri's nudes pose a challenge, indeed an eloquent one, to Clark's assertion that "we are immediately disturbed by wrinkles, pouches, and other small imperfections, which, in the classical scheme, are eliminated."[3]

Neri is anticlassical. He shows little interest in idealizing the figure, though resonances of the archaic emerge in much of his art, both in its forms and in his use of brightly painted surfaces. His anticlassicism is demonstrated quite clearly in some of his earliest plaster figures, dating from the late 1950s and early 1960s. Consider *Chula*, from the *Carla* series, in which the female figure is armless and slouches slightly forward. *Chula* means beautiful in Spanish—more specifically, Mexican American Spanish—but she is hardly that by any historical convention of the female nude. Her torso is squat, her belly bulges, and her legs are stout. In her ungainly proportions she seems intimately bonded to nature and the processes of aging, not removed from them, and thus she seems an affront to both classical and neoclassical concepts of the figure, which insist on a separation from nature by virtue of the idealization of the human form.

Opposite:
374. *Chula* (also known as *Carla I*), c. 1958–60.

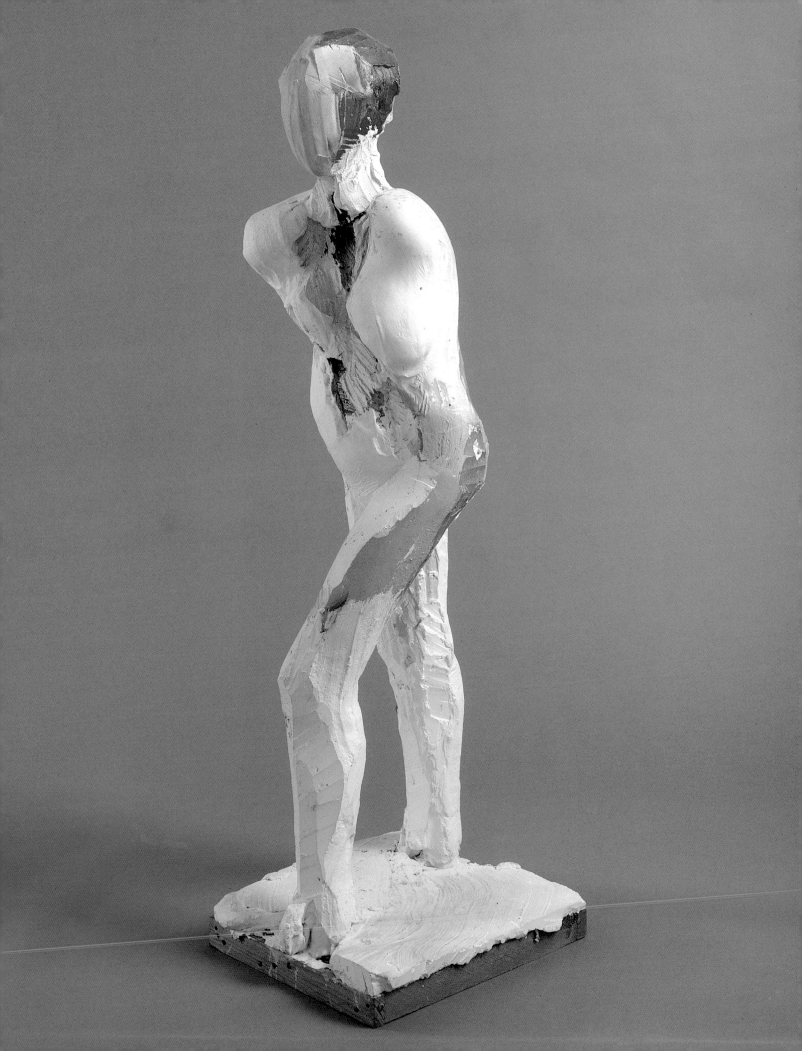

The figure of *Chula* will have none of this ideal. Its surface is not smooth but textured; the material is not marble, with its venerable association with the history of sculpture, but cheap plaster. *Chula* wears spare swatches of paint on her head and body. While insisting on the connection between his art and the Western tradition of sculpture (ancient Greek sculpture was also painted), Neri clearly wanted to revise and expand its history. He has aspired to re-create figures that evoke the twin forces of nature and sexuality. "I wanted an image," he said in 1988, "that represented all of mankind, and for me the female does that. Maybe it's that old earth-goddess thing of Europe, where the female represents magic—not sleight of hand, the real thing."[4]

Chula had always seemed a curiously isolated example of this expansive idea, but its isolation was the product of happenstance, not design. Newly discovered sculptures and drawings place this plaster in the context of a persuasive series, hence the brief meditation on anticlassicism found in *Chula* becomes an extended visual essay on the same.

The *Carla* series, named after the model, took the form of at least a dozen small ink and graphite studies, two large drawings, and a series of sculptures in painted plaster—three life-size figures and three slightly smaller. In the drawings—which function as studies, like so many of Neri's images on paper—he defines the volume of his subject's form with a light gray wash, and then articulates the figure's structure with graphite. In the *Carla* studies, Neri continued to explore the figure as sculptural form, loosely based on the shape of the model's body. What is particularly interesting and significant here is the close relationship of the drawings and sculptures, in the way that he translates the two-dimensional studies into sculptural form.

What emerges in these drawings are images that ask us to cast aside preconceived notions of beauty as they pertain to the female figure. The bulkier, disproportionate forms of the *Carla* series have their own sort of organic beauty, implying fertility, and the sheer grace of the line, the interplay between areas of wash and areas of unadorned paper (negative space, some call it) locates the appeal of her form.

Her shape shifts, too, revealing how the subject's shape is a point of departure for Neri, a source of multiple visions of the female. In *Carla No. 1*, breasts are more shapely, hips are narrower, and legs longer than in, say, *Study No. 1 for Carla Series* or *Study No. 8 for Carla Series*. In these studies, legs bow and breasts look more like granite boulders than breasts; the body becomes a kind of vital landscape. One can't help but recall the ancient Venus of Willendorf as an archetype of Neri's ambitions, here, for an art that invokes the concept of an earth goddess. This aspiration is evident in *Chula*. But clearly Neri didn't believe he had exhausted the potential of her anticlassical form with this sculpture—and he was right, in a sublime way.

Top, left to right:
375. *Study No. 1 for Carla Series*, c. 1958–60.

376. *Study No. 6 for Carla Series*, c. 1958–60.

377. *Study No. 8 for Carla Series*, c. 1958–60.

Bottom:
378. *Carla No. 1*, c. 1958–60.

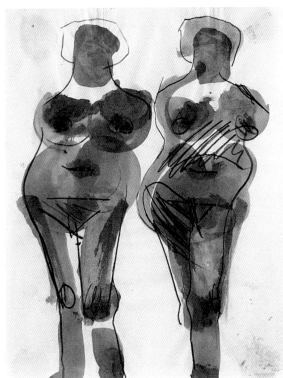

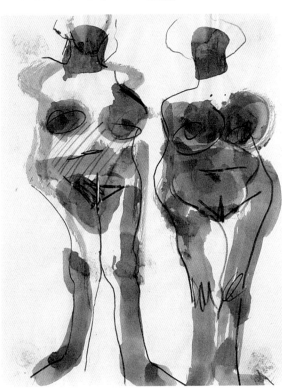

Top left:
379. *Study No. 3 for Carla
 Series*, c. 1958–60.

Top right:
380. *Study No. 9 for Carla
 Series*, c. 1958–60.

Bottom left:
381. *Study No. 10 for Carla
 Series*, c. 1958–60.

Bottom right:
382. *Study No. 2 for Carla
 Series*, c. 1958–60.

Opposite:
383. *Study No. 7 for Carla
 Series*, c. 1958–60.

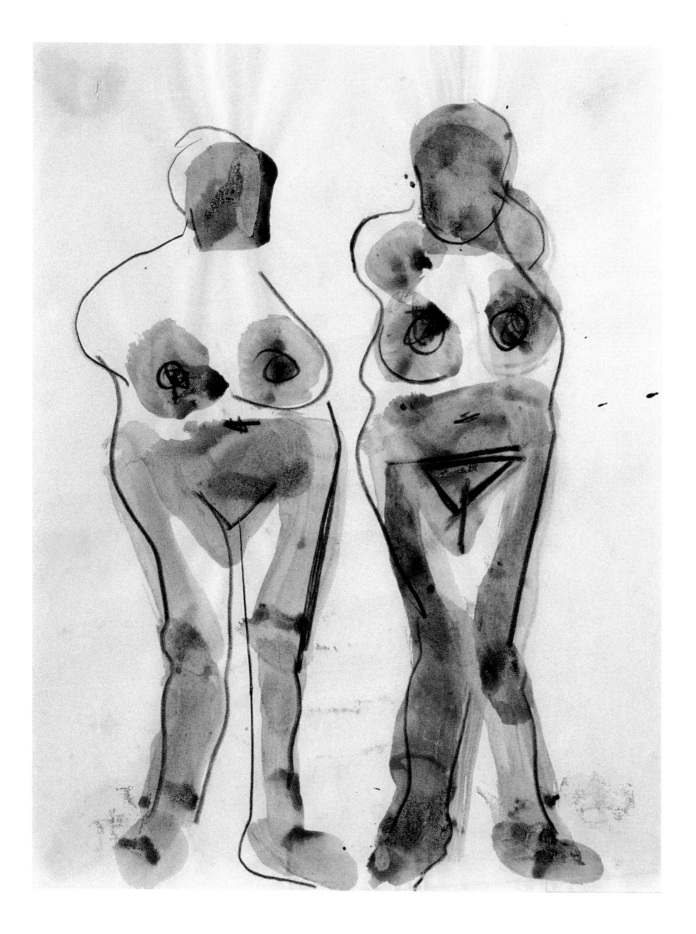

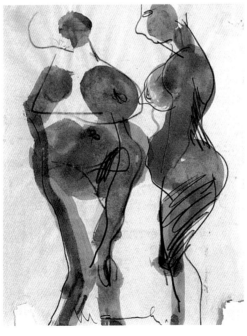

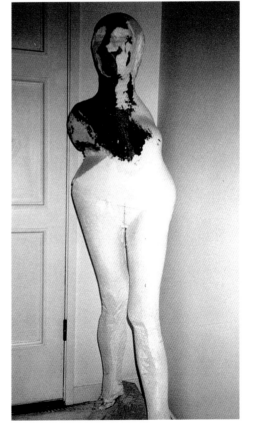

Top:
384. *Collage Drawing for
Carla II*, c. 1958–60;
Reworked 1963.

Bottom left:
385. *Study No. 4 for Carla
Series*, c. 1958–60.

Bottom right:
386. *Carla II*, c. 1958–60.

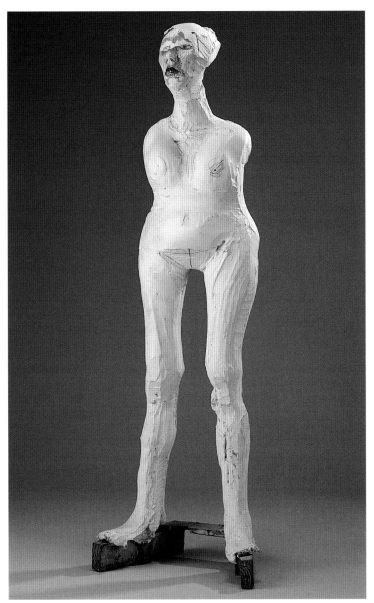
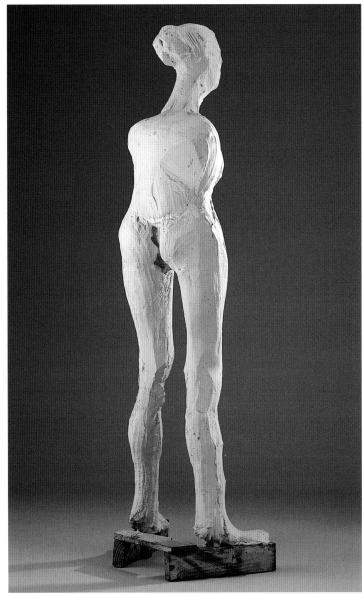

Like the drawings, the *Carla* sculptures demonstrate Neri's powers of invention, his ability to coax different meanings out of the same subject. While *Chula* expresses a kind of maternal beauty, *Carla III* displays a more regal bearing, both in her face and in the way she carries her ungainly torso on long legs. In *Carla V*, Neri is less concerned with character and more with the way paint creates mood. The figure, with a left-jutting hip, has a black, featureless face, red arm sockets, and a partially yellow thigh. There is something subtly gory about substituting red for arms, and in this sculpture, as in many others among Neri's oeuvre, paint doesn't decorate his sculptures so much as imbue them with ritual-like intensity. *Carla VI*, with its red face and hip, is in the same bold mode as *Carla V*; it seems a product of the belief that interpreting the figure is a mystical as much as an aesthetic activity.

387–88. *Carla III*, c. 1958–60.

Following pages:
Left:
389. *Carla No. 2*, c. 1958–60;
 Reworked 1964.

Right:
390. *Carla IV*, c. 1958–60.

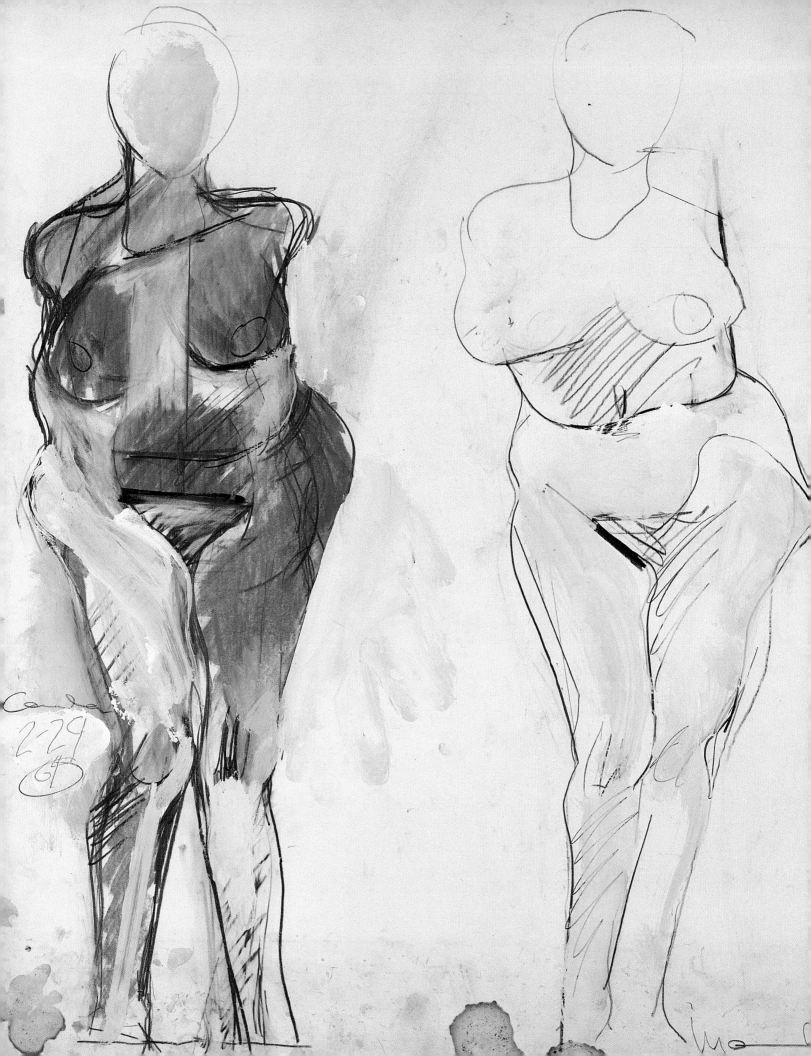

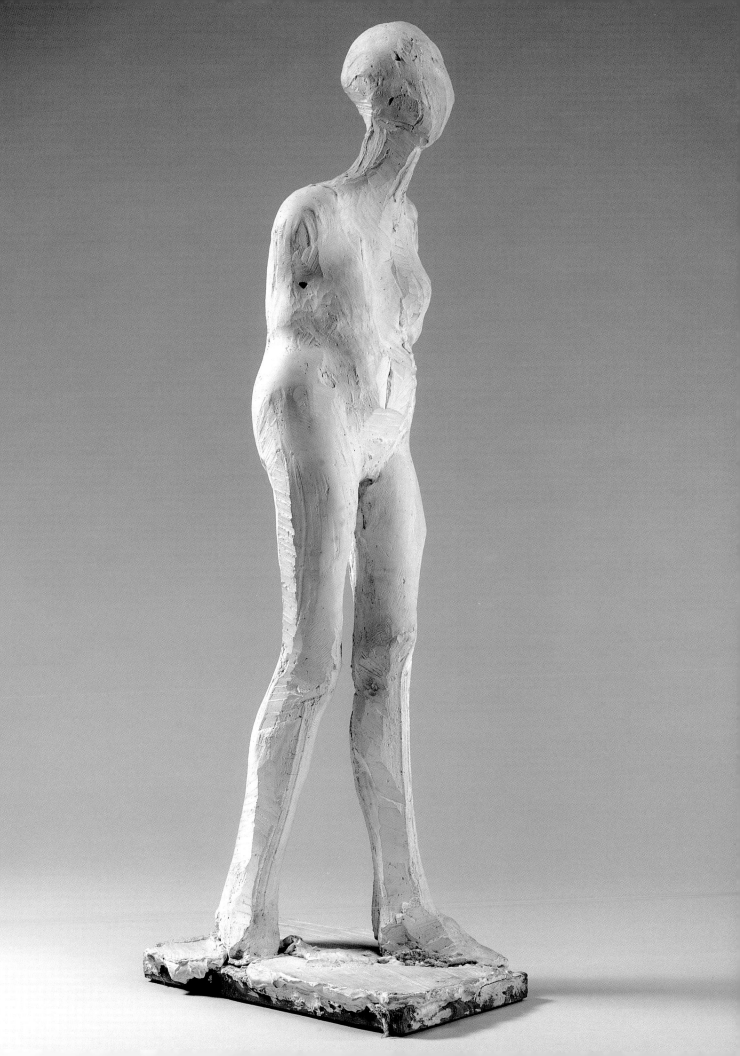

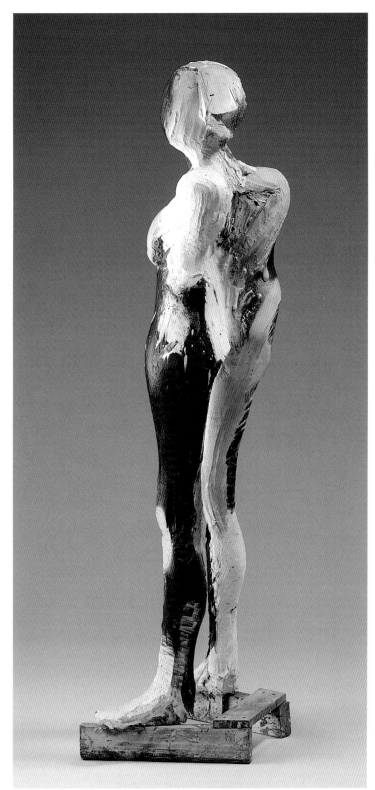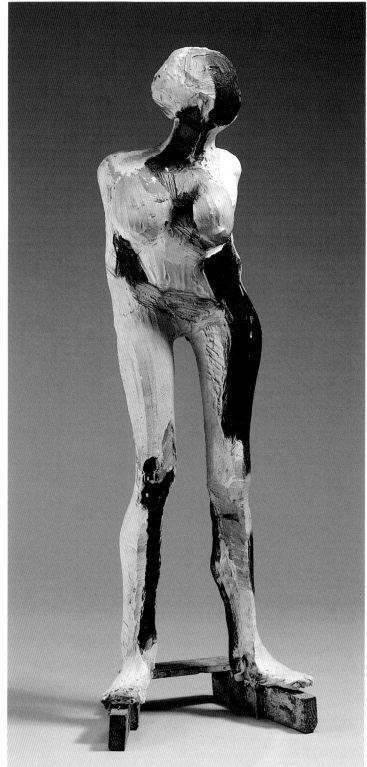

391–93. *Carla VI*, c. 1958–60.

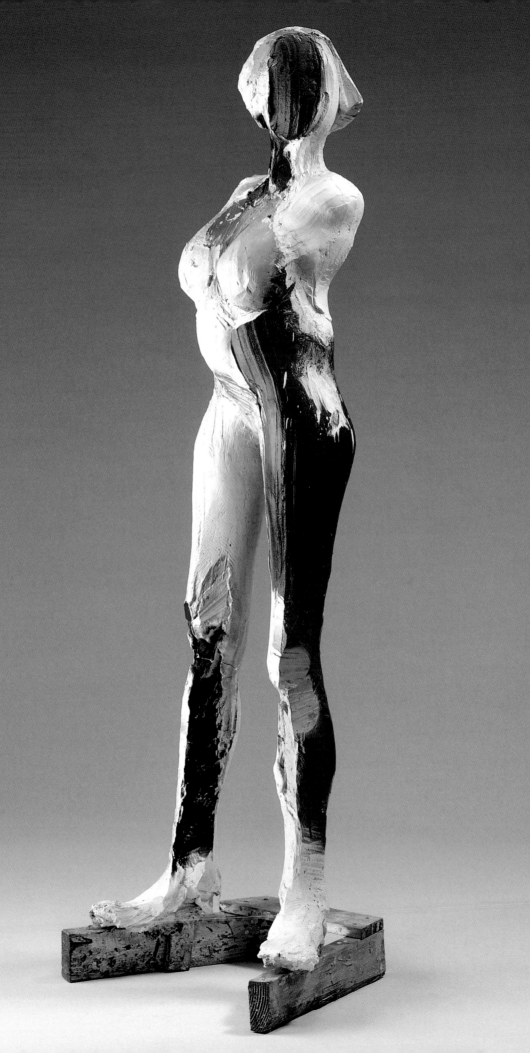

394. *Study No. 5 for Carla
Series*, c. 1958–60.

Opposite:
395. *Carla V*, c. 1958–60.

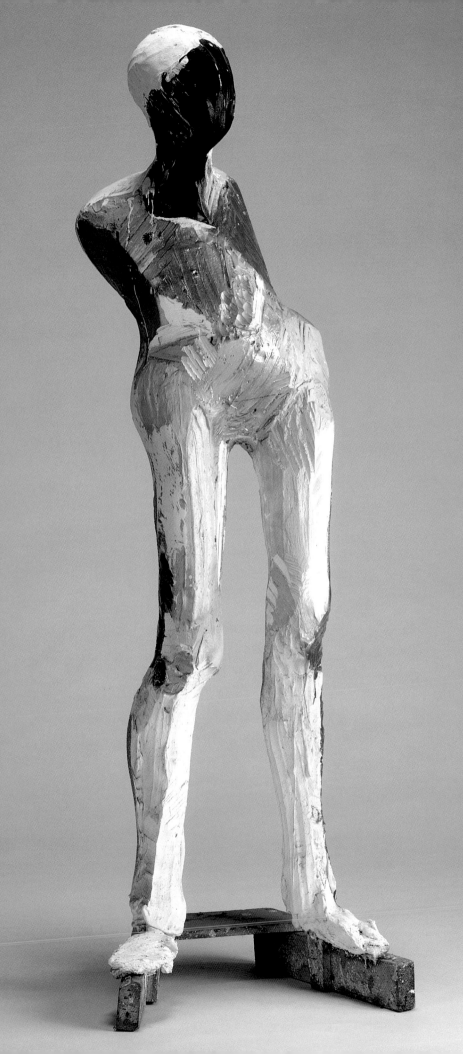

In other words, through his interpretation of female nature, of female form, Neri aspired to evoke the natural and supernatural realms simultaneously—no small ambition. He fast became an anomaly among post-1945 sculptors. Willem de Kooning managed to create expressive figures in bronze as a sideline to his paintings. But the dominant and related currents in sculpture, beginning in the 1960s, were clearly minimalism and pop—the first committed to fabricated, impersonal geometric forms, and the second to impersonal figurative images and objects; and this view still holds true when we look back on that decade and see the broad influence of these movements on subsequent sculpture. While minimalist artists such as Donald Judd relied on fabricated and repeated forms that were explicitly or implicitly abstract, and pop object-makers like Andy Warhol toyed with everyday items, both movements clearly focused on the here and now; their respective sensibilities were decidedly secular, cool, analytical, and often, in the case of pop, ironic or wry. Even contemporary artists who incorporated the figure in their work, as did Edward Kienholz and George Segal, were emphatically social. The sculptural personae they created (fashioned from plaster, but cast and not manually formed) were wedded to the settings in which these artists placed them.

By the early 1960s, Neri had emerged as one of the most distinctive figurative sculptors in the United States, and his fusion of romantic temperament and expressionist stylistics was idiosyncratic. This approach surely figures in the all-too-modest place he has been granted in general histories of American art of the post-1945 era. Obviously his decision to remain in the Bay Area is a factor, too; even more than today, in the 1960s an artist had to be in New York to garner a "national" reputation, and chronicles of the period display much of the same sensibility as Saul Steinberg's famous map of the United States for the *New Yorker.*

Plaster proved precisely the right medium for Neri's ambitions. Joan Brown correctly observed that his early figures and creatures in fabric and other materials stretched taut over wood and wire armatures possess some of the elegance and technical virtuosity that later found a dramatic vehicle in his plaster sculptures. An aura of whimsy and tenderness hovers about these works, particularly in the painted wood or cardboard assemblages of birds and animals, such as *Hawk* (fig. 77) and another untitled bird sculpture (figs. 78–81), both of circa 1957–60, qualities quite distinct from his plasters. They exude pleasure in the re-creation and interpretation of nature. Their rough-hewn quality—they are fusions of crude carving; simple, painted pattern and eyes; wire legs; and simple bases—argues for a primal relationship to nature. Looking closely, though, one perceives just how sophisticatedly "primitivist" these creatures are, harking back to related work by Picasso as well as a range of German expressionists.

In the beginning, Neri's crude figures (and fragments of figures) appeared in cloth, twine, and other cheap materials wrapped around partially exposed wire frames. Along with the early works of Wallace Berman, they clearly were an expression of the developing school of assemblage on the West Coast. None are titled. One holds an arm outstretched and the other behind him (or her?), as if in the middle of an earnest stride (*Wood Figure No. 1*, fig. 2). Another, propped on a wood slat pedestal, leans backward, as if about to fall flat on its back (*Sutee Figure III*, fig. 5). In retrospect, it is clear that he had found his prime subject, crudely but vigorously presented.

The talent that Neri revealed in these roughly made formative works is for gesture, an acute eye for the way a body positions itself to evoke emotion. Consider the artist's much-seen *Untitled Standing Figure*, 1957–58 (figs. 43, 396, 458). Although it is rough-hewn, one easily imagines the swell of its feminine but not superficially female chest and the slender grace of its legs. These earliest works lack a scale and presence that would allow them to compete persuasively with the vast tradition of figurative sculpture that preceded them. Neri's breakthrough plaster figures of the late 1950s and early 1960s express his simultaneous alienation from and his bond with that tradition. Think once more of his words from the *Rock Sketchbook:* "Spanish speaking/American living in/an alien world." Looking at his sculpture, one can sense his alienation from traditional (read "ideal") concepts of beauty. How apt for Neri to employ a Mexican American term for beauty in *Chula,* since his notion of beauty was surely vernacular, not lofty; it was rooted in his own psyche and eye, not in a self-conscious awareness of history. And it was grounded in what he saw, as an artist of an expressionist temperament. He concentrated on gesture, as we commonly use the term to describe a movement or pose of the body, as well as its importance in abstract expressionist painting, where the term was used to describe the shape and emotional connotations of brushstrokes. It was Neri's great insight to see that the two notions of gesture could be wedded in sculpture. This insight was his alone, and it explains why he was the only sculptor among the Bay Area figurative artists of his formative era.

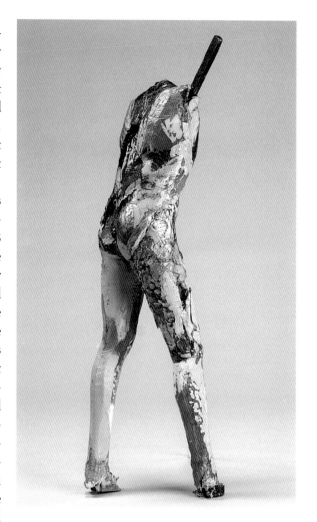

396. *Untitled Standing Figure,*
1957–58.

239

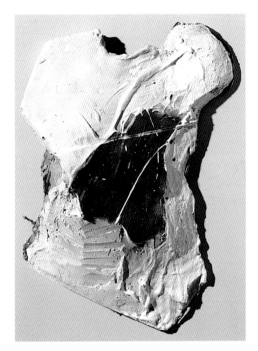

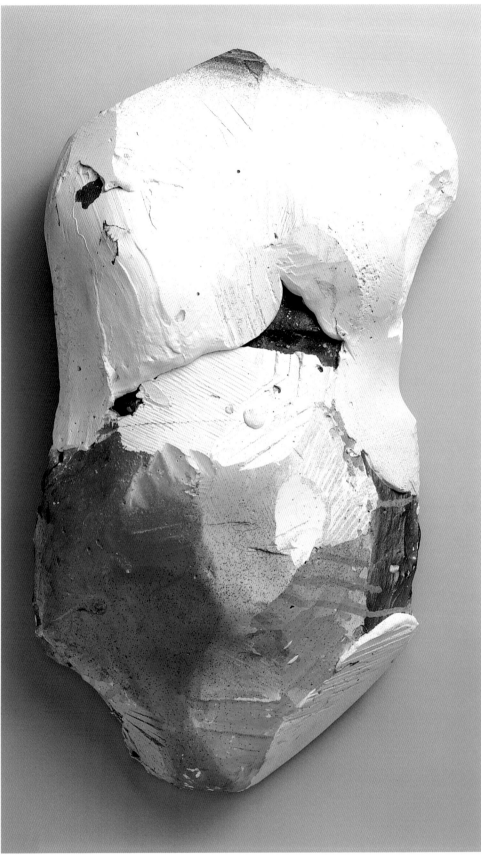

Left:
397. *Torso*, c. 1958–59.

Right:
398. *Untitled Torso II*, c. 1960.

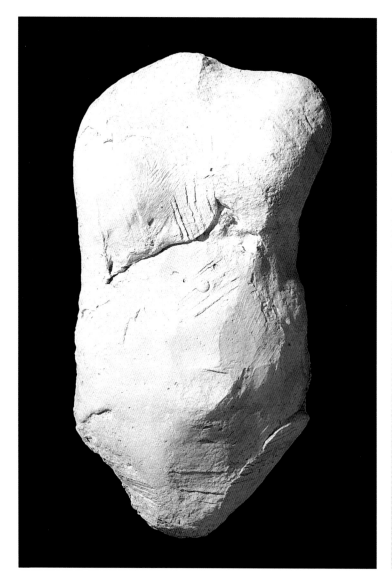

A body, or a fragment of one, became Neri's equivalent of the abstract expressionist gesture in painting and drawing. Neri realized this to be the case quite early. His untitled series of torsos of 1958 to circa 1960, richly painted in an expressionist manner, are nearly abstract forms that place in high relief his vision of the figure as form and gesture. For what one notices most is the swell of muscle and the topography of the torso; Neri has often said that the figure is a kind of landscape for him. The fragmentary nature of these wall compositions lends them the quality of archaeological finds, yet the painterly application of color, in an abstract and lyrical manner, is clearly of its moment. He reexamined these torsos in the mid-1970s and used them to make molds for casting torso fragments in fiberglass/resin and paper pulp. Other torsos were molded directly from the figure using burlap and plaster. His interest in torso fragments as expressive of a full range of emotion continued in the *Falling Woman Series* of 1978, and was expanded to include gesture in the *Posturing Series* begun that same year.

Left:
399. *Cast Paper Torso*, 1975.
Right:
400. *Fiberglass Torso No. 3*, 1975.

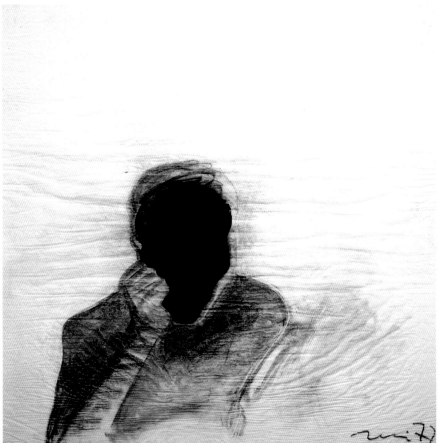

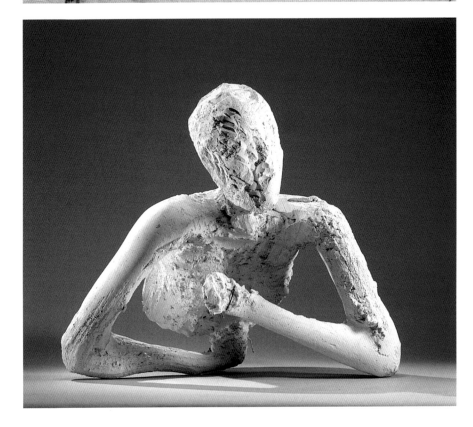

Left:
401. *Study No. 16 for Falling Woman Series*, c. 1977.

Top right:
402. *Falling Series No. 2*, 1977.

Bottom right:
403. *Untitled Bust V*, c. 1978.

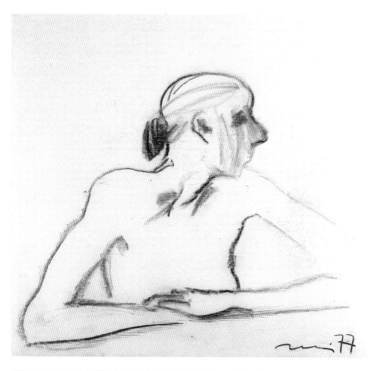

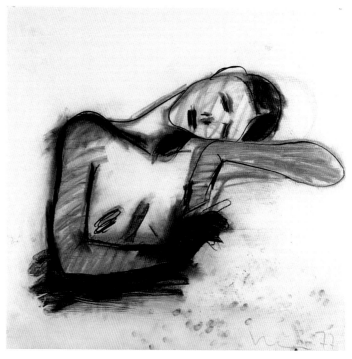

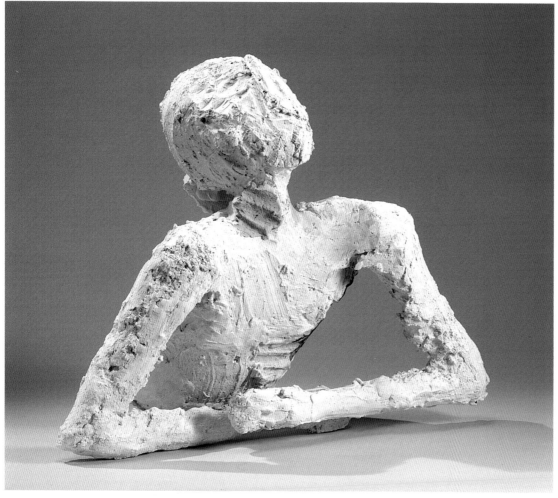

Top left:
404. *Falling Series No. 1*, 1977.

Top right:
405. *Falling Series No. 12*, 1977.

Bottom:
406. *Untitled Bust VI*, c. 1978.

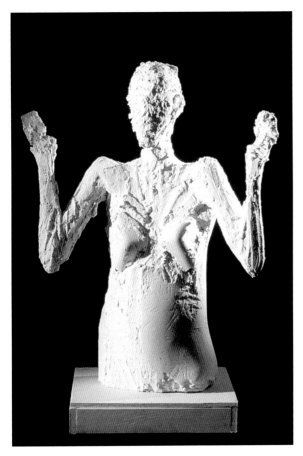

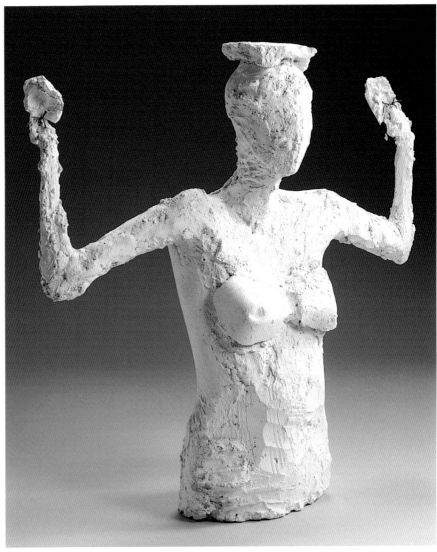

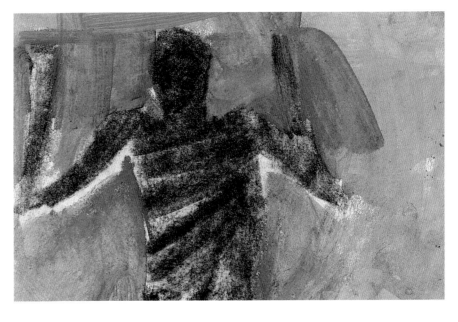

Top left:
407. *Posturing Series No. 7,*
 1978. Photographer
 unknown.

Top right:
408. *Posturing Series No. 1,*
 1978.

Bottom:
409. *Study for Posturing Series
 No. 1* from *Majic Act
 Sketchbook*, page 71
 (detail), c. 1975.

Opposite:
410. *Posturing Series No. 5,*
 1978.

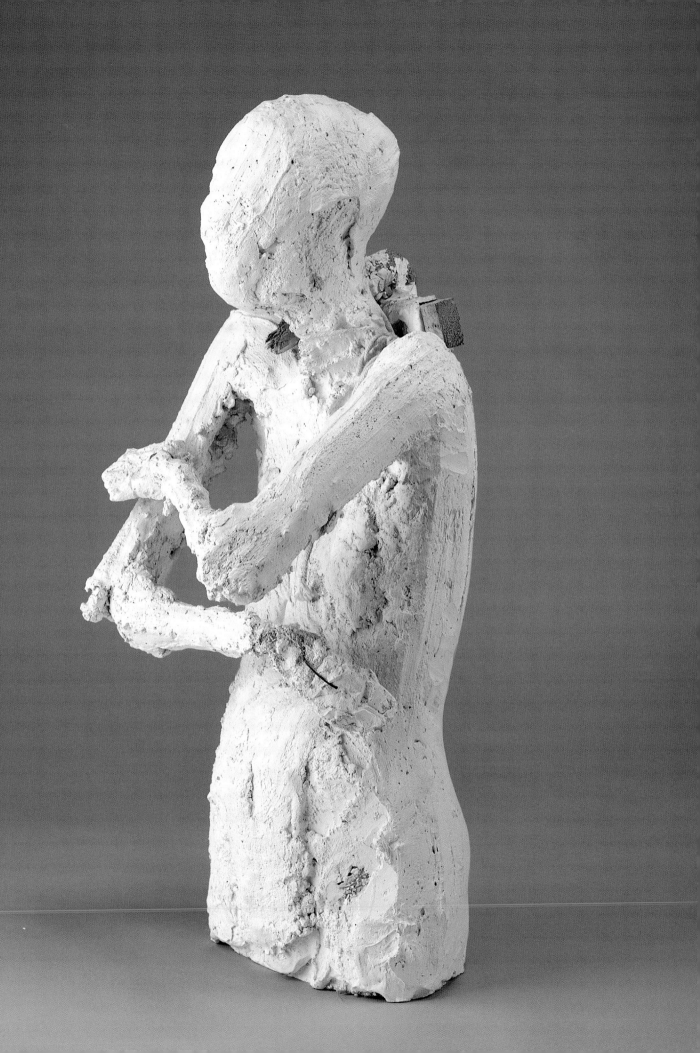

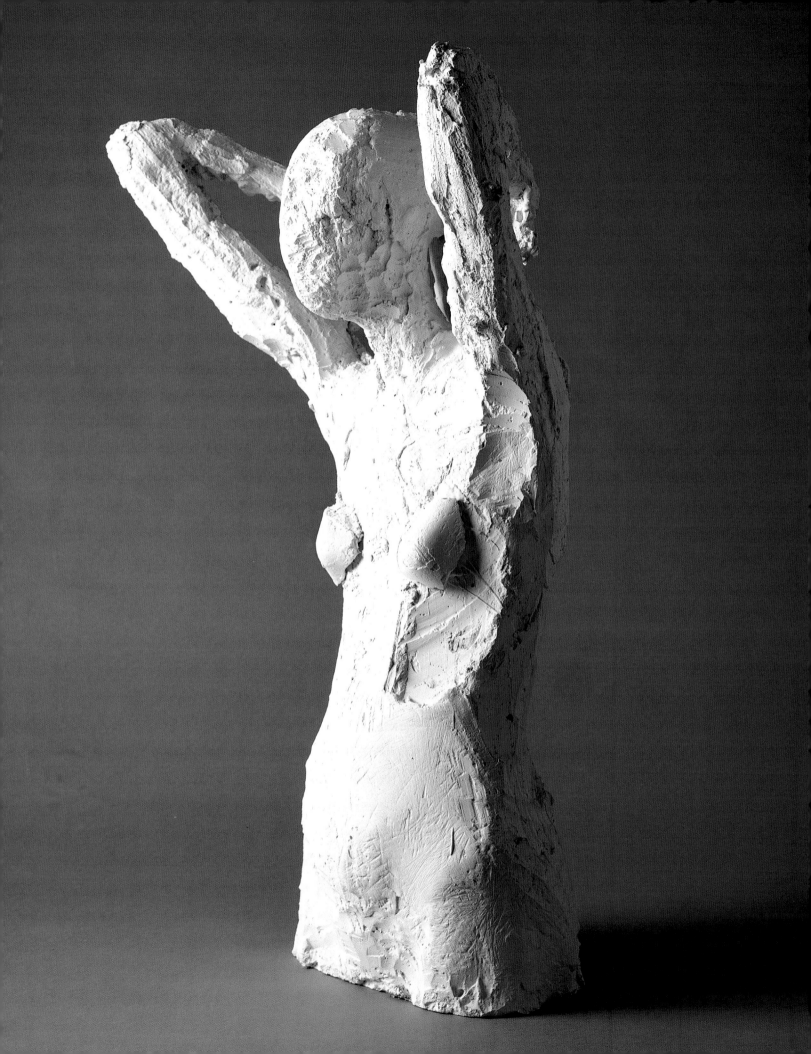

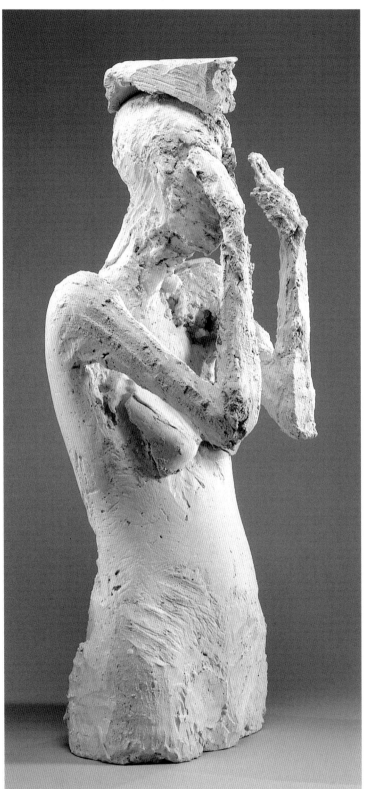

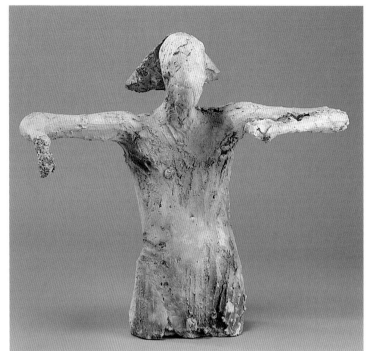

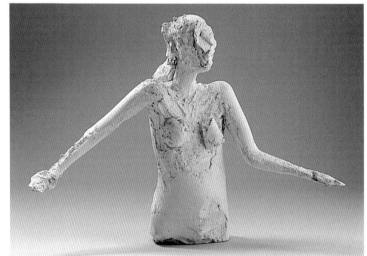

Left:
412. *Posturing Series No. 4,*
1978.

Top right:
413. *Posturing Series No. 3,*
1978.

Bottom right:
414. *Posturing Series No. 6,*
1978.

Opposite:
411. *Posturing Series No. 2,*
1978.

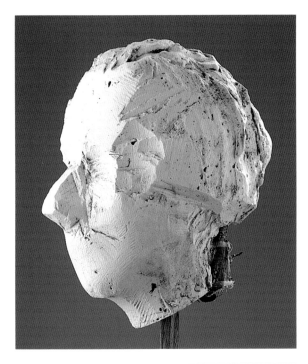

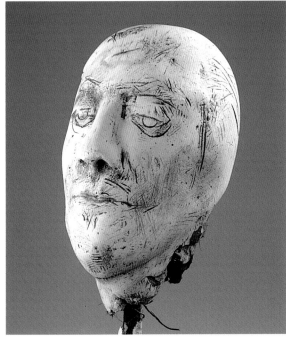

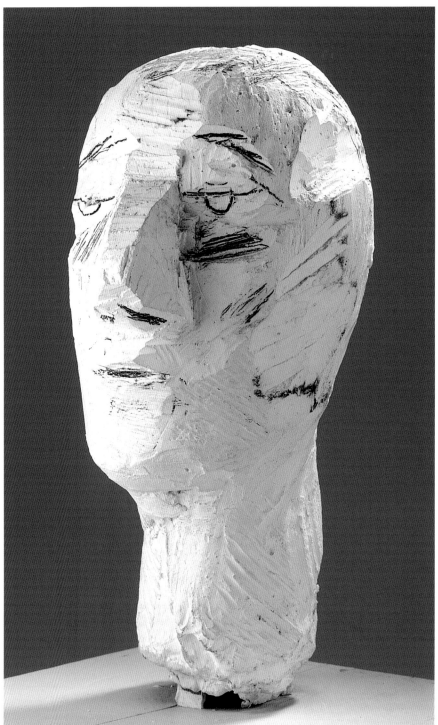

Top left:
415. *Head I*, 1957–58.

Bottom left:
416. *Cabeza Series No. 4*,
 1957–59.

Right:
417. *Head II*, 1957–58.

Opposite:
418. *Untitled Male Head*, 1958.

Scrutinized with the same vigor as the torso, Neri's early plaster heads have an eerie masklike quality. Their surfaces are scored, as if they were drawings or paintings, rather than the sculptural equivalent of skin. Other heads are shaped and gouged with the features emphasized and planes delineated with graphite markings. As with the torso fragments, these heads, too, were later molded to make "skins" of fiberglass/resin and paper pulp.

Top, left to right:
419. *Etter Sketchbook*, page 94,
 c. 1959.
420. *Etter Sketchbook*, page 71,
 c. 1959.
421. *Rock No. 3*, c. 1967–74.

Bottom:
422. *Rock No. 4*, c. 1967–74.

One can see Neri's commitment to the figure as form and gesture quite clearly by scrutinizing his sketchbooks of the mid-1950s to the mid-1970s and the related works on paper, in which, as we might expect, his ideas concerning the figure took form more quickly and more variously than in sculpture. For Neri, drawing served as a vital part of his process of developing ideas for sculptural form.

The females and occasional males in these drawings are rendered in watercolor, oil pastel, pencil, charcoal, acrylics, ink, and collage, yet they are strikingly consistent in vision. Even when an environment is evoked, the focus is on the figure. With few exceptions, such as the occasional drawing in which the face is made visible, Neri has concentrated on the contour and pose of the body, transforming it into a study in formal and emotive gesture.

423. *Rock No. 9*, c. 1967–74.

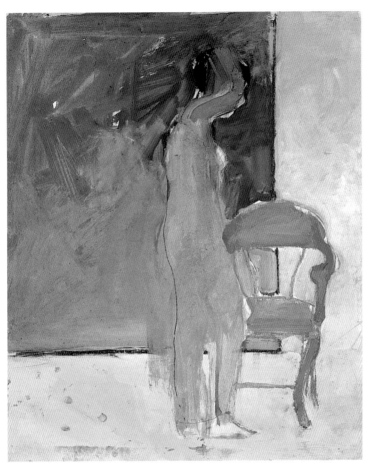

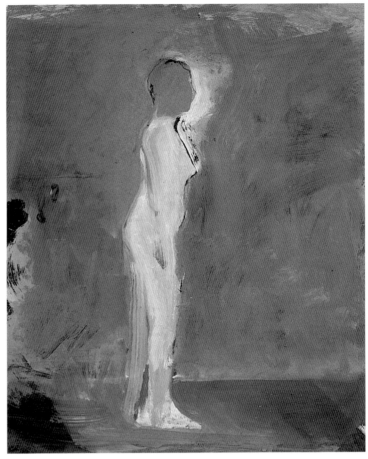

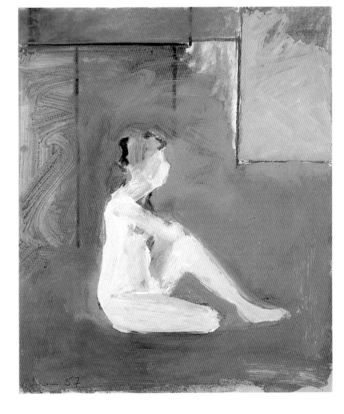

Top left:
424. *Untitled Figure Study*
 No. 3, 1957.

Top right:
425. *Untitled Figure Study*
 No. 8, 1957.

Bottom:
426. *Untitled Figure Study*
 No. 5, 1957.

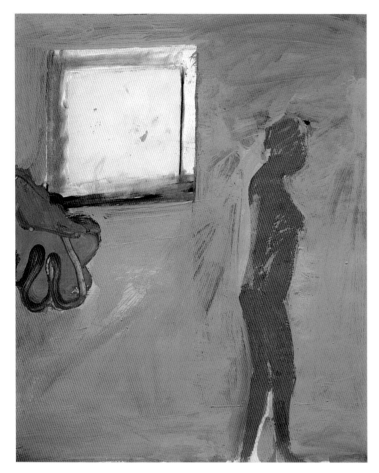
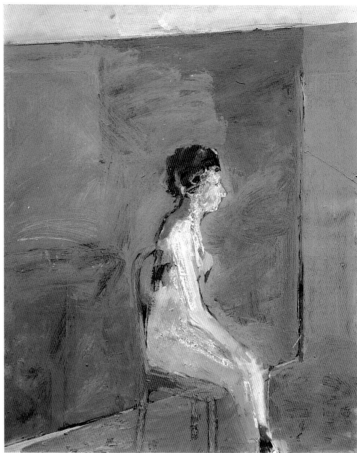

In 1957–58, working in tempera, pastel, and pencil, Neri did a series of vibrantly colored drawings that place the figure within abstracted architectural interiors. In *Untitled Figure Study No. 22,* for instance, a spectral female nude in a brilliant orange, seen in side view and seemingly caught in a slow gait, is located within a room where the wall is dominated by browns and pinks; the rectangle that suggests a window frames white space. Nearly all the figures in this series of studies are seen in profile: seated in an orange chair *(Untitled Figure Study No. 23)*; slouching and perhaps leaning on a green chair *(Untitled Figure Study No. 3)*; standing with belly slightly protruding and the head dramatically darkened to contrast with the pale body *(Untitled Figure Study No. 8)*; and seated on the floor and seemingly floating in reddish space *(Untitled Figure Study No. 5)*. Neri makes palpable his concentration on the outline of the body as a shape rich in abstract formal possibilities and replete with emotional implications. In some cases those implications are clear, and in other examples they are ambiguous. The woman of *Untitled Figure Study No. 23,* for instance, is stately, while the subject of *Untitled Figure Study No. 3* seems weary or dejected; in other selections, the mood is less easily elucidated.

Left:
427. *Untitled Figure Study No. 22,* 1957.

Right:
428. *Untitled Figure Study No. 23,* 1957.

253

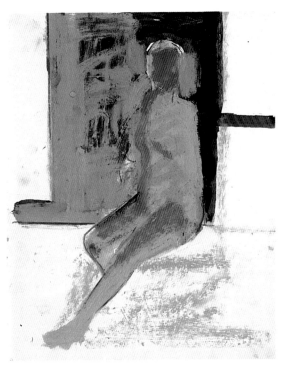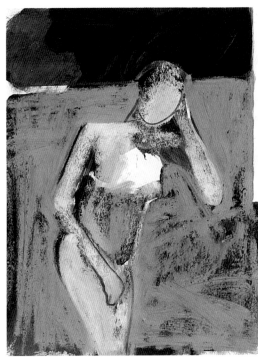

In most of Neri's sketchbooks, the bedrock ambition remains the same: to remove the individuality of the figure, concentrating on its formal power and its archetypal dimensions of emotional nuance and archaic resonances.

In his figure studies from a sketchbook of the late 1950s, reworked in circa 1980, Neri moved the figure around restlessly: a standing female has an arm on her hip; a seated subject has one leg extended and one positioned close to the body; an arm tilted upward at the elbow dominates the pose of one frontal nude; another, leaning head on hand, looks tranquil, even asleep, although she is standing. *Casting Sketchbook* features four drawings of the same figure, the first suggesting a surrounding room, and each successive rendering removing a detail of that interior while moving the figure closer to the viewer. The evolution of the quartet reveals an increasing removal of naturalistic rendering and heightened attention to the body as contour or outline. In the last image, the line is graceful, but the figure is broad and ungainly, in the manner of Neri's compelling plasters of those same years. The concentration on archetypes is readily evident.

The sketchbooks offer their own distinctive pleasures. In *Etter Sketchbook*, Neri employs delicate line and ethereal wash to define graceful arching of torsos and extensions of the limbs. *Unos Actos de Fe Sketchbook* favors two figures per image, offering subtle variations and doublings of gesture, while *Miseglia Sketchbook* emphasizes dark or pale phantomlike figures, elegantly defined, that heighten our attention to gesture itself. (The artist's 1980 *Gesture Study* series favors light figures set against dark grounds, done in much the same style as those in *Miseglia Sketchbook*. The style of this series, coupled with its title, underscores Neri's vision of the figure.)

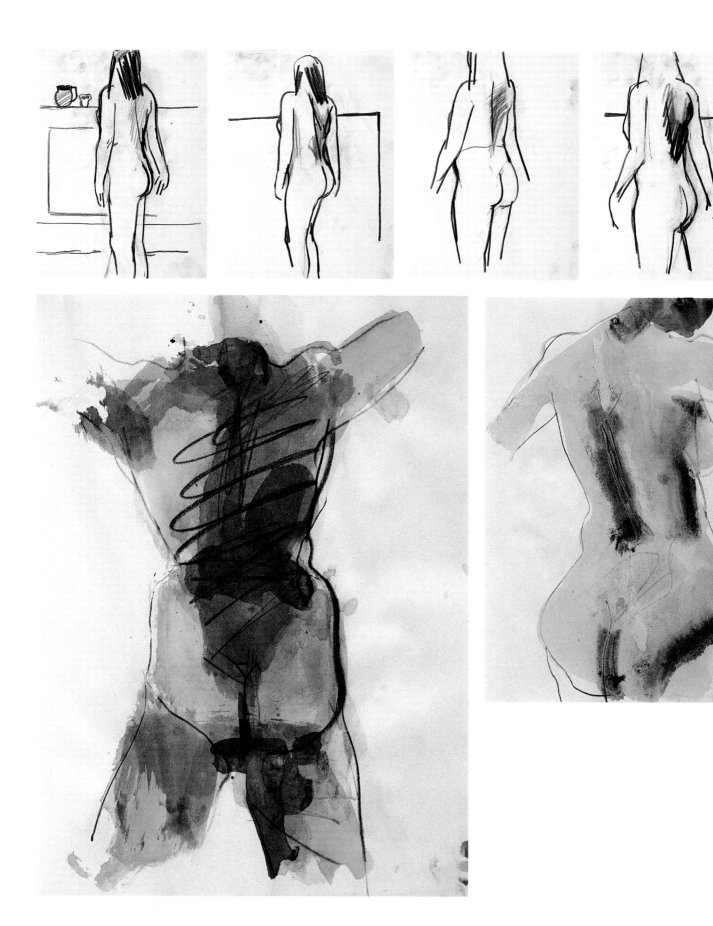

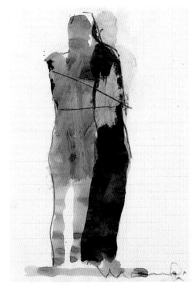

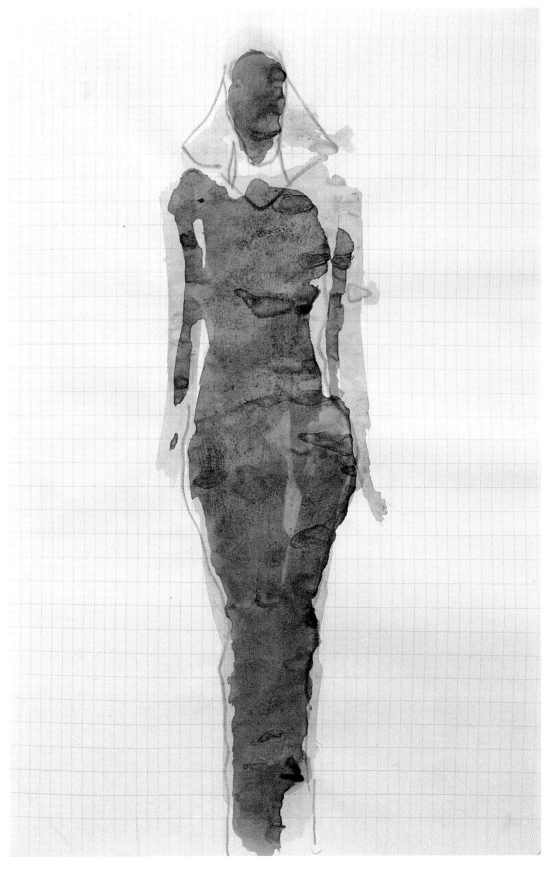

Top left:
437. *Double Figure Study
No. 16*, c. 1976.

Bottom left:
438. *Unos Actos de Fe
Sketchbook*, page 23,
c. 1974–76.

Right:
439. *Miseglia Sketchbook*,
page 80, c. 1975.

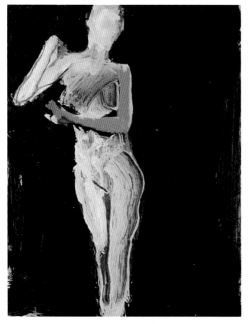
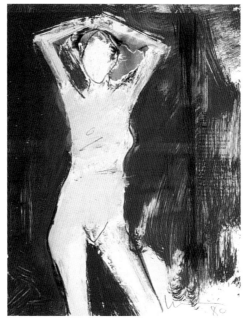
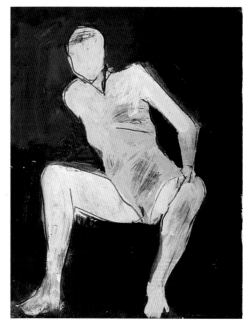

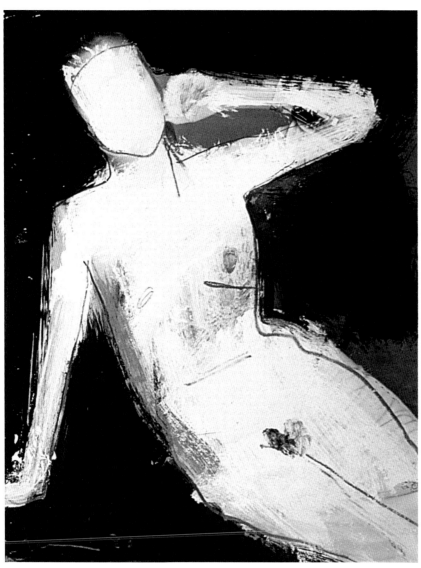

Top, left to right:
440. *Gesture Study No. 54,* 1980.

441. *Gesture Study No. 37,* 1980.

442. *Gesture Study No. 79,* 1980.

Bottom:
443. *Gesture Study No. 53,* 1980.

Neri's drawings and sketches display discrete strengths, and also of-fered a continuous means of exploring ideas that had an impact on his sculp-ture. For instance, the more theatrical gestures in his early sketchbooks would make their way into his sculpture in the 1970s. In fixing his gaze on gesture—the slant of a torso, the angle of an arm or the absence of it, the position of the legs—he aspired to and succeeded in giving the stron-gest of his figures the sort of magical dimension he has remarked upon, a wedding of natural form to spiritual aura.

Left:
445. *Legs*, 1963.
Right:
446. *Study for Legs*, c. 1965.

Opposite:
444. Untitled, 1957.

259

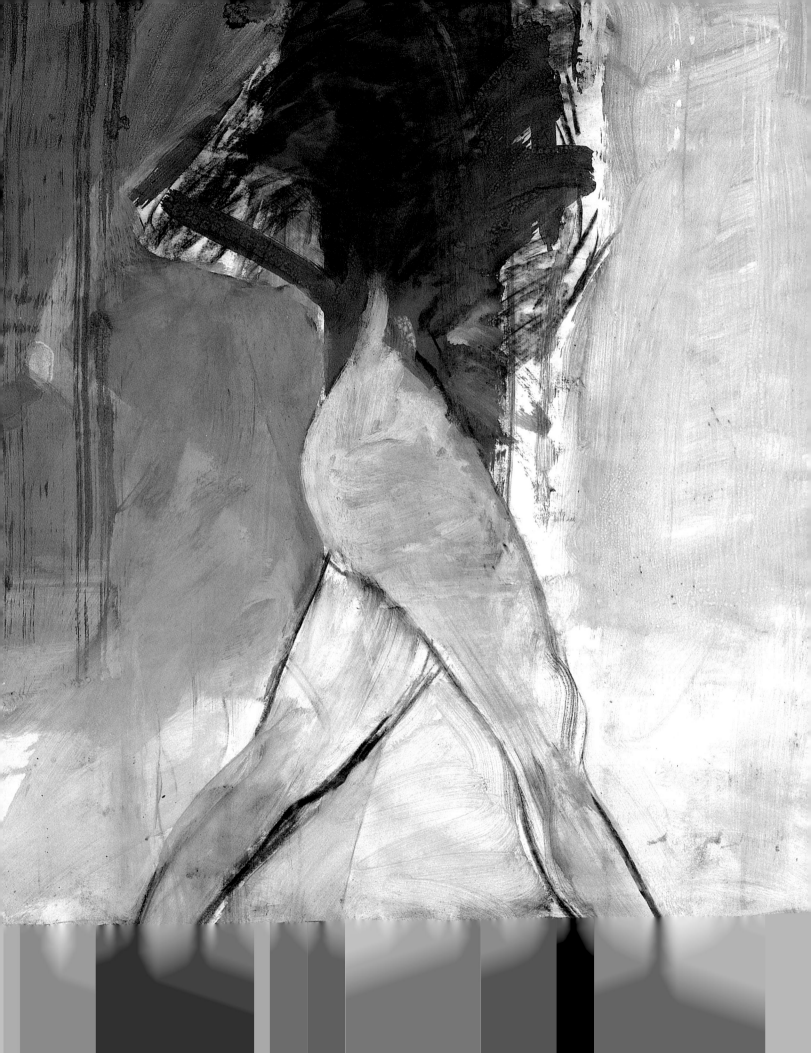

While specific ideas evolved in sketches and drawings may not immediately take form in sculpture, there are numerous examples in which Neri's process of developing an idea, on paper or in plaster, recurs over a twenty- or thirty-year period. This obsession with the continual reexamination of an idea is demonstrated in a series of drawings and sculptures of the lower portion of the body, and underscores the different qualities Neri achieves in each format, as he explores how posture and attitude are translated in the positioning of the legs, through subtle shifts in weight and balance. The drawings concentrate on the gestural possibilities of the legs and lower torso, evoking their sensuousness while at the same time becoming a means for expressively rooting the figure to the earth. Neri's first use of this fragment as a sculptural form was in the early 1970s, when he cast legs in both fiberglass/resin and paper pulp from full plaster figures, yet the idea was not fully developed in sculpture until the plaster and bronze *Sancas* series of the early 1990s. While the drawings are primarily gestural, the sculptures possess a double identity. In three dimensions, the half figure becomes more palpably physical, but less intimately related to flesh and bones. The human form becomes more archetypal and thus more transcendent.

Top, left to right:
448. *Fred and Laura Series No. 1,* c. 1973.

449. *Fred and Laura Series No. 4,* c. 1973.

450. *Fred and Laura Series No. 2,* c. 1973.

Opposite:
447. *Mary Julia's Legs,* 1972.

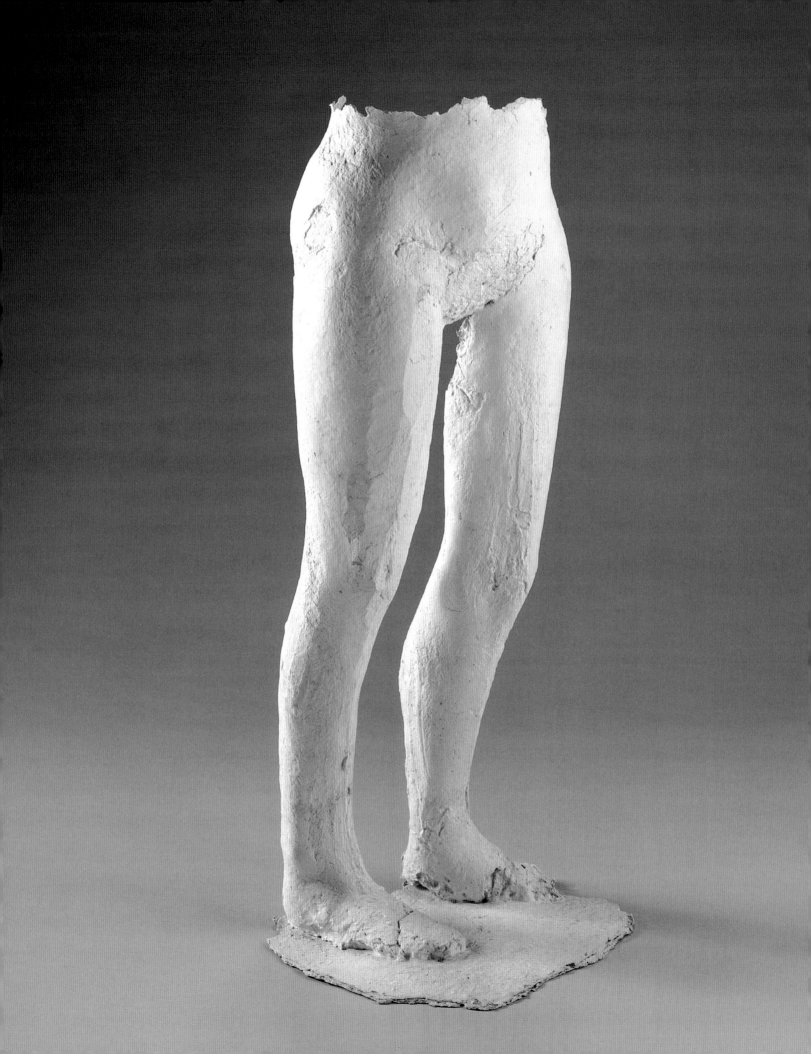

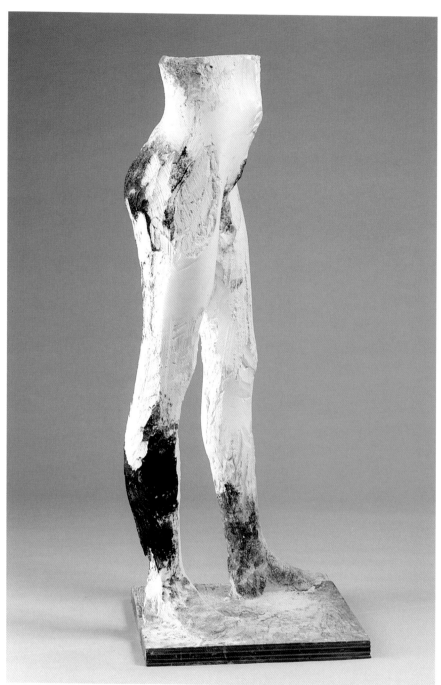

Top left:
452. *Sitting and Standing Study
No. 16,* 1978.

Bottom left:
453. *Sitting and Standing Study
No. 22,* 1978.

Right:
454. *Sancas I,* 1991.

Opposite:
451. *Cast Paper Legs,* 1975.

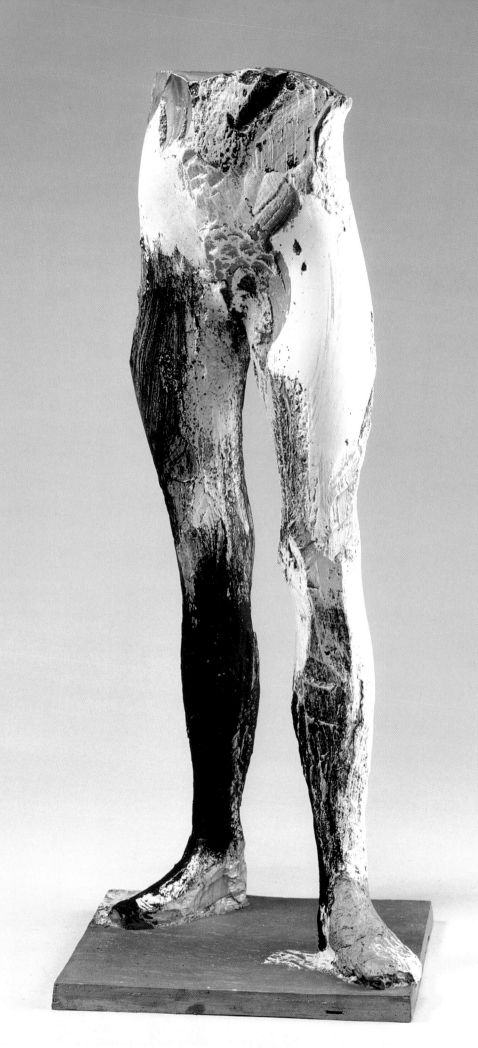

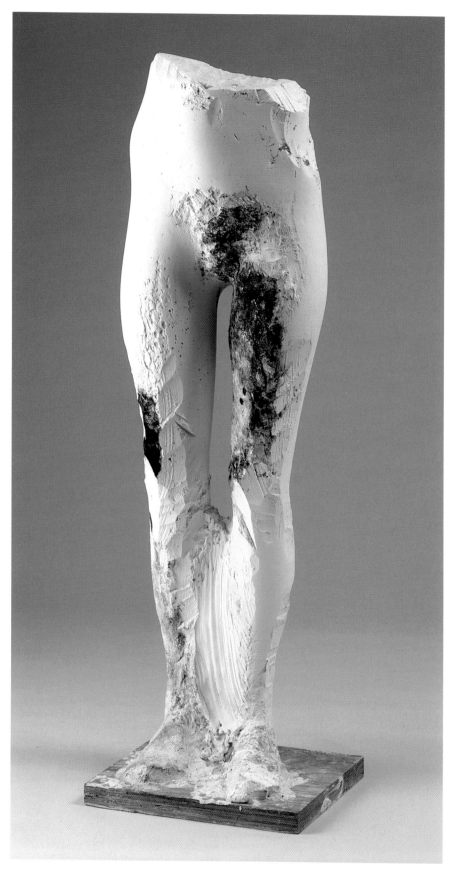

Left:
456. *Sancas II*, 1991.

Right:
457. *Study for Sancas Series II*,
1993.

Opposite:
455. *Sancas I* (Cast 1/4), 1991.

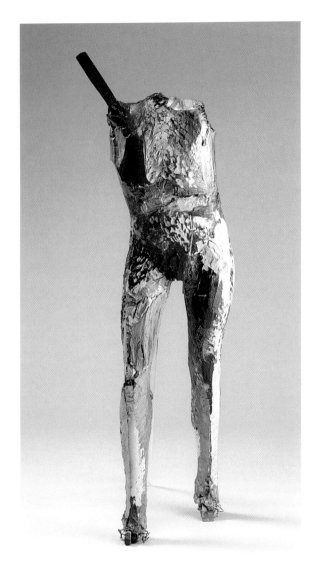

Plaster was particularly well suited to Neri's purposes because, unlike bronze or marble, it was not associated with the grand tradition of figurative sculpture. (Ironically, Neri eventually discovered how to translate his unorthodox approach to the figure into both bronze and marble.) Of necessity he needed a cheap material, and thus necessity is to some degree the mother of his inventions. As a medium, plaster's greatest virtue is its plasticity, and this is exactly what Neri was seeking—a medium that allowed for molding and for altering the surface considerably. Once the plaster dried, he could chop or gouge it as well. All these possibilities served his purposes, for he wanted the figure (predominantly female) to perform three symbolic functions in his work: to be a correlative of his psyche, an "other" who served as an emotional landscape that mapped some aspect of an inner self; to be erotic, a metaphor for desire and the varied emotions that desire stirs; and to be the carrier of associations with the antique world—goddesses, allegorical embodiments of the earth and regeneration—whole or fragmentary.

Untitled Standing Figure, 1957–58 cuts both ways—revealingly. Headless and footless, it resembles the ancient fragment ravaged by time and circumstance. It is also armless, except for the stick that protrudes savagely from the right arm socket, and this seems an expression of the artist's turmoil as much as any formal device. The slashing application of color only adds to the impression that the piece is a correlative for the artist's state of being as much as it is a meditation on the figure. Feeling alien could take the form of violence imposed upon the figure, which was, perhaps, a way of giving shape to the ambivalence Neri felt toward both the culture in which he lived and idealized approaches to the figure. Joan Brown's description of Neri at work, in the late 1950s, reinforces this last point: "Manuel would put on plaster real fast, take a hatchet real fast, cut that arm off, throw it away and twenty minutes later, he's got a new arm on there."[5] Working so rapidly, in what Brown called an "electric, terrible hurry," it was as if he were following the surrealists' recipe for automatic writing or Harold Rosenberg's notion of action painting.

As the late Thomas Albright perceptively surmised, Neri's approach to the making of the figure served to adapt Harold Rosenberg's concept of action painting to something other than picture making. In his famous essay "American Action Painters," Rosenberg, in the passage most relevant to Neri's art, asserted:

> A painting that is an act is inseparable from the biography of the artist. The painting itself is a 'moment' in the adulterated mixture of his life—whether moment means the actual minutes taken up with spotting the canvas or entire duration of a lucid drama conducted in sign language.[6]

458. *Untitled Standing Figure,*
 1957–58.

Opposite:
Left:
459. *Untitled Female Figure,*
 c. 1958.

Right:
460–61. *Untitled Male Figure,*
 c. 1958.

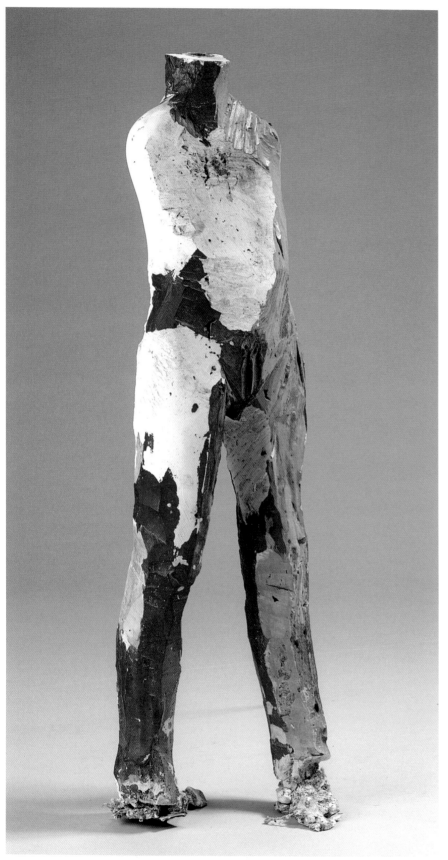
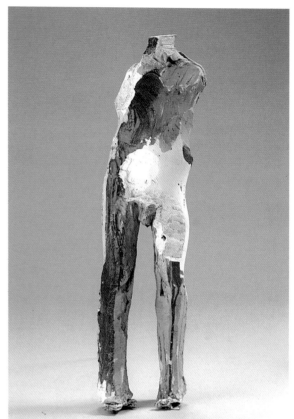
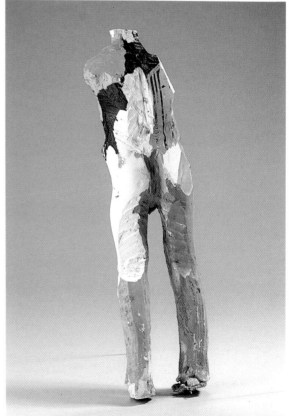

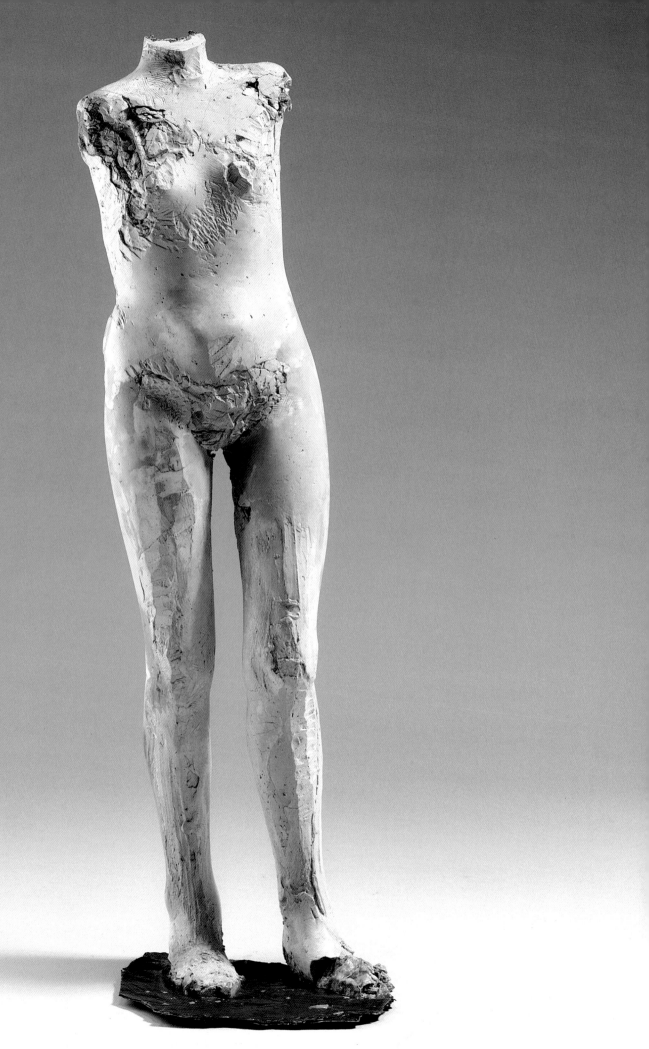

The figure became Neri's sign language, its inexhaustibly inventive permutations his vocabulary. But as with the oeuvre of most artists of enduring importance, that language and that vocabulary did not emerge full-voiced but in an evolutionary or accretionary fashion.

Clearly, the 1960s were a period of retrenchment and evaluation for Neri. His encounters with European art, recent and antique, clarified his understanding of the figure as sculptural form and the essential elements of gesture, as he continually explored a means to achieve the expressive power of the universal in a work securely rooted in the contemporary world. Accounts of Neri's and Joan Brown's 1961 trip to Europe have underscored its importance to his career (see John Beardsley's essay, "The Hand's Obligations," in this volume). "Neri was particularly inspired by the fertile imagination of Francis Picabia and by the Elgin marbles," writes Caroline A. Jones.[7] This view seems correct. He produced a number of important sculptures in 1961 and 1962: kneeling figures and shrouded figures, most made as fragments, which resonate powerfully with references to ancient objects. This trip made Neri rethink his relationship to the past. He confided to Thomas Albright in 1975 that his travels presented him with "the real tradition art has behind it." In that same interview, Neri also said, "I wanted to reinvestigate all the raw ideas that I'd thrown out over the past five years, to get something more than just immediacy. So all that junk I turned out during the funk period I carefully reexamined and reworked."[8]

Of course he was not producing "junk" during the 1950s and 1960s; rather, Neri was composing seminal and crucial works. The key phrase here is "reexamined and reworked," for this is what he was to do in the 1970s, beginning with fiberglass figures cast from earlier plasters, and with the committed resumption of his figurative work in plaster. (He had never stopped drawing the figure, even when his attention shifted to architectonic sculpture inspired by pre-Columbian architecture.)

Neri's choice of fiberglass is intriguing; through castings, it allowed him to accomplish something new with older works. Fiberglass, a translucent material, would highlight the spiritual dimension of Neri's attention to gesture. To the focus on surface, pose, and form, it adds the play of light. Skin becomes radiant, body seems nearly dematerialized. The results were stunning, though this medium clearly had limited appeal for Neri: he shortly turned, once again, to plaster, and in expanding his oeuvre turned to bronze and marble in a committed fashion, translating his vision of the figure into these media.

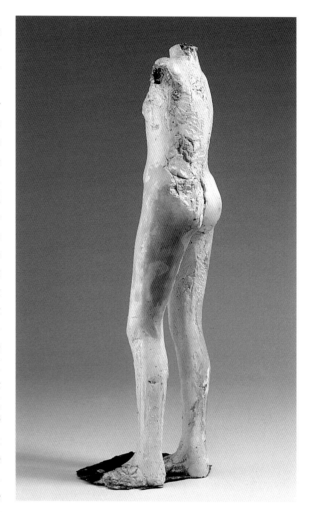

462–63. Untitled, c. 1960s; Reworked 1972.

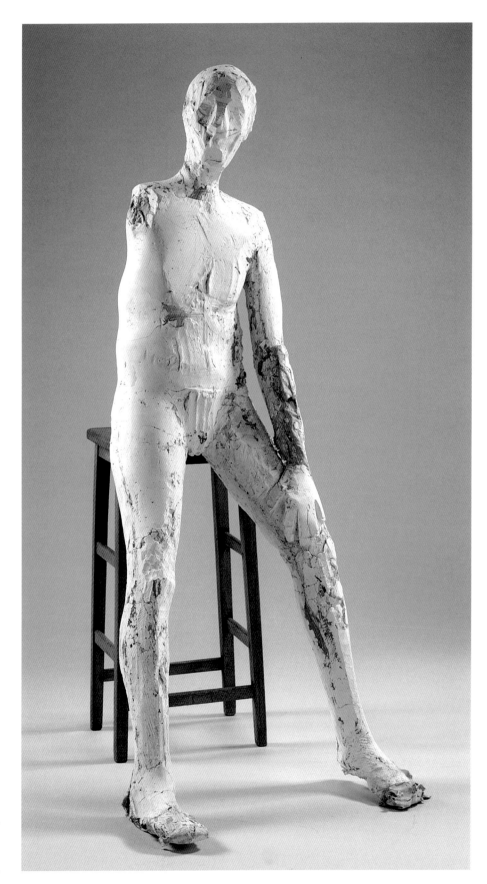

464. *Seated Male Figure*, 1959.

Opposite:
465. *Fragment No. 2 from
 Seated Male Figure*, 1972.

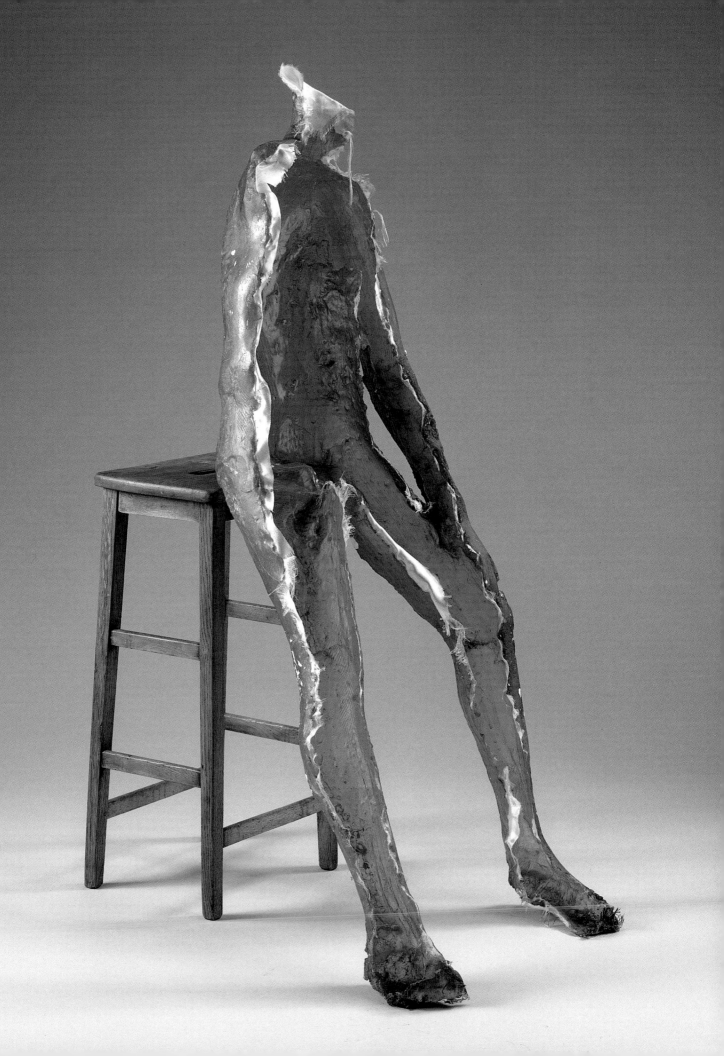

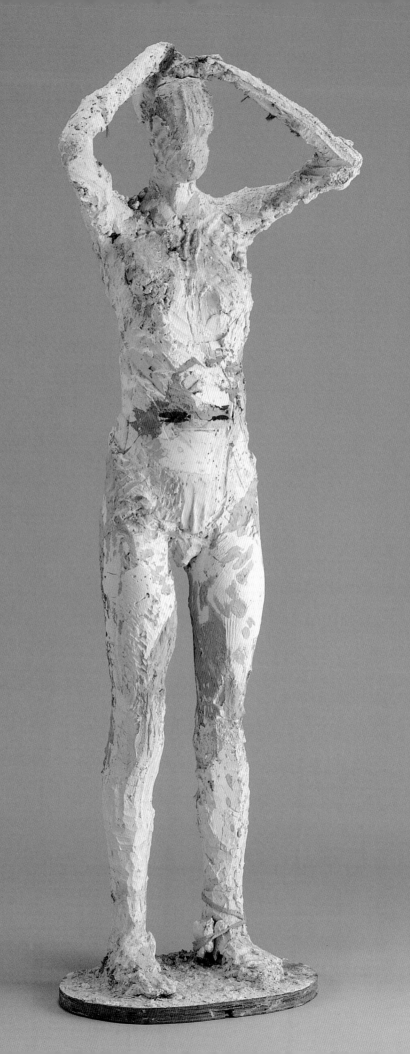

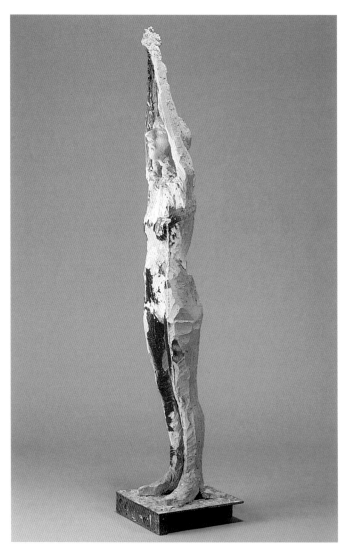

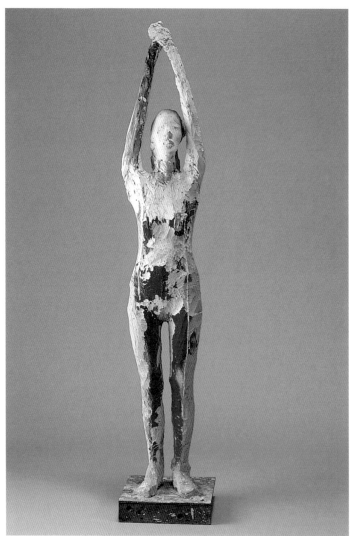

The early to mid-1970s were remarkable years for Neri. He crystal-
lized his vision of the figure, the fragment, and the head. In each category
he worked with greater confidence. In both figure and fragment the poses
were more theatrical, lending greater intensity to his concept of the gestural
and gesturing figure. It was as if, intentionally or not, he were thumbing
his nose at the formalist notion that art of our time should be antitheatrical,
that it should not depend on stage presence, as Michael Fried remarked in
his essay "Art and Objecthood" (1967).[9] One of Neri's accomplishments
during this time was to make his figures seem as if they were frozen per-
formers in some ongoing, unfolding emotional drama. An untitled painted
plaster figure stretches her arms and hands far above her head, making her
seem quite vulnerable to our gaze. Patches of red pigment on the sculp-
ture make that vulnerability all the more poignant, since she appears sym-
bolically wounded. *Untitled Standing Figure*, 1974, is spindly, female but
resonant with androgynous connotations; she holds her hands on her head
in a pose of puzzlement. Another untitled figure, without arms or head,
seems to stride confidently across the stage, its left leg extended forward
and body held straight (figs. 469–70).

467–68. Untitled, 1968;
Reworked 1974.

Opposite:
466. *Untitled Standing Figure*,
1974.

Following pages:
469–70. Untitled, 1974.

273

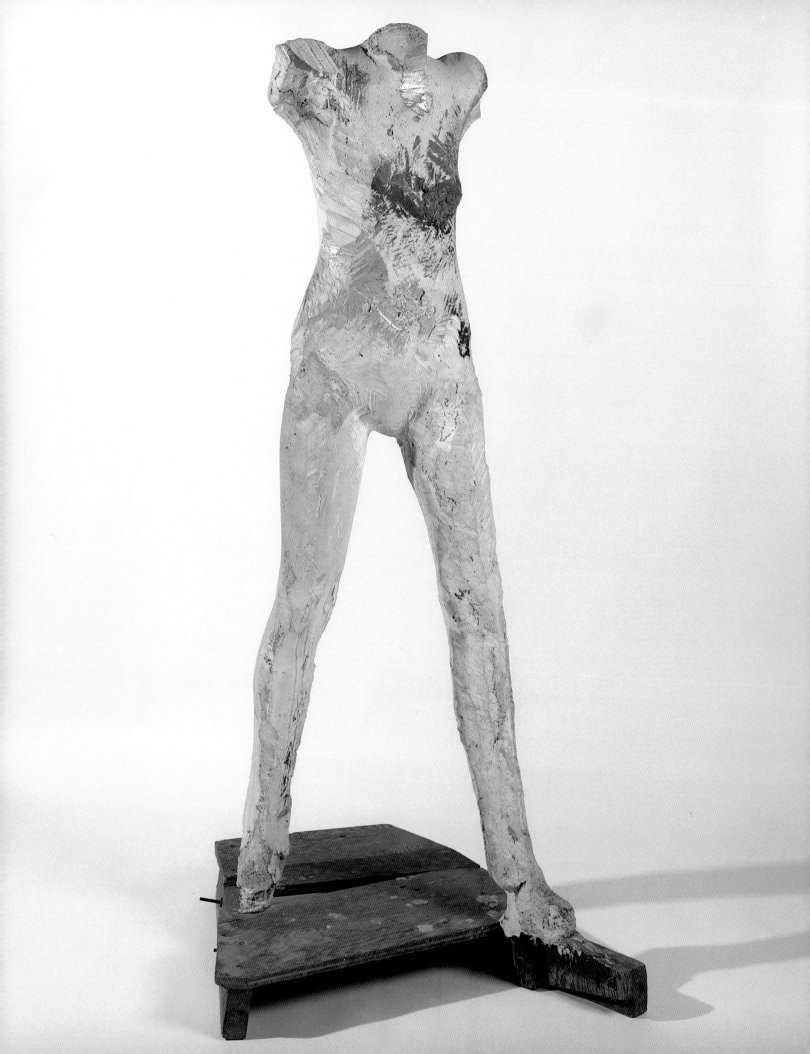

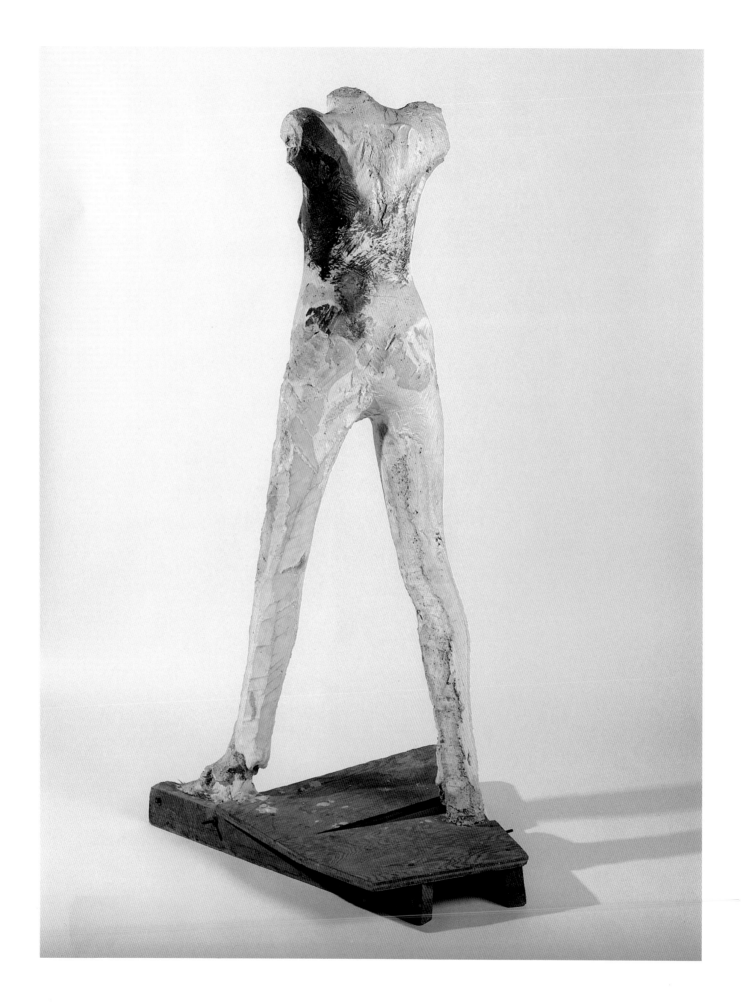

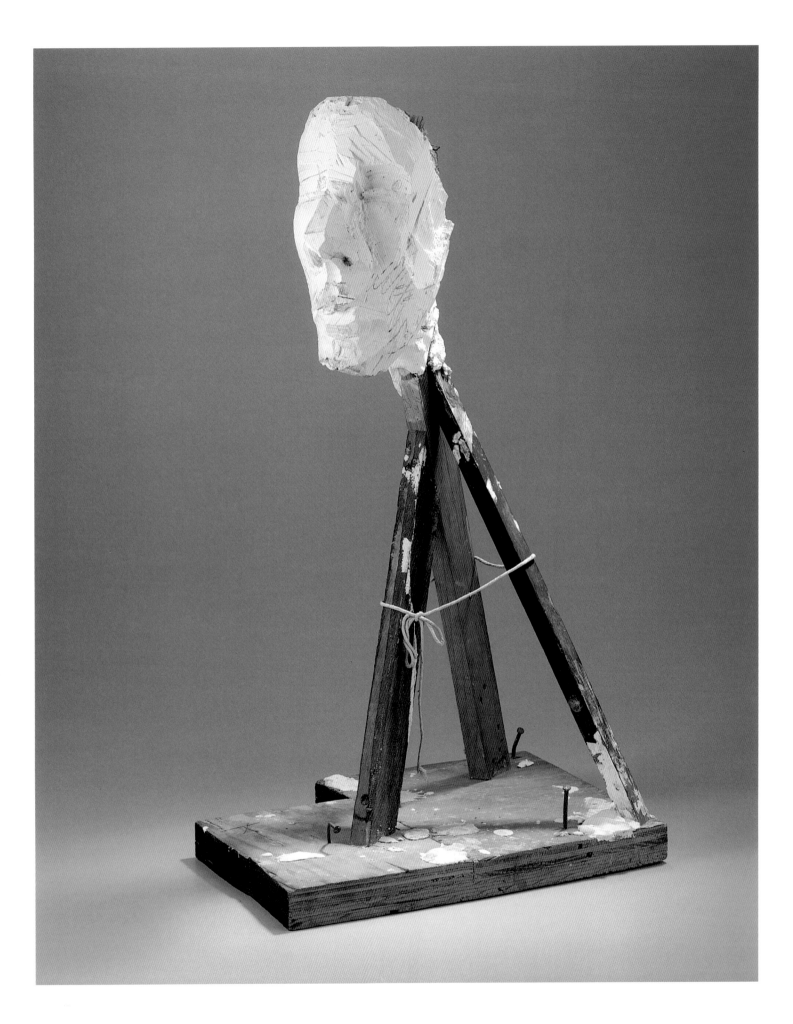

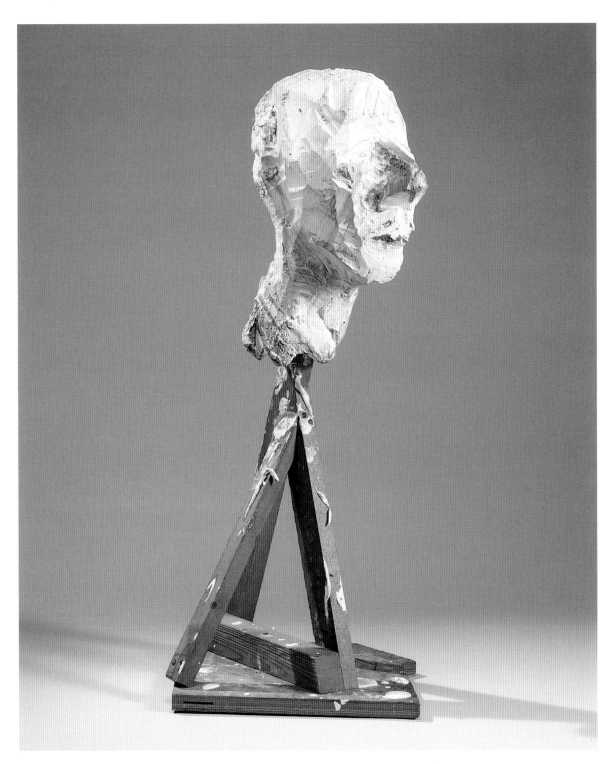

Neri's heads, many begun in the late 1960s and reworked during the early 1970s, offer a dramatically different experience, but the intensity is quite comparable. They appear almost stoic, until one scrutinizes them closely, for their seriousness is palpably somber; their bases, reminiscent of those Alberto Giacometti employed for his heads, are akin to curiously stunted bodies.

472. *Mi China,* c. 1969;
 Reworked 1972–74.

Opposite:
471. *Male Head No. 1,* c. 1969;
 Reworked 1973.

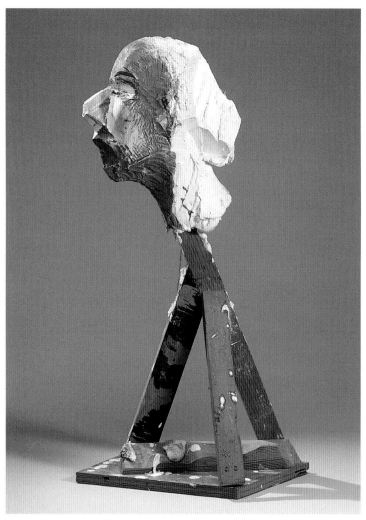

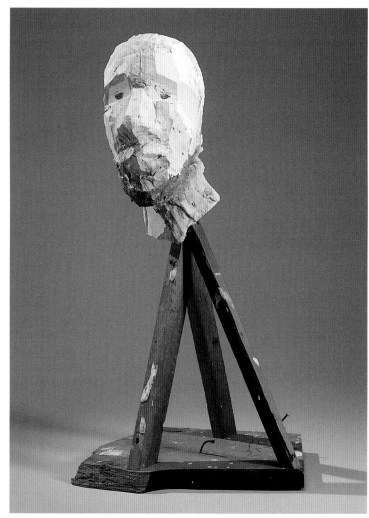

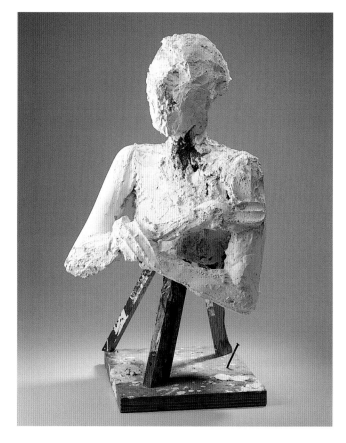

Top left:
473. *Female Head No. 2,*
 c. 1969; Reworked 1972–74.

Top right:
474. *Male Head No. 5,* c. 1969;
 Reworked 1972–74.

Bottom:
475. *Busto de Mujer No. 9,*
 c. 1969; Reworked 1972–74.

Opposite:
476. *Busto de Mujer No. 1,*
 c. 1969; Reworked 1972–74.

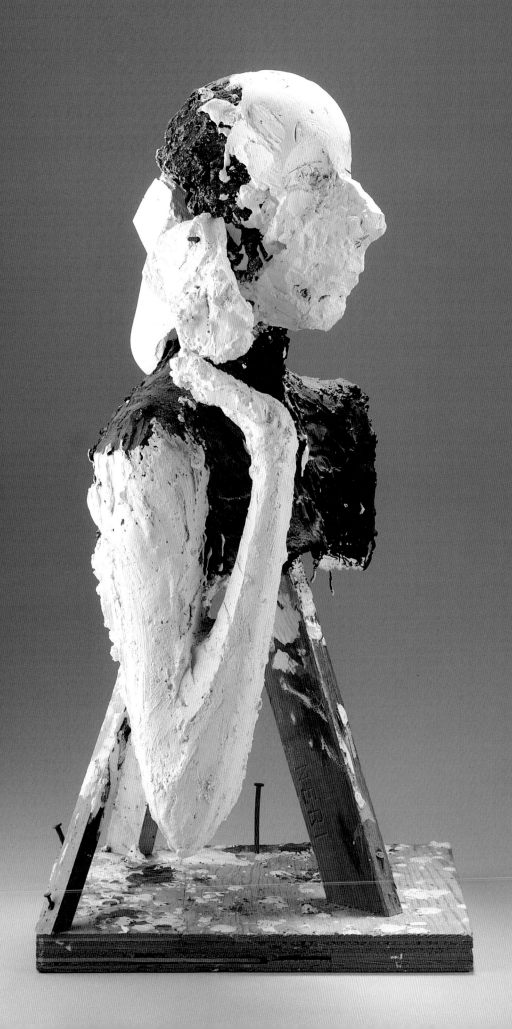

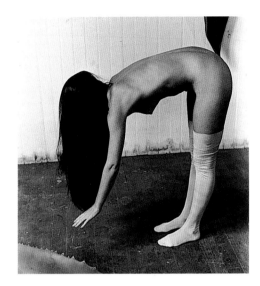

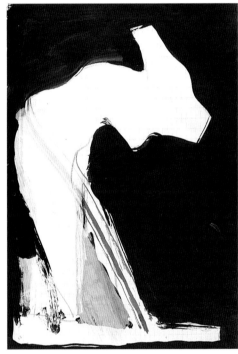

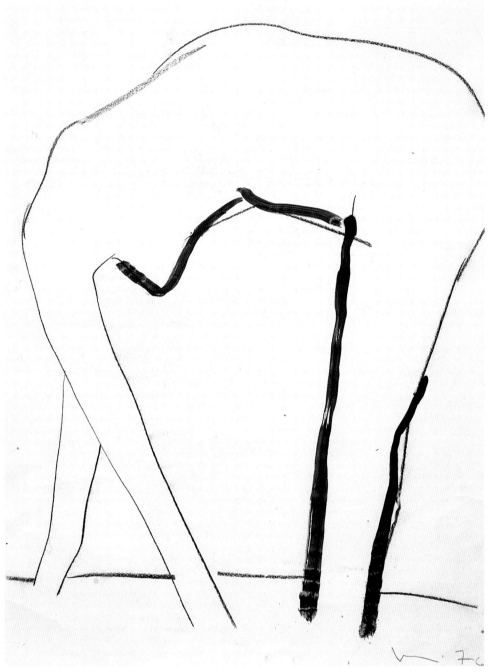

Top left:
477. Mary Julia posing, 1976.
 Photo by Manuel Neri.

Bottom left:
478. *Miseglia Sketchbook,*
 page 23, c. 1975.

Right:
479. *Figure Study—Didi No. 14,*
 1976.

Quite often, Neri has focused on a specific pose, attracted by both the gestural implications and abstract possibilities of the form, as well as historical associations. This is clearly demonstrated in a series of drawings from the mid-1970s titled *Didi*, in which Neri repeatedly explores an idea that first appears in an early sketchbook and is also reflected in his early plaster *Bather*s. The figure is bent so that hands and feet connect to the earth, in a pose related to the Egyptian goddess of night, Nut, whose form embraces the sky. Neri makes numerous sketches and drawings of the pose, which he abstracts through the use of color and distortion of the figure; but rather than merely serving as a direct allusion to the antique world, for Neri the pose becomes clearly erotic. The idea again comes forth as sculpture in the *Bull Jumper* series of plaster figures begun in 1980, and in the later *Isla Negra* series of drawings and plaster maquettes. The *Bull Jumper* series is unabashedly erotic, placing the woman in an animalistic pose, yet the sculptures also make direct reference, in the shape of the head and the variety of poses, to a small ivory figure with movable limbs of circa 1600 B.C. from the Palace at Knossos, thought to allude to an ancient ritual in Crete in which adolescents of both sexes performed death-defying acrobatics, grabbing the horns of a bull and vaulting over its back.

Left:
480. *Unos Actos de Fe Sketchbook*, page 21 (verso), c. 1974–76.

Right:
481. *Figure Study—Didi No. 3*, 1976.

281

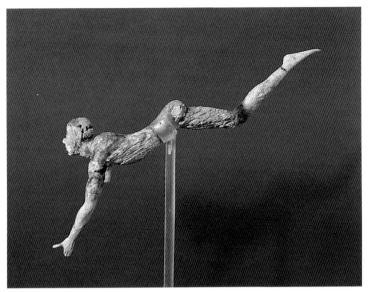

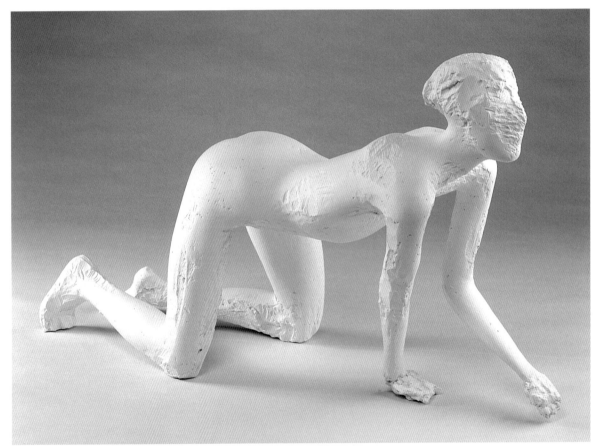

Top left:
482. Ivory figure of a bull-
 leaper from the palace
 at Knossos, c. 1600 B.C.

Top right:
483. *Study for Bull Jumper
 No. 11*, c. 1980.

Bottom:
484. *Bull Jumper* (in progress),
 1980.

Opposite:
Top left:
485. *Study for Bull Jumper
 No. 2*, c. 1980.

Top right:
486. *Study for Bull Jumper
 No. 3*, c. 1980.

Bottom:
487. *Isla Negra No. 13*, 1987.

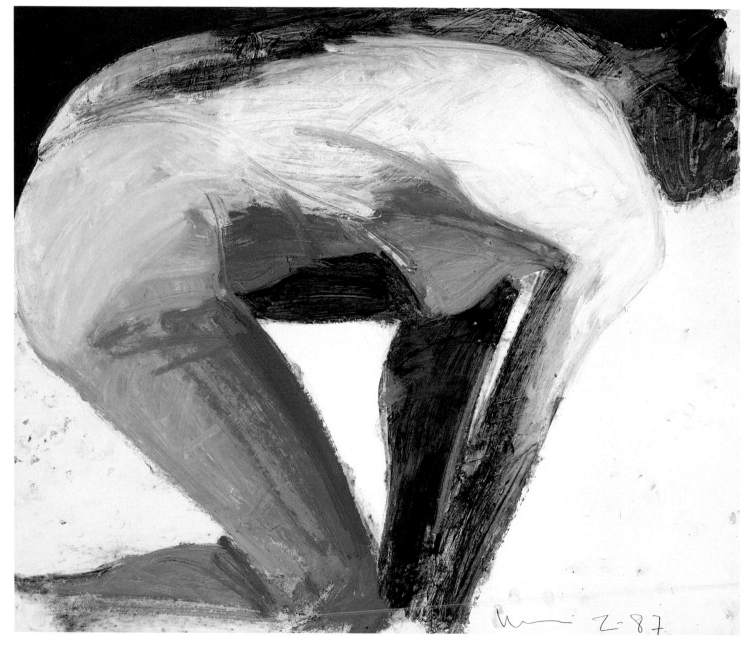

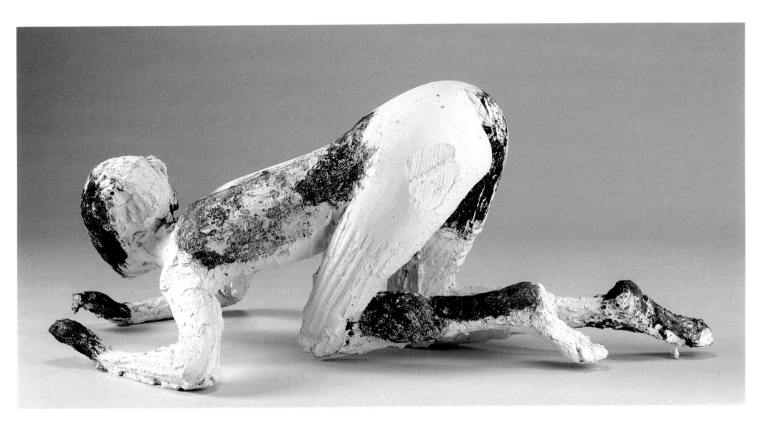

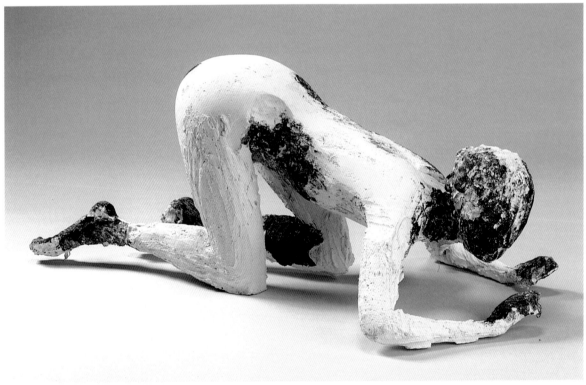

488–89. *Bull Jumper II*, 1989.

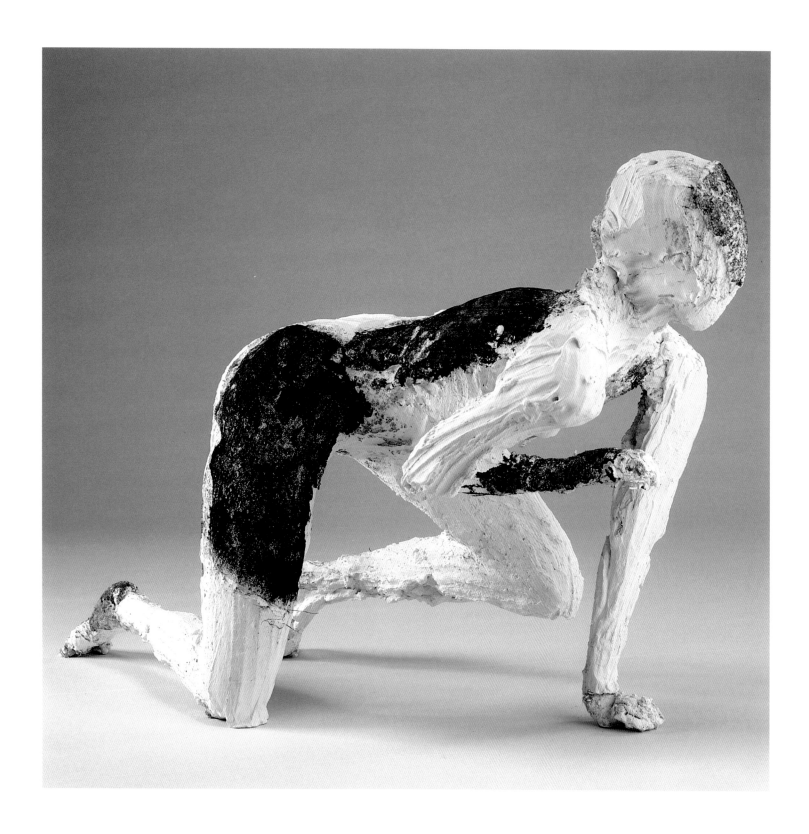

490. *Bull Jumper III*, 1989.

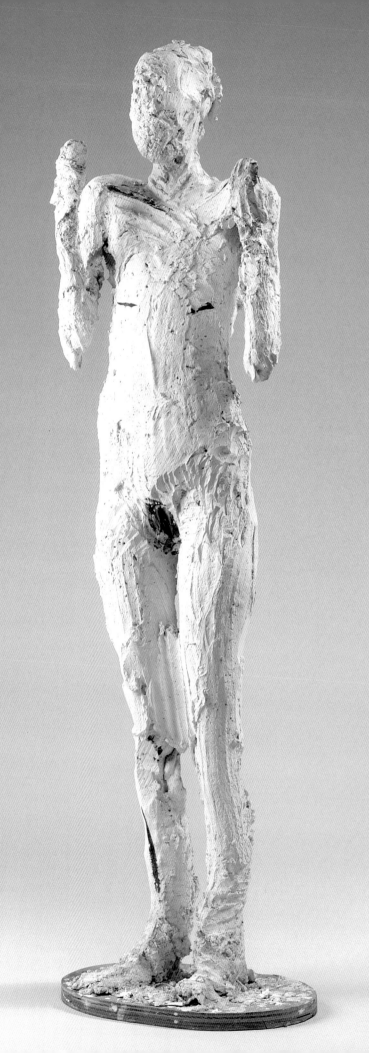

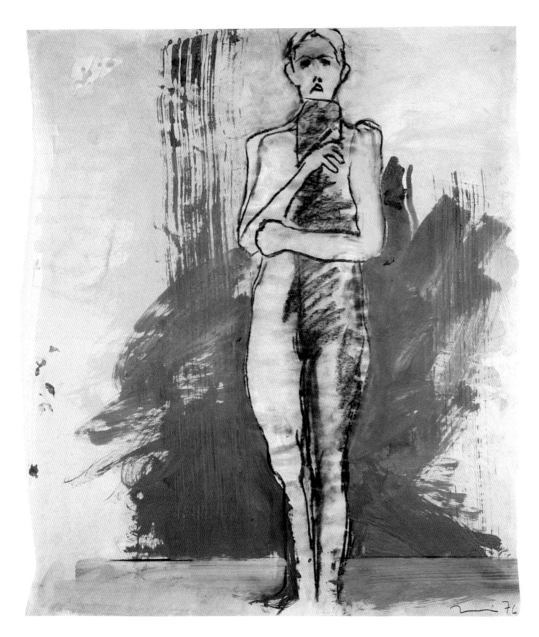

By 1976, the year of Neri's exhibition "The Remaking of Mary Julia," the poses had acquired a new vitality. Surely Mary Julia Raahauge herself, his primary model since 1972, was a key factor in this development. She "had a fantastic intensity about her body," Neri later recalled; for the sculpture, he added, "I wanted that same intensity with a varied, strong, active surface but as minimal as possible."[10]

Intriguingly, the impressive array of figures from 1975 and 1976 are also anticipated in his sketchbooks. The new armature of steel rebar and styrofoam, introduced in 1972, provided Neri's figures with a new malleability, a range of gesture closer to drawing. A powerful untitled standing figure of 1976 has a relaxed stance, one arm resting on her hip and the other raised, with tensed palm, as if she is signaling some message to the viewer; another, *Untitled VI* (figs. 496–97), has arms pulled taut behind her back, and the body is posed more tightly. Still others crouch, sit, and recline in highly theatrical ways.

492. *Mary Julia V,* 1976.

Opposite:
491. *Julia,* c. 1976.

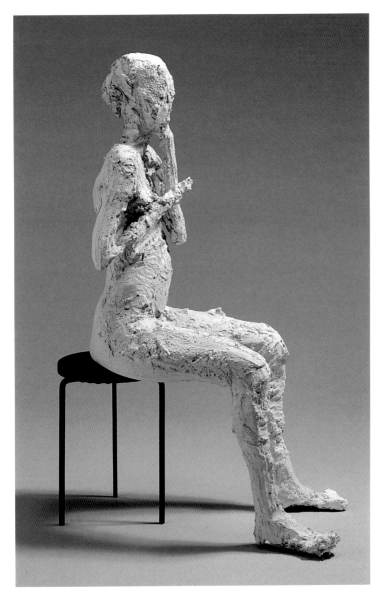

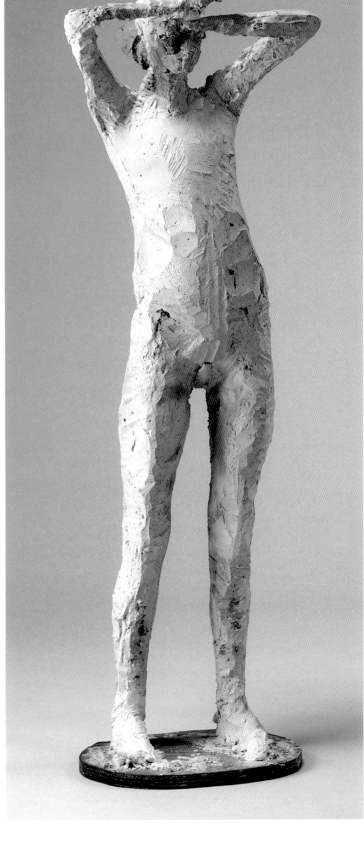

Left:
493. *Untitled Seated Female Figure No. 1*, 1976.

Right:
494. *Untitled I*, c. 1976.

Opposite:
495. *La Niña de la Piedra*, 1978.

Following pages:
496–97. *Untitled VI*, 1976.

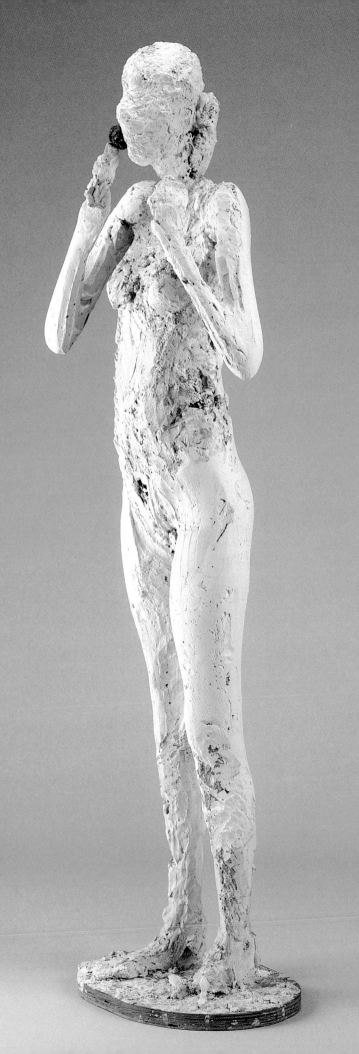

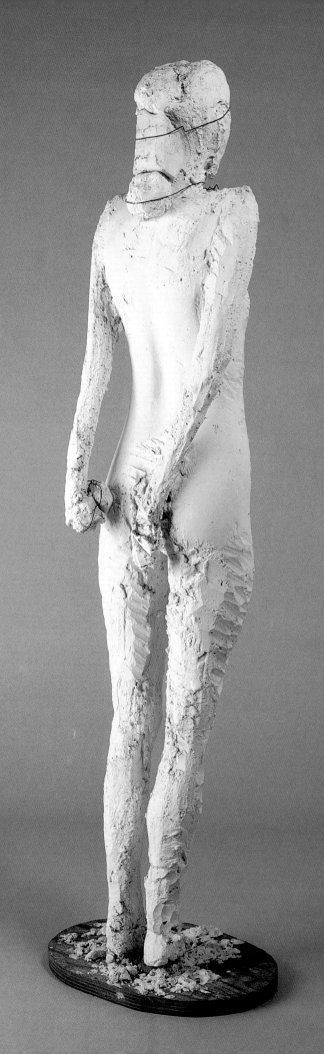

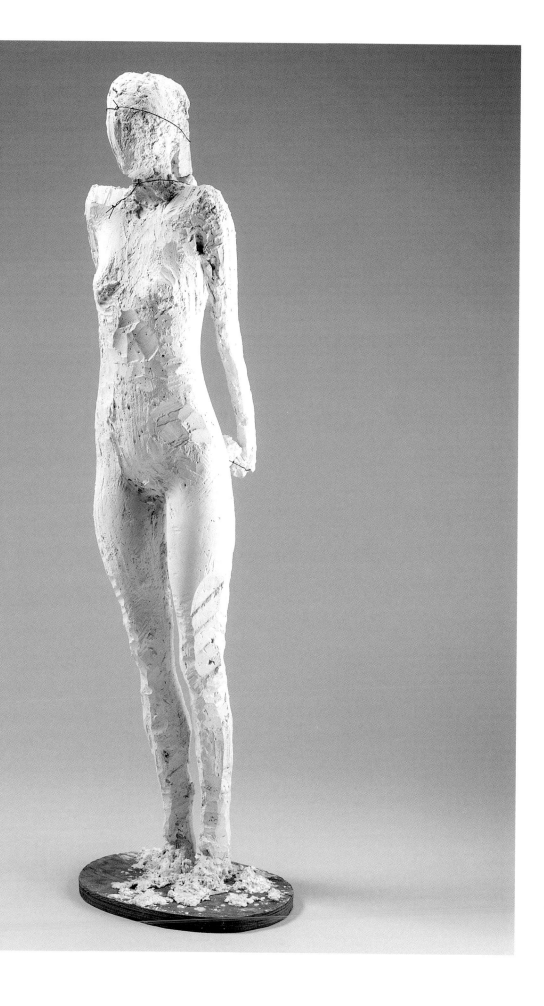

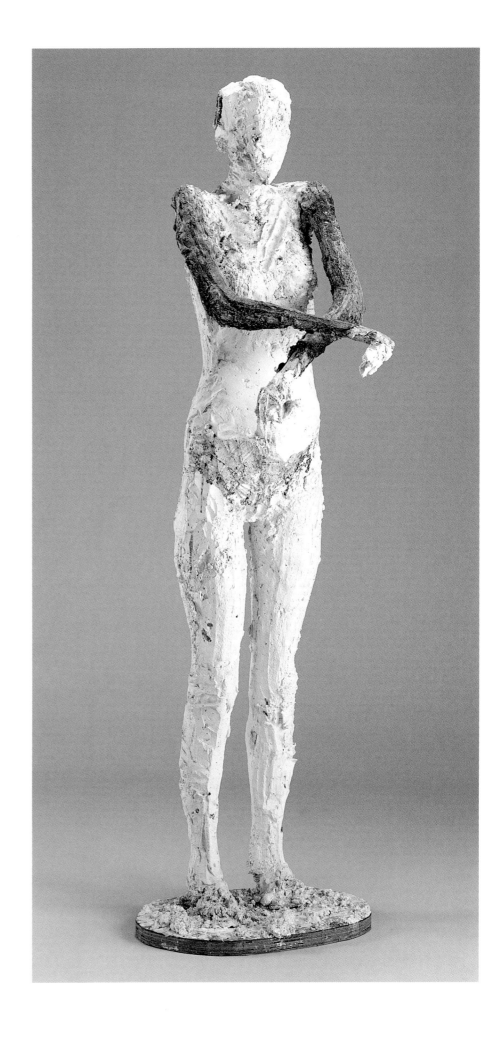

498. *Brazos Negros*, 1977–78.

Opposite:
499. *Untitled Standing Female
 Figure No. 4*, 1978.

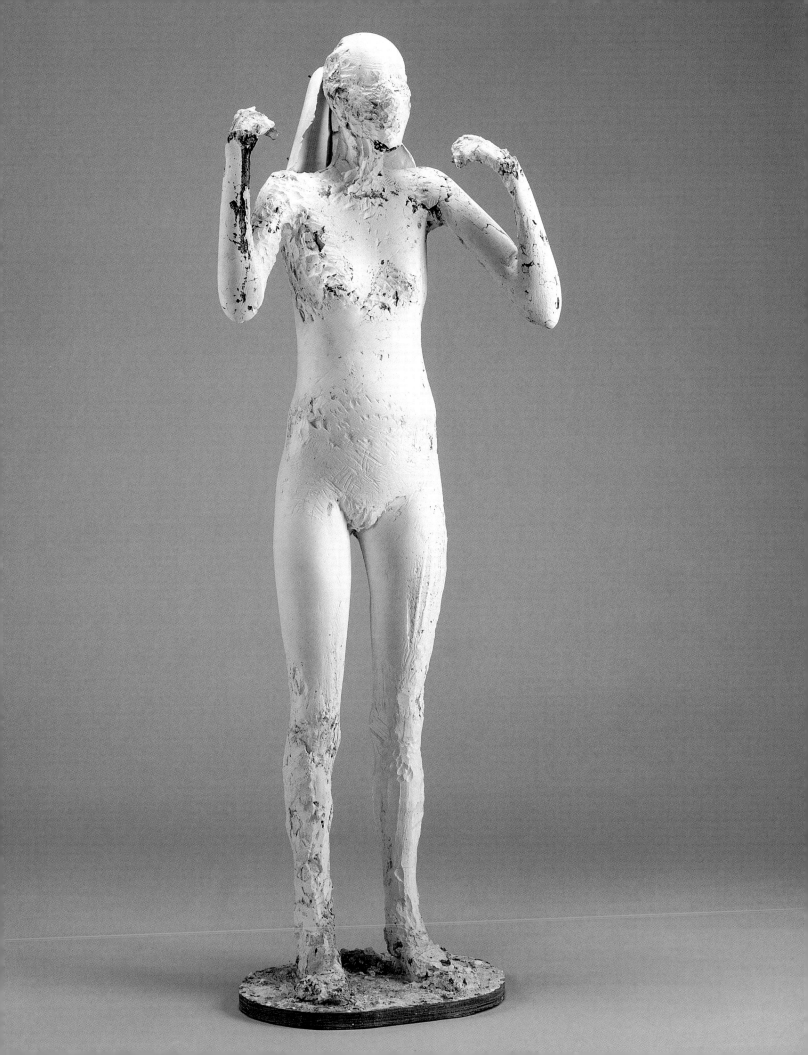

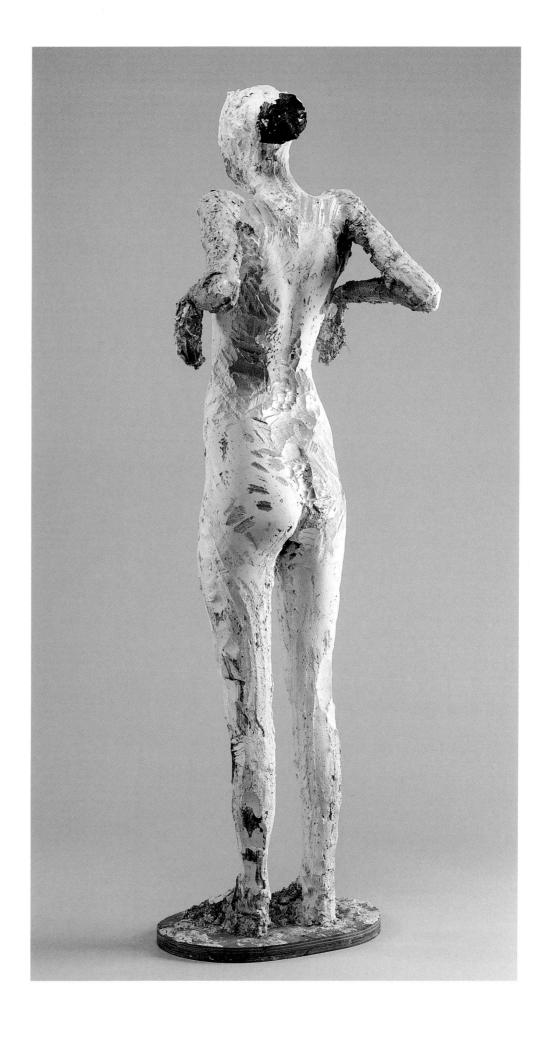

500–501. *Standing Figure No. 1,*
1976; Reworked 1979.

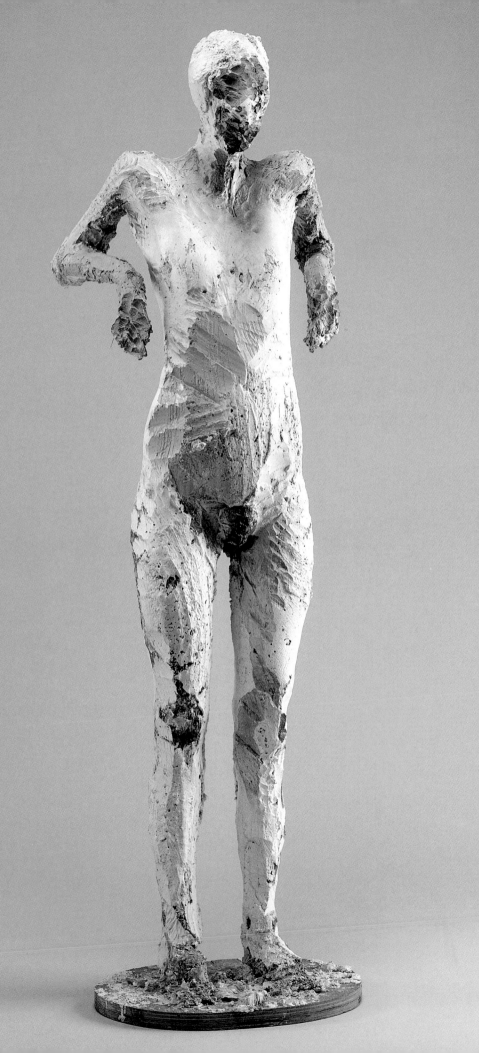

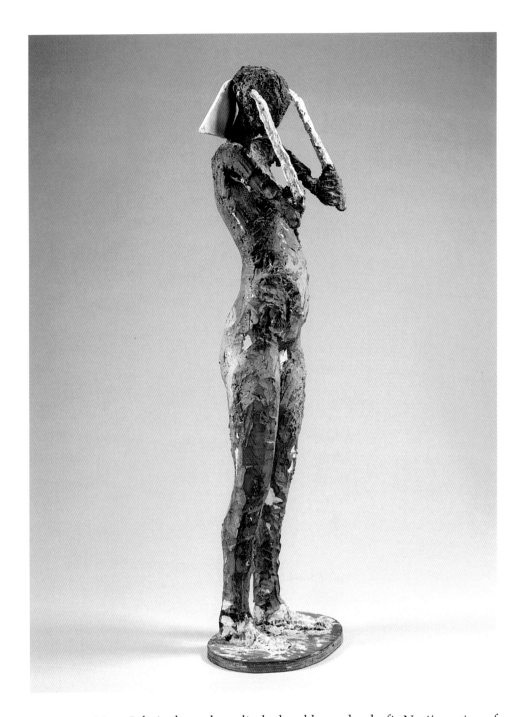

Mary Julia's shape, long-limbed and lean, clearly fit Neri's notion of anticlassical proportions. In place of the squat shape of the body in *Chula* and related sculptures of the late 1950s and early 1960s, however, she presents the viewer with a most graceful contour. With *Julia* (fig. 491), a figure clearly named for his longtime model, the figure is complete, her arms are raised, and Neri makes us acutely aware that this is a figure posing, since the posture is not one conventionally associated with sculpture. There is a greater willingness, in his figures of this period, to allow his formal virtuosity to reveal itself. Neri doesn't feel the need, as his 1975 interview with Albright reveals, to be funky as a way of apologizing for or concealing his power as a figurative sculptor.

The exhibition "The Remaking of Mary Julia" can be viewed as Neri's confident declaration of the importance of the model to his mature work. All of his sculptures are spectral presences that draw upon associations from the entire history of the figure, fragment, and bust; but at the same time they are quintessentially of our time, rife with anxiety about our place in the ecosystem and the cosmos. Thus figurative sculpture was intimately linked to nature, though Neri clearly never believed it should replicate it. His art embraces the flaws of nature—all those wrinkles, pouches, and blemishes that, as Kenneth Clark observes, the history of the figure has marginalized. Neri has made these flaws integral to his oeuvre through the proportions he gives his figures and in the ways he varies their surfaces. Yet his nudes have a dignity equal to if different from those of the past. By providing them with this dignity, he has made a significant accomplishment. Neri would have his sculptures speak to us in a more intimate fashion than nudes of the past. They do this quite decisively. They all seem to speak in the same tongue, each adding a line, some a stanza, to Neri's long and poignant poem made material, about the ways the figure embodies past and present, flesh and spirit, mortality and the yearning for immortality. In forging his own identity as a sculptor, Neri has expanded the concept of beauty as it applies to the figure.

NOTES

1. Federico García Lorca, *A Poet in New York*, edited by Christopher Maurer, translated by Greg Simon and Steven F. White (New York: Farrar, Straus, Giroux, 1988), pp. 155–63. Allen Ginsberg, *Collected Poems 1947–1980* (New York: Harper & Row, 1984), p. 136.

2. Ginsberg, *Collected Poems*, pp. 138–39.

3. Kenneth C. Clark, *The Nude: A Study in Ideal Form* (New York: Pantheon Books, 1956), p. 7.

4. Quoted in Caroline A. Jones, *Manuel Neri: Plasters*, exhibition catalogue (San Francisco: San Francisco Museum of Modern Art, 1989), p. 14.

5. Caroline A. Jones, *Bay Area Figurative Art: 1950–1965* (Berkeley: University of California Press, 1990), p. 136.

6. Harold Rosenberg, "The American Action Painters," in *The Tradition of the New* (New York: Horizon Press, 1959), pp. 27–28. Thomas Albright, *Manuel Neri* (San Francisco: John Berggruen Gallery; Santa Monica, CA: James Corcoran Gallery; New York: Charles Cowles Gallery, 1988), p. 7.

7. Jones, *Manuel Neri: Plasters*, p. 9.

8. Thomas Albright, "Manuel Neri: A Kind of Time Warp," *Currant* (April/May 1975), p. 14.

9. Michael Fried, "Art and Objecthood," *Looking Critically: 21 Years of Artforum Magazine*, edited by Amy Baker Sandback (Ann Arbor, MI: UMI Research Press, 1984), pp. 61–68.

10. Jones, *Manuel Neri: Plasters*, p. 10.

LIFE OF THE ARTIST:
An Illustrated Chronology

1930 John Manuel Neri is born April 12 near Sanger, in the San Joaquin Valley of California. His parents, Manuel and Guadalupe Penilla Neri, are Mexican immigrants from Arandas, Jalisco, who had fled the political turmoil that followed the Mexican Revolution.

Manuel's maternal grandfather José Ma. Penilla (1850–1937), in apron at left.

Opposite:
Manuel Neri, 1992.

Locket with photo of Manuel's paternal grandfather, José Neri.

Manuel Neri Sr.

Guadalupe Penilla Neri (left) with her sister, Francisca (Pachita), August 1947.

Manuel Neri, grammar school, c. 1940.

"Recuerdo de 1ra. Comunión." Cousins Emanuel and María Concepción Martínez Penilla, Arandas, Mexico, 1938.

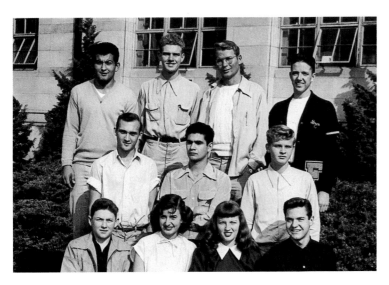

Fremont High School Science Club (Neri in center), c. 1948.

Neri with his cousin George Ramirez, c. 1948.

1932–
1934 The Neri family (Manuel Sr., Guadalupe, and children
 Andrew, María, Manuel, and Mary Helen) moves to Canoga
 Park, in the San Fernando Valley north of Los Angeles.
 Manuel Neri Sr. opens a shoe business. When the business
 fails he attends school to learn automobile repair. He eventu-
 ally finds agricultural work on a small ranch in Tarzana,
 California.

1935 The Neri family returns to Sanger, where Manuel Sr.
 continues to work in agriculture.

1940 *March 24* Manuel receives First Communion at St. Mary's
 Catholic Church in Sanger.

1942 *April 26* Manuel is confirmed at St. Mary's Church.

1943 Older brother Andrew dies from complications of
 pneumonia.

1944 Manuel Neri Sr., who has been diagnosed with tuberculosis
 and liver malfunction, dies.

 Guadalupe Penilla Neri moves with her children to Oakland,
 where she finds work at an electronics factory.

1947 *January* Completes Roosevelt Junior High School in
 Oakland.

 February Enters Fremont High School.

1948 *September* Drops out of high school to help support the
 family, working as an equipment installer for Western Union.

Guadalupe Penilla Neri (right) and Manuel's sister Helen on the front steps of their house in Oakland, California, June 24, 1950.

"Mad Genius," Oakland, June 1950.

Neri at the beach, July 3, 1950.

First year at California College of Arts and Crafts, 1951.

1949 *May* Returns to high school and takes summer courses.

1950 *June 16* Graduates from Fremont High School.

Although as a teenager Neri had seriously considered entering the priesthood, he decides to study engineering and enrolls at San Francisco City College. To offset the heavy science load at City College, he takes a ceramics class. Encouraged by his teacher, Roy Walker, he also audits classes at the California School of Fine Arts in San Francisco (CSFA, later renamed San Francisco Art Institute), including those taught by Clyfford Still and Mark Rothko.

In the fall, he completes the required pre-engineering courses at City College in order to enter the University of California, Berkeley.

1951 While auditing engineering classes at UC Berkeley, Neri remains registered at City College for the spring, and decides to dedicate himself fully to studying art. He leaves City College mid-semester and enrolls during the summer at California College of Arts and Crafts (CCAC) in Oakland. At CCAC, he studies in the ceramics department and meets fellow students Nathan Oliveira and Peter Voulkos (who was completing a Master of Fine Arts degree).

Manuel and Marilyn Hampson Neri leaving their wedding reception, August 2, 1953.

1952 Remains enrolled at CCAC through the fall term.

Spends the summer setting up a ceramics workshop with Peter Voulkos at the Archie Bray Foundation in Helena, Montana.

Drafted into the United States Army.

1953 Shows a large ceramic bull in the annual exhibition at the Oakland Art Gallery, for which he receives First Award in Sculpture.

April 18 Completes the army basic training.

August 2 Marries Marilyn Hampson (known as Miem), a fellow student at CCAC, in the Northern California town of Gasquet.

September 18 Completes a course in repeater and carrier equipment installation and maintenance at Southwestern Signal Corps Training Center, Camp San Luis Obispo, California. Is assigned to the Communications Center, Seoul, South Korea.

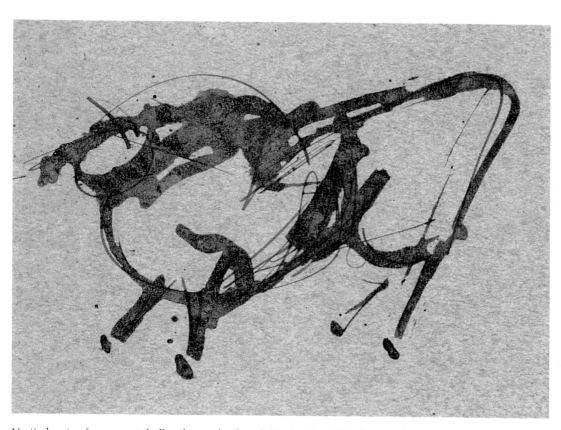

Neri's drawing for a ceramic bull sculpture that he exhibited at the Oakland Art Gallery, 1953.

With wife Miem, 1953.

Stationed in South Korea, 1954.

With son Raoul, 1955.

1954 Neri is posted to Inchon, South Korea.

February 4 While Neri is in South Korea, Miem gives birth to their first child, Raoul Garth.

1955 Discharged from the army, he returns to Oakland and lives with Miem and Raoul at 5103 Lawton Avenue, a house formerly occupied by artist Jay DeFeo. He sets up a studio in the rear and applies for G.I. benefits.

Under the G.I. Bill, Neri returns in the spring to CCAC, where he remains through the fall term of 1956. At CCAC he studies with Frank Lobdell, Jeremy Anderson, Nathan Oliveira, Leon Golden, and Richard Diebenkorn. Makes gestural abstract paintings, assemblage paintings and works on paper, and figurative sculptures.

Becomes involved with the 6 Gallery, a San Francisco artists' cooperative located at 3119 Fillmore Street.

October 7 Helps organize "6 Poets at 6 Gallery," a landmark event of the Beat era, where Allen Ginsberg gives the first full reading of his notorious poem *Howl*. With Kenneth Rexroth as emcee, the evening also features readings by Philip Lamantia, Michael McClure, Gary Snyder, and Philip Whalen.

December 9 Neri and Miem's daughter, Laticia Elizabeth, is born.

Miem with daughter, Laticia, and Raoul, 1956.

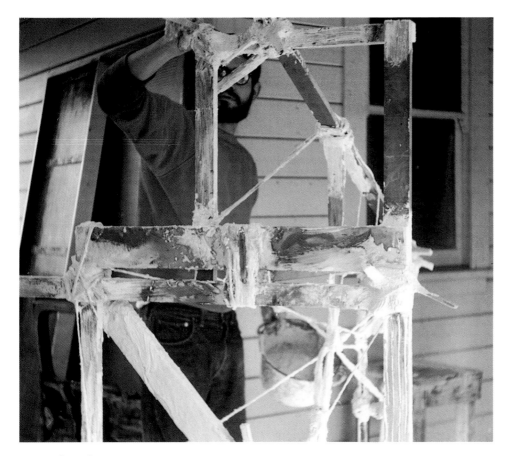

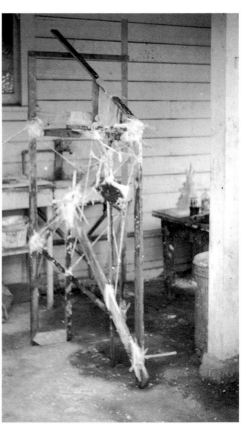

Neri sculptural constructions in progress at CCAC, c. 1955.

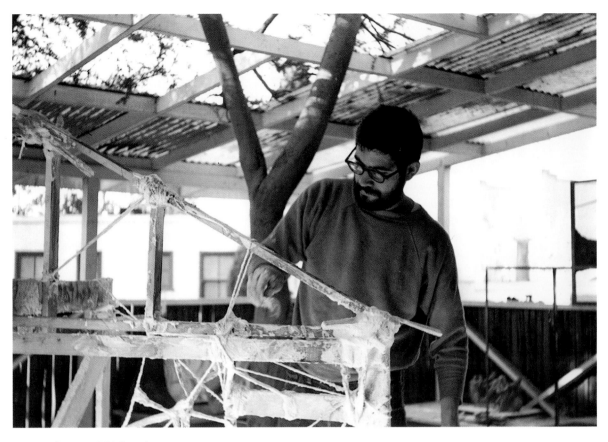

Neri working in CCAC studio, c. 1955.

Neri and CCAC instructor Richard Diebenkorn, c. 1955.

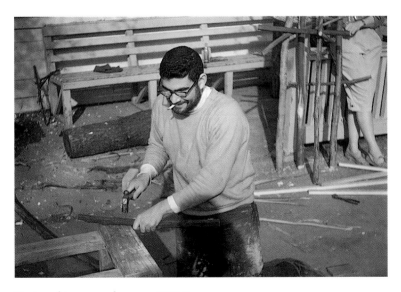

Neri working on sculpture at CCAC, c. 1955.

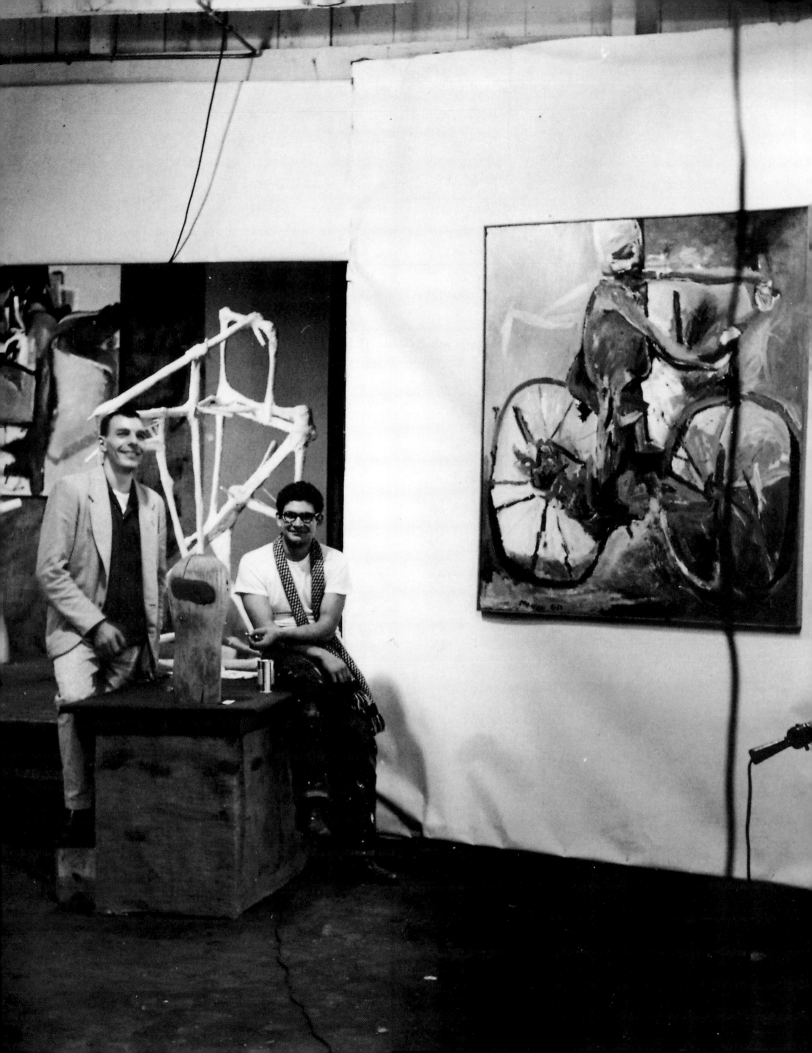

1956 *January* Neri has his first two-person exhibition, with Bruce McGaw, at the 6 Gallery, where he shows life-size plaster and cardboard figures, mixed-media constructions, and assemblage paintings.

Makes his first group of abstract glazed ceramic "loop" sculptures.

Shares his Lawton Avenue studio with fellow student Billy Al Bengston. In the summer he and Bengston travel together to Mexico, visiting archaeological sites.

Neri and Miem separate.

During the fall semester, while still enrolled at CCAC, Neri studies painting with Elmer Bischoff at CSFA. While painting figuratively, he makes abstract sculptures from manzanita and eucalyptus branches, as well as small, fetishlike figures made from materials at hand, such as cloth, string, wood, newspaper, and wire.

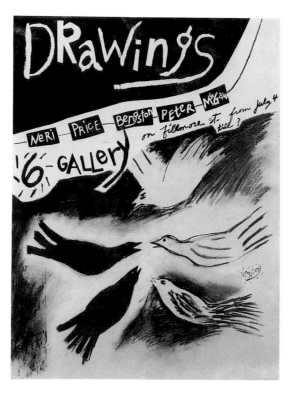

Exhibition poster from the 6 Gallery, c. 1957

Opposite:
With Bruce McGaw at the 6 Gallery during exhibition of
paintings by McGaw and sculptures by Neri, January 1956.

1957 *Spring* Transfers to CSFA and moves to San Francisco.

Continues to study with Elmer Bischoff as well as with Nathan Oliveira.

Meets painter Joan Brown and has impromptu exhibitions with her and other CSFA students at a jazz club called The Cellar in the North Beach area of San Francisco.

Neri has his first solo exhibition, at the 6 Gallery.

Lives with sculptor Peter Forakis at 977A North Point in San Francisco, beginning in June.

Receives a Purchase Award in Painting from the Oakland Art Museum.

Becomes friends with sculptor Mark di Suvero, whom he had met the previous year in Oakland.

Continues to make life-size figurative sculptures in plaster at CSFA. Neri, Forakis, Charles Ginnever, and Tom Hardy share a basement studio under Caffé Trieste on Grant Avenue in North Beach, which Neri later shares with sculptor Alvin Light.

November Moves to 845 Columbus Avenue in San Francisco.

Serves as director of the 6 Gallery until it closes in December.

Opposite:
With Bruce McGaw at the 6 Gallery, January 1956.

With Henry Villierme, c. 1957.

Cardboard armature for plaster bust in Neri's studio,
c. 1957. (Photo: Charles Ginnever)

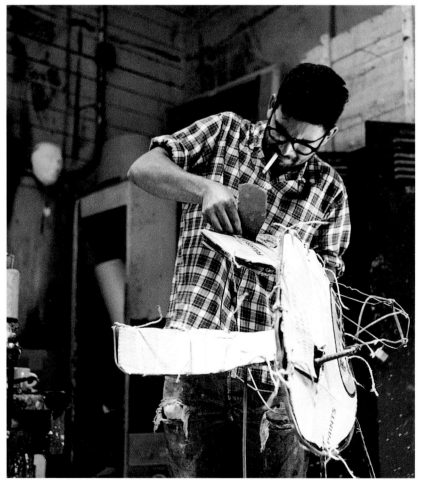

Working on mixed-media construction in sculpture studio, California
School of Fine Arts, c. 1957. (Photo: Charles Ginnever)

Neri's studio, c. 1957. (Photo: Charles Ginnever)

Plaster head in sculpture studio, CSFA, c. 1957.
(Photo: Charles Ginnever)

Plaster heads hanging in Neri's studio,
c. 1957. (Photo: Charles Ginnever)

1958 While working with figurative and abstract sculptural forms, Neri also continues a series of paintings and works on paper begun the previous year, which are thematically linked to the idea of windows as a vehicle for the passage of light.

Neri's G.I. benefits expire, and in the summer he withdraws from CSFA.

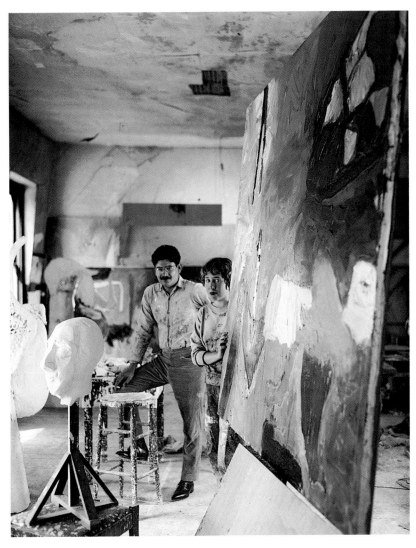

Joan Brown and Manuel Neri in their studio at 9 Mission Street, March 1959.
(Photo: Fred Lyon)

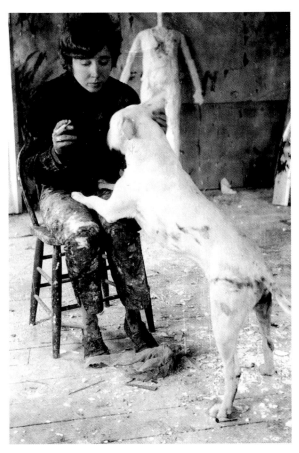

Joan Brown and Bob the dog in studio with Neri's sculptures, c. 1959.

316

1959　Begins teaching sculpture at CSFA after receiving the Nealie Sullivan Award, given annually by the school to a promising young artist, and uses the award to purchase supplies. His new teaching income allows him to rent a large studio, which he shares with Brown, at 9 Mission Street in the Embarcadero section of San Francisco, where he is able to work on a larger scale. Continues the *Window Series* paintings at the Embarcadero studio.

February　Neri's work is included in the exhibition "Four Man Show: Sam Francis, Wally Hedrick, Fred Martin, Manuel Neri," at the San Francisco Museum of Art, in which he shows abstract painted plaster and cardboard sculptures, and large plaster heads.

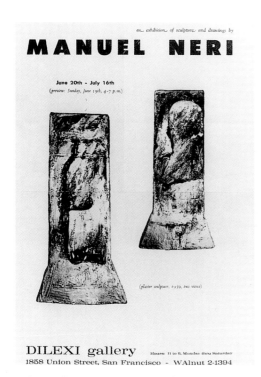

Dilexi Gallery's announcement for Neri's exhibition of sculpture and drawings, 1960.

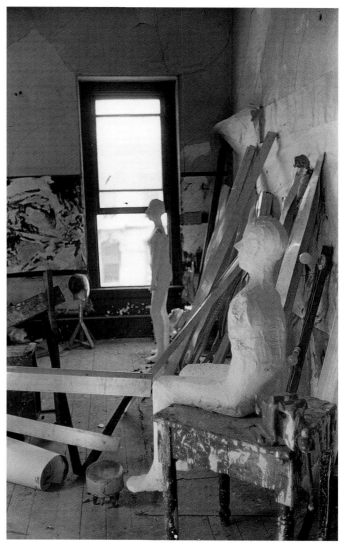

Neri sculptures in 9 Mission Street studio, c. 1959.

Contact sheet and statement, on reverse, submitted by
Neri as grant application, c. 1960–62.

The enclosed photographs are all I was able to gather
on two days notice. I have only these contact prints
of my figurative work which is mainly from 1955 to 1960.
Everything is more or less in chronological order. The
polaroid photos are of my most recent work. At the moment
I am involved in architectural structures and city planning,
mainly of the pre-columbian period, (Mayan and Inca cultures).

Lives with Brown in North Beach, first at 2233 Powell Street, in September, and then at 1815 Powell, in October.

The "Rat Bastard Protective Association" is founded by Brown, Neri, and other artists who incorporate discarded materials and processes of decay in their work, a precursor of what came to be known as "funk art." Neri participates in group shows with the "Ratbastards."

Solo exhibition at the Spatsa Gallery in San Francisco.

1960 *Spring* Leaves for his first visit to New York to stay with Mark di Suvero. He arrives shortly after di Suvero is seriously injured in an elevator accident and decides to return to San Francisco.

June–July Solo exhibition at the Dilexi Gallery in San Francisco, which consists primarily of painted plaster and cardboard sculptures.

Returns to New York to help di Suvero organize his studio and resume his work.

1961 *Summer* Travels with Joan Brown to Europe for the first time, visiting England, France, Italy, and Spain, where they are invited to stay at George Staempfli's house in Cadaques.

Impressed by the sculptures he has seen in Europe, and particularly by the degree of information conveyed through the figure fragments of classical Greek and Roman sculpture, Neri reexamines the relationship of his own work to history and tradition. After returning to California, he reworks a number of his earlier plaster figures, removing arms, legs, and heads to pare down the figure to essential elements of sculptural form, focusing on the expressive power of gesture for conveying emotion and meaning.

Di Suvero spends part of the fall working in Neri's studio.

Neri's work is shown in New York for the first time, in a group exhibition at Staempfli Gallery.

Teaches a ceramics course at CSFA.

With Joan Brown in Seville, Spain, 1961.

Venice, Italy, August 21, 1961.

Posing for tourist photos with Joan Brown at the Alhambra,
Granada, Spain, 1961.

Constructing Mark di Suvero's commissioned sculpture at the home of Virginia and Bagley Wright, Seattle, 1962.
From left: di Suvero, Larry Beck, Neri.

Rehanging Virginia and Bagley Wright's Rothko painting, Seattle, 1962.

1962 *February* Neri and Joan Brown marry.

August 20 Their son, Noel Elmer, is born.

Neri and Brown move their studio to Lombard Street in San Francisco. Neri continues to concentrate on figurative sculptures.

Travels to Seattle to help di Suvero install a commissioned sculpture at the home of collectors Virginia and Bagley Wright.

Neri exhibits in a group show at the Primus-Stuart Gallery in Los Angeles, where he shows life-size painted plaster figures.

With Joan Brown and son Noel (one week old), August 1962.

Neri with Noel.

With friends in Connecticut Street studio, c. 1963.

Neri with abstract torso sculptures in
Connecticut Street studio, c. 1963.

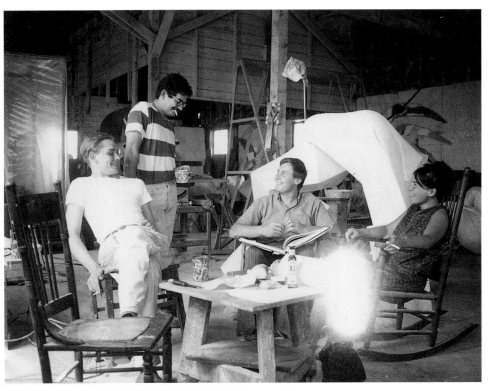

With friends in Connecticut Street studio, c. 1963.

1963 *March–April* Neri's work is included in the exhibition "Some New Art in the Bay Area" at the San Francisco Art Institute, where he receives the 82nd Annual Sculpture Award.

July–August Solo exhibition of painted plaster figures at the New Mission Gallery in San Francisco.

Di Suvero spends part of the summer working in Neri's studio.

Neri reworks plaster heads of Mark di Suvero, which he had begun in 1958.

Moves with Brown to Saturn Street in San Francisco.

August–September Included in "California Sculpture Today," organized by the Oakland Art Museum on the roof garden of the Kaiser Center in Oakland, where he shows painted plaster reliefs and figurative sculptures.

Teaches at UC Berkeley for the academic year 1963–64.

Moves studio to 41 Connecticut Street in San Francisco.

Poster from Neri's solo exhibiton at New Mission Gallery in San Francisco, 1963.

In Connecticut Street studio, c. 1963.

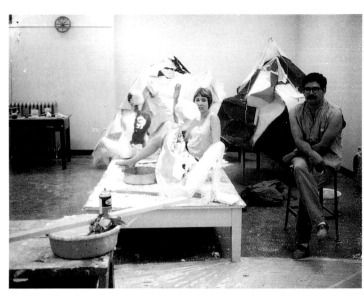

Neri and Brown with sculptures in Boulder, Colorado, studio, 1964.

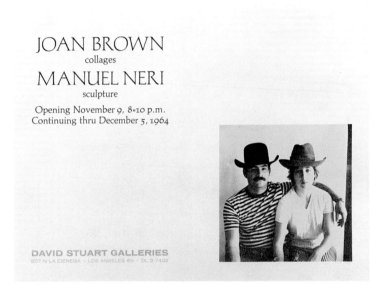

Announcement for exhibition with Joan Brown at David Stuart Galleries, Los Angeles, 1964.

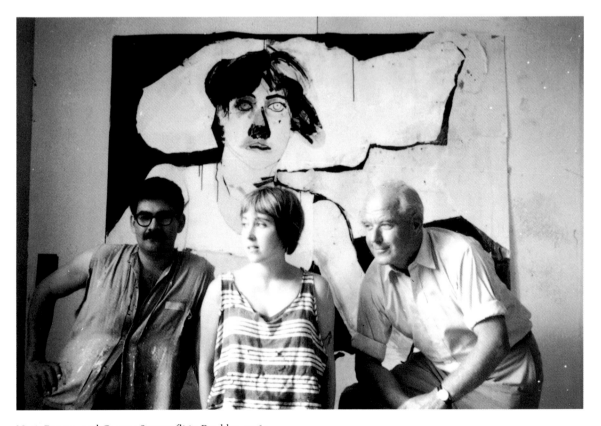

Neri, Brown, and George Staempfli in Boulder, 1964.

1964 *Summer* Neri and Brown serve as Visiting Artists at the University of Colorado, Boulder. While there, Brown models for some plaster figures by Neri.

Shows plaster heads and full figures in a solo exhibition at Berkeley Gallery in Berkeley.

November–December Exhibits with Brown at David Stuart Galleries in Los Angeles, where he shows plaster figures, and she exhibits large collages.

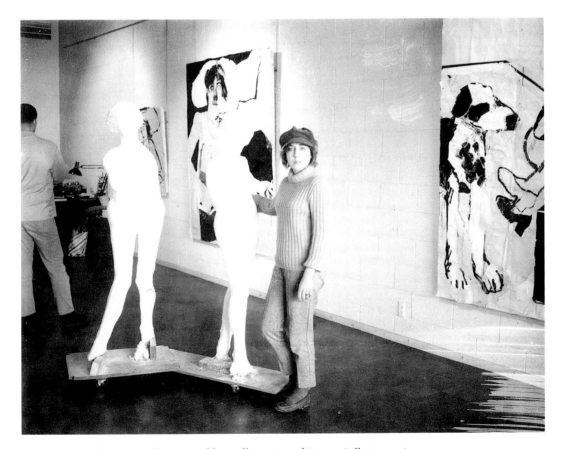

Joan Brown with Neri's sculptures and her collages, David Stuart Galleries, 1964.

Neri's birthday party at Lynn Landor's, April 1964 or 1965. Back row, from left: Mark di Suvero, unidentified woman, Nick Stephens, Jenny Stephens (in front of Nick), Mark Villagran, unidentified woman, David MacKenzie, Lisa Esherick, unidentified woman, Fred Wollschlager, Julius Hatofsky (behind Fred), two unidentified men with child. Front, from left: unidentified man, Kate Hobe, David Melchert, Lynn Landor, Neri; Catherine, Gardner, Kevin, and Caitlin McCaulay (behind Neri); Jim, Renee, Mary Ann, and Christophe Melchert. (Photo: Peter Hobe)

On back of photo: "Noted surveyor of art scene arrives at Neri home. He is not expected for dinner."
San Francisco Chronicle art critic Thomas Albright at Neri's studio, Benicia, c. 1965.

1965	Neri and Joan Brown separate. Neri moves to a new studio on California Street.

Receives a National Art Foundation Award.

Two-artist exhibition with Wayne Thiebaud at the San Francisco Museum of Art.

Leaves his teaching position at the Art Institute (formerly CSFA) and teaches as a Visiting Lecturer in art at the University of California, Davis. The Art Department faculty at Davis also includes Robert Arneson, Roy de Forest, Ralph Johnson, Richard L. Nelson, Roland Petersen, Daniel Shapiro, Wayne Thiebaud, and William T. Wiley.

Purchases a former Congregational church in Benicia, thirty miles east of San Francisco, and converts it into a studio and residence. Begins a series of drawings on religious subjects for a planned group of large-scale plaster reliefs.

Meets Susan Morse, a student at CCAC.

1966 Neri and Joan Brown divorce.

Begins work on a new series of abstract drawings and sculptures based on the box form, which are shown in a solo exhibition at Quay Gallery in San Francisco.

Hears Pablo Neruda give his only poetry reading on the West Coast, in Berkeley.

His ceramic loops from 1961 are included in "Abstract Expressionist Ceramics" at the University of California, Irvine, which travels to the San Francisco Museum of Art.

Exhibits in "The Slant Step Show" at the Berkeley Gallery.

Appointed to the faculty of UC Davis as Lecturer in Art.

Neri with Susan Morse in front of Benicia studio, c. 1967.

Susan Morse, c. 1967.

With Susan in Benicia studio, 1967.

Susan with son, Max, 1968.

1967 Neri and Susan Morse marry.

 His ceramic loops are included in the "Funk Art" exhibition
 at the University Art Museum, Berkeley.

1968 *October 19* Neri and Susan's son, Maximillian Anthony, is
 born.

 Shows open geometric forms in a solo exhibition at Quay
 Gallery in San Francisco.

Installation at Quay Gallery, San Francisco, 1968.

Dinner with friends, Benicia, c. 1970. Standing, from left: Jim Pomeroy, Susan and Max, Jean Lockhart, Bruce Beasley (in hat) with friend. Seated (from back corner of table): Dave Lynn(?), Ann Adair, Peter Voulkos, unidentified woman, Emmy and Jimmy Suzuki with baby. Foreground: Jim, Mary Ann, and Christophe Melchert.

Later the same night.

UC Davis, c. 1970, from left: Robert Arneson (seated), unidentified man, Bruce Nauman, William Wiley, David Gilhooly (seated), and Neri.

1969 *Summer* Teaches at UC Berkeley.

Named Assistant Professor of Art at UC Davis.

Fall Takes a six-week trip to Central and South America, and upon his return begins a series of drawings and sculptures based on pre-Columbian architecture. Many of these works have titles that make reference to ancient Mayan sites at Tula and Tikal. Shows *The Great Steps of Tula*, a wood and wire mesh construction covered with magnesite, and *Monument for the Repair of a National Image* in "The Repair Show" at the Berkeley Gallery in San Francisco.

1970 *May 19* Neri and Susan's daughter, Ruby Rose Victoria, is born.

Neri continues to draw from his experiences in Latin America, most notably in linear drawings and sculptures inspired by the Nazca lines in Peru. Some of the sculptures are included in "Annual Exhibition: Contemporary American Sculpture" at the Whitney Museum of American Art in New York City.

Shows recent sculptures in a solo exhibition at San Francisco Art Institute.

Although he exhibits primarily architecturally based works, he continues working directly with live models, drawing the figure in sketchbooks and making figurative sculptures.

Receives the first in a series of sculpture grants from UC Davis (1970–75).

Susan with daughter, Ruby, and son, Max, 1970.

Neri with students and plein-air sculpture projects, c. 1970.

Student sculpture projects, c. 1970.

Neri in front of a wall sculpture (now owned by Charles Boone) from the *Tikal* series, 1972. (Photo: Leroy Wilsted)

1971	Begins working with fiberglass, taking molds from earlier plaster figures to make figure fragments, or "skins."

August–September Solo exhibition at the San Francisco Museum of Art, in which he shows the fiberglass figure fragments together with the plasters from which they were molded.

October Two-person exhibition with William Wiley, at the University of Nevada, Reno.

1972	Continuing his interest in architectural sites of Mexico and South America, Neri makes a group of geometric and gridlike abstract sculptures in wood, wire mesh, and fiberglass, titled the *Emborados* series. This title is also used for a series of collage drawings on the pages of *Artforum*, in which he inks out images and blocks of type to structure the composition.

Named Associate Professor of Art at UC Davis.

Neri and Susan separate.

Begins a relationship with photographer Joanne Leonard.

Meets Mary Julia Raahauge (Klimenko), and she becomes his model. Working with Mary Julia, he begins a series of life-size plasters that are clearly identified with her gestures and proportions.

Begins using steel rebar and styrofoam, wrapped with burlap, as an armature for his plaster sculptures, which expands the range of gestural possibilities for the figure.

October Participates in "A Ladder Show" at the Artists Contemporary Gallery in Sacramento.

Sculpture-in-progress exhibition at the Davis Art Center, Davis, California, during which he works on several life-size plaster figures in the gallery.

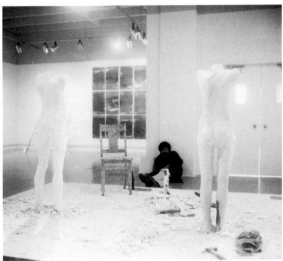
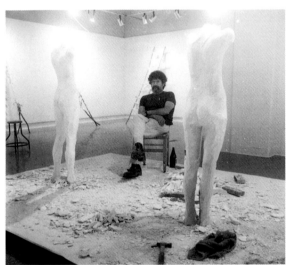

Sculpture-in-progress exhibition at the Davis Art Center, Davis, California, 1972.
Every third night Neri reworked the plaster sculptures.

Joanne Leonard, 1972. (Photo: Joanne Leonard)

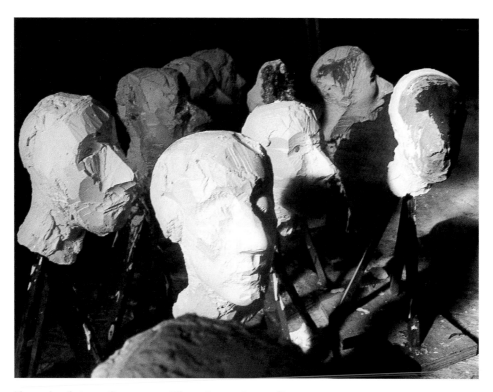

Mary Julia Raahauge, 1972.

With Mary Julia, c. 1972.

Plaster heads in studio, c. 1972. (Photo: Joanne Leonard)

1973 Neri is asked to submit a proposal for religious figures for a Catholic convent near Los Altos, California. For this proposed commission, he creates numerous drawings and watercolor studies of Christ, for which Mary Julia models. Rather than presenting a maquette, Neri makes several life-size plaster sculptures of Christ and the Virgin Mary. He decides to present a unique interpretation of the transfiguration, making translucent fiberglass molds of the Christ figure to represent the passage from the physical to the spiritual. However, this concept is not accepted by the nuns for their chapel, and Neri is not awarded the commission.

Neri's daughter Laticia (Tish) and son Raoul, whom he has not seen since they were small children, return from Europe, where they have been living with their mother and stepfather.

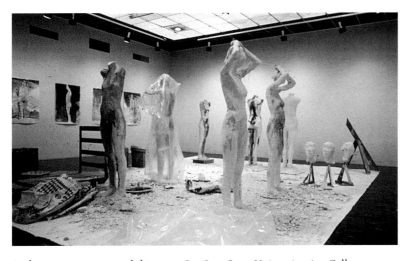

Sculpture-in-progress exhibition at San Jose State University Art Gallery, 1974.

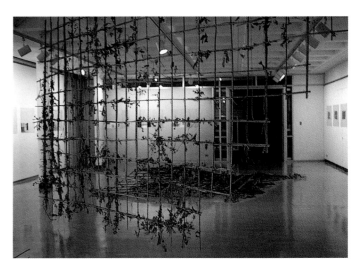

Installation at Davis Art Gallery, Stephens College, Columbia, Missouri, 1974.

1974 *February–March* Sculpture-in-progress exhibition at San Jose State University Art Gallery. With Mary Julia as his model, Neri creates several painted plaster figures in the gallery.

Granted a sabbatical from UC Davis for the academic year 1974–75, spends several months in Mexico and Central America. Continues working out his ideas based on architectural sites and city grids.

October Working with students as a Visiting Artist, constructs several large linear structures related to his previous *Tikal* and *Emborados* series for an installation at the Davis Art Gallery at Stephens College, Columbia, Missouri, also showing a series of drawings for sculptures.

Neri's first bronze sculptures are cast by Don Rich at the Berkeley Art Foundry from small wax originals.

Neri, Jack Zajac, and Doyle Foreman at UC Santa Cruz, 1974.

"The Davis gang," including William Allen (far left), Joanne Leonard (in rear, fifth from left), Roy de Forest (center rear), William Wiley (in rear, third from right), Robert Arneson, and Sandra Shannonhouse (right front), 1970s.

"The Davis gang," including William Allen (standing at right), Robert Arneson, and Sandra Shannonhouse (seated, right), 1970s.

1975 Makes paper pulp casts from earlier figurative sculptures, which he shows with life-size painted plaster figures in a solo exhibition at Quay Gallery in San Francisco in April.

April 29 Neri and Joanne Leonard's daughter, Julia Marjorie Leonard, is born.

Makes his first visit to the quarries and marble workshops in Carrara, Italy, and then travels through Yugoslavia, Greece, and southern Italy.

1976 Neri and Susan divorce.

Named full Professor of Art at UC Davis.

March–April First solo exhibition in New York, at Braunstein/Quay Gallery, where he shows figurative works in plaster, as well as fiberglass and paper pulp fragments molded from earlier plaster figures.

May 4–15 With Mary Julia as his model, Neri makes eight plaster figures in an exhibition titled "The Remaking of Mary Julia: Sculpture in Progress" at 80 Langton Street, an alternative exhibition space in San Francisco.

Summer Teaches a drawing class at the San Francisco Art Institute.

Spends part of the summer in Carrara, where he enrolls in a workshop to learn stone-carving techniques.

September Included in the San Francisco Museum of Modern Art exhibition "California Painting and Sculpture: The Modern Era," organized by Henry Hopkins and Walter Hopps, which travels to the National Collection of Fine Arts in Washington, D.C.

Retrospective exhibition at The Oakland Museum, curated by George Neubert, which is documented in a catalogue later published by the museum. The exhibition includes plaster figures and busts, with a small representation of early assemblages, fiberglass figure fragments, and architectural sculptures.

Neri and Mary Julia load the truck for Neri's first solo show in New York, at Braunstein/Quay Gallery, 1976.

Mary Julia at 80 Langton Street, 1976. (Photo: Manuel Neri)

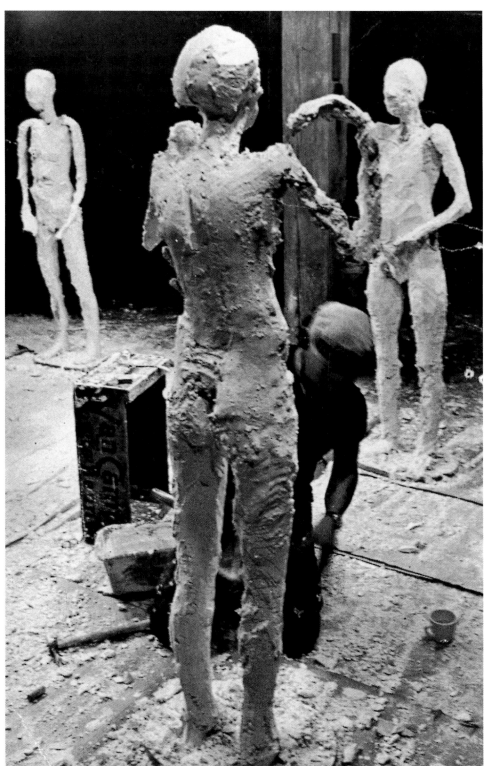

Neri working at 80 Langton Street, San Francisco, during sculpture-in-progress exhibition "The Remaking of Mary Julia," May 4–15, 1976. (Photo: Phillip Galgiani)

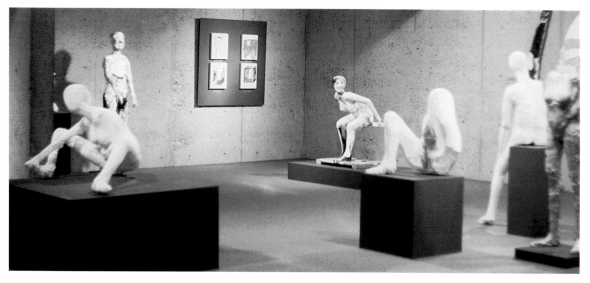

Installation of Neri's retrospective exhibition at The Oakland Museum, 1976. From left: *Seated Female Figure, Untitled Standing Figure, Drawings from Window Series, Seated Girl II (Bather), Shrouded Figure, Untitled Seated Male Figure.* (Photo: Lorraine Capparell)

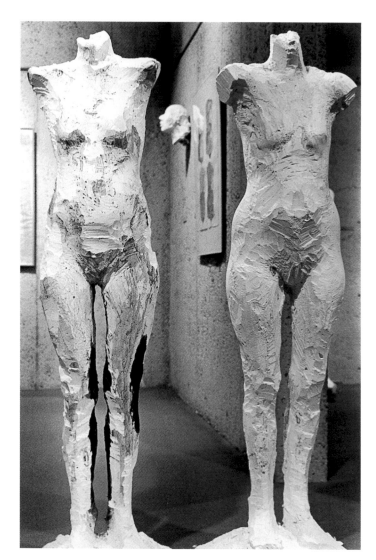

Neri retrospective at The Oakland Museum, 1976. On rear wall at left are paper pulp sculptures *Female Figure Fragment* and *Seated Male Figure Fragment.* On pedestals, from left: *Reclining Figure Fragment* and busts from the *Bustos de Mujer* series. (Photo: Lorraine Capparell)

Untitled plaster figures in Neri retrospective at The Oakland Museum, 1976. On the wall at right is *Virginia Woolf.* (Photo: Lorraine Capparell)

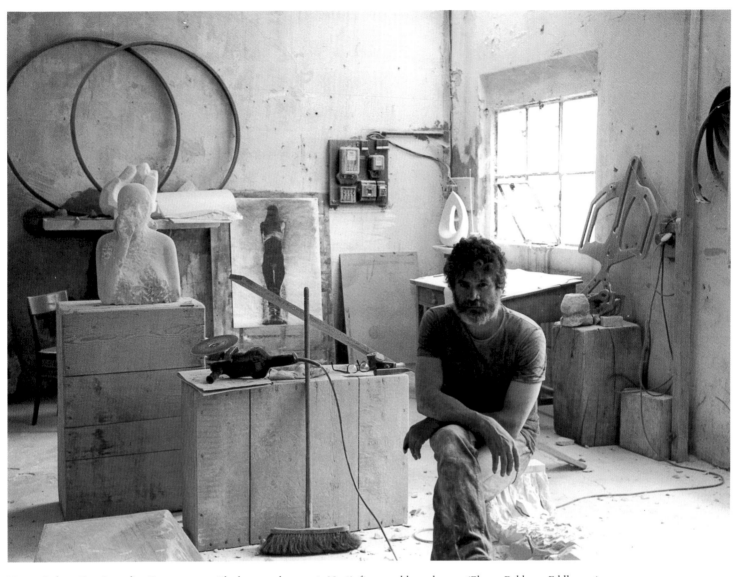

Neri in Robert Gove's studio, Carrara, 1977. The bust on the crate is Neri's first marble sculpture. (Photo: Babbette Eddleston)

Neri in Carrara, 1977.

Neri with Anne Kohs.

1977 *Summer* Returns to Carrara and works on marble sculp-
tures in a studio he rents from Robert Gove.

1978 Creates a new series of gestural torsos in plaster, titled
Posturing Series and *Falling Woman Series*.

Lectures on "Sculpture: Modern and Primitive" at California
State University, Sacramento.

December Begins working with Anne Kohs.

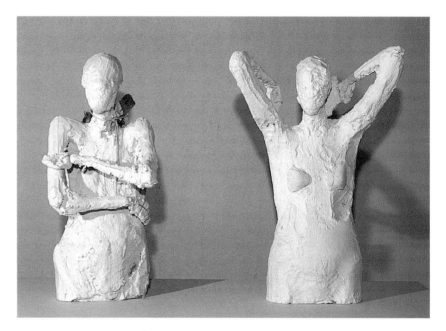

Posturing Series No. 5 and *Posturing Series No. 2*, 1978.

Neri with daughter Julia Leonard, c. 1978.

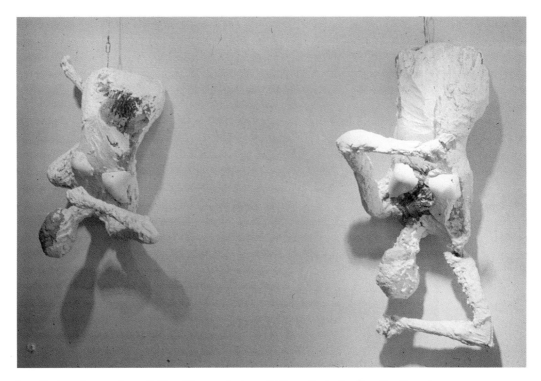

Installation of torsos from *Falling Woman Series* at Gallery Paule Anglim, San Francisco, 1979.

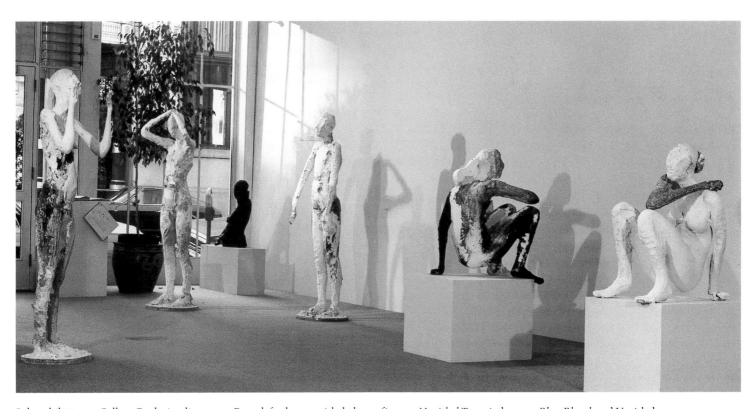

Solo exhibition at Gallery Paule Anglim, 1979. From left: three untitled plaster figures, *Untitled Torso* in bronze, *Blue Blond*, and Untitled.

1979 *Spring* Neri is notified that he is a recipient of a Guggenheim Foundation Fellowship.

May Serves as a guest lecturer at the San Francisco Art Institute.

In a solo exhibition at Gallery Paule Anglim in San Francisco, he shows the *Posturing Series* and *Falling Woman Series*, seated and standing plaster figures painted in vivid colors, several small bronzes cast from wax originals, and drawings.

Fall Takes a yearlong leave of absence from teaching. With funds from the Guggenheim grant, he returns to Carrara and begins work on life-size marble figures.

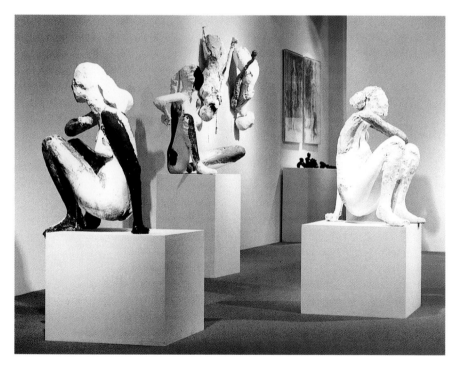

Solo exhibition at Gallery Paule Anglim, 1979. Sculptures, from left: *Blue Blond, Red Legs, Falling Woman Series IV, Falling Woman Series II,* small untitled bronze figures (on rear pedestal), and Untitled.

Neri with *Untitled Bust II,* Christmas, 1979.

Neri in Benicia with children Julia, Max, Ruby, and Raoul, c. 1980.

Commissioned sculpture *Tres Marías* in progress in Carrara, 1980.

Joan Brown's marriage to Michael Hebel at the San Francisco Museum of Modern Art, 1980. Neri was asked to "give the bride away."

1980 Receives a National Endowment for the Arts Individual
 Artist Fellowship.

 During a trip to Mexico with Mary Julia, begins the *Indios
 Verdes* series of drawings, and has a group of earlier life-size
 figures cast in bronze by Fundidores Artísticos in Mexico
 City, arranged through Paule Anglim.

 Begins a series of kneeling plaster figures.

 Awarded a commission by the Art in Public Buildings
 Program of the California Arts Council and the Office of
 the State Architect for a large-scale marble sculpture for
 the Bateson Building in Sacramento.

 Represented in New York by Charles Cowles Gallery.

 June Travels to Carrara and stays in an apartment he has
 purchased there. Completes three marble sculptures begun
 the previous year, titled *Carrara Figure No. 1*, *Carrara Figure
 No. 2*, and *Carrara Figure No. 3*, for an exhibition the follow-
 ing year at Charles Cowles Gallery.

 In Carrara, he meets artist Makiko Nakamura, who models
 for a series of plaster heads, for which she arranges her hair
 in traditional Japanese styles. Later that year, the *Makiko*
 heads are cast in bronze at a foundry in Pietrasanta, Italy.

 In his Benicia studio, molds are taken from several life-size
 plaster figures, which are cast in bronze at Walla Walla Foun-
 dry in Washington State. (Walla Walla will remain Neri's pri-
 mary foundry for producing bronze sculptures.)

 Represented by John Berggruen Gallery in San Francisco.

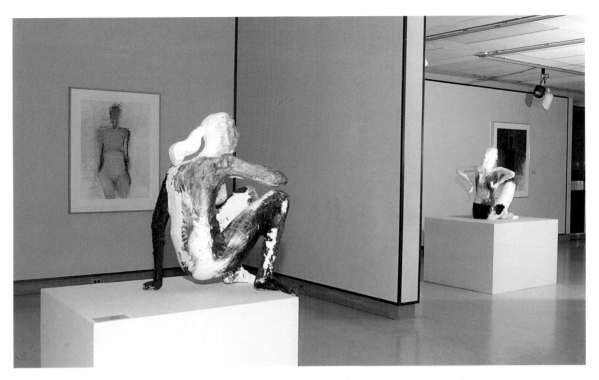

Solo exhibition at the Seattle Art Museum, January 1981. From left: *Indios Verdes No. 1, Blue Blond,* and *Red Legs.*

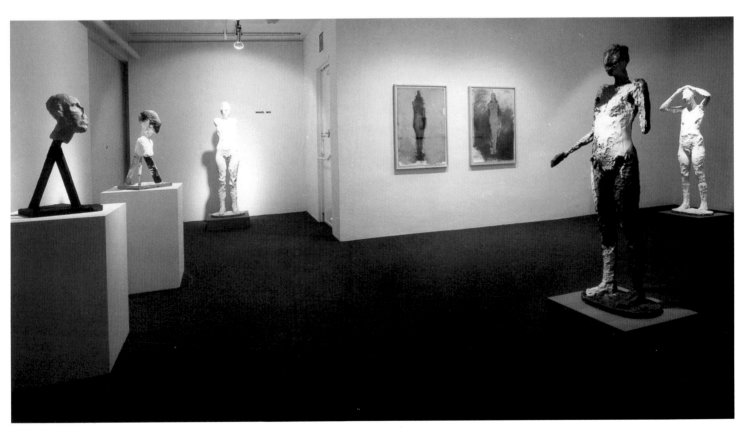

Neri's first solo exhibition at Charles Cowles Gallery, New York, February 1981. From left: *Scribe* (Cast 1/4), *Untitled Bust, Mary Julia, Torano No. 6, Torano No. 5, Coming in Last Thursday* (Cast 1/4), and *Untitled Standing Figure No. 3.*

1981 *January* Solo exhibition at the Seattle Art Museum, organized by Bruce Guenther, for which a catalogue is published.

February Charles Cowles Gallery presents its first solo exhibition of Neri's work, where his marble sculptures are shown for the first time.

Summer The Art Museum Association organizes an exhibition of Neri's drawings and bronzes, which travels through 1983 to museums in the United States.

Purchases a studio in Carrara.

June 28 CBS Sunday Morning television show, hosted by Charles Kuralt, airs a story titled "Profile of Manuel Neri," which shows Neri at work in his studios in Benicia and Carrara, and includes interviews with Neri, Mary Julia, and others.

November First solo exhibition at John Berggruen Gallery, where he shows marble and bronze sculptures.

Neri's studio, Carrara, 1981.

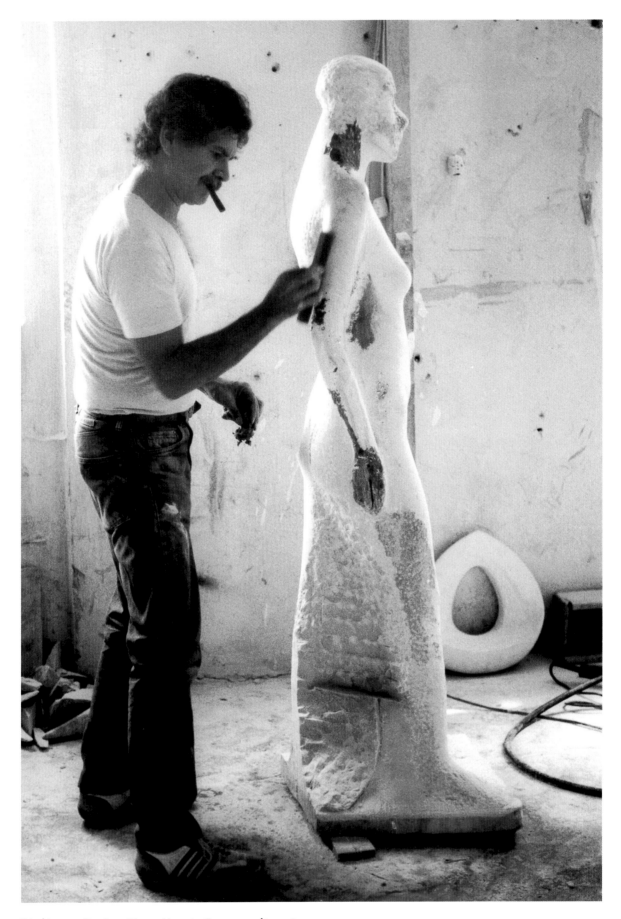

Working on *Carriona Figure No. 1* in Carrara studio, 1981.

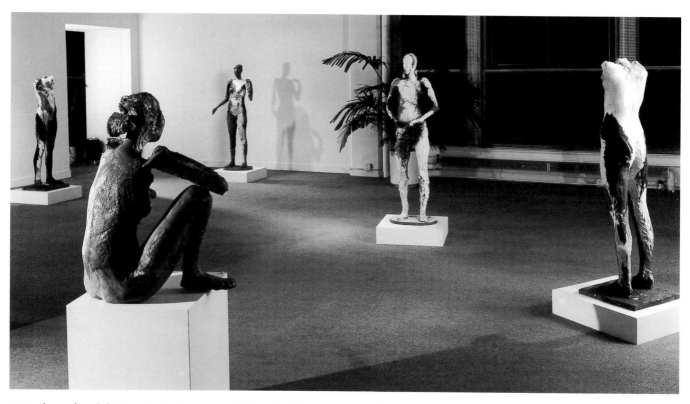

Neri's first solo exhibition at John Berggruen Gallery, San Francisco, November 1981. From left: *Untitled Armless Figure* (Cast 2/4), *Squatting Woman* (Cast 3/4), *Coming in Last Thursday* (Cast 2/4), *Remaking of Mary Julia* (Cast 1/4), *Untitled Armless Figure* (Cast 1/4). (Photo: M. Lee Fatherree)

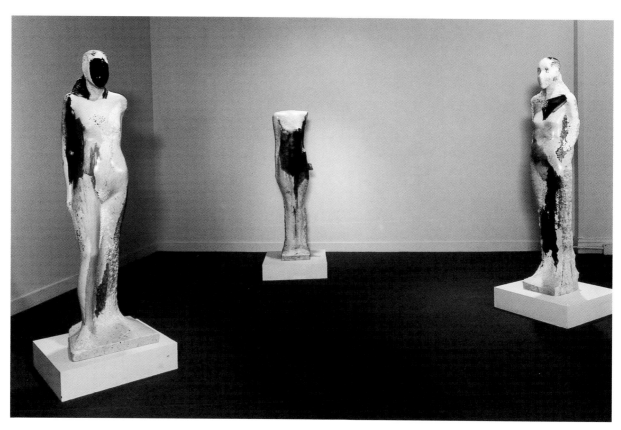

Marble sculptures in solo exhibition at John Berggruen Gallery, November 1981. From left: *Carriona Figure No. 1, Carriona Figure No. 2, Carriona Figure No. 3.* (Photo: M. Lee Fatherree)

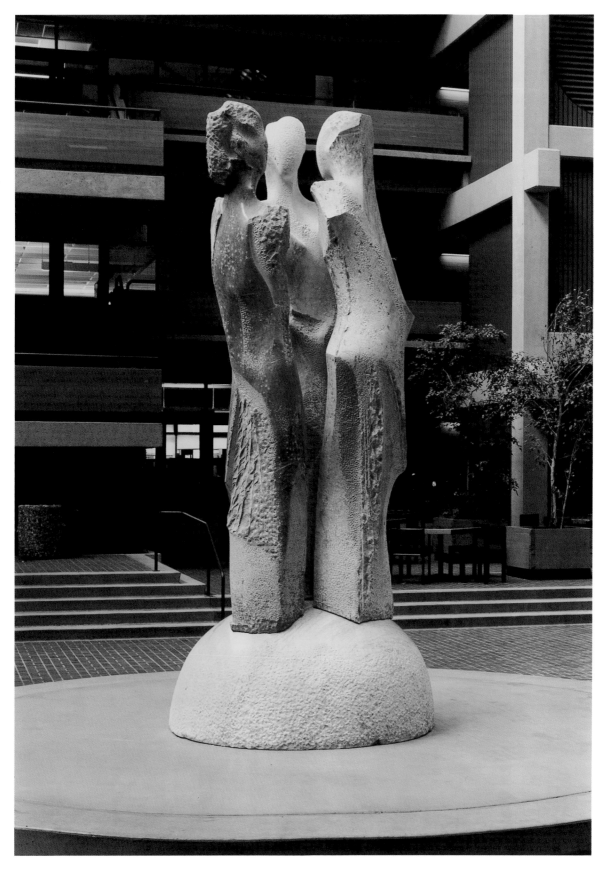

Tres Marías, marble sculpture commissioned by the State of California, installed at the Bateson Building, Sacramento, 1982. (Photo: M. Lee Fatherree)

1982 The American Academy and Institute of Arts and Letters
 awards Neri the Academy-Institute Award in Art.

 March Installs *Tres Marías*, a fifteen-foot-high marble
 sculpture of three figures, commissioned by the State of
 California, at the Bateson Building in Sacramento.

 Lectures at the University of Michigan, Ann Arbor, and the
 University of Wisconsin, Milwaukee, and serves as a panelist
 for the 1982 International Sculpture Conference in Oakland.

 A fire at Berkeley Art Foundry destroys several of Neri's wax
 originals and molds for bronze sculptures.

In Carrara studio with marble sculptures and plaster heads of Makiko Nakamura, 1983.

In Carrara studio with *Cipolina No. 2* (in progress), 1983.

1983 Takes a leave of absence from teaching at UC Davis during winter and spring quarters.

February Lectures as keynote speaker at Louisiana State University, Baton Rouge.

Spring Travels to Carrara and works through the summer on marble sculptures.

October Travels to Tucson to lecture at the University of Arizona in conjunction with the exhibition "Manuel Neri: Drawings and Bronzes," organized by the Art Museum Association.

October 28 In Tucson, marries Kate Rothrock, whom he had met earlier in the year.

Kate and Manuel Neri, Benicia, 1984. (Photo: Leo Holub)

Installation of "Drawings 1974–1984" at the Hirshhorn Museum and Sculpture Garden, Washington, D.C., 1984, showing Neri's drawings *Mary Julia,* Untitled, *Torrano No. 2, K. C. No. 1,* and *Indios Verdes No. 4,* with drawings by Chuck Close in the background.

Manuel Neri

Geboren 1930 in Sanger, California. Nach College-Ausbildung in San Francisco Ingenieur-Studium an der University of California in Berkeley. Bricht das Studium ab und besucht 1952–1957 die California School of Arts in Oakland, dann bis 1959 die California School of Fine Arts in San Francisco, wo er anschliessend eine Lehrtätigkeit aufnimmt. Seit 1964 hat er eine Professur für Bildhauerei an der University of California in Davis.

Manuel Neri lebt wechselweise in Kalifornien und in Carrara/Italien.

Ausstellungen: Seit 1955 hat sich Manuel Neri an zahlreichen Gruppenausstellungen beteiligt, zuerst in Kalifornien, später in Galerien und Museen der übrigen Vereinigten Staaten, zuletzt 1983 im San Francisco Museum of Modern Art, im Seattle Art Museum und, 1984, im Hirshhorn Museum in Washington D.C.

Einzelausstellungen gab es seit 1957 in Galerien und Museen zahlreicher amerikanischer Städte. Seit 1981 stellt Manuel Neri regelmässig in der John Berggruen Gallery in San Francisco sowie der Charles Cowles Gallery in New York aus. Die Ausstellung vom Frühjahr 1984 in den Gimpel-Hanover und André Emmerich Galerien in Zürich ist seine erste europäische Ausstellung.

Zur Ausstellung erscheint in Zusammenarbeit mit der John Berggruen Gallery, San Francisco, und der Charles Cowles Gallery, New York, ein Katalogbuch: Text Pierre Restany (französisch, englisch, deutsch), 72 farbige und 20 Schwarzweissabbildungen, ausführliche Bio- und Bibliographie. Preis Fr. 25.–.

Manuel Neri – gesehen von Pierre Restany

Der Kalifornier Manuel Neri nimmt in der zeitgenössischen Skulptur eine Sonderstellung ein: eine Art einsames Abenteuer, ein lebendes Paradox.

Er ist sicher eine der bedeutendsten Persönlichkeiten auf der Kunstszene von San Francisco und der Bay Area. In Kalifornien ist er geboren und aufgewachsen. In San Francisco, Berkeley und wieder San Francisco hat er studiert...

Zunächst Maler und Keramiker, ist er durch die Schule des abstrakten Expressionismus gegangen. Nie aber hat er, vor allem als Plastiker, auf die Darstellung der menschlichen Figur vollständig verzichtet... Seine neuesten, stets bemalten Werke aus Gips, Bronze oder Marmor verraten einen meisterlichen, ausgesprochen originellen Stil. Sie machen Neri zu einem der bedeutendsten Vertreter der polychromen Bildhauerei. Seine lebensgrossen stehenden, hockenden oder sitzenden Frauenfiguren, seine fragmentierten Büsten, seine kopf- und armlosen Torsi erinnern an die zeitlosen Qualitäten der ‹Elgin Marbles› im British Museum, an die letzten, unvollendeten Arbeiten Michelangelos und die fragmenthaften Figuren Rodins...

Er behandelt die Keramik in der gleichen Weise wie Medardo Rosso, er modelliert den Gips und giesst die Bronze wie Rodin, er zeichnet im Geiste von Giacometti und er meisselt den Marmor im reinsten hellenischen Stil! Das ist Manuel Neri. Aber er ist gleichzeitig etwas anderes: ein authentischer kalifornischer Funk-Künstler... der seine ibero-amerikanische Herkunft keineswegs verleugnet, ein Mann, der seine Kunst wie eine fixe Idee lebt, wie ein existentielles Abenteuer...

Er ist ein grosser Bildhauer und ein grosser Humanist. Er ist ein einsamer Demiurg, der in der Stille und im Geheimen eine vergeistigte Ikonographie der Alltags-Menschheit schafft, das neue Bild unserer Götter.

Pierre Restany

(Auszug aus einem Text vom August 1983.)

Gegenüber: ‹Lucca Nr 1›, 1982/83, 167 x 35 cm, Marmor bemalt

Announcement for Neri's first solo exhibition in Europe, at Gimpel-Hanover + André Emmerich Galerien, Zurich, 1984, with image of marble sculpture *Lucca No. 1.*

1984 *February* A solo exhibition of Neri's marble sculptures and drawings opens at John Berggruen Gallery.

March Neri suffers a mild heart attack and takes a medical leave from UC Davis.

Several of his drawings are included in the exhibition "Drawings 1974–1984" at the Hirshhorn Museum and Sculpture Garden, Washington, D.C., curated by Frank Gettings.

April First solo exhibition in Europe opens at Gimpel-Hanover + André Emmerich Galerien in Zurich, Switzerland. A catalogue is published for the exhibition, with an essay by Pierre Restany.

June Returns to Carrara, where he remains until August.

August After his return to California, undergoes quadruple bypass surgery.

October Travels to France for the opening of the "California Sculpture Show," organized by California/International Arts Foundation, at the Musée d'Art Contemporain in Bordeaux. The exhibition subsequently tours to the Stadtische Kunsthalle in Mannheim, Germany, Yorkshire Sculpture Park, West Bretton, England, and Sonja Henies og Neils Onstads Stiftelser, Hovikodden (Oslo), Norway.

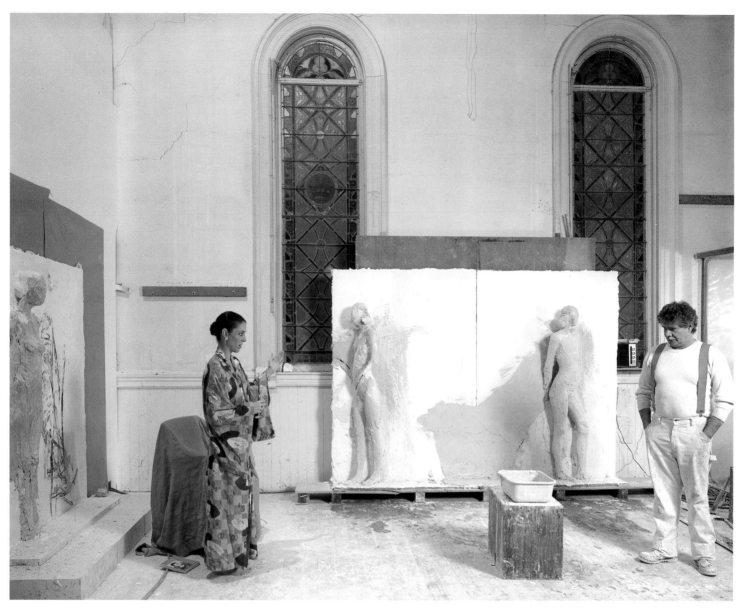

Working with Mary Julia on *Arcos de Geso* series in Benicia studio, 1985.
(Photo: M. Lee Fatherree)

1985 *February 10* Neri and Kate's son, Gustavo Manuel, is born.

Receives Award of Honor for Outstanding Achievement in Sculpture from the San Francisco Arts Commission.

With Mary Julia as his model, Neri begins work on the *Arcos de Geso* series in plaster, in which figures are shown in high relief against architectural backgrounds. Later, molds are taken from the plasters for casting bronze editions at Walla Walla Foundry.

In Carrara, he continues working with the idea of the figure in relief, in the *Mujer Pegada* series of life-size marble sculptures.

November Lectures at the School of Fine Arts at the University of Kansas, Lawrence, and participates in the Visual Artists Forum on Figurative Sculpture at the Otis Art Institute of Parsons School of Design, Los Angeles.

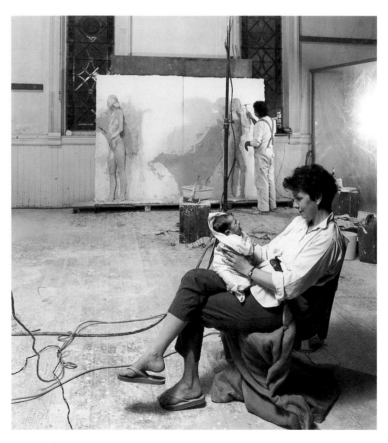

Kate with son, Gus, in Benicia studio, 1985.
(Photo: M. Lee Fatherree)

Plaster sculptures in progress showing steel rebar
armature, Benicia studio, 1985. (Photo: M. Lee Fatherree)

In Benicia studio with Gus, 1985. (Photo: M. Lee Fatherree)

From left: Bob Hudson, Neri, Mark di Suvero, and Roy de Forest, c. 1985.

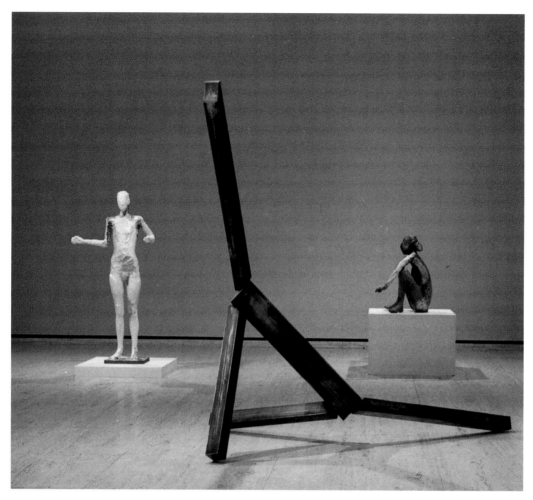

Installation views of the exhibition "Contemporary Bronze: Six in the Figurative Tradition" at Sheldon Memorial Art Gallery, Lincoln, Nebraska, 1985, showing Neri's *Rosa Negra No. 1* (Cast 3/4) and *Squatting Woman* (A/P), along with sculptures by Joel Shapiro.

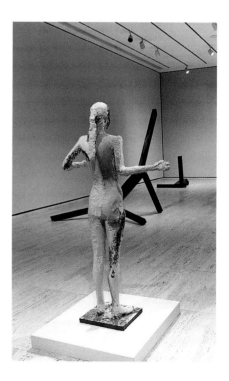

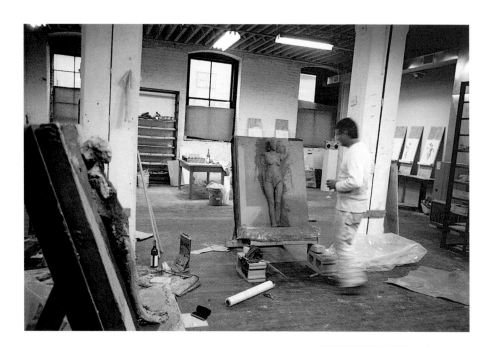

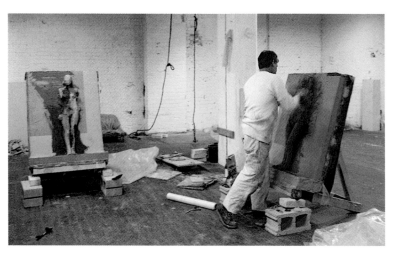

Working on ceramic relief sculptures at the Bemis Project, Omaha, Nebraska, 1986.

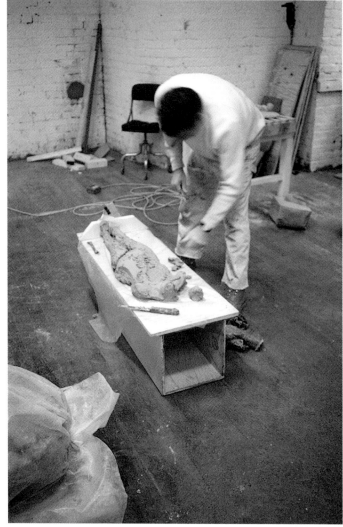

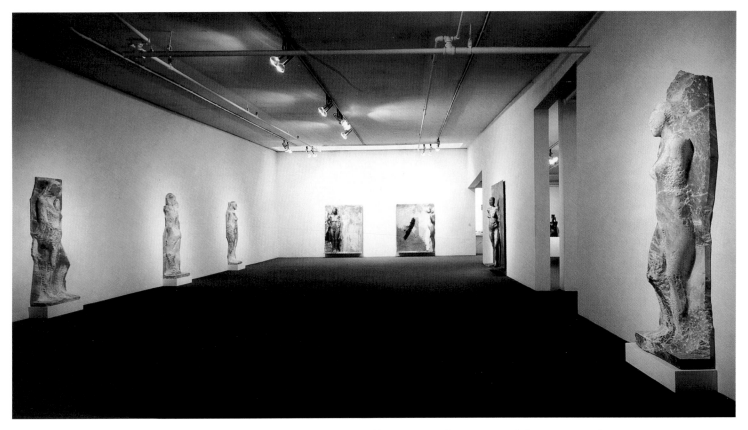

Marble and bronze relief sculptures in solo exhibition at Charles Cowles Gallery, New York, 1986. From left: *Mujer Pegada No. 3, Mujer Pegada No. 4, Mujer Pegada No. 2, Mujer Pegada Series No. 2* (Cast 1/4), *Mujer Pegada Series No. 1* (Cast 1/4), *Mujer Pegada Series No. 3* (Cast 1/4), and *Mujer Pegada No. 1*.

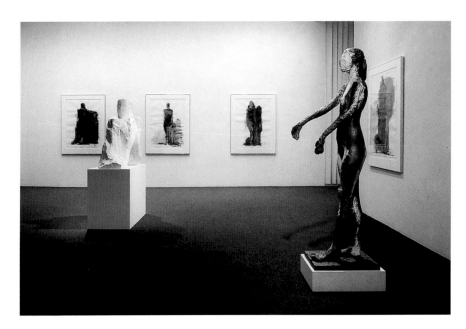

Solo exhibition at Charles Cowles Gallery, 1986, showing marble sculpture *Mujer Pegada No. 5* and bronze *Rossa* (A/P). On the wall, from left, are drawings from 1985: *Untitled VI, Untitled VII, Untitled IV,* and *Untitled III.*

1986 *February* The *Mujer Pegada* marbles and *Mujer Pegada Series* in bronze are shown in a solo exhibition at Charles Cowles Gallery.

Lectures at the Kansas City Art Institute in conjunction with the exhibition "Contemporary Bronze: Six in the Figurative Tradition," curated by George Neubert, and at the Knight Gallery/Spirit Square Arts Center in Charlotte, North Carolina, in conjunction with "Body and Soul: Aspects of Recent Figurative Sculpture," traveled by the Contemporary Arts Center in Cincinnati.

Summer Returns to Carrara to work through the summer.

October Serves as Visiting Artist at North Dakota State University, Fargo, during an exhibition and workshop on bronze casting.

October–November With Kate and son Gus, spends two months as Artist-in-Residence at the Alternative Work Site/ Bemis Project in Omaha, Nebraska, where he continues to explore the idea of the figure in an architectural setting, creating figurative ceramic reliefs and the *Maha* series of drawings.

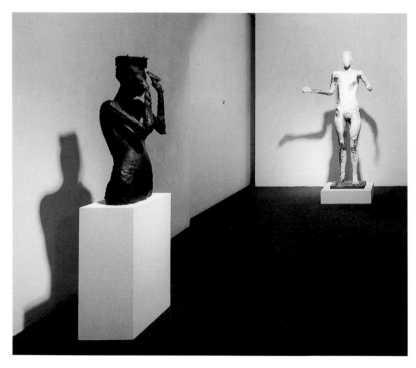

Posturing Series No. 4 (A/P) and *Rosa Negra No. 1* (Cast 1/4) in solo exhibition at Charles Cowles Gallery, 1986.

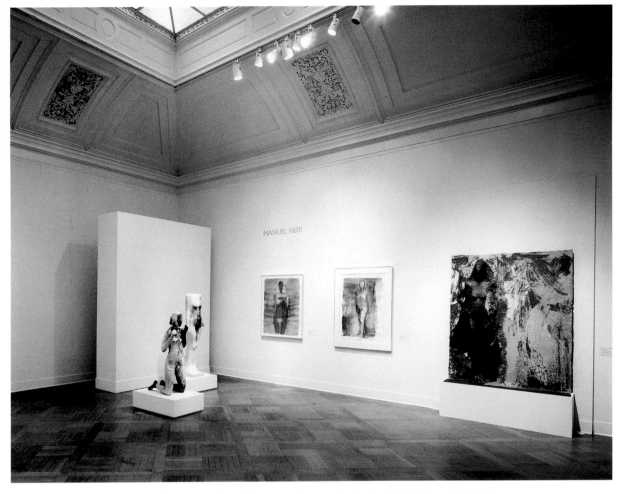

Sculptures and works on paper by Neri in the exhibition "Hispanic Art in the United States," The Corcoran Gallery of Art, Washington, D.C., 1987. From left: *Annunciation No. 2,* Untitled marble figure, *Indios Verdes No. 4, Untitled V,* and *Mujer Pegada Series No. 2* (Cast 1/4).

Neri's drawings *Maha No. 9* and *Isla Negra No. 4* in "Sculptors on Paper: New Work" at the Madison Art Center, Madison, Wisconsin, December 1987–January 1988.

1987 Working with Mary Julia, begins the *Isla Negra* series of drawings, inspired by a poem by Pablo Neruda. Mary Julia also models for maquettes for commission proposals for marble relief sculptures.

February The *Isla Negra* drawings are shown in a solo exhibition at Fay Gold Gallery in Atlanta.

Receives commissions for marble relief sculptures for the Federal Courthouse, Portland, Oregon (from the General Services Administration's Art-in-Architecture Program); the North Carolina National Bank building in Tampa, Florida; and the Christina Gateway Project in Wilmington, Delaware. Serves on the artist selection panel of the G.S.A. Art-in-Architecture program for a proposed Federal Building in Oakland.

Drawings and sculptures by Neri are included in the exhibition "Hispanic Art in the United States," organized by The Corcoran Gallery of Art, which opens at the Museum of Fine Arts, Houston, and tours to museums throughout the country.

Drawings by Neri are included in the exhibition "Sculptors on Paper: New Work" at the Madison Art Center, Madison, Wisconsin.

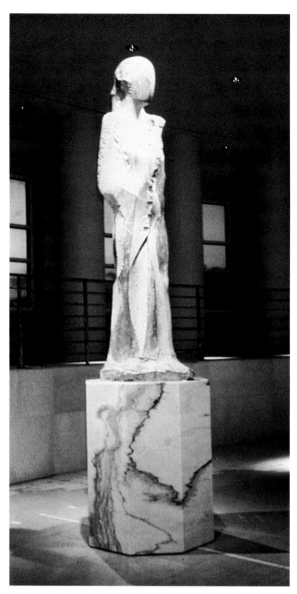

Installation view of the exhibition "Lost and Found in California" at James Corcoran Gallery, Santa Monica, summer 1988, showing Neri's early mixed-media sculptures *Hawk, Wood Figure No. 1*, and *Sutee Figure I* at right.

Commissioned marble sculpture *Española*, installed at North Carolina National Bank, Florida headquarters, Tampa, 1988.

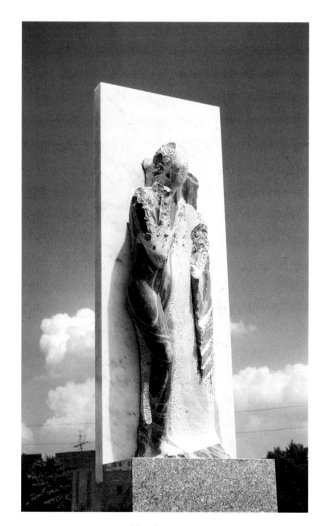

Passage, commissioned by the Linpro Company, installed at the Christina Gateway Project, Wilmington, Delaware, 1988. (Photo: James F. Wilson)

1988 Begins work on the *La Palestra* series of plaster sculptures and the *Isla Negra* series of maquettes, some of which are later cast in bronze.

Installation of *Española,* a marble relief sculpture commissioned by North Carolina National Bank, at NCNB headquarters in Tampa, Florida.

May Juries an annual fellowship competition at the School of the Art Institute of Chicago, and serves on the annual Sculpture Panel of the Massachusetts Artists Fellowship Program in Boston.

June Early mixed-media sculptures are included in the exhibition "Lost and Found in California: Four Decades of Assemblage Art" at James Corcoran Gallery in Santa Monica.

Summer Included in the exhibition "The Latin American Spirit: Art and Artists in the United States, 1920–1970," which opens at the Bronx Museum and travels to U.S. museums during the next two years.

A major exhibition of Neri's marble sculptures, bronzes and plasters from the *La Palestra* series, and drawings is presented at James Corcoran Gallery. A catalogue is published for the exhibition.

Fall Lectures and conducts a workshop at the School of Fine Arts of Indiana University, Bloomington.

Installation of *Passage,* a marble relief sculpture commissioned by the Linpro Company, at the Christina Gateway Project in Wilmington, Delaware.

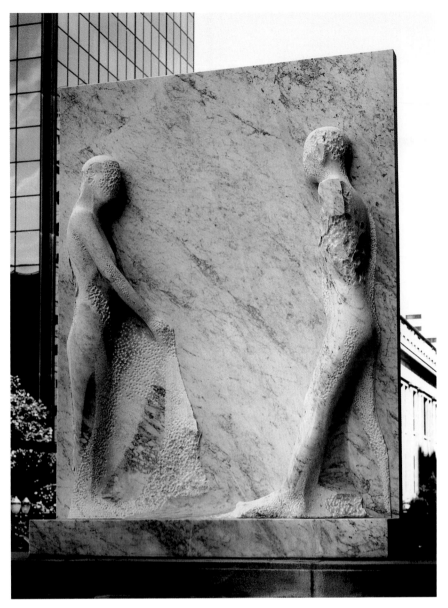

Commissioned marble relief sculpture *Ventana al Pacífico,* installed at the Federal Courthouse, Portland, Oregon, 1989. (Photo: Guy Orcutt)

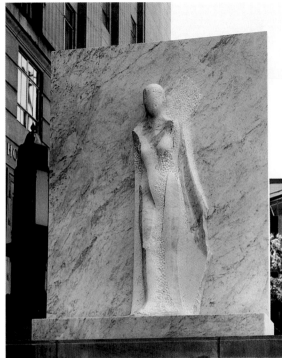

Ventana al Pacífico at the Federal Courthouse, Portland. (Photo: Guy Orcutt)

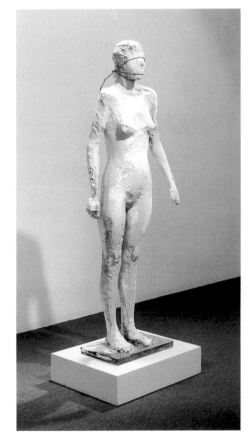

Catun Series I in solo exhibition at Charles Cowles Gallery, 1989.

1989 *April* Installation of *Ventana al Pacífico*, a marble relief sculpture commissioned by the G.S.A., at the Federal Courthouse in Portland, Oregon.

April–May Solo exhibition of marble and plaster sculptures at Charles Cowles Gallery.

May–June The San Francisco Museum of Modern Art organizes a retrospective exhibition of Neri's figurative sculptures in plaster, for which a catalogue is published.

Summer Neri and Kate separate.

November Riva Yares Gallery in Scottsdale, Arizona, presents its first solo exhibition of Neri's sculptures and works on paper.

December A selection of early plaster figures by Neri is included in the exhibition "Bay Area Figurative Art: 1950–1965," curated by Caroline A. Jones, at the San Francisco Museum of Modern Art. The exhibition travels through 1990 to the Hirshhorn Museum and Sculpture Garden in Washington, D.C., and the Pennsylvania Academy of the Fine Arts in Philadelphia.

At Christmas, Neri travels to Mexico with children Ruby, Max, Noel, and Raoul.

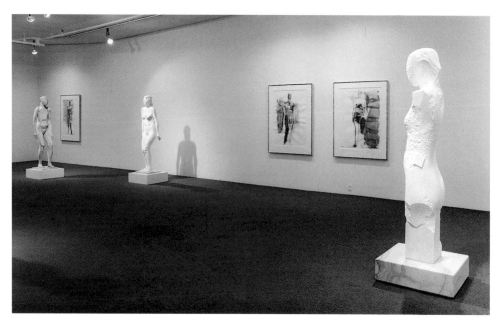

Solo exhibition at Charles Cowles Gallery, 1989. At left are plaster sculptures *On the Up No. 2* and *On the Up No. 1*. The marble *Carrara 88* is at right. Drawings, from left, are: *Axe Rust Series No. 7*, *Axe Rust Series No. 8*, and *Axe Rust Series No. 1*.

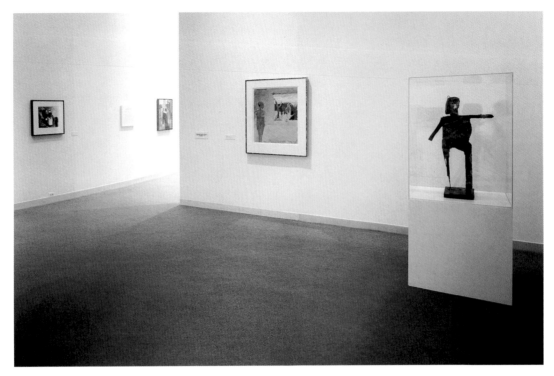

Installation view of the 1989 exhibition "Bay Area Figurative Art: 1950–1965" at the Hirshhorn Museum and Sculpture Garden, Washington, D.C., showing Neri's *Untitled (Nude Model with Bischoff Painting)* at center, and *Wood Figure No. 1* at right.

Neri drawing during trip to Mexico, December 1989.

With Ruby in Mexico, 1989.

1990 Retires from UC Davis.

Spring Lectures at the Fine Arts Museums of San Francisco and at the University of Pennsylvania School of Fine Arts.

May The San Francisco Art Institute awards Neri an Honorary Doctorate for Outstanding Achievement in Sculpture.

Lectures at Memphis Brooks Museum of Art in Memphis, Tennessee, in conjunction with the installation of his marble sculpture *Carrara 88.*

Neri and Kate divorce.

Brighton Press in San Diego begins work on a collaborative limited edition book featuring poems by Mary Julia Klimenko and etchings by Neri. With Mary Julia as his model, Neri creates etchings of heads, which are imagined portraits of famous women authors. The first and last of the eight etchings in the book, each hand-colored by Neri, are portraits of Mary Julia. Neri's work for the book also develops into a series of drawings titled *She Said.*

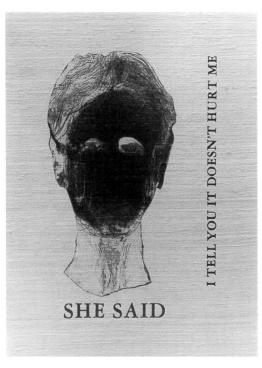

Cover of limited edition book *She Said: I Tell You It Doesn't Hurt Me* with etchings by Neri and poems by Mary Julia.

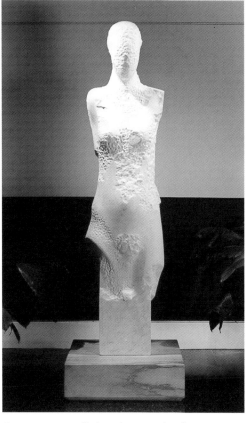

Carrara 88 installed in the rotunda of Memphis Brooks Museum of Art, 1990.

Neri's birthday party, 1991.

377

Mel Ramos and Neri selecting stones at the marble quarries in Carrara, c. 1990.
(Photo: Leta Ramos)

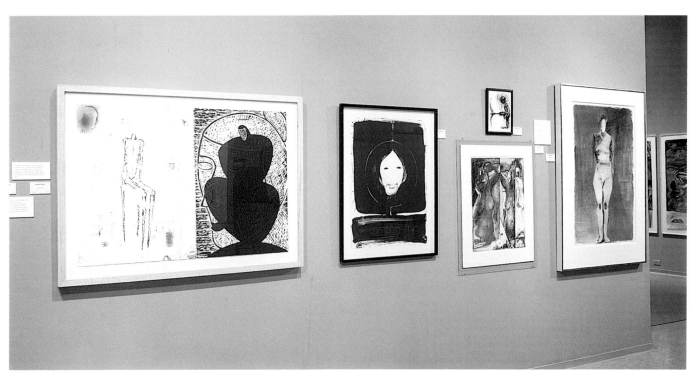

Neri's *Agatas de Isla Negra* (far right) in "Visiting Artist Program: 20th Anniversary Show" at C.U. Art Galleries,
University of Colorado, Boulder, January 1992.

1991 The completed book, titled *She Said: I Tell You It Doesn't Hurt Me*, is published by Brighton Press. The Library of Congress makes the first purchase from the edition.

February Charles Cowles Gallery shows the book and drawings from the *She Said* series in a solo exhibition of Neri's recent work.

1992 *January–February* Neri's work is included in the exhibition "Visiting Artist Program: 20th Anniversary Show" at the C.U. Art Galleries, University of Colorado, Boulder.

May Awarded an Honorary Doctorate by California College of Arts and Crafts.

Represented by Campbell-Thiebaud Gallery in San Francisco.

Lectures in Montana at the State University in Bozeman, the State College in Billings, and the University of Montana in Missoula.

Neri (seated at center) at ceremony to receive an Honorary Doctorate from California College of Arts and Crafts, 1992. (Photo: Rolando Dal Pezzo)

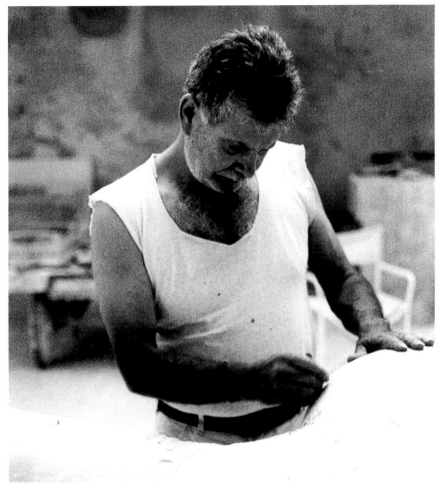

Working on *Odalisque IV* in Carrara studio, 1993.

Working on marble head from *Maki* series, Carrara studio, 1993.

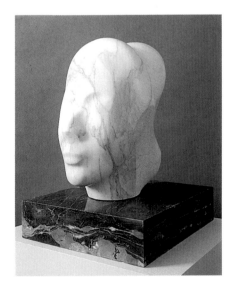

Makida I from *Makida* series of marble heads, 1993.

Plaster maquettes in Carrara studio, 1993.

1993 Brighton Press publishes a second collaborative limited edition book, *Territory*, with poems by Mary Julia Klimenko and an original drawing by Neri bound into each book.

In Carrara, begins work on a large reclining figure related to the *Odalisque* series, two smaller figures, and a series of marble heads based on the earlier plaster heads for which sculptor Makiko Nakamura modeled, which are titled *Maki* and *Makida*.

Neri's mother, Guadalupe Penilla Neri, dies in the summer at age eighty-three.

July Henry Geldzahler organizes an exhibition of sculptures and works on paper by Neri at the Dia Center for the Arts in Bridgehampton, New York, for which a catalogue is published.

August Campbell-Thiebaud Gallery presents its first solo exhibition of Neri's work, showing drawings and a new series of plaster figures titled *Prietas*.

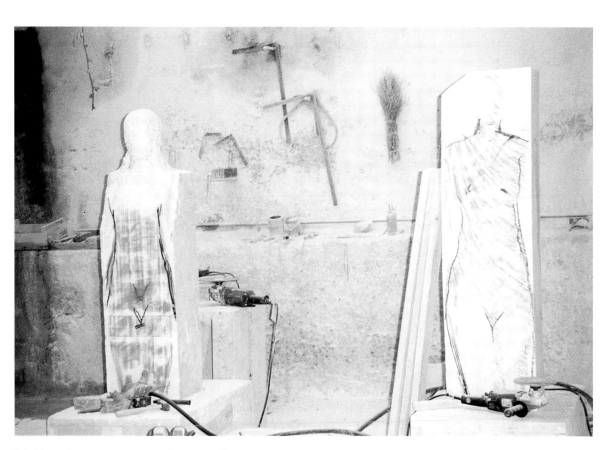

Marble sculptures in progress, Carrara studio, c. 1993.

With Henry Geldzahler at Dia Center for the Arts, Bridgehampton, New York, 1993.

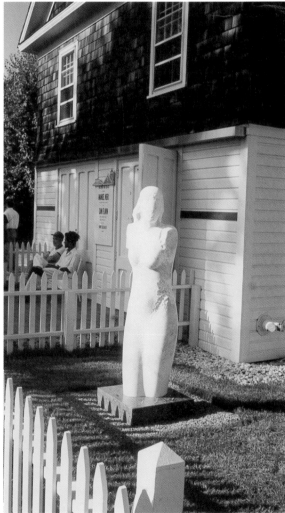

Aurelia No. 1 installed in front of Dia Center for the Arts, 1993.

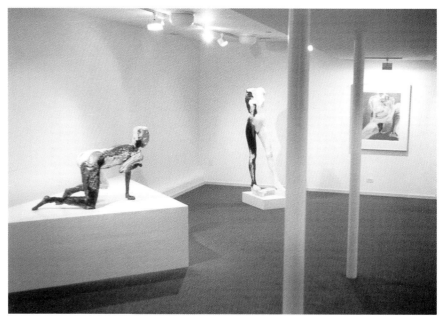

Installation view of Neri's solo exhibition at Dia Center for the Arts, curated by Henry Geldzahler, 1993. From left: *Bull Jumper III* (Cast 2/4), *Untitled II* (Cast 2/4), and *Isla Negra No. 2*.

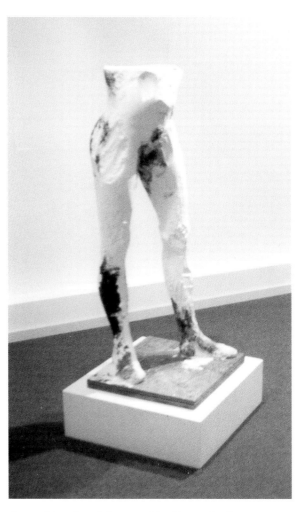

Sancas I in solo exhibition at Dia Center for the Arts, 1993.

Solo exhibition, Dia Center for the Arts, 1993. From left: *Markos, Makiko No. 4* (Cast 1/4), *Makiko No. 2* (Cast 1/4), and drawing, *Makiko*.

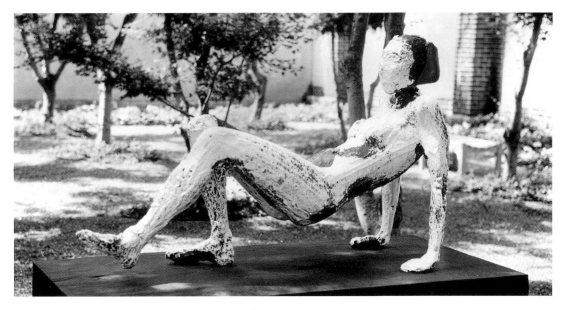

La Palestra No. 5 (Cast 2/4) installed at Grounds for Sculpture, Hamilton, New Jersey, 1994.

Neri and Dr. Beej Nierengarten-Smith, Director of Laumeier Sculpture Park, St. Louis, Missouri, with the maquette for *Aurelia Roma*, 1994.

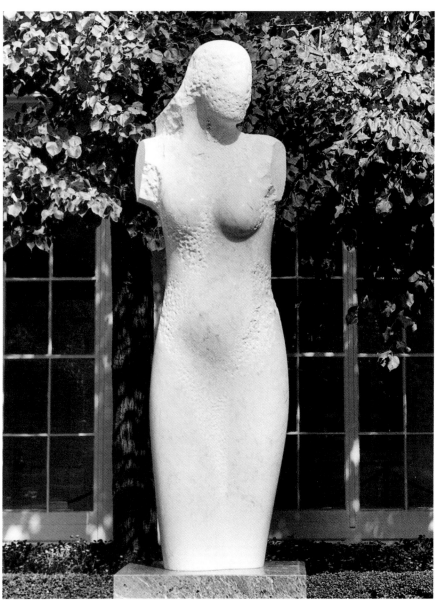

Aurelia No. 1 installed for exhibition in the First Lady's Garden, The White House, 1994.

1994 *May* Neri's sculptures *La Palestra No. 5* (Cast 2/4) and *Untitled Standing Figure No. 5* (A/P) are included in the "Spring/Summer Exhibition 94" at Grounds for Sculpture, Hamilton, New Jersey.

August Receives a commission from Laumeier Sculpture Park in St. Louis, Missouri, for an over-life-size marble sculpture in honor of long-time supporters Aurelia and George Schlapp.

October Neri's marble sculpture *Aurelia No. 1* is included in the exhibition "Twentieth Century American Sculpture at The White House," organized by George Neubert at the request of First Lady Hillary Clinton.

Dr. Beej Nierengarten-Smith, Director of Laumeier Sculpture Park, travels to Carrara for a second phase approval of the commissioned sculpture *Aurelia Roma*.

Dr. Beej Nierengarten-Smith and Neri with *Aurelia Roma*, Carrara, 1994.

Neri with Carla Verri in doorway of building in Carrara where Michelangelo worked, 1994.

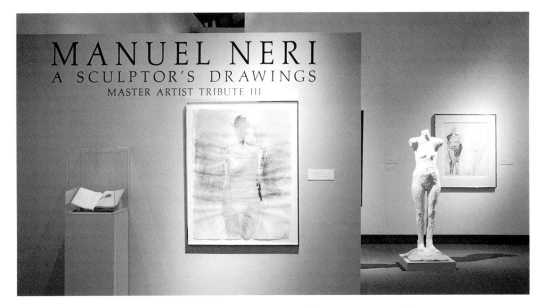

Installation view of "Manuel Neri: A Sculptor's Drawings," the Master Artist Tribute exhibition at Hearst Art Gallery, St. Mary's College, Moraga, California, 1994. From left: *Indios Verdes No. 4, Untitled Standing Figure,* and *Carla No. 2.*

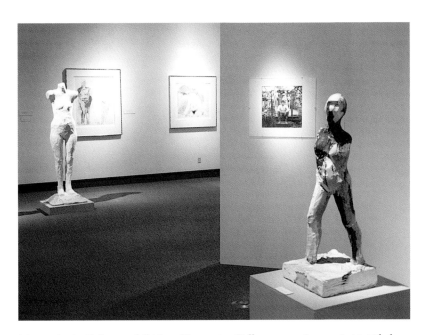

Neri, right, with Nathan Oliveira and Betty Hine at reception for Master Artist Tribute exhibition, Hearst Art Gallery, December 1994.

Master Artist Tribute exhibition, Hearst Art Gallery, 1994. In rear is *Untitled Standing Figure,* 1971, with *Untitled Figure,* c. 1960, at right. Drawings, from left, are *Carla No. 2* and *Collage Drawing for Carla II.*

Neri sketchbooks and framed drawings from sketchbooks in Master Artist Tribute exhibition, Hearst Art Gallery, 1994. In case at left is *Repair Sketchbook.* Drawings at right are *Figure Study No. 54* and *Figure Study No. 7.*

November–December Marble sculptures by Neri are included in "The Essential Gesture," curated by Bruce Guenther at the Newport Harbor Art Museum, Newport Beach, California.

December St. Mary's College in Moraga, California, honors Neri with a Master Artist Tribute exhibition of drawings at the Hearst Art Gallery. In conjunction with this exhibition, the catalogue *Manuel Neri: A Sculptor's Drawings* is published by The Corcoran Gallery of Art, Washington, D.C.

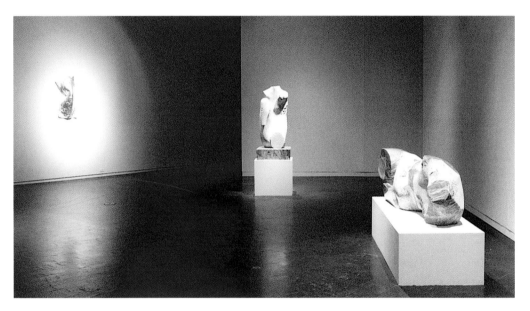

Installation of the exhibition "The Essential Gesture" at Newport Harbor Art Museum, Newport Beach, California, 1994, showing Neri's marble sculptures *Oka*, center, and *Piedra Negra*, right. On wall at left is sculpture by Lynda Benglis.

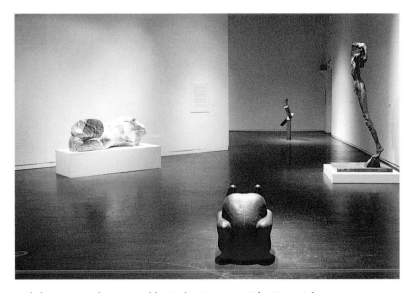

At left, Neri's reclining marble *Piedra Negra* in "The Essential Gesture," Newport Harbor Art Museum, 1994.

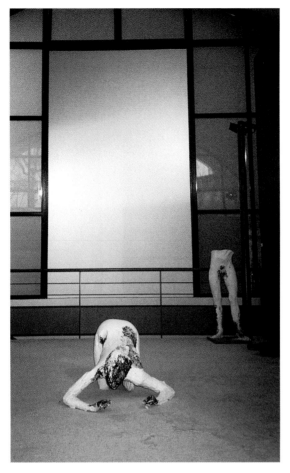

Installation view of Neri's exhibition at Galerie Claude Samuel in Paris, 1995, with plaster sculptures *Bull Jumper II* and *Sancas I*.

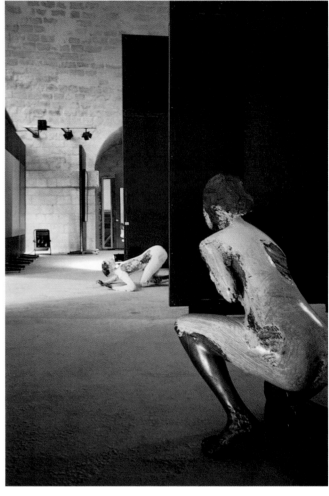

Plaster *Bull Jumper II* and bronze Untitled (Cast 1/4), 1991, at Galerie Claude Samuel in Paris, 1995.

Review in *Le Monde* for Neri's first solo exhibition in Paris, at Galerie Claude Samuel, February 1995. ". . . The painting and sculpture of Manuel Neri are very much more at ease in this gallery space. His work in bronze and plaster has a brutal impact, and his crouching women take over the gallery in a spirit of fabulous exhibitionism. This is the first show in France of this great Californian sculptor, who will be a discovery for many here."

1995 *January* Neri's early plaster sculpture *Chula* is included in
the inaugural exhibition of the new San Francisco Museum
of Modern Art.

February Galerie Claude Samuel in Paris opens its new
gallery space with an exhibition of sculptures and drawings
by Neri, and paintings by German artist Peter Reicheberger.

Neri's exhibition at Galerie Claude Samuel is the setting for a
French video about music, *Illusique et compagnie*, produced
by Glass, Adams et Cie. for national television broadcast.

March Charles Cowles Gallery presents a solo exhibition of
marbles, drawings, and bronzes, which includes several of the
Maki and *Makida* heads in marble.

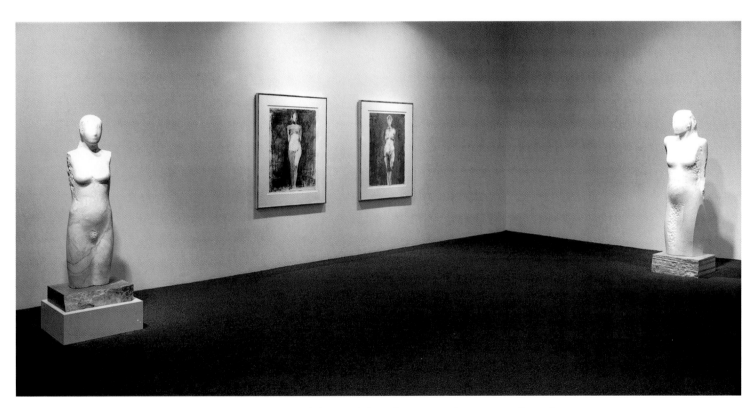

Solo exhibition at Charles Cowles Gallery, March 1995. From left: *Untitled II, Alicia No. 7, Alicia No. 8,* and *Aurelia No. 3.*

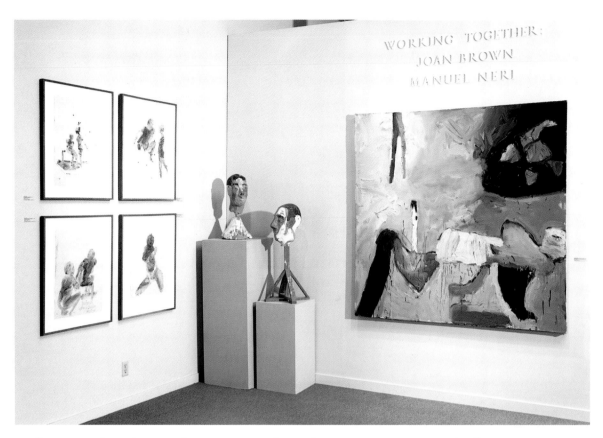

Installation view of "Working Together: Joan Brown and Manuel Neri, 1958–1964" at Wiegand Gallery, College of Notre Dame, Belmont, California, 1995, showing Neri drawings at left and plaster heads *Dr. Zonk* and *Portrait Series No. 1* alongside Joan Brown's painting *Swimming Party and Bicycle Ride.*

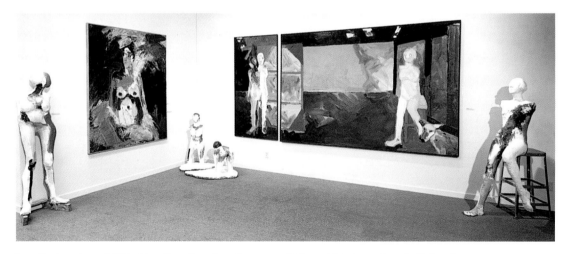

Installation view of "Working Together: Joan Brown and Manuel Neri, 1958–1964," showing Neri's plaster sculptures, from left, *Carla II, The Bathers,* and *Seated Female Figure,* with Brown's paintings *Portrait of the Old Lady Who Stole Our Dog from the Surf* and *Models with Manuel's Sculpture.*

March Neri gives the opening lecture at the Santa Barbara Sculpture Symposium in Santa Barbara, California.

The Wiegand Gallery at the College of Notre Dame in Belmont, California, organizes the exhibition "Working Together: Joan Brown and Manuel Neri, 1958–1964," featuring paintings, drawings, and sculptures created by both artists during the years in which they worked in shared studios. A catalogue is published for the exhibition.

The marble *Aurelia No. 1* is included in the "Spoleto Festival USA" exhibition at the Gibbes Museum of Art in Charleston, South Carolina.

May Awarded Honorary Doctorate by The Corcoran School of Art in Washington, D.C.

Aurelia No. 1 in "Spoleto Festival USA," Gibbes Museum of Art, Charleston, South Carolina, 1995.

Neri receives an Honorary Doctorate from The Corcoran School of Art, May 1995. From left: Deputy Director/Chief Curator Jack Cowart, Nathan Lyons, Director of Visual Studies Workshop in Rochester, NY, Trustee Michael Wyatt, Thomas Geismar, of Chermayeff & Geismar, keynote speaker Peggy Cooper Cafritz, Chairman Emeritus Robin B. Martin, Neri, Director and President David C. Levy, and Samuel Hoi, Dean of the School of Art.

Installation view of "Beat Culture and the New America, 1950–1965" at the Whitney Museum of American Art, New York, 1995, showing *Wire Figure No. 1* (on pedestal, third from right).

Solo exhibition at Robischon Gallery, Denver, 1995. From left: *Ostraca* (Cast 3/4), *Andrea No. 17, Andrea No. 4,* and *Study for Española* (Cast 3/4).

The marble sculpture *Aurelia Roma* is installed at Laumeier Sculpture Park in St. Louis, Missouri.

November *Wire Figure No. 1* is included in the Whitney Museum of American Art exhibition "Beat Culture and the New America, 1950–1965," which travels to the Walker Art Center, Minneapolis, and the M. H. de Young Memorial Museum, San Francisco.

The drawing *Alberica No. 1* is included in "Treasures of the Achenbach Foundation for the Graphic Arts," an inaugural exhibition at the newly renovated California Palace of the Legion of Honor, San Francisco.

Neri lectures in Denver for the Alliance for Contemporary Art, in conjunction with a solo exhibition at Robischon Gallery.

The Nevada Institute for Contemporary Art in Las Vegas presents a solo exhibition of sculptures and drawings, for which a catalogue is published.

Neri with Dianne Vanderlip, Denver Art Museum Curator of Contemporary and Modern Art, at Robischon Gallery, Denver, 1995.

Study for *Aurelia No. 1* (Cast 4/4) and *Jo II* in solo exhibition at Lisa Kurts Gallery in Memphis, Tennessee, 1996.

Aurelia No. 2 marble sculpture in solo exhibition at Lisa Kurts Gallery, 1996.

1996 *February* Solo exhibition of recent drawings and sculpture opens at Lisa Kurts Gallery in Memphis, Tennessee.

Riva Yares Gallery in Scottsdale, Arizona, presents solo exhibition "Manuel Neri: Classical Expressions/Sculptures and Drawings."

March Neri speaks in California Artist Series at the National Art Education Association Convention in San Francisco.

April Neri is juror for the "1996 North American Sculpture Exhibition" at Foothills Art Center in Golden, Colorado, and lectures in conjunction with the opening.

Solo exhibition at Riva Yares Gallery in Scottsdale, Arizona, 1996. Sculptures, clockwise from front: *Odalisque IV, Prietas Series I, Untitled Standing Female Figure No. 2, Bull Jumper I (A/P), Bull Jumper II, (Cast 1/4), Prietas Series VI (Cast 1/4), Prietas Series II (Cast 1/4), Prietas Series V (Cast 1/4)*, and *Aurelia No. 1*. Drawing on rear wall is *Mujer Ladina*; on wall at right are *Study II for Mujer Pegada Series* (Cast 1/4) and *Study I for Mujer Pegada Series* (Cast 1/4).

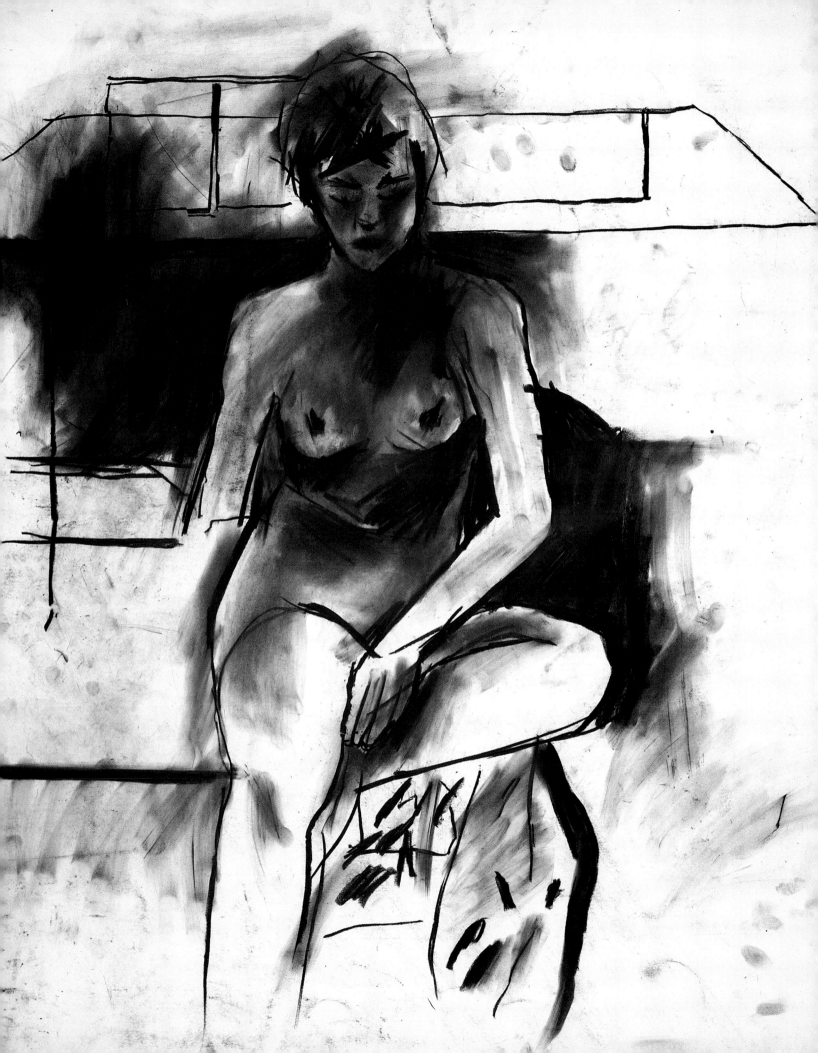

LIST OF ILLUSTRATIONS

38. *Untitled (Nude Model with Bischoff Painting)*, 1957
Tempera, charcoal, pastel on paper
30⅝"h × 25¼"w
Collection of William and Penny True, Seattle, WA

39. *Untitled Figure Study No. 11*, 1957
Tempera, charcoal on paper
30¼"h × 25¼"w

40. *Chanel*, c. 1957–58
Plaster, oil-based enamel, wood, canvas
67¼"h × 17"w × 19"d

41–42. *Hombre Colorado*, c. 1957–58
Plaster, oil-based enamel, wood, wire, canvas
69"h × 16"w × 20¼"d

43. *Untitled Standing Figure*, 1957–58
Plaster, oil-based enamel, aluminum paint, wood, wire, burlap
61"h × 22"w × 16¼"d
Private Collection, San Francisco, CA

44–45. *Beach Figure*, 1958
Plaster, oil-based enamel, aluminum paint, wood, wire
48"h × 19"w × 17¼"d

46–47. Untitled, 1959
Plaster, oil-based enamel, aluminum paint, wood, wire, burlap
60"h × 22"w × 13¼"d
San Francisco Museum of Modern Art, William L. Gerstle Collection, William L. Gerstle Fund Purchase
Photo courtesy of San Francisco Museum of Modern Art

48. Elmer Bischoff, *Two Figures at the Seashore*, 1957
Oil on canvas
56"h × 56¾"w
Collection Newport Harbor Art Museum, Museum purchase with a matching grant from the National Endowment for the Arts
Photo courtesy of Newport Harbor Art Museum

49. David Park, *Standing Nude Couple*, 1960
Gouache on paper
15¼"h × 13½"w
Collection of The Oakland Museum, Museum Donors Acquisition Fund
Photo courtesy of The Oakland Museum

50. *The Bathers*, 1958
Plaster, oil-based enamel, aluminum paint, wood, wire, canvas
left: 39"h × 16"w × 12"d
right: 20¼"h × 28¼"w × 25"d

51. *Couple: Male Figure*, 1962
Plaster, oil-based enamel, aluminum paint, wood, wire, burlap
60"h × 14"w × 15"d

52. *Couple: Female Figure*, 1962
Plaster, oil-based enamel, aluminum paint, wood, wire, burlap
60¼"h × 15⅛"w × 16¼"d

53. David Park, *Couple*, 1959
Oil on canvas
25¼"h × 47"w
Collection of Flagg Family Foundation, Monterey, CA
Photo courtesy of Flagg Family Foundation

54. *Dr. Zonk*, 1958
Plaster, oil-based enamel, graphite, wood, burlap
22"h × 10¼"w × 10¼"d

55. *Portrait Series I*, c. 1959
Plaster, oil-based enamel, graphite, wood, burlap
32"h × 16"w × 16"d

56. *Plaster Mask I*, c. 1960
Plaster, oil-based enamel, graphite, wire, burlap
9⅞"h × 6¼"w × 5⅝"d

57. *Plaster Mask II*, c. 1960
Plaster, oil-based enamel, wire, burlap
10¼"h × 6¼"w × 6"d

58. *Plaster Mask III*, c. 1960
Plaster, oil-based enamel, graphite, wire, burlap
9"h × 6"w × 4"d

59. David Park, *Crowd of Ten*, 1960
Gouache on paper
13⅜"h × 19¾"w
Collection of Harry W. and Mary Margaret Anderson
Photo courtesy of Anderson Collection

60–62. *Head of Joan Brown*, c. 1959
Plaster, graphite, wood, wire, burlap
16"h × 7"w × 8"d
Collection of Charles and Glenna Campbell, San Francisco, CA

63. *Seated Male Figure*, 1959
Plaster, graphite, wood, wire, burlap
67"h × 26"w × 27"d

64. *Standing Male Figure*, c. 1960;
Reworked mid-1960s
Plaster, oil-based enamel, wood, wire, burlap
70"h × 13¼"w × 19"d
Private collection, San Francisco, CA

65. Joan Brown, *Models with Manuel's Sculpture*, 1961
Oil on canvas
left panel: 72¼"h × 36"w
right panel: 72"h × 120"w
Collection of The Oakland Museum, Gift of Concours d'Antiques, Art Guild, Oakland Museum Association
Photo courtesy of The Oakland Museum

66. Joan Brown, *Figure with Manuel's Sculpture*, 1961
Mixed media and collage on paper
40"h × 30"w
Collection of Museum of Contemporary Art, San Diego, Gift of Mr. and Mrs. Robert J. Silver
Photo courtesy of Museum of Contemporary Art, San Diego

67. *Seated Female Figure with Leg Raised*, 1959
Plaster, oil-based enamel, graphite, wood, wire, canvas
67¼"h × 25¼"w × 23¼"d

68. *Moon Sculpture I*, c. 1960
Wood, plaster, cardboard, oil-based enamel
79"h × 15½"w × 2¼"d

69. *Drawing for Moon Sculpture No. 4*, c. 1960
Water-based pigment, graphite on paper
30¼"h × 25¾"w
The Manuel Neri Archive, The Corcoran Gallery of Art, Washington, DC

70. *Drawing for Moon Sculpture No. 5*, c. 1960
Water-based pigment, graphite on paper
30"h × 22"w
The Manuel Neri Archive, The Corcoran Gallery of Art, Washington, DC

71. Joan Brown, *Dogs Dreaming of Things and Images*, 1960
Oil and enamel on canvas
three panels: each 72"h × 69"w
Collection of Barbara and Ron Kaufman, San Francisco, CA

72. *Drawing for Moon Sculpture No. 3*, c. 1960
Water-based pigment, pastel, graphite, collage on paper
40"h × 26"w
The Manuel Neri Archive, The Corcoran Gallery of Art, Washington, DC

73. *Moon Sculpture II*, c. 1960
Wood, plaster, cardboard, oil-based enamel
61¼"h × 29⅜"w × 3"d

74. Joan Brown, *Untitled (Bird)*, c. 1960
Cardboard, twine, gauze, wood, electrical wire
12"h × 6"w × 8"d
Collection of Noel Neri, San Francisco, CA

75. Joan Brown, *Refrigerator Painting*, 1964
Oil on canvas
60"h × 60"w
Collection of Harry Cohn, Hillsborough, CA

76. *Pink Spooned Snap*, c. 1960
Cardboard, plaster, wire, twine, staples, graphite, acrylic on wood base
22¾"h × 8½"w × 19"d

77. *Hawk*, c. 1957–60
Cardboard, oil-based enamel, graphite, wire, plaster, string, nails, wood
14¼"h × 9"w × 5"d

78–81. *Untitled (Bird)*, c. 1957–60
Cardboard, plaster, oil-based enamel, string, wire, nails, staples on wood base
15¾"h × 15"w × 9¼"d
Collection of Mr. and Mrs. Gerald D. Kohs, Portola Valley, CA

82. *Joan Brown and Sculpture No. 1*, 1963
Water-based pigment, graphite on paper
19⅞"h × 17¼"w
The Manuel Neri Archive, The Corcoran Gallery of Art, Washington, DC

83. *Joan Brown and Sculpture No. 2*, 1963
Water-based pigment, graphite on paper
19⅞"h × 17¼"w
The Manuel Neri Archive, The Corcoran Gallery of Art, Washington, DC

84. *Joan Brown Working on Sculpture of Seated Girl*, 1963
Water-based pigment, graphite on paper
23¼"h × 18"w
The Manuel Neri Archive, The Corcoran Gallery of Art, Washington, DC

85. *Seated Girl I (Bather)*, c. 1960
Plaster, oil-based enamel, aluminum paint, wood, wire, burlap
47⅛"h × 29½"w × 25"d
Collection of Mavis and Robert Hudson, Cotati, CA

86. *Seated Girl II (Bather)*, c. 1960–63
Plaster, oil-based enamel, aluminum paint, wood, wire, burlap
44"h × 29½"w × 27¼"d
Collection of Elmer Schlesinger Trust

87. *Untitled Figure Study*, 1977
Water-based pigment, ink, graphite on paper
13⅞"h × 14"w

88. *Miseglia Sketchbook*, page 36, c. 1975
Water-based pigment, graphite on paper
8⅛"h × 12⅛"w
The Manuel Neri Archive, The Corcoran Gallery of Art, Washington, DC

89. *Shrouded Figure*, c. 1960; Reworked 1962–64
Plaster, water-based pigment, wood, wire, burlap
28"h × 32"w × 15"d

90. *Seated Female Figure*, 1961
Plaster, wood, wire, burlap
28"h × 56"w × 36"d
Collection of Kent Wright and Victor Bonfilio,
San Francisco, CA

91. *Study for Seated Female Figure*, 1963
Water-based pigment, graphite on paper
23¼"h × 18"w
The Manuel Neri Archive, The Corcoran
Gallery of Art, Washington, DC

92. *Study for Kneeling Figure*, 1963
Water-based pigment, graphite on paper
20"h × 17¼"w
The Manuel Neri Archive, The Corcoran
Gallery of Art, Washington, DC

93. *Kneeling Figure*, c. 1960; Reworked 1962–64
Plaster, oil-based enamel, aluminum paint,
wood, wire, burlap
28½"h × 18½"w × 20"d

94. *Torso Grande I*, 1963
Plaster with aggregate, oil-based enamel,
graphite, wood, wire, burlap
26½"h × 67¼"w × 27"d

95. *Torso Grande II*, 1963
Plaster with aggregate, oil-based enamel,
graphite, wood, wire, burlap
25½"h × 70"w × 21"d

96. *Studies for Geometric Sculptures I*, 1966
Graphite and oil pastel on paper, mounted
on stainless steel
approx. 27¼"h × 33¾"w

97. *No Hands Neri Sketchbook*, page 58
(verso), c. 1966
Graphite, ink, oil pastel on paper
10¾"h × 13⅞"w
The Manuel Neri Archive, The Corcoran
Gallery of Art, Washington, DC

98. *Study No. 1 for Geometric Sculptures*, 1963
Ink, graphite on paper
10¾"h × 13¼"w

99. *No Hands Neri Sketchbook*, page 67
(verso), c. 1966
Water-based pigment, graphite on paper
10¾"h × 13⅞"w
The Manuel Neri Archive, The Corcoran
Gallery of Art, Washington, DC

100. *Geometric Sculpture No. 2*, 1966
Stainless steel, oil-based enamel, wood armature
61"h × 42"w × 23"d

101. *Geometric Sculpture No. 1*, 1966
Stainless steel, oil-based enamel, wood armature
58½"h × 29"w × 16⅛"d

102. *No Hands Neri Sketchbook*, page 75
(verso), c. 1966
Graphite, water-based pigment on paper
10¾"h × 13⅞"w
The Manuel Neri Archive, The Corcoran
Gallery of Art, Washington, DC

103. *No Hands Neri Sketchbook*, page 82
(verso), c. 1966
Oil pastel, water-based pigment, graphite
on paper
13⅞"h × 10¾"w
The Manuel Neri Archive, The Corcoran
Gallery of Art, Washington, DC

104. *No Hands Neri Sketchbook*, page 83
(verso), c. 1966
Oil pastel, water-based pigment, graphite
on paper
13⅞"h × 10¾"w
The Manuel Neri Archive, The Corcoran
Gallery of Art, Washington, DC

105. *No Hands Neri Sketchbook*, page 43
(verso), c. 1966
Water-based pigment, oil pastel, graphite
on paper
13⅞"h × 10¾"w
The Manuel Neri Archive, The Corcoran
Gallery of Art, Washington, DC

106. *No Hands Neri Sketchbook*, page 24
(verso), c. 1966
Graphite, water-based pigment on paper
13⅞"h × 10¾"w
The Manuel Neri Archive, The Corcoran
Gallery of Art, Washington, DC

107. *Open Box Form I*, 1968
Plaster, wood, wire mesh
33"h × 27¹¹⁄₁₆"w × 21⅛"d

108. *Open Box Form II*, 1968
Plaster, wood, wire mesh
35"h × 37¼"w × 44¾"d

109. *Ink Drawing of Crucifixion I*, 1965
Ink and graphite on paper
40"h × 26"w
The Manuel Neri Archive, The Corcoran
Gallery of Art, Washington, DC

110. *Ink Drawing of Crucifixion IV*, 1965
Ink and graphite on paper
30"h × 36"w
The Manuel Neri Archive, The Corcoran
Gallery of Art, Washington, DC

111. Drawing of Crucifixion, c. mid-14th century
Pen drawing in red and olive-green pigment
on parchment
3⅞"h × 2"w
Illustrated in *Gothic Drawing*, Zoroslava
Drobna (Jean Layton, trans.). Artia Prague,
publisher (n.d.)

112. *Crucifixion Drawing No. 1*, 1963
Water-based pigment, ink, graphite,
collage on paper
8⅞"h × 11¼"w
The Manuel Neri Archive, The Corcoran
Gallery of Art, Washington, DC

113. *Crucifixion Drawing No. 4*, 1963
Water-based pigment, ink, graphite on paper
8⅞"h × 11¼"w
The Manuel Neri Archive, The Corcoran
Gallery of Art, Washington, DC

114. *Crucifixion Drawing No. 3*, 1963
Water-based pigment, ink on paper
8⅞"h × 11¼"w
The Manuel Neri Archive, The Corcoran
Gallery of Art, Washington, DC

115. *Crucifixion Drawing No. 2*, 1963
Water-based pigment, ink on paper
8⅞"h × 11¼"w
The Manuel Neri Archive, The Corcoran
Gallery of Art, Washington, DC

116. *Crucifixion Drawing No. 5*, 1963
Water-based pigment, ink on paper
8⅞"h × 11¼"w
The Manuel Neri Archive, The Corcoran
Gallery of Art, Washington, DC

117. *Crucifixion Drawing No. 6*, 1963
Water-based pigment, graphite, ink on paper
8⅞"h × 11¼"w
The Manuel Neri Archive, The Corcoran
Gallery of Art, Washington, DC

118. *Study for Relief Icons No. 2*, c. 1965
Wax crayon, graphite on paper
8"h × 10"w
The Manuel Neri Archive, The Corcoran
Gallery of Art, Washington, DC

119. *Study for Relief Icons No. 1*, c. 1965
Wax crayon, graphite on paper
8"h × 10"w
The Manuel Neri Archive, The Corcoran
Gallery of Art, Washington, DC

120. *Crucifixion Drawing No. 7*, 1963
Water-based pigment, graphite, ink on paper
8⅞"h × 11¼"w
The Manuel Neri Archive, The Corcoran
Gallery of Art, Washington, DC

121. *Study No. 4 for Tikal Series*, c. 1969
Water-based pigment, graphite, collage on paper
13⅝"h × 10¼"w

122. *Study No. 2 for Tikal Series*, c. 1969
Water-based pigment, graphite, collage on paper
13¼"h × 10¼"w

123. *Repair Sketchbook*, page 37, c. 1969
Water-based pigment, graphite on paper
14"h × 11"w
The Manuel Neri Archive, The Corcoran
Gallery of Art, Washington, DC

124–25. *Tikal Series I* and *Tikal Series II*
Works in progress in Benicia studio, 1969
Plaster with aggregate, water-based pigment,
wood armature, wire mesh
approx. 72"h
Photographer unknown

126. *Architectural Forms III from Tula Series*, 1969
Plaster with aggregate
front: 5¼"h × 25¼"w × 25¼"d
middle: 5¼"h × 25¼"w × 25¼"d
back: 5¼"h × 25"w × 28"d

127. *Rock No. 73*, c. 1967–69
Water-based pigment, graphite on paper
10¼"h × 13⅝"w

128. *Rock No. 75*, c. 1967–69
Water-based pigment, graphite on paper
10¼"h × 13⅝"w

129. *Study No. 2 for Architectural Forms III
from Tula Series*, 1969
Water-based pigment, graphite on paper
14"h × 10¼"w
The Manuel Neri Archive, The Corcoran
Gallery of Art, Washington, DC

130. *Study No. 1 for Architectural Forms III
from Tula Series*, 1969
Water-based pigment, graphite on paper
14"h × 10¼"w
The Manuel Neri Archive, The Corcoran
Gallery of Art, Washington, DC

131. *Architectural Forms IV from Tula Series*, 1969
Plaster with aggregate
left: 38"h × 24"w × 5¼"d
right: 36"h × 24"w × 5¼"d
Collection of Rena Bransten, San Francisco, CA

132. *Rock No. 77a*, c. 1967–74
Water-based pigment on paper
13⅜"h × 8¾"w
The Manuel Neri Archive, The Corcoran
Gallery of Art, Washington, DC

133. *Architectural Form V from Tula Series*, 1969
Plaster with aggregate, wire, burlap
37"h × 37"w × 13"d
Collection of Charles Boone, San Francisco

134. *Study No. 3 for Architectural Form V
from Tula Series*, c. 1969
Water-based pigment, graphite on paper
10¼"h × 13¹⁵⁄₁₆"w
The Manuel Neri Archive, The Corcoran
Gallery of Art, Washington, DC

135. *Ladder Sketchbook*, page 66 (verso), 1971–72
Water-based pigment, graphite, collage on paper
13¾"h × 10⅞"w
The Manuel Neri Archive, The Corcoran
Gallery of Art, Washington, DC

136. *Ladder Sketchbook*, page 75, 1971–72
Graphite, water-based pigment, collage on paper
13¾"h × 10⅞"w
The Manuel Neri Archive, The Corcoran
Gallery of Art, Washington, DC

137. *Emborados Series—Nazca Lines III*, 1972
Cardboard, tape, pigments, resin
40¼"h × 21¼"w × 2¾"d

138. *Ladder Sketchbook*, page 51, 1971–72
Graphite, water-based pigment, cutout on paper
13¾"h × 10⅞"w
The Manuel Neri Archive, The Corcoran
Gallery of Art, Washington, DC

139. *Projections Sketchbook*, page 18, c. 1965–83
Dry pigment/water, color pencil, graphite,
collage, cutout on paper
13⅜"h × 10⅞"w
The Manuel Neri Archive, The Corcoran
Gallery of Art, Washington, DC

140. *Emborados Series—Nazca Lines II*, 1972
Cardboard, tape, pigment, resin
43¼"h × 55¾"w × 2"d

141. *Mary Julia No. 1*, 1972
Acrylic, graphite on paper
46"h × 40"w
Collection of Mary Julia Klimenko, Benicia, CA

142. *Mary Julia No. 2*, 1972
Acrylic, graphite on paper
48¼"h × 42"w

143. *Crucifixion Sketchbook*, page 31 (verso), 1973
Water-based pigment, ink, graphite on paper
13⅜"h × 10¾"w
The Manuel Neri Archive, The Corcoran
Gallery of Art, Washington, DC

144. *Crucifixion Sketchbook*, page 29 (verso), 1973
Water-based pigment, graphite on paper
13⅜"h × 10¾"w
The Manuel Neri Archive, The Corcoran
Gallery of Art, Washington, DC

145. *Crucifixion Sketchbook*, page 34 (verso), 1973
Water-based pigment, ink, graphite on paper
13⅜"h × 10¾"w
The Manuel Neri Archive, The Corcoran
Gallery of Art, Washington, DC

146. *Study for Ascension No. 17*, 1973
Watercolor, graphite on paper
13¼"h × 10¼"w
The Manuel Neri Archive, The Corcoran
Gallery of Art, Washington, DC

147. *Study for Ascension No. 22*, 1973
Watercolor, graphite on paper
13¼"h × 10¼"w
The Manuel Neri Archive, The Corcoran
Gallery of Art, Washington, DC

148. *Study for Ascension No. 16*, 1973
Watercolor, graphite on paper
13¼"h × 10¼"w
The Manuel Neri Archive, The Corcoran
Gallery of Art, Washington, DC

149. *Study for Ascension No. 29*, 1973
Watercolor, graphite on paper
13¼"h × 10¼"w
The Manuel Neri Archive, The Corcoran
Gallery of Art, Washington, DC

150. *Christ Figure III*, 1973
Plaster, wood, wire, burlap
69"h × 24¼"w × 17¼"d

151. *Untitled Male Figure Fragment*
(Cast from *Christ in Ascension*), 1974
Bronze with patina
60¼"h × 13¼"w × 24"d
Collection of Crocker Art Museum, Sacra-
mento, CA, Gift of Crocker Art Gallery
Association, purchased with aid of funds
from the National Endowment for the Arts
and Maude T. Pook Fund
Photo courtesy of Crocker Art Museum

152. Installation of *Christ in Ascension*, 1973
Fiberglass, resin
60¼"h × 13¼"w × 24"d
Photographer unknown

153. *Mi Judia*, 1973
Plaster, wire, burlap
10¼"h × 7"w × 8¼"d
Collection of Joanne Leonard, Ann Arbor, MI

154. *Mary's Feet*, 1973
Plaster
approx. 26"h × 20"w × 20"d

155. *Virgin Mary*, 1973
Plaster, dry pigment/water, wood, wire, burlap
78¼"h × 29"w × 16¼"d

156. *Untitled Standing Figure*, 1974
Plaster, dry pigment/water, oil-based enamel,
wood, wire, burlap
61¼"h × 20"w × 17¼"d
Collection of Mr. and Mrs. Joachim Bechtle,
San Francisco, CA

157. *Untitled Standing Figure I*, 1974
Plaster, dry pigment/water, oil-based enamel,
wood, wire, burlap
64¼"h × 20¼"w × 20"d
Private Collection, San Francisco, CA

158. *Mary Julia*, 1973
Acrylic, graphite on paper
42"h × 29¾"w

159. *Mary Julia*, 1975; Reworked 1991
Plaster, dry pigment/water, steel armature,
styrofoam, burlap on wood base
66¼"h × 19¼"w × 14¼"d
Collection of Russell Solomon, Sacramento, CA

160. *Acha de Noche II*, 1975
Plaster, dry pigment/water, steel armature,
styrofoam, burlap
19¼"h × 62"w × 26¼"d

161. *Acha de Noche I*, 1975
Plaster, lampblack, steel armature,
styrofoam, burlap
12"h × 65"w × 14"d

162. Installation of *Acha de Noche I* and *Acha de
Noche IV* in "Manuel Neri, Sculptor,"
The Oakland Museum, 1976
Photo by Lorraine Capparell

163. *Sculpture Study No. 2 (Acha de Noche III)*,
c. 1975
Graphite, dry pigment/water on paper
11"h × 14"w

164. *Study for Acha de Noche III* (detail) from
Majic Act Sketchbook, c. 1975
Oil paint stick, charcoal, graphite on paper
13⅞"h × 10⅜"w

165. *Acha de Noche III*, 1975
Plaster, lampblack, steel armature,
styrofoam, burlap
16¼"h × 56"w × 14¼"d
Collection of Rene di Rosa, Napa, CA

166. Mary Julia posing for *Acha de Noche III*, 1975
Photo by Manuel Neri

167–69. "The Remaking of Mary Julia: Sculpture
in Progress" at 80 Langton Street,
San Francisco, 1976
Photos by Phillip Galgiani

170–72. Photographs taken by Mary Julia of Neri
working at 80 Langton Street, 1976

173–74. Photographs taken by Mary Julia of Neri
working at 80 Langton Street, 1976

175. Photograph taken by Manuel Neri of Mary
Julia at 80 Langton Street, 1976

176. *Remaking of Mary Julia No. 1*
(in progress), 1976
Plaster, steel armature, styrofoam, burlap
on wood base
66"h × 21"w × 13"d
Collection of Rita and Toby Schreiber, CA
Photo by Phillip Galgiani

177. *Remaking of Mary Julia No. 2*
(in progress), 1976
Plaster, steel armature, styrofoam, burlap
on wood base
64"h × 29¼"w × 13¼"d
Photo by Phillip Galgiani

178. *Remaking of Mary Julia No. 3*
(in progress), 1976
Plaster, steel armature, styrofoam, burlap
on wood base
64¼"h × 24¼"w × 14¼"d
Photo by Phillip Galgiani

179. *Remaking of Mary Julia No. 4*
(in progress), 1976
Plaster, steel armature, styrofoam, burlap
on wood base
66¼"h × 19¾"w × 13¼"d
Photo by Phillip Galgiani

180. *Remaking of Mary Julia No. 5*
(in progress), 1976
Plaster, steel armature, styrofoam, burlap
on wood base
66"h × 20"w × 18"d
Photo by Phillip Galgiani

181. *Remaking of Mary Julia No. 6* (later titled
Nancy), 1976
Plaster, steel armature, styrofoam, burlap
52"h × 17"w × 38"d

182. *Remaking of Mary Julia No. 8*, 1976
Plaster, steel armature, styrofoam, burlap
on wood base
65¼"h × 23"w × 14¼"d

183. *Remaking of Mary Julia No. 8*, 1976
Plaster, steel armature, styrofoam, burlap
on wood base
65¼"h × 23"w × 14¼"d

MANUEL NERI'S EARLY SKETCHBOOKS
Price Amerson

184. *Figure Study No. 54*, c. 1957; Reworked c. 1980
Oil paint stick, ink, graphite on paper
13⁹⁄₁₆"h × 10¾"w

185. *Catalogue of Reprints in Series Sketchbook*,
pages 108–109, c. 1953
Water-based pigment, pastel on paper
9¹⁵⁄₁₆"h × 13"w
The Manuel Neri Archive, The Corcoran
Gallery of Art, Washington, DC

186. *Raoul Sketchbook*, page 12, c. 1955–59
Graphite on paper
10⅝"h × 8⅛"w
The Manuel Neri Archive, The Corcoran
Gallery of Art, Washington, DC

187. *Raoul Sketchbook*, page 30 (verso), c. 1955–59
Graphite on paper
10⅝"h × 8⅛"w
The Manuel Neri Archive, The Corcoran
Gallery of Art, Washington, DC

188. *Clipper Sketchbook*, page 23, 1955–59
Water-based pigment, ink, graphite on paper
14"h × 11"w
The Manuel Neri Archive, The Corcoran
Gallery of Art, Washington, DC

189. *Clipper Sketchbook*, page 21, 1955–59
Graphite, ink on paper
14"h × 11"w
The Manuel Neri Archive, The Corcoran
Gallery of Art, Washington, DC

190. *Clipper Sketchbook*, page 22, 1955–59
Water-based pigment, ink, graphite on paper
14"h × 11"w
The Manuel Neri Archive, The Corcoran
Gallery of Art, Washington, DC

191. *Clipper Sketchbook*, page 25, 1955–59
Water-based pigment, ink, graphite,
wax crayon on paper
14"h × 11"w
The Manuel Neri Archive, The Corcoran
Gallery of Art, Washington, DC

192. *Casting Sketchbook*, page 55, c. 1959
Oil pastel, water-based pigment, graphite
on paper
10⅞"h × 8¼"w
The Manuel Neri Archive, The Corcoran
Gallery of Art, Washington, DC

193. *Raoul Sketchbook*, page 27 (verso), c. 1955–59
Oil pastel, graphite on paper
10⅝"h × 8⅛"w
The Manuel Neri Archive, The Corcoran
Gallery of Art, Washington, DC

194. *Casting Sketchbook*, page 51, c. 1959
Oil pastel, water-based pigment, graphite
on paper
10⅞"h × 8¼"w
The Manuel Neri Archive, The Corcoran
Gallery of Art, Washington, DC

195. *Green Trees Sketchbook*, page 4, c. 1955–58
Graphite on paper
9¾"h × 7¼"w
The Manuel Neri Archive, The Corcoran
Gallery of Art, Washington, DC

196. *Green Trees Sketchbook*, page 12, c. 1955–58
Graphite on paper
9¾"h × 7¼"w
The Manuel Neri Archive, The Corcoran
Gallery of Art, Washington, DC

197. Untitled, 1955–56
Wood, plaster, mixed media
approx. 48"h
Photo by Gerald Orer

198. *Green Trees Sketchbook*, page 16, c. 1955–58
Graphite on paper
9¾"h × 7¼"w
The Manuel Neri Archive, The Corcoran
Gallery of Art, Washington, DC

199. *Ceramic Loop III*, c. 1956–61
Glazed ceramic
24"h
Location, photographer unknown

200. *Ceramic Loop II*, c. 1956–61
Glazed ceramic
18¼"h
Location, photographer unknown

201. *SFAI Sketchbook*, page 16, c. 1956–60
Oil pastel, graphite, collage on paper
10⅞"h × 8¼"w
The Manuel Neri Archive, The Corcoran
Gallery of Art, Washington, DC

202. *SFAI Sketchbook*, page 8, c. 1956–60
Oil pastel, ink, graphite, collage on paper
10⅞"h × 8¼"w
The Manuel Neri Archive, The Corcoran
Gallery of Art, Washington, DC

203. *SFAI Sketchbook*, page 57, c. 1956–60
Oil pastel, ink, graphite, collage on paper
10⅞"h × 8¼"w
The Manuel Neri Archive, The Corcoran
Gallery of Art, Washington, DC

204. *Ceramic Loop IV*, c. 1956–61
Ceramic, glaze, epoxy
24"h × 20½"w × 19¼"d
Collection of Frank Kolodny, Princeton, NJ
Photo by Phillip Galgiani

205. *SFAI Sketchbook*, page 60, c. 1956–60
Oil pastel, ink, graphite, collage on paper
10⅞"h × 8¼"w
The Manuel Neri Archive, The Corcoran
Gallery of Art, Washington, DC

206–7. *Plaster Loop I*, c. 1960
Plaster, wood, oil-based enamel, cloth
43⅛"h × 44"w × 21¼"d

208. *Study for Loop Sculpture*, c. 1957
Graphite on paper
13⁹⁄₁₆"h × 10¾"w

209–10. *Plaster Loop VI*, c. 1960
Plaster, oil-based enamel, wood, wire
approx. 43"h

211. *Study for Loop Sculpture* (verso), c. 1957
Graphite on paper
13⁹⁄₁₆"h × 10¾"w

212–13. *Plaster Loop V*, c. 1960
Plaster, oil-based enamel, wood, wire
approx. 43"h

214. *Plaster Loop II*, c. 1960
Plaster, oil-based enamel, wood,
chicken wire, burlap
43"h × 24"w × 7"d

215. *Clipper Sketchbook*, page 23, 1955–59
Wax crayon, graphite, ink, collage on paper
14"h × 11"w
The Manuel Neri Archive, The Corcoran
Gallery of Art, Washington, DC

216. *Landscapes Sketchbook*, page 23, c. 1955–56
Graphite on paper
9¾"h × 7⅝"w
The Manuel Neri Archive, The Corcoran
Gallery of Art, Washington, DC

217. *Landscapes Sketchbook*, page 22 (verso),
c. 1955–56
Graphite on paper
9¾"h × 7⅝"w
The Manuel Neri Archive, The Corcoran
Gallery of Art, Washington, DC

218. Alberto Giacometti, *Figurine dans une boîte
entre deux maisons*, 1950
Bronze, glass, paint
11¹³⁄₁₆"h × 21½"w × 3¾"d
Alberto Giacometti-Foundation,
Kunsthaus Zurich
Photo courtesy of Alberto
Giacometti-Foundation

219. Alberto Giacometti, *The Chariot*, 1950
Bronze, wood base
64⅝"h × 27"w × 26⅜"d
National Gallery of Art, Washington, DC,
Gift of Enid A. Haupt
Photo courtesy of National Gallery of Art

220. *Landscapes Sketchbook*, page 43 (verso),
c. 1955–56
Water-based pigment, graphite on paper
9¾"h × 7⅝"w
The Manuel Neri Archive, The Corcoran
Gallery of Art, Washington, DC

221. *Landscapes Sketchbook*, page 36 (verso),
c. 1955–56
Water-based pigment, graphite on paper
9¾"h × 7⅝"w
The Manuel Neri Archive, The Corcoran
Gallery of Art, Washington, DC

222. *Casting Sketchbook*, page 8, c. 1959
Graphite on paper
10⅞"h × 8¼"w
The Manuel Neri Archive, The Corcoran
Gallery of Art, Washington, DC

223. *Casting Sketchbook*, page 7, c. 1959
Graphite on paper
10⅞"h × 8¼"w
The Manuel Neri Archive, The Corcoran
Gallery of Art, Washington, DC

224. *Casting Sketchbook*, page 9, c. 1959
Graphite on paper
10⅞"h × 8¼"w
The Manuel Neri Archive, The Corcoran
Gallery of Art, Washington, DC

225. *Casting Sketchbook*, page 21, c. 1959
Graphite, ink on paper
10⅞"h × 8¼"w
The Manuel Neri Archive, The Corcoran
Gallery of Art, Washington, DC

226. *Casting Sketchbook*, page 31, c. 1959
Graphite on paper
10⅞"h × 8¼"w
The Manuel Neri Archive, The Corcoran
Gallery of Art, Washington, DC

227. *Casting Sketchbook*, page 60, c. 1959
Graphite on paper
10⅞"h × 8¼"w
The Manuel Neri Archive, The Corcoran
Gallery of Art, Washington, DC

228. *Fair Play Compositions Sketchbook*,
page 25, c. 1959
Graphite on paper
9¼"h × 7⅝"w
The Manuel Neri Archive, The Corcoran
Gallery of Art, Washington, DC

229. *Etter Sketchbook*, page 68, c. 1959
Water-based pigment, graphite on paper
10¼"h × 8½"w
The Manuel Neri Archive, The Corcoran
Gallery of Art, Washington, DC

230. *Figure Study No. 34*, c. 1957; Reworked c. 1980
Water-based pigment, graphite on paper
13⁵⁄₁₆"h × 10¾"w

231. *Figure Study No. 53*, c. 1957; Reworked c. 1980
Water-based pigment, graphite on paper
13⁵⁄₁₆"h × 10¾"w

232. *Figure Study No. 4*, c. 1957; Reworked c. 1980
Oil paint stick, ink, graphite on paper
13⁵⁄₁₆"h × 10¾"w

233. *Figure Study No. 33*, c. 1957; Reworked c. 1980
Oil paint stick, water-based pigment,
graphite on paper
13⁵⁄₁₆"h × 10¾"w

234. *Green Trees Sketchbook*, page 31 (verso),
c. 1955–58
Graphite on paper
9¼"h × 7¼"w
The Manuel Neri Archive, The Corcoran
Gallery of Art, Washington, DC

235. *Green Trees Sketchbook*, page 32, c. 1955–58
Graphite on paper
9¼"h × 7¼"w
The Manuel Neri Archive, The Corcoran
Gallery of Art, Washington, DC

236. *Unos Actos de Fe Sketchbook*, page 35
(verso), c. 1974–76
Graphite on paper
13"h × 8¼"w
The Manuel Neri Archive, The Corcoran
Gallery of Art, Washington, DC

237. *Unos Actos de Fe Sketchbook*, page 36,
c. 1974–76
Graphite on paper
13"h × 8¼"w
The Manuel Neri Archive, The Corcoran
Gallery of Art, Washington, DC

238. *Repair Sketchbook*, page 72, c. 1968–75
Graphite, watercolor, oil pastel on paper
11"h × 14"w
The Manuel Neri Archive, The Corcoran
Gallery of Art, Washington, DC

239. *Makiko No. 3 (Cast 1/4)*, 1981
Bronze with oil-based enamel
15¼"h × 11¼"w × 9¼"d
Collection of Mr. and Mrs. G. Turin,
Berkeley, CA

240. *Makiko*, 1980
Charcoal, dry pigment/water on paper
39"h × 29¼"w

241. *Maki No. 3*, 1994
Marble with oil-based enamel
19¼"h × 19"w × 14"d

242. *Repair Sketchbook*, page 77 (verso),
c. 1968–75
Graphite, ink, acrylic on paper
14"h × 11"w
The Manuel Neri Archive, The Corcoran
Gallery of Art, Washington, DC

243. *Repair Sketchbook*, page 83, c. 1968–75
Graphite, ink, acrylic on paper
14"h × 11"w

244. *Repair Sketchbook*, page 74, c. 1968–75
Graphite, acrylic on paper
14"h × 11"w
The Manuel Neri Archive, The Corcoran
Gallery of Art, Washington, DC

245. *Repair Sketchbook*, page 81, c. 1968–75
Graphite, ink, acrylic on paper
14"h × 11"w
The Manuel Neri Archive, The Corcoran
Gallery of Art, Washington, DC

246. *Repair Sketchbook*, page 78, c. 1968–75
Ink, acrylic on paper
14"h × 11"w
The Manuel Neri Archive, The Corcoran
Gallery of Art, Washington, DC

247. *Repair Sketchbook*, page 79, c. 1968–75
Graphite, ink, acrylic on paper
14"h × 11"w
The Manuel Neri Archive, The Corcoran
Gallery of Art, Washington, DC

248. *Landscapes Sketchbook*, page 2, c. 1955–56
Graphite on paper
7⅝"h × 9¼"w
The Manuel Neri Archive, The Corcoran
Gallery of Art, Washington, DC

249. *Casting Sketchbook*, page 1, c. 1959
Ink on paper
8¼"h × 10⅞"w
The Manuel Neri Archive, The Corcoran
Gallery of Art, Washington, DC

250. *Fair Play Compositions Sketchbook*,
page 16, c. 1959
Graphite on paper
9¼"h × 7⅝"w
The Manuel Neri Archive, The Corcoran
Gallery of Art, Washington, DC

251. *Fair Play Compositions Sketchbook*,
page 3, c. 1959
Graphite on paper
9¼"h × 7⅝"w
The Manuel Neri Archive, The Corcoran
Gallery of Art, Washington, DC

252. *Fair Play Compositions Sketchbook*,
page 17, c. 1959
Graphite on paper
9¼"h × 7⅝"w
The Manuel Neri Archive, The Corcoran
Gallery of Art, Washington, DC

253. *Fair Play Compositions Sketchbook*,
page 29, c. 1959
Graphite on paper
9¼"h × 7⅝"w
The Manuel Neri Archive, The Corcoran
Gallery of Art, Washington, DC

254. *Fair Play Compositions Sketchbook*,
page 28, c. 1959
Graphite, oil pastel on paper
9¼"h × 7⅝"w
The Manuel Neri Archive, The Corcoran
Gallery of Art, Washington, DC

255. *Fair Play Compositions Sketchbook*,
page 26, c. 1959
Graphite, oil pastel on paper
9¼"h × 7⅝"w
The Manuel Neri Archive, The Corcoran
Gallery of Art, Washington, DC

256. *Fair Play Compositions Sketchbook*,
page 27, c. 1959
Graphite, oil pastel on paper
9¼"h × 7⅝"w
The Manuel Neri Archive, The Corcoran
Gallery of Art, Washington, DC

257. *Stick No. 46*, c. 1970
Water-based pigment, collage, graphite on paper
10¾"h × 13"w

258. *Stick No. 43*, c. 1970
Water-based pigment, graphite on paper
10¾"h × 13"w

259. *Stick No. 51*, c. 1970
Water-based pigment, collage, graphite on paper
10¾"h × 13"w

260. *Bee IV*, c. 1970
Paper, cardboard, string, tape, glue, wax
3"h × 6"w × 3½"d

261. *Rock No. 26*, c. 1967–74
Dry pigment/water, graphite on paper
10¼"h × 13⅜"w

262. *Rock No. 27*, c. 1967–74
Graphite, water-based pigment on paper
10¼"h × 13⅜"w

263. *Fair Play Compositions Sketchbook*,
page 79, c. 1959
Graphite on paper
9¼"h × 7⅝"w
The Manuel Neri Archive, The Corcoran
Gallery of Art, Washington, DC

264. *Casting Sketchbook*, page 22, c. 1959
Graphite on paper
10⅞"h × 8¼"w
The Manuel Neri Archive, The Corcoran
Gallery of Art, Washington, DC

265. *Fair Play Compositions Sketchbook*,
page 73, c. 1959
Graphite on paper
7⅝"h × 9¼"w
The Manuel Neri Archive, The Corcoran
Gallery of Art, Washington, DC

266. Drawing by Susan Morse Neri from
No Hands Neri Sketchbook, page 6, c. 1966
Graphite on paper
13⅞"h × 10¼"w
The Manuel Neri Archive, The Corcoran
Gallery of Art, Washington, DC

267. *CSFA Sketchbook*, page 13, c. 1962–64
Water-based pigment, graphite on paper
10⅝"h × 13¼"w
The Manuel Neri Archive, The Corcoran
Gallery of Art, Washington, DC

268. *CSFA Sketchbook*, page 5, c. 1962–64
Water-based pigment, graphite on paper
10⅝"h × 13¼"w
The Manuel Neri Archive, The Corcoran
Gallery of Art, Washington, DC

269. *Projections Sketchbook*, page 64, c. 1965–83
Dry pigment/water, graphite on paper
10⅞"h × 13⅝"w
The Manuel Neri Archive, The Corcoran
Gallery of Art, Washington, DC

270. *No Hands Neri Sketchbook*, page 65, c. 1966
Oil pastel, water-based pigment, graphite
on paper
13⅞"h × 10¾"w
The Manuel Neri Archive, The Corcoran
Gallery of Art, Washington, DC

271. *No Hands Neri Sketchbook*, page 66, c. 1966
Oil pastel, water-based pigment, graphite on paper
13⅞"h × 10¾"w
The Manuel Neri Archive, The Corcoran Gallery of Art, Washington, DC

272. *Study No. 5 for Tikal Series I*, c. 1969
Graphite, ink, collage on paper
10¼"h × 13⅜"w
The Manuel Neri Archive, The Corcoran Gallery of Art, Washington, DC

273. *Repair Sketchbook*, page 33, c. 1968–75
Dry pigment/water, graphite on paper
10¼"h × 14"w
The Manuel Neri Archive, The Corcoran Gallery of Art, Washington, DC

274. *The Great Steps of Tula* and *Monument for the Repair of a National Image* in "The Repair Show," Berkeley Gallery, 1969
Photo by Jack Fulton

275. *Repair Sketchbook*, page 39, c. 1968–75
Dry pigment/water, graphite on paper
14"h × 10¼"w
The Manuel Neri Archive, The Corcoran Gallery of Art, Washington, DC

276. *Repair Sketchbook*, page 40, c. 1968–75
Dry pigment/water, graphite on paper
14"h × 10¼"w
The Manuel Neri Archive, The Corcoran Gallery of Art, Washington, DC

277. *Repair Sketchbook*, page 41, c. 1968–75
Dry pigment/water, graphite on paper
14"h × 10¼"w
The Manuel Neri Archive, The Corcoran Gallery of Art, Washington, DC

278. *Repair Sketchbook*, page 71, c. 1968–75
Dry pigment/water, graphite on paper
10¼"h × 14"w
The Manuel Neri Archive, The Corcoran Gallery of Art, Washington, DC

279. *Ladder Sketchbook*, page 17, 1971–72
Graphite, water-based pigment, collage on paper
10⅞"h × 13¾"w
The Manuel Neri Archive, The Corcoran Gallery of Art, Washington, DC

280. *Ladder Sketchbook*, page 20, 1971–72
Water-based pigment, graphite on paper
10⅞"h × 13¾"w
The Manuel Neri Archive, The Corcoran Gallery of Art, Washington, DC

281. *Repair Sketchbook*, page 57, c. 1968–75
Dry pigment/water, collage, graphite, cutout on paper
14"h × 10¾"w
The Manuel Neri Archive, The Corcoran Gallery of Art, Washington, DC

282. *Emborados Series—Nazca Lines V*, 1971
Wire mesh, wood, fiberglass, resin
97¼"h × 51¼"w × 1"d

283. *Repair Sketchbook*, page 59, c. 1968–75
Water-based pigment, collage, cutout, graphite on paper
10¾"h × 14"w
The Manuel Neri Archive, The Corcoran Gallery of Art, Washington, DC

284. *Crucifixion Sketchbook*, page 30 (verso), c. 1972–73
Watercolor, ink, graphite on paper
13⅜"h × 10¼"w
The Manuel Neri Archive, The Corcoran Gallery of Art, Washington, DC

285. *Rock No. 40*, c. 1967–74
Watercolor, ink, graphite on paper
13⅜"h × 10¼"w

286. *Crucifixion Sketchbook*, page 24 (verso), c. 1972–73
Charcoal on paper
13⅜"h × 10¼"w
The Manuel Neri Archive, The Corcoran Gallery of Art, Washington, DC

287. *Crucifixion Sketchbook*, page 22, c. 1972–73
Water-based pigment, graphite on paper
13⅜"h × 10¼"w
The Manuel Neri Archive, The Corcoran Gallery of Art, Washington, DC

288. *Rock No. 6*, c. 1967–74
Water-based pigment, graphite on paper
10¼"h × 13⅜"w

289. *Rock No. 44*, c. 1967–74
Water-based pigment, graphite on paper
13⅜"h × 10¼"w

A LA PINTURA
Jack Cowart

290. *Untitled Figure Study No. 12*, 1957
Tempera, pastel, charcoal on paper
30¼"h × 25⅝"w

291. *Untitled (Nude Model with Bischoff Painting)*, 1957
Tempera, charcoal, pastel on paper
30⅝"h × 25¼"w
Collection of William and Penny True, Seattle, WA

292. *Untitled Figure Study No. 3*, 1957
Tempera, charcoal on paper
30⅝"h × 25¼"w
Private Collection, New York, NY

293. *Untitled Figure Study No. 16*, 1957
Tempera, pastel, charcoal on paper
30¼"h × 25¼"w

294. Richard Diebenkorn, *Girl in a Room*, 1958
Oil on canvas
27⅛"h × 26"w
Collection of The Corcoran Gallery of Art, Gift of the Woodward Foundation
Photo courtesy of The Corcoran Gallery of Art

295. *Untitled Figure Study No. 5*, 1957
Tempera, pastel, charcoal on paper
30⅝"h × 25¼"w

296. *Untitled Figure Study No. 17*, 1957
Tempera, charcoal on paper
30¼"h × 25¼"w

297. *Untitled Figure Study No. 11*, 1957
Tempera, charcoal on paper
30¼"h × 25¼"w

298. *Untitled Figure Study No. 2*, 1957
Tempera, charcoal on paper
30¼"h × 25⅝"w
Private Collection, San Francisco, CA

299. *Untitled Figure Study No. 23*, 1957
Tempera, charcoal on paper
30⅝"h × 25¼"w
Private Collection, San Mateo, CA

300. *Untitled Figure Study No. 21*, 1957
Tempera, charcoal on paper
25¾"h × 23⅝"h

301. *Untitled Figure Study No. 26*, 1957
Tempera, charcoal on paper
24½"h × 25¼"w
Private Collection, Los Angeles, CA

302. *Untitled Figure Study No. 25*, 1957
Tempera, charcoal on paper
28⅝"h × 35½"w
Private Collection, Chicago, IL

303. *Untitled Figure Study No. 4*, 1957
Tempera, charcoal on paper
30¼"h × 25⅝"w
Private Collection, Washington, DC

304. *Untitled Figure Study No. 22*, 1957
Tempera, charcoal, pastel on paper
30¼"h × 25⅝"w
Private Collection, Hillsborough, CA

305. *Untitled Figure Study No. 1*, 1957
Tempera, charcoal, graphite on paper
30¼"h × 25⅝"w
Private Collection, Hillsborough, CA

306. *Woman Bath*, 1955
Water-based pigment, charcoal, collage on canvas
42"h × 56"w
Collection of Bruce McGaw

307. Henri Matisse, *The Joy of Life*, 1905–6
Oil on canvas
69⅛"h × 94⅞"w
Collection of the Barnes Foundation, Merion, PA
Photo © 1966 by the Barnes Foundation, all rights reserved

308. *Ritual Dance No. 16*, 1957–58
Tempera, graphite on paper
13"h × 12¾"w
Private Collection, Washington, DC

309. *Ritual Dance No. 14*, 1957–58
Tempera, graphite on paper
17⅞"h × 17¾"w
Private Collection

310. *Ritual Dance No. 13*, 1957–58
Tempera, graphite on paper
17"h × 17¼"w
Private Collection, Lafayette, CA

311. *Ritual Dance No. 20*, 1957–58
Tempera, graphite on paper
12¾"h × 13½"w
Private Collection, Dallas, TX

312. *Ritual Dance No. 10*, 1957–58
Tempera, charcoal on paper
25"h × 25⅛"w

313. *Ritual Dance No. 17*, 1957–58
Tempera, graphite on paper
17¾"h × 21¾"w

314. *Ritual Dance No. 5*, 1957–58
Tempera, graphite on paper
17¾"h × 18½"w

315. *Woman Dressing for Kabuki I, Drawing 1*, late 1950s
Acrylic, graphite on paper
12¼"h × 9¼"w
Private Collection, Los Angeles, CA

316. *Woman Dressing for Kabuki I, Drawing 2*, late 1950s
Acrylic, graphite on paper
12¼"h × 9¼"w
Private Collection, Los Angeles, CA

317. *Woman Dressing for Kabuki I, Drawing 3*, late 1950s
Acrylic, graphite on paper
12¼"h × 9¼"w
Private Collection, Los Angeles, CA

318. *Woman Dressing for Kabuki I, Drawing 4,*
late 1950s
Acrylic, graphite on paper
12¼"h × 9¼"w
Private Collection, Los Angeles, CA

319. *Woman Dressing for Kabuki II, Drawing 1,*
late 1950s
Acrylic, graphite on paper
12¼"h × 9¼"w
Private Collection, Los Angeles, CA

320. *Woman Dressing for Kabuki II, Drawing 2,*
late 1950s
Acrylic, graphite on paper
12¼"h × 9¼"w
Private Collection, Los Angeles, CA

321. *Woman Dressing for Kabuki II, Drawing 3,*
late 1950s
Acrylic, graphite on paper
12¼"h × 9¼"w
Private Collection, Los Angeles, CA

322. *Woman Dressing for Kabuki II, Drawing 4,*
late 1950s
Acrylic, graphite on paper
12¼"h × 9¼"w
Private Collection, Los Angeles, CA

323. *Young Man Stealing,* 1958
Oil-based pigment, graphite on canvas
22¾"h × 24⅜"w

324. Untitled, 1958
Oil-based pigment, graphite on linen canvas
23½"h × 23½"w

325. *Floral Study No. 1,* 1957
Tempera, graphite on paper
19"h × 22"w

326. *Floral Study No. 2,* 1957
Tempera, graphite on paper
22"h × 19"w

327. *Floral Study No. 3,* 1957
Tempera, graphite on paper
22"h × 19"w

328. *Floral Study No. 4,* 1957
Tempera, graphite on paper
24½"h × 25⅛"w

329. *Sketches for Painting Series No. 6,* 1958
Ink on paper
11"h × 8¼"w

330. *Sketches for Painting Series No. 8,* 1958
Ink on paper
11"h × 8¼"w

331. *Sketches for Painting Series No. 9,* 1958
Ink on paper
11"h × 8¼"w

332. *Pastel Studies for Painting Series No. 7,*
c. 1958–60
Acrylic, pastel on paper
8¼"h × 11"w

333. *Pastel Studies for Painting Series No. 4,*
c. 1958–60
Acrylic, pastel on paper
11"h × 8¼"w

334. *Pastel Studies for Painting Series No. 14,*
c. 1958–60
Acrylic, pastel on paper
8¼"h × 11"w
The Manuel Neri Archive, The Corcoran
Gallery of Art, Washington, DC

335. *Pastel Studies for Painting Series No. 18,*
c. 1958–60
Pastel, ink, graphite on paper
10⅞"h × 8¼"w
The Manuel Neri Archive, The Corcoran
Gallery of Art, Washington, DC

336. *Sketches for Painting Series No. 2,* 1958
Ink on paper
11"h × 8¼"w

337. *Sketches for Painting Series No. 17,* 1958
Graphite on paper
9½"h × 8¾"w

338. *Pastel Studies for Painting Series No. 2,*
c. 1958–60
Acrylic, oil pastel, graphite on paper
29½"h × 25¼"w

339. *Pastel Studies for Painting Series No. 5,*
c. 1958–60
Acrylic, pastel on paper
30¼"h × 25¼"w

340. *Collage Painting No. 3,* 1958–59
Oil-based pigment, collage on canvas
57"h × 56¾"w
The Manuel Neri Archive, The Corcoran
Gallery of Art, Washington, DC

341. *Collage Painting No. 5,* 1958–59
Oil-based pigment, collage on canvas
30¼"h × 27½"w
The Manuel Neri Archive, The Corcoran
Gallery of Art, Washington, DC

342. Joan Brown, *Swimming Party and Bicycle
Ride,* 1959
Oil on canvas
65"h × 66"w
Collection of David J. and Jeanne Carlson,
Carmel, CA
Photo courtesy of Carlson Gallery, Carmel, CA

343. *Collage Painting No. 1,* 1958–59
Oil-based pigment, collage on canvas
61¼"h × 50½"w
The Manuel Neri Archive, The Corcoran
Gallery of Art, Washington, DC

344. *Collage Painting No. 2,* 1958–59
Oil-based pigment, collage on canvas
67"h × 54¼"w
The Manuel Neri Archive, The Corcoran
Gallery of Art, Washington, DC

345. *Collage Painting No. 4,* 1958–59
Oil-based pigment, collage on canvas
67"h × 52"w
The Manuel Neri Archive, The Corcoran
Gallery of Art, Washington, DC

346. *Drawing for Window Series No. 5,* 1958
Water-based pigment, charcoal, pastel on paper
30⅝"h × 25¼"w
The Manuel Neri Archive, The Corcoran
Gallery of Art, Washington, DC

347. *Drawing for Window Series No. 2,* 1958
Water-based pigment, charcoal, pastel on paper
30¼"h × 25¼"w

348. *Drawing for Window Series No. 6,* 1958
Water-based pigment, charcoal, pastel on paper
30¼"h × 25¼"w

349. *Drawing for Window Series No. 7,* 1958
Water-based pigment, charcoal, pastel on paper
30¼"h × 25¼"w

350. *Drawing for Window Series No. 10,* 1958
Water-based pigment on paper
30¼"h × 25¼"w

351. *Drawing for Window Series No. 11,* 1958
Water-based pigment, charcoal, pastel on paper
30¼"h × 25¼"w

352. *Drawing for Window Series No. 1,* 1958
Water-based pigment, charcoal, pastel on paper
30¼"h × 25¼"w

353. *Drawing for Window Series No. 8,* 1958
Water-based pigment, charcoal, pastel on paper
30¼"h × 25¼"w

354. *Window Series No. 10,* 1958–59
Oil-based pigment on cotton canvas
57"h × 53¼"w
The Manuel Neri Archive, The Corcoran
Gallery of Art, Washington, DC

355. Richard Diebenkorn, *Interior with View
of the Ocean,* 1957
Oil on canvas
49¼"h × 57½"w
Phillips Collection, Washington, DC
Photo courtesy of the Phillips Collection

356. *Window Series No. 12,* 1958
Oil-based pigment on cotton canvas
35¼"h × 45"w
The Manuel Neri Archive, The Corcoran
Gallery of Art, Washington, DC

357. *Window Series No. 14,* 1958
Oil-based pigment on cotton canvas
Dimensions, location unknown

358. *Window Series No. 15,* 1957
Oil-based pigment on cotton canvas
Dimensions, location unknown

359. *Window Series No. 1,* 1958–59
Oil-based pigment on cotton canvas
70¾"h × 68⅝"w
The Manuel Neri Archive, The Corcoran
Gallery of Art, Washington, DC

360. *Window Series No. 2,* 1958–59
Oil-based pigment on cotton canvas
69"h × 71"w
The Manuel Neri Archive, The Corcoran
Gallery of Art, Washington, DC

361. *Window Series No. 4,* 1958–59
Oil-based pigment on cotton canvas
56¾"h × 56¾"w
The Manuel Neri Archive, The Corcoran
Gallery of Art, Washington, DC

362. *Window Series No. 6,* 1958–59
Oil-based pigment on cotton canvas
70¼"h × 67⅞"w
The Manuel Neri Archive, The Corcoran
Gallery of Art, Washington, DC

363. *Window Series No. 7,* 1958–59
Oil-based pigment on cotton canvas
34"h × 31¼"w
The Manuel Neri Archive, The Corcoran
Gallery of Art, Washington, DC

364. *Window Series No. 8,* 1959
Oil-based pigment on cotton canvas
71"h × 71"w
The Manuel Neri Archive, The Corcoran
Gallery of Art, Washington, DC

365. *Window Series No. 11,* 1959
Oil-based pigment on cotton canvas
42¼"h × 29¼"w
The Manuel Neri Archive, The Corcoran
Gallery of Art, Washington, DC

366. *Window Series No. 17*, 1958–59
Oil-based pigment on cotton canvas
50"h × 30"w
The Manuel Neri Archive, The Corcoran
Gallery of Art, Washington, DC

367. *Window Series No. 20*, 1958–59
Oil-based pigment on cotton canvas
79"h × 68"w
The Manuel Neri Archive, The Corcoran
Gallery of Art, Washington, DC

368. *Window Series No. 18*, 1958–59
Oil-based pigment on cotton canvas
47⅜"h × 47⅜"w
The Manuel Neri Archive, The Corcoran
Gallery of Art, Washington, DC

369. *Window Series No. 19*, 1958–59
Oil-based pigment on cotton canvas
68⅞"h × 76¹¹⁄₁₆"w
The Manuel Neri Archive, The Corcoran
Gallery of Art, Washington, DC

370. *Window Series No. 13*, 1959
Oil-based pigment on cotton canvas
56¾"h × 57"w
The Manuel Neri Archive, The Corcoran
Gallery of Art, Washington, DC

371. *Window Series No. 5*, 1958–59
Oil-based pigment on cotton canvas
68¾"h × 68¹³⁄₁₆"w
The Manuel Neri Archive, The Corcoran
Gallery of Art, Washington, DC

372. *Window Series No. 3*, 1959
Oil-based pigment on cotton canvas
81⅛"h × 81"w
The Manuel Neri Archive, The Corcoran
Gallery of Art, Washington, DC

THE MAKING OF MANUEL NERI
Robert L. Pincus

373. *Male Head No. 4*, c. 1969; Reworked 1972–74
Plaster, water-based pigment, graphite,
wood, wire
29"h × 14"w × 20"d
Collection of Kent Wright and Victor Bonfilio,
San Francisco, CA

374. *Chula* (also known as *Carla I*), c. 1958–60
Plaster, oil-based enamel, wood, wire, burlap
46"h × 14"w × 16¼"d
San Francisco Museum of Modern Art,
Partial Gift of Mary Heath Keesling
Photo by Ben Blackwell

375. *Study No. 1 for Carla Series*, c. 1958–60
Ink wash, graphite on paper
13¼"h × 10¼"w

376. *Study No. 6 for Carla Series*, c. 1958–60
Ink wash, graphite on paper
13¼"h × 10¼"w

377. *Study No. 8 for Carla Series*, c. 1958–60
Ink wash, graphite on paper
13¼"h × 10¼"w

378. *Carla No. 1*, c. 1958–60
Graphite, ink, acrylic on paper
30¾"h × 25⅝"w

379. *Study No. 3 for Carla Series*, c. 1958–60
Ink wash, graphite on paper
13¼"h × 10¼"w

380. *Study No. 9 for Carla Series*, c. 1958–60
Ink wash, graphite on paper
13¼"h × 10¼"w

381. *Study No. 10 for Carla Series*, c. 1958–60
Ink wash, graphite on paper
13¼"h × 10¼"w

382. *Study No. 2 for Carla Series*, c. 1958–60
Ink wash, graphite on paper
13¼"h × 10¼"w

383. *Study No. 7 for Carla Series*, c. 1958–60
Ink wash, graphite on paper
13¼"h × 10¼"w

384. *Collage Drawing for Carla II*, c. 1958–60;
Reworked 1963
Pastel, oil-based pigment, ink wash,
collage on paper
23¾"h × 26"w
The Manuel Neri Archive, The Corcoran
Gallery of Art, Washington, DC

385. *Study No. 4 for Carla Series*, c. 1958–60
Ink wash, graphite on paper
13¼"h × 10¼"w

386. *Carla II*, c. 1958–60
Plaster, oil-based enamel, wood, wire
approx. 48"h
Private Collection, San Francisco, CA
Photographer unknown

387–88. *Carla III*, c. 1958–60
Plaster, oil-based enamel, graphite, wood,
wire, burlap
50"h
Collection of Elmer Schlesinger Trust

389. *Carla No. 2*, c. 1958–60; Reworked 1964
Graphite, ink, acrylic, oil pastel on paper
30¾"h × 25⅝"w

390. *Carla IV*, c. 1958–60
Plaster, wood, wire, burlap
65"h × 16"w × 24"d
Collection of Sandra Shannonhouse,
Benicia, CA

391–93. *Carla VI*, c. 1958–60
Plaster, oil-based enamel, graphite, wood,
wire, burlap
64"h × 13¾"w × 10¼"d

394. *Study No. 5 for Carla Series*, c. 1958–60
Ink wash, graphite on paper
13¼"h × 10¼"w

395. *Carla V*, c. 1958–60
Plaster, oil-based enamel, wood, wire, burlap
67"h × 22¼"w × 20"d

396. *Untitled Standing Figure*, c. 1957–58
Plaster, oil-based enamel, aluminum paint,
wood, wire, burlap
61"h × 22"w × 16¼"d
Private Collection, San Francisco, CA

397. *Torso*, c. 1958–59
Cardboard, plaster, oil-based enamel
25"h × 17"w × 6¾"d

398. *Untitled Torso II*, c. 1960
Plaster, oil-based enamel, wood, wire
24"h × 14"w × 6"d

399. *Cast Paper Torso*, 1975
Cast paper pulp
24"h × 13"w × 5¾"d

400. *Fiberglass Torso No. 3*, 1975
Fiberglass, resin, pigments
24¼"h × 15"w × 6½"d

401. *Study No. 16 for Falling Woman Series*, c. 1977
Charcoal on paper
10⅝"h × 13⅝"w

402. *Falling Series No. 2*, 1977
Charcoal on paper
35"h × 35¼"w

403. *Untitled Bust V*, c. 1978
Plaster, steel armature, wire, burlap
20¼"h × 23¼"w × 15"d
Collection of Mr. and Mrs. Paul LeBaron
Thiebaud, San Francisco, CA

404. *Falling Series No. 1*, 1977
Charcoal on paper
35"h × 35¼"w

405. *Falling Series No. 12*, 1977
Charcoal on paper
35"h × 35¼"w

406. *Untitled Bust VI*, c. 1978
Plaster, dry pigment, wire, burlap
23"h × 26"w × 15"d

407. *Posturing Series No. 7*, 1978
Plaster, steel armature, styrofoam, burlap,
string, wood
32"h × 27¼"w × 9¼"d
Private Collection, Boulder, CO
Photographer unknown

408. *Posturing Series No. 1*, 1978
Plaster, steel armature, styrofoam, burlap
32"h × 27¼"w × 9¼"d
Private Collection, San Francisco, CA

409. *Study for Posturing Series No. 1* from
Majic Act Sketchbook, page 71 (detail), c. 1975
Oil paint stick, charcoal, graphite on paper
13⅝"h × 10¼"w

410. *Posturing Series No. 5*, 1978
Plaster, steel armature, styrofoam, wire, burlap,
string, wood
30"h × 14"w × 11¼"d
Private Collection, San Francisco, CA

411. *Posturing Series No. 2*, 1978
Plaster, steel armature, styrofoam, wire, burlap
31"h × 21¼"w × 12"d
Collection of George and Eva Neubert,
Lincoln, NE

412. *Posturing Series No. 4*, 1978
Plaster, steel armature, styrofoam, wire, burlap
33"h × 13¼"w × 11"d
Collection of The Corcoran Gallery of Art,
Washington, DC, Gift of the FRIENDS

413. *Posturing Series No. 3*, 1978
Plaster, steel armature, styrofoam, wire, burlap
31"h × 35"w × 15¼"d
Private Collection, San Francisco, CA

414. *Posturing Series No. 6*, 1978
Plaster, steel armature, styrofoam, wire, burlap
32½"h × 44"w × 21"d
Private Collection, San Francisco, CA

415. *Head I*, 1957–58
Plaster, wood, wire, cloth
10"h × 7"w × 9¼"d

416. *Cabeza Series No. 4*, 1957–59
Plaster, pigment, graphite, wood, wire,
cloth, nails
24"h × 8¼"w × 10½"d

417. *Head II*, 1957–58
Plaster, graphite, wood, wire, cloth,
19¼"h × 12"w × 11⅞"d

418. *Untitled Male Head*, 1958
Plaster, pigment, graphite, wire, cloth
14⅝"h × 10¾"w × 6¼"d
San Francisco Museum of Modern Art,
Gift of Robert B. Howard
Photo courtesy of San Francisco Museum of
Modern Art

419. *Etter Sketchbook*, page 94, c. 1959
Graphite, ink on paper
10¼"h × 8½"w
The Manuel Neri Archive, The Corcoran
Gallery of Art, Washington, DC

420. *Etter Sketchbook*, page 71, c. 1959
Graphite, ink on paper
10¼"h × 8½"w
The Manuel Neri Archive, The Corcoran
Gallery of Art, Washington, DC

421. *Rock No. 3*, c. 1967–74
Dry pigment/water, graphite on paper
13⅝"h × 10¼"w

422. *Rock No. 4*, c. 1967–74
Graphite, ink on paper
13⅝"h × 10¼"w

423. *Rock No. 9*, c. 1967–74
Graphite, ink on paper
10¼"h × 13⅝"w

424. *Untitled Figure Study No. 3*, 1957
Tempera, pastel, graphite on paper
30⅝"h × 25¼"w
Private Collection, New York, NY

425. *Untitled Figure Study No. 8*, 1957
Tempera, pastel, charcoal on paper
30⅝"h × 25¼"w

426. *Untitled Figure Study No. 5*, 1957
Tempera, pastel, graphite on paper
30⅝"h × 25¼"w
Private Collection, San Francisco, CA

427. *Untitled Figure Study No. 22*, 1957
Tempera, pastel, charcoal on paper
30¼"h × 25⅝"w
Private Collection, Washington, DC

428. *Untitled Figure Study No. 23*, 1957
Tempera, charcoal, pastel on paper
30⅝"h × 25¼"w
Private Collection, San Mateo, CA

429. *Figure Study No. 65*, c. 1957; Reworked c. 1980
Oil paint stick, dry pigment/water, graphite
on paper
13⁹⁄₁₆"h × 10¾"w

430. *Figure Study No. 45*, c. 1957; Reworked c. 1980
Oil paint stick, dry pigment/water, graphite
on paper
13⁹⁄₁₆"h × 10¾"w

431. *Casting Sketchbook*, page 24, c. 1959
Graphite on paper
10⅞"h × 8¼"w
The Manuel Neri Archive, The Corcoran
Gallery of Art, Washington, DC

432. *Casting Sketchbook*, page 25, c. 1959
Graphite on paper
10⅞"h × 8¼"w
The Manuel Neri Archive, The Corcoran
Gallery of Art, Washington, DC

433. *Casting Sketchbook*, page 26, c. 1959
Graphite on paper
10⅞"h × 8¼"w
The Manuel Neri Archive, The Corcoran
Gallery of Art, Washington, DC

434. *Casting Sketchbook*, page 27, c. 1959
Graphite on paper
10⅞"h × 8¼"w
The Manuel Neri Archive, The Corcoran
Gallery of Art, Washington, DC

435. *Etter Sketchbook*, page 24, c. 1959
Graphite, ink on paper
10¼"h × 8½"w
The Manuel Neri Archive, The Corcoran
Gallery of Art, Washington, DC

436. *Etter Sketchbook*, page 69, c. 1959
Graphite, ink on paper
10¼"h × 8½"w
The Manuel Neri Archive, The Corcoran
Gallery of Art, Washington, DC

437. *Double Figure Study No. 16*, c. 1976
Graphite, ink on paper
12"h × 8½"w

438. *Unos Actos de Fe Sketchbook*, page 23,
c. 1974–76
Graphite, water-based pigment, acrylic on paper
13"h × 8¼"w
The Manuel Neri Archive, The Corcoran
Gallery of Art, Washington, DC

439. *Miseglia Sketchbook*, page 80, c. 1975
Water-based pigment, graphite on paper
12⅛"h × 8⅝"w
The Manuel Neri Archive, The Corcoran
Gallery of Art, Washington, DC

440. *Gesture Study No. 54*, 1980
Acrylic, graphite, mixed media on printed paper
12½"h × 9½"w

441. *Gesture Study No. 37*, 1980
Acrylic, graphite on printed paper
12½"h × 9½"w
Cottrell-Lovett Collection, New York, NY

442. *Gesture Study No. 79*, 1980
Acrylic, graphite, mixed media on printed paper
12½"h × 9½"w
Private Collection, San Francisco, CA

443. *Gesture Study No. 53*, 1980
Acrylic, graphite, mixed media on printed paper
12½"h × 9½"w

444. Untitled, 1957
Water-based pigment, graphite on paper
15½"h × 14⅞"w
Private Collection, Honolulu, HI

445. *Legs*, 1963
Acrylic, charcoal, graphite on paper
42"h × 32"w

446. *Study for Legs*, c. 1965
Graphite, ink on paper
22"h × 17"w

447. *Mary Julia's Legs*, 1972
Charcoal, acrylic on paper
42"h × 37"w

448. *Fred and Laura Series No. 1*, c. 1973
Charcoal on paper
30"h × 22½"w

449. *Fred and Laura Series No. 4*, c. 1973
Charcoal on paper
30"h × 22½"w

450. *Fred and Laura Series No. 2*, c. 1973
Charcoal on paper
30"h × 22½"w

451. *Cast Paper Legs*, 1975
Cast paper pulp
40¼"h × 18"w × 14"d
Private Collection

452. *Sitting and Standing Study No. 16*, 1978
Acrylic, graphite on printed paper
11"h × 8½"w

453. *Sitting and Standing Study No. 22*, 1978
Acrylic, graphite on printed paper
11"h × 8½"w

454. *Sancas I*, 1991
Plaster, dry pigment/water, steel armature,
styrofoam, burlap on wood base
47½"h × 19"w × 19¼"d

455. *Sancas I (Cast 1/4)*, 1991
Bronze with oil-based enamel
48"h × 19"w × 18½"d

456. *Sancas II*, 1991
Plaster, dry pigment/water, steel armature,
styrofoam, burlap on wood base
50¼"h × 13¾"w × 16"d

457. *Study for Sancas Series II*, 1993
Dry pigment/water, charcoal on paper
40¼"h × 25⅞"w

458. *Untitled Standing Figure*, 1957–58
Plaster, oil-based enamel, aluminum paint,
wood, wire, burlap
61"h × 22"w × 16¼"d
Private Collection, San Francisco, CA

459. *Untitled Female Figure*, c. 1958
Plaster, oil-based enamel, burlap, steel armature
38"h × 11"w × 6½"d

460–61. *Untitled Male Figure*, c. 1958
Plaster, oil-based enamel, burlap, steel armature
37¼"h × 10½"w × 6¾"d

462–63. Untitled, c. 1960s; Reworked 1972
Plaster, pigment, resin, wood, wire
62"h × 12"w × 12"d
Collection of Dr. and Mrs. Leo Keoshian,
Palo Alto, CA

464. *Seated Male Figure*, 1959
Plaster, wood, wire, burlap
65"h × 26"h × 27"d

465. *Fragment No. 2 from Seated Male Figure*, 1972
Fiberglass, resin
57"h × 24"w × 25"d
Collection of Rene di Rosa, Napa, CA

466. *Untitled Standing Figure*, 1974
Plaster, dry pigment/water, steel armature,
styrofoam, burlap on wood base
67"h × 22¾"w × 14¼"d
Private Collection, San Francisco, CA

467–68. Untitled, 1968; Reworked 1974
Plaster, oil-based enamel, wood, wire, burlap
85¼"h × 16¼"w × 17"d

469–70. Untitled, 1974
Plaster, pigment, wood, wire, burlap
62¼"h × 28"w × 27"d
Collection of Harry Hinson, New York, NY

471. *Male Head No. 1*, c. 1969; Reworked 1973
Plaster, graphite, wood, wire, burlap, nails
27¼"h × 12¼"w × 16"d

472. *Mi China*, c. 1969; Reworked 1972–74
Plaster, water-based pigment, graphite,
wood, wire
28"h × 14¼"w × 13"d
Private Collection

473. *Female Head No. 2*, c. 1969; Reworked 1972–74
Plaster, dry pigment/water, wood, wire
28"h × 13"w × 17"d

474. *Male Head No. 5*, c. 1969; Reworked 1972–74
Plaster, water-based pigment, wood, wire
28"h × 14"w × 17¼"d
Private Collection, San Francisco, CA

475. *Busto de Mujer No. 9*, c. 1969; Reworked
1972–74
Plaster, dry pigment/water, steel armature,
wood, wire, burlap
29"h × 16¾"w × 18"d

476. *Busto de Mujer No. 1*, c. 1969; Reworked
1972–74
Plaster, dry pigment/water, steel armature,
wood, wire, burlap
27¼"h × 12"w × 13"d
Collection of Mr. and Mrs. Kent Logan,
Tiburon, CA

477. Mary Julia posing, 1976
Photo by Manuel Neri

478. *Miseglia Sketchbook*, page 23, c. 1975
Water-based pigment, acrylic, graphite on paper
12⅛"h × 8⅝"w
The Manuel Neri Archive, The Corcoran
Gallery of Art, Washington, DC

479. *Figure Study—Didi No. 14*, 1976
Charcoal, ink, graphite on paper
34¾"h × 23¼"w

480. *Unos Actos de Fe Sketchbook*, page 21
(verso), c. 1974–76
Water-based pigment, acrylic, graphite on paper
13"h × 8¼"w
The Manuel Neri Archive, The Corcoran
Gallery of Art, Washington, DC

481. *Figure Study—Didi No. 3*, 1976
Charcoal, water-based pigment on paper
35"h × 23¾"w
The Manuel Neri Archive, The Corcoran
Gallery of Art, Washington, DC

482. Ivory figure of a bull-leaper from the palace
at Knossos, c. 1600 B.C.
Collection of Archaeological Heraklion
Museum, Crete
Photo courtesy of Archaeological
Heraklion Museum

483. *Study for Bull Jumper No. 11*, c. 1980
Ink, graphite on paper
8¼"h × 11"w

484. *Bull Jumper (in progress)*, 1980
Plaster, steel armature, styrofoam, wire, burlap
30½"h × 19"w × 52"d

485. *Study for Bull Jumper No. 2*, c. 1980
Acrylic, ink, graphite on paper
8¼"h × 11"w

486. *Study for Bull Jumper No. 3*, c. 1980
Acrylic, ink, graphite on paper
8¼"h × 11"w

487. *Isla Negra No. 13*, 1987
Charcoal, oil paint stick on paper
25"h × 34½"w
Private Collection, San Francisco, CA

488–89. *Bull Jumper II*, 1989
Plaster, dry pigment/water, steel armature,
styrofoam, burlap
19¼"h × 30"w × 50¼"d

490. *Bull Jumper III*, 1989
Plaster, dry pigment/water, steel armature,
styrofoam, burlap
30½"h × 21¼"w × 42"d

491. *Julia*, c. 1976
Plaster, steel armature, styrofoam, wire, burlap
on wood base
67"h × 19¼"w × 13¾"d
Collection of Mr. and Mrs. Gerald D. Kohs,
Portola Valley, CA

492. *Mary Julia V*, 1976
Water-based pigment, charcoal on paper
41¾"h × 35¾"w

493. *Untitled Seated Female Figure No. 1*, 1976
Plaster, steel armature, styrofoam, wire, burlap
57¾"h × 16"w × 31"d

494. *Untitled I*, c. 1976
Plaster, steel armature, styrofoam, wire
on wood base
67"h × 22"w × 14¼"d
Private Collection, San Francisco, CA

495. *La Niña de la Piedra*, 1978
Plaster, steel armature, styrofoam, burlap,
stone on wood base
65¼"h × 23½"w × 13¾"d
Destroyed in Oakland hills fire, 1992; formerly
Collection of Anne and Stephen Walrod,
Berkeley, CA

496–97. *Untitled VI*, 1976
Plaster, steel armature, styrofoam, wire, burlap
on wood base
approx. 66"h × 19"w × 13"d

498. *Brazos Negros*, 1977–78
Plaster, dry pigment/water, steel armature,
styrofoam, wire, burlap on wood base
65"h × 19"w × 14"d
Collection of Mr. and Mrs. Peter Bradford

499. *Untitled Standing Female Figure No. 4*, 1978
Plaster, dry pigment/water, steel armature,
styrofoam, wire, burlap on wood base
64¼"h × 24¼"w × 14¼"d
Collection of Robert Harshor Shimshak
and Marion Brenner

500–501. *Standing Figure No. 1*, 1976; Reworked 1979
Plaster, oil-based enamel, steel armature,
styrofoam, burlap on wood base
66¼"h × 20"w × 14"d
Private Collection, San Francisco, CA

502. *Untitled Standing Female Figure*, 1976–79
Plaster, dry pigment/water, steel armature,
styrofoam, burlap on wood base
65¼"h × 19"w × 14"d
Private Collection, San Francisco, CA

p. 396: *Untitled Figure Study No. 18*, 1957
Charcoal on paper
30⅝"h × 25½"w
Collection of Mr. and Mrs. Wayne Thiebaud

p. 408: *Untitled Collage*, 1963
Graphite, ink, tempera, collage on paper
27⅛"h × 24¾"w

p. 422: *Double Figure Study*, 1977
Charcoal, water-based pigment on paper
35"h × 35½"w

p. 425: *No Hands Neri Sketchbook*, page 85, c. 1966
Graphite on paper
13⅞"h × 10¾"w
The Manuel Neri Archive, The Corcoran
Gallery of Art, Washington, DC

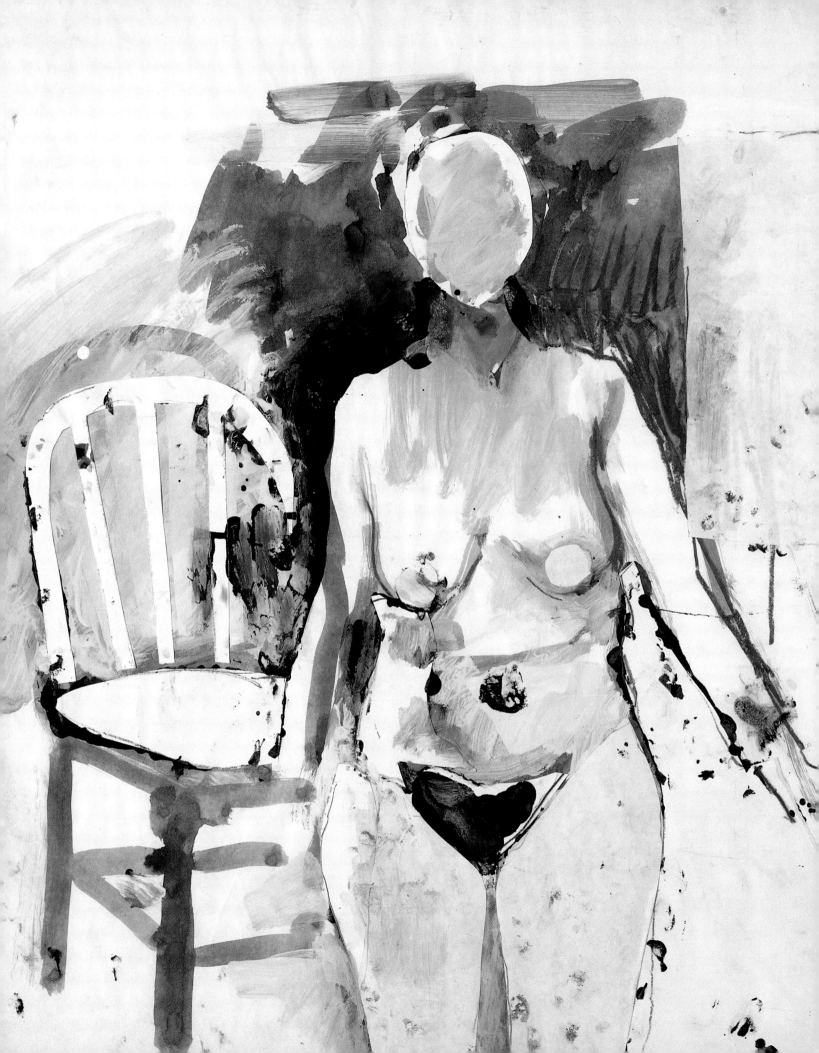

BIOGRAPHY

BORN
1930 Sanger, CA

EDUCATION
1949–50 San Francisco City College
1951–52 University of California, Berkeley
1951–56 California College of Arts and Crafts, Oakland
1956–58 California School of Fine Arts, San Francisco

TEACHING
1959–65 California School of Fine Arts, San Francisco
1963–64 University of California, Berkeley
1965–90 University of California, Davis

GRANTS AND AWARDS
1953 Oakland Art Museum, First Award in Sculpture
1957 Oakland Art Museum, Purchase Award in Painting
1959 Nealie Sullivan Award, California School of Fine Arts, San Francisco
1963 San Francisco Art Institute, 82nd Annual Sculpture Award
1965 National Art Foundation Award
1970–75 University of California, Davis, Sculpture Grants
1979 Guggenheim Foundation Fellowship
1980 National Endowment for the Arts, Individual Artist Grant
1982 American Academy and Institute of Arts and Letters, Academy-Institute Award in Art
1985 San Francisco Art Commission, Award of Honor for Outstanding Achievement in Sculpture
1990 San Francisco Art Institute, Honorary Doctorate for Outstanding Achievement in Sculpture
1992 California College of Arts and Crafts, Honorary Doctorate
1995 Corcoran School of Art, Washington, DC, Honorary Doctorate

COMMISSIONS
1980–82 Office of the State Architect, State of California, Commission for marble sculpture *Tres Marías* for the Bateson Building, Sacramento
1987 North Carolina National Bank, Commission for marble sculpture *Española* for NCNB Tower, Tampa, FL
 The Linpro Company, Commission for marble sculpture *Passage* for the Christina Gateway Project, Wilmington, DE
 U.S. General Services Administration, Commission for marble sculpture *Ventana al Pacífico* for U.S. Courthouse, Portland, OR
1994 Laumeier Sculpture Park, Commission for marble sculpture *Aurelia Roma*, St. Louis, MO

SOLO EXHIBITIONS
1957 The 6 Gallery, San Francisco, June
1959 Spatsa Gallery, San Francisco
1960 Dilexi Gallery, San Francisco, June 20–July 16
1963 New Mission Gallery, San Francisco, *Neri Sculpture*, July 20–August 17
1964 Berkeley Gallery, Berkeley, CA
1966 Quay Gallery, San Francisco, *Neri Sculpture*
1968 Quay Gallery, San Francisco
1969 Louisiana State University, Baton Rouge
1970 St. Mary's College Art Gallery, Moraga, CA
 San Francisco Art Institute
1971 Art Gallery, University of Nevada, Reno
 San Francisco Museum of Art, *Arts of San Francisco: Manuel Neri*, August 6–September 5. Brochure
 Quay Gallery, San Francisco, *Manuel Neri at Quay*, November 9–27
1972 Sacramento State College Art Gallery, Sacramento, CA, *Work by Manuel Neri*, March 22–April 18
 Davis Art Center, Davis, CA, *Manuel Neri: New Sculpture*, October 27–November 16
1974 Art Gallery, San Jose State University, San Jose, CA, February 13–March 8
 Davis Art Gallery, Stephens College, Columbia, MO, *Manuel Neri: Sculpture and Installations*, October 3–23

1975 Quay Gallery, San Francisco, *Manuel Neri: Sculpture and Drawings*, April 1–26
1976 Braunstein/Quay Gallery, New York, *Neri Sculpture*, March 16–April 10
 80 Langton Street, San Francisco, *The Remaking of Mary Julia: Sculpture in Progress*, May 4–15
 The Oakland Museum, Oakland, CA, *Manuel Neri, Sculptor*, September 21–November 28. Travel to Utah Museum of Fine Arts, Salt Lake City, March 12–May 1, 1977. Catalogue
1977 ArtSpace/Open Ring, E. B. Crocker Art Gallery, Sacramento, CA, *Manuel Neri: Recent Sculpture and Drawings*, July 22–August 20. Catalogue
1979 Gallery Paule Anglim, San Francisco, *Manuel Neri*, May 15–June 9
1980 Whitman College, Walla Walla, WA, *Manuel Neri: Sculpture and Drawings*, April 1–30
 Richmond Art Center, Richmond, CA, *Manuel Neri: Drawings*, July 1–31
 Grossmont College Gallery, El Cajon, CA, *Manuel Neri*, November 10–December 10
1981 Seattle Art Museum, *Manuel Neri Sculpture & Drawings*, January 15–March 1. Catalogue
 Charles Cowles Gallery, New York, *Manuel Neri*, February 7–28. Brochure
 The Mexican Museum, San Francisco, *Manuel Neri: Sculpture/Drawings*, May 7–June 5
 The Art Museum Association, *Manuel Neri: Drawings & Bronzes*. Travel through 1983 to: Redding Museum and Art Center, Redding, CA; Fresno Art Center, Fresno, CA; Gardiner State University Art Gallery, Stillwater, OK; San Jose Museum of Art, San Jose, CA; North Dakota State University, Fargo; Arkansas Art Center, Little Rock; Abilene Fine Arts Museum, Abilene, TX; Art Museum of Santa Cruz County, Santa Cruz, CA; Florida International University, Miami; Springfield Art Museum, Springfield, MO; Honolulu Academy of Art, Honolulu, HI; Laumeier Sculpture Park, St. Louis, MO. Brochure
 John Berggruen Gallery, San Francisco, *Manuel Neri*, November 17–December 19
1982 Charles Cowles Gallery, New York, *Manuel Neri*, November 7–27
1983 Middendorf/Lane Gallery, Washington, DC, *Manuel Neri, Sculpture and Drawings*, January 26–February 22
1984 John Berggruen Gallery, San Francisco, *Manuel Neri, Sculpture and Drawings*, February 23–March 24
 Middendorf Gallery, Washington, DC, *Manuel Neri*, March 10–31
 Art Gallery, California State University, Chico, *The Human Figure: Sculpture and Drawings by Manuel Neri*, March 26–April 13
 Gimpel-Hanover + André Emmerich Galerien, Zurich, Switzerland, *Manuel Neri*, April 16–June 7. Catalogue
1985 Robert Else Gallery, California State University, Sacramento, *Manuel Neri: Sculpture and Drawings*, October 15–November 12. Catalogue
1986 Charles Cowles Gallery, New York, *Manuel Neri*, February 1–March 1
1987 Fay Gold Gallery, Atlanta, *Manuel Neri: Sculpture and Drawings*, March 14–April 22
 San Antonio Art Institute, San Antonio, TX, *Manuel Neri*, November 24–December 22
1988 College of Notre Dame, Belmont, CA, *Manuel Neri, A Personal Selection*, April 1–May 21. Brochure
 John Berggruen Gallery, San Francisco, *Manuel Neri: Recent Sculpture and Drawings*, April 28–May 28
 James Corcoran Gallery, Santa Monica, CA, October 29–November 27
1989 Sheppard Fine Arts Gallery, University of Nevada, Reno, March 10–April 3
 Charles Cowles Gallery, New York, *Manuel Neri, New Works: Marble and Plaster*, April 29–May 27
 San Francisco Museum of Modern Art, *Manuel Neri: Plasters*, May 25–July 23. Catalogue
 Greg Kucera Gallery, Seattle, *Manuel Neri: Sculpture and Drawings*, June 1–July 9
 Riva Yares Gallery, Scottsdale, AZ, *Manuel Neri: Sculpture of the 1980s*, November 18–December 25. Catalogue

1990 John Berggruen Gallery, San Francisco, *Manuel Neri,* March 21–
April 21
Crocker Art Museum, Sacramento, CA, *Manuel Neri: Bronzes,*
August 10–October 21. Catalogue
Bingham Kurts Gallery, Memphis, TN, *Manuel Neri: Works on Paper,*
October 19–November 13
Dominican College, San Rafael, CA, November 15–December 15
Margulies/Taplin Gallery, Coconut Grove, FL, *Manuel Neri,*
December 28, 1990–January 23, 1991
1991 Charles Cowles Gallery, New York, *Manuel Neri,* February 2–23
Richard L. Nelson Gallery, University of California, Davis, *Manuel
Neri: Drawings, Part I, 1953–1974,* April 7–May 19
Eve Mannes Gallery, Atlanta, *Manuel Neri,* April 12–June 15
Riva Yares Gallery, Santa Fe, NM, *Manuel Neri,* June 1–August 31
1992 John Berggruen Gallery, San Francisco, *Manuel Neri,* March 5–April 4
Morgan Gallery, Kansas City, MO, *Manuel Neri,* March 27–May 2
Margulies/Taplin Gallery, Boca Raton, FL, May 7–June 11
Fresno Art Center, Fresno, CA, *She Said: I Tell You It Doesn't
Hurt Me,* June 5–August 16
1993 Bingham Kurts Gallery, Memphis, TN, *Manuel Neri,* January 8–31
Charles Cowles Gallery, New York, *Manuel Neri, New Work:
Marbles, Bronzes and Works on Paper,* January 28–March 6
Riva Yares Gallery, Scottsdale, AZ, *Manuel Neri,* February 11–
March 9
University of Alabama Art Gallery, Tuscaloosa, *Manuel Neri:
Drawings and Sculpture,* March 26–May 2
Dia Center for the Arts, Bridgehampton, NY, *Manuel Neri: Sculpture
Painted and Unpainted,* July 31–September 19. Catalogue
Campbell-Thiebaud Gallery, San Francisco, *Manuel Neri: Recent
Work,* August 31–October 2. Catalogue
1994 Margulies/Taplin Gallery, Boca Raton, FL, February 2–23
Hearst Art Gallery, St. Mary's College, Moraga, CA, *Manuel Neri:
Master Artist Tribute III,* November 11–December 23. Catalogue
Morgan Gallery, Kansas City, MO, December 2, 1994–January 15,
1995
1995 Galerie Claude Samuel, Paris, *Manuel Neri: Sculptures et dessins,*
January 21–February 26
Charles Cowles Gallery, New York, March 11–April 15
Campbell-Thiebaud Gallery, San Francisco, *Manuel Neri: Recent
Drawings,* May 23–June 24
Robischon Gallery, Denver, CO, November 10, 1995–January 6, 1996
Nevada Institute for Contemporary Art, Las Vegas, *Manuel Neri:
Classical Expressions/Sculpture and Drawings,* November 16–
December 31. Travel to Riva Yares Gallery, Scottsdale, AZ,
February 15–March 16, 1996; Riva Yares Gallery, Santa Fe, NM,
July 5–30, 1996. Catalogue
1996 Lisa Kurts Gallery, Memphis, TN, *Manuel Neri: Recent Drawings and
Sculpture,* February 9–March 7
1997 The Corcoran Gallery of Art, Washington, DC. Travel. Catalogue

GROUP EXHIBITIONS
1955 The 6 Gallery, San Francisco
Oakland Annual, Oakland, CA
1956 The 6 Gallery, San Francisco, *Bruce McGaw/Manuel Neri,* January
1957 Richmond Art Center, Richmond, CA
The 6 Gallery, San Francisco, *Manuel Neri/Jo Ann Bentley Low,*
February–March
Oakland Annual, Oakland, CA
1958 San Francisco Art Annual, San Francisco
Berkeley Gallery, Berkeley, CA
1959 San Francisco Museum of Art, *Four Man Show: Sam Francis, Wally
Hedrick, Fred Martin, Manuel Neri,* February 3–22
1960 Batman Gallery, San Francisco, *Group Show,* December
1961 Staempfli Gallery, New York
California Palace of the Legion of Honor, San Francisco, *The Nude,*
September
1962 Stanford University Art Gallery, Stanford, CA, *Some Points of View—
'62,* October 30–November 20. Catalogue
Houston Contemporary Arts Museum, *San Francisco 9.* Catalogue
Primus-Stuart Gallery, Los Angeles, *Joan Brown/Manuel Neri*
San Francisco Art Institute, *Works in Clay*
Staempfli Gallery, New York

1963 San Francisco Art Institute, *Some New Art in the Bay Area,*
March–April
The Oakland Museum, Oakland, CA, *California Sculpture Today,*
August 4–September 15
Kaiser Center, Oakland, CA, *California Sculpture Today*
San Francisco Art Institute, *82nd Annual Invitational*
Primus-Stuart Gallery, Los Angeles
1964 Stanford University Art Museum, Stanford, CA, *Current Painting and
Sculpture of the Bay Area,* October 8–November 29. Catalogue
David Stuart Galleries, Los Angeles, *Joan Brown/Manuel Neri,*
November 9–December 5
1965 San Francisco Museum of Art, *Bay Region: Prints and Drawings*
(two-artist show with Wayne Thiebaud), January 12–February 21
1966 Fine Arts Gallery, University of California, Irvine, *Abstract Expres-
sionist Ceramics.* Travel to the San Francisco Museum of Art.
Catalogue
Berkeley Gallery, San Francisco, *The Slant Step Show,* September
1967 University Art Museum, Berkeley, CA, *Funk Art,* April 18–May 29.
Catalogue
California State College, Fullerton, *Recorded Images/Dimensional
Media,* October 20–November 12
1968 Portland Art Museum, Portland, OR, *The West Coast Now,*
February 9–March 6. Travel to San Francisco and Los Angeles
San Francisco Museum of Art, *On Looking Back: Bay Area, 1945–
1962,* August 8–September 8
University of Nevada, Reno, *1968 Sculpture Invitational.* Catalogue
1969 Berkeley Gallery, San Francisco, *The Repair Show,* March 13–April 4
Worth Ryder Gallery, University of California, Berkeley, *Visiting
Artists: Leonard Edmondson, Joseph Raffael, Manuel Neri,*
August 8–31
Jason Aver Gallery, San Francisco, *Four Man Show: Tony DeLap,
Craig Kauffman, Ed Moses, Manuel Neri,* December
Reed College, Portland, OR, *Six Bay Area Artists*
1970 Memorial Union Gallery, University of California, Davis, *Garden
Show,* January
University Art Museum, Berkeley, CA, *The Eighties,* March 17–
April 12
San Francisco Art Institute, *Manuel Neri and William Geis,*
September–October
Whitney Museum of American Art, New York, *Annual Exhibition:
Contemporary American Sculpture*
1971 The Oakland Museum, Oakland, CA, *Sculptured Lines* (with Harold
Paris and Gerald Walburg), July 27–September 5
University of Nevada, Reno, *Manuel Neri and William Wiley,*
October
St. Mary's College Art Gallery, Moraga, CA, *The Good Drawing
Show,* October 30–November 26. Catalogue
Quay Gallery, San Francisco, *Group Show*
1972 E. B. Crocker Art Gallery, Sacramento, CA, *Sacramento Sampler I,*
April 1–May 7. Travel to The Oakland Museum, Oakland, CA,
May 23–July 2. Catalogue
Walnut Creek Civic Arts Gallery, Walnut Creek, CA, *It's for the Birds,*
September 29–October 29
Artists Contemporary Gallery, Sacramento, CA, *A Ladder Show,*
October 6–31. Catalogue
Quay Gallery, San Francisco, *Group Show*
1973 Palo Alto Cultural Center, Palo Alto, CA, *First Sculpture Invitational,*
January 13–February 18
St. Mary's College Art Gallery, Moraga, CA, *The Small Format,*
September 1–28. Catalogue
Nelson I. C. Gallery, University of California, Davis, *Manuel Neri,
Cornelia Schulz, and Elyn Zimmerman,* October 1–26
San Francisco Art Institute, *Drawing Invitational*
1974 San Francisco Museum of Art, *A Third World Painting and Sculpture
Exhibition,* June 8–July 28. Catalogue
Quay Gallery, San Francisco, *Group Show,* August
1975 The Oakland Museum, Oakland, CA, *Public Sculpture/Urban
Environment,* September–December
University of California, Davis, *Department Faculty Exhibition,*
April 2–29
Gallery Smith-Anderson, Palo Alto, CA, *Print Show.* Travel to Insti-
tute of Experimental Printmaking, Santa Cruz, CA, June–July
Helen Euphrat Gallery, De Anza College, Cupertino, CA, *A Survey of
Sculptural Directions in the Bay Area,* October 3–30. Catalogue

Linda Farris Gallery, Seattle, *Images of Woman*, November
Hansen Fuller Gallery, San Francisco, *Hansen Fuller Gallery Pays Tribute to the San Francisco Art Institute* (Curated by Fred Martin), November–December. Catalogue
JPL Fine Arts, London, *Sculptors as Draughtsmen*
JPL Fine Arts, London, *California Gold* (Sponsored by the U.S. Information Agency), October 15–November 21. Travel through 1978 to Europe, the Middle East, and India. Catalogue

1976 James Willis Gallery, San Francisco, *Retrospective of Sculpture in the Bay Area*, January 23–March 12
Martha Jackson Gallery, New York, *Graphics from the International Institute of Experimental Printmaking*, February 12–March 6
San Francisco Museum of Modern Art, *Painting and Sculpture in California: The Modern Era*, September 3, 1976–January 2, 1977. Travel to The National Collection of Fine Arts, Washington, DC, May 20–September 11, 1977. Catalogue
San Francisco Art Institute, *Other Sources: An American Essay*, September 17–November 7. Catalogue
Santa Barbara Museum of Art, Santa Barbara, CA, *The Handmade Paper Object*, October 29–November 29. Travel to The Oakland Museum, Oakland, CA, December 21, 1976–February 6, 1977; The Institute for Contemporary Art, Boston, May 10–June 14, 1977; The Johnson Museum at Cornell University, Ithaca, NY, July 6–August 14, 1977; Jacksonville Museum of Art, Jacksonville, FL, September 8–October 9, 1977. Catalogue
Braunstein/Quay Gallery, San Francisco, *New Work: Bruce Conner and Manuel Neri*, November 2–27
Art Gallery of New South Wales, Sydney, Australia, *The Biennale of Sydney*, November 11–December 19. Catalogue

1977 Diablo Valley College Art Gallery, Diablo Valley, CA, *Artist's Studio Floor Sweeping Show*, March 2–30
Braunstein/Quay Gallery, New York, *Works on Paper*, March 8–April 2
Huntsville Museum of Art, Huntsville, AL, *California Bay Area Art—Update*, May 6–June 15. Catalogue
Kenmin Prefecture Hall, Tokyo, Japan, *Tokyo/Bay Area Exchange of Contemporary Art: Kenmin Prefecture Hall, Tokyo/80 Langton Street, San Francisco*, October 25–November 12
Santa Rosa Junior College Art Gallery, Santa Rosa, CA, *Contemporary Figurative Sculpture*, November 6–14
Lang Art Gallery, Scripps College, Claremont, CA, *Paper Art*, November 9–December 21
Center for the Visual Arts, Oakland, CA, *Sculpture Show*, November 19–December 15
Smithsonian Institution Traveling Exhibition Service, Washington, DC, *Paper as Medium*. Catalogue
Braunstein/Quay Gallery, San Francisco, *Gallery Group Show*
Weatherspoon Art Gallery, University of North Carolina, Greensboro

1978 University of New Mexico Art Museum, Albuquerque, *Bay Area Art of the 60's and 70's, The Gift of Dr. Sam West*, January 8–March 19. Catalogue
Gallery Paule Anglim, San Francisco, January
Sonoma State College, Sonoma, CA, *Northern California Artists*, April 7–May 5
Hayward Area Festival of the Arts, Hayward, CA, *Seventeenth Annual Hayward Festival of the Arts—Invitational Exhibit*, May 19–21. Catalogue
Everson Museum of Art, Syracuse, NY, *A Century of Ceramics in the United States 1878–1978*. Catalogue

1979 Hansen Fuller Gallery, San Francisco, *Related Figurative Drawings*, January
Gallery Paule Anglim, San Francisco, *Manuel Neri, Jay De Feo, Hassel Smith, Nathan Oliveira, Philip Guston*, January 6–February 3
Sarah Spurgeon Gallery, Central Washington University, Ellensburg, *Second Annual Invitational Drawing Exhibition* (Curated by Elmer Bischoff), February. Catalogue
Walnut Creek Civic Arts Gallery, Walnut Creek, CA, *Humanform*
Independent Curators, New York, *Masks*. Travel in U.S. through 1981
The Oakland Museum, Oakland, CA, *10" × 10"*

1980 Gallery Paule Anglim, San Francisco, *Manuel Neri and Hassel Smith: Drawings*, March
San Diego Museum of Art, San Diego, CA, *Sculpture in California 1975–1980*, May 9–June 22. Catalogue
International Sculpture Center, Washington, DC, *The Eleventh International Sculpture Conference Exhibition*, June

Nassau County Museum of Fine Art, Roslyn, NY, *Contemporary Naturalism: Works of the 1970's*, June 8–August 24. Catalogue
San Francisco Museum of Modern Art, *Twenty American Artists*, July 24–September 7. Catalogue
Palo Alto Cultural Center, Palo Alto, CA, *Painted Sculpture*, August 31–October 26
Art Gallery, Santa Rosa Junior College, Santa Rosa, CA
The Mexican Museum, San Francisco, *Los Primeros Cinco Años/Fifth Anniversary Exhibit*, November 20, 1980–January 11, 1981. Brochure

1981 John Berggruen Gallery, San Francisco, *Salute to the San Francisco Art Institute: Elmer Bischoff, Ron Davis, Richard Diebenkorn, Manuel Neri, Nathan Oliveira, Wayne Thiebaud*, January
Triton Museum of Art, Santa Clara, CA, *San Francisco Alumni Exhibition*, January 9–March 9
Gallery Paule Anglim, San Francisco, *A View from 1959 San Francisco Museum of Modern Art: Sam Francis Selects Wally Hedrick, Fred Martin, Manuel Neri, Sam Francis*, January 10–February 14
California College of Arts and Crafts, Oakland, CA, *California College of Arts and Crafts Alumni Exhibition*, January 15–February 10
Sierra Nevada Museum of Art, Reno, NV, *Davis School: Prints and Drawings*, January 24–February 22
Walnut Creek Civic Arts Gallery, Walnut Creek, CA, *"Remember It's Only Art": From the Collection of the San Francisco Museum of Modern Art*, February 5–March 28. Catalogue
Provincetown Art Association and Museum, Provincetown, MA, *The Sun Gallery*, July 24–August 30. Catalogue
Middendorf/Lane Gallery, Washington, DC, *The Figure in Bronze: Small Scale*, October 13–November 17
Tulane University, New Orleans, LA, *Variants: Drawings by Sculptors*, October 15, 1981–May 30, 1982
Quay Gallery, San Francisco, *Sculptors' Work on Paper*, November 3–28
American Academy and Institute of Arts and Letters, New York, *Hassam Fund Purchase Exhibit*, November 16–December 20

1982 John Berggruen Gallery, San Francisco, *Recent Works*, February 17–March 24. Catalogue
American Academy and Institute of Arts and Letters, New York, *Paintings and Sculpture by Candidates for Art Awards*, March 8–April 4
Studio Nine, Benicia, CA, *Benicia Sculptors*, March 27–April 16
Okun-Thomas Gallery, St. Louis, MO, April
Dart Gallery, Chicago, *Non-Objective Sculpture*, April 10–May 4
The Mexican Museum, San Francisco, *Cinco de Mayo Inaugural Exhibit at Fort Mason Center*, May 5–July 3. Brochure
American Academy and Institute of Arts and Letters, New York, *Paintings and Sculptures by Recipients of Art Awards*, May 19–June 13
University Art Museum, Berkeley, CA, *Bay Area Sculpture from the Collection*, Summer
TransAmerica Pyramid, San Francisco, *Survey of Bay Area Figurative Sculptors*, July 8–August 16
Fuller Goldeen Gallery, San Francisco, *Casting: A Survey of Cast Metal Sculpture in the 80's*, July 8–August 28. Catalogue
John Berggruen Gallery, San Francisco, *Aspects of Sculpture*, August 4–September 4
Claremont Hotel, Berkeley, CA, *Project Sculpture*, August 4–October 31. Catalogue
The Oakland Museum, Oakland, CA, *100 Years of California Sculpture*, August 7–October 17. Catalogue
Kaiser Center, Oakland, CA, *The Brook House Sculpture Invitational at Kaiser Center*, August 8, 1982–January 19, 1983. Catalogue
Fresno Arts Center, Fresno, CA, *Forgotten Dimension: A Survey of Small Sculpture in California Now*. Traveled by the Art Museum Association to San Francisco International Airport, August 6–September 17; Center for the Visual Arts, Illinois State University, Normal, October 11–November 22; Aspen Center for the Visual Arts, Aspen, CO, December 10, 1982–January 20, 1983; Florida International University, Miami, February 10–March 24, 1983; Laumeier Sculpture Park, St. Louis, MO, April 14–June 2, 1983; Mary and Leigh Block Gallery, Northwestern University, Evanston, IL, July 27–September 11, 1983; Colorado Gallery of the Arts, Littleton, October 6–November 24, 1983. Catalogue

Richard L. Nelson Gallery, Memorial Union Art Gallery, and Pence Gallery, University of California, Davis, *Sculptors at UC Davis: Past and Present*, September 20–October 29. Catalogue

De Saisset Museum, University of Santa Clara, Santa Clara, CA, *Northern California Art of the Sixties*, October 12–December 12. Catalogue

1983 San Francisco Museum of Modern Art, *Resource/Reservoir, CCAC: 75 Years*, January 13–February 27. Brochure

Sarah Lawrence Gallery, Sarah Lawrence College, Bronxville, NY, *The United States of the Arts*, February 1–March 13. Brochure

Seattle Art Museum, *Recent West Coast Acquisitions*, February 12–April 26

Glastonbury Gallery, San Francisco, *A Selection of Contemporary Drawings*, February 17–March 31

John Berggruen Gallery, San Francisco, *Selected Sculpture*, March 23–April 2

Frumkin-Struve Gallery, Chicago, *Bronze Sculpture*, March 25–April 30

San Francisco Museum of Modern Art, *Selections from the Permanent Collection/Sculpture*, April–June 5

San Francisco Museum of Modern Art, *Bay Area Collects*, April 21–June 26

Monterey Peninsula Museum of Art, Monterey, CA, *California Contemporary: Recent Work of Twenty-three Artists*, May 1–29. Catalogue

Museum of Anthropology, California State University, Hayward, *Sons of the Shaking Earth*, May 2–June 10. Brochure

Renaissance Society, University of Chicago, *The Sixth Day*, May 8–June 15. Catalogue

Michael Himovitz Gallery, Carmichael, CA, *Continuum*, September–October 5

Institute of Contemporary Art of the Virginia Museum, Richmond, *Sculpture Now: Recent Figurative Works*, October 11–November 13

1984 Spokane Center Gallery, Eastern Washington University, Cheney, *Figurative Bronze Sculpture*, January 13–February 23

Richard L. Nelson Gallery, University of California, Davis, *Painters at UC Davis, Part I: 1950s–1960s*, January 23–February 21. Catalogue

Stephen Wirtz Gallery, San Francisco, *Artist's Call*, February 5

California State University, Long Beach, *Figurative Sculpture: Ten Artists/Two Decades*, March 13–April 29. Catalogue

Hirshhorn Museum and Sculpture Garden, Washington, DC, *Drawings 1974–1984*, March 15–May 13. Catalogue

Gille Mansillon Gallery, Santa Monica, CA, *Twelve Californian Artists*, May

The Mexican Museum, San Francisco, *Spectrum: A View of Mexican American Art*, May 2–September 30

Charles Cowles Gallery, Venice, CA, June–July

Fisher Gallery, University of Southern California, Los Angeles, *California Sculpture Show* (Organized by California/International Arts Foundation), June 2–August 12. Travel to CAPC (Musee d'Art Contemporain de Bordeaux), Bordeaux, France, October 5–December 12; Stadtische Kunsthalle, Mannheim, W. Germany, February–April 1985; Yorkshire Sculpture Park, West Bretton, England, May 1985; Sonja Henies og Neils Onstads Stiftelser, Hovikodden (Oslo), Norway, September 1985. Catalogue

Gille Mansillon Gallery, Santa Monica, CA, *SF–LA*, June 21–July 27

Richard L. Nelson Gallery, University of California, Davis, *Juxtapositions*, September 12–October 26

Concourse Gallery, Bank of America World Headquarters, San Francisco, *Highlights: Selections from the BankAmerica Corporate Art Collection*, October 11–November 27

The Oakland Museum, Oakland, CA, *The Dilexi Years 1958–1970*, October 13–December 16. Catalogue

Art Gallery, Sonoma State University, Rohnert Park, CA, *Works in Bronze: A Modern Survey*, November 2–December 16. Travel through 1986. Catalogue

Seattle Art Museum, *American Sculpture: Three Decades*, November 15, 1984–January 27, 1985

American Academy and Institute of Arts and Letters, New York, *36th Annual Purchase Exhibition: Hassam and Speicher Fund*, November 19–December 16. Brochure

San Francisco Museum of Modern Art, *The 20th Century: The San Francisco Museum of Modern Art Collection*, December 9, 1984–February 17, 1985. Catalogue

1985 John Berggruen Gallery, San Francisco, *Recent Acquisitions*, January 9–February 2

Santa Barbara Museum of Art, Santa Barbara, CA, *Santa Barbara Collects, Part I*, January 26–March 24. Catalogue

Sheldon Memorial Art Gallery, University of Nebraska, Lincoln, *New: Selected Acquisitions*

John Berggruen Gallery, San Francisco, *Group Exhibition*, March 13–April 6

Gallery One, Fort Worth, TX, *Drawings: Coast to Coast*, April 27–June 1

The Oakland Museum, Oakland, CA, *Art in the San Francisco Bay Area, 1945–1980*, June 15–August 18

Concourse Gallery, Bank of America World Headquarters, San Francisco, *M. Lee Fatherree: Photographs of Artists*, August 1–October 1

The Contemporary Arts Center, Cincinnati, OH, *Body & Soul: Aspects of Recent Figurative Sculpture*, September 5–October 12. Travel to Knight Gallery, Charlotte, NC, February 1–March 30, 1986; Fresno Arts Center, Fresno, CA, May 3–June 28, 1986; Loch Haven Art Center, Orlando, FL, August 17–October 12, 1986; Visual Arts Gallery, Florida International University, Miami, October 24–December 1, 1986; Joslyn Art Museum, Omaha, NE, January 31–March 28, 1987; Jacksonville Art Museum, Jacksonville, FL, May 2–June 27, 1987. Catalogue

San Francisco Museum of Modern Art, *American Realism: Twentieth-Century Drawings and Watercolors from the Glenn C. Janss Collection*, November 7, 1985–January 12, 1986. Travel to De Cordova and Dana Museum, Lincoln, MA, February 13–April 6, 1986; Huntington Art Gallery, University of Texas, Austin, July 31–September 21, 1986; Mary and Leigh Block Gallery, Northwestern University, Evanston, IL, October 23–December 14, 1986; Williams College Museum of Art, Williamstown, MA, January 15–March 1987; Akron Art Museum, Akron, OH, April 9–May 31, 1987; Madison Art Center, Madison, WI, July 2–September 20, 1987. Catalogue

Sheldon Memorial Art Gallery, University of Nebraska, Lincoln, *Contemporary Bronze: Six in the Figurative Tradition*, November 19, 1985–January 19, 1986. Travel to Kansas City Art Institute, Kansas City, KS, February 11–March 23, 1986; Des Moines Art Center, Des Moines, IA, April 8–May 13, 1986. Catalogue

1986 John Berggruen Gallery, San Francisco, *Selected Works by 20th Century Masters*, January 15–February 8

University Art Museum, Berkeley, CA, *Cal Collects*, April 2–May 18. Brochure

Kaufman Astoria Studios, Astoria, NY, *Human Form from the Media Age*, May 1–July 15

909 Third Avenue and The Mendik Company, New York, *Universal Images: People and Nature in Sculpture*, May 21–September 5

Marilyn Pearl Gallery, New York, *Figurative Sculpture: The 80's*, June 10–July 3

San Francisco Museum of Modern Art, *California Sculpture: 1959–1980*, July 20–August 24

John Berggruen Gallery, San Francisco, *Selected Acquisitions*, September 9–October 11

Carl Schlosberg Fine Arts, Sherman Oaks, CA, *Contemporary Figurative Sculpture*, September 28–October 31

Center for the Arts, Vero Beach, FL, *Collectors' Choice*, October 1986–February 1987

John Berggruen Gallery, Monadnock Building, San Francisco, *Sculpture and Works in Relief*, October 9–November 29. Catalogue

North Dakota Museum of Art, Grand Forks, *Casting Across America: An Artist Selects*, October 10–November 9

Pacific Bell, San Ramon, CA, *The Contemporary Bay Area Figurative School* (Organized by Fine Arts Services, Inc., Los Angeles), November 24–December 19

1987 Charles Cowles Gallery, New York, *New Works*, January 17–February 21

Palm Springs Desert Museum, Palm Springs, CA, *California Figurative Sculpture*, January 30–March 15. Catalogue

John Berggruen Gallery, Monadnock Building, San Francisco, *New Acquisitions*, January 27–March 28

Natsoulas/Novelozo Gallery, Davis, CA, *Artists for Amnesty*, February. Catalogue

Foster/White Gallery, Seattle, *National Sculpture Exhibition, 1987*, February 5–March 1

The Art Store Gallery, San Francisco, *Sculpture and Paint*, March 26–April 23

Vorpal Gallery, San Francisco, *Hospitality House Art Auction*, April 21–May 2

Sheppard Fine Arts Gallery, University of Nevada, Reno, *30 from 25*, April 24–May 22. Catalogue

Museum of Fine Arts, Houston, *Hispanic Art in the United States*, May 2–July 26. Travel to The Corcoran Gallery of Art, Washington, DC; Brooklyn Museum, Brooklyn, NY; Museum of Fine Arts and Museum of International Folk Art, Santa Fe, NM; Denver Art Museum; Los Angeles County Museum of Art. Catalogue

John Berggruen Gallery, Monadnock Building, San Francisco, *New Acquisitions*, May–June

Richmond Art Center, Richmond, CA, *Bay Area Drawing*, May 15–July 16

International House, Davis, CA, *Local Artists for Global Thought*, June

Charles Cowles Gallery, New York, *Summer Exhibition Space, 1987*

871 Fine Arts, San Francisco, *The Triumph of the Figure in Bay Area Art: 1950–1965*, September 5–December 31. Brochure

Philbrook Museum of Art, Tulsa, OK, *The Eloquent Object*, September 20, 1987–January 3, 1988. Travel to The Oakland Museum, Oakland, CA, February 20–May 15, 1988. Catalogue

Art Gallery, University of Nebraska, Lincoln, *Sculptors' Works on Paper*, September 28–October 14

San Francisco International Airport, *The Right Foot Show*, October 5, 1987–January 15, 1988

Davis Art Center, Davis, CA, *Three Decades of Davis Art*, November 13–December 20

American Academy and Institute of Arts and Letters, New York, *39th Annual Academy-Institute Purchase Exhibition*, November 16–December 13

Madison Art Center, Madison, WI, *Sculptors on Paper: New Work*, December 5, 1987–January 31, 1988. Travel to Pittsburgh Center for the Arts, Pittsburgh, PA; Kalamazoo Institute of Arts, Kalamazoo, MI; Sheldon Memorial Art Gallery, University of Nebraska, Lincoln. Catalogue

Charles Cowles Gallery, New York, *New Works by Gallery Artists*, December 5, 1987–January 9, 1988

Sheldon Memorial Art Gallery, University of Nebraska, Lincoln, *Sheldon Sampler: One Hundred American Masterworks*. Catalogue

1988 Walnut Creek Civic Arts Gallery, Walnut Creek, CA, *Bay Area Bronze*, January 13–March 12

John Berggruen Gallery, Monadnock Building, San Francisco, *Selected Sculpture*, January 16–February 27

John Berggruen Gallery, San Francisco, *Works on Paper*, January 19–February 20. Catalogue

Gallery Camino Real, Boca Raton, FL, *The Figurative Image Today*, January 29–March 1

Art Gallery, Santa Rosa Junior College, Santa Rosa, CA, *Drawing*, February 2–March 2

Palo Alto Cultural Center, Palo Alto, CA, *Bay Area Sculpture: Metal, Stone and Wood*, February 21–April 24

Memorial Union Gallery, University of California, Davis, *Bronze Works: Northern California Artists*, February 28–April 17

Pine Street Lobby Gallery, Gerald D. Hines Inc., San Francisco, *The Downtown Foot Show*, February 29–May 5. Brochure

John Berggruen Gallery, San Francisco, *Selected Paintings and Sculpture*, March 23–April 23

Natsoulas/Novelozo Gallery, Davis, CA, *30 Ceramic Sculptors*, April 8–May 10. Catalogue

Mendocino Arts Center, Mendocino, CA, *In Relief: Works of Cast Paper*, June 14–July 24

Eve Mannes Gallery, Atlanta, *Top Choices*, July 8–August 31

Sierra Nevada Museum of Art, Reno, NV, *West Coast Contemporary*, July 14–August 14

James Corcoran Gallery, Santa Monica, CA, *Lost and Found in California: Four Decades of Assemblage Art*, July 16–September 7. Catalogue

Natsoulas/Novelozo Gallery, Davis, CA, *New Work '88*, August 12–October 1

John Berggruen Gallery, San Francisco, *Works on Paper*, September 8–October 8. Catalogue

The Bronx Museum of the Arts, Bronx, NY, *The Latin American Spirit: Art and Artists in the United States, 1920–1970*, September 29, 1988–January 27, 1989. Travel to El Paso Museum of Art, El Paso, TX, February 27–April 23, 1989; San Diego Museum of Art, San Diego, CA, May 22–July 16, 1989; Instituto de Cultura Puertorriqueña, San Juan, PR, August 14–October 8, 1989; Center for the Arts, Vero Beach, FL, January 28–March 31, 1990. Catalogue

Leavenworth Carnegie Arts Center, Leavenworth, KS, *Contemporary Masters Kansas Tour: Selections from the Collection of Southwestern Bell Corporation*, November 4–December 26. Travel in Kansas to Baker Arts Center, Liberal, January 5–February 12, 1989; Edwin A. Ulrich Museum of Art, Wichita State University, Wichita, April 5–30, 1989; Salina Arts Center, Salina, June 5–July 21, 1989; Norman R. Eppink Art Gallery, Emporia State University, Emporia, July 31–October 1, 1989; Mulvane Art Museum, Washburn University, Topeka, October 8–31, 1989. Catalogue

Carl Schlosberg Fine Arts, Sherman Oaks, CA, *Sculpture: Works in Bronze*, November 6–27

Weatherspoon Art Gallery, University of North Carolina, Greensboro, *Art on Paper*, November 13–December 11

Sheehan Gallery, Whitman College, Walla Walla, WA, *Cast in Walla Walla*, November 14–December 16

Art Department Gallery, San Francisco State University, *Counter Visions: Pioneers in Bay Area Art*, November 16–December 9. Brochure

1989 Charles Cowles Gallery, New York, *The Cowles Art Show*, February 4–25

San Francisco International Airport, *California Artists Who Are Educators*, February 13–March 30

Walnut Creek Civic Arts Gallery, Walnut Creek, CA, *The Benicia Studio Community*, February 18–March 25

California Museum of Science and Industry, Los Angeles, *Marmo: The New Italian Stone Age*, March 16–April 30. Catalogue

Natsoulas/Novelozo Gallery, Davis, CA, *30 Ceramic Sculptors*, April–May 6. Catalogue

Richard L. Nelson Gallery, University of California, Davis, *A.C.D.H.H.H.J.N.P.P.S.T.*, April 23–May 24

John Berggruen Gallery, Monadnock Building, San Francisco, *Sculpture*, July 19–September 2

Security Pacific Gallery, Los Angeles, *Sculptural Intimacies—Recent Small-Scale Work*, November 12, 1989–January 6, 1990. Catalogue

San Francisco Museum of Modern Art, *Bay Area Figurative Art: 1950–1965*, December 14, 1989–February 4, 1990. Travel to Hirshhorn Museum and Sculpture Garden, Washington, DC, June 13–September 9, 1990; Pennsylvania Academy of the Fine Arts, Philadelphia, October 15–December 30, 1990. Catalogue

1990 Natsoulas/Novelozo Gallery, Davis, CA, *Lyrical Vision: The '6' Gallery, 1954–1957*, January 12–February 23. Catalogue

Arkansas Art Center, Little Rock, *National Drawing Invitational*, March 1–April 8. Catalogue

Natsoulas/Novelozo Gallery, Davis, CA, *30 Ceramic Sculptors*, April 6–May 3. Catalogue

Socrates Sculpture Park, Long Island City, NY, *No Man's Land*, April 8, 1990–March 8, 1991. Catalogue.

Campbell-Thiebaud Gallery, San Francisco, *Works on Paper*, May 1–June 2

Charles Cowles Gallery, New York, *Newer Sculpture*, June 1–29

Barbara Kornblatt Gallery, Washington, DC, *Manuel Neri, Erik Levine, Mel Chin*, June 5–July 28

Braunstein/Quay Gallery, San Francisco, *Bay Area Sculpture of the '60's, Past to Present*, June 7–July 7. Catalogue

Queens Museum, Queens, NY, *The Expressionist Surface: Contemporary Art in Plaster*, June 9–August 1. Catalogue

Butler Institute of American Art, Youngstown, OH, *California A–Z and Return*, June 24–August 19. Catalogue

The Mexican Museum, San Francisco, *From Folk to Fine: Fifteenth Anniversary Celebration*, December 7, 1990–April 31, 1991

1991 John Berggruen Gallery, San Francisco, *Large Scale Works on Paper*, February 21–March 16. Catalogue

Larry Evans Fine Art, San Francisco, *A Group Show of Bay Area Artists*, March–April

Carl Schlosberg Fine Arts, Malibu, CA, *Malibu in June*, June 1–29

Eve Mannes Gallery, Atlanta, *Top Choices*, June 15–August

John Berggruen Gallery, San Francisco, *Small Format Works on Paper*, June 26–August 3

Charles Cowles Gallery, New York, *Summer Group*, July 1–31

Anne Reed Gallery, Ketchum, ID, *Sculpture: Visions Transformed III*, July 5–August 9

John Berggruen Gallery, San Francisco, *Selected Sculpture*, August 7–28

The Fine Arts Museums of San Francisco, M. H. de Young Memorial Museum, *New Acquisitions*, September 11–November 17

Muckenthaler Cultural Center, Fullerton, CA, *Sculptural Perspectives for the Nineties*, October 6–December 29. Catalogue

Museo Estudio Diego Rivera, Mexico City, *Pasión por Frida*, October 11, 1991–January 31, 1992. Travel. Catalogue

Campbell-Thiebaud Gallery, San Francisco, *Twenty-five Treasures*, October 15–November 23

Tavelli Gallery, Aspen, CO, *Figures*, December 19, 1991–February 1, 1992

1992 Colorado University Art Galleries, Boulder, *Visiting Artist Program: 20th Anniversary Show*, January 17–February 15. Catalogue

Aspen Art Museum, Aspen, CO, *California North and South*, February 13–April 15

Hearst Art Gallery, St. Mary's College, Moraga, CA, *The Crucifixion Through the Modern Eye*, March 7–April 27

Carl Schlosberg Fine Arts, Sherman Oaks, CA, *George Rickey— Honoring 85 Years*, April 5–May 5

Margulies/Taplin Gallery, Boca Raton, FL, May 7–June 11

Whitney Museum of American Art, New York, *Gifts and Acquisitions in Context*, May 21–July 5

I. Wolk Gallery, St. Helena, CA, *"23"—23 Artist from John Berggruen Gallery*, June 22–July 24

Anne Reed Gallery, Ketchum, ID, *Visions Transformed IV*, July 8–August 5

John Berggruen Gallery, San Francisco, *Sculpture*, July 11–August 29

Syntex Corporation, Palo Alto, CA, *Bay Area Greats*, September 18–November 4

1993 One Market Plaza, San Francisco, *Revolution—Into the Second Century at San Francisco Art Institute*, January 4–March 26

Greg Kucera Gallery, Seattle, *Walla Walla Foundry: Selected Sculpture*, January 7–February 28

Anne Reed Gallery, Ketchum, ID, March 5–April 15

The Albuquerque Museum, Albuquerque, NM, *The Human Factor: Figurative Sculpture Reconsidered*, March 14–July 4. Catalogue

Newport Harbor Art Museum, Newport Beach, CA, *Beyond the Bay: The Figure*, May 12–June 27

Marriott Hotel, San Francisco, *Ventriloquist* (Exhibition for the 40th Assembly of the American Psychiatric Association), May 21–26. Catalogue

Eve Mannes Gallery, Atlanta, *Group Show of Gallery Artists*, July–August

Art Museum of Santa Cruz County, Santa Cruz, CA, *Now and Again: Figure and Landscape*, October 2–November 21

Laguna Gloria Art Museum, Austin, TX, *Human Nature Human Form*, October 30–December 12. Catalogue

American Academy and Institute of Arts and Letters, New York, *45th Annual Academy Purchase Exhibition*, November 8–December 5

1994 Palo Alto Cultural Center, Palo Alto, CA, *Lyricism and Light*, January 20–April 24. Brochure

TransAmerica Pyramid, San Francisco, *The Figure in Sculpture*, February 2–April 13

Frumkin/Adams Gallery, New York, *California in the '70s: Bay Area Painting and Sculpture Revisited*, March 2–30

The Oakland Museum, Oakland, CA, *Here and Now: Bay Area Masterworks from the Di Rosa Collection*, March 11–May 8. Catalogue

Grounds for Sculpture, Hamilton, NJ, *Spring/Summer Exhibition 94*, May 21–September 30. Catalogue

Newport Harbor Art Museum, Newport Beach, CA, *The Essential Gesture*, October 15–December 31. Catalogue

The White House, Washington, DC, *Twentieth-Century American Sculpture at The White House*, October 1994–February 24, 1995. Brochure

1995 John Natsoulas Gallery, Davis, CA, *The Figure*, January 7–February 5

Robert Kidd Gallery, Birmingham, MI, *Figurative Concepts: John Buck, Manuel Neri, Gary Kulak*, January 14–February 18

Nationsbank Plaza, Charlotte, NC, *Black & White & Read All Over*, January 16–October 31. Catalogue

San Francisco Museum of Modern Art, *Selections from the Permanent Collection of Painting and Sculpture* (SFMOMA Inaugural Exhibition), January 18–April 25

Frumkin/Adams Gallery, New York, *California in the 1960s: Funk Revisited*, February 1–28

Wiegand Gallery, College of Notre Dame, Belmont, CA, *Working Together: Joan Brown and Manuel Neri, 1958–1964*, March 21–April 29. Catalogue

Gibbes Museum of Art, Charleston, SC, *Spoleto Festival USA*, March 26–June 11

The Corcoran Gallery of Art, Washington, DC, *Recent Acquisitions*, April 12–June

Campbell-Thiebaud Gallery, San Francisco, *The Figure*, April 18–May 20

Anne Reed Gallery, Ketchum, ID, August 1–31

Campbell-Thiebaud Gallery, San Francisco, *Twenty-five Treasures*, September 5–October 7. Catalogue

Palo Alto Cultural Center, Palo Alto, CA, *Concept in Form: Artists' Sketchbooks & Maquettes*, October 5, 1995–January 7, 1996

Triton Museum of Art, Santa Clara, CA, *A Bay Area Connection: Works from the Anderson Collection*, November 1, 1995–January 28, 1996

Whitney Museum of American Art, New York, *Beat Culture and the New America, 1950–1965*, November 8, 1995–February 4, 1996. Travel to Walker Art Center, Minneapolis, MN, June 2–September 15, 1996; M. H. de Young Memorial Museum, San Francisco, October 5–December 31, 1996. Catalogue

California Palace of the Legion of Honor, San Francisco, *Treasures of the Achenbach Foundation for the Graphic Arts*, November 11, 1995–June 1996

Udinotti Gallery, Scottsdale, AZ, *Within the Figurative Tradition*, November 30–December 31

BIBLIOGRAPHY

BOOKS

Albright, Thomas. *Art in the San Francisco Bay Area, 1945–1980.* Berkeley: University of California Press, 1985.

Andersen, Wayne. *American Sculpture in Process: 1930–1970.* Boston: New York Graphic Society, 1975.

Cancel, Luis R., et al. *The Latin American Spirit: Art and Artists in the United States, 1920–1970.* Bronx, NY: Bronx Museum of the Arts and Harry N. Abrams, 1988.

Clark, Garth, and Hughto, Margie. *A Century of Ceramics in the United States, 1878–1978.* New York: E. P. Dutton in association with the Everson Museum of Art, 1979.

Gilbert, Rita. *Living with Art.* New York: Random House, 1985.

Hopkins, Henry. *50 West Coast Artists.* San Francisco: Chronicle Books, 1981.

Jones, Caroline A. *Bay Area Figurative Art: 1950–1965.* Berkeley: University of California Press, 1990.

Klimenko, Mary Julia. *She Said: I Tell You It Doesn't Hurt Me.* San Diego, CA: Brighton Press, 1991. Handpainted etchings by Manuel Neri. Limited edition of 33.

———. *Territory.* San Diego, CA: Brighton Press, 1993. Photolithograph illustrations by Manuel Neri with one original drawing. Limited edition of 55.

Krantz, Les. *American Artists: An Illustrated Survey of Leading Americans.* Chicago: The Krantz Company Publishers, 1985.

Manhart, Marcia, and Manhart, Tom, eds. *The Eloquent Object.* Tulsa, OK: Philbrook Museum of Art, 1987.

Martin, Alvin. *American Realism: Twentieth-Century Drawings and Watercolors from the Glenn C. Janss Collection.* New York: Harry N. Abrams, Inc., 1985.

Paz, Octavio; Beardsley, John; and Livingston, Jane. *Hispanic Art in the United States.* New York: Abbeville Press, 1987.

Plagens, Peter. *Sunshine Muse.* New York: Praeger Publishers, 1974.

Quirarte, Jacinto. *Mexican American Artists.* Austin: University of Texas Press, 1973.

CATALOGUES

Adelphia Society. *A Bid for Human Rights.* San Francisco: Adelphia Society, 1988.

Albright, Thomas. *Manuel Neri.* San Francisco: John Berggruen Gallery; Santa Monica, CA: James Corcoran Gallery; New York: Charles Cowles Gallery, 1988.

The Albuquerque Museum. *The Human Factor: Figurative Sculpture Reconsidered.* Albuquerque: The Albuquerque Museum, 1993.

Amnesty International. *Artists for Amnesty.* Davis, CA: Amnesty International, 1987.

Armstrong, Richard. *Sculpture in California 1975–80.* San Diego, CA: San Diego Museum of Art, 1980.

Art Against AIDS, San Francisco. *Art Against AIDS.* New York: American Foundation for AIDS Research and Livet Reichard Co., 1989.

The Artists Association, San Francisco Art Institute. *Art Bank 64/66.* San Francisco: San Francisco Art Institute, 1966.

Barilleaux, Rene Paul. *Sculptors on Paper: New Work.* Madison, WI: Madison Art Center, 1987.

Bates, Mary, and Moulton, Susan. *Works in Bronze: A Modern Survey.* Rohnert Park, CA: Sonoma State University, 1984.

Bischoff, David A. *Manuel Neri: Sculpture and Drawings.* Sacramento: Robert Else Gallery, California State University, 1985.

Bledsoe, Jane K. *Figurative Sculpture: Ten Artists/Two Decades.* Long Beach: University Art Museum, California State University, 1984.

Bolomey, Roger. *Forgotten Dimension: A Survey of Small Sculpture in California Now.* Fresno, CA: Fresno Arts Center, 1982.

Boynton, James, ed. *San Francisco 9.* Houston: Houston Contemporary Arts Museum, 1962.

Braunstein Gallery. *Braunstein Gallery Twentieth Anniversary.* San Francisco: Braunstein Gallery, 1981.

Brook House/Victor Fischer Fine Arts. *The Brook House Sculpture Invitational at Kaiser Center.* Orinda, CA: Victor Fischer Fine Arts, 1982.

Bush, Martin. *Figures of Contemporary Sculpture 1970–1990: Images of Man.* Tokyo: Brain Trust, Inc., 1992.

Butterfield, Jan, and Wortz, Melinda. *California Sculpture Show.* Los Angeles: California/International Arts Foundation, 1984.

Butterfield & Butterfield. *Contemporary Paintings, Watercolors, Drawings and Sculpture.* San Francisco: Butterfield & Butterfield, 1988.

Byer, Robert H. *Sculptural Intimacies: Recent Small-Scale Sculpture.* Los Angeles: Security Pacific Corporation, 1989.

Campbell-Thiebaud Gallery. *Manuel Neri: Recent Work.* San Francisco: Campbell-Thiebaud Gallery, 1993.

Castellon, Rolando. *A Third World Painting and Sculpture Exhibition.* San Francisco: San Francisco Museum of Art, 1974.

Clisby, Roger, ed. *Sacramento Sampler I.* Sacramento, CA: E. B. Crocker Art Gallery, 1972.

Coplans, John, ed. *Abstract Expressionist Ceramics.* Irvine: Fine Arts Gallery, University of California, 1966.

Costello, Daniel W.; Earls-Solari, Bonnie; and Stankus, Michelene. *BankAmerica Corporation Art Program 1985.* San Francisco: BankAmerica Corporation, 1986.

Cowart, Jack, and Amerson, Price. *Manuel Neri: A Sculptor's Drawings.* Washington, DC: The Corcoran Gallery of Art, 1994.

Culler, George D. *Some Points of View—'62.* Stanford, CA: Stanford University Art Gallery, 1962.

DeGroot, George. *California Contemporary: Recent Work of Twenty-three Artists.* Monterey, CA: Monterey Peninsula Museum of Art, 1983.

Denton, Monroe. *No Man's Land.* Long Island City, NY: Socrates Sculpture Park, 1990.

Dickson, Joanne. *Manuel Neri: Sculpture & Drawings.* Seattle: Seattle Art Museum, 1981.

E. B. Crocker Art Gallery. *Manuel Neri: Recent Sculpture and Drawings.* Sacramento, CA: E. B. Crocker Art Gallery, 1977.

80 Langton Street. *80 Langton Street: Documentation of the First Year.* San Francisco: 80 Langton Street, 1976.

FitzGibbon, John. *California A–Z and Return.* Youngstown, OH: Butler Institute of American Art, 1990.

Flood, Richard. *The Sixth Day.* Chicago: The Renaissance Society at the University of Chicago, 1983.

Foley, Suzanne. *Remember: It's Only Art.* Walnut Creek, CA: Walnut Creek Civic Arts Gallery, 1981.

Fuller Goldeen Gallery. *Casting: A Survey of Cast Metal Sculpture in the '80s.* San Francisco: Fuller Goldeen Gallery, 1982.

Garduño, Blanca, and Rodriguez, Jose Antonio. *Pasión por Frida.* Mexico City: Museo Estudio Diego Rivera, 1991.

Geldzahler, Henry. *Manuel Neri: Sculpture, Painted and Unpainted.* Bridgehampton, NY: Dia Center for the Arts, 1993.

———. *Manuel Neri: Classical Expressions/Sculpture and Drawings.* Las Vegas, NV: Nevada Institute for Contemporary Art, in association with Riva Yares Gallery, 1995.

Gettings, Frank. *Drawings 1974–1984.* Washington, DC: Hirshhorn Museum and Sculpture Garden, 1984.

Goodwin, Erin. *A Survey of Sculptural Directions in the Bay Area.* Cupertino, CA: De Anza College, 1975.

Grounds for Sculpture. *Spring/Summer Exhibition 94.* Hamilton, NJ: Grounds for Sculpture, 1994.

Guenther, Bruce. *The Essential Gesture.* Newport Beach, CA: Newport Harbor Art Museum, 1994.

Hayward Area Festival of the Arts. *17th Annual Hayward Festival of the Arts.* Hayward, CA: Hayward Area Festival of the Arts, 1978.

Henning, Robert, Jr., et al. *Santa Barbara Collects.* Santa Barbara, CA: Santa Barbara Museum of Art, 1985.

Holland, Katherine Church. *The Art Collection.* San Francisco: Federal Reserve Bank of San Francisco, 1986.

John Berggruen Gallery. *John Berggruen Gallery.* San Francisco: John Berggruen Gallery, 1986.

———. *Sculpture and Works in Relief.* San Francisco: John Berggruen Gallery, 1986.

———. *John Berggruen Gallery: Works on Paper.* San Francisco: John Berggruen Gallery, 1988.

———. *Large Scale Works on Paper.* San Francisco: John Berggruen Gallery, 1991.

Jones, Caroline A. *Manuel Neri: Plasters.* San Francisco: San Francisco Museum of Modern Art, 1989.

J.P.L. Fine Arts. *California Gold.* London: J.P.L. Fine Arts, 1975.

Kagawa, Paul, et al. *Other Sources: An American Essay.* San Francisco: San Francisco Art Institute, 1976.

Kiechel, Vivian. *Contemporary Bronze: Six in the Figurative Tradition.* Lincoln: Sheldon Memorial Art Gallery, University of Nebraska, 1985.

Lagoria, Georgianna M., and Martin, Fred. *Northern California Art of the Sixties.* Santa Clara, CA: De Saisset Museum, University of Santa Clara, 1982.

Laguna Gloria Art Museum. *Human Nature Human Form.* Austin, TX: Laguna Gloria Art Museum, 1993.

Linhares, Philip. *Here and Now: Bay Area Masterworks from the Di Rosa Collection.* Oakland, CA: The Oakland Museum, 1994.

Magloff, Joanna, ed. *Current Painting and Sculpture of the Bay Area.* Stanford, CA: Stanford University Art Museum, 1964.

Matilsky, Barbara C. *The Expressionist Surface: Contemporary Art in Plaster.* Queens, NY: Queens Museum, 1990.

Matthews, Gene. *Visiting Artist Program: 20th Anniversary Show.* Boulder: CU Art Galleries, University of Colorado, 1992.

McCormick, Jim. *30 from 25.* Reno: Sheppard Fine Arts Gallery, University of Nevada, 1986.

McCullough, Tom; Thomas, Daniel; and Nicholson, Harry. *Three Views on the 1976 Biennale—Recent International Forms in Art.* Sydney, Australia: Art Gallery of New South Wales, 1976.

Morris, Dan W. *National Drawing Invitational.* Little Rock: Arkansas Art Center, 1990.

Muckenthaler Cultural Center. *Sculptural Perspectives for the Nineties.* Fullerton, CA: Muckenthaler Art Center, 1991.

Nassau County Museum of Fine Art. *Contemporary Naturalism: Works of the 1970's.* Roslyn, NY: Nassau County Museum of Fine Art, 1980.

Natsoulas/Novelozo Gallery, with foreword by John Allen Ryan. *Lyrical Vision: The '6' Gallery, 1954–1957.* Davis, CA: Natsoulas/Novelozo Gallery, 1989.

———, with foreword by John Natsoulas. *30 Ceramic Sculptors.* Davis, CA: Natsoulas/Novelozo Gallery, 1989.

———, with foreword by John Natsoulas. *30 Ceramic Sculptors.* Davis, CA: Natsoulas/Novelozo Gallery, 1990.

Neubert, George. *Manuel Neri, Sculptor.* Oakland, CA: The Oakland Museum, 1976.

———. *Bay Area Sculptors of the 1960s: Then and Now.* San Francisco: Braunstein/Quay Gallery, 1990.

Nierengarten-Smith, Beej. *Laumeier Sculpture Park First Decade, 1976–1986.* St. Louis, MO: Laumeier Sculpture Park, 1986.

Novakov, Anna. "Funk Art: A San Francisco Phenomenon." In *Painters at UC Davis.* Davis: Richard L. Nelson Gallery, University of California, 1984.

The Oakland Museum. *100 Years of California Sculpture.* Oakland, CA: The Oakland Museum, 1982.

Orr-Cahall, Christina. *The Art of California: Selected Works from the Collection of The Oakland Museum.* Oakland, CA: The Oakland Museum; San Francisco: Chronicle Books, 1984.

———, ed. *The Dilexi Years 1958–1970.* Oakland, CA: The Oakland Museum, 1984.

Project Sculpture. *Project Sculpture.* Oakland, CA: Project Sculpture, 1982.

Provincetown Art Association and Museum. *The Sun Gallery.* Provincetown, MA: Provincetown Art Association and Museum, 1981.

Rannells, Susan, and Richardson, Brenda. *Free.* Berkeley, CA: University Art Museum, 1970.

Restany, Pierre. *Manuel Neri.* San Francisco: John Berggruen Gallery; New York: Charles Cowles Gallery; Zurich: Gimpel-Hanover + André Emmerich Galerien, 1984.

Richard L. Nelson Gallery. *Sculptors at UC Davis: Past and Present.* Davis: Richard L. Nelson Gallery, University of California, 1972.

Riva Yares Gallery. *Manuel Neri: Sculpture of the 1980s.* Scottsdale, AZ: Riva Yares Gallery, 1989.

Rodriguez, Peter. *The Mexican Museum.* San Francisco: The Mexican Museum, 1981.

Rogers-Lafferty, Sarah. *Body & Soul: Aspects of Recent Figurative Sculpture.* Cincinnati: The Contemporary Arts Center, 1985.

St. Mary's College Art Gallery. *The Small Format.* Moraga, CA: St. Mary's College, 1973.

———. *The Good Drawing Show.* Moraga, CA: St. Mary's College, 1976.

San Diego Museum of Art. *San Diego Museum of Art: Selections from the Permanent Collection.* San Diego, CA: San Diego Museum of Art, 1993.

San Francisco Art Institute. *Other Sources: An American Essay.* San Francisco: San Francisco Art Institute, 1976.

San Francisco Art Institute. *Reflections: Alumni Exhibitions, San Francisco Art Institute.* San Francisco: San Francisco Art Institute, 1982.

San Francisco Museum of Modern Art. *Twenty American Artists.* San Francisco: San Francisco Museum of Modern Art, 1980.

———. *50th Anniversary Commemorative Program 1985.* San Francisco: San Francisco Museum of Modern Art, 1985.

———. *San Francisco Museum of Modern Art: The Painting and Sculpture Collection.* San Francisco: San Francisco Museum of Modern Art, 1985.

San Francisco Museum of Modern Art and National Collection of Fine Arts, Smithsonian Institution. *Painting and Sculpture in California: The Modern Era.* San Francisco: San Francisco Museum of Modern Art; Washington, DC: National Collection of Fine Arts, Smithsonian Institution, 1976.

Sarah Spurgeon Gallery, Central Washington University. *Second Annual Invitational Drawing Exhibition.* Ellensburg: Sarah Spurgeon Gallery, Central Washington University, 1979.

Schipper, Merle. *Marmo/Marble: A Contemporary Aesthetic.* Los Angeles: California Museum of Science and Industry, 1989.

Scios Nova. *Ventriloquist.* Baltimore: Scios Nova, 1993.

Selz, Peter, ed. *Funk Art.* Berkeley, CA: University Art Museum, 1967.

Southwestern Bell Corporation. *Contemporary Masters Kansas Tour: Selections from the Collection of Southwestern Bell Corporation.* Wichita, KS: Southwestern Bell Corporation, 1988.

Starr, Sandra Leonard. *Lost and Found in California: Four Decades of Assemblage Art.* Santa Monica, CA: James Corcoran Gallery, 1988.

University of Nevada. *1968 Sculpture Invitational.* Reno: University of Nevada, 1968.

Zakian, Michael. *California Figurative Sculpture.* Palm Springs, CA: Palm Springs Desert Museum, 1987.

BROCHURES

American Academy and Institute of Arts and Letters. *36th Annual Purchase Exhibition: Hassam and Speicher Fund.* New York: American Academy and Institute of Arts and Letters, 1984.

Butterfield, Jan. *Manuel Neri: Drawings & Bronzes.* San Francisco: Art Museum Association, 1981.

Charles Cowles Gallery. *Manuel Neri.* New York: Charles Cowles Gallery, 1981.

Community Arts, Inc. *The Downtown Foot Show.* San Francisco: Community Arts, Inc., 1988.

Heyman, Ira Michael, and Elliott, James. *Cal Collects 1.* Berkeley, CA: University Art Museum, 1986.

Leonard, Michael. *The Triumph of the Figure in Bay Area Art: 1950–1965.* San Francisco: 871 Fine Arts, 1987.

Mayfield, Signe. *Lyricism and Light.* Palo Alto, CA: Palo Alto Cultural Center, 1994.

The Mexican Museum. *Los Primeros Cinco Años/Fifth Anniversary Exhibit.* San Francisco: The Mexican Museum, 1981.

Museum of Anthropology, California State University. *Sons of the Shaking Earth.* Hayward: California State University, 1983.

Neri, Kate. *Manuel Neri, A Personal Selection.* Belmont, CA: Wiegand Art Gallery, College of Notre Dame, 1988.

Neubert, George W. *Twentieth-Century American Sculpture at The White House.* Washington, DC: The White House, 1994.

Nordland, Gerald. *Arts of San Francisco: Manuel Neri.* San Francisco: San Francisco Museum of Art, 1971.

Rodriguez, Peter. *Cinco de Mayo Inaugural Exhibit at Fort Mason Center.* San Francisco: The Mexican Museum, 1982.

San Francisco Museum of Modern Art. *Resource/Reservoir, CCAC: 75 Years.* San Francisco: San Francisco Museum of Modern Art, 1983.

Sarah Lawrence College Art Gallery. *The United States of the Arts.* Bronxville, NY: Sarah Lawrence College, 1983.

University of California, Davis. *Department of Art.* Davis: University of California Publications, 1982.

Walters, Sylvia Solochek. Introduction to *Counter Visions: Pioneers in Bay Area Art.* San Francisco: Art Department Gallery, San Francisco State University, 1988.

ARTICLES

"Acquisitions." *Artweek*, vol. 16, no. 42, Dec. 14, 1985, p. 9.

Albin, Edgar A. "The Arts: Sculpture Park Offers New Views, Second Chance on Exhibit." *Springfield News-Leader* (Springfield, MO), July 10, 1983.

Albrecht, Herbert. "Die Farbe hat die Plastik Wieder." *Die Welt* (Mannheim, Germany), Feb. 18, 1985.

Albright, Thomas. "Rooted in the Tradition of the Human Figure—A Sense of Magical Equilibrium." *San Francisco Chronicle*, Nov. 13, 1971, p. 38.

———. "'Good Drawing Show': Some First-Rate Works at St. Mary's College." *San Francisco Chronicle*, Nov. 1971.

———. "Myth Makers." *Art Gallery*, vol. 18, no. 5, Feb. 1975, pp. 12–17, 44–45.

———. "Neri: Still Sticking with Humans." *San Francisco Chronicle*, Apr. 5, 1975, p. 33.

———. "Manuel Neri: A Kind of Time Warp." *Currant*, vol. 1, no. 1, Apr./May 1975, pp. 10–16.

———. "Spin-Off." *Artnews*, vol. 74, no. 6, Summer 1975, pp. 113–14.

———. "Santa Cruz: Mecca for Experimental Printmaking." *San Francisco Chronicle*, July 4, 1975.

———. "Top-Notch Studio Offerings." *San Francisco Chronicle*, May 12, 1976, p. 54.

———. "The Magnificence of Manuel Neri." *San Francisco Chronicle*, Sept. 30, 1976, pp. 49–50.

———. "Ron Davis, Then and Now." *Artnews*, vol. 75, no. 9, Nov. 1976, pp. 100–101.

———. "The Cream of the Shows." *San Francisco Chronicle*, Nov. 11, 1976, p. 50.

———. "California Art Since the 'Modern Dawn.'" *Artnews*, Jan. 1977, pp. 68–72.

———. "An Insider's View of Aging." *San Francisco Chronicle*, Sept. 1, 1977, p. 55.

———. "Large Sculpture in Adequate Space." *San Francisco Chronicle*, Nov. 23, 1977, p. 42.

———. "The Possibilities of Hand-Made Paper." *San Francisco Chronicle*, Jan. 13, 1978, p. 44.

———. "Forceful Masterpieces from Manuel Neri." *San Francisco Chronicle*, May 17, 1979, p. 47.

———. "The Growth of Manuel Neri." *San Francisco Chronicle*, Mar. 11, 1980, p. 58.

———. "Bay Area Art: Time of Change." *Horizon*, vol. 23, no. 7, July 1980, pp. 24–35.

———. "A Wide-Ranging Modern Art Exhibition." *S.F. Sunday Examiner & Chronicle*, Aug. 3, 1980, "This World" section, pp. 35–36.

———. "Manuel Neri's Survivors: Sculpture for the Age of Anxiety." *Artnews*, vol. 80, no. 1, Jan. 1981, pp. 54–59.

———. "Art Isn't Easily Divided Into Decades." *San Francisco Chronicle*, Feb. 16, 1981.

———. "Neri's Contradictions." *San Francisco Chronicle*, Dec. 3, 1981, p. 76.

———. "San Francisco: Different and Indifferent Drummers." *Artnews*, vol. 81, no. 1, Jan. 1982, pp. 86–90.

———. "Looking Back at a Unique Decade in Art." *San Francisco Chronicle*, Nov. 1, 1982.

———. "Our Public Sculpture—A Disgrace?" *S.F. Sunday Examiner & Chronicle*, Aug. 21, 1983, "Review" section, pp. 11–12.

———. "Magnificent New Figures From Manuel Neri." *San Francisco Chronicle*, Mar. 1, 1984, p. 58.

"American Academy 1982 Art Awards." *Art World*, Apr. 22, 1982.

Anderson, Wayne. "California Funk and the American Express." *Journal of Art*, vol. 4, no. 6, June/July/Aug. 1991, pp. 65–66.

Applebome, Peter. "The Varied Palette of Hispanic Art in America." *New York Times*, June 21, 1987, "Arts & Leisure" section, p. 31.

"Art Is Thriving in Berkeley—Hayter, Peterdi on Display." *Oakland Tribune*, Dec. 4, 1960, pp. C3, C1.3.

"Art Magazines: The Pictures are Nice, But . . ." *Oakland Tribune*, June 1, 1975.

"Artists Look at the Crucifixion." *Contra Costa Sun*, Mar. 11, 1992, p. 9

Artnews, vol. 78, Sept. 1979, p. 118.

"Arts Center Slates Neri Exhibit." *Fresno Bee*, June 28, 1981, p. C5.

Atkins, Richard. "From Photography to Funk." *Horizon*, July/Aug. 1981.

Atkins, Robert D. "A Gallery for Every Salary." *New West*, Mar. 10, 1980, pp. 21–24.

———. "Bay Area Art: Mirror of the Moment." *Scene*, Apr./May 1982, pp. 9–12.

"Awards of Honor." *Artweek*, vol. 16, no. 23, June 15, 1985, p. 2.

Ayres, Jane. "Important Images in Metal, Stone, Wood." *Times-Tribune* (Palo Alto, CA), Mar. 20, 1988, p. 3.

———. "Braunstein's Art Support Stays Strong." *Times-Tribune*, July 4, 1990, "Lifestyle" section.

———. "Three Diverse Artists Showcase New Works in Garden." *Times-Tribune*, Dec. 21, 1990, "Lifestyle" section.

Baker, Kenneth. "Legacy of a Journalist/Historian." *S.F. Sunday Examiner & Chronicle*, June 23, 1985, "Review" section, pp. 1, 12–13.

———. "A Modest and Upbeat Show of Sculpture." *S.F. Sunday Examiner & Chronicle*, July 27, 1986, "Review" section, pp. 12–13.

———. "Crown Press Moves to SOMA; New Berggruen Space." *San Francisco Chronicle*, Oct. 16, 1986, p. 60.

———. "Home-Grown Sculpture." *San Francisco Chronicle*, Mar. 31, 1988, p. E2.

———. "The Two Sides of Manuel Neri." *San Francisco Chronicle*, May 17, 1988, p. E2.

———. "Powerhouse of Figurative Painting." *San Francisco Chronicle*, May 28, 1989.

———. "Odd Poses Lend Tension to Manuel Neri's Sculptures." *San Francisco Chronicle*, June 4, 1989, "Review" section, pp. 14–15.

———. "Viola Frey's Ceramic Mysteries." *San Francisco Chronicle*, Mar. 31, 1990, p. C5.

———. "Sublimated Eroticism and Frenzied Funk." *San Francisco Chronicle*, Sept. 10, 1993, pp. 42–43.

Bellet, Henri. "Manuel Neri, Peter Reicheberger." *Le Monde* (Paris), Feb. 26–27, 1995.

Bloomfield, Arthur. "Sculptor's Boxing Packs No Punch." *San Francisco Examiner*, Aug. 12, 1966.

———. "20 Years of San Francisco Sculpture." *San Francisco Examiner*, Feb. 5, 1976, p. 24.

———. "Out of the Piazzas With Extra Pizzazz." *San Francisco Examiner*, Nov. 22, 1977.

Blum, Walter. "A Showcase for Contemporary Art." *San Francisco Examiner*, Aug. 10, 1980, pp. 16–20.

Boettger, Suzaan. "Manuel Neri—Recent Work." *Artweek*, Sept. 13, 1977, p. 7.

"Book Explores Artist's Relationship with 20-year Model." *Neighbor Want Ads* (Atlanta), Apr. 1991, p. 7A.

Braff, Phyllis. "Life-Size Figures and Reality Relating to Fantasy." *New York Times*, Aug. 29, 1993, p. 16.

Brenson, Michael. "Figurative Sculpture of the 80's." *New York Times*, June 13, 1986, p. C1.

———. "Plaster as a Medium, Not Just an Interim Step." *New York Times*, June 1990.

———. "The State of the City as Sculptors See It." *New York Times*, July 27, 1990, pp. C1, C22.

Brzezinski, Jamey. "A Printmaker's Paradise." *Artweek*, Nov. 21, 1991, p. 9.

"Bronze Show Continues." *Encore!* (Reno, NV), July 1986, p. 3.

Brooks, Valerie F. "The State of Contemporary Sculpture." *MD*, Feb. 1983, pp. 59–66.

Brown, Erica. "Precision with Playfulness." *New York Times*, July 9, 1979, Sunday Magazine, p. 53.

Brumfield, John. "The Olympics California Sculpture Show." *Artweek*, vol. 15, no. 27, July 28, 1984, p. 1.

Burkhart, Dorothy. "Splashy Figures at Mexican Museum: Manuel Neri's Sculptures Show Mysterious Quality." *San Jose Mercury News*, June 7, 1981, "The Tab," pp. 10–11.

———. "Battered Forms Put Humanity Back on Display." *San Jose Mercury News*, Sept. 23, 1982, pp. 1D, 7D.

———. "The 60's Art Experience." *San Jose Mercury News*, Oct. 17, 1982, "The Tab," pp. 1A–8A.

———. "The Figure's Beauty Realized in the Abstract." *San Jose Mercury News*, June 4, 1989.

———. "Working Together: Joan Brown and Manuel Neri, 1958–1964." *Artnews*, vol. 94, no. 8, Oct. 1995, p. 157.

Butterfield, Jan. "Ancient Auras—Expressionist Angst: Sculpture by Manuel Neri." *Images and Issues*, Spring 1981, pp. 38–43.

Caen, Herb. "Along the Presidio." *Architectural Digest*, Dec. 1985, pp. 118–26.

Caldwell, Sandra. "Manuel Neri, Sculptor." *Oakland Museum Bulletin*, Sept. 1976.

Carlsen, Peter. "Elements of Style." *Architectural Digest*, Nov. 1985, pp. 150–56.

Casasco, Ermanno. "La Casa di Una Collezionista d'Arte Moderna: Paule Anglim." *Casa & Giardino* (Milano, Italy), no. 132, May 1983, pp. 40–45.

Cathro, Morton. "Taking up the Cross." *Oakland Tribune*, Mar. 29, 1992, p. 2C.

Chipp, Herschel B. "Exhibition in San Francisco." *Artnews*, vol. 59, no. 6, Oct. 1960, p. 50.

Ciaffardini, David. "What's a Noted Artist Doing in a Place Like This?" *Vacaville Reporter*, Jan. 31, 1982, pp. 1A, 8A.

Coffelt, Beth. "The Big Wave Was Rising." *SF Sunday Examiner & Chronicle*, Nov. 9, 1975, "California Living," p. 24–28.

Cohn, Terri. "Abstraction and Figuration Integrated." *Artweek*, vol. 20, no. 25, July 15, 1989, p. 3.

Coke, Van Deren. "Bay Area Art of the 50s and 60s, the Gift of Dr. Samuel West." *Bulletin, The University of New Mexico Art Museum*, no. 11, 1977–78, pp. 6–13.

"Collectors Forum Hosts a Glamorous Gathering of Artists, Collectors and Curators." *Sausalito Review*, no. 58, Aug. 1980, pp. 18–19.

Collins, Meghan. "Benicia's Lively Arts." *Art Well*, Mar./Apr. 1984, pp. 4–5.

Cope, Penelope Bass. "Public Sculptures Polish the Gateway." *Sunday News Journal* (Wilmington, DE), Aug. 21, 1988, pp. K1, K3.

Coplans, John. "Sculpture in California." *Artforum*, Aug. 1963, pp. 3–6.

———. "The Nude: Drawings by Alvin Light, Manuel Neri, Gordon Cook, Joan Brown." *Artforum*, Nov. 1963, p. 39.

———. "Circle of Styles on the West Coast." *Art in America*, vol. 52, no. 3, June 1964, p. 30.

———. "Abstract Expressionist Ceramics." *Artforum*, vol. 5, no. 3, Nov. 1966, pp. 34–41.

Coplans, John, and Leider, Philip. "West Coast Art: Three Images." *Artforum*, vol. 1, no. 12, June 1963, pp. 21–25.

Cotter, Colleen. "Major Exhibit of Bronzes on Display at Museum." *Record Searchlight* (Redding, CA), May 1985.

"The Crucifixion." *San Mateo Times*, Mar. 11, 1992, p. 20.

Dalkey, Victoria. "Icons of the Flesh." *Sacramento Bee*, Nov. 3, 1985, "Encore," p. 28.

———. "Cultural Crossroads." *Horizon*, vol. 31, no. 1, Jan./Feb. 1988, "Valley Arts," pp. 12–14.

———. "Forms of Expression." *Sacramento Bee*, Aug. 26, 1990, "Encore," p. 10.

Davis, Randal. "Bay Area Figurative Painting." *Artweek*, vol. 25, no. 5, Mar. 10, 1994, p. 14.

Delatiner, Barbara. "Nassau Museum Ready to be Open." *New York Times*, June 1, 1980.

Delehanty, Hugh J. "Manuel Neri: Cast From A Different Mold." *Focus Magazine* (San Francisco), Jan. 1982, pp. 24–27.

Delmar, John Davies. "A Cast of Artists Who Shape in Plaster." *Newsday*, part 2, p. 11.

Donnelly, Kathleen. "How Much House Does $2 Million Buy?" *Palo Alto Weekly* (Palo Alto, CA), Oct. 9, 1985, p. 3A.

Donohue, Marlena. "The Galleries." *Los Angeles Times*, Nov. 4, 1988, part 6, p. 15.

Drohojowska, Hunter. "A Northwestern Passage." *Architectural Digest*, Sept. 1990, pp. 196–201.

Dunham, Judith. "Images of Woman." *Artweek*, vol. 6, no. 41, Nov. 29, 1975, pp. 13–14.

———. "Manuel Neri: Life with the Figure." *Artweek*, Nov. 13, 1976, pp. 1, 7.

———. "Stars, Stripes and Celebrities." *Artweek*, Aug. 30, 1980, pp. 1, 9.

Evans, Ingrid. "Notes from a Nevada History." *Artweek*, vol. 18, no. 19, May 16, 1987, p. 1.

———. "Funk and Figurative." *Reno Gazette-Journal*, Mar. 12, 1989.

"Events." *Sculpture*, May/June 1987, ill. p. 41.

Fahlman, Betsy. "Manuel Neri: Sculpture of the 1980s." *Latin American Art*, Winter 1990, p. 65.

Feeser, Sigrid. "Frischer Wind von der Westkuste." *Rheinpfalz*, (Mannheim, W. Germany), Feb. 8, 1985.

"Fighting Apartheid at Michael Jackson's." *San Francisco Chronicle*, Apr. 8, 1988, p. 5B.

Figoten, Sheldon. "Building and Painting the Figure." *Artweek*, June 20, 1981, pp. 5–6.

"Foster/White Gallery: National Sculpture Exhibition, 1987." *Signature* (Edmonds, WA), Feb. 1987, p. 6.

"Four Drawings: Manuel Neri." *Artforum*, vol. 2, no. 10, April 1964, pp. 32–33.

Fowler, Carol. "The Art of Plaster: Love of the Craft Shapes Neri's Style." *Contra Costa Times*, May 19, 1989, "Time Out" section, pp. 12–13.

———. "Artists of Modern Times Consider the Crucifixion." *Contra Costa Times*, Mar. 28, 1992, p. 2C.

———. "Model Finds Inspiration, Support for Poetry from Artist." *Contra Costa Times*, Nov. 11, 1994, "Time Out" section, p. 24.

———. "Neri's Sketchbooks Opened to Public Eye." *Contra Costa Times*, Nov. 11, 1994, "Time Out" section, p. 23.

Frank, Peter. "Manuel Neri (Braunstein/Quay)." *Artnews*, vol. 75, no.5, May 1976, p. 128.

Frankenstein, Alfred. "In '71—A Controversial Fountain, A Merger and Acquisitions." *S.F. Sunday Examiner & Chronicle*, Jan. 2, 1972, "This World" section, pp. 37–38.

———. "The Old and the New in Oakland Shows." *S.F. Sunday Examiner & Chronicle*, May 28, 1972, "This World" section, pp. 34–35.

———. "Hansen Fuller Commemorative." *San Francisco Chronicle*, Oct. 30, 1975.

———. "A Gallery Full of Sculpture." *San Francisco Chronicle*, Jan. 29, 1976, p. 36.

———. "Public Art and the Abstracts in the Modern Era." *S.F. Sunday Examiner & Chronicle*, Sept. 19, 1976, "This World" section, p. 35.

———. "Innovative Sculptor of the Life Cast." *San Francisco Chronicle*, Feb. 25, 1979, p. 49.

Frantzis, Peggy. "Triton Adds 3 Works to Sculpture Garden." *Santa Clara Valley Weekly*, Jan. 3, 1991, p. 2.

French, Christopher. "Portraits of Artists." *Artweek*, Oct. 30, 1982, p. 11.

———. "Manuel Neri: Figures Out of Time." *Artweek*, vol. 15, no. 11, Mar. 17, 1984, p. 1.

———. "Looking Back to the Dilexi." *Artweek*, vol. 15, no. 37, Nov. 3, 1984, p. 1.

———. "Art in the San Francisco Bay Area." *The Museum of California* (The Oakland Museum), July/Aug. 1985, pp. 13–16.

Fribourgh, Cindy. "Photographs, Bronzes Shown at Arts Center." *Arkansas Democrat*, Apr. 4, 1982.

Fried, Alexander. "Violent Fantasy in Art." *San Francisco Chronicle*, Feb. 1959.

Friedlander, Lisa M. "Pair Collaborate on Limited Edition." *Arts Benicia*, July/Aug. 1992, pp. 1, 5, 7.

"From Humans to Boxes." *San Francisco Chronicle*, Aug. 1966.

Fuller, Mary. "San Francisco Sculpture." *Art in America*, vol. 52, June 1964, pp. 52–59.

Gale, Andrew. "Art Views: Limited Ceramics, Sculpture Which Searches to Believe." *Sacramento Bee*, Mar. 26, 1972, "Leisure," pp. 10–11.

Garcia, John. "Once They Sneered, Now Artists Get Plastered." *Daily News*, June 8, 1990.

Garver, Thomas. "Omaha: Space-Rich and Hungry for Art." *Artnews*, vol. 87, no. 5, May 1988, pp. 31–32.

Gerard, Paul. "Paper Route." *Isthmus* (Madison, WI), Dec. 4, 1987, p. 32.

Gidfrey, Dominique. "Art Contemporain Bordeaux: Un Octobre Californien." *TV Loisirs* (Bordeaux, France), Sept. 16, 1984, p. 35.

Gimelson, Deborah. "Los Angeles Redux." *Art & Auction*, Mar. 1988, p. 54.

Glowen, Ron. "Neri's Figures Are Striking and Gaunt." *Everett Herald* (Everett, WA), Feb. 5, 1981, p. 2C.

Goldberger, Paul. "Architecture: Robert A. M. Stern." *Architectural Digest*, Oct. 1990, pp. 196–205.

Goldman, Saundra. "New Exhibit Goes 'Off the Map.'" *Austin American Statesman*, Nov. 27, 1993, p. 13.

Gomez, Edward M. "The San Francisco Rebellion." *Time*, Feb. 5, 1990, pp. 74–75.

Gordon, Harvey. "'Sculptors on Paper' Disappoints, Lacks Substance." *Kalamazoo Gazette*, Sept. 16, 1988.

Gottlieb, Shirley. "The Human Body: Back But Never Gone." *Long Beach Press Telegram*, Apr. 4, 1984.

Graham, Barbara. "Art Attack at 80 Langton." *Focus Magazine*, Dec. 1981, pp. 22–25.

Green, Blake. "Yuppies Discover Art." *San Francisco Chronicle*, Sept. 1, 1987, pp. 15, 17.

Hackett, Regina. "Woman's Many Facets." *Artweek*, vol. 6, no. 41, Nov. 29, 1975, pp. 13–14.

———. "SAM Exhibit Pushes Beyond Stereotypes." *Seattle Post-Intelligencer*, Feb. 1, 1981, pp. H7–8.

———. "30 Years of American Sculpture." *Seattle Post-Intelligencer*, Nov. 15, 1984, pp. C1, C9.

———. "Neri Work is a First for Seattle." *Seattle Post-Intelligencer*, Sept. 4, 1991, p. C6.

Hagan, R. H. "Dilexi: To Select, to Value, to Love." *The Museum of California* (The Oakland Museum), Sept./Oct. 1984, pp. 11–13.

Hale, David. "Bronze Making a Big Comeback in FSU Exhibit." *Fresno Bee*, Sept. 22, 1986, p. G12.

Hamlin, Jesse. "Art Auction at Michael Jackson's House." *San Francisco Chronicle*, Apr. 11, 1988, p. 2A.

Hancock, Lorie. "Real Art is Really Good." *Union* (Long Beach, CA), Mar. 22, 1984, p. 6.

Harper, Paula. "Sculptor's Nudes Embody Mankind." *Miami News*, Nov. 5, 1982.

Hartness, Ruth. "Top Choices Strong but Restrained." *Creative Loafing* (Atlanta), July 30, 1988, p. 4B.

Hazard, Paul. "The Northwest: This Month's Tour from Michigan to California." *Horizon*, Jan. 1981, pp. 25–29.

Heartney, Eleanor. "Manuel Neri at Charles Cowles." *Art in America*, vol. 79, no. 5, May 1991, pp. 175–76.

Hemphill, Chris. "Sculptural Drama." *Architectural Digest*, Mar. 1980, pp. 68, 120.

Hendricks, Mark. "Bay Area Exhibit Paints Diverse Styles, Movements." *Daily Nebraskan*, Oct. 4, 1984, pp. 11–12.

Hoffman, Donald. "Figures Show Masterful Ways of Working with Bronze." *Kansas City Star*, Feb. 23, 1986, p. 9D.

Huber, Alfred. "Wenn die Linie einen Bogen kreuzt." *Mannheimer Morgen* (Mannheim, W. Germany), Feb. 4, 1985.

Hughes, Robert. "Heritage of Rich Imagery." *Time*, vol. 132, no. 2, July 11, 1988, pp. 62–64.

Hurlburt, Roger. "A Celebration of Life and Limb." *News/Sun Sentinel*, Feb. 7, 1988, p. 3F.

ICA News (University of California, San Diego), vol. 1, no. 3, Spring 1984.

"In the Galleries." *ArtTalk*, Mar. 1992, p. 42.

"Injecting Bold Style Into a City Co-op." *House and Garden*, Mar. 1982, pp. 118–20.

Jinkner-Lloyd, Amy. "'Top Choices' Few in Number, Strong in Content." *Atlanta Journal*, July 27, 1988, p. 3C.

Johnsrud, Even Hebbe. "Fantasi-utfordring." *Aftenposten* (Oslo, Norway), Sept. 13, 1985.

Jones, Marianna. "Manuel Neri: Obsession with Depicting Human Forms Distinguishes Californian's Art Work." *Walla Walla Union Bulletin*, Apr. 3, 1980.

Juris, Prudence. "Neri's Second Skins." *Artweek*, vol. 2, no. 41, Nov. 27, 1971, p. 12.

———. "Interview with Sam West: Collecting 'Of Our Time and Our Community.'" *San Francisco Progress*, July 28, 1972.

Kangas, Matthew. "Rebirth of Venus." *Sculpture*, vol. 9, no. 6, Nov./Dec. 1990, pp. 48–55.

Kattman, Sarah. "Living Theater." *House Beautiful*, Nov. 1991, pp. 75–83.

Katz, Vincent. "Manuel Neri at Charles Cowles." *Art in America*, vol. 83, no. 10, Oct. 1995, p. 129.

Kaufman, Charles. "Neri Leads New Exhibits at Arts Center." *Arkansas Gazette* (Little Rock), Apr. 2, 1982, p. 1C.

Kimmelman, Michael. "30 Hispanic Artists at the Brooklyn Museum." *New York Times*, June 9, 1989, p. B12.

Klein, Elaine. "New Exhibit Offers Look into Sculptors' Thoughts." *Kalamazoo Gazette*, Sept. 11, 1988, p. H1.

Kohen, Helen L. "Sculpting the Everyman in Brash, Bold Bronze." *Miami Herald*, Oct. 29, 1982, p. 2D.

———. "Art Looks for a Place in the Sun." *Artnews*, vol. 82, no. 2, Feb. 1983, pp. 62–65.

"Kooky Group Repair Show." *San Francisco Chronicle*, Mar. 1969.

Kramer, Hilton. "Art: First Solo Show for Manuel Neri." *New York Times*, Feb. 27, 1981.

"La Maison Blanche." *Maison & Jardin*, Mar. 1991.

Lee, Anthony. "The Gang of Six." *Artweek*, vol. 21, no. 3, Jan. 25, 1990, pp. 1, 20.

Leider, Philip. "Manuel Neri, New Mission Gallery" *Artforum*, Sept. 1963, p. 45.

———. "California After the Figure." *Art in America*, vol. 51, no. 5, Oct. 1963, p. 77.

Le Van, Brook B. "The Bemis Experience." *Sculpture*, vol. 7, no. 3, May/June 1988, pp. 26–27.

Lewis, Jo Ann. "Peopled Paradox." *The Washington Post*, Feb. 3, 1983.

Lofstrom, Mark. "Character of Our Age & History in Sculpture." *Cultural Climate* (Honolulu), Apr. 1983, p. 7.

Long, Robert. "Artist's Style Presents Paradox." *Southampton Press*, Sept. 9, 1993, pp. 21, 24.

Macias, Sandra. "Getting a Handle on Sculpture." *Reno Gazette-Journal*, June 29, 1986, p. 5E.

MacMillan, Kyle. "Sculptors Confront Limitations of Two Dimensions." *Sunday World Herald* (Lincoln, NE), Apr. 9, 1989, "Entertainment" section.

"Madison." *Wisconsin Woman*, Dec. 1987, p. 31.

Magloff, Joanna. "California Sculpture at the Oakland Museum." *Artnews*, vol. 62, no. 9, Jan. 1964, p. 51.

"Manuel Neri." *Art Well*, Mar./Apr. 1984, p. 23.

"Manuel Neri at Middendorf/Lane." *Art Now/U.S.A.: The National Art Museum and Gallery Guide*, Feb./Mar. 1983, p. NY9.

"Manuel Neri: Escultura y Dibujos." *Art Nexus*, May 1991, pp. 112–13.

"Manuel Neri Exhibit at Park." *St. Louis Post-Dispatch*, June 23, 1983.

"Manuel Neri: Woman." *Artweek*, vol. 6, no. 16, Apr. 19, 1975.

Marger, Mary Ann. "Sculpture Unveiled at Bank Building." *St. Petersburg Times*, Mar. 31, 1988, "Tampa" section, p. 3.

Marlowe, John. "Power, Politics and Publicity, But Is It Art?" *San Francisco Magazine*, vol. 2, no. 5, May 1988, pp. 20–24, 123.

Marmer, Nancy. "Los Angeles." *Artforum*, vol. 3, no. 4, Jan. 1965, pp. 13–14.

Maslon, Laura Stevenson. "Art Chatter about Art Matters." *Art Talk*, Dec. 1988, p. 26.

"Master Artist Tribute III Puts Neri in Spotlight." *Benicia Herald* (Benicia, CA), Nov. 24, 1994, p. A6.

McCann, Cecile N. "Geis and Neri at SFAI." *Artweek*, vol. 1, no. 31, Sept. 26, 1970, p. 3.

McColm, Del. "Blockbuster Show of Recent UCD Art Exhibited." *Davis Enterprise* (Davis, CA), Oct. 17, 1980.

———. "Sculptures Dominate." *Davis Enterprise*, Mar. 22, 1984.

———. "Fantasies Fulfilled." *Davis Enterprise*, Apr. 5, 1984.

McDevitt, Lorelei Heller. "Inspired by a Collection." *Designers West*, vol. 34, no. 6, Apr. 1987, pp. 84–88, 168.

McDonald, Robert. "Manuel Neri." *Artweek*, June 2, 1979, pp. 1, 19.

McKinley, Cameron Curtis. "Adaptability: A Personal Expression in a Designer's Own San Francisco Home." *Architectural Digest*, Nov. 1982, pp. 104–11.

McRae, Jacqueline. "Visions in Bronze." *Walla-Walla Union Bulletin*, Nov. 17, 1988.

Medina, Danny. "Manuel Neri." *Art Talk*, Feb. 1991, pp. 28–29.

———. "Danny's Column." *Art Talk*, Sept. 1992, p. 41.

Meisel, Alan. "Letter from San Francisco." *Craft Horizons*, no. 31, Dec. 1971, p. 55.

Mennin, Mark. "Innovations with the Figure: The Sculpture of Manuel Neri." *Arts*, vol. 60, no. 8, Apr. 1986, pp. 76–77.

Merritt, Robert. "'Sculpture Now' Unsettling." *Richmond Times-Dispatch*, Oct. 14, 1983.

Michael, Peggy. "Sculptors on Paper." *FORUM* (Kalamazoo Institute of the Arts), vol. 1, no. 2, Sept. 1988.

Mills, Paul. "Bay Area Figurative." *Art in America*, vol. 52, no. 3, June 1964, p. 44.

"Modesto Lanzone's." *San Francisco Chronicle*, Apr. 4, 1984, p. 38.

Monte, James. "Manuel Neri and Wayne Thiebaud." *Artforum*, vol. 3, no. 44, Mar. 1965.

Morch, Al. "San Francisco." *Artforum*, vol. 5, no. 2, Oct. 1966, p. 56.

———. "We're Still in the Bronze Age." *San Francisco Examiner*, Aug. 2, 1982, p. E6.

———. "S/12: Sculpture around the Bay." *San Francisco Examiner*, Aug. 4, 1982, p. E6.

Morris, Gay. "Sculptor Manuel Neri Brings Figurative Influence to the Female Form." *Oakland Tribune*, May 30, 1989.

———. "Report from San Francisco: Figures by the Bay." *Art in America*, vol. 78, no. 11, Nov. 1990, pp. 90–97.

Morse, Marcia. "A Fascination for the Human Figure." *Sunday Star-Bulletin and Advertiser* (Honolulu), May 8, 1983.

Moss, Stacey. "Neri Sculptures: An Art Show That Renews the Faith." *Peninsula Times Tribune* (Palo Alto, CA), May 25, 1979, pp. C1, C11.

———. "The Oakland Museum Struts Its Stuff in Style." *Peninsula Times Tribune*, Nov. 5, 1979, p. C4.

"Museum Officers Honored." *Oakland Tribune*, Mar. 12, 1974.

Nadaner, Dan. "Direct Marks and Layers of Mystery." *Artweek*, vol. 18, no. 21, May 30, 1987, p. 1.

"National Sculpture Show at Foster/White Gallery." *Seattle Guide*, Feb. 1987, p. 8.

Neri, Manuel. "Chan-Chan." *Artweek*, vol. 6, no. 14, Apr. 5, 1965.

"Neri Plasters Critic." *University of California at Davis Aggie*, Nov. 1, 1972.

"Neri Posture." *S.F. Sunday Examiner & Chronicle*, June 7, 1981.

"Neri's Quartet." *San Francisco Chronicle*, Sept. 30, 1976, p. 50.

"Neri Takes on Local Figurative Movement with Sculptures." *Alameda Times Star* (Alameda, CA), June 2, 1989.

"Neri Works Featured in Laumeier Exhibition." *St. Louis Weekly*, June 29, 1983, p. 33.

Neumann-Cosel-Nebe, Isabelle von. "Olympischer Nachgeschmack." *Rhein-Neckar-Zeitung* (Mannheim, W. Germany), Mar. 5, 1985.

"New Contemporary Gallery." *Artweek*, vol. 1, no. 2, Jan. 10, 1970, p. 2.

"New Gallery Lures Back Some Artists." *San Francisco Chronicle*, Dec. 18, 1969.

Nieto, Margarita. "Manuel Neri." *Latin American Art*, vol. 1, no. 2, Fall 1989, pp. 52–56.

Nixon, Bruce. "The Way Things Were." *Artweek*, vol. 21, no. 1, Jan. 11, 1990, pp. 1, 8.

"Northern California's Guggenheims." *San Francisco Chronicle*, Apr. 12, 1979, p. 27.

Northington, Suzanne. "John Berggruen: High Priest of Price-Tag Art." *San Francisco Magazine*, vol. 1, no. 2, Feb. 1987, pp. 32–36, 70.

Northwood, Bill. "S/12: Sculptural Bonanza." *The Museum of California* (The Oakland Museum), July/Aug. 1982, pp. 4–5.

"On the Road." *Artweek*, vol. 15, no. 18, May 5, 1984, p. 10.

O'Neil, Mollie. "All About Birds." *Artweek*, Oct. 14, 1972.

"Pacific Art Festival Award." *Oakland Tribune*, Oct. 1, 1952, p. 20.

"Un 'passaporto' da scultore." *Nazione Carrara* (Carrara, Italy), Nov. 20, 1987.

Paulsen, Jane. "Living with Her Livelihood." *SF*, Aug. 1990, pp. 80–85.

"Pedro Rodríguez: Fundador del Museo de Arte Mexicano en San Francisco y Representant del Chicano en Ambos Países." *El Sol de Mexico en la Cultura*, Feb. 28, 1982, pp. 4–5.

Perkins, Janet. "A Glimpse into Other Worlds." *UC Davis Magazine*, Summer 1992, pp. 22–23.

Pincus, Robert L. "The Making of Manuel Neri." *Sculpture*, Jan./Feb. 1994, pp. 34–37.

Polley, E. M. "Benicia Area Is Now Seen As Newest Haven for Varied Artists, Craftsmen." *Sunday Times-Herald* (Benicia, CA), Aug. 14, 1966, p. W8.

"The Prospect Over the Bay." *Arts*, vol. 37, no. 4, May/June 1963, p. 20.

Reuter, Laurel. "Bronze Casting." *Grand Forks Herald* (Grand Forks, ND), Oct. 3, 1986, p. 8D.

"Review." *Artforum*, vol. 1, no. 5, Oct. 1962, p. 39.

Rice, Nancy N. "Manuel Neri." *New Art Examiner*, Oct. 1983, p. 21.

Richardson, Brenda. "Bay Area Survey." *Arts*, vol. 45, no. 1, Sept. 1970, pp. 52–53.

Robins, Cynthia. "AIDS Art Benefit to Open May 18." *San Francisco Chronicle*, Mar. 30, 1989, p. A10.

Robinson, Teri. "The Art of Giving." *UC Davis Magazine*, vol. 2, no. 3, Winter 1985, pp. 16–19.

Roder, Sylvie. "A Look at Collections." *Artweek*, vol. 16, no. 14, Apr. 6, 1985, p. 3.

———. "A Sampling of Sculpture." *Palo Alto Weekly* (Palo Alto, CA), Mar. 2, 1988, p. 32.

Ronck, Ronn. "Manuel Neri." *Honolulu Advertiser*, May 3, 1983.

Rubin, Michael G. "Neri Sculpture at Laumeier." *St. Louis Globe-Democrat*, July 2–3, 1983, p. 7E.

"San Francisco." *Artforum*, vol. 9, no. 3, Nov. 1970, pp. 89–90.

"San Francisco." *Arts*, vol. 39, no. 1, Oct. 1964, pp. 23, 25.

"San Francisco Art Institute Exhibition." *Arts*, vol. 45, no. 1, Sept. 1970, pp. 52–53.

"San Francisco: Manuel Neri at Paule Anglim." *Art in America*, Oct. 1979.

"San Francisco Museum of Modern Art." *San Francisco Focus*, June 1989, pp. 128, 135.

"San Francisco Sculptor Neri Given Art Award." *San Francisco Chronicle*, May 9, 1959.

Sanders, Luanne. "Manuel and Mary." *Creative Loafing*, April 20, 1991, pp. 69–70.

Scarborough, James. "A Dialog of Color and Form." *Artweek*, vol. 18, no. 16, Apr. 25, 1987, p. 4.

Scarborough, Jessica. "Sculptural Paper: Foundations and Directions." *Fiberarts*, vol. 2, no. 2, Mar./Apr. 1984, pp. 32–35, 73.

Schlesinger, Norma. *Sausalito Review*, no. 40, Feb. 1979, p. 21.

———. "The Art Review." *Sausalito Review*, Jan./Feb. 1981, p. 15.

———. "A Modern Medici." *Sausalito Review*, Oct. 1982, p. 15.

Schwartz, Joyce Pomeroy. "Public Art." *Encyclopedia of Architecture (Design, Engineering & Construction)*, no. 4, 1990, pp. 112–39.

Schwendenwien, Jude. "Grounds for Sculpture, Hamilton, New Jersey." *Sculpture*, vol. 13, no. 6, Nov./Dec. 1994, pp. 18–19.

"Sculpting a Niche in Modern Art." *Marin Independent Journal* (San Rafael, CA), June 5, 1989, p. D5.

"Sculptor Manuel Neri to Lead Art Lecture Series." *Baton Rouge Advocate*, Feb. 6, 1983.

"Sculpture Exhibits Open in Santa Rosa." *Argus-Courier* (Santa Rosa, CA), Nov. 4, 1977, p. 6B.

"Sculpture 1982/ISC12 and Beyond." *Images & Issues*, Nov./Dec. 1982, pp. 38–50.

Seehafer, Mary. "Injecting Bold Style into a City Co-op." *House & Garden*, Mar. 1982, pp. 118–20.

Selz, Peter. "A Modern Looks at Itself: San Francisco." *Arts*, vol. 59, no. 8, April 1985, pp. 87–93.

———. "Art in the San Francisco Bay Area, 1945–1980." *California Monthly*, vol. 96, no. 2, Dec. 1985, p. 10.

Seymour, Ann. "Gallery Owners and Artists: Adversaries or Partners?" *Nob Hill Gazette* (San Francisco), May 1984, pp. 21, 23.

———. "The Vision of San Francisco." *San Francisco Magazine*, vol. 2, no. 5, May 1988, pp. 32–37, 124.

"Sheldon to Host Sculpture Exhibition." *Independent* (Grand Island, NE), Mar. 19, 1989.

Shere, Charles. "The Figurative Tradition Gets Triple Boost." *Oakland Tribune*, Apr. 20, 1975.

———. "Impressive Showing of Bay Sculpture." *Oakland Tribune*, Feb. 22, 1976, p. E18.

———. "Show by Sculptor-Painter Neri One of Magnificence." *Oakland Tribune*, Dec. 3, 1981, pp. D14–15.

———. "Sculpture That Is Drawing with Vitality." *Oakland Tribune*, Jan. 21, 1982, p. I24.

———. "A Resort and A Park Become Galleries." *Oakland Tribune*, Sept. 26, 1982, pp. H3–5.

———. "An Exhibit Looks at the '60s." *Oakland Tribune*, Nov. 7, 1982, p. H25.

———. "A Long-Awaited Ode to California Art." *Oakland Tribune*, May 24, 1985.

———. "Oakland Museum Show Strains to Cover Rich Bay Area Art Scene Since 1945." *Oakland Tribune*, June 21, 1985, p. D3.

Slivka, Rose C. S. "From the Studio." *East Hampton Star*, Aug. 12, 1993, p. H9.

"Slouching Mortality and Inky Galaxies." *Artnews*, Jan. 1977.

Smallwood, Lyn. "Manuel Neri Lets the Ghosts of Art History Surface from His Sculptures." *Seattle Post-Intelligencer*, June 8, 1989, p. C7.

Snoeyenbos, Theresa. "Works by Expressionist Artist Displayed." *NewsPress Weekender*, Oct. 9, 1981, pp. 1–2.

Sokolov, Raymond. "What's New at the White House? It's the Art, Stupid." *Wall Street Journal*, Oct. 15, 1994, p. A18.

Somlo, Patty. "A Place in Time: Bay Area Figurative Art." *San Francisco Chronicle*, Sept. 16, 1990, "Review," p. 4.

Speer, Robert. "Manuel Neri's 'Spirit Figures.'" *Chico News & Review* (Chico, CA), Mar. 29, 1984, p. 45.

Stack, Peter. "Airport Shoes: One Show Fits All." *San Francisco Chronicle*, Dec. 2, 1987, p. E1.

Stamets, Russell A. "Art Center Exhibits Bat One-for-Three." *Wisconsin State Journal* (Madison), Dec. 17, 1987, sec. 4.

"Statue Study." *Sacramento Bee*, April 2, 1982.

Steele, Nancy. "Neri Retrospective." *Benicia Herald*, May 28, 1989, p. 6.

Steele, Sabrina. "Art Exhibit Explores Human Form." *Daily Forty-Niner* (California State University, Long Beach), Apr. 12, 1984, p. 5.

Steger, Pat. "A Star-Studded Odyssey into Art and Antiquity." *San Francisco Chronicle*, Feb. 19, 1982.

Stein, Ruthe. "A Makeshift Movement." *San Francisco Chronicle*, Dec. 13, 1989, pp. B3, B5.

Stiles, Knute. "San Francisco." *Artforum*, vol. 10, no. 3, Nov. 1971, pp. 87–88.

———. "Manuel Neri at the Oakland Museum and Braunstein/Quay." *Art in America*, Jan. 1977, p. 131.

———. "San Francisco: Manuel Neri at Paule Anglim." *Art in America*, Oct. 1979.

Stofflet, Mary. "Twenty American Artists at S.F. Museum of Modern Art." *Images & Issues*, vol. 1, no. 3, Winter 1980–81, p. 44.

Szabat, A. M. "'Sculptures on Paper' Serves as Letters of Introduction to Most Lincolnites." *Lincoln Journal* (Lincoln, NE), Mar. 19, 1989.

Tamblyn, Christine. "Bay Area Figurative Art 1950–1965." *Artnews*, Apr. 1990, p. 175.

Tarshis, Jerome. "Art in Northern California Since 1960: Anything Goes." *Portfolio*, July/Aug. 1983, pp. 44–51.

——. "Jazz Shapes Caught in Marble." *Christian Science Monitor*, Oct. 4, 1988, pp. 30–31.

Tarzan, Deloris. "Pair of Contemporary Painters Offer Exhibit of Freewheeling Arts." *Seattle Times*, Jan. 22, 1981.

Tarzan Ament, Deloris. "Engineer Training Shows in Neri's Work." *Seattle Times*, June 8, 1989, pp. F1–2.

Taylor, Dan. "Bronze Look." *Press Democrat* (Sonoma, CA), Oct. 19, 1984.

Taylor, Joan Chatfield. "In San Francisco." *Architectural Digest*, vol. 48, no. 2, Feb. 1991, pp. 116–23.

Temko, Allan. "Olé! It's Already a Triumph." *San Francisco Chronicle*, Dec. 28, 1980, pp. 13–14.

——. "The Odd Couple of Ethnic Art." *San Francisco Chronicle*, June 18, 1981.

"The Third World Painting and Sculpture." *Artweek*, vol. 15, no. 24, July 13, 1974, p. 4.

The Threepenny Review, vol. 5, no. 1, Spring 1984, illustrations.

Tromble, Meredith. "A Conversation with Manuel Neri." *Artweek*, April 8, 1993, p. 20.

Tuchman, Phyllis. "A Sculptor Captive to Body Language of the Female Form." *Newsday*, Feb. 16, 1986, part 2, p. 15.

——. "The Sunshine Boys." *Connoisseur*, vol. 217, no. 901, Feb. 1987, pp. 62–69.

"Two Views of the Figure: Neri, Adair, Art in Berkeley." *The Oakland Tribune*, May 10, 1964, p. 5.

"Un Ballo in Maschera." *San Francisco Opera Magazine*, 1977.

Van Proyen, Mark. "Commemorating a Critic's Eye." *Artweek*, vol. 16, no. 25, July 13, 1985, p. 1.

——. "Nuances of the Particular." *Artweek*, vol. 18, no. 37, Nov. 7, 1987, p. 1.

Venturi, Anita. "The Prospect over the Bay." *Arts*, May 1963, pp. 19–21.

——. "San Francisco: A Field Day for Sculptors." *Arts*, vol. 38, no. 1, Oct. 1963, p. 64.

——. "Manuel Neri." *Contemporary Sculpture: Arts Yearbook 8*, 1965, p. 138.

Villani, John. "Small Presses Have A Lot to Say about Quality Says Owner of One." *Pasatiempo*, Dec. 6, 1991, pp. 13, 42.

"Visual Arts." *Walla-Walla Union Bulletin*, Nov. 10, 1988, p. 14.

"Walking the Night Away: Second Summer Gallery Openings Friday." *Journal Newspapers* (Ketchum, ID), July 3, 1991, pp. 6B, 12B.

Wallace, Dean. "Action Sculpture by Manuel Neri." *San Francisco Chronicle*, July 1980.

Watson, Lloyd. "'Mr. Carneros' Switching from Wine to Art." *San Francisco Chronicle*, Feb. 5, 1986, p. 25.

——. "French Unveil $35 Million S.F. Realty 'Toe-Hold.'" *San Francisco Chronicle*, Mar. 1, 1989, p. C3.

Webster, Mary Hull. "Mysteries of Death and Light." *Artweek*, Apr. 23, 1992, p. 20.

Weddington, Diane. "College to Show Provocative Artwork on Jesus' Crucifixion." *Contra Costa Times*, Mar. 7, 1992, p. 4D.

"Weekend's Best." *Press Democrat* (Santa Rosa, CA), Dec. 7, 1984, p. 3E.

Weeks, H. J. "Bay Area Sculpture Survey." *Artweek*, vol. 7, no. 10, Mar. 6, 1976, p. 9.

Weisang, Miriam. "The Mexican Museum." *Northern California Home and Garden*, vol. 2, no. 7, May 1989, pp. 38–44, 87.

Weisburg, Ruth. "Ten Sculptors Working with the Figure." *Artweek*, vol. 15, no. 15, Apr. 14, 1984, p. 1.

Wells, Peggy Sue. "Engineering to Sculpturing." *Benicia Herald*, July 9, 1980, p. 10.

Where—San Francisco, June 5–8, 1989.

"Where Sculpture Stands its Ground." *American Artist*, vol. 58, no. 628, Nov. 1994, p. 66.

"White House Sculpture Garden." *Art in America*, vol. 82, no. 11, Nov. 1994, p. 152.

Wiley-Robertson, Salli. "Art in the Bay Area: 1945–1980." *Art & Antique Collector*, vol. 2, no. 10, Aug. 1985, pp. 14–16.

Wilson, William. "Sculpture: California Dreaming." *Los Angeles Times*, Aug. 29, 1982, "Calendar," p. 82.

Winokur, Scott. "Manuel Neri—At Home with His Plaster Ladies." *Oakland Tribune*, Mar. 2, 1977, pp. 15–18.

Winter, David. "Reliving Northern California Art of the Sixties." *Peninsula Times Tribune*, Nov. 2, 1982, p. C3.

Workman, Andrea. "Twenty American Artists of SFMMA." *West Art*, Aug. 22, 1980.

Zickerman, Lynne. "In Art with Manuel Neri." *The Daily Californian Arts Magazine* (Berkeley, CA), Sept. 20, 1972, pp. 12–13, 18.

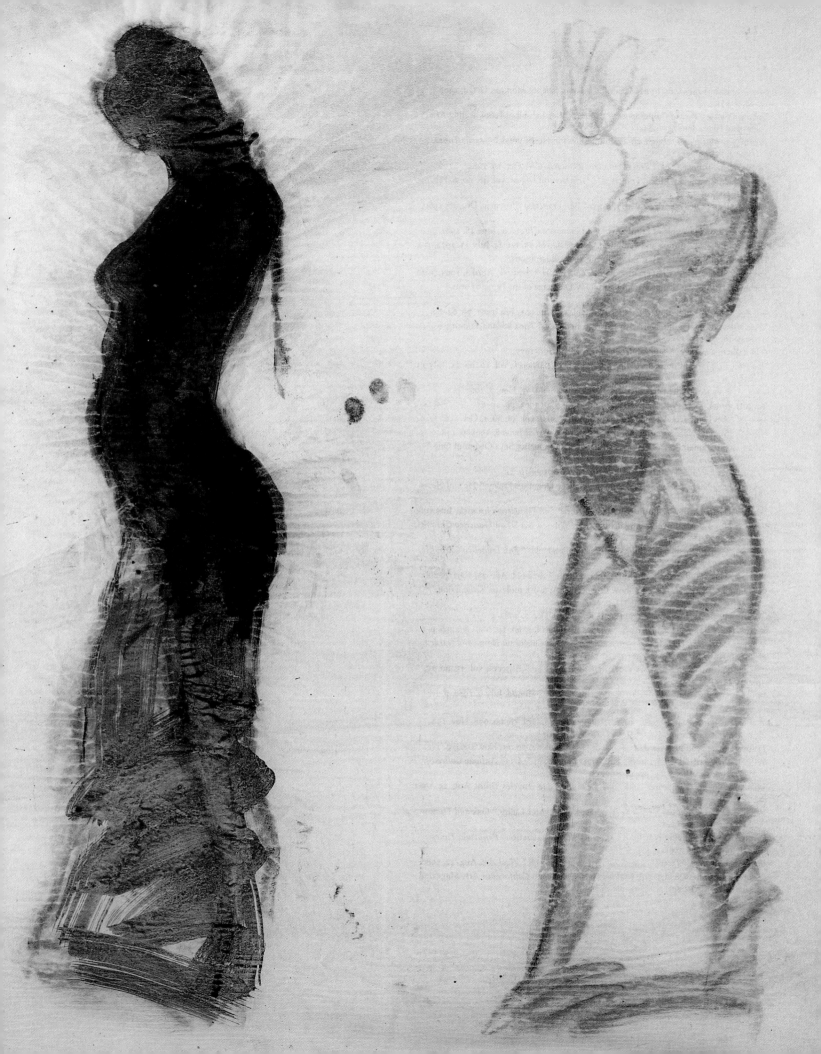

SELECTED COLLECTIONS

Bank of America Corporate Collection, San Francisco, CA
Bass Brothers Enterprises, Fort Worth, TX
Bedford Properties, Lafayette, CA
Brentwood Associates, Los Angeles, CA
Eli Broad Family Collection, Los Angeles, CA
Broida Collection, New York, NY
California Brand Flowers, Oakland, CA
The Capital Group, Inc., Los Angeles, CA
Central Bancompany, Inc., Jefferson City, MO
The Chaffey Corporation, Kirkland, WA
Chaickasha Cotton Oil Co., Fort Worth, TX
The Corcoran Gallery of Art, Washington, DC
Crocker Art Museum, Sacramento, CA
Denver Art Museum, Denver, CO
Des Moines Art Center, Des Moines, IA
Eastdil Realty Company, New York, NY
EDM Investments, San Francisco, CA
Ellis & Guy Advertising, Inc., Omaha, NE
Federal Reserve Bank, San Francisco, CA
The Fine Arts Museums of San Francisco, San Francisco, CA
Flagg Family Foundation, Monterey, CA
Forstmann Little, New York, NY
The Fox Group, Foster City, CA
Fred Jones Industries, Oklahoma City, OK
Gap Collection, San Francisco, CA
Henry Geldzahler Collection, East Hampton, NY
The Gibson Company, San Jose, CA
Grove Isle Sculpture Garden, Coconut Grove, FL
Harrold Washington Library, City of Chicago, IL
Hawaii State Council on the Arts, Honolulu, HI
Hinson & Company, New York, NY
Hirshhorn Museum and Sculpture Garden, Smithsonian Institution, Washington, DC
Honolulu Academy of the Arts, Honolulu, HI
Honolulu Advertiser/Twigg-Smith Collection, Honolulu, HI
Janss Collection, Sun Valley, ID
Kaplan, McLaughlin & Diaz, San Francisco, CA
KMS Corporation, Seattle, CA
The Lannan Foundation, Los Angeles, CA
Laumeier Sculpture Park, St. Louis, MO
Leading Artists, Inc., Beverly Hills, CA
Levi Strauss Associates, Inc., San Francisco, CA
The Linpro Company, Wilmington, DE
McDonald Management Company, San Francisco, CA
McKeller Development of La Jolla, San Diego, CA
Memphis Brooks Art Museum, Memphis, TN
The Mexican Museum, San Francisco, CA
Morrison & Foerster, San Francisco, CA
National Westminister Bank, New York, NY
Newport Harbor Art Museum, Newport Beach, CA
North Carolina National Bank, Tampa, FL
The Oakland Museum, Oakland, CA
Palm Springs Desert Museum, Palm Springs, CA
PLM International, Inc., San Francisco, CA
R. L. Nelson Gallery, University of California, Davis, CA
Raychem Corporation, Menlo Park, CA
Rene di Rosa Collection, Napa, CA

Robertson, Coman & Stephens, San Francisco, CA
Rosenberg Capital Management, San Francisco, CA
San Diego Museum of Art, San Diego, CA
San Francisco Arts Commission, San Francisco, CA
San Francisco International Airport, San Francisco, CA
San Francisco Museum of Modern Art, San Francisco, CA
Seattle Art Museum, Seattle, WA
Sheldon Memorial Art Gallery, Lincoln, NE
South West Bell, Houston, TX
State of California, The Bateson Building, Sacramento, CA
Steelcase, Inc.
Steve Chase Associates, Rancho Mirage, CA
Tampa Museum of Art, Tampa, FL
U.S. General Services Administration, Federal Courthouse, Portland, OR
University of Colorado, Boulder, CO
Virlane Foundation, New Orleans, LA
Washington State Art in Public Places, Washington State Arts Commission, Olympia, WA
Whitney Museum of American Art, New York, NY
Wright, Runstad & Company, Seattle, WA

This book serves as the catalogue for a traveling exhibition organized
by The Corcoran Gallery of Art, Washington, D.C., and held at the
Corcoran January 31–May 5, 1997, and at San Jose Museum of Art
June 7–September 14, 1997.

Library of Congress Cataloging-in-Publication Data

Neri, Manuel, 1930–
 Manuel Neri : early work 1953–1978 / with essays by John Beardsley
 . . . [et al.].
 p. cm.
 Includes bibliographical references.
 ISBN 0-88675-046-6 (cloth : alk. paper). — ISBN 0-88675-047-4
 (paper : alk. paper)
 1. Neri, Manuel, 1930– —Themes, motives. I. Beardsley, John.
 II. Title.
 N6537.N43A4 1996
 709′.2—dc20 96-11220

Catalogue concept, research, and project coordination by
Anne Kohs & Associates, Inc., San Francisco
Produced by Marquand Books, Inc., Seattle
Designed by John Hubbard and Ed Marquand
Edited by Lorna Price, with assistance from Diane Roby and
Jessica Altholz Eber
Except where noted, all photography by M. Lee Fatherree, Oakland, CA,
with assistance from Nick Cedar
Photography in the Illustrated Chronology is from a variety of sources,
with credit listed when the photographer is known.

Printed by C & C Offset Printing Co., Ltd., Hong Kong